Arts of the Pennsylvania Germans

ARTS OF THE PENNSYLVANIA GERMANS

HAS BEEN SELECTED BY

THE PENNSYLVANIA GERMAN SOCIETY

AS VOLUME 17 IN THEIR SERIES OF PUBLICATIONS

ARTS OF THE
Pennsylvania Germans

SCOTT T. SWANK

WITH

BENNO M. FORMAN, FRANK H. SOMMER,

ARLENE PALMER SCHWIND, FREDERICK S. WEISER,

DONALD H. FENNIMORE, & SUSAN BURROWS SWAN.

EDITED BY CATHERINE E. HUTCHINS

A Winterthur Book

PUBLISHED FOR

THE HENRY FRANCIS DU PONT WINTERTHUR MUSEUM

BY W. W. NORTON & COMPANY

First Edition
Library of Congress Cataloging in Publication Data
Swank, Scott T.
Arts of the Pennsylvania Germans.
Includes index.
1. Art, Pennsylvania Dutch—Pennsylvania—Addresses,
essays, lectures. I. Henry Francis du Pont Winterthur
Museum. II. Title.
N6530.P4S8 1983 745'.089310748 82-22300
ISBN 0-393-01749-4
W. W. Norton & Company, Inc., 500 Fifth Avenue, New York, N. Y. 10110
W. W. Norton & Company Ltd., 37 Great Russell Street, London WC1B 3NU
1 2 3 4 5 6 7 8 9 0

Contents

Acknowledgments

Seven authors incur a multitude of debts on a project of this size. First and foremost we thank James Morton Smith, director of Winterthur, who marshaled the resources of the museum behind this project, and The Pennsylvania German Society, who expressed interest in this book from the start. We also extend our thanks to the Friends of Winterthur, whose generosity enabled several of us to undertake an intensive month-long study tour in regions of Germany, Austria, and Switzerland from which many of the Pennsylvania Germans emigrated.

While we did research at many institutions in Pennsylvania, we extend our special thanks to the helpful staffs of Berks County Historical Society, Lancaster County Historical Society, Library Company of Philadelphia, Moravian Archives, Pennsylvania State Library at Harrisburg, Van Pelt Library at University of Pennsylvania, and the Office of Register of Wills in both Berks and Lancaster counties. Those people whom we must thank by name for their help and advice in our research include Theresa Beard, Deborah J. Binder, Lester P. Breiniger, Jr., Charles L. Brownell, Mr. and Mrs. C. J. Bryer, Jr., Sheldon Butts, Désireé M. Caldwell, Karin Calvert, Jonathan P. Cox, Phillip H. Curtis, Ellen P. Denker, Henry P. Deyerle, Nancy Goyne Evans, Ellen Gehret, Barbara A. Hearn, Susan Hearn, Bernard L. Herman, Patricia Herr, Mrs. David Hottenstein, Charles F. Hummel, Alan J. Keyser, Kenneth Lyon, Susan H. Myers, Larry M. Neff, Sandra C. Northrup.

Charlotte and Edgar Sittig, June Sprigg, Beatrice K. Taylor, Maja Teufer, Neville McD. Thompson, Vicky Uminowicz, Dell Upton, Anita Van Sand, Edwin P. Wolf 2nd, and Don Yoder.

We also thank the members of our families who critiqued early drafts and helped us refine our ideas as we turned research notes into manuscripts. Specific and heartfelt thanks go to Kathleen B. Swank, Elizabeth V. Forman, and Wilmot Schwind, Jr.

Many people at Winterthur assisted in the various technical stages of creating this book. Patricia R. Bullen took care of numerous details and scheduled many meetings and research trips for us. Linda A. Carson made the word processing center available. Anne T. Hart, Ann Marie Keefer, Deidre McPherson, and Jane M. Mellinger typed countless drafts for us. Karol A. Schmiegel, Alberta M. Brandt, and Kathryn K. McKenney coordinated the fine photography by George J. Fistrovich and Wayne B. Gibson. Ian M. G. Quimby took this on as a Winterthur Book. Catherine E. Hutchins and Patricia R. Lisk deftly edited and copy edited the disparate manuscripts into a cohesive whole.

Finally, we must thank the late Henry Francis du Pont, founder of Winterthur Museum, who amassed the largest and finest public collection of Pennsylvania German artifacts in the world and brought together a teaching and a curatorial staff so that each might benefit from proximity to the other.

Introduction

Arts of the Pennsylvania Germans is a popular introduction to the material aspects of one of the most long lived subcultures in the United States—Pennsylvania Germans. While Germans migrated to many areas of what are now the United States and Canada, this book focuses on the eighteenth- and early nineteenth-century Pennsylvania experience, most particularly those Pennsylvania German domestic furnishings, books, and manuscripts assembled by Henry Francis du Pont for several rooms in his home, Winterthur, in Delaware.

Arts of the Pennsylvania Germans is also a historical dialogue between past and present. The objects presented here, many shown for the first time, are statements by the culture that produced them between 1750 and 1840 and of the culture that preserved and collected them from 1840 to 1970. Over these two centuries the distinctive Pennsylvania German subculture emerged, faded into obscurity, and experienced a twentieth-century renaissance.

The historical dialogue explores the intricate relationships between Old World and New World and partially delineates the complexity of the transmission of culture through people, cultural practices, printed materials, and material culture. It also examines the complexity of that transmission process within Pennsylvania's urban and rural areas. The modern dialogue is equally complex—the simultaneous revival of self-consciousness among the state's Pennsylvania Germans and the discovery of the culture and its so-called folk art by non-German contemporaries.

Arts of the Pennsylvania Germans tries to capture the significance of the centuries' long reverberations between Germanic and English cultures that culminated in the acceptance of Pennsylvania German artifacts as art in major American museums and private collections in the 1920s and 1930s. The national recognition of things Pennsylvania German by collectors, museums, and the government-sponsored folk art survey of the 1930s, the Index of American Design, created a mood of respect never before experienced by the settlers and their descendants. The popular expression of this respect appeared in the 1940s and 1950s with the revival of so-called peasant painting by decorators like Peter Hunt, the promotion of Dutchy interior decorating by national magazines like *House and Garden*, and the proliferation of commercial products with Pennsylvania Dutch symbols and slogans on their labels.

At the same time that they were being discovered by the "outside world," Pennsylvania Germans were reasserting their ethnic pride. Within the Pennsylvania German community some enterprising Dutchmen began cashing in on the commercial possibilities of renewed ethnic identity. Scholarly and popular manifestations of ethnic pride were strengthened by the revival of craft traditions, the inauguration of folk festivals, the creation of academic programs at colleges like Franklin and Marshall and Ursinus, the establishment of major periodicals, including the *Pennsylvania Dutchman* (now *Pennsylvania Folklife*), and concerted efforts at dialect maintenance through radio, newspapers, and formal instruction in public schools and private colleges.

In the enthusiasm of discovery and self-consciousness, the historical and the contemporary became intertwined to such an extent that it is now difficult to distinguish between the history of the Pennsylvania Germans and our preconceptions and projections about that history. Artifacts, the high visibility of the Amish and Mennonites (sectarian groups that were a minority in the eighteenth and nineteenth centuries), and our own views of nineteenth-century folk culture intrude upon an understanding of the complexity of eighteenth-century life among the Pennsylvania Germans. The surviving folk art, in particular, has been glossed with a veneer that hinders understanding of the expressive qualities of the objects.

Many of the objects discussed and illustrated in this book can be classified as masterpieces of Pennsylvania German culture. Henry Francis du Pont collected the best material

available to him from 1926 until his death in 1969, with *best* defined according to his own aesthetic standards. Because of these limitations, the Winterthur collection is not representative of the entire Pennsylvania German society in the eighteenth and nineteenth centuries. The museum's strengths are furniture, pewter, earthenware, Fraktur, printed books, and manuscripts. Less well represented are glass, metals, and textiles. With the exception of pewter, which Charles F. Montgomery analyzed in depth in *The History of American Pewter*, and the many, but miscellaneous, toys, boxes, baskets, and household utensils, *Arts of the Pennsylvania Germans* reflects the collection that du Pont assembled for Winterthur.

Like many collectors, du Pont purchased those Pennsylvania German objects that he regarded as folk art. Consequently, he passed up the typical but undecorated and strictly utilitarian household items in favor of ornamented ones. Similarly, authors of the many books about the Pennsylvania Germans have stressed the ornamented household objects and have analyzed the possible meanings of the many ornamentations and forms rather than the methods of construction or the cultural context from which they sprang. The former approaches are important and appealing, but they have obscured and retarded other approaches to examining the artifacts. *Arts of the Pennsylvania Germans* explores some of these alternate paths.

Based on a study of a selective corpus of Pennsylvania German material life, this book sets forth eight propositions:

First, the florescence of Pennsylvania German arts occurred within a narrow time frame. Of the thousands of extant handcrafted, hand-decorated Pennsylvania German objects, approximately 80 percent are dated or can be assigned to the years 1770 to 1840. Although certain artifacts, such as slip-decorated earthenwares and painted furniture, were made long after 1840, and all media have examples predating and postdating these years, the arts in Pennsylvania flourished in these seven decades.

Second, handcrafted and hand-decorated objects can be traced to all major areas of Pennsylvania German migration, particularly western Pennsylvania, the Shenandoah Valley of Virginia, and Ontario, Canada, but the heartland of production was southeastern Pennsylvania. The flowering of Pennsylvania German arts had a circumscribed geographical source. This heartland is a relatively small territory stretching from Bucks and Northampton counties in the east through York County in the west, and from Lancaster County in the south to Northumberland County in the north. The area lying at the juncture of Lancaster, Lebanon, and Berks counties has been remarkably productive of the type of material illustrated in this volume and must be considered the epicenter of Pennsylvania German folk culture.

Third, the flowering of Pennsylvania German art coincides with a similar phenomenon in central, northern, and eastern Europe. The process began earlier in Europe and continued later, reaching a peak in Scandinavia and eastern Europe in the late nineteenth century, but central Europe's experience is chronologically analogous to Pennsylvania's. In the twentieth century this common experience opened the way for a considerable body of central European material to be peddled in America as Pennsylvania German, particularly painted glass, slip-decorated earthenware, and decorated boxes.

Fourth, the realization that the Pennsylvania German experience, although unusual in many details, had its analogue in Europe, enables us to suggest that so-called peasant or folk art is primarily rural bourgeois art. Preindustrial bourgeois attitudes, certain types of economic activity, geographic concentration, and a particular level of prosperity appear to be characteristic of each of the societies that produced significant quantities of art. The decorated and individualized artifacts are material expressions of modernizing cultures basically free of the restraints of the past and perched on the brink of modernization. While manifested chiefly in a rural context, the art of the rural bourgeoisie owes a great debt to urban bourgeois influences in Europe and America. Without the urban impulses of the eighteenth century there would have been no great florescence of rural folk art in Europe or in America. The objects presented in this volume are the result of a synthesis of Germanic and English cultures and of urban and rural forces.

The European side of this process at work is visible in the material culture of the Hohenlohe region of Württemburg. Hohenlohe is a rural agricultural region watered by the Kocher River. Its principal urban center is Schwäbisch Hall. In the eighteenth century the region reached a high level of prosperity based on commercial cattle raising. The regional society included a small group of noblemen and a large middle class of independent farmers and tradesmen. The pride and prosperity of the people were demonstrated in several tangible ways. The houses of the middle class increased in size throughout the eighteenth century and well into the nineteenth century. As the houses expanded, the ornamentation of them flourished. Key decorative features of the region's architecture became the carved and painted exterior corner posts. To match the house exteriors and the fancy work of the house carpenters, cabinetmakers began producing decorated furniture. A few even signed their work. Both architecture and furniture expressed Hohenlohe pride and self-sufficiency and communicated that the Hohenlohe

farmer was in control of his world. The colorful furniture is rich in traditional associations but eclectic in its borrowing. Motifs are drawn from religious, political, and urban sources, and the patterns often imitate in paint the contrasting inlay or carved features of urban rococo furniture. However, the work of Hohenlohe craftsmen was not simply derivative. Their work had to be expressive of the needs and aspirations of their local customers. Consequently, one of the most distinctive features of their furniture is the frequent use of painted medallions with portraits of the farmer and his wife rather than the prince and his lady. This was one of many ways that the people adapted the motifs, symbols, and forms of other times and another class to their particular desires.

The labeling of German farmers in Europe and America has become a semantic game. The term *peasant* is one favorite, as is the designation *bourgeois*. Both terms are misleading because of their twentieth-century overtones. If by *peasants* is meant antiurban, antiintellectual, anticapitalist rural folk imbued with love of land, family, and community, dwelling simply in peace and harmony, then we must reject the term. If calling these farmers *bourgeois* is construed to mean market-oriented, highly individualized entrepreneurs, capitalists, for whom wealth was the only worthwhile goal, then it too must be rejected. But in a sense both views have some merit. Looking at German and Pennsylvania German society in eighteenth- and nineteenth-century terms, rather than by twentieth-century standards, the Pennsylvania Germans were preindustrial bourgeoisie, holding a mixture of traditional and modern values that prevented them from being pure peasants or capitalists. They were not content just to get by; they did engage in capital accumulation; they were tied in to a market economy. Yet, they retained many traditional values and were often content to be comfortable by their standards rather than rich by the standards of the Anglo-American culture around them. They were urban as well as rural based, in contrast to the classic peasant model, and were caught up in the inexorable process of modernization.

A fifth characteristic of the arts of the Pennsylvania Germans is that they are overwhelmingly Protestant. In Europe, both Protestant and Catholic regions experienced a similar flowering of folk art, good evidence that no single religious persuasion was the central force behind the emergence and production of folk art. Nevertheless, religion exercised a strong influence, particularly on surface ornamentation. Most Catholic visual imagery was not transferred to America; the arts of the Pennsylvania Germans were Protestant, with appropriate substitutes for Catholic signs and symbols. In Pennsylvania, the materials now called folk art were produced in a narrowly circumscribed framework. Most of the professionals and artisans produced artifacts for a Lutheran and Reformed clientele, and most of the craftsmen were also of the same persuasions. Although sectarians did produce important bodies of folk art, the central lifeline of Pennsylvania German culture pulsated with Lutheran and Reformed blood. The major religious events of Reformed and Lutheran experience—birth, baptism, confirmation, and marriage—provided occasions that called for material expressions of faith and celebration, but not all Pennsylvania folk art was religious in nature. While generally governed by Protestant, rather than Catholic, aesthetic principles, most of the decoration was only nominally or distantly religious in inspiration, and much was devoid of any spiritual associations. Most decoration was a proudly worn badge of cultural identity, rather than a sermon in paint.

A sixth observation about the arts of the Pennsylvania Germans is that the categories of material culture represented in this volume—commonly called folk art or decorative art—were rarely considered art in their native culture. They were primarily tools to facilitate daily living and at the same time devices that helped manipulate social interaction, control the material and nonmaterial environment of their owners, and convey meaning. These artifacts were a form of communicative expression—a "silent" but powerful language. Material expressions actively conveyed culture, actively transmitted meaning, and were essential elements in components achieving cultural and personal goals. They were more than consumer goods of temporary and low-level significance. Because they were produced by hand, often to order, for a society in which traditional values had meaning, even though undergoing change, the artifacts of Pennsylvania German culture communicated the life experiences of their producers and consumers. Even the most mundane objects participated in this process, and some items were invested with more significance than others.

Seventh, the bulk of the art described in this book, except for Fraktur, was produced by rural, village, and town artisans. These craftsmen served a prosperous bourgeois community and became active transmitters of Pennsylvania German culture. Their products were usually executed with abnormally fine skill and recognized as appropriate by the hybrid culture that constituted the bulk of their clientele. Most of today's highly prized Pennsylvania German folk art was crafted by full- or part-time professionals—potters, weavers, joiners, metalworkers, and, in the graphic arts, literate men trained in the arts of the scrivener—rather than the noble tillers of the soil passing the time on winter days. And in some fields, especially glass production, work was

often confined to a factory system. These facts have been overlooked because many researchers have begun by looking for folk artists, the untrained individuals creatively and intuitively shaping raw material to suit the whim of either the producer or the customer. We must recognize that all performers, whether modern artists, dancers, musicians, or artisans working at a craft, achieve mastery through grounding in the rules and conventions (the grammar) of their medium and through practice. Modern society tends to give lip service to innovation, but craftsmen in traditional societies held another view. Some degree of spontaneity was tolerated within the proved structure of process and stylistic convention, but drastic variation in the grammar could lead to economic disaster. Consequently, there was a sameness to craft production that made it recognizable and acceptable. The material objects conformed to the community sense of "good fit."

The eighth proposition is that Pennsylvania German artisans did not produce exclusively Pennsylvania German products. In all fields, the preponderance of pottery, furniture, and other material goods probably never was Germanic in appearance. Pennsylvania German furniture craftsmen produced more furniture in the English manner, and in American adaptations, than in pure Germanic form. Except for sgrafittowares, which were produced mostly in Montgomery County, Pennsylvania German earthenware production is similar to that of non-German regions of Pennsylvania. Furthermore, Germanic influence, particularly in technology, was much more extensive throughout Pennsylvania than has previously been thought.

In order to begin to understand the arts of the Pennsylvania Germans we must abandon terminology and concepts that utilize the term *simple*. Time after time the popular literature on the Pennsylvania Dutch has referred to their "simple" furniture and the rejuvenating "simplicity" of their way of life. We must also eschew ideas of homogeneity. There was not a unified German culture in Pennsylvania or in Germany.

The story of the Pennsylvania Germans is one of fascinating complexity. The process of forging a Pennsylvania German identity consumed the better part of the eighteenth century and involved a winnowing process that we are only beginning to comprehend. Pennsylvania was a trading post of European cultural options, and the Pennsylvania Germans had more choices than we have previously thought possible. For example, the dialect of the Pennsylvania Germans is one of many transferred to America from Germanic Europe. Gradually one South German dialect prevailed. And the *Fraktur schrift* of Pennsylvania Germans was one particular writing style chosen from the several available in Germanic Europe. The religious preferences of the Pennsylvania Germans appear hopelessly segmented when one looks at the plethora of sects in southeastern Pennsylvania, yet most of the church groups and sects were strongly influenced by pietism, a particular brand of Protestantism. Architecture and decorative arts also show a winnowing process. Many forms, construction techniques, and specific decorative patterns known in Europe were never transferred to America.

In decoration in particular a moderating tendency appears in Pennsylvania German objects when compared to European counterparts. This reflects, in varying degrees, (1) the governing aesthetic principles of pietistic Protestantism in America, (2) the lack of certain types of highly skilled craftsmen in America, (3) the narrow pool of visual imagery in America, for example, the lack of urban and royal models, the relative scarcity of books and prints, and the loss of visual stimuli emanating from Catholic Europe, especially Italy, (4) the socioeconomic conditions in America which discouraged the selection of expensive options on standard forms, and (5) the fact that the artisans who emigrated to America were predominantly conservative in the practice of their crafts. Thus, even had there been no English culture forcing accommodation, the material culture of the German immigrants would have taken on a character distinct from that of their European homelands.

From the date of first settlement—1683—through the 1770s, the story of the Pennsylvania Germans is a saga of the transmission of ideas and the sorting of options. Between 1780 and 1840 a Pennsylvania German consensus emerged. The urban centers were crucial to the development of the consensus, but by the 1830s they were losing their influence among Pennsylvania Germans because the inhabitants were rapidly acculturating. The distinctive Pennsylvania German culture became increasingly confined to rural villages and the countryside as the nineteenth century progressed. Yet in the twentieth century this nineteenth-century rural folk culture has been too often misread as an eighteenth-century survival. In order to avoid that trap we shall begin by exploring the German culture that put new roots in Pennsylvania's soil during the eighteenth century.

SCOTT T. SWANK

Arts of the Pennsylvania Germans

The Germanic Fragment

SCOTT T. SWANK

MIGRATION

In August 1733 the *Elizabeth* sailed into Philadelphia and unloaded an anxious band of German immigrants. Men, women, and children sighed with relief as they touched solid earth and gave thanks for their lives. They were the lucky ones, able to sense the hope of the future beginning to waft over their escape from the past. The immediate past had been gruesome. On the voyage the Cowalls, aged 32 and 24, lost both of their children—a set of twins. The Houswets, aged 34, had watched their three youngest children die one by one. The Smiths lost their only child. Two of the three Tinick children died. Other families also experienced the loss of one or more children. All had left their homes with great anticipation of life in the New World, but now doubts intruded. Had they made the right decision? They had not been starving at home. . . . Family members had warned them of danger. . . . Perhaps a few more years would have turned fortunes around. . . . How would they tell the grandparents about the loss of their grandchildren?[1]

The story of the German migration is the composite of thousands of individual biographies, some of which resound with triumph and others of which reverberate with pathos. One of the latter is that of Christian Lenz from Beutelsbach, Württemberg. Lenz, born in 1699 and by trade a mason, left for Pennsylvania in 1746 with his wife and four children. The records say "[he left because of an] aggra-

vated case of syphilis, taking leave neither from his father nor his pastor. Was a restless fellow here. Died before he got to Pennsylvania."[2]

For every tragedy the records and the history of Pennsylvania bear witness to many successes. The individual, the single family, the particular ship list must be blended into a whole in order to comprehend the magnitude of these migrations. The largely eighteenth-century movement of German peoples to Pennsylvania is a small fragment of one of the major demographic movements of world history. From the late sixteenth to the early twentieth centuries Europe disgorged millions of her inhabitants into all parts of the globe—to other parts of Europe, to African colonies, to South America, and to North America. The resulting transformations are staggering to contemplate.

Louis Hartz, a distinguished political scientist from Harvard University, has proposed a theory regarding these transformations of people and cultures in *The Founding of New Societies*. Hartz contended that "when a part of a European nation is detached from the whole of it, and hurled outward on to new soil, it loses the stimulus toward change that the whole provides." The fragment essentially freezes in its development vis-à-vis its parent culture and undergoes a self-generated transformation. This metamorphosis is a realization of potential inherent in the old society. The new society is both an escape from the challenges and threats of the past and a denial of the future as it would have been

[1] Ralph B. Strassburger, *Pennsylvania German Pioneers: A Publication of the Original Lists of Arrivals in the Port of Philadelphia from 1727 to 1808*, ed. William J. Hinke, vol. 1 (Norristown, Pa.: Pennsylvania German Society, 1934), pp. 765–67. Several of the family names on the passenger list of the *Elizabeth* are either non-Germanic or have had their spelling distorted, for example, Cowall.

[2] Don Yoder, "Emigrants from Wuertemberg: The Adolf Gerber Lists," in *Pennsylvania German Immigrants, 1709–1786: Lists Consolidated from Yearbooks of the Pennsylvania German Folklore Society*, ed. Don Yoder (Baltimore: Genealogical Publishing Co., 1980), p. 84. Of the 435 names, 231 have known occupations. Most of the others are women and children. Most of the group emigrated between 1749 and 1764.

worked out in Europe among contending forces—political antagonisms, religious tensions, class conflicts, and pressures of overpopulation. Removal from the parent culture permitted full self-realization by the child. In the case of the United States, the child was a Protestant bourgeois fragment. The development of a capitalistic, politically liberal American society was a natural consequence given the ideological homogeneity of the fragment.[3]

While Hartz said nothing specific about the German fragment of American colonial culture, these German immigrants were solidly bourgeois. Not as ideologically self-conscious as many of their English counterparts, but just as supportive of the practical principles of eighteenth-century liberalism, the Germans at first created an enclave within the English fragment, but they also endorsed the English societal pillars of Protestantism, capitalism, and liberalism.

From the founding of the American colonies to the present, German-speaking immigrants have constituted the largest and most evenly distributed cultural subgroup in United States history. Forty-eight of fifty states have experienced significant German settlement.[4] We define Pennsylvania Germans as those German-speaking Europeans who settled in Pennsylvania between 1683 and about 1820 and their descendants. The flowering of their folk culture occurred a bit later, between 1750 and 1840. After 1840 dramatic social and economic changes occurred that drastically altered the composition of Pennsylvania German culture.

At the core of any examination of ethnic culture lies the problem of group identity formation. Other writers have been quick to point out that these German-speaking immigrants shared no single group identity before arrival on American soil. They came principally from the Rhenish Palatinate, the German cantons of Switzerland, Württemberg, Hesse, and Alsace-Lorraine, but they also came from nearly every German state.

By the eighteenth century the shaky Holy Roman Empire contained hundreds of large and small separate principalities and territories and was a congeries of "virtually independent states" with "particularism" rather than centralization as its overarching political ideology. A few, like Prussia and Austria, achieved eighteenth-century greatness under enlightened rulers and embraced vast territory.

Others were so small they barely represented a challenge for a strong walker on a Sunday stroll.[5]

As important as the political divisions were in the eighteenth century, "the horizontal cleavages between the 'estates' of society were far wider in fact than the vertical ones between states." Religious divisions, especially the Catholic-Protestant cleavage, also transcended political issues. The Germans who migrated to Pennsylvania carried with them strong concepts of religious, political, and cultural particularism, reinforced by the mountain / valley geography of their homelands. Even their language, which appeared to be the most "immediate unifying factor in an English society," accentuated differences because of the multitude of dialects. This lack of a national language and culture stimulated one observer to quip that the Germans "are even reduced to swearing in French for lack of a national oath."[6]

The forging of Pennsylvania German identity out of such diverse elements was no slight task, but over time a distinct Pennsylvania German culture did emerge. These eighteenth-century German immigrants shifted their political allegiances, created a new sense of place, coped with disruption in deeply rooted patterns of life, and faced a new world. In the American environment, prestigious and powerful forces offered alternatives for group and personal identity, for example, an urban life in Philadelphia with English language and customs. In this maelstrom of opportunities and shifting boundaries the newly arrived Germans faced at least three options: assimilation, rejection, and acculturation.

Total assimilation required a general abandonment of old allegiances and German identity and entrance into the mainstream English colonial culture. This usually involved anglicizing names, a very symbolic step, since name, next to race and costume, has always been a person's most important badge of identity. Most German immigrants followed this path.

Second option, the rejection of the mainstream English colonial culture, was the most difficult of all options since it required intense effort to maintain tradition and to resist new and sometimes attractive ideas. (The Old Order Amish have been more successful at cultural-boundary maintenance than any other German group in Pennsylvania.) In addition to being socially and psychologically difficult, such

[3] Louis Hartz, *The Founding of New Societies: Studies in the History of the United States, Latin America, South Africa, Canada, and Australia* (New York: Harcourt, Brace and World, 1964), pp. 3, 6–7.

[4] Heinz Kloss, "German as an Immigrant, Indigenous, Foreign, and Second Language in the United States," in *The German Language in America: A Symposium*, ed. Glenn G. Gilbert (Austin and London: University of Texas Press, 1971), pp. 108–9.

[5] W. H. Bruford, *Germany in the Eighteenth Century* (Cambridge: At the University Press, 1965), pp. 1–3; Karl Scherer, "The Emigration from the Palatinate to Pennsylvania" (paper delivered at the annual meeting of the Pennsylvania German Society, Millersville, Pa., May 4, 1974), p. 3.

[6] Bruford, *Germany*, p. 46; Lester W. J. Seifert, "The Word Geography of Pennsylvania German: Extent and Causes," in Gilbert, *German Language*, pp. 17–18.

resistance was not attractive to most of the German immigrants. While no studies have yet satisfactorily explored the motivations of the immigrants, general evidence confirms that only a tiny minority of Germans fled Europe in order to retain a way of life. Instead, the overwhelming majority were disenchanted with the future they saw before them and wanted a change of place and circumstances. They wanted opportunities to improve their positions economically and psychologically. Those migrating from Wertheim, for example, claimed poverty and expressed fear of becoming beggars as their debts mounted. In some cases they confided that opportunities for their trades were shrinking, as did Lorenz Albert in 1754. Albert, a cartwright, claimed his trade could no longer support him now that farmers in his region made their own plows. "Poverty and uneasiness over his wife and child" drove them to immigrate to Pennsylvania.[7]

A third alternative, controlled acculturation, falls between assimilation and rejection on the continuum. This usually means that the minority group controls the space and degree of accommodation and retains the spirit of its own culture yet moves toward acculturation quite steadily. A significant minority of Germans pursued this course in Pennsylvania.

The German immigrants were not as resistant to English culture as either native Americans or Afro-Americans. They shared with the English a common Western civilization. Continual waves of migration and contact with Europe reinforced the deep structure of Germanic culture they brought with them. These factors combined to produce, in the years 1750 to 1840, a hybrid culture. It was both European and American, both English and German—a fragment caught between two worlds.

Until recently, studies of the Pennsylvania German culture were generally ethnic celebrations.[8] In 1976 James Lemon achieved a major breakthrough with his *comparative* study of Germans and English (including Scots Irish and Welsh) in southeastern Pennsylvania.[9] Most other books on the Pennsylvania Germans are marked by strong genealogical and contributionist biases. Their focus is on German origins, early settlers, pioneer conditions (chiefly set in physical terms of hardship, which these sturdy Germans whacked out of the way with ease), process of assimilation, and ethnic achievement. In consequence these books are often defensive in tone, endeavoring to correct misconceptions and dispel stereotypes, or aggressive in efforts to elevate the Pennsylvania Germans to a more prominent position. Lemon's work is significant because it offers a comparison of Germans and non-Germans in a particular frame of time (1681–1800) and space (Lancaster and Chester counties), and it presents a detailed socioeconomic analysis to understand regional development.

The actual number of German immigrants to Pennsylvania between 1683 and 1820 is impossible to determine, but the general estimate is at least 75,000. The migration came in waves, and the highest crests were between 1749 and 1754. As mentioned above, the chief sources of emigration were the Palatinate, Württemberg, and German-speaking cantons of Switzerland.

The extent of Palatine emigration can be gauged from a few case studies. They suggest that up to one-fifth of the population left certain villages between 1709 and 1789. Specifically, over a span of 100 years, approximately 1,000 persons emigrated from Grumbach, near Lauterecken, maintaining the population of this village at 250 during this long period. According to Karl Scherer, director of the Heimatstelle Pfalz in Kaiserslautern, nearly 85 percent of them emigrated to the United States.[10]

The Duchy of Württemberg, in the heart of South Germany, experienced heavy losses also. This rural, agricultural, Lutheran territory was more densely settled than most

[7] Otto Langguth, "Pennsylvania German Pioneers from the County of Wertheim," in Yoder, *Pennsylvania German Immigrants*, pp. 191–254.

[8] One of the earliest ethnic celebrations is William Beidelman, *The Story of the Pennsylvania Germans: Embracing an Account of Their Origin, Their History and Their Dialect* (Easton, Pa.: Express Book Printers, 1898). It is representative of the antiquarian scholarship of the late nineteenth and early twentieth centuries and is a fascinating revelation of prevailing attitudes among a historically conscious Pennsylvania German elite. The best of the general accounts are Ralph Wood, ed., *The Pennsylvania Germans* (Princeton: Princeton University Press, 1942); Fredric Klees, *The Pennsylvania Dutch* (New York: Macmillan Co., 1958); Homer T. Rosenberger, *The Pennsylvania Germans, 1891–1965: Frequently Known as the "Pennsylvania Dutch"* (Lancaster: Pennsylvania German Society, 1966); and William T. Parsons, *The Pennsylvania Dutch: A Persistent Minority* (Boston: Twayne Publishers, 1976). None of these adequately treats Pennsylvania German material culture. Members of the Pennsylvania German community, with strong ethnic ties, have provided most that is published

on material culture. For the most general treatments, see John Joseph Stoudt, *Pennsylvania German Folk Art: An Interpretation*, Pennsylvania German Folklore Society, vol. 28 (Allentown, Pa., 1966); John Joseph Stoudt, *Early Pennsylvania Arts and Crafts* (New York: A. S. Barnes, 1964); and Thomas J. Wertenbaker, *The Founding of American Civilization: The Middle Colonies* (New York: Charles Scribner's Sons, 1938). More specialized treatments of Fraktur, architecture, and furniture have also been written by Pennsylvania Germans such as G. Edwin Brumbaugh, Monroe H. Fabian, Donald Shelley, Frederick S. Weiser, and Don Yoder.

[9] James T. Lemon, *The Best Poor Man's Country: A Geographical Study of Early Southeastern Pennsylvania* (Baltimore and London: Johns Hopkins University Press, 1972). Lemon's conclusions about the Germans in Lancaster County are generally applicable to Berks County.

[10] Scherer, "Emigration," p. 9. Heimatstelle Pfalz, based in Kaiserslautern, is an organization interested in Palatine customs and traditions and their dispersion throughout the world.

German states. From June 1747 through June 1750, 4,049 residents emigrated, but only 2,480 ventured across the Atlantic. Pomerania attracted 1,512 and Hungary 57. The 1760s were also years of heavy migration to the American colonies and to Pomerania.[11]

The tendency of Germans to migrate with countrymen, with neighbors from the same village, and even occasionally as an entire congregation, enabled the Germans to hold English culture at bay long enough to create their own society in Pennsylvania. Another factor crucial to cultural maintenance was the adherence of most of the immigrants to an established Protestant religion. The preponderance of the eighteenth-century immigrants were either Lutheran or Reformed, with small but self-conscious minorities of Brethern (Dunkards), Mennonites, Moravians, and Schwenkfelders. There were also two small Catholic settlements—one at Goshenhoppen, which straddled Berks and Montgomery counties, the other at Conewago, which straddled York and Adams counties. A third reinforcement to German culture was family. If the ship lists that provide details on women and children can be taken as a reliable sampling of the total pattern, the Germans migrated as families.

The earliest mass German migration went to England in 1709 and to New York in subsequent years. Between May 1 and June 12, 1709, 6,520 "Palatines" arrived in London (table 1). The figures indicate that more than 50 percent of the immigrants were young people and children. The migration was one of 1,278 nuclear families, and the average family had 2.77 children.[12]

Of the hundreds of ship lists published in Ralph Strassburger and William Hinke's monumental *Pennsylvania German Pioneers*, only a few provide the names of women and children. In each case the women and children greatly outnumber the men, and families can be reconstructed. A sampling of the lists reveals that in addition to being married parents, most of the German adults were in the prime of life. Only a few ship lists provide ages, but on these less than 5 percent of the total immigrant pool were fifty or older. For ages over sixty the percentage drops to approximately 1 percent. In seeking their opportunities in a new land, German immigrants forsook their parents as well as their homes. Their new culture in Pennsylvania became an immediate rarity—a society without elders.

On the snow *Two Sisters*, 110 immigrants sailed from Rotterdam to Philadelphia, arriving September 9, 1738.

[11]Yoder, "Emigrants from Wuertemberg," pp. 9, 14.
[12]For more information, see Frank R. Diffenderffer, "The German Exodus to England in 1709," in *Pennsylvania-German Society Proceedings*, vol. 7 (Reading, Pa., 1897), p. 307.

TABLE 1

German Immigrants to England May 1–June 12, 1709

Men with families	1,278
Wives	1,234
Widows	89
Single men	384
Single women	106
Boys 14 and above	379
Girls 14 and above	374
Boys under 14	1,367
Girls under 14	1,309

Source: Frank R. Diffenderffer, "The German Exodus to England in 1709," in *Pennsylvania-German Society Proceedings*, vol. 7 (Reading, Pa., 1897), p. 307.

There were 41 men, 30 women, and 39 children under age sixteen. The passenger list reported no one over sixty and only 4 people (2 men, 2 women) in their fifties. Ten percent of the group were forty and older, roughly 35 percent were under twenty, and 55 percent were in their twenties and thirties.[13]

While the number of passengers per ship varies considerably, the percentages remain fairly constant. For example, the *Samuel*, arriving in Philadelphia from Rotterdam on August 17, 1733, conveyed 291 persons. Nine men and 9 women were in their fifties, and 1 woman was sixty-two. These 19 plus 39 people in their forties constitute 20 percent of the total, while the 138 passengers under age twenty constitute 47 percent. Only 33 percent were in their twenties and thirties as compared to 55 percent on the *Two Sisters*.[14]

The *Two Sisters* and the *Samuel* demonstrate the approximate range of ages on ship lists of the 1734–54 period, the first heavy wave of German immigration. No list that provides ages contains more than a 20 percent composition of people aged forty and over, and the twenty to thirty-nine

[13]Strassburger, *Pioneers*, list 54A, pp. 209–11.
[14]Strassburger, *Pioneers*, list 29A, pp. 106–10. A complete statistical analysis of ship lists is in Marianne Wokeck, "The Flow and Composition of German Immigration to Philadelphia, 1727–1775," *Pennsylvania Magazine of History and Biography* 105, no. 3 (July 1981): 249–78. Wokeck estimated that 70,410 German immigrants entered the port of Philadelphia between 1683 and 1775. Of these, 26,188 were men and 44,222 were women and children. Approximately 50 percent of the immigrants arrived in the peak years, 1748–54. She confirmed that the Germans generally migrated in nuclear families and that the immigration was a youthful one. The chief exceptions were the sectarian groups such as the Mennonites, who tended to migrate as extended families and congregations, bringing some of their patriarchs with them.

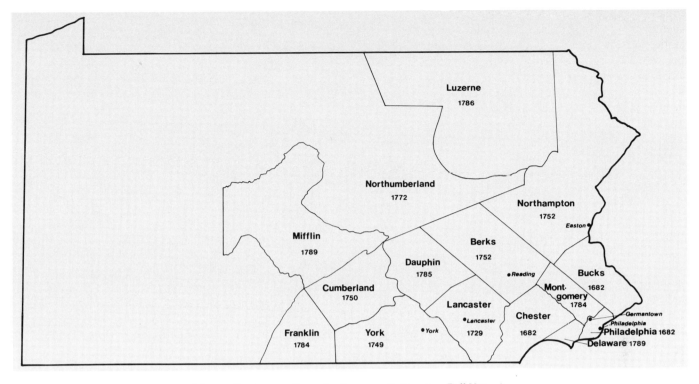

Map. 1. Southeastern Pennsylvania, ca. 1798. (*Drawing, Dell Upton.*)

age bracket is never less than 33 percent of the total. The young people and children under twenty vary from 20 to 47 percent.

Extrapolating from a small sample is dangerous when the bulk of the lists are mute about women and children as well as about age, marital status, and other vital statistics of men. But, since in Philadelphia the captains were required to provide a list of men's names in addition to a total number of freights, those names can be assumed to refer primarily to heads of households. Since the immigrants continued to flow from the same region of Europe until the 1820s, any drastic change in social profile over time is unlikely.

The typical German male immigrant was a family man seeking to improve his future. His age, most likely early thirties, meant he had several decades of productive life to accomplish his goals. Consequently, he was an ideal worker for a developing society. He and his spouse brought large numbers of children and younger brothers and sisters with them, creating a rapid growth potential for their new settlements.

The absence of the elderly is one of the startling facts to emerge from the skimpy statistics at hand. The Germanic fragment did not have to sustain a large number of aged people incapable of substantial productivity. This suggests that the Pennsylvania German agriculturally based society

does not fit the currently accepted explanation of eighteenth-century colonial society.[15] The Pennsylvania German preindustrial economy was not marked by extended families or dominated by a tiny elite of patriarchs who controlled the land, and its agrarian economy was already heavily salted with artisans and a bourgeois mentality. If the Pennsylvania German experience is indicative of general eighteenth-century immigration patterns, then the steady influx of young to middle-aged foreign-born people, still in the prime years for childbearing, played a major role in maintaining the youthful profile of the American population.

The youthful Germanic fragment created a prosperous society in Pennsylvania, but the land was so fertile that they could hardly have missed (map 1).[16] Of vital significance for the creation of a rapidly modernizing economy and the emergence of a hybrid Pennsylvania German culture was a symbiotic relationship with the dominant English culture that fostered economic cooperation but allowed a degree of self-sufficiency for German newcomers. Their margin of prosperity depended on exporting wheat and other agricul-

[15] David H. Fischer, *Growing Old in America: The Bland-Lee Lectures Delivered at Clark University* (New York: Oxford University Press, 1977), pp. 27, 31–32.

[16] Lemon, *Poor Man's Country*, pp. 32, 227.

TABLE 2

Occupations of Male German Immigrants to England
May 1–June 12, 1709

Baker	32	Miller	27
Bricklayer	4	Miner	3
Brickmaker	6	Saddler	7
Butcher	15	Schoolmaster	10
Carpenter	90	Shoemaker	40
Carver	2	Silversmith	2
Cook	1	Smith	46
Cooper and brewer	48	Stocking weaver	5
Glazier	2	Student	1
Hatter	3	Surgeon	3
Herdsman	4	Tailor	58
Hunter	5	Tanner	7
Husbandman & vinedresser	1,083	Turner	6
Joiner	20	Weaver	66
Locksmith	2	Wheelwright	13
Mason	48		

Source: Frank R. Diffenderffer,
"The German Exodus to England in 1709,"
in *Pennsylvania-German Society Proceedings*,
vol. 7 (Reading, Pa., 1897), p. 307.

TABLE 3

Occupations of Eighteenth-Century Emigrants
from Württemberg

Army officer (Heeroffizier)	2	Lawyer (Jurist)	1
Baker (Bäcker)	13	Linen weaver (Leinweber)	4
Barber (Friseur)	1	Mason (Maurer)	6
Brewer & baker (Brauer & Bäcker)	1	Miller (Müller)	2
Butcher (Metzger)	7	Miner (Erzgraber)	1
Carpenter (Zimmerman)	8	Nailsmith (Nagelschmied)	3
Cartwright (Wagner)	6	Needle & pin maker (Nadler)	1
Clothmaker (Tuchweber)	4	Potter (Hafner)	1
Cobbler (Schuhflicker)	4	Ropemaker (Seiler)	1
Cooper (Küfer)	8	Schoolmaster (Schulmeister)	2
Day laborer (Tagelöhner)	18	Servant (Knecht, Magd, Diener)	2
Dealer in lace (Spitzenhändler)	1	Shepherd (Schäfer)	9
Dyer (Fäber)	1	Shoemaker (Schuhmacher)	13
Fancy baker (Zucherbacher)	1	Smith (Schmied)	8
Farmer (Bauer)	21	Stocking weaver (Strumpfweber)	2
Farmhand (Landarbeiter)	5	Stonecutter (Steinhauer)	2
Farrier (Hufschmied)	2	Surgeon (Chirurgus)	3
Fisherman & peddler (Fischer & Hausierer)	1	Tailor (Schneider)	19
Grave digger (Totengräber)	1	Tilemaker (Ziegler)	1
Huntsman (Jäger)	1	Toolmaker (Werkzeugmacher)	1
Innkeeper (Gastwirt)	1	Vinedresser (Weingärtner)	9
Joiner (Schreiner)	6	Watchman (Wächter)	2
Judge (Richter)	1	Weaver (Weber)	23

Source: Don Yoder, "Emigrants from Wuertemberg: The
Adolf Gerber Lists," in *Pennsylvania German Immigrants,
1709–1786: Lists Consolidated from Yearbooks of the Penn-
sylvania German Folklore Society*, ed. Don Yoder (Balti-
more: Genealogical Publishing Co., 1980), p. 84.

TABLE 4

Württemberg Emigrants
1804–5

Trade	Margaret September 19, 1804	Margaret August 26, 1805	Trade	Margaret September 19, 1804	Margaret August 26, 1805
Apothecary		1	Miller	1	
Architect	1		Millwright		1
Baker	2	3	Musician	1	
Barber		1	Potter		1
Blacksmith	1	2	Printer	1	
Bookbinder	1		Ropemaker	1	
Brewer	1		Schoolmaster	1	
Butcher	3	4	Servant boy		1
Carpenter	2	1	Servant maid		6
Clerk	3	2	Shepherd	1	
Cooper		2	Shoemaker	5	3
Cooper/brewer	3		Silk dyer	1	
Distiller	1		Silversmith		1
Doctor	1		Soap boiler	2	
Farmer	25	25	Stocking weaver	1	
Farmer/distiller		1	Stonemason		6
Farmer/vinedresser		1	Stonecutter	2	
Gentlewoman		1	Tailor	3	6
Geometer	1		Tobacco-box maker	1	
Glassmaker	1		Turner	1	
Goldsmith		2	Vinedresser		2
House carpenter		1	Weaver	12	6 (2 Irish)
Joiner	1		Weaver/midwife		2 (husband & wife)
Merchant	1	1	Wine gardener		1
Military officer	1 (Dutch)		Total	81	84

Source: Ralph B. Strassburger, *Pennsylvania German Pioneers: A Publication of the Original Lists of Arrivals in the Port of Philadelphia from 1727 to 1808*, ed. William J. Hinke, 3 vols. (Norristown, Pa.: Pennsylvania German Society, 1934), 3:153–56, 163–69.

tural products through Philadelphia and, until the Revolution, through English merchants, but within the Pennsylvania German heartland stretching from York County to Northampton County, they produced nearly everything they needed for a comfortable existence. They were from the start an aggressive bourgeois culture of farmers and tradesmen, not a placid society of peasant folk.[17]

[17] Most popular writings on the Pennsylvania Germans continue to use the terms *peasant* and *folk* loosely and interchangeably as did Robert Redfield in *The Little Community: Viewpoints for the Study of a Human Whole* (Chicago: University of Chicago Press, 1955) and in *Peasant Society and Culture: An Anthropological Approach to Civilization* (Chicago: University of Chicago Press, 1956). Wertenbaker in *Founding of American Civilization* expressed the Turnerian viewpoint that the American frontier transformed the German peasant into the American farmer. My research has shown that the transformation was well underway before the immigrants left the German states.

The records of the 1709 migration of Palatines to England provide an occupational listing for the men who arrived between May 1 and June 12 (table 3).[18] But, unfortunately, early ship lists rarely provide information on the occupations of the immigrants. The *Elizabeth* brought sixty-one men to Philadelphia in 1733. Twenty-four were listed as farmers, and ten were undesignated. If we assume that the latter were chiefly agricultural laborers, then the immigrants on this ship were predominantly engaged in agricultural and related pursuits. But twenty-five others were tradesmen—eight weavers, three carpenters, three shoemakers, two joiners, two smiths, one tailor, one cooper, one sadler, one miller, one wagoner, one butcher, and one

[18] Most of these went on to New York, but in occupation they are similar to those who went to Pennsylvania 25, 50, and 100 years later (Diffenderffer, "German Exodus," p. 307).

bonemaker—and two were fiddlers.[19] Lists of eighteenth-century Württemberg emigrants are more explicit about trades and provide a complementary profile (table 3).

Ship lists made between 1800 and 1820 more regularly provide occupations. They reveal the same range of trades found on the Württemberg lists and in sufficient quantity to demonstrate that the Pennsylvania German community received a continual influx of new artisans. This infusion was important, for the new tradesmen brought the evolving traditions of Germany and strengthened the Germanic side of the hybrid Pennsylvania German culture. Two lists of Württembergers after 1800 indicate the same types of trades and occupations as the earlier period and a similar high ratio of artisans to farmers (table 4).

Existing treatments of the Pennsylvania Germans provide inadequate analysis of the socioeconomic situation in Europe in the eighteenth century. Although most of Germany trailed England in the shift to preindustrial values, by the start of the eighteenth century Germany was a middle-class society. The eagerness to migrate, in spite of the risks and costs, in order to improve one's lot in life is in itself a key signal of the change in values. Many who migrated from Germany were farther along the path to middle class than those left behind.[20]

Germany was in transition, not feudal, but not yet wholly modern. Class consciousness was still evident in the pattern of life. The nobility maintained a multitude of symbolic and direct marks of distinction, for example, in costume, in titles, and in customs such as the privilege of wearing a sword or powdering one's hair. The education of the nobility was isolated. Their consumption patterns encouraged luxuries such as porcelains and fine textiles, art and architecture. At the other extreme, the peasantry, although no longer legally serfs, still remained outside the market economy. The sizable and emerging middle-class society was town and village based but not necessarily urban. Most German towns were semirural; tradesmen kept gardens and livestock and often practiced some agriculture. The villages were primarily centers for agricultural activities.[21]

Agriculture was in the throes of a prolonged depression from 1700 until about 1750. Population growth outstripped increases in arable land, and the result was a large number of day laborers and nonagricultural workers. In 1750, this nonagricultural sector may have totaled a third of the population. After 1750, economic conditions allowed for agricultural expansion. New acreage, improved grain yields, sustained high grain prices, and the introduction of new and improved tools and techniques brought new prosperity to middle-class farmers. At the same time, many of the German states actively sought to improve their economic position by stimulating the "embourgeoisiement" of society. Their chief tactics were to encourage industry, expand the trades (and weaken the guilds), found schools, foster wider distribution of land, and expand armies and bureaucracies.[22]

Although many of the immigrants to America were landless farmers and day laborers, most were landed farmers (Bauern) and tradesmen caught in the economic transition and eager to improve their opportunities. While it is important to suggest that large numbers of German artisans continually flowed into Pennsylvania from the 1720s to the 1820s, it is more important for us to determine what happened to the farmers and tradesmen once they settled in Pennsylvania.

SETTLEMENT

Historians have described the "pull" of America in terms of religious freedom and economic opportunity, the latter most often couched in terms of the abundance of cheap land. Many believe the lure of land was so strong that it changed settlement patterns. In their view, it prompted Germans in America to abandon village life for independent family farms. Lemon suggested that the shift occurred because village-based farmers, who already saw themselves as individual operators in a market economy, tried to organize their farming enterprise in the most efficient manner. By living within their own farms, rather than in villages, they could save time and gain important individual control over their source of livelihood.[23] Yet, even if all German immigrants could have afforded land, which by midcentury in settled areas near Philadelphia they could not, not all German immigrants needed land, because many were not farmers. Thousands of German immigrants chose to remain in Philadelphia, and thousands more settled the country towns of

[19] Strassburger, *Pioneers*, list 30A, pp. 765–66, app. 1.

[20] John U. Nef, *The Conquest of the Material World* (Chicago: University of Chicago Press, 1964), pp. 69, 84, 110–11. E. E. Rich and C. H. Wilson, eds., *The Economic Organization of Early Modern Europe*, Cambridge Economic History of Europe, vol. 5 (Cambridge: At the University Press, 1977), p. 131.

[21] Bruford, *Germany*, pp. 53, 69, 103, 131–32. An example of middle-class prosperity is the eighteenth-century cattle and grain farmers of the Hohenlohe region of Württemburg. See W. M. Einsiedel-Schömer, *Bauernkunst in Hohenlohe* (Schwäbisch Hall: Eppinger-Verlag, 1972), pp. 8–9.

[22] Rich and Wilson, *Economic Organization*, pp. 131, 55–56, 583.

[23] Lemon, *Poor Man's Country*, pp. 106–9; Parsons, *Pennsylvania Dutch*, p. 55.

the Pennsylvania German region such as Lancaster, Reading, and York.[24]

A recent examination of Germantown by Stephanie Wolf revealed that from the outset Pennsylvania Germans living there displayed an urban, industrial impulse. Much of this impulse developed out of the economic opportunities afforded by nonagricultural activities and the number of artisans who settled in Germantown, but part of it was conveyed through the urbanity of the founder, Francis Daniel Pastorius.[25]

Pastorius was the earliest and most influential of the urban Germans. Educated principally in Nuremberg, Strasbourg, and Basel, he settled into the practice of law in Frankfurt about 1679. Influenced by the pietist movement, Pastorius rejected his upper-class life and sailed to Pennsylvania in 1683 as the agent for the German Company of Frankfurt. In Germantown, Pastorius served as a land agent and from 1702 to 1718 ran a school that specialized in English instruction.[26]

Although Pastorius should rank as one of the most literate and urbane Americans at the beginning of the eighteenth century, his reputation among historians trails those of prominent Puritan divines, Philadelphia and Boston merchants, and southern planters of the same period. Neither he nor Germantown typifies the American or the Pennsylvania German experience as historians have customarily delineated it. "It was craft and processing, raised to a surprisingly complex and sophisticated level, rather than commerce and trade, that formed the backbone of the economic system in Germantown and made it unique among Pennsylvania towns." By 1798 Germantown had fifty-one industrial establishments and eighty-five shops. Among the industries were slaughterhouses, tanneries, breweries, gristmills, a sawmill, an oil mill, a corn mill, and a chocolate mill. In 1773 the ratio of craftsmen to tradesmen (merchants, innkeepers, shopkeepers) was eleven to one, as compared to three to one in Lancaster, Philadelphia, and Reading. Although its economy was diversified, Germantown specialized in textile processing. Out of 457 residents for whom occupations were listed in 1773, fifty-seven were fabric crafts such as weaving. In 1793 eighty-two fabric

craftsmen were listed among the 597 taxables. From 1683 to 1793 weaving and related activities were a staple of the Germantown economy, even though these trades remained among the lowest in vocational worth throughout the period.[27]

Whereas Germantown was atypical in the seventeenth and early eighteenth centuries, by the late eighteenth century towns in the rest of the Pennsylvania German heartland were conforming to Germantown's pattern. The most Germanic of the large towns was Reading.[28] Reading was also representative of the social and economic development of the urban centers in the region. It was both market town for a large agricultural region and seat of the county government. Situated at the juncture of Schuylkill River and Tulpehocken Path, Reading was not on the major migratory route west and consequently was more isolated than country towns like Lancaster and York. Most visitors to Reading were German.

Thomas Penn's agents had laid out the town in the 1740s. Lot sales began in 1749. In 1752, Berks County was established, and Reading became the county seat. The frontier nature of the region and the French and Indian Wars slowed economic growth at midcentury, but after 1764 the town experienced rapid economic growth. Population growth may have been spurred by the wars, for the population doubled from 113 married taxables in 1755 to 230 in 1761. Over the next twelve years to 1773 the population of Reading increased only 11 percent. The Revolution temporarily gorged the town with transients, and after the war steady infusions of immigrants brought the population to 1,095 men and boys and 1,118 women and girls by 1790.[29]

The composition of the population of Reading hovered at 87 percent German and French Huguenot and 13 percent English throughout the 1760s and 1770s. Most of the English were American born, often from Philadelphia or Berks County families, whereas the majority of the German stock were German born (63.4 percent in 1767, 54.1 percent in 1773).[30] In 1767, most of the residents (perhaps as

[24] Moravians as a group were urban oriented; see William J. Murtaugh, *Moravian Architecture and Town Planning: Bethlehem, Pennsylvania, and Other Eighteenth-Century American Settlements* (Chapel Hill: University of North Carolina Press, 1967).

[25] Stephanie G. Wolf, *Urban Village: Population, Community, and Family Structure in Germantown, Pennsylvania, 1683–1800* (Princeton: Princeton University Press, 1976), pp. 126.

[26] Marion D. Learned, *The Life of Francis Daniel Pastorius, the Founder of Germantown* (Philadelphia: William J. Campbell, 1908), pp. 62, 83, 88, 116.

[27] Wolf, *Urban Village*, pp. 102–3, 122–23; Lemon, *Poor Man's Country*, p. 128, table 23.

[28] I refer to the following counties as the Pennsylvania German heartland: Lehigh, Northampton, Montgomery, Berks, Schuylkill, Lancaster, York, Lebanon, and Dauphin. Bethlehem may have been more Germanic than Reading, but the tight control over its affairs by the Moravian church and its communal nature guaranteed that Bethlehem would be an anomaly.

[29] Laura Leff Becker, "The American Revolution as a Community Experience: A Case Study of Reading, Pennsylvania" (Ph.D. diss., University of Pennsylvania, 1978), p. 26.

[30] Becker, "Reading," pp. 29, 31. These percentages are conservative figures because not all birthplaces of Germans could be determined. Most recent immigrants first settled in towns not townships.

many as two-thirds to four-fifths of the German born) had arrived in Reading between 1750 and 1754.

The German population of Reading was a youthful one with artisan training. In origin they were chiefly South German (the Palatinate and Württemburg). Of the 138 men whose ages are known, twenty-five (18 percent) were over fifty, with only six men (4.4 percent) over sixty. By the 1780s, 18 percent were sixty or older. The mean age at death in Reading in 1767 was approximately forty-two.[31]

In Reading even the most eager assimilators had a difficult time breaking away, whereas in Germantown efforts to maintain ethnic identity were lax or deliberately discouraged. Of the forty-five marriages in Reading from 1767 to 1791 where ethnic background is identifiable, only two involved a German-English marriage. The English population was so small that the Church of England had no building in the colonial period to serve its tiny band of adherents.[32] The class and religious differences between the Germans and their Anglican and Quaker neighbors reinforced the ghetto qualities of the lives of the English minority. Germans in Reading could and did learn the English language and English ways and built English-style buildings, but rapid acculturation was impossible because of the overwhelming Germanic character of both Reading and Berks County. The use of German language persisted and ethnic loyalties remained strong into the mid nineteenth century, at which time Reading attracted a new wave of German migration.

In this stable German community the English were more transient than any other segment of the population. While they did exercise strong political and legal power in the town, they certainly did not control the social and economic life (table 5), and many English of wealth longed to escape social isolation.[33]

Reading began life as a middle-class town and remained stable in the distribution of wealth. In 1767 the top 10 percent of taxpayers controlled 33.2 percent of the wealth. In 1773 they controlled 32.6 percent, much less than that held by the top 10 percent of taxpayers in colonial cities—63 percent of the wealth in Boston in 1771 and 72 percent in Philadelphia in 1774.

In 1773 approximately 75 percent of the Reading men owned their own houses compared to 20 percent in Philadelphia. In addition, Reading was a family town of strong religious convictions. Churches and church schools flourished more than civic and cultural organizations. At least 75 percent of the German population was church affiliated.

[31] Becker, "Reading," pp. 57–59, 68.
[32] Wolf, *Urban Village*, p. 139; Becker, "Reading," pp. 81, 46, 97.
[33] Becker, "Reading," pp. 96–97, 222.

	TABLE 5

Distribution of Wealth in Reading
1767

Taxpayer group	Percentage of wealth controlled by national groups		Total
	English	German	
Top 10%	26.0%	7.2%	33.2%
Next 30%	33.3%	24.6%	57.9%

Source: Laura Leff Becker, "The American Revolution as a Community Experience: A Case Study of Reading, Pennsylvania" (Ph.D. diss., University of Pennsylvania, 1978), p. 132.

In 1767 nearly 50 percent were Lutheran, with 22 percent Reformed, and over 20 percent unknown or unaffiliated. German sectarians were totally absent except for one known Mennonite. English and German Catholics numbered only eight (3.3 percent).[34] The compatibility of the Lutheran and Reformed traditions, coupled with the absence of Catholics and sectarians, added to the homogeneity.

Most Reading Germans were comfortable and prosperous. They remained aloof from major political office, preferring to reelect continuously certain prominent English and to concentrate on their economic well-being and local politics. These patterns persisted through the revolutionary war. The war provided economic and political opportunities for the Germans in Reading to gain more control over their town. Many well-to-do Germans increased their worth during the war, and the wealthy German and English elite of Reading seized a greater proportion of the town's total wealth. In 1779 the top 10 percent controlled 54.1 percent of the total compared to 32.6 percent in 1773. But generally the war did not alter the economic profile of the community. The war did cut the flow of immigration, which had spurted between 1767 and 1773, and by 1790 Reading was an American town, with slightly less than 50 percent of its population being foreign born.[35]

All through its eighteenth-century history, Reading, like Germantown, was a town of tradesmen, and its primary economic importance lay in the great number of trades and industries practiced there. From the establishment of the town, craftsmen constituted at least 60 percent of all men whose occupations we can ascertain, and the occupational profile shifted only moderately from 1750 to 1791. The principal changes occurred in the increasing specialization

[34] Becker, "Reading," pp. 129–30, 132, 180–81, 234, 35, 46.
[35] Becker, "Reading," pp. 275, 282–84, 440.

of trades and the success of certain types of businesses, particularly hatting, the fabric crafts, and those associated with livestock processing for meat and hides. All of the building and woodworking trades remained strong during this period. During the last half of the eighteenth century Germans dominated the trades; at least 60 percent of all German males in Reading were employed in a craft occupation.[36]

In 1784 Reading listed 349 taxable heads of households. Of these, 171 were engaged in crafts and trades, with the majority in food processing, leather, hatting, cloth processing, building trades, and woodworking and metal crafts. Only 6 were professionals—doctors, surveyors, scriveners—whereas 27 were engaged in trade—such as merchants and shopkeepers—or services—such as innkeepers and carters. Two millers and 3 laborers were also listed. In sum, 209 of the 349 taxables had listed occupations. These figures then should be regarded as conservative estimates of the actual numbers in each category, but it is clear that at least 50 percent of all English and German taxables were engaged in craft occupations. The increased specialization is illustrated by the metalworking trades. Those formerly designated as just smiths were in 1784 differentiated as silversmiths (4), gunsmiths (2), locksmiths (1), coppersmiths (1), nailsmiths (1), and smiths or blacksmiths (9). In 1784, 17 individuals were listed as weavers or stocking weavers and 2 as blue dyers. In the woodworking trades in 1784 there were 9 joiners, 5 turners, and 4 carpenters.[37]

Reading represents a country town in contrast to Germantown's urban village. While in many respects the most German of the large Pennsylvania German country towns in the eighteenth century, it was by no means the largest or most important. That honored placed was held by Lancaster, the colonies' largest and most prosperous inland town, and the one in closest contact with Philadelphia.

Lancaster was laid out by 1735, and by 1740 Germans held 75 percent of the lots. As in Reading, Germans of Lutheran and Reformed persuasions dominated the town's German population, but the legal and political control of the town remained in the hands of English lawyers, speculators, and businessmen. In 1742 Lancaster was incorporated as a borough. Its lowland site along the modest Conestoga Creek was a less choice site than that of Reading, but its location on the major migratory route from Philadelphia to the west and south soon outweighed any detrimental features. Lancaster quickly became a major trade and market center for the Pennsylvania and Maryland frontiers and as early as 1759 listed thirty-eight shopkeepers and one merchant, many of whom had close ties to Philadelphia merchants and access to world trade. Its status as county seat provided political ties to Philadelphia.[38]

From the outset, Lancaster was a much more cosmopolitan town than Reading, with more ethnic diversity and a constant flow of transients headed to and from Philadelphia and other points east, west, or south. While still a German town in terms of the majority of the population, Lancaster was an intellectual and cultural center with numerous printers, its own newspaper, a library, and a college (Franklin College, founded 1787).

The non-German population was larger and more firmly rooted in Lancaster than in Reading and accounted for roughly a third of the total population between 1759 and 1788 as compared to approximately 15 percent in Reading.[39] It was primarily British, including Scots Irish, and it was strong enough religiously to support four non-German religious bodies—Church of England, Quaker, Presbyterian, and Roman Catholic. The Lancaster elite was in town to stay, and it controlled the social and economic life of the town as well as its legal and political life. Through religious, cultural, and political institutions the elite offered the German population a challenge. The Germans had to make *substantial* concessions to English ways in order to succeed in Lancaster. As in Germantown, many saw no reason to cling to their German identity. They anglicized their names, joined the Church of England, and married into English families. Because Lancaster had a much faster rate of assimilation than Reading, it was a hybrid town well before the 1790s.

Lancaster was most like Reading in the prevalence of craftsmen. In 1759 Lancaster was already an important leather-working center. Although most of the wealthiest tanners were English Quakers, a few were Germans, and most of the tannery workers were German. Of Lancaster's 249 artisans 26 percent were leather workers, including 34 shoemakers and 19 saddlers. Twenty percent of the artisans worked in the building trades, 18 percent in the textile-processing trades, and 15 percent in metalworking (a significant percentage of the last engaged in gunsmithing). The production and processing of food and beverages occupied 10 percent of the tradesmen.[40] Not all of these artisans were German, but all of the trades were dominated by German artisans.

While the occupational profiles of Reading and Lancas-

[36] Becker, "Reading," p. 113.

[37] *Pennsylvania Archives*, 3d ser., vol. 18 (Harrisburg, 1898), pp. 650–58.

[38] Jerome H. Wood, Jr., *Conestoga Crossroads: Lancaster, Pennsylvania, 1730–1790* (Harrisburg: Pennsylvania Historical and Museum Commission, 1979), pp. 7–20, 23–45, 93–110.

[39] Wood, *Conestoga Crossroads*, p. 159.

[40] Wood, *Conestoga Crossroads*, pp. 123–25.

ter in the 1780s were still similar, by then Lancaster had a larger population and a number of trades not found in Reading. For example, Lancaster had a glassblower in 1780 and in 1788 a stonecutter, a weaver's plate maker, two brass founders, an organmaker, and a wigmaker. Between 1759 and 1788 the total number of artisans in Lancaster increased from 249 to 322, but the percentage of artisans to taxables declined from 73 percent to 61 percent.[41]

Germantown, Reading, and Lancaster were three of the most important urban centers in the Pennsylvania German heartland. Since they pursued three different patterns of development, we cannot assume that they represent the spectrum of possible variations. Bethlehem, Easton, Harrisburg, Lebanon, Sunbury, and York as well as smaller villages like Gettysburg, Hamburg, Hanover, Lititz, Manheim, Marietta, Nazareth, Schaefferstown, and Womelsdorf were centers of German artisanship whose development remains unstudied. The same is true of towns of mixed ethnicity. For example, Marietta, Lancaster County, had a large number of German craftsmen. In 1814 Marietta listed 209 heads of households and 50 single men. Of these men, there were 22 joiners, 2 cabinetmakers, and 38 carpenters. Approximately a third to half of these woodworkers were German.[42]

The large number of craftsmen in the towns and villages before 1800 demonstrates that a significant proportion of the population engaged in nonagricultural pursuits in an agrarian economy. To this urban contingent we must add the large number of rural artisans. While it is often assumed that rural artisans were nearly full-time farmers and part-time. In Berks County (map. 2) in the eighteenth century the different profile.

A study of the tax lists reveals that rural craftsmen were consistently among the lowest third of the taxpayers, often only one step above farm laborers. Most owned no land or very little. Second, while the names of many rural artisans remain on the tax lists over time, most disappear in a short time. In Berks County (map 2) in the eighteenth century the mobility rate is much higher for artisans than for farmers. A few artisans moved to Reading, but most of those who migrated moved out of the county altogether. Third, among those who remained there was a tendency to abandon their trade or at least drop the occupational label in later tax listings; however, this may reflect the fact that men were taxed for the occupation that yielded the highest income. Inventory listings of tools reveal that many farmers had the tools

TABLE 6		
Occupations of Cumru Township Taxables		
1767		
Craftsman	*Miller*	*Other*
Smith-5	Fuller-1	Farmer-1
Papermaker-1	Grist-2	Innkeeper-2
Shoemaker-1	Grist & Saw-3	
Tailor-2	Saw-4	
Wagoner-1		
Weaver-2		

Source: *Pennsylvania Archives,*
3d ser., vol. 18 (Harrisburg, 1898).

to practice one or more trades, but to what extent most of them did so is unknown. Obviously, the pressures on rural artisans were substantial. They could remain in their trade and rural location and rarely achieve significant economic success, they could move to better their situation, or they could buy land and move into the yeoman class. Evidence shows most migrated or became farmers, and a few remained in place in their same trade, achieving mixed degrees of financial success. The following analysis of Berks County tax returns illustrates the relative status of artisans in 1767 and 1784.[43]

In Cumru Township 145 heads of households paid taxes ranging from one to fifty-five shillings in 1767. Twenty-five are identified by occupation, 12 of whom are craftsmen (table 6). Only 27 householders paid 10s. or more in taxes, and 7 of these paid 20s. or more. The latter were not craftsmen. George Meyer (1,000 acres of land) led the list with a tax of 55s., followed by Samuel Flower (400 acres, 40s. tax), Jonas Seely, Esq. (700 acres, 35s. tax), Peter Road, gristmiller (300 acres, 30s. tax), William Huttenstein (130 acres, 24s. tax), Nathan Evans, gristmiller (300 acres, 20s. tax), and Ludwig Moore (400 acres, 20s. tax).

Two of the twelve artisans paid taxes higher than five shillings: Christian Maurer, papermaker, with 30 acres of land, paid a 16s. tax, and John Bullman, blacksmith, with a farm of 200 acres, paid a 15s. tax. No other craftsman owned a large farm, and four owned no land. Aside from Bullman's farm, the acreage owned by artisans ranged from 67 down to 14 acres, well below the average owned by farmers. Of course, there were other craftsmen in the township in 1767 in addition to those designated as such on the tax list. For example, in 1768 Jonas Adams, undesignated but present in 1767, was listed as a shinglemaker. Similarly,

[41] Franklin Ellis and Samuel Evans, *History of Lancaster County* (Philadelphia: Everts and Peck, 1883), pp. 369–71; Wood, *Conestoga Crossroads*, pp. 124–25.

[42] Ellis and Evans, *Lancaster County*, p. 626.

[43] Both the 1767 and 1784 provincial and state tax returns and assessments for Berks County are in *Pennsylvania Archives*, 3d ser., vol. 18. The 1767 tax returns lack occupational listings for many townships.

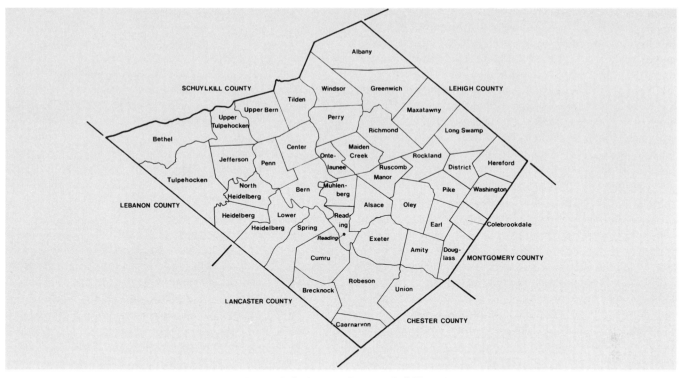

Map. 2 Berks County. (*Drawing, Dell Upton.*)

farmers who practiced trades on a part-time basis rarely are identified as artisans on the tax lists.

The picture changed only slightly by 1784. The number of artisans in Cumru had increased to sixteen. Four were weavers, and one was a "joyner." The joiner owned no land but had two cows and supported a family of three. Only one of the four weavers owned land (63 acres).

Heidelberg Township in 1767 contained 220 heads of households paying taxes ranging from one to sixty shillings. Only 46 paid tax of 10s. or more, and 14 paid 20s. or more. The highest taxes were paid by men with substantial lands: William Allen, Esq. (500 acres, 60s. tax); John Patton (1,000 acres, 40s. tax); Frederick Kobel, gristmiller and sawmiller (200 acres, 26s. tax); Adam Hain (300 acres, 27s. tax); and Dietrich Marshall (200 acres, 27s. tax). The 220 heads of households included 17 craftsmen, 7 of whom owned no land and paid minimum taxes (table 7). Five owned 50 acres or less and paid taxes of one to three shillings while 5 others owned more than 50 acres and paid taxes ranging from two to twenty-two shillings. The only artisan taxed more than 10s. was tailor John Ekert, who owned 180 acres and paid 22s. tax.

A remarkable transformation occurred in Heidelberg Township. By 1784 it carried 48 artisans on its tax list, including 10 in the town of Middletown (now Womels-

dorf). But outside of Middletown the 1784 list reveals the development of a specialization in the township. Among the 300 heads of households were 18 weavers, the most weavers in any one Berks County township in 1784 and more than 10 percent of all weavers in Berks County in 1784.

The influx of weavers in Heidelberg is part of a phenomenon that occurred throughout Berks County during the

TABLE 7

Occupations of Heidelberg Township Taxables
1767

Craftsman	Miller
Butcher-1	Grist-1
Saddler-1	Grist & Saw-6
Shoemaker-2	
Skinner-1	
Smith-3	
Tailor-4	
Turner-2	
Wagoner-1	
Weaver-2	

Source: *Pennsylvania Archives*, 3d ser., vol. 18 (Harrisburg, 1898).

revolutionary war years. Heidelberg in 1767 had 2 weavers; in 1784, 18. In 1767, Rockland Township listed 2 weavers; in 1784, 15. By 1784 Berks County had at least 134 weavers (compared to 36 in 1767) working outside of Reading. They were the largest single occupational group other than farmers. Relatively little capital was needed to start weaving, and the majority of these weavers owned no land. (In Heidelberg, 16 of the 18 weavers were landless.) Of those weavers who owned land throughout the county, approximately 20 percent owned 50 or more acres, with only 10 percent owning more than 100 acres.

Other trades with strong representation in rural areas in the eighteenth century were the building trades (masons, carpenters), woodworking (joiners, turners), smithing, and tailoring. In contrast the number of potters outside Reading only increased to six in 1784, a small number compared to the population increase. The few potters had low tax assessments which, when combined with the very low value placed on earthenware in household inventories, suggests that potting was hardly a profitable trade in rural Berks County. The local demand for earthenware was weak, and sources of supply outside the county undermined the local trade.

Tulpehocken Township, one of the oldest Pennsylvania German settlements, had 224 heads of households in 1767, but only a few were identified by occupations other than farming (table 8). The 224 taxables paid taxes ranging from 1 to 150 shillings, with 52 paying 10s. or more, and 13 paying 20s. or more. The highest taxpayers owned considerable land, a mill, or both. In contrast to most other townships in the county in 1767, all 12 artisans of Tulpehocken owned land; nonetheless, they all were at the bottom of the socioeconomic scale. Only 3 paid more than 5s. tax (Henry Groff, smith, 100 acres, 8s.; Nicholas Kintzer, smith, 150 acres, 19s.; and Andreas Salzgeber, saddler, 10 acres, 21s.),

even though 8 owned 50 or more acres of land.

The comparison of the 1767 and 1784 tax lists, plus other lists that provide occupational data, confirms that full-time rural artisans constituted at least 5 percent of the heads of households in Berks County, excluding Reading, through the 1760s. By 1784 the figure had risen to at least 10 percent, and as new towns and villages developed late in the century this percentage grew steadily larger. Throughout the same period, artisans constituted at least 60 percent of the heads of households in Reading.

Eighteenth-century Berks County craftsmen were generally among the lowest third of all taxables. Those most likely to rise above this level were the luxury specialists, such as clockmakers, a few of the smiths, and an occasional carpenter, joiner, mason, or tailor. The majority of artisans owned little or no land. In summary, the life of the ordinary artisan in Berks County was clearly not one of high rewards or status, but it was also not one of serious deprivation for, as inventories indicate, many could and did rent some land to farm for their own needs; however, upward mobility was difficult.

The same general picture prevailed in Lancaster County in the eighteenth century (map 3). Lemon calculated that in 1758/59 36 percent of the county's taxables owned no land, and that by 1782 the figure had dropped only slightly, to 32 percent. He also suggested that in the rural areas of the county in 1758/59 approximately 20 percent of the taxables were artisans, 15 percent laborers, and 65 percent landed farmers. But Lemon's figures on the number of artisans seem high based on a sampling of Manor Township (table 9).[44]

Manor was an agricultural township near the Susquehanna, southwest of Lancaster. It had a population nearly 100 percent German and predominantly Mennonite. Artisans represented at least 10 percent of the population of the township throughout the eighteenth century. Their decline in 1811 most probably reflects the drift of artisans to the towns of the area, principally Lancaster and Millersville. As in the townships of Berks County, the artisan class of Manor Township remained mired in the lowest third of the taxpayers, but unlike their Berks County counterparts these individual artisans show a greater tendency to be upwardly mobile. Normally, moving up meant dropping a trade designation and becoming a farmer. Nearly all the artisans of Manor Township owned some land and many were the sons of prosperous Mennonite farmers for whom a trade was only a temporary expediency, as it is still among the Old Order Amish of Lancaster County.

[44] Lemon, *Poor Man's Country*, pp. 94, 96. Manuscript tax lists for 1759, 1771, 1780, 1786, 1811, Manor Township, are deposited in Lancaster County Historical Society, Lancaster.

TABLE 8

Occupations of Tulpehocken Township Taxables
1767

Craftsman	Miller
Cooper-1	Grist-2
Joiner-1	Grist & Saw-3
Potter-1	Saw-1
Saddler-1	
Smith-4	
Tailor-1	
Tanner-1	
Wagoner-2	

Source: *Pennsylvania Archives*, 3d ser., vol. 18 (Harrisburg, 1898).

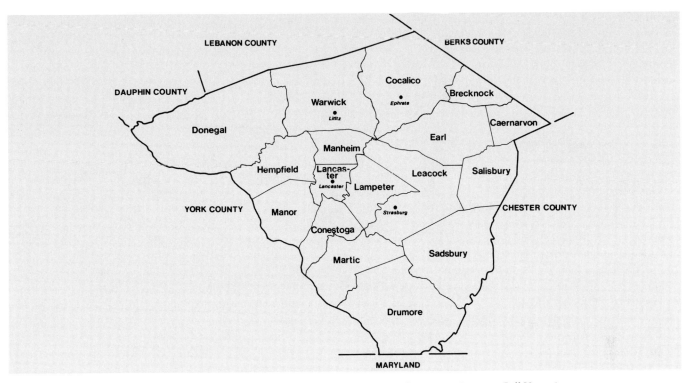

Map. 3. Present-day Lancaster County, with township lines of ca. 1735. (*Drawing, Dell Upton.*)

In 1759 the Manor Township tax list recorded four joiners and five weavers. The joiners, Henry Bull, Jacob Eshleman, and Ludovich and Frederick Zigler, owned 20, 100, and 150 acres respectively. (The Zigler brothers jointly owned their farm.) The weavers, John and Frederick Grafe, Henry Killhover, Casper Souder, and Jacob Shock, owned 60, 100, 100, and 120 acres respectively. (The Grafe brothers shared the 60-acre farm.) In 1765 and subsequent years, many of these men remained in the township, but they dropped trade designations. This was true of all four joiners. By 1771 Henry Bull had enlarged his farm to 100 acres, although only 30 acres were cleared for cultivation. Jacob Eshleman's farm remained 100 acres, but the Zigler brothers had added 50 acres to theirs. Although Eshleman had turned to farming, by 1786 his sons, John and Henry, were listed on the tax rolls as carpenters. Undoubtedly they learned woodworking from their father.

In spite of their generally low economic status, rural artisans were critical to the economy because they provided essential goods and services and enabled the region to maintain a high degree of self-sufficiency. By the end of the eighteenth century some were also providing substantial amounts of excess goods for sale outside the region, especially those who produced hats, stockings, and cloth.

The nature of the colonial economy has for many years been symbolized by the spinning wheel. That romantic but misleading vision portrays loyal hard-working women toiling over the wheel and under a compulsive drive for self-sufficiency. They made their family's clothing—at home from raw materials nurtured on the family farm—and laid the foundation for America's economic growth. This rose-colored vision of the past was codified in Rolla Tyron's *Household Manufacture*, the outgrowth of his 1917 doctoral dissertation. According to Tryon's model, the family

TABLE 9

Occupations of Manor Township Taxables
1759–1811

Trade	1759	1771	1780	1786	1811
Carpenter	1	1	0	4	0
Cooper	0	0	3	2	0
Joiner	4	1	1	0	10
Shoemaker	0	3	8	2	2
Smith	3	2	6	4	1
Tailor	1	3	1	2	1
Turner	0	0	1	0	0
Weaver	5	4	4	7	1

Source: Lancaster County tax lists,
Historical Society, Lancaster

stage of the economy lasted until approximately 1815. In the early nineteenth century shop production began to prevail over home production, and between 1840 and 1860 the transition to an industrial economy was fairly well completed. Tryon subordinated the independent tradesmen to the rural farmer. Even when artisans began to appear on the economic landscape, Tryon depicted them as itinerant workers who fashioned their finished products in the farm home and peddled their wares throughout the countryside. Tryon's conclusions clearly do not fit southeastern Pennsylvania and the Pennsylvania German culture region.[45]

Our more recent occupational analyses have produced very different images. Well before 1800 there were numerous shops in towns, in villages, and in the countryside. Rapid growth of trades and specialization within them are apparent by the 1780s. While farmers produced some of their own goods, especially shoes and cloth, the evidence demonstrates that farming was demanding and left little time for establishing a profitable trade on the side. If farmers practiced a trade it was usually for their own or their family's benefit, not as a business. Similarly, the operation of a craft business was also demanding and left the artisan with little time for commercial farming. One could profitably do either one, but combining the two was difficult. The tax records indicate that few Pennsylvania artisans owned horses, a factor that would have inhibited artisan itinerancy in the eighteenth century and limited their farming capability. Evidence in account books of the 1750–1820 period confirms that a rural artisan generally served a clientele within several miles of his shop and farmed primarily for his own needs.

By the time of the American Revolution, craft shops and industries existed simultaneously with household manufacture. Both systems facilitated structural changes that fostered rapid growth of the eastern economy after 1815. This growth was marked by the expansion of urban centers and urban markets, by the penetration of the rural Pennsylvania German region with consumer goods, and by the rapid development of intersectional trade between major eastern economic subsections (New England, the Mid-Atlantic, and the South).[46]

Eighteenth-century Pennsylvania was a prosperous region, with an economic well-being based on wheat, flour, and livestock, textile production (including hats), and iron manufacture. Tench Coxe in A View of the United States (1794) cited figures for flour exports: 1786, 150,000 barrels; 1787, 202,000 barrels; 1788, 220,000 barrels; 1789, 369,000 barrels; 1792, 420,000 barrels; 1793, 200,000 barrels (first quarter only).[47] Much of this flour came from Pennsylvania with a lesser amount from Virginia. Supporting this rapid growth in flour production for domestic and foreign consumption were numerous stone gristmills built between 1785 and 1815. The Pennsylvania German heartland had been feeling the pangs of depression since the end of the Napoleonic Wars in 1815 and the decline of wheat exports. Few of its mills were running at capacity by 1820. The 1820 Census of Manufactures provides a partial picture of the flour-milling industry in Conestoga, Lampeter, and Strasburg townships of Lancaster County, contiguous townships heavily populated with Pennsylvania German Mennonites. In Conestoga the census received forms from two mills, one built in 1814, while in Strasburg Township nine mills reported, five of them built after 1795. In Lampeter Township two of the five reporting gristmills were built in 1790 and 1817; another mill, reputedly "the oldest . . . in this country," was built in 1720 and no longer ground superfine flour for export. In fact, in all three townships mills specified that they were dependent on "country work" and were chopping grain for distilleries and grinding gypsum. All complained of poor business.[48]

The fullest description was provided by a Strasburg Township mill which ran nine months of the year. The owner reported grinding 15,000 bushels of wheat for flour and chopping 18,500 bushels of grain for distilling in the past year. He employed three men at wages of $100 each per year, and the mill generated a substantial profit of approximately $3,000 annually against a capital outlay of $18,500.[49]

Gristmills were a vital part of the distilling process, and distilling became an industry bolstering the prosperity of the Pennsylvania German farmers. The boom came in the years following the Revolution, and by 1790 the distilling of spirits was one of the most important manufacturing processes in the state. Unfortunately, most of the wooden still houses

[45] Christopher Monkhouse, "The Spinning Wheel as Artifact, Symbol, and Source of Design," in Furniture in Victorian America, ed. Kenneth L. Ames (forthcoming) suggested making the spinning wheel a national icon. Rolla M. Tryon, Household Manufacture in the United States, 1640–1860 (1917; reprint ed., New York: Johnson Reprint Corp., 1966), pp. 75, 84, 244. Contrary to Tryon's impression, women were economic partners in a full sense, even though most goods and property were in the husband's name.

[46] Diane Lindstrom, Economic Development in the Philadelphia Region, 1810–1850 (New York: Columbia University Press, 1978), pp. 9, 12–13.

[47] Tench Coxe, A View of the United States of America in a Series of Papers Written . . . between . . . 1787 and 1794 (1794; reprint ed., New York: Augustus M. Kelley, 1965), p. 64.

[48] No. 967, Lampeter Township, Lancaster County, in United States Bureau of the Census, "Record of the 1820 Census of Manufactures," National Archives, Washington, D.C. (microfilm).

[49] No. 934, Lampeter Township, Lancaster County, "1820 Census of Manufactures."

have disappeared from the Pennsylvania landscape. Conestoga Township reported ten distilleries in 1820. The dates of construction were given for only seven, and those were built between 1800 and 1818. Strasburg Township reported twelve stills, and all but three were built between 1806 and 1818. Of the earlier ones, one was dated at 1771, another was simply "old," and a third was "an old affair and the winters of its age are numberless." Lampeter Township reported nine distilleries, all built between 1809 and 1818. One owner placed a value of thirty-five cents per gallon on whiskey from his still, explaining that each good bushel of rye or corn produced about 2½ gallons of whiskey. At the time grain sold for forty-five cents a bushel.[50]

According to Coxe, the other major products of Pennsylvania in 1790 were hats, tanned hides, iron, wool, linen, cotton, paper, iron and metal products (stoves, hollowware), ships, sugar, cabinetware and turnery, gunpowder, glass, earthenware, and stoneware. Hats, paper, shoes, hollowware, and glass were largely the products of German artisans. The Scots Irish and Welsh contributed strongly to textile production, the English to tanning and cabinetwares, and all groups to iron production, but in nearly every category Germans provided the bulk of the work force. Coxe, one of the most knowledgeable Americans of his day and strongly biased in favor of economic nationalism, held the Pennsylvania German region in high regard. "It may be safely affirmed, that the counties of Lancaster, . . . York and Berks are among the most vigorous in Pennsylvania, perhaps in the union, and that there are none in the state in which there are more manufactures, is beyond all question. They are all fifty miles or more, from the nearest seaport." Coxe's statistics credit Pennsylvania with a greater total value of exports ($3,820,646) than any other state,

closely trailed only by Virginia ($3,549,499).[51]

Throughout the nineteenth century, Pennsylvania's international market for flour and spirits suffered, but the "dull" times bemoaned in the 1820 Census of Manufactures were fleeting ones. Annual incomes rose handsomely after 1820 as regional markets ate up the flour and wheat. Coal from the northern counties became the most valuable single commodity of the region and fueled the rapid industrial development of Philadelphia and other industrial towns. Textile production remained strong in the antebellum era. Household manufacturing was practically nonexistent in the Pennsylvania German heartland by 1840, but Philadelphia's industrial growth defused urban development and manufacturing growth thus keeping most of the Pennsylvania German region on an agricultural / commercial course.[52]

By 1840 Philadelphia County derived 44 percent of its income from manufacturing and another 45 percent from commerce. In contrast, counties in the Pennsylvania German hinterland fluctuated between 55 and 65 percent agricultural. They had modest but growing manufacturing interests and, in some areas, small but strong metal and mining operations. Philadelphia clearly reaped the greatest harvest in terms of per capita income and land value increase, but all of southeastern Pennsylvania prospered. By 1840 the bourgeois Germanic fragment had been folded successfully into the new nation's building process. With each succeeding generation the majority of Pennsylvania Germans lost their ethnic identity in the inexorable process of acculturation. Nonetheless, by 1840 a hybrid Pennsylvania German folk culture had become firmly entrenched, and a significant percentage of Pennsylvania's population was maintaining its distinctive way of life, nourished by dialect, religion, and rural folkways.

[50] For pictures of a few remaining still houses, see Amos Long, Jr., *The Pennsylvania German Family Farm*, Publications of the Pennsylvania German Society, vol. 6 (Breinigsville, Pa., 1972), pp. 168–78. For examples of houses with basement distilleries, see Robert C. Bucher, "The Swiss Bank House in Pennsylvania," *Pennsylvania Folklife* 18, no. 2 (Winter 1968/69): 2–11. Nos. 942, 978, Strasburg Township, Lancaster County, "1820 Census of Manufactures."

[51] For a scholarly assessment of Coxe, see Jacob E. Cooke, *Tench Coxe and the Early Republic* (Chapel Hill: University of North Carolina Press, 1978); discussion of Coxe's *View of the United States* is on pp. 212–16. Coxe, *View of the United States*, pp. 313, 420.

[52] Lindstrom, *Economic Development*, pp. 131, 134, 141, 145–46, 151, 157.

The Architectural Landscape

SCOTT T. SWANK

The Germanic fragment of European culture which peopled southeastern Pennsylvania in the eighteenth century contained seeds of dissolution as well as cohesion. The immigrants were overwhelmingly Protestants of pietistic persuasion, but, in a new situation devoid of a Catholic threat, these Protestants could easily have accentuated sectarian bickering rather than toleration. They did share a common linguistic framework and a general sense of place, but provincial dialects and particular geographic ties could have exercised more influence than a shared feeling of being from Germania.[1] In addition to their Protestantism and their Germanness, the German immigrants were predominantly bourgeois in values and in behavior, as were many non-German immigrants to the colonies. While these values were not incompatible with economic cooperation, they could have led to the pursuit of individual benefit at the expense of community.

In fact, dialect multiplicity, religious differences, and diversity of origin worked against Pennsylvania German ethnicity and for American loyalty with many immigrants. In the period from 1683 to 1840 the majority of German immigrants, particularly those in urban centers, assimilated quickly and with little apparent remorse. A significant minority assimilated gradually and created an identity of being "Pennsylvania German." Between 1750 and 1840 those who most successfully resisted total acculturation and maintained that identity were those who combined dialect, religion, and geography, whether in Pennsylvania, the Shenandoah Valley of Virginia, or the Niagara peninsula of Ontario.

The sectarian groups—Amish, Brethren (Dunkards), Mennonites, and Schwenkfelders—settled in rural clusters, claimed their territory, and rooted deeply. Sectarian families intertwined through intermarriage, and, like crabgrass, sectarian communities began creeping outward in all directions in an effort to extend their boundaries. The Mennonites established enclaves in Lancaster and Montgomery counties where they shared space with the Dunkards. The Amish community settled at what is now the juncture of Berks, Chester, and Lancaster counties and spread south and east into Lancaster and Chester counties. The Schwenkfelders seized and held on to a tiny principality in Montgomery County.

The sectarians established psychological and spiritual boundaries for their communities that separated them from both English *and* German neighbors. They were particles within the Germanic fragment. Yet each sect served as an anchor and reference point for the larger Pennsylvania German community. Given their attitude of separation and the fact that in number they constituted less than 10 percent of the total Pennsylvania German population in the eighteenth and nineteenth centuries, their influence was significant but limited.

A self-conscious Pennsylvania German culture might never have formed had Pennsylvania been settled only by sectarians. The hybrid Pennsylvania German culture that developed between 1750 and 1840 was primarily the work of the more numerous urban and rural German immigrants who were members of Reformed and Lutheran churches.[2]

[1] Many called their birthplace Germania. See, for example, will of Hans Hoober, February 17, 1745/46, Earl Township, Will Book H, 1730–78, Lancaster County Courthouse, Lancaster.

[2] A definitive study of the Lutheran and Reformed churches is Charles H. Glatfelter's *Pastors and People: German Lutheran and Reformed Churches in the Pennsylvania Field, 1717–1793*, vol. 2, *The History*, Publications of the Pennsylvania German Society, vol. 15 (Breinigsville, Pa., 1980/81).

They, too, settled in clusters and in rural areas gradually displaced their Welsh, English, and Scots Irish neighbors. In the eighteenth century they created a heartland stretching across portions of present-day Northampton, Lehigh, Montgomery, Berks, Schuylkill, Lancaster, York, Lebanon, and Dauphin counties. A larger periphery surrounded this and included portions of present-day Chester, Philadelphia, Bucks, Monroe, Luzerne, Columbia, Northumberland, Union, Snyder, Mifflin, Juniata, Perry, Franklin, and Adams counties.

Place in the geographical sense is important to our interpretation. The Germans of southeastern Pennsylvania were a "valley" people, and studies of their culture need to concentrate on these valleys.[3] Well into the nineteenth century the valleys nurtured pockets of Pennsylvania German culture and protected them from extensive outside intrusion. Nevertheless, while geography is an ingredient in the formation of Pennsylvania German culture, ethnicity is the synthesizing force. Ethnicity manifests itself in many intangible ways, most of which leave a residue imperceptible to the historical observer. Language, costume, food ways, and folk customs are difficult to reconstruct beyond the memories of informants. Legal records, especially when collected and maintained by a parent culture, do not eagerly yield reliable data on ethnic fragments. The tangible material culture is more obvious than other sources in revealing its ethnic traits, but it is deceptively unrepresentative, as the surviving structures on the Pennsylvania German architectural landscape demonstrate.

Ever since the first studies of Pennsylvania architecture appeared, the spotlight has been fixed on the monuments of Pennsylvania German culture. These monumental buildings have generally been treated as art. The *Architectural Record*, established in New York in the 1890s, featured "colonial" architecture from an early point in its history, and in 1911 its searchlight paused in rural Pennsylvania. Aymar Embury focused on nine farmhouses of Berks, Chester, and Montgomery counties as yet another trace of "that exquisite architecture which, for lack of a better name, we call Colonial." Nine years later the magazine published A. Lawrence Kocher's five-part series, "Early Architecture of Pennsylvania," which included outstanding buildings from Lancaster and York counties as well as Berks, Chester, and Montgomery counties. Where Embury's article had been weighted to English Georgian buildings, Kocher's tried to compare English and German architecture. The so-called Hans Herr House, which was actually built by Christian Herr, was one of his headliners.[4]

Neither author knew a great deal about German or Pennsylvania German building traditions, so they worked from the buildings they had at hand and used the assumptions of the architectural profession in the early twentieth century. For both of them this meant judging the rural German buildings from a classical aesthetic. As a result, Embury observed, the buildings revealed little sense of design, and what design there was had been altered by "ignorant (although tasteful) builders." Kocher presented his ideology more coherently, espousing an evolutionary point of view. The Pennsylvania German architectural continuum stretched from (1) primitive, "a time of pathetic groping in the dark," through (2) mature English architecture modified by local needs, and on to (3) federal, "when, under conditions of self-government, both dwelling houses and public buildings took on a monumental and more purely classical character."[5] For each author the ideal against which all buildings were judged was composed of English Georgian characteristics of proportion and symmetry. The Pennsylvania German examples, by that definition, could not be classified as great architecture, but they were "exquisite," "picturesque," and "charming."

The first author to concentrate on Pennsylvania German architecture and analyze it for its own merits was architect G. Edwin Brumbaugh, who presented his findings to the forty-first annual meeting of the Pennsylvania German

For a discussion of the union church movement, a cooperative arrangement between the two denominations that is fundamentally indigenous to the American experience, Glatfelter's text is quite useful (pp. 161–70).

[3] Unfortunately, such studies will emerge slowly, for counties and political entities had relatively little significance in eighteenth-century daily life but generated the records on which historical research is dependent. The geographers' perspectives of the region are presented in Raymond Gastil, *Cultural Regions of the United States* (Seattle: University of Washington Press, 1976); Joseph W. Glass, "The Pennsylvania Culture Region: A Geographical Interpretation of Barns and Farmhouses" (Ph.D. diss., Pennsylvania State University, 1971); Henry Glassie, *Pattern in the Material Folk Culture of the Eastern United States* (Philadelphia: University of Pennsylvania Press, 1968); Mark Allen Hornberger, "The Spatial Distribution of Ethnic Groups in Selected Counties in Pennsylvania, 1800–1880: A Geographic Interpretation" (Ph.D. diss., Pennsylvania State University, 1974); James T. Lemon, *The Best Poor Man's Country: A Geographical Study of Early Southeastern Pennsylvania* (Baltimore and London: Johns Hopkins University Press, 1972); and Wilbur Zelinsky, *The Cultural Geography of the United States* (Englewood Cliffs, N.J.: Prentice Hall, 1973).

[4] Aymar Embury, "Pennsylvania Farmhouses: Examples of a Hundred Years Ago," *Architectural Record* 30, no. 5 (November 1911): 475–85; Lawrence Kocher, "Early Architecture of Pennsylvania," *Architectural Record* 48, no. 6 (December 1920): 512–30; 49, no. 1 (January 1921): 31–48; 49, no. 2 (February 1921): 135–55; 49, no. 3 (March 1921): 233–48; 49, no. 4 (April 1921): 310–30.

[5] Embury, "Pennsylvania Farmhouses," p. 475; Kocher, "Early Architecture," p. 514.

Society in 1931. Brumbaugh singled out the monuments—Ephrata Cloisters, Moravian buildings in Bethlehem, Millbach House, "Hans Herr House," Fort Zeller, and Augustus Lutheran church at Trappe—and he argued that these were not exotic, atypical structures, but the best examples of a vernacular tradition.[6]

Working in an art historical framework, Brumbaugh demonstrated a high degree of sensitivity toward vernacular buildings and made several observations which many later writers have ignored. First, without totally substantiating his case, Brumbaugh asserted that the flow of architectural ideas in colonial Pennsylvania was German to English as well as English to German. Late eighteenth- and early nineteenth-century Pennsylvania buildings were not simply adaptations of English Georgian but a blend of two traditions. Second, in the seventeenth and eighteenth centuries, Germany, like England, experienced its own response to the Renaissance classicism of Andrea Palladio and others. Although the Renaissance had a lesser impact on vernacular architecture in Germany than in England, it did produce a German variation of the international Georgian style. Third, the spirit behind Pennsylvania German architecture was a blend of medieval building types and practices and Protestant plainness. For him the result was a sturdy simplicity echoing the peaceful peasant traditions of the Rhine Valley. Last, Brumbaugh emphasized the domestic orientation of the Pennsylvania German architectural repertoire. None of the monuments were public buildings like courthouses; they were dwellings and domestically inspired religious "meetinghouses."[7]

For us today the difficulty with the study of Pennsylvania German architecture, in addition to overcoming the traditional architectural fixation on a few monumental buildings, is the misleading and elusive nature of the surviving evidence. The twentieth-century landscape of the Pennsylvania German region is decorated with unusual cultural artifacts. In no other region of the country do we find middle-class dwellings of the number, size, and quality of the stone and brick complexes that dot Pennsylvania from Montgomery County in the east to Franklin County in the west. Two-story masonry houses with massive overshot barns and a smattering of remaining washhouses, springhouses, and smokehouses bear testimony to the eighteenth-century perception that southeastern Pennsylvania was "the best poor man's country."

Stone buildings are generally considered to be the hallmarks of the Middle Atlantic region, for as one travels south brickwork predominates, and as one travels north, especially to New England, frame buildings saturate the landscape. These stone buildings in Pennsylvania are not exclusively German, for they were built by Scots Irish throughout southeastern Pennsylvania and are common in Chester and Bucks counties also, areas settled by English and Welsh.

The stone houses of Pennsylvania have enraptured architectural historians, antiquarians, and old-house romantics for decades. Lancaster County's "Hans Herr House," made of fieldstone, was already a Mennonite shrine by the late nineteenth century. Throughout the twentieth century large central-hall-plan stone mansions have been avidly sought as secular shrines by affluent old-house buffs and have been lovingly cared for by families fortunate enough to have retained ownership through nearly two centuries.

Log cabins, on the other hand, have attracted attention in popular literature and ephemera since William Henry Harrison's "Log Cabin" presidential campaign in 1840, but architectural historians and preservationists in Pennsylvania long ignored them. The log cabin, as featured in popular imagery—literature, graphics, films, television, and political ephemera—has been firmly grafted to frontier mythology as an expression of pioneer spirit. The settled East forgot its log cabin heritage and assumed log buildings were part of a wave of pioneer housing that was quietly discarded for more permanent building materials. While debate has continued over which ethnic group contributed the most to log building technology in the Delaware Valley, full appreciation of log buildings had to await the pioneering work of modern geographers and folklorists such as Fred Kniffen and Henry Glassie, but in the early 1960s local antiquarian Robert Bucher called attention to the forgotten log dwellings of the Pennsylvania Germans. He had found 50 to 100 survivals in southeastern Pennsylvania in relatively pristine condition and many more with major interior alterations.[8] We now know that many more lie buried beneath wooden clapboards, asbestos shingles, or aluminum siding. Nevertheless, compared to their original numbers, few are left.

Whether or not there was a wave of temporary housing is

[6] G. Edwin Brumbaugh, "Colonial Architecture of the Pennsylvania Germans," in *Pennsylvania German Society Proceedings*, vol. 41 (Norristown, 1933), p. 6.

[7] Brumbaugh, "Colonial Architecture," pp. 7, 8–9, 20.

[8] Robert C. Bucher, "The Continental Log House," *Pennsylvania Folklikfe* 12, no. 4 (Summer 1962): 15. For a more detailed and theoretical approach to Continental log houses, see Henry Glassie, "A Central Chimney Continental Log House," *Pennsylvania Folklife* 18, no. 2 (Winter 1968 / 69): 33–39. Glassie emphasized that so-called Continental houses are not pure survivals of European prototypes but selectively adapted American Continental dwellings. For a study of Germanic traditions of log contruction, see Terry G. Jordan, "Alpine, Alemannic, and American Log Architecture," *Annals of the Association of American Geographers* 70, no. 2 (June 1980): 154–80.

hard to determine. But from what we now know of central European building traditions we cannot infer that when Pennsylvania's eighteenth-century German builders used log they thought they were building impermanent housing. While log buildings were less expensive than masonry ones to construct, they still required skilled workmen and were generally intended to be the permanent house by those who commissioned them.

In the Alpine and south German regions of Europe, from which many of the Pennsylvania Germans emigrated, wood was a revered construction material. It worked easily and was a good insulator. Log houses outlasted the lives and memories of several generations. That was as much permanence as ordinary people desired. While stone may have been an upper-class building material in Europe because of the expense in quarrying, dressing, and laying it, not all Germans aspired to it. In fact, because stone held both cold and moisture and was difficult to bring to a level of comfortable warmth, in a cold climate it could be a distinct disadvantage.

In order to determine the configuration of eighteenth-century Pennsylvania's architectural landscape and compare it to the architectural imagery presented by early twentieth-century romantics and the visual records of early photographers, we must examine documentary records as well as surviving buildings. The United States Direct Tax of 1798, more commonly known as the glass or window tax because assessors were to count windows and lights (panes of glass) and use the figures as a basis for establishing valuations, is the most useful eighteenth-century document for detailed information concerning Pennsylvania's architectural landscape. While the extant returns have gaps, and while township and county assessors did not provide uniform detail or use identical terminology, the existing data is rich and reliable. The forms contain schedules A through K and generally specify the following for dwellings: occupant; owner; number of dwelling houses, outbuildings, and appurtenances; dimensions; building material; number of stories, windows, and lights; and evaluation. In some, lot acreage and comments on the condition of the property are included. One schedule contains data on nonresidential buildings and overall property size.[9]

[9] All following references to 1798 tax lists are derived from the microfilm records of the Pennsylvania Direct Tax, 1798, National Archives, Washington, D.C. For background information on the tax and an index of place names, see the pamphlet *United States Direct Tax of 1798: Tax Lists for the State of Pennsylvania* (Washington, D.C.: National Archives, 1963), pp. 1–21. Modern scholars of vernacular (folk) architecture are less interested in building materials than were those of the past several generations. Geographers and folklorists base their housing typologies on vertical height, spatial volume, floor plan, and placement of doors, windows, and hearths.

In Montgomery County, the 1798 records for few of the townships survive. They indicate that stone was the predominant building material, and in certain English townships, such as Abington in the southeast, stone was used almost exclusively. Brick was used in approximately 2 percent of the houses, and the few other dwellings were designated as "frame" or "wood." Frame implies a type of joined construction that denotes English building practice; therefore, wood probably refers to the log construction used by many German and Scots Irish carpenters. Townships of mixed ethnic settlement also contained a mixture of building materials but in different proportions than in purer ethnic areas. Lower Merion, Norriton, and Providence townships along the Schuylkill River had nearly as many wood (log) buildings as stone. Records for only a few of the German townships survive, among which are those of Lower Salford located in the center of the county. According to the 1798 tax schedules, Lower Salford Township contained seventy-five dwellings. The predominant building material was stone (47 percent), and the predominant building type was a one-story cabin (table 1). This suggests that in rural Montgomery County the Germans followed regional practices rather than their ethnic traditions. The construction techniques (and house plans) used in this Germanic township show evidence of some assimilation. English frame construction had invaded the area, but English brick construction, which was common in urban areas, had not. The few houses of mixed construction (log and stone, frame and stone) are less easily categorized. They may have been houses with later additions, such as a frame addition to a stone house, or houses of half-timber construction which was a common Germanic mode that was transferred to Pennsylvania. By and large the surviving Pennsylvania German houses that predate 1798 reveal persistent German influ-

Their method is based on the assumption that the skin of a building (its building material and exterior ornamentation) is less expressive of deep cultural patterns than is its interior arrangement. The increasing sophistication of such studies in Great Britain and the United States will eventually transform our understanding of the Pennsylvania German architectural landscape. This study does not pretend to do more than offer one more piece to the puzzle. Its contribution probably lies in the suggestion that historical materials must be taken more seriously if the students of folk architecture are to realize the potential of their very promising methods. Because geographers and folklorists are more concerned with general form and diffusion than chronology and specificity, and thus concentrate on building survivals, they downplay archival work and stress fieldwork. Without denying the superb contributions of that approach, I am convinced that we need to continue to study the specific and general history of all buildings and that we must continue to assume that the appearance of a building is as important to its interpretation as its floor plan. Only by combining both elements can we achieve an understanding of its builders and its inhabitants.

TABLE 1

Houses in Lower Salford Township, Montgomery County, 1798

House type	Log	Frame	Stone	Mixed	Total
One story	14	12	29	8	63
Two story	2	2	6	2	12
Total	16	14	35	10	75

Source: 1798 Direct Tax, Schedule A.

TABLE 3

Houses in Windsor Township, York County, 1798

House type	Log	Stone	Stone & log	Total
One story	121	10	—	131
Two story	23	4	2	29
Total	144	14	2	160

Source: 1798 Direct Tax, Schedule A.

TABLE 2

Houses in Plainfield Township, Northampton County, 1798

House type	Wood	Stone	Stone & wood	Total
One story	109	1	1	111
Two story	12	4	—	16
Total	121	5	1	127

Source: 1798 Direct Tax, Schedule A.

TABLE 4

Houses in Longswamp Township, Berks County, 1798

House type	Log	Stone	Stone & log	Total
One story	56	6	—	62
Two story	23	4	3	30
Total	79	10	3	92

Source: 1798 Direct Tax, Schedule A.

ences, and the English Georgian traits are most prevalent in the few expensive two-story masonry dwellings owned by prosperous farmers or town residents.

Northampton County, to the north of Bucks and Montgomery counties and along the Delaware River, shows architectural characteristics shared up and down the Pennsylvania side of the river in English, German, and ethnically mixed settlements. The eastern part of the county displayed a predilection for stone dwellings. Bethlehem, Lower Saucon, and Nazareth townships contained as much stone construction as log in 1798. In the western part of the county, exemplified by Plainfield Township, log construction predominated. Out of a total of 127 dwellings in Plainfield, nearly 86 percent were one-story log (table 2). The preference for stone in the eastern part of the county was not due to wealth entirely or to the abundance of stone; it must relate to Moravian choice and a sizable number of masons.

Data from other parts of the Pennsylvania German heartland dispels any comfortable conclusion offered by Montgomery and Northampton counties. York County was populated by a mixture of English, Scots Irish, and Germans in 1798. The predominant building material throughout the county was wood. When we look at rural areas and small towns, we find that nearly 90 percent of dwellings were described as "wood." Surviving structures that were recorded on the tax list lead us to assume "wood" houses were predominantly log. The remaining 10 percent of the county's houses were stone, with an occasional reference to frame construction.

More specifically, an overwhelming percentage of the houses outside York Borough in 1798 were one-story log dwellings. Shrewsbury Township, located south of York, had 112 houses listed, 93 of which were one-story log. Windsor Township, east of York along the Susquehanna, had a similar profile (table 3). The assessor of that township chose to describe the houses with an uncommon precision that cleared up some questions of spatial use. He described most houses as one and one-half stories, an unmistakable sign that the majority of one-story houses had a loft area that was used for storage, sleeping, or both.

The comparison of Montgomery County—in close proximity to Philadelphia, with strong English influences, and well settled by the revolutionary war—with York County—on the western frontier of the Pennsylvania German heartland, with strong Scots Irish influence—illustrates that we cannot make firm statements based on either extant buildings or one township. Housing is a measure of both economics and culture, and its interplay in a region of mixed ethnicity makes generalization difficult and perilous. Clearly all ethnic groups in Pennsylvania before 1798 were erecting log and stone dwellings, but they were not all building the same type of house. And no general conclusions about the Pennsylvania German heartland can be drawn without examination of Berks and Lancaster counties.

Unfortunately, the 1798 tax records for Berks County are scant, but the data from Longswamp Township provides further evidence that most Pennsylvania Germans lived in log houses (table 4). Of the ninety-two houses, 61 percent were one-story log, and 25 percent were two-story log.

TABLE 5

Houses in Warwick Township, Lancaster County, 1798

House type	Log	Frame	Stone	Sandstone	Limestone	Brick	Mixed	Total
One story	180	2	38	—	1	1	15	237
Two story	36	—	57	1	1	1	5	101
Total	216	2	95	1	2	2	20	338

Source: 1798 Direct Tax, Schedule A.

TABLE 6

Houses in Manor Township, Lancaster County, 1798

House type	Log	Round log	Square log	Frame	Stone	Brick	Stone & log	Total
One story	11	12	137	—	29	5	8	202
Two story	—	—	18	1	19	6	1	45
Total	11	12	155	1	48	11	9	247

Source: 1798 Direct Tax, Schedule A.

The Longswamp records are unusual in that they offer a glimpse of the general condition of the township's housing. The assessor took it upon himself to describe the quality of the houses. He noted that only one house was new and one was old. The remaining ninety fell neatly into three equal groups he labeled "good," "middling," and "low."

Lancaster County's 1798 lists are also incomplete, but they are more comprehensive than those of Montgomery, York, or Berks counties. Its data on housing is similar to that of York and Berks counties. For example, 64 percent of the 338 houses in Warwick Township, a predominantly German rural township on the northern edge, were log, and 83 percent of the log houses were one story (table 5).

Manor Township likewise had a predominance of one-story log houses (65 percent). The schedules filled in by the assessor of this western township have an additional distinction that helps us further interpret the architecture landscape. He differentiated between houses built with "square logs" and those with "round logs" (table 6). His accompanying tax valuations have confirmed what scholars of vernacular building have had to infer from practical considerations: round-log houses were inexpensive but not desirable. First, he consistently assessed round-log houses at lower values than square-log houses of comparable size. Second, round logs were more frequently used in farm outbuildings, especially barns and stables, than in houses or even domestic outbuildings such as washhouses and springhouses. Third, all two-story log houses, undoubtedly sizable undertakings, were made of square logs. Obviously round-log construction offered the least expensive building technology, but householders were well aware of its long-term limitations.

Hempfield Township, just north and west of Lancaster Borough, contained a large number of stone houses (and barns), a few brick houses, and some frame dwellings, but its domestic architecture was predominantly log. The same pattern applies to most other German townships for which records survive regardless of the county. For example, Mifflin County had been established in 1789, and it fit the log-house pattern with one important variation—the two-story log house was nearly as prevalent as the one-story version. Mifflin's records introduce an interesting feature in that the outbuilding lists frequently forsake designation of building material in favor of "cabbin barn" or "cabbin stable." The term *cabin*, which is also used in returns from other counties, is an indirect reference to height and size and indicates a small one-story building. The assessor for Lycoming County rarely mentioned the number of stories for the houses; instead he specified "log houses" or "cabin houses." The returns indicate nearly 100 percent log construction for dwellings.

The profile established thus far is that the rural areas of the Pennsylvania German heartland were characterized by log housing and log barns. The majority of all German housing (55 to 60 percent) was the one-story (actually one-and-one-half story) log house (fig. 1). The chief exceptions to this pattern occurred in the eastern fringe of the region and in the towns. Towns presented a very different visual image due to the mixed nature of the building materials and the greater variety of building types.

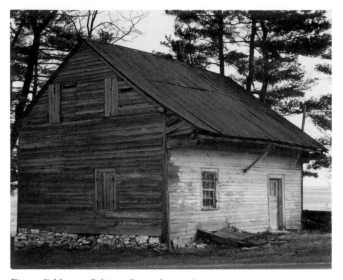

Fig. 1. Eshleman Cabin, a Pennsylvania German log house built by Swiss Mennonites south of present-day Strasburg, Lancaster County, about 1730. Its white oak logs are fully dovetailed. (Photo, Winterthur.) For a measured drawing of the first floor, see fig. 5.

TABLE 7				
Houses in Borough of Eastern, Northampton County, 1798				
House type	Wood	Stone	Mixed	Total
One story	63	22	1	86
Two story	26	37	—	63
Total	89	59	1	149

Source: 1798 Direct Tax, Schedule A.

York was predominantly a "wood" town in 1798, and most of these wood buildings were undoubtedly log. The ratio of wood to masonry was approximately two to one. About 200 houses (55 percent) were one story, 176 (46 percent) were two story, and 3 were newly fashionable brick three-story town houses.

In contrast, the Borough of Easton, fifty-five miles north of Philadelphia in Northampton County, had no brick dwellings but, typical of its region, sported many stone houses (table 7).

Lancaster, sixty-five miles west of Philadelphia, was the largest inland town in the United States and may well have been the most visually stimulating and architecturally variegated town in the country. By 1798 Lancaster was an architectural quilt pieced together by many ethnic groups. Housing in the wealthy northeast and northwest wards (tables 8, 9) was the most highly textured architecturally: 37 percent log, 25 percent brick, 18 percent frame, 12 percent stone, and 8 percent mixed construction—brick and stone, brick and log, log and stone, and stone and frame. Much of the mixed construction may have been of half-timbering. Evidence of it survives in Lancaster's visual and documentary records as well as in existing buildings. In contrast to the two northern wards, the southeast and southwest wards were less ethnically mixed. They had a heavy concentration of Germans and a predominance of one-story log houses supplemented by a sizable number (roughly one-third) of brick houses.

Artisan housing remains difficult to reconstruct. In towns and villages artisans' dwellings constituted the bulk of middle-class housing. We will not have precise information for many trade centers until specific research is completed; however, general historical knowledge suggests that whether owners or renters, artisans generally combined shop and living quarters in a single building. This pattern persisted throughout the eighteenth century, even among well-to-do artisans. It must be added that the elite of the artisan world had quarters on a par with others of similar socioeconomic status. Towns more than villages reflected class consciousness, and ethnic building patterns, even in the houses of artisans, gave way quickly to economic considerations and fashions that cut across ethnic boundaries.

The housing of rural artisans is even more difficult to trace. What little evidence we have suggests that their housing differed little from that of lower-income farm neighbors in size and composition. The 1798 tax lists do reveal, however, a considerable number of rural craft shops, particularly for blacksmiths, joiners, saddlers, and an occasional tailor or shoemaker.

A profile of dwellings provides only one part of the Pennsylvania German mosaic of 1798. This study cannot pursue the equally important analyses of public buildings, many of which were English in inspiration, and farm buildings. In 1798 nearly every Pennsylvania German farmhouse and a sizable number of town residences possessed at least one outbuilding—on farms a barn and in towns a stable. (Some small or poor farms had only a stable.) If extant buildings and the Manor Township tax list are reliable indicators, barns were typically built of square logs, while stables were built of round logs.[10]

[10] For an analysis of barn types, see Charles H. Dornbusch and John K. Heyl, *Pennsylvania German Barns*, Pennsylvania German Folklore Society, vol. 21 (Allentown, 1956). One example of a square-log barn is found on pp. 94–95. Arthur C. Lord, "Barns of Lancaster County: 1798," *Journal of the Lancaster County Historical Society* 77, no. 1 (Hilarymas 1973): 26–39. See also Robert Ensminger, "A Search for the Origin of the Pennsylvania Barn," *Pennsylvania Folklife* 30, no. 2 (Winter 1980/81): 50–71; and Alan Keyser and William Stein, "The Pennsylvania German Tri-Level Ground Barn," *Der Reggeboge (The Rainbow): Quarterly of the Pennsylvania German Society* 9, no. 3 (December 1975): 1–25.

TABLE 8

Houses in the Northeast Ward of the Borough of Lancaster, Lancaster County, 1798

House type	Log	Frame	Stone	Limestone	Sandstone	Brick	Log & stone	Log & brick	Brick & frame	Brick & stone	Total
One story	47	24	1	4	1	17	2	3	6	—	105
Two story	5	5	1	8	5	25	1	—	2	1	53
Three story	—	—	—	—	—	8	—	—	—	—	8
Total	52	29	2	12	6	50	3	3	8	1	166

Source: 1778 Direct Tax, Schedule A.

TABLE 9

Houses in the Northwest Ward of the Borough of Lancaster, Lancaster County, 1798

House type	Log	Frame	Stone	Limestone	Sandstone	Brick	Log & stone	Log & brick	Brick & frame	Brick & stone	Total
One story	85	42*	1	10	—	20	—	9	12	4	183
Two story	1	2	1	12	4	34	—	—	—	1	55
Three story	—	—	—	—	—	1	—	—	—	1	2
Total	86	44	2	22	4	55	—	9	12	6	240

* includes 1 "board" house

Source: 1798 Direct Tax, Schedule A.

Perhaps as many as a third of the Pennsylvania German farms in 1798 also had at least one additional outbuilding to support domestic functions, commonly a springhouse, a washhouse, or a kitchen.[11] Separate bakehouses or smokehouses were rarely on the tax lists, so we must assume these functions remained in the main house or were performed in the back parts of springhouses, washhouses, or kitchens. Probably less than 10 percent of the farms had more than two major outbuildings. The two-story stone house did at times have a small cluster of outbuildings surrounding it, sometimes built en suite with the house, and occasionally an old cabin was part of the scene.[12]

Small domestic outbuildings extended work space but rarely living space. Most were constructed after the dwelling house, especially the one-story log or stone house. Two-story log houses usually had fewer supporting domestic outbuildings than their stone counterparts, and these outbuildings were not usually built to match the parent dwelling (fig. 2). It was not unusual for log houses to sport stone outbuildings and stone houses to be flanked by log outbuildings. The springhouses were generally stone, as would be expected.

In review, by 1798 the rural Pennsylvania German domestic landscape was dotted with one-story stone and one- and two-story square-log houses, accompanied by what seemed to travelers as proportionately large barns of log and stone. Accenting the landscape were an occasional stone farm complex, forges and furnaces, mills, carefully placed inns, country churches, and scattered towns and villages.

The landscape remained predominately log well into the nineteenth century, a fact that reflected both ethnic preference and economic necessity. Only the well-to-do used stone for domestic buildings. It was more generally deemed suitable for churches and for large public and commercial structures such as inns, mills, and forges. Among the German settlers brick was reserved for urban architecture until, after 1840, it gradually replaced stone as the preferred building material for middle-class housing. Eighteenth-century rural Pennsylvania Germans used little brick except for churches. Whether of brick or of stone, these churches became important trend setters, often conveying English Georgian architectural ideas into a rural community (fig.

[11] Illustrations of these buildings can be found in Amos Long, Jr., *The Pennsylvania German Family Farm*, Publications of the Pennsylvania German Society, vol. 6 (Breinigsville, Pa., 1972), but Long provides no theoretical framework, and his conclusions on chronology are at times contradicted by the 1798 Direct Tax.

[12] En suite architecture reached the Pennsylvania German culture region after the American Revolution, simultaneously with the same phenomenon in interior furnishings.

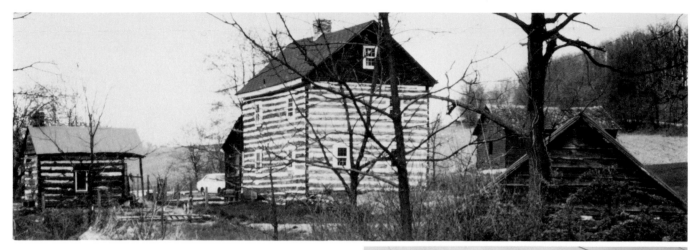

Fig. 2. Complex of log buildings near Glen Rock, York County. Built 1790–1820. (Photo, Scott T. Swank.) The buildings are under restoration; the house will have a pent roof. The property also has a log springhouse.

3). Before 1840 all three building materials—log, stone, and brick—were readily available, although some variations of each were more difficult to obtain and hence more expensive. Dressed stone and brick required extensive work to shape them to an artificial state; squared logs were a less expensive version of the same phenomenon.

Tax lists tell us what the building materials were but reveal little about the outward appearance of the house. For example, were the houses with square logs clapboarded, whitewashed, or left in a natural state? A few travel accounts of the late eighteenth and early nineteenth centuries help fill in the picture.

Theophile Cazenove was born in Amsterdam, married into Dutch wealth, and worked as an American agent for Dutch investors in the United States. He embarked on an excursion through New Jersey and Pennsylvania in 1794 as an agent for Holland Land Company, and his journal reveals a keen sensitivity to land values.[13]

Cazenove traveled as handsomely as possible on land in the 1790s, with his own coach, servants, and spare horses. The notes for his journal were kept by his manservant.[14] The itinerary led him from New York City through northern New Jersey's German Valley to Easton, Pennsylvania. Except for an excursion to Nazareth, his path paralleled what is now U.S. Route 22 from Easton to Harrisburg. He continued west into Cumberland Valley to Carlisle, Shippensburg, and Chambersburg before turning east and head-

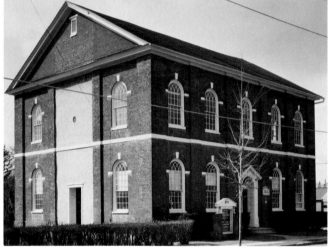

Fig. 3. Saint Michael's Evangelical Lutheran Church, Strasburg, Lancaster County. Built 1806. (Photo, Winterthur.) The architectural inspiration was probably either Trinity Lutheran Church, Lancaster, a steepled Georgian church built between 1761 and 1766, or Zion Lutheran Church, Philadelphia. The congregation, founded in 1754, built the original log meetinghouse near Beaver Creek, south of Strasburg.

ing back on what was many years later known as Lincoln Highway, now U.S. Route 30. On this major road to Philadelphia he visited numerous small towns as well as York and Lancaster.

Because the trip was taken in 1794, so close in date to the Direct Tax of 1798, we can check Cazenove's journal against the itemized assessments. At the same time Cazenove's prose fills in the images on the Pennsylvania German landscape. For example, Cazenove observed that farmers rarely had more than 100 acres in pasture and cultivation on farms of 150 acres.[15] His implication that nearly every farmer had a

[13] Theophile Cazenove, *Journal, 1794: A Record of the Journal of Theophile Cazenove through New Jersey and Pennsylvania*, ed. Rayner Wickersham Kelsey (Haverford: Pennsylvania History Press, 1922), pp. vii–ix.

[14] Cazenove, *Journal*, pp. xi, xiv.

[15] Cazenove, *Journal*, pp. 28–29, 35.

substantial woodland is borne out in tax records. (Gradually Pennsylvania German farmers placed all their land under cultivation, so that today the major valleys are unbroken expanses of fields and pastures.)

Cazenove was especially impressed by the land in Berks and Lancaster counties, but his opinions on taverns, architecture, and people fluctuated considerably throughout the trip. He obviously regarded stone and brick as the only truly civilized building materials. Easton he saw as a pretty town, "with good houses of blue stone." In Bethlehem and Allentown he also took note of the many stone houses. In Reading Cazenove saw brick houses, the newest of which were built in what he termed the Philadelphia style, with belt courses of white marble on the facades. Chambersburg, Lancaster, Harrisburg, and York were other prosperous towns in which he discovered many new houses of brick. In passing through Kutztown Cazenove took note of log houses and pointed out that the best of them had boards over the beams painted to simulate bricks. Cazenove was less complimentary regarding the log construction he designated as "beams and mortar," or "logs and mortar." And on his journey he observed a great preponderance of log construction in villages, towns, and rural areas. Hummelstown in Dauphin County contained "50 little houses, of logs and mortar, yet with little English windows; inhabited by workmen who work for the farmers around; a large retail store and four tavern-keepers." York he estimated to have some 400 houses, of which 60 were brick and the rest log and mortar. Lancaster, too, he noted was chiefly log and mortar in its "less conspicuous parts."[16]

While generally impressed with the fertile lands and growing towns, Cazenove found Pennsylvania German farmers to be an enigma. It was incomprehensible that these obviously prosperous farmers lived with so little regard for what Cazenove regarded as the necessary comforts of life.

Near Gap, Pennsylvania, Cazenove visited the 320-acre farm of Leonard Elmaker, who, he was told, was worth at least £15,000. He was appalled that "the whole family (seven children) were having a very bad dinner around a very dirty little table, and the furniture in the main room was not worth 200 dollars." One reason for the slovenliness and lack of comfort among the Germans, he concluded, was their ignorance; however, the Irish, "who like comfort more," were teaching the Germans of Cumberland Valley how to live. Germans there were adopting English and American clothing, and, Cazenove predicted, "from clothes" the more comfortable Irish ways would pass to household furnishings. Elsewhere (for example, Myerstown, Lebanon

County), Cazenove was shocked to see "people [who might as well have been] coming out of church in Westphalia, so much have all these farmers kept their ancestors' costume."[17]

Indefatigable antiquarian John Fanning Watson, who witnessed the disappearance of log houses from Philadelphia, included an 1829 travel manuscript in *Annals of Philadelphia*. The anonymous traveler described the Tulpehocken region of Lebanon and Berks counties:

The whole face of the country looks *German*—all speak that language, and but very few can speak English. Almost all their houses are of squared logs neatly framed—of two stories high. They look to the eye like "Wilmington stripes," for the taste is to white-wash the smooth mortar between the logs, but not the logs themselves, thus making the house in stripes of alternate white, and dusky wood color. . . . The barns were large and well filled, generally constructed of squared logs or stone, but all the roofs were of *thatched straw*—a novelty to my eye—said to last 15 years. Their houses were shingled with lapped shingles. Saw *no* stately or proud mansions, but all looked like able owners. This character of houses and barns, I found the same throughout my whole range of tour.[18]

The 1829 scene was probably not much different from that of 1798, but, unfortunately, the 1798 tax list for Tulpehocken Township does not survive.

An aristocratic German visitor traversed another portion of the Pennsylvania German region in 1832. Maximilian, prince of Wied-Neuwied, arrived with the intention of visiting the interior of the North American continent to collect accurate information on the "natural face of North America, and its aboriginal population." The prince, aiming to write a publication for an elite European clientele, also wanted to see for himself how the American experiment was developing for the many Germans who had migrated to the New World.[19]

Waiting for his luggage to arrive, the prince toured German settlements in southeastern Pennsylvania. In Philadelphia he was pleasantly surprised to find parts of the city in which German was spoken almost exclusively. In the countryside he was shocked by the character of the Pennsylvania German settlements. The appearance of the countryside en route to Bethlehem was "not particularly pleasing." An abundance of wooden fences intruded on a disorderly land-

[16]Cazenove, *Journal*, pp. 17, 24, 27, 31, 37, 49, 51, 64, 70, 72–73.

[17]Cazenove, *Journal*, pp. 75, 84, 45.
[18]John Fanning Watson, *Annals of Philadelphia, and Pennsylvania, in the Olden Time*, vol. 2 (Philadelphia: J. B. Lippincott, 1870), p. 529. For visual documentation, see Don Yoder, ed., "The Pennsylvania Sketchbooks of Charles Leseuer," *Pennsylvania Folklife* 16, no. 2 (Winter 1966/67): 30–37.
[19]Maximilian, prince of Wied-Neuwied, *Travels in the Interior of North America*, trans. H. Evans Lloyd (London: Ackermann, 1843), preface.

scape, and the houses he judged as small and "often rather poor," "frequently composed of boards, covered with shingles; sometimes they are merely great block-houses, like the cowkeeper's cottage in Switzerland." However, the poor houses adorned with flower gardens with many European plants—hollyhocks, hibiscus, and larkspur—helped compensate for the "poorly and dirtily dressed" children of the "peasant" population. [20]

Prince Maximilian did not see in the Pennsylvania Germans the nobility he would later find among the native American population. While some of his disdain needs to be discounted in light of his aristocratic prejudices, the observations of this well-educated naturalist cannot be dismissed. Pennsylvania was not then an orderly landscape. It is constructive to compare his view with that of William Cobbett, English radical and agricultural reformer who visited eastern Pennsylvania about the same time. Cobbett generally could see only positive traits when comparing the United States with Europe. While he noted that the general run of farmhouses was superior to those in England, an "out of doors slovenliness" prevailed which he had never seen in England. Also, Cobbett observed, the "out-buildings, except the barns, and except in the finest counties of Pennsylvania, are not so numerous, or so capacious, as in England, in proportion to the size of the farms." [21]

By the 1830s, the Pennsylvania German culture had been maturing for nearly a century. Yet, the rural landscape retained a raw edge which may have partially masked the significance of the Pennsylvania German achievement. Architecturally there had been a century-long building boom with only temporary slowdowns, and this boom contrasted sharply with the relatively depressed building situation in Europe. The most startling fact is that the Pennsylvania Germans throughout the heartland were already replacing their houses with English-inspired houses.

Few documents survive to detail Pennsylvania's rural vernacular building boom. Obviously, the need to create a built environment provided marvelous opportunities for the building trades. Stagnant or narrowing opportunities in Europe and the corresponding expansion in America propelled large numbers of artisans in the building trades to the colonies. In addition, the labor shortage in the colonies and the absence of a guild system provided incentive for unskilled workers to learn a building trade upon arrival in the region and later in the century offered craft opportunities to the sons of farmers.

The cost of building a modest house and erecting farm buildings in the eighteenth century was within the reach of the middle-class farmer. An indication of these costs can be seen in the estate account of Martin Mylin of Lancaster County. Mylin died in 1751 with an inventory of £1,643.2.4. His total estate, worth £2,479.5.3, was settled in 1760. The following record lists repairs to farm and outbuildings from 1751 to 1760.

	£	s.	d.
To cash paid Peter Bowman for thatching the barn	1	15	0
" pd. John Newcomber for laying of Barn Flore	1	10	0
To Laying & New floreing too Stable	1	0	0
To makeing a new Shed for a Dwelling Houss for Shingling etc.	4	15	0
To 2000 Shingles for Covering a Dwelling Houss	4	0	0
To makeing Shingling & a Shed for the Other Houss	1	0	0
To Lathing & Shingling the said Houss	1	5	0
To 20 Nail bought of George Graf	0	15	0
To puting ground Sils & building a Chimney in the Still Houss	4	10	0
To floreing, glassing, and makeing 2 Doors in the Still Houss	1	10	0
To cash pd. Peter Bowman for Repairing a Barn a Stable and Thatching an Outhouss	4	0	0
To cash pd. Jos. Miller & Corman[?] for makeing shingles & shingling one Dwelling Houss and one Stable	3	2	6
To 12 Nails bought of Ludwich Lowman	0	10	0
To a New Door & Hinges for the Cellar	0	10	0
To Cash pd. Albright Heylar [Heller?] for glazing[?]	1	10	0
To makeing a new Locus Fence round the Garden	2	10	0
To Cash pd. John Hendrick for Sawing Laths & Scantling	1	2	9
To Cash pd. John Rorah[?] for Sawing[?] Boards and Scantling	3	8	3
To Laying 170 feet of pipes to lead the Water to the Houss from the Spring	3	18	6
To Building a New Addition to the Barn of 30 by 25 ft.	21	0	0[22]

A second account, from Reading in 1753, provides data on the cost of building an urban brick dwelling.

1753 To Estate of George Albert
 Acct against the estate of George Albert decd aforesaid

[20] Maximilian, *Travels*, pp. 21–23, 29.

[21] William Cobbett, *A Year's Residence in the United States of America* (1818; reprint ed., Foutwell, Sussex: Centaur Press, 1964), pp. 177–78.

[22] Estate accounts of Martin Mylin, 1760, Lancaster County Historical Society, Lancaster. For information on Mylin, see Clyde L. Groff, "The Mylins, Hans and Martin," *Journal of the Lancaster County Historical Society* 75, no. 3 (Trinity 1971): 107–14.

being charges in compleating the buildings begun in the life time of the decd & finished by the Martin Cost.

		£	s.	d.
To	John George H[?]elebiess Mason & Plaister	18	19	6
	John Philippy nailer	3	19	9
	Henry Goodhart for haleing [hauling]	1	2	0
	Henry Smith tanner for hair		8	
	Jacob Raubolt brickmaker	1	17	2
	Christopher Simon joiner	3	4	6
	Adam Gyer carpenter	1	8	
	Jacob Eyder laborer	5	2	
	An—eas [Andreas] Engle, locksmith	1	0	
	Christian Goodshalt locksmith	1	5	
	Andrew Steel blacksmith	3	0	
	John Knor mason	1	4	
	Frederick Parlet carpenter	1	4	
	Philip Smith joiner	3	9	
	Nicholas Vost for boards	4	2	
	John Wolf for halering [hauling]	1	2	
	Michael Greeter for nails	1	4	7
	Casper Streyder, carpenter	0	18	
	Adam Kerner, joiner	0	12	
	Peter Allbert, for work	0	12	
	David Meyerly, for mason work	1	1	1
	Andreas Wolf for bricks	0	16	
	Henry Schnyder for planks	1	6	6
	Paul Joloar[?], carpenter	0	18	6
		60	1	7[23]

Both records indicate the range of trades necessary for the erection of ordinary buildings. From the date of earliest settlement, every Pennsylvania German community had skilled workmen available for housebuilding. While account books provide details on materials, prices, and craftsmen, they never explicitly describe the type of house being erected. That must be inferred from other data. The 1798 tax lists provide vital clues to house type by listing the number of windows and the dimensions.

Most of the one-story log cabins that dominated the Pennsylvania German landscape contained three to seven windows, a few of which were described as "leden." The houses, regardless of material or number of stories, were generally square or moderately rectangular. For example, Manor Township's one-story stone houses tended to be about 32 feet long and 28 feet wide and had five to seven windows.[24]

The two-story log houses fit the same basic framework as the one-story stone ones, although running slightly larger and with considerably more windows. In Manor Township two-story log houses were about 32 by 30 feet or, if square, were about 30 feet on a side. The two-story stone dwellings were slightly larger and modestly rectangular, with dimensions approximately 34 by 30 feet.

The greatest variety of dimensions appeared in the one-story log structures. In Manor Township they could be as small as 22 by 18 feet or as large as 45 by 25 feet, but many were approximately square. A minority was clearly rectangular and may have represented a doubling of one of the original dimensions.[25]

Except for barns, which were always rectangular and of very generous dimensions, outbuildings also tended to be square or nearly so.[26] In Manor Township in 1798 fourteen washhouses measured from 10 feet on a side to 20 by 26 feet. The more common springhouses were slightly smaller than the washhouses and rarely had a dimension larger than 20 feet. Outbuilding kitchen dimensions ranged from 12 by 12 feet to 22 by 18 feet.[27]

The 1798 tax was never collected, having been declared unconstitutional, but while the government never reaped its harvest, historians are finally able to do so. The unfortunate fact for historians is that the tax that had the potential of delivering detailed architectural data at regular intervals was cut down after one trial. However, a similar direct tax in 1815 survives for one portion of the Pennsylvania German heartland—Lancaster County. In this tax assessment 12,132 houses and barns were recorded, with assessors listing data on types of building material, numbers of stories, dimensions, and valuations.

The 1815 returns reveal that throughout Lancaster County 63 percent of the 8,168 houses were wood, 21 percent stone,

[23] Administration and Inventory of George Allbert, 1753, Office of the Register of Wills, Berks County Courthouse, Reading.

[24] The majority of the houses appear to be the type that Bucher and Glassie described in their articles on Continental log houses. Comparisons are difficult since Bucher does not provide details on window openings or interior and exterior dimensions and Glassie concentrates on one house. Manor Township's one-story stone houses were 35' x 30', 32' x 30', 32' x 29', 30' x 28', 30' x 27', 30' x 24', and 28' x 24'; an atypical one was 50' x 20'.

[25] One-story log houses were as follows: 30' x 27', 28' x 26', 27' x 25', 26' x 24', 25' x 24', 23' x 20', 22' x 20'. Those with one dimension doubled ran 45' x 25', 41' x 27', 40' x 19', 38' x 19'.

[26] In 1815 the barns of German settlers averaged 1,732 square feet, while those of English settlers were 1,099 square feet. Thomas A Lainhoff, "The Buildings of Lancaster County, 1815" (M.A. thesis, Pennsylvania State University, Capitol Campus, 1981), p. 15.

[27] The fourteen washhouses measured 26' x 20', 26' x 15', 25' x 20', 24' x 20' (2), 24' x 18', 23' x 20', 21' x 20', 21' x 14', 20' x 18', 18' x 15' (2), 12' x 10', 10' x 10'. Springhouses measured 20' x 18' (4), 18' x 16' (2), 10' x 8' (2), 7' x 6' (2). Outbuilding kitchens measured 22' x 18', 20' x 18', 16' x 16', 16', x 14', 14' x 10', 12' x 12'.

9 percent brick, and 7 percent mixed material. Most of the houses (61 percent) were one-story structures, with 38 percent two-story and 1 percent the urban three-story variety.[28] As in 1798 the assessors used a variety of terms to describe what they saw. For example, wood houses were almost equally divided between log on the one hand and wood, timber, or frame on the other. The wood houses were most likely clapboarded log structures. Comparisons of German, English, and mixed ethnic townships are possible because of the completeness of the 1815 returns. The returns confirm that brick was still an urban building material, but in no town or village did brick buildings constitute a majority of the dwellings. The highest percentage of brick (36 percent) appeared in the county's largest town—Lancaster—with the next highest (30 percent) in the village of Strasburg and (21 percent) in the booming Susquehanna River town of Marietta.

Stone remained the building material of the rural gentry, but, as in 1798, a large number of one-story stone houses served middle-class artisans in the Moravian town of Lititz and farmers in townships like Caernarvon. The prevalence of stone houses in Lititz (38 percent) was a consequence of the mid eighteenth-century growth and prosperity of the town and the Moravian predilection for stone construction. Caernarvon had the county's highest percentage of stone dwellings (48 percent), but that was consistent with other areas of heavy Welsh settlement. Throughout most other townships, regardless of ethnic majority, approximately one-fourth of the housing was stone. The chief exceptions were in the very prosperous and largely Germanic Lancaster and Lampeter townships, where 36 percent and 34 percent respectively were stone.

In spite of the dramatic increase in brick housing from 1798 to 1815 and the slow, steady accretion of stone housing, particularly two-story structures, the staple house throughout the Pennsylvania German townships was still the one-story log cabin. In fact, this was also true in Scots Irish areas and townships of mixed ethnic character. (Areas of English settlement had more frame than log construction.) In the Scots Irish townships the log dwellings were considerably smaller (Little Britain, 24 by 18 feet average size, 440 square feet average area) than their counterparts in German townships (Manor, 27 by 23 feet average size, 630 square feet average area).[29] It is true that dimensions and overall square footage of floor space are directly related to economic well-being. Consequently, areas of general high prosperity have a larger average size and area than town-

ships of moderate wealth. But in Lancaster County there is evidence that the Pennsylvania Germans in 1815 enjoyed more commodious living accommodations than their neighbors of equal wealth but different ethnic heritage. A similar situation prevailed in the size of barns.

As tax records of 1798 and 1815 show, the remarkable detail of these two documents alone would not provide conclusive evidence of ethnic differences in the domestic buildings of southeastern Pennsylvania. But scholars of vernacular building contend that dimensions are important as indicators of house type. These domestic measurements and the number of window openings, coupled with measurements of surviving houses, suggest that most of the dwellings recorded in the 1798 tax lists were more Continental in inspiration than English. Surviving eighteenth-century houses support this view.[30]

Numerous architectural studies have begun to develop the profile of Continental housing in Pennsylvania. One of the most important strains of architectural influence was Swiss. Pockets of Swiss-type housing have been identified in Lancaster, Lebanon, and Montgomery counties. In Lancaster County three of the earliest and most important surviving Swiss houses are the so-called Hans Herr House (Lampeter Township, 1719, built by Christian Herr), the Weber House (fig. 4), and the Eshleman Cabin (figs. 1, 5). All three were built by South German Mennonites of Swiss ancestry. The first two were stone houses with four-room first-floor plans and large lofts used for sleeping and storage. Very similar in plan and detail, the Herr and Weber houses were most likely built by the same mason. The Eshleman Cabin is a three-room-plan log cabin covered at a much later date with clapboards.

English architectural influence is nonexistent in these first-generation Pennsylvania German buildings, yet the houses are not purely Swiss or Palatine. In size, building materials, and placement on the land the houses had already taken a major step toward accommodation with the American experience. One of the most interesting aspects of the biographies of these houses is that eventually all three became obsolete as dwellings. For example, in 1763, a third-generation Weber—Jacob—began to build a new house on the original 260-acre Weizenthal plantation. Jacob had been educated in a nearby Quaker classical academy. His new

[28] Lainhoff, "Buildings of Lancaster County," pp. 12, 24–26.
[29] Lainhoff, "Buildings of Lancaster County," pp. 55–57.

[30] Arthur J. Lawton, "The Pre-Metric Foot and Its Use in Pennsylvania German Architecture," *Pennsylvania Folklife* 19, no. 1 (Autumn 1969): 37–45; and Arthur J. Lawton, "The Ground Rules of Folk Architecture," *Pennsylvania Folklife* 23, no. 1 (Autumn 1973): 13–19. For a study of two important houses that fit Lawton's conclusions, see Robert Barakat, "The Herr and Zeller Houses," *Pennsylvania Folklife* 21, no. 4 (Summer 1972):2–22.

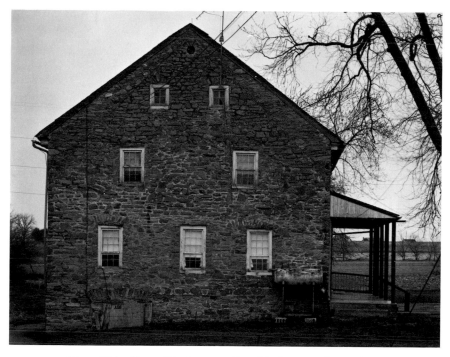

Fig. 4. Weber House, West Lampeter Township, Lancaster County, begun by Johannes Weber about 1724. (Photo, Winterthur.) The roofline has been altered and an additional window added to the gable end. In 1763/64 the Webers built a fashionable brick dwelling close by, and descendants of the Webers (Weavers), the William Moedingers, still occupy that house.

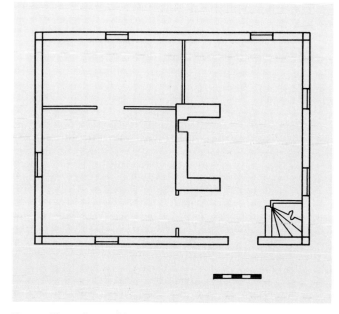

Fig. 5. Floor plan, Eshleman Cabin, Strasburg Township, Lancaster County, about 1730. (Drawing, courtesy Bernard L. Herman.) See fig. 1 for exterior. The cabin has a cellar under the parlor / sleeping chamber section and a second floor of four small rooms.

dwelling was a two-story Georgian brick, built at a time when the only rural brick buildings in reasonably close proximity were English Quaker.[31]

Many other Continental houses in Pennsylvania have no direct Swiss connections, but share a similar Germanic floor plan and the American traits discussed above. One of the largest and finest examples is the Hehn-Kershner house from Wernersville, Berks County, discussed in detail in chapter 5. Its common floor plan is found throughout the Pennsylvania German heartland in one- and two-story houses built of log, stone, or half-timbering, and it is these German American houses, primarily constructed before the American Revolution, that served as the dwelling places for the people who were creating a Pennsylvania German subculture.

We now know that in the eighteenth century the Pennsylvania German region had a prevailing Continental look

[31] William Woys Weaver, " 'Weizenthal' and the Early Architecture of Neu-Strasburge: Swiss Plantations in the Province of Pennsylvania" (M.A. thesis, University of Virginia, 1973), pp. 107–10. See also Robert C. Bucher, "The Swiss Bank House in Pennsylvania," *Pennsylvania Folklife* 18, no. 2 (Winter 1968/69): 2–11.

and flavor, but in the nineteenth century that landscape changed rapidly as an English Georgian architectural revolution swept through the Middle Atlantic region. Since buildings are among man's most outwardly expressive artifacts—they present the cultural patterns at the heart of daily existence—rapid acculturation in architecture is a major sign of internal change in the total culture. But in the countryside of Pennsylvania this shift occurred slowly, unevenly, and, to some extent, undramatically. Pennsylvania's rural Germans were slow to step across the vernacular threshold. Pennsylvania's Continental landscape endured into the 1830s and 1840s when the rapid increase in the number and size of towns led to more frequent use of brick to the exclusion of stone and log, and the full impact of the Georgian revolution permanently altered the architectural landscape. The most popular house type of Pennsylvania Germans—the one-and-one-half-story Continental-plan log cabin—faded into the past (figs. 6, 7).

Continental house types survived only as long as they represented the spiritual core of the culture. As the culture evolved, new types of buildings communicated the shifting of values. But for several generations distinctive dwellings provided not only physical nurturing for Pennsylvania German families but also shelter for the hearts and minds of a people faced with a raw land and an alien culture, caught between two worlds.

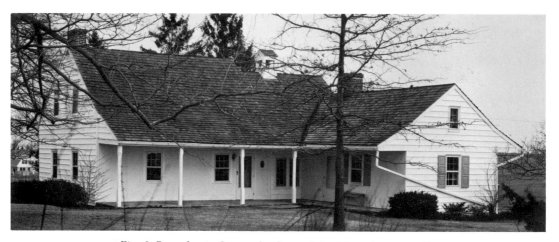

Fig. 6. Pennsylvania German log house, late eighteenth century, East Lampeter Township, Lancaster County. (Photo, Winterthur.) The major alterations to this dwelling include clapboarding, the removal of the interior chimney stack to the gable end, the addition of a link between the original house and its summer kitchen, and the porch posts. The second floor repeats the three-room plan of the first floor.

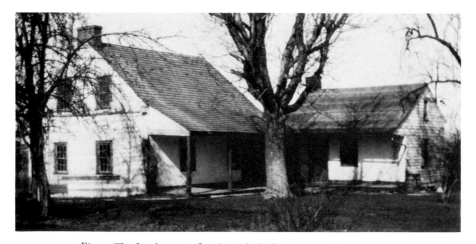

Fig. 7. The farmhouse in fig. 6 as it looked in 1931. At that time it was no longer a working farm, but the farm buildings remained.

Proxemic Patterns

SCOTT T. SWANK

A house reflects one way of organizing space to achieve a good fit, both in the way it relates to the larger architectural landscape and in the way it assists its inhabitants in the routines of daily life. Vernacular architecture, which by definition is built according to ethnic and regional traditions, is the product of a particular group's need for efficiently usable space. As machines for living, vernacular houses change slowly, following perceived shifts in living habits. Consequently, when architectural alterations do occur they usually first appear on the exterior and often are cosmetic. Changes in floor plans, spatial differentiation, and the shifting of personal interaction with household furnishings occur more slowly, even in modern societies.[1]

The study of how the German immigrants to Pennsylvania arranged and furnished the interiors of their houses, a study that could be termed historical proxemics, is facilitated by a visible living symbol of the larger eighteenth- and nineteenth-century fragment—the Old Order Amish of Lancaster County.[2] We can combine the information about patterns in their present-day households and furnishings with eighteenth- and nineteenth-century travelers' accounts, tax lists, estate inventories, account books, and surviving buildings and furniture to explore the paths the Germans took along the route to acculturation and assimilation.

THE AMISH

The Old Order Amish are a black-garbed plain folk who, with their "quaint" ways, have been fodder for tourist mills,

targets for juvenile pranks and vandalism, ready-made snapshots for insensitive photographers, and unique news for a flock of journalists. They have been vaunted for their simple way of life and denigrated for their ignorance. All of this by an outside world that rarely penetrates deeply enough beneath the surface of Amish culture to understand it.[3]

Popularizers often depict the Amish as a mirror of the past: human artifacts, frozen in an eighteenth-century and early nineteenth-century way of life. From that restricted vantage point the Amish become the epitome of early Pennsylvania German culture. From another perspective, scholars have attempted to set the record straight by pointing out that the Amish have always been a small minority of the Pennsylvania German population, that their particular brand of Anabaptist religious faith was and is atypical, and that they provide little useful historical information.

The truth lies somewhere between the two positions. The Amish are an important mirror of the past, although they retain little of their eighteenth-century culture. They do, however, represent nineteenth-century rural America prior to mechanization and modernization, and we can learn specific things about the past by observing their present practices. More important, the Amish retain elements of the fundamental structure of Pennsylvania German culture and thus serve as a vital resource in excavating proxemic patterns of all Pennsylvania Germans in the eighteenth and nineteenth centuries.

The Amish are continually changing, but as their most astute observer, John Hostetler, notes, the changes are reg-

[1] The study of the structuring of space and the process of interaction between man and his objects and space is known as proxemics.

[2] The leading theorist of proxemics is Edward T. Hall, author of *The Silent Language* (Garden City, N.Y.: Doubleday, 1959); *The Hidden Dimension* (Garden City, N.Y.: Doubleday, 1966); and *Beyond Culture* (Garden City, N.Y.: Doubleday, 1976).

[3] The best treatment of the Old Order Amish is John Hostetler, *Amish Society* (3d ed.; rev., Baltimore and London: Johns Hopkins University Press, 1980).

ulated and buffered to ensure smooth transitions and maintenance of traditional values.[4] By examining Amish domestic proxemics, which by their very nature reflect traditional cultural patterns, we can gain important insights into the past and present. Furniture and its deployment express identity. Because the Amish deemphasize individual expression, there is a marked similarity among Old Order Amish interiors and Amish furniture. Examination of one Lancaster County Amish house will suffice to suggest primary proxemic patterns.

THE FARM

John and Rebecca Stoltzfus live with their daughter Sadie Stoltzfus Fisher and her husband Amos Fisher on a seventy-four-acre farm near White Horse in Lancaster County.[5] John and Rebecca have lived on this farm ever since their marriage in the early 1940s. John is approximately sixty years of age. Amos and Sadie have lived at this location since shortly after their marriage. Amos is thirty-seven. The Stoltzfus farm lies on a ridge in a well-tilled valley. Tree-lined hills rim the valley and close off the eastern end near Honey Brook. The residents of the valley are predominately Amish.

On their seventy-four acres the Stotzfuses and Fishers raise corn and hay and graze dairy cattle. They have a capacity for thirty-eight cows, but at the time of our initial visit are milking only thirty-two. The first part of this visit includes a tour of the farm complex which comprises a two-family house, a carriage shed for horse-drawn buggies, a barn which has been enlarged several times to expand the cow stables, and a variety of smaller outbuildings. The farm shows signs of prosperity and reveals the obvious pride of the owners. The yard is larger than usual for an Amish family and sports an unusually large number of flower beds and carefully shaped shrubs. The care of the yard and the flower garden and the size of each may well reflect the fact that there are no young children being reared in this household. The family is sustained by two large gardens in separate locations, one for sweet corn, pumpkins, and strawberries and the other for flowers and for vegetables like potatoes, asparagus, green beans, lima beans, onions, and carrots.

THE HOUSE

The two-story house is a large, rambling, white frame structure of nineteenth-century origin. The original house, a

four-room dwelling with two front doors, was expanded into a double home by the addition of a kitchen wing on each side of the central core. As a result, each unit has three main rooms on the first floor laid out in a Germanic plan. The two parts are nearly identical in size and furnishings. The only major difference is in the kitchens. That of the parents, on the side of the house farthest from the barn, has been divided into two rooms of unequal size. The smaller of the two faces the front of the house (southern exposure) and serves primarily as a plant room, whereas the larger rear part serves as a kitchen for the parents, who occasionally prepare and take their meals separately from the Fishers. The Fisher kitchen runs the full depth of the house on the barn side. The entrance to this kitchen serves as the principal entrance to the entire house.

THE FURNISHINGS

In Old Order Amish homes the location of the important pieces of furniture is regularized. The downstairs bedroom of each family has a large double bed, a desk (which belongs to the husband), and a chest of drawers (which belongs to the wife).[6] Both parlors contain pieces of new and antique furniture, namely floral-decorated side chairs, shelf clocks, a corner cupboard to store the wife's best dishes, a sideboard—the top of which displays ceramics—and at least one sofa. The floors are covered with rag carpet overlaid with hooked and braided rugs. The windows have no curtains, only green pull blinds that are characteristic of Amish houses. Easy chairs and sofas in the parlors are protected with slipcovers. The predominant color of textiles in these two parlors is bright blue with accent colors of green, brown, and purple. The decorated wooden furniture sparkles with high-gloss varnish.

The parlors of this double house are strikingly similar in furnishings and color scheme. The chief differences are in the types and numbers of chairs and in the fact that the parents' furnishings are slightly more worn than those of the children. Specific display items vary. Those that were gifts of relatives, for example, the dishes in Sadie Fisher's corner cupboard, are proudly singled out. Rebecca Stoltzfus prizes her grandmother's Staffordshireware platter perched high on her corner cupboard. While some of the personal treasures are antique, most of the furniture is not.

The Fishers' large kitchen is sparsely furnished for its size. The permanent features include a coal-fired heating stove, a gas cooking stove, and large built-in cupboards around the sink. In the corner closest to the outside entrance, the Fish-

[4] Hostetler, *Amish Society*, pp. 353–71.

[5] The description of the residents and farm is based on two visits to one Amish farm in the summer of 1979 and the winter of 1980, but the material is grounded in extensive fieldwork and observation over many years. The names of the individuals visited have been changed to protect their privacy.

[6] Bedrooms might also contain several other items of furniture, including a clothes or storage closet, a night table, and chairs, but the principal pieces are always a bed, a desk, and a chest of drawers.

ers have a modern tall clock which they purchased from money bequeathed to them by Amos's aunt. Amos explained that the clock was something he had always wanted but thought he would be unable to afford until he was much older. He regards the clock as an appropriate reminder of his aunt. The kitchen also has a second clock, an antique shelf clock. Another prominent piece of furniture is an oversized kitchen cupboard with drawers and doors below, a counter top, and shelves with glass doors above. This cupboard holds many of the dishes used daily. The spacious room also contains a sofa, approximately a dozen chairs, and an extension table. The table is usually reduced to its smallest size and kept in the center of the room, but it can be extended with twelve boards. This empire-style table (recently made by Moses Horning, an Ephrata cabinet-maker) has a matching set of chairs. All are made out of red birch and finished naturally.

Several items in the downstairs individualize the house. A small floor cabinet with glass doors contains some twenty books, mostly German, a small collection of ceramic and metal poodle dogs, and a variety of other prized items including a model of a team of Budweiser horses pulling a wagon filled with kegs of beer. Next to his clock, the model is Amos's pride and joy. He had always wanted one of them and finally "just went out and bought it"; however, he notes wryly, the manufacturers do not have the team "hitched up" properly and he is thinking of devising something for the lead team. Each of the four residents of the household has a reverse painting on glass with a record of their immediate family, namely their brothers, sisters, and parents. The Fisher parlor contains a wooden wall plaque made by Amos. The plaque is composed of three separate layers of jigsaw-cut wood overlaid in a pattern; the overall effect is that of a pierced piece of wood. On top of these layers are wooden deer and little balconies like those of a Swiss chalet. Amos learned how to make these plaques from his father.

THE PEOPLE

John and Rebecca Stoltzfus are local Amish leaders. John is a deacon in the Amish church and a highly respected farmer who owns two farms. He purchased this farm in the early 1940s, and it is approximately a mile from his boyhood home. Amos and Sadie Fisher are also highly regarded in the community. Amos is a preacher in the Amish church even though he is relatively young for such a position, only thirty-seven. Sadie cannot bear children, a serious stigma for a married woman in the Amish faith. In place of children she projects her emotion and energies to her yard, garden, pets (including a white poodle dog named Cindy who performs tricks and a young colt named Toby who is the

son of one of her favorite draft mares), and a series of elaborate scrapbooks. Sadie keeps the scrapbooks in her bedroom but brings them out for special guests. The scrapbooks consist of pictures and appropriate poetry cut from magazines and greeting cards. Two are topical; one features horses and the other baskets. Sadie's other prized possessions are her dishes and her collection of miniature ceramic and metal poodles. Everyone in the family takes delight in bringing home surprise additions to Sadie's collections.

After a house and farm tour, we are invited to sit in the best seats in the kitchen to talk. The best seats are the upholsted ones, including a cushioned recliner rocker and a padded desk chair on rollers. Conversation flows easily because the Amish love to visit and are very inquisitive about their guests. They enjoy listening to and telling stories. John Stoltzfus in particular displays a keen sense of humor and tells numerous stories, one about a crusty veterinarian who years ago visited the farm to treat a sick cow. At one point in the visit the vet said brusquely, "Tell me, John, why is it that when an Amish child dies it's always the Lord's will, but when an Amish animal dies it's always my fault?" John roars with laughter and insists that he will never forget that incident.

During our conversation Amos Fisher shows us two objects decorated by his invalid father, a teakettle painted with a summer and winter scene and an earthenware pitcher decorated in the round with primitive farm scenes. Amos's father usually gets his ideas from memories, but the pictures are composites rather than exact recreations. Amos makes it clear that his father usually paints these for pleasure to give to family and friends, but occasionally he does them for unrelated Amish and the so-called English people who bring the objects to his house.

THE MEAL

We arrive at seven in the evening and spend approximately two hours touring and conversing before any move is made to provide refreshments. At nine o'clock the head of the house (Amos) says that it is time to "give these people what they came for." Nothing in the kitchen indicates preparation of food, but at these words the women get up and extend the kitchen table, put on a table cloth, and bring out dishes and silverware. The men disappear to get the homemade strawberry ice cream. By the time they return with the ice cream, the hanging Coleman kerosene lights are glowing brightly and the table is loaded with pretzels, chips, cookies, a homemade topping called strawberry delight, coffee, and grape juice. The kitchen transformation takes five minutes. What follows is a veritable orgy as we are encouraged again and again to fill our plates and keep on

eating. This is customary in an Amish household, for a hearty appetite is evidence of appreciation for the host's food. Through this informal ritual of eating we completed the cycle of friendship begun by the invitation to visit.

After the refreshments, Amos pushes his chair back from the table, a signal that the meal is done. While we are encouraged to stay and continue to chat, we are aware that during the summer darkness signifies bedtime for an Amish family and that eating is intended to conclude the evening. After lengthy good-byes, Amos Fisher lights a kerosene lantern so that he can escort us to our car. We leave about ten knowing that all of the dishes will be cleaned and put away, the kitchen will be returned to its original state, and our hosts will be in bed before we reach our home.

THE RETURN VISIT

Our second visit to the Stoltzfus and Fisher farm occurs on a blustery winter night. Our arrival about seven is greeted by Amos and a flashlight waving gaily from the kitchen door. We rush to the house and the warmth of a coal-heated kitchen. After initial pleasantries we are invited for another house tour, this time of the upstairs of the Fisher side of the double house.

The kitchen staircase leads to three upstairs bedrooms. Two of their floors are covered with printed linoleum, and the rooms are sparsely furnished compared to the downstairs rooms. Each contains a double bed and two other major items of furniture, in one room a modern wardrobe and a desk, in each of the other two a chest of drawers and a chest. All three rooms, like those downstairs, are immaculately clean. Few signs of personal life are visible. The tops of all chests of drawers and chests sport special displays of favorite things. Only the "spare" room has antique furniture, and the top of the chest of drawers there is decorated with antique china. The pillowcases are embroidered with Sadie Fisher's name. New hooked rugs, made by Sadie, adorn the only bare wooden floor in the house.

In the other bedrooms the chief decorative items are Sadie's shell creations, but her prize is hidden under the old bed in the spare room—a birthday present for Amos. It is a horse-drawn Conestoga wagon (made from shells) complete with landscape. An unusual framed picture hangs on another bedroom wall. It was created by Amos's father and consists of 300 to 400 buttons of various colors and sizes sewn to a fabric background. Approximately 12 inches square, the picture is a colorful tree with a broad trunk composed of white buttons.

After returning to the ground floor we are invited to take the best seats (rockers and upholstered chairs) in the Fisher parlor. Our hosts take the hard plank-seat chairs. For nearly an hour we swap stories and news, including one prolonged exchange on rural peddlers and tramps. The Amish remember them well and even gave them nicknames. The tramps visited once a year, begging food, selling trinkets, and sleeping in Amish barns. Few stayed more than one night, and none offered to do chores in return for their keep; however, John always asked them to leave their matches in the house before retiring at night and made them split wood before breakfast.

John chuckles as he remembers the stubborn individuality of these rural vagabonds. One morning as he came to the barn to milk his cows, John found a tramp sleeping "crossways" in the barn entry. After stepping over him several times, John asked the visitor to lie "longways" to make it easier for the farmers to do their work. John laughs heartily as he recalls that the man never returned!

About half-past eight the men mention that it is time for a snack. At this cue the women once again spread the kitchen table and load it with favorite Amish snacks, including more ice cream—this time homemade black raspberry ice cream—served up in cereal bowls. As on the previous visit, the ritual of eating is prolonged by pleasant conversation but signals the end of the evening.

INTERPRETATION:

PARALLELS WITH THE PAST

A visit to an Amish home is folklore material and intrinsically worth analyzing by itself; however, when we combine it with eighteenth-century data from probate inventories, household vendues, surviving artifacts and personal documents we have material with which to make historical generalizations. Working back from contemporary experience among traditional Pennsylvania Germans and forward from the earliest documents we can begin to piece together what can be called the proxemics of the past.

The Amish have come far along the road of change. Present-day Amish farmers, like other Pennsylvania German farmers in the twentieth century, are a completely different breed from their eighteenth-century counterparts. For example, Amish farming in southeastern Pennsylvania today is predominantly dairying supplemented by corn and tobacco as cash crops. In the eighteenth century it was mixed farming with wheat as the principal cash crop. But the differences run more deeply than the surface change indicates (figs. 8, 9).

Although resistant to English culture in dress, language, and folkways, the Old Order Amish have been strongly influenced by English ways. These influences are illustrated

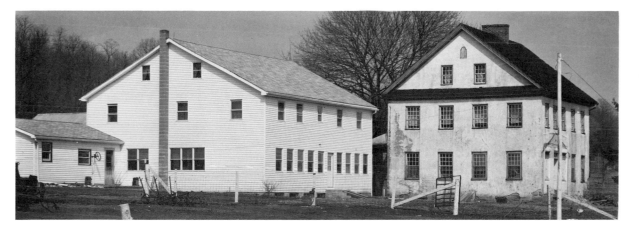

Fig. 8. Early nineteenth-century Pennsylvania German house, a few miles south of Strasburg, Lancaster County, now owned by Amish. The new house to the left was built in 1981 because the space of the old one did not suit the needs of a modern Old Order Amish family, who hold large religious gatherings in their homes. (Photo, Winterthur.)

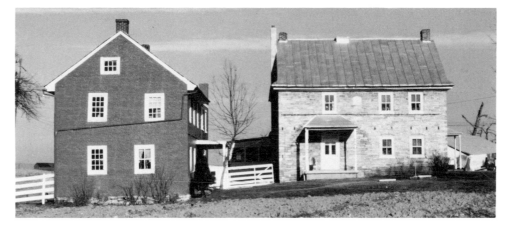

Fig. 9. Eighteenth-century Pennsylvania German house north of Lititz, Lancaster County, with its nineteenth-century brick Georgian counterpart. (Photo, Scott T. Swank.)

in the furniture forms today most common among the Old Order Amish of Lancaster County: beds, benches, chairs, chests, chests of drawers, corner cupboards, desks, kitchen dressers, night tables, sideboards, sofas, stoves, tables, wardrobes, and woodboxes. The chests of drawers, corner cupboards, desks, chairs, night tables, sideboards, and sofas are English in inspiration. The others are traditionally German in form but rarely retain the characteristic German decoration and construction. The mainstream Pennsylvania German culture began to use certain English forms by the 1770s in the country towns such as York, Reading, and Lancaster and even earlier in Philadelphia. But Amish and Mennonites responded more cautiously to fashion and the trend

toward assimilation. Most did not begin using English forms until the early nineteenth century.

Knowledge of the furniture used by the Amish and Mennonites in the eighteenth and nineteenth centuries can be gleaned from documentary sources and surviving objects.[7] One vital eighteenth-century source is the accounts of the Clemens family who lived in Lower Salford Township, Montgomery County. The accounts, listing gifts of Mennonite parents to their children over several generations, reveal deeply rooted cultural values, specifically what a Mennonite family believed was necessary to give a son or

[7] See, for example, Henry Lapp, *A Craftsman's Handbook,* ed. Beatrice B. Garvan (Philadelphia: Philadelphia Museum of Art, 1975).

daughter a proper material start in housekeeping.[8] Because of fundamental similarities in Amish and Mennonite cultures, these early account books can be studied in light of current Amish practice.

Antiques dealers, collectors, and historians have long labeled this starter set a dowry, meaning that which the bride brought to the marriage. In Pennsylvania German culture the records show that from adolescence both boys and girls received gifts preparing them for marriage and housekeeping. The Amish still continue the practice, and one Amish informant calls the starter set a recipe. The Old Order Amish recipe varies according to sex, socioeconomic status of the family, and region, but the principles governing gift giving, and the types of gifts, remain constant. Most Amish have no formal concept of the dowry. The lack of self-consciousness surrounding this ritual is demonstrated by the fact that if someone were to ask an Amish recipient where he or she got a particular dowry artifact he or she would most likely respond "I got it from home."

MALE RECIPE

In spite of variations according to family wealth, family tradition, and location (Old Order Amish in western Pennsylvania or the Midwest may have a different recipe), there are standard male and female recipes among the Old Order Amish of Lancaster County.[9] The standard items for an Amish boy are a bed, a set of bedding, a set of chairs, a chest or a chest of drawers, a desk, and a "team" (which means one horse and carriage with harness). Farm implements are normally not included.

Almost 200 years ago, in 1789, Jacob Clemens, a son of Gerhard Clemens, received the following items, which became relatively standard for males in the Clemens family: 2 horses, a harness, a wagon, and a saddle; 1 cow, 7 sheep, and 5 pigs; 1 bed, bedstead, and coverlet; and a silver pocket watch.[10] On May 27, 1809, Gerhard gave his son Henrich a desk, about two-and-a-half years after Henrich married Anna Kratz. Henrich's recipe also contained a room stove which then became a standard part of the male gifts for sons in the Clemens family. (Currently among the Amish the heating stove is given to the daughter.) For his sons, Henrich expanded the recipe to include a desk, a variety of textiles for bed coverings and other purposes, feathers, an ax,

[8]*The Account Book of the Clemens Family of Lower Salford Township, Montgomery County, Pennsylvania, 1749–1857,* trans. Raymond E. Hollenback, ed. Alan G. Keyser (Breinigsville, Pa.: Pennsylvania German Society, 1975).

[9]This information on Amish practice is based upon interviews during the winter of 1980 with several Amish, but the principal informants were Joseph and Sadie Beiler of Intercourse, Pennsylvania.

[10]*Clemens Account Book,* p. 70.

and a Bible. And, of course, all of the sons received land and cash.[11]

Of all the items mentioned in the male recipe, the desk became the most important single item in the nineteenth century, and it is still considered the most personal gift to the Amish male. The writing compartment of the desk contains all of the most confidential papers of the man of the house, including his will (and no member of the family would consider breaking the confidentiality of that desk), while the lower part of the desk has drawers that hold his best clothing.

FEMALE RECIPE

Among the Amish in the eastern part of Pennsylvania, the following recipe is relatively standard for girls: a heating stove, a kitchen table, a drop-leaf table, a sideboard, a chest of drawers, 3 beds with appropriate bedding, a corner cupboard, and a range of household and practical utensils. Of these household goods, the item that corresponds in importance to the desk is the corner cupboard (fig. 10). It is placed in the best room of the house once the bride goes to housekeeping and is used to store her best dishes. The piece of furniture most comparable to the desk in confidentiality is her chest of drawers, which, like the desk, is always placed in the bedroom.

In the Clemens's account book the first listing of gifts for girls occurred for Jacob's daugher Anne, who married Michael Ziegler on August 17, 1749 (or at least that is the date on which the entries are made in the journal). For Anne the items break down into the following categories:

Bedding: 2 bed cases, 2 bolster cases, 4 pillowcases, 4 white linen sheets, 1 bed tick for the upper bed, 1 bed tick for the under bed, ticking for the bolster and 2 small pillows, and 30 pounds of feathers.
Furniture: a bedstead; a pine chest with two drawers, a lock, and hinges; an English baking trough with lid; a cupboard; and a spinning wheel.
Metals: copperware, pewterware, a copper kettle, iron pots and pans, iron spoons, and a meat fork.
Livestock: 2 cows, 1 filly, 2 sheep, seeds, 8 bushels of seed oats (the Amish still provide seeds as part of the dowry recipe).
Money: £10 (cash, rather than land, was a standard item in the recipe for daughters in the Clemens family).

For later daughters of Jacob Clemens, the recipe remained approximately the same, but some items were spelled out more specifically and a few new items were added. For example, the cupboard was identified as a dish cupboard in

[11]In every case where bedding was mentioned, so, too, were feathers. Three generations of sons received feathers purchased "in the city," meaning Philadelphia.

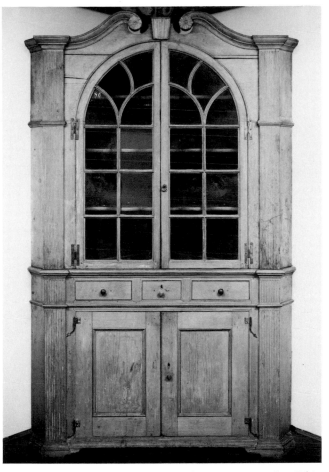

Fig. 10. Corner cupboard, Lancaster or Berks county, 1790–1820. White pine, traces of red paint; H. 92⅝″, W. 54½″, D. 27¼″. (Winterthur 65.1328.) The drawers are contructed in the German manner. The center drawer has the name Sarah S. Shirk stenciled twice on the right side. The drawer and door pulls and the H-hinges are replacements. A central finial is missing from the pediment.

the gifts to Esther in 1751. Esther also received a butter churn. In the account for Maria in 1755 bed curtains were specified. Maria was the first to receive a clothespress, which became a standard part of the recipe. In the gifts to Elizabeth in 1763 bed tick was identified as "English" bed tick, and new items were a woman's saddle, earthenware, a walnut chest with drawers and lock, and a walnut table. (The table is still a standard part of the female recipe among the Amish.) In 1773 Margrada did not receive a clothespress, but she did receive two "chairs with backs."[12] In 1774 Katharine was the first to receive a lighting device, but Katharine was unique in that no mention was made of her

marriage. She was probably the only one of Jacob Clemens's daughters to remain unmarried, and that would explain why the listing of gifts to her contains no furniture. Instead she was given cloth, which she probably used for bedding and clothing, and some cash. In 1778 her sister Suzanna received the standard recipe and a coverlet.

In the next generation, Gerhard Clemens gave his daughters essentially the same items that his sisters had received. The new items that began to appear in 1792 were looking glasses and *sets* of chairs, but regrettably, there is no mention of where any of the furniture was made or purchased.[13] On April 1, 1792, Elizabeth, who married George Reiff on February 7, 1792, received copperware, ironware, pewter, tinware, and the ubiquitous feathers, all of which were purchased in Philadelphia.

One of the most interesting shifts in the Clemens recipe occurred with the marriage of Sara Clemens to Jacob Reiff on September 19, 1793. Sara received a tea set, a pewter teapot, a tea box, and a tea table. Two other new items that appeared in her list were armchairs (possibly to match the side chairs) and a sprinkling can. This sprinkling can, and the digging shovels mentioned in several of the Clemens accounts, are indicators of the women's responsibility for the family garden. (In Amish households daughters still receive garden tools.) Katharine, who married Jacob Schumacher on April 11, 1799, received the first teakettle mentioned in the accounts. She was also the first daughter to get two bedsteads and, predictably, sufficient bedding for both.

Other new items appeared in the recipes for the daughters of Henrich Clemens, Gerhard's son. The first reference to a corner cupboard in the Clemens accounts was the specific mention of a walnut corner cupboard with glass front in the 1827 listing of Henrich's daughter Valle, who was married on April 1, 1827, to Jacob Godschal. The next appeared in Henrich's gifts for Elizabeth in 1834. Elizabeth's account also contained a description of her two beds—one had high posts and the other low posts. Instead of six chairs, she received nine. New listings included a quilt and a large Bible.

The items that Elizabeth and Valle received deserve further comment. The mention of a large Bible is interesting because today the Pennsylvania German Amish give the family Bible only to a son.[14] The shift to quilts may indicate

[12] This strange designation of chairs with backs may refer to the introduction of a new form of seating but more likely relates to the fact that the most common seating form was the bench.

[13] Joseph Beiler has indicated to me that the entire practice of gift giving to children "follows family lines," and, even today, the amount of new furniture given by the Amish depends on the wealth of the family and the family tradition.

[14] Joseph Beiler stated that among western Amish the older practice of giving the family Bible to the daughter is still carried on, and many old Amish Bibles have been traced through the female line.

that coverlets were going out of fashion. The daughters still received the long-standing gift of feathers, which for Henrich's daughters had now reached thirty-two pounds. As for the corner cupboards, one reason they do not appear in the listings before 1827 is that they were generally built into houses rather than being separate, movable pieces of furniture. Also, they were an English form, and the late date may reflect the delayed acceptance of it in German households. Since then, however, the corner cupboard has become one of the most important gifts to a daughter in the Amish community.

TWENTIETH-CENTURY PRACTICES

Amish parents are generally careful not to show preferential treatment in the giving of gifts. The exception might be a child who has been sickly for a time and receives gifts during that illness. Those gifts are added to the accumulation of treasure in preparation for marriage and independent housekeeping.

In some Amish families the tradition of gift giving and gift collecting begins with birth. For example, one Amish woman related that on her first visit to see a newborn granddaughter she always takes a dish as that child's first gift. The grandfather usually takes a penny bank to encourage a tradition of saving.[15] As each child grows older, the collection of gifts is assigned a place that belongs to that child. In most cases this is a drawer in a chest of drawers until the child receives a chest as a teenager. The serious accumulation of gifts to prepare for housekeeping usually begins at the time the child finishes school, approximately age fourteen, and continues until the age of marriage, which for a daughter is normally before her twenty-first birthday and for a son is in his early twenties.

Among the Amish the recipe is augmented by gifts from relatives and friends and contains a number of things made by the child. The parents, however, are responsible for providing the basic recipe. Since the recipe has become such a tradition within the Amish culture, parents express concern over the fact that their children may come to expect that these gifts *must* be given prior to going to housekeeping. The Amish parents work hard to inculcate the idea that the recipe cannot be taken for granted.

Usually the gifts to all the children are stored in a single upstairs room, most likely the least desirable bedroom. If the family has insufficient storage space, gifts are assigned to several bedrooms or the family tries to provide most of

the recipe at the time of the establishment of the new household. Differences of practice reflect different family traditions and socioeconomic standings.

If a child remains single, the situation is a difficult one for the Amish community to handle. Their world view endorses the ideal that every child should marry. If a daughter reaches age twenty-one without marrying, her chances of marrying diminish each year, and she is soon considered an old maid. Normally, a woman who does not marry remains at home to care for her parents through their old age. This means that she inherits many of her mother's furnishings as the parents scale down their level of housekeeping or die. In most cases, any gifts accumulated prior to age twenty-one remain her possessions. Men rarely remain single unless mentally or physically incapacitated.

In the Amish culture, the concept of a recipe is related to marriage but in no way connected to the marriage ceremony. Marriage is a religious act, not to be confused with the practice of accumulating material objects. While the bride does receive gifts at her wedding, there is no ceremonial presentation of the recipe. During the period of time between the marriage and when the couple actually go to housekeeping, the recipe and all wedding gifts remain at the home of the bride's parents. At the time the young couple sets up housekeeping, all the objects are moved to the new house. While not a formal ceremony, this ritual act of moving is tradition-bound and has European analogies. The gifts are used to furnish three historically and functionally important spaces: the kitchen, the master bedroom, and the parlor. The parlor is clearly the best room in the house and is used only on special occasions. In the beginning this may be the only room in the house to be carpeted and to have a sofa. The room will also contain the corner cupboard with a display of antique or treasured dishes. The bedroom, the most intimate of the three rooms, contains the husband's desk and the wife's chest of drawers. The kitchen is the center of the house and the actual living room for the Amish family because most Amish entertain friends and visitors there. (The Amish of western Pennsylvania and the Midwest are more likely to use the parlor to entertain visitors.)

Domestic artifacts are vital props in the drama of daily life but are often mute until placed into an interpretive context. Our preliminary study of Old Order Amish proxemics suggests insights about past behavior and assists in interpreting the silences of the historical record. Amish conservatism makes their cultural patterns especially useful in historical research, but we cannot assume that their current practice always reflects survival of Germanic custom. Such study must be complemented by analysis of other historical documents and surviving artifacts. No one type of source can

[15]Joseph and Sadie Beiler maintain this practice.

adequately tell the history of the Pennsylvania German structuring of domestic space.

DOMESTIC LIFE, 1730–1830

We have already established that in 1798 the majority of Pennsylvania German dwellings, even in the prosperous heartland, were the one-and-one-half-story stone and log Continental-style cabins that are now so rare on the contemporary landscape. The most common floor plan was three rooms on the first floor with loft above. The same basic house plan was found in two-story log and a few two-story stone buildings and in two- and four-room variants. If two rooms, the plan normally contained a kitchen and a combined bed chamber–stove room. If four rooms, the extra room was usually a storage room off the kitchen. While an increasing number of people of Pennsylvania German descent were signaling their assimilation by participating in the urban-sparked English Georgian housing revolution that was sweeping the region, in 1798 they were a minority of the Pennsylvania German population outside the principal towns.

Knowing that the most common eighteenth-century Pennsylvania German house was a one-and-one-half-story log dwelling of two to four rooms with a garret sleeping and storage area and at least a partial cellar facilitates the understanding of the eighteenth-century household inventories of the Pennsylvania Germans. Wills and household inventories that constitute much of Pennsylvania's probate records are the most valuable historical sources for the study of eighteenth-century domestic life. Fortunately, these legal records exist for all counties and townships in the Pennsylvania German heartland, although the records for many individuals were never written or have disappeared. In spite of missing thousands of persons, the extant records are a reliable sampling of white males of all classes. The same generalization does not apply to women. Many widows' records survive, but these represent only a small percentage of the total female population and not all classes.

The inventories in Pennsylvania were taken by court appointed neighbors of the deceased. Because of the variety of inventory takers, the documents vary widely, but the framework remained constant for generations. Usually two men compiled a fairly detailed listing of all personal property, including cash, apparel, livestock, tools, household furnishings, and outstanding notes, bonds, and book debts. This method remained the same whether the decedent was a gentleman, a farmer, or a tradesman.

Among the Pennsylvania Germans, inventories were generally written in or translated to English at the time of recording to satisfy local authorities, but many written in Pennsylvania German or High German (Moravian) do survive. The following inventory given in both Pennsylvania German and English provides comparative information and a sampling of the inventory format. This particular example is rich in detail and presents the goods of a prosperous Pennsylvania German farmer. While atypical it does illustrate the range of material possessions available to the Pennsylvania German community in Berks County early in the nineteenth century, and it is representative of a significant wealthy segment of the Pennsylvania German population by 1809.

Ein wahres und vollständiges Inventarium und gewissenhafte Schatzung, von allem und jedem dem fahrenden Vermögen des verstorbenen Daniel Althaus, weiland von Bern Taunschip, Berks Caunty in Staat Pennsylvanien, Bauersmann.
A true and complete inventory and conscientious appraisal of all and singular the moveable possessions of the deceased Daniel Althaus, late of Bern Township, Berks County in the state of Pennsylvania, farmer.

Die Kleidungs Stücke des verstorbenen	£ 10.—.—
The clothing of the deceased	
Haus-Uhr £7.10 Ofen und Rohr £7.10	15.—.—
House clock £7.10 Stove and pipe £7.10	
Tisch und zwei Bänk	1.17. 6
Table and two benches	
Acht Windsor und zwei andere Stühle	1.10.—
Eight windsor and two other chairs	
Ein Bett, Bettlade und Umhang	7.10.—
A bed, bedstead, and curtains	
Drei Kisten 22/6. Vier Better und Bettladen £18.	19. 2. 6
Three chests 22s. 6d. Four beds and bedsteads £18	
Zwei Bettladen 37/6. ohngefahr 20ᵇ gekammte Wolle £4.10	6. 7. 6
Two bedsteads 37s. 6d. approximately 20 lb. combed wool £4.10	
Eine Glattbuchs und Jagdtasche	2. 5.—
A smooth-bore rifle and hunting bag	
16 Yärd Wergen Tuch 32/ 6 1/2 Yärd Streifen 13/	2. 5.—
16 yards tow 32s. 6 1/2 yards striped 13s.	
Woll-Rad und Haspel 11/3 54 busch: Buchweitzen £8.2.	8.13. 3
Wool-wheel and reel 11s. 3d. 54 bushels buckwheat £8.2	
Acht und zwanzig, drei Buschel Säck	2.16.—
Twenty-eight, three-bushel sacks	
Zehn buschel Flachs-saamen	3.—.—
Ten bushels flax seeds	

Ein Mann, 2 Weiber Sättel, 3 Zäum u[nd] Sattelbäck 1.17. 6
One man's, 2 women's saddles, 3 bridles and saddlebags

Ein Faß mit Salz £1. Weitzen £3 4.—.—
A barrel with salt £1. Wheat £3

Zwei Fässer und eine kist 2/. Federn u[nd] Wolle 57/6 2.19. 6
Two barrels and a chest 2s. Feathers and wool 57s. 6d.

Gießkanne 7/6. Baumwoll-Rad u[nd] 3 Spinnräder 30/ 1.17. 6
Watering can 7s. 6d. Cotton-wheel and 3 spinning wheels 30s.

Kleiner Schrank u[nd] Holzener Schraubstock —. 2.—
Small cupboard and wooden vise

Acht Irdene Häfen 3/ Sieben Sicheln 3/9 —. 6. 9
Eight earthen pots 3s. Seven sickles 3s. 9d.

Alter Stuhl, Klingelstock, Leder u[nd] Schumachers Geschirr —. 7. 6
Old chair, —, leather and shoemaker's tools

Streifen 15/ 15 Yärd Hableinen £4.10 5. 5.—
Striped [cloth] 15s. 15 yards half-linen £4.10

Zwei Kopfkissen Züge, Tuch Für zwei Hemder u[nd] Tuch 1.10.—
Two pillow cases, cloth for two shirts and cloth

Acht Yärd Flächsen Tuch £2. eilf Tischtücher £4.2.6 6. 2. 6
Eight yards flax cloth £2. Eleven table cloths £4.2.6

Acht Handtücher 12/ drei Leintücher 22/6 1.14. 6
Eight hand towels 12s. Three sheets 22s. 6d.

Garn 7/6. Brille 2/. zwei Schachteln 1/10 —.11. 4
Yarn 7s. 6d. Spectacles 2s. Two boxes 1s. 10d.

Küchen Schrank, zinn u[nd] irden Geschirr darinnen 9.—.—
Kitchen cupboard, pewter and earthen dishes therein

Schnellwaage und andere Waage 1. 2. 6
Steelyard and other scales

Eisene Häfen, Pfannen u[nd] ander eisen Geschirr 3.—.—
Iron pots, pans, and other ironware

Hölzen u[nd] blechen Geschirr 1. 2. 6
Wooden and tin dishes

Backkörb, Messer, u[nd] Gabeln —.15.—
Bake-baskets, knives, and forks

Tisch, Botteln, und Biegeleisen —.15. 6
Table, bottles, and flatiron

Vier Äxte 15/ zwei Kaffe-Mühlen 7/6 1. 2. 6
Four axes 15s. Two coffee mills 7s. 6d.

Bettzüge 15/ Baumsäge 15/ zwei Schlösser 2/ 1.12.—
Bedcover 15s. Tree saw 15s. Two locks 2s.

Zehn Bärrel und drei halb Bärrel 3.15.—
Ten barrels and three half barrels

Ohngefähr 40 Gallen Äpfel Branntewein 6.—.—
Approximately 40 gallons apple brandy

Schreiner, Zimmer und ander Geschirr 3.—.—
Joiner's, carpenter's, and other tools

Krauthobel und drei kleine Fässer —.10.—
Cabbage slicer and three small barrels

Zwei Gallen Rum 15/ Butterfaß 10/ 1. 5.—
Two gallons rum 15s. Butter barrel 10s.

Grundbeeren £3. Irdene Häfen 13/4 3.13. 4
Potatoes £3. Earthen pots 13s. 4d.

Alter Tisch, Backmulde u[nd] kleine Zuber —. 7. 6
Old table, dough tray, and small tub

Zehn Immen Körb u[nd] Klein Zuberchen —.11. 3
Ten beehives and small tub

Wagenwinde 30/ Eisener kessel 3/9 1.13. 9
Wagon jack 30s. Iron kettle 3s. 9d.

Splittäxte, Keil, Schaufeln, Hacken u[nd] Beil 1. 2. 6
Splitting axes, wedge, shovels, hoes, and hatchet

Messinger Kessel £3. Roggen im Stroh £30 33.—.—
Brass kettle £3. Rye in the straw £30

Weitzen im Stroh £30. Haber im Stroh £8 38.—.—
Wheat in the field £30. Oats in the field £8.

Gerst im Stroh £10. Heu £37.10. Ohmet £15 62.10.—
Barley in the field £10. Hay £37.10. Second cutting of hay £15

Windmühl 22/6. Strohbank 15/ 1.17. 6
Windmill 22s. 6d. Straw-bench 15s.

Sieben Stück Gäuls-Vieh 113. 5.—
Seven horses

Heu, Mist und Schüttel Gabeln 1.—.—
Hay, dung, and shaking forks

Gäuls-Geschirr £3.15. Sechs Rechen 4/ 3.19.—
Horse equipment £3.15. Six rakes 4s.

Wagen mit Bady £20. Kleiner Wagen £6 26.—.—
Wagon with body £20. Small wagon £6

Drei Pflug 30/ zwei Eggen 25/ 2.15.—
Three plows 30s. Two harrows 25s.

Zwei Paar Heu Leitern 1. 2. 6
Two pairs hay ladders

Eilf Kühe £66. Acht Rinder £21. Sechs kälber £6 93.—.—
Eleven cows £66. Eight oxen £21. Six calves £6

Acht Schafe £5.5. neunzehn Schweine £33 38. 5.—
Eight sheep £5.5. Nineteen hogs £33

Schubkarren 7/6 Plenken 15/ zwei Ketten 22/6 2. 5.—
Wheelbarrow 7s. 6d. Planks 15s. Two chains 22s. 6d.

Zuber u[nd] Ständer 30/. Schindeln 5/ 1.15.—
Tub and water-tub 30s. Shingles 5s.

Sechs Körb mit Immen £3. Webstuhl u[nd] Geschirr £3. 3 6. 3.—
Six hives with bees £3. Loom and accessories £3.3

Schmiedegeschirr £9. Sieben sensen 22/6 10. 2. 6
Smith's tools £9. Seven scythes 22s. 6d.

Steinschlegel, Hebeisen, Schleifstein, alt Eisen —.15.—
Stone mallet, crowbar, grindstone, old iron

Stahl und Eisen 5/ zwei Fischgarn 7/6 —.12. 6
Steel and iron 5s. Two fishing lines 7s. 6d.

Zwei Brechen £1. Ziegeln 15/. Peinbretter 5/ 2.—.—
Two [e.g., flax-] brakes £1. Tiles [bricks?] 15s. Pine boards 5s.

Schwingmühle 15/. Ofen und Rohr 45/ 3.—.—
Scutch 15s. Stove and pipe 45s.

Drei Hecheln 15/. Stütz und Bettstangen 2/6 —.17. 6
Three flax-combs 15s. Supports and bedposts 2s. 6d.

Fünf Haber Reff 37/6. Popler Bretter 7/6 2. 5.—
Five oats cradles 37s. 6d. Poplar boards 7s. 6d.

Grosse Bibel u[nd] unterschiedene andere Bücher 3 —.—
Large Bible and various other books

Wollkarten, Barbier messer, Hörner u[nd] Wetzstein —.11. 3
Wool card, barber's knife, horns and whetstone

Flachs £2.12.6 Welschkorn im Feld £30 32.12. 6
Flax £2.12.6 Corn in the field £30

Wallnüße Bretter 45/ Sechs Gänse 11/3 2.16. 3
Walnut boards 45s. Six geese 11s. 6d.

Buchschulden 15. 0. 5
Book debts

Ein Band von Wendel Bernhard 43.15.—
A bond from Wendel Bernhard

In baarem Gelde 45.13.10½
Cash

 Belauf des ganzen £735. 8. 0½[16]
 Sum total

For our study inventories were used to provide data on the household furnishings of the Pennsylvania Germans, particularly their furniture. The focus was several hundred inventories from Berks and Lancaster counties, the core of Pennsylvania German culture.

Initially the inventories of all persons who died before 1830 and whose last names began with certain letters of the alphabet were examined. This approach enables researchers to slice through time, class, and geography. It also permits tracing the male line of particular families, and it delineates long-term trends.

A second sampling was made by chronology. Inventories

from A to Z were read for years at regularly spaced intervals from approximately 1730 to 1830.

A third sampling was more deliberately subjective than the other two procedures. Particular names—known political and economic leaders, craftsmen, and so forth—were checked. Detailed inventories were sought because they provide room-by-room information or documentation of particular household items.

The inventories reveal that German farmers and tradesmen who lived in the eighteenth and early nineteenth centuries had sparsely furnished houses. However, two qualifications to this generalization must be considered. First, if the Germans followed the traditions of their homeland, then their houses tended to have more built-in furniture than did English houses. Second, the inventories are only one part of the records of the deceased. Often certain household movables were given to children and wives before death, so we can never be certain that what is listed is a totally accurate picture of the owners' household. [17]

The goods of Caspar Walter of Leacock Township, Lancaster County, were appraised by Emanuel Carpenter and another neighbor in 1734. The entire inventory runs as follows:

	£	s.	d.
Plantation & crops	100	0	0
Livestock	38	0	0
Apparel, Horse etc	7	5	0
Debts outstanding	21	10	10
Linen Cloth, baggs, bibel & spoons	2	10	0
Iron tools	2	10	0
Farm implements, wagon etc	3	15	0
large Cettell	3	0	0
Crosscut saw	0	15	0
house mobels [furniture] all together	3	0	0
Total	179	65	10

It should be noted that all the furniture was equal in value to his one large kettle, probably brass.

Rudolf Heller, also of Leacock Township, another of Carpenter's neighbors who died in 1734, had an estate of £57.7 excluding the value of his farm. Carpenter valued the

[16] Daniel Althaus Inventory, 1812, Berks County Courthouse, Reading.

[17] The so-called Hans Herr House, for example, has such built-in furniture. Johann David Schoepf, *Travels in the Confederation* (1783–1784), trans. and ed. Alfred J. Morrison, vol. 1 (Philadelphia: William J. Campbell, 1911), p. 104, mentions that the typical German farmer in Pennsylvania possessed a "great four-cornered stove, a table in the corner with benches fastened to the wall, everything daubed with red." Alice Hanson Jones, *American Colonial Wealth*, vol. 1 (New York: Arno Press, 1977), pp. 17–18, 21, concludes that the inventories are reliable economic indicators. It should be noted, however, that if the inventory was taken for someone who had reached old age, it may reflect a reduced standard of living.

improvements to the property, which is to say the house and any outbuildings, at £30. "Household goods and Implements of several sorts" he valued at £6.2. The remainder of the estate was in livestock, apparel, and cash.

Christian Musselman of Lancaster Township also died in 1734. He had two separate plantations (each valued at £60) and considerable livestock in a total inventory of £173.10. "Kiching ware . . . £1" and "bed and cloths . . . £7.15.0" are the only references to household goods.

In the new settlement of Lancaster the appraisers were more explicit, but the household goods for middle-class residents were meager. John George Camer (Cramer), a stockingweaver who died in 1734, possessed a bed with furniture (£7), a kitchen cupboard and two "chists" (£2.14), two old clocks (£2.10), kitchen ware (£5.15), a gun (£1.10), and other miscellaneous household items (£1.18). The most unusual possessions for 1734 were "punch bowl glasses mustard potts and salts" (10s.). But, in an inventory valued at £178.18, the most highly valued item was the "improvement [made] upon 3 lotts" (£130). Of course, as a stockingweaver operating out of his home, he also had lining yarn, wool, two spinning wheels, "stocking loom and tackel" (£6), and "all the rest that belongs to the stockingmaker's trade (£4.15)."[18]

Even prosperous German farmers had a paucity of household goods throughout the eighteenth century. Hans Graff (Groff), a Swiss Mennonite, traveled to Germantown in 1696 and returned to Switzerland for a visit before settling in Pequea Valley of present-day Lancaster County (then Chester County). He then moved to Earl Township, Lancaster County, where by 1724 he owned some 1,400 acres of choice land. He built the first mill in the area of "Graffthal" (Groffdale) and raised six sons and three daughters, founding a veritable dynasty.[19] At the time of his death in 1746 much of his land had been dispersed to his sons. Graff's inventory, totaling about £620, included £300 for his plantation, £123.7.2 in notes and credits, and £73.16 for livestock. Household goods were worth less than £30, including £8.14.3 for "Bibles and other books," 17s. 6d. for grease, and 15s. for a wolf trap. Graff's furniture is listed as two spinning wheels, a "chist," beds (£6.11), a clock (£3.15), and three chests "and other things" (£1.1). Graff also possessed "Trincking Glasses," tinware, earthenware, pewterware, and woodenware. Among the "several sorts of tools" were potter's tools, indicating that Graff may have been a potter as well as a miller and a farmer.

Even as late as 1754 inventories reflect the same paucity of household goods. Michael Rith (Reith), Tulpehocken Township, Berks County, whose total estate was £693.12.4, had only a clock (£6), "chests and drawers" (£3), and several old books (£1). The rest of his inventory consisted of farm tools and animals and cash and bonds, including £57.15.6 in gold which he bequeathed to his wife. His farm was not included in the inventory. Jacob Weikert, also of Tulpehocken Township, died in 1755 leaving one bed, two bedsteads, household textiles, a few kitchen utensils, and farm equipment. Nearly £300 of the total estate of £310.3.6 was in bonds and notes. The next year Henry Zeller's Tulpehocken inventory of 1756 listed a large Bible and other books, a candlestick, looking glass and lamp, a bedstead with bedding, and three chests in addition to his apparel, farm animals and tools, and an unusual assortment of shoemaker's tools, smith's tools, a supply of iron, and a weaver's loom. Of a total estate of £222.1.4, nearly £100 was in bonds and notes.[20]

Jacob Hostetter, a Swiss Mennonite and one of the original settlers of Lancaster Township, had an estate inventoried at £247.19.3 in 1761. Of this, £200.10.6 was in cash, £22 in horses and wagons, and the remainder in personal and household goods, including £6.3.6 in "Holy Books," iron, pewter, and some tubs. The only furniture listed was feather beds (£2.2.5) and a wool wheel.

Emanuel Carpenter of Leacock Township, Lancaster County, the man who appraised so many estates in his area, died in 1780 after a long and distinguished career as a lawyer, farmer, and politician. His estate, valued at approximately £1,390, included £52.10 in cash and bonds and notes worth nearly £1,200. His riding horse and gear were valued at £34. His wearing apparel, valued at £26.10, equaled the total of the household goods of many of his neighbors, and at nearly £80, Carpenter's household goods were valued several times above those of the typical Pennsylvania German farmer. But in 1780 prices were greatly inflated by the war. If we eliminate his extensive collection of books (£17.15) and his watch (£12), then Carpenter's possessions were modest. He owned 2 beds with bedsteads (£10), a double clothespress (£3), a single clothespress (£2), a small clothespress (£1.15), a kitchen cupboard (£1), a walnut chest (£1), 2 spinning wheels (£1), 2 walnut tables (£1.15), 2 Windsor chairs (£1.5), 5 other chairs (15s.), an "Armstool" (£1.10), and a looking glass (5s.). His kitchenware (£17.19.6) was mostly pewter, with 1 brass and 1 copper kettle.

Emanuel's brother Jacob, of Earl Township, Lancaster

[18] All Lancaster County inventory references are based on inventories on deposit at Lancaster County Historical Society, Lancaster.

[19] Frank R. Diffenderffer, *The Three Earls* (New Holland, Pa.: Rauch and Sandoe, 1876), p. 23.

[20] All references to Berks County Inventories are based on probate records on deposit in the Office of the Register of Wills, Berks County Courthouse, Reading.

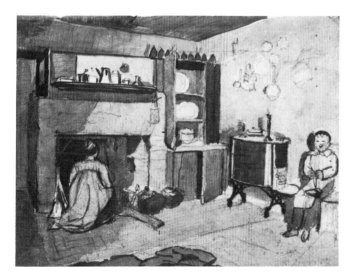

Fig. 11. John Lewis Krimmel, sketch of a plain Pennsylvania German kitchen, July 1819. Pencil and watercolor; H. 11.75 cm., W. 18.1 cm. (Joseph Downs Manuscript and Microfilm Collection 59 × 5.6.17, Winterthur Museum Library.) Note that the family had detached the heating stove during the summer.

County, died in 1784. His £584.5.3 estate lists cash, bonds, and notes worth £366.1.1 and livestock at £79. Personal and household goods, excluding farm tools and grain, totaled approximately £25. These included a house clock (£3), three bedsteads and beds (£6), a table and four chairs (£1), a chest (15s.), a kitchen dresser (£1.2.6), Bible and books (£4), and smaller items such as a looking glass, spinning wheels, and a reel.

Emanuel's brother John, also of Earl Township, who died in 1786, had an inventory of £1,188.17.3, of which approximately £1,050 was in cash, bonds, and notes. Household furnishings totaled nearly £35, including a clock (£11), bedsteads and bedding (£8.10), a ten-plate stove (£3.5), 2 chests, 2 tables, and 4 chairs (£1.3.6), and a "covered Dresser" (15s. 9d.). His Bible and books were valued at £3.17.6.

Until the 1790s, the furniture listings were sparse for the typical farmer and artisan.[21] Nearly all had at least one bed and bedstead, a chest, and a variety of other items, such as looking glass, kitchen cupboard, and spinning wheel, but few possessed a house full of furniture. Their houses were filled with farm and kitchen tools, saddles, grain, and various crocks and tubs for storage, rather than furniture and decorative accessories (fig. 11).

While many Pennsylvania German farmers and artisans

in the eighteenth century simply could not afford to purchase extra household items, many probably could but chose not to, or saw no need to. In certain regions scholars might explain this restraint as sectarian compulsion, for example, Mennonites resisting materialism; however, inventories of the pre-Revolutionary era provide no basis for any claim that sectarian principles governed the consumption patterns of Pennsylvania German farmers. The amount and type of furniture does not vary significantly throughout the region. In Berks County, which was overwhelmingly Lutheran and Reformed, sectarian principles did not apply, yet the same sparse furnishings pattern prevailed. Most German farmers and artisans, regardless of creed, put money into land, livestock, bonds, and notes rather than into houses and household goods.

Theophile Cazenove remarked on the paucity of household goods during his brief trip through Pennsylvania in 1794 and drew a comparison to his homeland. "In France you see the farmers having first, several large wardrobes, filled with clothes and linen, more or less, silver spoons, knives and forks, large silver drinking cups for each member of the family. . . . much linen underwear and table-linen, good wines and brandy in the cellar." He estimated that French farmers had four times as much furniture as Pennsylvania German farmers.[22]

Cazenove also saw a discrepancy between the size of many Pennsylvania German farmhouses and their sparsely furnished interiors. Fine stone houses, "two stories high" with "English" windows, were, to his eye, unfurnished. Beds lacked curtains, mirrors were rare, and good furniture of any kind, especially chairs, tables, and clothespresses, were lacking. Yet these same farms possessed large barns and good horses. Cazenove concluded, "If the farmers liked money less, they would surround themselves with more conveniences and live in plenty."[23]

Pennsylvania German farmers had a proclivity for interest-bearing bonds and notes. A sampling of the inventories from Berks and Lancaster counties makes generalization possible. First, the majority of Pennsylvania German farmers extended credit to someone, and the preponderance of their creditors appears to have been family members. Second, before 1800 little evidence exists of speculative investment in banks, turnpikes, or distant tracts of land. Instead, first-generation settlers tended to purchase large tracts of land which they then usually sold or bequeathed to friends and relatives. There were a few large landholders among later

[21] Occasionally an inventory listed no furniture, not even a bed, as in the cases of farmer Michael Ritter, Leacock Township, Lancaster County, 1760 (£166.3.10), and weaver Leonhard Ried, Tulpehocken Township, Berks County, 1761 (£136.2.4).

[22] Theophile Cazenove, *Journal, 1794: A Record of the Journal of Theophile Cazenove through New Jersey and Pennsylvania*, ed. Rayner Wickersham Kelsey (Haverford: Pennsylvania History Press, 1922), p. 42.

[23] Cazenove, *Journal*, pp. 84, 44.

generations, but most farmers were content with a somewhat smaller but workable farm.

The landholding patterns and the extension of credit to family and neighbors are clues to the network of community relations that existed in the Pennsylvania German heartland. The wealthiest members of a family or a community served as bankers to the poorer and younger members. Often the community was primarily an extension of the family, as is illustrated by the Herr family of Lancaster County. The Herrs are one of the most prolific of Pennsylvania German families, and one of the most tangled genealogically.[24] Abraham Herr's branch of this family was typical, where names and land were passed on in an unbroken stream for generations. Land warrant records show almost no land purchases for Herrs after 1730, although the family name remained a prominent one in the county, particularly in Manor, Lampeter, and Lancaster townships.

The tax records of Manor Township are extant from 1751, and at that time an Abraham Hear (Abraham II) paid the highest taxes (12s.) on the list of forty-two taxpayers.[25] In 1754 he fell to second place behind his son Rudolf Hear. The 1756 tax list provides some information on the extent of Abraham's agricultural holdings. In that year he possessed a 150-acre farm in a township where most farms fell in the range of 50 to 150 acres. (The largest farm, 300 acres, was owned by a township nonresident.) He kept 3 horses, 6 horned cattle, and 2 sheep. He was still the second-ranking taxpayer in 1756, but Rudolf was no longer listed. John Stoneman, with 200 acres, paid a tax of £1.2, and Andrew Cofman, Jr., with 150 acres, was tied with Abraham Herr at 15s.

The 1759 record provides information on the source of the family's prosperity, for it lists Abraham (II) as a miller with 100 acres of land. In fact, all four millers in Manor Township in 1759 were named Hear. By 1780 the tax lists refer to Abraham as "old," and to John, Rudolf, Christian, and Abraham as "old Abram's" sons. All four sons are variously listed as farmers or millers, including Rudolf who in 1771 was labeled a "jinier."

By the 1780s the population of Manor Township was probably five times as large as it was in the 1750s, and the Herrs began to lose preeminence as wealth and land were divided among old Abraham's family and that of his nephew Samuel. Nevertheless, all were prosperous, and some were

more well-to-do than the tax lists indicate. Old Abraham's sons and grandsons continued the family accumulation of wealth as the inventory of Abraham III (1824) adequately illustrates. It also shows that farming and milling were not the only enterprises Herrs pursued (*table 1*).

The inventory reconfirms a number of the generalizations made earlier about Pennsylvania Germans. Abraham Herr III was one of the wealthiest farmers in Lancaster County with a personal estate valued at $52,557.73 in 1824. Of this total, which does not include real estate, approximately $180 (0.3%) represents the value of household furnishings, as compared to nearly $900 in farm animals, tools, and produce. The rest of the estate is in bonds, notes, and stock.

For such a wealthy man the household goods are incredibly modest. Obviously Abraham Herr could have purchased anything he wanted for his house. Even the supposition that his family skimmed some of the choice items before his death cannot explain the paucity of consumer goods. Abraham must have chosen to live simply and to use his assets differently than did most of his urban and non-German contemporaries.

Abraham Herr's bonds were principally in the names of family members:

Christian Herr—Bond of $939
Abraham Herr—Bonds of $3094, 1000, 1000, 1000, 1000
John Herr—Bonds of $1000, 1000
Jacob Strickler—Bonds of $440, 440, 440, 440, 440, 440, 193
John Neidig—Bond of $1109
John Hoover—Bond of $820
his son Benjamen Herr—$8040
his daughter Barbara, the wife of John Schenck—$6000
his daughter Elizabeth, the widow of Jacob Smith—$6525
his daughter Veronica, the widow of John Kendig—$4107.20

He also owned lots in nearby Millersburg (now Millersville), a town laid out in 1764 which experienced rapid growth only after 1800. Herr's ground rents in Millersburg were worth $160 per year. With the rents in arrears, the ground rents due Herr's estate were $2,000. Herr's credits also included a number of other items not typically found in Pennsylvania German inventories—85 shares of Lancaster Bank stock ($2,337), 50 shares of Farmers Bank of Lancaster stock ($2,500), and 17 shares of Susquehanna Bridge stock ($1,700).

Only the more Anglicized Germans or the extremely well-to-do participated in the proliferation of household goods which by the 1760s and 1770s was characterizing town life and English colonial society in general. Michael Rice (Reith) of Tulpehocken Township, Berks County, possessed a total estate of £1,193.3.0½ when his goods were appraised in

[24] Martin Hervin Brackbill, "New Light on Hans Herr and Martin Kendig," *Papers Read before the Lancaster County Historical Society* 39, no. 4 (1935): 73–102.

[25] Manor Township tax list, 1751, Lancaster County Historical Society. All references to Manor Township tax lists are gleaned from microfilmed lists at the historical society.

TABLE 1

Abraham Herr
Household Goods, 1824

	$	Cts
1 silver watch		1.50
2 tables and 19 Chairs		14.70
a Looking Glass		7.00
a smooth rifle		6.00
picters Candlesticks and Sundries		13.00
a stove and pipe		12.00
a desk and table		7.00
a Kitchen dresser and tin and pewter ware		12.00
Spinning wheels and Sundries		16.70
2 beds and bedsteads		12.00
a Chest and Sundries		6.50
a looking glass chairs and Sundries		10.00
2 Tables Soap and Sundries		11.70
a bed and bedstead		9.00
3 beds and bedsteads		22.00
2 stoves		17.50
all the books		8.00
	$186.60	

Source: Abraham Herr Inventory, 1824,
Lancaster County Historical Society, Lancaster.

1766. Rice's inventory lists traditional German items among an extensive list of English furnishings and some items that cannot be assigned an ethnic identity. The German items were a clock and case, a kitchen cupboard, a clothespress, "Dutch" books, and a six-plate stove. The English items were a tea table, a chafing dish, candlesticks, and 3 snuffers. The items that cannot be assigned to either culture are 5 tables, 15 chairs, 3 beds and bedsteads (one with curtains), a bellows, pewterware, a watch, 4 lamps, an old lantern, a pewter teapot, 2 glass saltcellars, a glass and pewter milkpot, 21 glasses and tumblers, a delft teapot, and 3 delft plates. Most unusual are the presence of a tea service, delft, and extensive glassware and the absence of chests. And, as we have noted earlier, few German farmers possessed as many tables and chairs as Rice had in 1766.

The inventories indicate that both wealth and acculturation followed family lines within the Pennsylvania German culture. The Carpenters of Lancaster County were successful Pennsylvania Germans, and Emanuel Carpenter, at least, mingled easily in the English colonial political world. Nevertheless, the Carpenters of the eighteenth century retained traditional Germanic proxemic patterns in their daily lives and controlled the degree of their acculturation. In the nineteenth century the family continued to express its strong German identity in its religious preferences. Most

belonged to Carpenter's Church, a nondenominational family church, while other members of the family provided leadership for Lancaster Borough's small, German-based Swedenborgian community.[26]

The Herr family of Lancaster County was similar to the Carpenters in that it was rurally based and controlled the pace of its acculturation. It was more religiously conservative than the Carpenters, being Mennonite, and less politically active, but it was no less successful economically. Like the Carpenters, the Herrs eventually sent sons to Lancaster Borough where they distinguished themselves in the town's English-oriented society.

Conrad Weiser, a major figure in Pennsylvania politics until his death in 1760, set the pace of rapid acculturation in his family. The family inventories show considerable Anglicization even for family members who were not wealthy. They were change agents for acculturation, yet they remained Pennsylvania Germans.

Conrad Weiser's inventory (Reading, 1760) totaled £2,641 and took William Hottenstein, Christopher Witman, and William Reser two days to compile. Many of the following items in his inventory may represent the earliest listing of these articles in Berks County. Among the fashionable English household goods were a "couch" (£1); a black walnut desk (£5); 2 corner cupboards (£2.5); a chest of drawers "with rubbish in it" (£3.7.6); fire shovel, tongs, and two pairs of andirons; 14 large silver spoons (£14); a large "prospect" of Philadelphia; 6 maps, including a large framed map of Pennsylvania; and several sets of bed curtains (green, spotted, and linen).

Frederick Weiser, yeoman of Heidelberg Township, died in 1773. His inventory, evaluated at £386.19.2, contained one large and one small chest of drawers (£3.15 and £3 each), a dressing table (15s.), a dining table (£1), and two pairs of window curtains (10s.). John Weiser, Heidelberg Township yeoman, died in 1775 or 1776. His estate was a moderately wealthy £559.3.10, and his inventory also contained a number of English and fashionable items rarely found in rural Pennsylvania German households in the 1770s. Among these were "a mape and three pictures"; "an armchair and seven other chairs [a set?]"; teacups, teapots, and a tea box; and a china bowl, a sugar bowl, and a mustard pot. Benjamin Weiser, Middletown (present-day Womelsdorf), Heidelberg Township, in 1782 left an inventory of goods worth a modest £204.17.7. His furniture was predominantly expensive walnut and included an inlaid chest of drawers (£5), a plain bureau (£3.10), a round break-

fast table (£1), a 30-by-15-inch looking glass with walnut case (£2.10), and a "three plated walnutt" table (£1.10). Weiser also possessed silver, a rare commodity among Pennsylvania Germans of the eighteenth century. His inventory listed silver knee and shoe buckles, a pair of silver-plated spurs, a silver watch, and a sword with silver-plated hilt.

Certain families throughout the region served as change agents and precursors of the Anglicization that in time pervaded the Pennsylvania German culture as a whole. The more significant agents of change, however, were the towns. German residents of towns such as Lancaster and Reading faced English culture daily. Economics rather than ethnicity played the major role in shaping consumption patterns, and few of the wealthy Germans maintained traditional furnishing and consumption patterns.

John Crush of Lancaster, who died in 1776, is a case in point. Crush was a carpenter who prospered at his trade. In addition to the items we would expect to find in the estate of a prosperous Pennsylvania German, for example, a clothespress (£12), a clock and case (£8), and German books, Crush's inventory spills over with fashionable goods such as "1/2 doz. Glass Pictures Guilt" (£3); "Chane" plates, teacups, saucers, and chocolate bowls; delft; wine glasses; a desk and bookcase (£5); a dressing table (£2); and a "Numberella" (£9.7.6). The total value of Crush's tools, apparel, and household goods was recorded at £214.6.

Clocks, beds, and clothespresses (wardrobes) were the premier furniture forms among eighteenth-century Pennsylvania Germans. All three were traditional and highly expressive Germanic symbols, and all were expensive, but they were not confined to wealthy households. Many middle-class German farmers possessed clothespresses, and nearly all Pennsylvania Germans, unlike their English neighbors, owned a clock (fig. 12).

The passion for clocks was an outgrowth of the eighteenth-century desire to monitor time. German craftsmen in both Europe and America excelled in the production of precision timepieces. This brought clocks and watches within an affordable albeit expensive range for most Pennsylvania Germans.

Christian Scholly, Manheim Township, Lancaster County, in 1760 had an estate of £235.5, with personal and household goods valued at approximately £25. His clock alone was valued at £7.5. John Carpenter of Earl Township, Lancaster County, whose inventory in 1786 was discussed previously, possessed a clock whose £11 value represented nearly a third of the total value of his house furnishings (£35). Michael Albert of Tulpehocken Town-

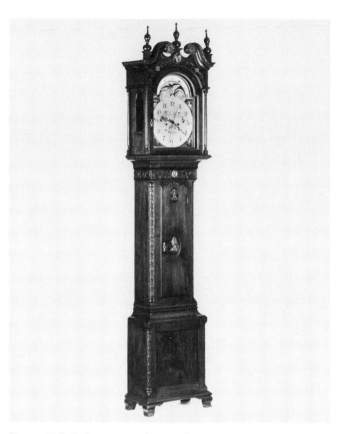

Fig. 12. Tall clock, movement by Daniel Oyster, Reading, Berks County, 1790–1800. Walnut case; 97⅝″, W. 21⅝″, D. 10⅞″. (Winterthur 59.2807.)

ship, Berks County, with an estate of £192.17, had approximately £30 worth of household goods as well as apparel. The most highly valued item was a house clock at £9. Clearly the Pennsylvania Germans placed relatively low value on general household goods but prized certain things highly, among them watches and clocks. Consistently in the inventories, watches and house clocks carry much higher evaluations than any other single item of furniture. Among traditional Pennsylvania Germans of the middling sort in the eighteenth century, the value of household goods generally ranged from £20 to £35 per inventory, while the total inventory may vary by hundreds and even thousands of pounds sterling. Timepieces for poor and middling Germans often represented a quarter to a third of the value of their household furnishings.

The only other household item that maintained such high value throughout the eighteenth and early nineteenth centuries was the bed. Like clocks, beds are often recorded among the first few items in inventories because of their value and because the bed of the deceased, like the clock, was considered an extension of person. Consequently, the

bed and clock were placed in the same category with a person's riding horse, saddle, and wearing apparel. The bed of the deceased was symbolic of the processes of life—conception, birth, sickness, and death—and this "best" bed was often elaborately adorned with textile hangings.

The inventories are explicit on this point. The most highly valued beds were those accompanied by curtains and other furniture. While Pennsylvania Germans of all classes had beds and bedsteads, fully hung high-post beds were a mark of the elite. While a middle-class home might have one such bed, the homes of the well-to-do would have several. The quality of textiles varied accordingly.[27]

In those parts of Europe from which the Pennsylvania Germans emigrated, and particularly among prosperous Catholics, the bed was adorned with painted decoration in addition to textiles. These beds often had decorated headboards and footboards and decorated wooden canopies and ceilings. No Pennsylvania examples of this form survive. Perhaps textiles completely supplanted the painted decoration in America, perhaps the tradition transferred but simply did not leave any artifactual evidence, or perhaps Protestants simply did not wish to express the meaning of the bed in explicit visual imagery. Many Pennsylvania German beds are painted in plain colors or decorated in various types of graining, but few of these can be safely documented to the eighteenth century. A few eighteenth-century cradles do survive. They are similar in form to European cradles (fig. 13).

In the area of south Germany, Austria, and Switzerland in the late eighteenth century, the bed was often part of a suite of furniture. Its companion pieces were the clothespress and chest. Occasionally these three forms were made and decorated en suite for the master bedchamber. No Pennsylvania examples of this kind of ensemble are known, but clearly the clothespress and chest were accorded an important role in the Pennsylvania German household, along with the bed and clock. The clothespress in its double form (two doors) was an expensive and showy piece of furniture. It could be upgraded, in expense and expressiveness, by inlay or paint or, in one instance, marquetry (see pl. 3). It also could be made in a much less expensive single version (one door).

The German clothespress, often used by husband and wife, was eventually replaced by two pieces of furniture, either separate chests of drawers or one for the wife and a desk for the husband. While examples from the 1800–1840 period are relatively common in European collec-

[27] Alan G. Keyser, "Beds, Bedding, Bedsteads and Sleep," *Der Reggeboge (The Rainbow): Quarterly of the Pennsylvania German Society* 12, no. 4 (October 1978): 1–28.

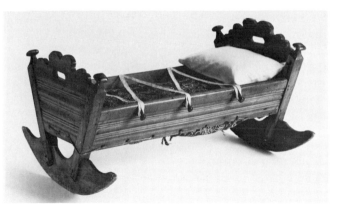

Fig. 13. Cradle, Pennsylvania, 1730–80. Walnut, tulip; H. 20½", L. 39¾", D. 30¼". (Winterthur 65.2260.)

tions, dated and decorated clothespresses are rare in Pennsylvania after 1810.

The chest, on the other hand, remained a popular and expressive form among Germans on both sides of the Atlantic throughout the nineteenth century, long after it was abandoned by Anglo-Americans (figs. 14, 15). Inventory records and craftsmen's account books show that it was always a cheap piece of furniture as compared to clocks, beds, and clothespresses. But the chest remains the most stable and traditional of all Pennsylvania German furniture forms from settlement to the present.

In spite of the high economic and cultural value placed upon these furniture forms, a generally low level of domestic consumption persisted among the Pennsylvania Germans until the 1820s in rural areas. In towns like Lancaster and Reading and in prosperous areas such as Berks County's Oley Valley, a larger percentage of inhabitants with relatively high assessments and more extensive inventories emerged as early as the 1760s. But in more rural townships, such as Greenwich and Bern in Berks County and Lampeter and Manor in Lancaster County, farmers who could afford to put a greater proportion of their assets into consumer goods chose not to do so and probably did not feel deprived.

Jacob Allweins of Bern Township, Berks County, who died in 1781, is an example. Of an inventory of £877.12.2, Allweins had £469.14 in notes and bonds and most of the rest in livestock and tools. His household goods (£13.11.6) included 1 bedstead with feather bed and curtains, another feather bed and straw bag, 4 spinning wheels, 1 reel, 3 chests (1 walnut), 7 chairs, 1 walnut table, 1 stove, 1 looking glass, some kitchen utensils including pewterware and a brass crane, and some bedding and textiles, including 2 coverlets and 1 sheet.

Christian Althouse, yeoman of Bern Township who died

in 1788, leaving an estate of £245.7.1, possessed personal apparel and household furnishings worth approximately £20. One ten-plate and one five-plate stove were valued at £6.[28] Althouse also owned a clock (valued only at 10s.), a complete bed, bedstead and bedding (£3), 1 table, 1 chest, 1 small box, 1 candlestick, 1 large spinning wheel, a second bed with 2 blankets, a kitchen dresser with furniture, other kitchen utensils, and a meal chest.

In order to gain appreciation and understanding of the full extent of household possessions, we must consider possessions transferred to widows (table 2). In general, the widow retained rights to what she brought to the marriage in the way of material possessions and received enough additional goods to sustain her comfortably.[29] Widows' inventories can be supplemented by the occasional notation "widow" beside items on the husband's inventory or, less frequently, by a separate list of items left for the widow.

David Harnish of Conestoga Township, Lancaster County, died in 1821 and left several items to his widow. Harnish, a Mennonite, was a farmer with goods valued at $1,380.44. He is atypical in that his inventory contained no notes, bonds, or credits of any kind. He is typical in the percentage of his estate devoted to household goods; approximately 10 percent was household furnishings.[30] The following goods listed in Harnish's inventory were not transferred to his widow: a family table ($3.50), 4 chairs ($2), 1 rocking chair ($.50), 1 bed and bedstead ($15), 1 desk ($20), 1 silver watch ($12), 1 looking glass ($1), 5 chairs ($3), 2 beds and bedsteads ($12 each), 1 drawer ($15), 1 chest ($2), 1 small table ($2), 1 spinning wheel ($2), 1 kitchen dresser ($8), and another bed and bedstead ($6), for a total value of $116. For the sake of perspective it is interesting to note that Hanish's three houses were valued at $80, $85, and $90, and his barrel of cherry bounce was appraised at $3. The following items were set aside for the widow and carried a value of $82.75, a sum that was included in the total of Harnish's estate: 1 white-spotted cow ($10), 2 beehives ($4), a rocking chair ($.50), a looking glass ($1), 5 chairs ($3), 2 beds and bedsteads ($12 each), a drawer ($15), a small table ($2), a spinning wheel ($2), a lot of yarn ($1), a lot of goods in the dresser ($6), 2 iron and 2 copper pots ($4), a watering can ($.50), a sidesaddle ($8), a tub ($.75), and a bag of chestnuts ($.50).

[28] A five-plate stove is a Pennsylvania German heating device; the English used the less efficient open fireplace. The five-plate stoves had to be built into the fireplace, and because they were built in they are rarely listed in inventories (inventories normally listed only moveable furniture).

[29] A more thorough treatment of the possessions of widows can be found in Russell Weider Gilbert, *Pennsylvania German Wills*, Pennsylvania German Folklore Society, vol. 15 (Allentown, Pa., 1951).

[30] The inventory contains a $100 error and should total $1,280.44.

TABLE 2			
Aprill the 19the 1785			
A True Inventory of the goods & Chattle			
of Susanna Cerbenter. wido in Earl Town			
ship Lancaster Couty & Stat of pennsylvania			
Leatly Decesesd As followethe.			
£	s.	d.	
To Hor wearing Aparrel	7	0	0
To Bed and Bedstet & haning	8	0	0
To A deable clath and 5 hand doub	1	10	0
To A biese of have moustert About 3 yeart & 1 garter	0	7	6
To About 30 yeart of heamb Lining	3	10	0
To A litle ——— of flax lining A bout yeart	2	17	6
To A New Testament and 5 othler Sombre Books	0	15	0
To A leey poud & Crame Chock	0	5	0
To A old women Satle	0	10	0
To A old Chist and Spining wile	0	15	0
To A marter an pestle of a marter & prefs Cafe bout	1	2	6
To a Bond vich is A bon Inbrefs	200	0	0
To Cash	45	17	6
	£270	10	

Source: Susanna Cerbenter Inventory, 1785, Lancaster County Historical Society, Lancaster.

An example from the low end of the socioeconomic spectrum is David Herr of Conestoga Township who died in 1815 leaving an estate of £335. His inventory lists no farm tools but does list shoemaker's tools, a turner's bench, carpenter's tools, and blacksmith's tools (£20.12.6). Because of the relatively low values placed on the other tools, it is safe to label Herr a blacksmith. Herr set aside for his widow a mare with saddle and bridle, two cows, an eight-day clock (£15), a bed and bedstead (£9), a chest, and a small table. The total value of these goods was £54.15. The other furnishings were to be sold at public vendue, but there was not much left to sell—three beds with bedsteads, a clothespress, a small desk, a stove with pipe, a kitchen dresser, a small chest, a dough trough, a cradle, a wool wheel, and two spinning wheels.

While these inventories may illustrate retention patterns more clearly than consumption patterns, and inventories may reflect a paucity of goods due to declining activity in old age, moving to a smaller dwelling, or transferring goods to children and widows, they overwhelmingly confirm a sparseness of material life. They also demonstrate that the rural way of life changed slowly. Rural inventories of 1770 are not very different in content from those of 1820. However, general economic indicators of the region reveal that

prosperity did accelerate in this time span as wheat prices rose following the Revolution. Consequently, more German farmers began to expand their domestic consumption after 1790. This trend is reflected in architecture (larger houses, more in an English Georgian mode) and in the range and type of household goods. While these changes seem to occur in all types of material—ceramics, textiles, and metals, for example—we will keep our focus on furniture.

Throughout the eighteenth century, Pennsylvania Germans selected their household furniture from a narrow and standard repertoire. Surviving pieces, cabinetmaker's account books, and inventories all confirm this. We should not assume, however, that self-conscious Germans purchased Germanic furniture only. From the beginning German settlers readily accepted certain English forms and practices but on a controlled and limited basis. They chose those that posed no threat to their way of life. The English plow and English dough tray or trough are two such examples.

It should be added, however, that although Pennsylvania German farmers by the 1780s and 1790s were beginning slowly to adopt English furniture forms, their non-German counterparts rarely adopted German forms beyond the iron stove.

Our survey of inventories from Berks and Lancaster counties revealed that most of the one-story stone or log cabins dotting the Pennsylvania German heartland held the following furnishings:

1 bed with bedstead and beddings (perhaps a feather bed with curtains)
1 bed and bedding (perhaps straw)
1 clock
1 table
3–5 chairs
1 chest
1 dough trough
1–2 spinning wheels
1 kitchen dresser
1 candlestick, lantern, or lamp
1 stove
several baskets (rye, straw, and willow)
textiles (tablecloths, bedsheets, and so on)
pewterware and tinware
earthenware
a few iron pots and kettles
some wooden tubs
1 brass or copper kettle
a few books, including a Bible
1 looking glass

Inventories alone cannot convey the degree of difference between cultures. Pennsylvania German and English inte-

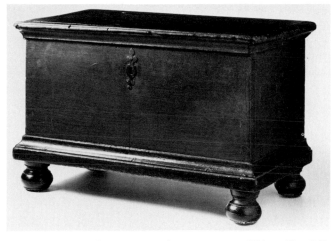

Fig. 14. Chest, southeastern Pennsylvania, 1750–70. Walnut; H. 16¾", W. 26½", D. 13¾". (Corbit-Sharp House, Winterthur in Odessa, 59.3583.) This small chest, with feet and base painted black, box and lid painted red, is an exception to the rule that walnut furniture was not painted. The scaled-down hardware is characteristic of full-size, eighteenth-century Pennsylvania German chests, and, as with larger chests, the lid moldings are applied to the front and sides, but the rear molding is cut into the lid.

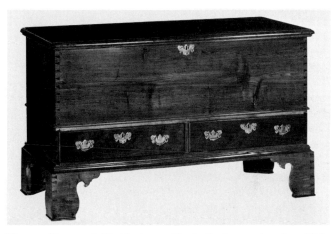

Fig. 15. Chest, probably Virginia or North Carolina, 1780–1800. Walnut, tulip; H. 27¼", W. 47¾", D. 22¾". (Wilson-Warner House, Winterthur in Odessa, 71.599.) The construction of this chest is not like that of Pennsylvania chests: it is a dovetailed box made of relatively narrow walnut boards that are set in an open-bottom frame. Larger corner blocks support high, mitered, and dovetailed feet that rest on narrow triangular pads.

riors were radically different to the eye. Floor plan, interior decor, and furniture (forms, placement, and decoration) immediately signaled the origin of the house owner.

Color is a critical element of interior decor, but unfortunately we know little regarding the interior color schemes of Pennsylvania German houses. Surviving artifacts, especially those in museums and private collections, have cre-

ated the impression that most Pennsylvania German furniture was decorated. Winterthur, for example, possesses only one unpainted walnut chest of German construction, and it is probably not of Pennsylvania origin (fig. 14). Winterthur also owns only one plain, painted Pennsylvania German chest (fig. 15). Both types were much more common than our collection indicates.

Inventories confirm that walnut, pine, and poplar were the dominant furniture woods for all eighteenth-century Pennsylvanians, including Pennsylvania Germans; cherry became an important furniture wood in the nineteenth century. In both centuries walnut was prized, and on inventories walnut objects were given higher values than those with painted woods. Walnut usually was not painted. Most painted or decorated pieces were probably made of pine and poplar. But paint was an expensive addition for inexpensive furniture, and inventories indicate that many pieces remained unpainted.

A few inventories do provide some color or wood designations for some of the furniture. The inventory of John Crush, Lancaster, 1776, itemizes "1/2 doz. Rush Bottom Chears (Blue)" (£1). The 1781 inventory of Adam Witman, well-to-do Reading innkeeper, lists 2 walnut tables (£2.5 and £1.5), 1 walnut table and 1 red table (£4 total), 1 red table (£1), 1 tea table (£2.5), a green and white bed, 7 red chairs, a gray mare and several red cows, along with hundreds of other items in an estate totaling a staggering £16,909.2. John Weidehammer, Jr., Maiden Creek Township, and John Adams of Bern Township, Berks County, both died in 1792. Weidehammer left 1 blue chest (10s.), and Adams left 1 red pine table (5s.). In contrast Abraham Wenger, Union Township, Berks County (d. 1794), had no painted furniture. He left a walnut desk, 2 walnut tables (1 small), and a walnut chest, as well as 3 small "poppeler" tables (1 round) and a "poppeler" meal chest.

So little painted decoration of the eighteenth century survives intact on interior woodwork that generalization is precarious. A few such interiors can still be found in the Kutztown and Oley Valley areas of Berks County, and a handful of examples are scattered throughout other areas of Pennsylvania German settlement, including the Shenandoah Valley and North Carolina. More survive from the early nineteenth century. The extant material suggests that some Pennsylvania German interiors were flamboyantly colorful.[31] Black, blue, red, green, and yellow, all often combined with white and frequently stippled or marbelized, created a polychromed effect rarely seen in the English-style

houses. In the first half of the nineteenth century the use of paint was universal in the Pennsylvania German culture region, but as time passed it declined in drama and became less ethnically identifiable.

Suggestions of the early paint use are rare in written records. A German schoolmaster, Johann Heinrich Gudehus, who served the conservative Zion Moselem Lutheran Church school in Berks County for a few years in the 1820s, left a few enticing references.[32]

The schoolmaster found the county a haven for someone like himself who spoke no English and chose it because it was one of the few areas near Philadelphia where German language was still taught to children as a matter of course. Upon arriving in Berks County, Gudehus stayed wih Heinrich Spang, Jr., the eldest son of a wealthy farmer who maintained a store, a farm, and a foundry. Gudehus was generally impressed with the size of American houses, but the young Spang's dwelling, he wrote, "stirred great awe in me and put me into great wonder and amazement. All of the rooms, even the kitchen, were painted in the most beautiful way and the wooden floors of the house were almost all covered with colorful woolen rugs. Even the steps were not forgotten."[33]

While Spang's may have been the first house to impress Gudehus, it was not the last. After some time in the region he generalized:

The new houses of the farmers, however, are almost all massive, constructed of stones and bricks and very nice inside as well as out; especially, however, the dwellings of the big, well-to-do and rich country inhabitants which one should consider in part princely palaces. Their beauty from outside as well as their neatness inside and the comfortable arrangement of the same not seldom brought me to wonder and amazement. All the houses usually have beautiful plank floors which are almost all cleaned each Saturday by means of a big brush, soap and hot water and are constantly white as hail and almost mirror bright. The rooms one also finds frequently very tastefully painted and the floors and stairs . . . covered with beautiful colored wool and cotton carpets.[34]

The placement of furniture can be discussed with more precision than painted decoration, since it can be surmised from our knowledge of house form and room function and can be confirmed by the occasional room-by-room inventory. (English inventories can often be deciphered room by

[31] An example, startling to modern eyes, can be seen at the Peter Wentz Farmstead, Worcester, Montgomery County. The exact date of the Wentz color scheme is difficult to determine.

[32] Johann Heinrich Gudehus, *Journey to America*, trans. Larry M. Neff, Publications of the Pennsylvania German Society, vol. 14 (Breinigsville, Pa., 1980), pp. 186, 188, 240. Gudehus returned to Germany after a few discouraging years.

[33] Gudehus, *Journey*, p. 217.

[34] Gudehus, *Journey*, p. 306. The old houses being replaced by the farmers were built from logs.

room because they were taken as the appraisers walked through the house; German inventories, however, reflect a hierarchy of values, and appraisers began with the most important personal possessions. Kitchen items were usually listed just above the enumeration of farm tools.)[35]

In spite of the problems, we can determine the placement of furniture because Pennsylvania Germans in the eighteenth century adhered to traditional proxemic patterns. In a three-room plan the *Küche* (kitchen) and its outbuildings held the dresser, dough trough, meal chest, worktable, old chairs, and a large assortment of tubs, crocks, and kitchen vessels and utensils. The *Kammer* (chamber) held the best bedstead and perhaps a second bed or a cradle, clothespress if the family possessed one, and at least one chest. The *Stube* (parlor-stove room) held the five-, six-, or ten-plate stove, clock, best table, benches, best chairs, spinning wheels, and the family bookshelf or a hanging cupboard. In the two-room variant, chamber and stove room functions and furnishings were combined in one large space.

The room-by-room inventory of Daniel Womelsdorf's house, Amity Township, Berks County, 1759, provides documentation for, and some exceptions to, the general pattern. Womelsdorf's house was either a four-room one-story or a four-room two-story Germanic house. In either case, the inventory shows that the parlor was not the English type but was used for sleeping (table 3).

Most room-by-room inventories that have come to light for Pennsylvania Germans reveal a high degree of assimilation, as in the case of John Hubley of Lancaster Borough. Hubley's house, probably three-story brick, had two fashionable parlors, an entry hall, an office, a kitchen, and a pantry on the first floor; a front room, three bedrooms, a nursery, and a storeroom on the second floor; and five garret rooms. The property also held a stable and a barn. The total value was $12,840.83.

John Hubley, a lawyer and politician, was one of Lancaster's leading citizens. His grandfather, George Hubley, had come to the colony in 1732 and after a short stay in Philadelphia moved to the new town of Lancaster in 1740. His father, Michael Hubley (1722–1804), was a Lancaster County magistrate for twenty-seven years and served for forty-three years as an official in Trinity Lutheran Church. John Hubley (1747–1821) was born in Lancaster, and his life and career paralleled the development of Lancaster itself. He remained a staunch Lutheran in a church that was a bastion of German identity and married a woman from the Pennsylvania German community, Maria Magdalena Lauman.

[35] Carol Kessler, "Ten Tulpehocken Inventories: What Do They Reveal about a Pennsylvania German Community?" *Pennsylvania Folklife* 23, no. 2 (Winter 1973 / 74): 16–30.

TABLE 3

Inventory of Daniel Womelsdorf, 1757

	£	s.	d.
The Stove Room			
A Clock and Case	7	0	0
A Case of Drawers	5	0	0
His Bedd and furniture	6	0	0
one other Bead	5	0	0
one old Chest and Small Walnut Box	0	7	6
one Small Round Table	0	12	0
Ten Chairs	0	12	6
In the Kitchen			
Pewter Tin and Earthan wares	2	00	0
Two Copper Ladles a Brass Colender and Tea Kettles	1	00	0
Three Small Potts and a Kettle	1	4	0
A frying Pan and 4 CandleSticks One Pair hand irons Two Smoothing Irons		4	0
Bake Iron Tongs and Stylyards		17	6
Pails and Buckets		4	0
A Small Table Lanthorn Dough Traugh		3	0
In His Daughter's Room			
A Bead and furniture	5	00	0
In the chamber			
Three old Chaff Beads	0	12	6
Five old Spinning Wheels	0	12	6

Source: Daniel Womelsdorf Inventory, 1757,
Office of the Register of Wills, Berks County, Reading.

Yet Hubley linked his career to the English elite of Lancaster. He studied law with Edward Shippen. In 1776 he became a delegate to the convention that drafted the Pennsylvania constitution. He distinguished himself as a soldier in the American Revolution and, in 1787, was a member of the convention that ratified the Constitution of the United States.

Hubley represented the successful third generation of his family in America and is a prominent example of the urban Pennsylvania Germans who saw no reason to resist assimilation, as the inventory of his principal rooms reveals (table 4). The second-floor rooms were as fashionable as the first. Bedrooms were furnished with bureaus, cases of drawers, looking glasses, pictures, and carpeting as well as the expected bed, bedstead, and bedding. If any of Hubley's furnishings were distinctively Pennsylvania German in form or decoration, there is no indication in the inventory of the first two floors, except for the presence of an eight-day clock. The garret listings show that old furniture had been pushed upstairs, for in those five garret rooms were numerous old carpets, tables, cases of drawers, beds, and other old fur-

TABLE 4

Inventory of John Hubley, 1821
(partial listing)
Lancaster Borough

Front Parlor, No. 1		1 desk	3.00
1 looking glass	$ 15.00	1 ditto	3.00
10 chairs	10.00	3 paper cases	3.00
3 tables	4.00	2 tables and 5 chairs	4.00
1 piano forte	60.00	1 oil cloth	.75
1 carpet and rug and stools	30.00	1 crumb cloth	.75
1 pr. brass andirons	3.00	2 small trunks	.75
5 waiters	6.00	*Pantry, No. 4*	
1 set candlesticks	6.00	"Sundry Queens Ware flat Ivory & Irene Pat."	9.00
1 picture	2.00	2 dough troughs ——— baskets	2.00
1 sofa	12.00		
Back Parlor, No. 2		*Kitchen, No. 4*	
1 lot of silver ware ———	200.00	sundry articles of kitchen furniture	15.00
1 sideboard	15.00	*Entry, No. 5*	
10 chairs	15.00	1 settee and 2 chairs	2.50
2 ditto	1.00	1 glass globe (broken)	1.50
1 looking glass	12.00	1 India matting	1.50
2 dining tables and 2 ends	8.00	1 stair carpeting and brass rods	6.00
1 stand	1.00	*Nursery, No. 10*	
1 pr. andirons and fender, shovel and tongs	3.50	1 bedstead and bedding	15.00
1 open stove	5.00	1 eight day clock	20.00
1 set mantle ornaments and candlesticks	2.00	1 looking glass	4.50
4 pictures	2.00	5 chairs and 2 tables	2.50
sundry queensware in cupboard	2.50	1 stand	.75
1 writing desk and table	1.00	1 stove and pipe	14.00
3 small waiters	.25	11 pictures	2.75
1 India matting	2.00	1 cupboard and contents	6.00
Articles in Office, No. 3		1 old carpet	.75
sundry books	100.00	3 old waiters	.75

Source: John Hubley Inventory, 1821,
Lancaster County Historical Society, Lancaster.

nishings, but, surprisingly, no chests for the storage of clothing and textiles. Among the other items were an old clothespress ($1), three old stools ($.30), an old "Flower Chest," and spinning wheels ($2.50). Hubley had relegated what was left of his Germanic furnishings, and much of his ethnic heritage as well, to the attic of his house and mind.

Now that we have established the range of forms and the general quantity of furniture possessed by the majority of Pennsylvania Germans in the 1730–1830 period, it is necessary to ask where and how they obtained their furniture, how was it constructed, and what was its appearance. Once again, because surviving artifacts skew the picture, we must combine documentary and artifactual sources.

The options for acquisition of furniture were numerous. Furniture could be brought from Germany by an immigrant or imported from Germany. It could be inherited or purchased at vendue. It could be made by the person who wanted it or ordered from a local craftsman. And by the late eighteenth century, some items could be purchased ready-made from urban craftsmen.

Immigration records are helpful in regard to human cargo but nearly mute in respect to personal baggage. A few references, our knowledge of shipping practices, and the surviving artifacts all lead to the conclusion that very little furniture, besides chests or trunks, was carried or imported to the Pennsylvania German community from Europe during the eighteenth century. The exceptions to this are clocks, some of which were carried over or imported because they

TABLE 5

Vendue of John Bowers
October 17, 1746

Augustine Weather—hatchet
John Hare [Herr]—1 old bag, 2 shirts, 1 coat
John Cunckle—1 feather bed and 1 sheet, table cloth
Andrew Pence—sheet, chrencher
Emanuel Hare [Herr]—table cloth, 1 mattock, pair of wool stockings, powder horn, leather apron
Jacob Foutz—mare and colt
Peter Syder—bridle
Henry Kindrick—1 ax, salt box
John Hickman, Sen.—1 gun
John Urich—1 Bible
Abraham Kindrick—whetstones, 1 hatt
Daniel Shaver—1 jacket
David Longenecker—1 ax
Jacob Painter—4 shirts
Joseph McKinney—1 old coat
Hugh McKenney—hoe
James McGee (Mullatoe)—2 shirts, 2 hand towels, feather bed and sheets
Thomas Smith—2 old jackets, pair old stockings, black breeches, old jacket, 2 shirts, 1 sheet, 1 sheet
John Segrist—scyth
Mitcheal Sherabough—pair linin breeches
Mitcheal Shirtz—pair of stockings
Jacob Miraw—pair breeches, knife, sickle
John Rush—Syth, pair of pinchers, knife
John Gosser—pair shoes, hammer and anvil, chairs, 1 hand towel, 1 pair of shoe brushes
Anne Fry—1 sheet
Henry Creesman—pair buckles
Jacob Light—looking glass and razor
Lawrence Slaymaker—horse shoes
Jacob Brewer—handkerchief, white curtains, 1 sheet
Charles Birbitt—leather straps, saddle
Paul Wilt—1 jacket

Source: Vendue papers attached to John Bowers inventory, 1746, Lancaster County Historical Society, Lancaster.

were highly prized and because demand far exceeded the supply made by colonial clockmakers.[36]

In the early decades of Pennsylvania German settlement the prospects for inheriting furniture were slim. Furniture was in short supply and the population was relatively young. As time passed, certain items of furniture began appearing over and over again in probate records. These are the most personal, the most symbolic, and frequently the most expensive pieces of furniture. Clocks, clothespresses, beds, and chests commonly received special attention in wills and inventories, just as they were the core of housekeeping furniture recipes.[37]

In light of the paucity of furniture until approximately 1760, vendues took on special significance. Then, as now in rural areas, neighbors waited like vultures for the final funeral rite of a household, the public vendue. The vendue was always an important social event, and it served a vital economic function by recycling household goods within the community. As such, in townships of mixed ethnic heritage the vendue served as agent of assimilation because Germans, English, Welsh, and Scots Irish exchanged goods.

An example is the Lancaster County vendue of John Bowers on October 17, 1746. The sale may have attracted a sizable crowd, but that we will never know. The record does reveal that thirty-one persons, including one woman and a mulatto, purchased goods (table 5).[38]

Bowers's inventory also survives. A comparison of the two documents suggests what other vendue records confirm, namely that inventory valuations tend to the low side when compared with prices that the articles sold for at public vendue but are generally accurate appraisals of the economic worth of personal property. For most of the personal items the inventory value and the vendue price vary by only a few shillings. In Bowers's case the difference was substantial only in a few instances. A Bible appraised at 10s. brought £1.0.6 at the sale. Bowers's new coat, jacket, and doublet, appraised at £4, sold for £5.6. Unfortunately, Bowers had very little furniture in his inventory or the vendue listing, but his three beds, valued at a total of £1.10 in the inventory, brought considerably more at the sale. Only two of the beds appear on the vendue list, and they brought £1.1 and 15s. 7d. A number of other items in the inventory are not on the vendue list, among them the intriguing "Three Cushiens and a great Cushien" and "four Cushien-Cloths."

The names of purchasers at the Bowers vendue are ethnically mixed, as was frequently the case at such events. Whether or not anyone refused to buy furnishings and tools across ethnic lines cannot be determined. (House sales and fire-company auctions in Pennsylvania today show that a good Dutchman will buy anything if the price is right.) In the eighteenth century, tools, textiles, and furniture were in short supply and purchased by the person who needed them most. In this way English plows and dough trays quickly found their way into German households, and Dutch stoves, sickles, and chests migrated to English and

[36] Monroe H. Fabian, *The Pennsylvania-German Decorated Chest*, Publications of the Pennsylvania German Society, vol. 12 (New York: Universe Books, 1978); Monroe H. Fabian, "An Immigrant's Inventory," *Pennsylvania Folklife* 25, no. 4 (Summer 1976): 47–48.

[37] Gilbert, *Pennsylvania German Wills*, pp. 18–19.
[38] Vendue papers for John Bowers are filed with his inventory in the county probate records, Lancaster County Historical Society.

Scots Irish homes. The vendue was a showcase in the great American trading post. Ethnic groups mingled, saw each other's homes, and bought each other's personal possessions.[39]

While ethnic interaction at the material level at first proceeded slowly, time and prosperity brought an abundance of consumer goods to the Pennsylvania German region, and the pace quickened. Town vendues undoubtedly attracted both urban and rural residents and may have introduced new forms and styles into rural areas. During the American Revolution especially, vendues of Tory estates attracted large crowds, and no one seemed too patriotic to carry away Tory goods.[40]

On February 18, 1778, in Reading, the estate of prominent Reading attorney and Tory John Biddle, was auctioned by Johannes Frey who received £3 for "Crying a Vendue" (table 6).[41] Most of the purchasers of the wealthy Englishman's goods were Frey's fellow Pennsylvania Germans. Biddle's estate brought £1,688.9.9 at inflated wartime prices. Significantly, his fashionable English goods—pictures, silver, mahogany furniture, and tea equipage, to name a few— were snapped up quickly by the German citizens of Reading. For many the Philadelphia merchandise in Biddle's estate may have been their initial exposure to certain forms and styles. Certainly silver, tea tables, rocking chairs, and umbrellas were not common among Reading's Pennsylvania German households in 1778.

Whatever may have been imported, acquired through inheritance, or purchased at vendue accounts for only a small percentage of furniture in the eighteenth century. While evidence suggests that some men in rural areas made furniture on a part-time basis for their families and neighbors, most furniture was produced by woodworking artisans.[42]

A few urban and rural craftsmen have left accounts of their trade that reveal the scope of their activity. These books are invaluable because they reveal prices (a measure of time, material, and social value), list purchases, provide a sense of the volume and rhythm of work, and at times describe the product. Unfortunately, these records are rare, although two rich ones left by Peter Ranck and Abraham Overholt

[39] Henry Glassie, "Log Architecture in Pennsylvania" (lecture delivered at Pennsbury Manor Americana Forum, September 26, 1980).

[40] In order to bid at Tory vendues, citizens were required to swear to an oath of allegiance to the new government. Public vendue, estate of John Biddle, February 18, 1778, Reading, *Pennsylvania Archives*, 6th ser., vol. 12 (Harrisburg, 1907), pp. 29–34.

[41] Biddle vendue, pp. 29.

[42] Jonathan Cox, "The Woodworking Community in Allentown, Salisbury Township, and Whitehall Township, Pennsylvania, 1753–1805" (M.A. thesis, University of Delaware, 1982).

TABLE 6

Public Vendue of estate of John Biddle, February 18, 1778, Reading

Item	Purchaser	Price
brass watch stand	David Lindsley	2/15/0
old table		0/ 6/0
old chair		5/ 2/6
6 pictures in frames	Henry Haller	11/ 5/0
1 mahogany desk	Thomas Warren	29/ 0/0
Ink stand	Isaac Levan, Jr.	2/ 0/0
Doughtrough and sundries		8/ 0/0
2 chairs and sundry	Widow Rees	0/ 6/0
2 pictures in frames	Thomas Atkinson	8/ 5/0
a walnut Jack		0/10/0
6 mahogany chairs	Jacob Bower	27/ 0/0
1 mahogany dressing table	George Shultz	18/15/0
1 mahogany tea table	Thomas Atkinson	16/17/6
1 square mahogany table	Colonel Lutz	15/15/0
1 square mahogany table	Captain Hedrick	17/ 5/0
3 chairs	Daniel Levan	5/ 5/0
1 rush buttom chair	Michael Ritner	0/11/0
a chaff bed	George Snyder	2/ 0/0
6 chairs	Casper Fleisher	12/ 0/0
Pictures	Jacob Bower	2/ 5/0
chair and sundry	Widow Rees	0/ 9/0
small chest and sundry		2/11/6
window curtains	Leonard Fealer	0/11/0
looking glass	Isaac Levan	9/15/0
1 arm chair	Captain Hedrick	2/ 1/0
small table		1/14/0
bedstead, bed and bedding	Isaac Coplin	48/15/0
1 high case of drawers	Thomas Youngman	44/15/0
1 pair bedsteads and wool	Jacob Dick	1/13/6
Kitchen dresser	Colonel Lutz	0/10/0
cupboard	Jacob Dicks	7/ 5/0
small table		1/11/0
tea table	Nicholas Sheffer	12/ 0/0
small chair and brush		0/19/0
7 silver tea and 5 tablespoons	Mrs. Barre	27/10/0
table		1/ 5/0
kitchen dresser		0/ 8/0
umbrella	Gabriel Hiester	1/15/0
a partition door and lock in ye seller	Adam Sleagle	0/12/0
a wig and sundries	Jacob Morgan, Jr.	3/10/0
1 iron stove	Jacob Morgan, Jr.	10/ 6/0
1 set green curtains	Peter Rapp	12/10/0
pics and a little cradle	Casper Fleisher	0/10/0
1 bedstead	Mrs. Barre	14/ 9/0
1 bedstead	Philip Wager	5/ 0/0
cradle	Henry Christ, Jr.	2/10/0
window curtains	Thomas Warren	7/ 1/0
high case mahogany drawers	Isaac Young	40/15/0
large arm chair	John Spohn	5/ 0/0
1 bedstead	Colonel Miflin	4/10/0
1 rocking chair	Thomas Warren	0/12/6

Source: *Pennsylvania Archives*, 6th ser., vol. 12 (Harrisburg, 1907), pp. 29–34.

have recently been translated and published by the Pennsylvania German Society.

The Peter Ranck account book portrays the activity of a Jonestown, Lebanon County, chestmaker. Between 1790 and 1840 Jonestown was a chestmaking center. Ranck, the grandson of German immigrants and the son of a Lancaster County farmer, was born in 1770 and baptized John Peter Ranck. He was one of eleven children, among them an older brother who was also trained as a joiner. In 1794 Ranck married and purchased a lot in Jonestown. He later built a large Georgian house on the square, and by 1814 he was operating an inn at a separate location in Jonestown. He died in 1851.[43] Between 1794 and 1817, Ranck fabricated approximately 80 bedsteads (high- and low-post), 60 chests, 45 tables, 20 dough trays (both table-top models and at least 1 with legs), 10 kitchen dressers, 6 cradles, 4 desks, 4 corner cupboards, 3 chairs, 1 clothespress, 1 chest of drawers, 2 saltboxes, and 1 picture frame. For students and collectors of furniture, Ranck's account book is tantalizing but unfulfilling because he provides no details on the construction or finished appearance of the furniture.

By contrast the account book of Abraham Overholt of Plumstead Township, Bucks County, provides elaborate detail, but because Overholt specialized in the turning and assembling of spinning wheels, his range of production was severely limited. Overholt used walnut, poplar, and pine, the only three woods mentioned in our sampling of Berks and Lancaster inventories. His unpainted walnut furniture, consistently cost more than the same form in soft wood, even when painted. For example, in 1791 two walnut chests sold for £2.8 and £2.5. In the same year Overholt charged £1.12 for a poplar chest with two drawers, painted red, and £1.17.6 for a three-drawer poplar chest with a "blue speckled" finish. His top-of-the-line chest in 1793 was a three-drawer walnut version with drawers until the till (£2.10).[44]

Overholt, like Ranck, produced more bedsteads and chests than all other forms combined. Whether high- or low-posted, Overholt's bedsteads were always painted—4 brown, 3 blue, 3 green, and 1 red. The red bedstead he produced in 1826. Overholt's chests were almost equally divided between painted pine and poplar and unpainted walnut. While he produced a few other pieces of furniture, these were also of mixed construction and finish. Included in the accounts are a walnut clock case with "arched top," a ten-drawer walnut chest of drawers, a walnut drop-leaf table with "crooked feet," a red painted kitchen cupboard with "24 panes," and a three-drawer chest, painted blue with red moldings.[45]

In conjunction with his descriptions, which conform to surviving furniture and offer no surprises, other researchers will find Overholt's prices a helpful tool when examining probate inventories. They should remember, however, that cabinetmakers' account books and family accounts contain information on prices of new furniture and the introduction of new forms and stylistic features. In contrast, inventories taken at the end of an individual's life put a value on used goods, and only certain items, like clocks, textiles, silver and brass, retain a generous percentage of their value after a generation of use.

A third and important account book is that of joiner John Bachman of Lancaster County. John Bachman (generally designated "II" to distinguish him from his father and his son of the same name) was born into a Swiss Mennonite family in 1746. He married Mary Rohrer of Lampeter Township and lived most of his working life in a two-story log house on a twenty-five-acre farm in Conestoga Township. The farm contained a separate joiner's shop where Bachman worked for more than thirty years. He died in 1828, leaving his estate in equal shares to his four children.[46]

Bachman's comprehensive record yields much valuable data on the rhythm of life and work of a country joiner, 1769–1828. While Bachman ran the business and was the only craftsman continuously associated with the shop, two sons and eight other woodworkers received training or provided assistance between 1775 and 1810. John Bachman III (1775–1849) trained with his father and set up his own business near McCartney's Corner in Pequea Township sometime after 1797. Jacob Bachman I (1782–1849) was the second son who established his own business in the Lampeter area. The apprentices were Johannes Miller, who eventually established his business in Strasburg Township, and Johan Rohrer, a relative who went into farming in Leacock Township. Others who worked for him were Valentine Meyer, Jacob Brand, Kitschli Miller, Heinrich Jung, Gottlieb Sener, and Jacob Sener.[47]

Bachman's output demonstrates that he was a full-time

[43] *The Accounts of Two Pennsylvania German Furniture Makers: Abraham Overholt, Bucks County, 1790–1833, and Peter Ranck, Lebanon County, 1794–1817,* trans. and ed. Alan G. Keyser, Larry M. Neff, and Frederick S. Weiser, Sources and Documents of the Pennsylvania Germans, vol. 3 (Breinigsville, Pa.: Pennsylvania German Society, 1978) (hereafter cited as *Overholt / Ranck*).

[44] *Overholt / Ranck*, pp. 3–4.

[45] *Overholt / Ranck*, pp. 3, 12, 19, 7, 10.

[46] John J. Snyder, Jr., "Chippendale Furniture of Lancaster County, Pennsylvania, 1760–1810," (M.A. thesis, University of Delaware, 1976), pp. 9–13.

[47] Snyder, "Chippendale Furniture," pp. 12–17.

woodworker who maintained a small farm for his own agricultural needs. He was a house carpenter and coffin maker as well as a furniture maker. Bachman produced at least 376 coffins between 1769 and 1808. His furniture output consisted of more than 400 bedsteads, at least 185 chests, and a range of other traditional forms including cradles, tables, dough troughs, clock cases, kitchen cupboards, and clothespresses. He also made fashionable English items such as tea tables, chests of drawers, breakfast tables, corner cupboards, desks, and desk-and-bookcases. According to the account book, he tried only one chair.[48]

The account book does not even hint at the use of inlay or veneer or the presence of carving. It does refer to the painting of furniture, for Bachman used large amounts of poplar as well as walnut. A surviving walnut desk-and-bookcase in the Chippendale style proves that Bachman was capable of good craftsmanship in the plain style to which his largely Mennonite clientele was accustomed. The desk-and-bookcase cost £16 in 1797, the fourth most expensive item in Bachman's accounts. Even so, it had no carving and was a conservative country statement that revealed no traces of the newly popular federal style.[49]

The peak business years for Bachman were in the prosperous post-Revolutionary era from 1784 to 1800. For example, from 1790 to 1799 fifty persons purchased furniture items costing £1 or more from his shop. Of these, forty-five lived within four miles of his shop and hailed from the adjacent townships of Conestoga (19), Lampeter (14), Strasburg (6), Manor (3), and Martic (2) as well as Lancaster Borough (1). The majority were Mennonite, as was Bachman, and many were relatives. Most of them were third-generation descendants of the pioneer band of Mennonites who settled Conestoga tract between 1710 and 1717.[50] Nearly all were prosperous farmers, with a few very wealthy patrons such as Abraham Witmer for whom a £20 set of "drawers" was made in 1792.

John Bachman's entire account book is written in Pennsylvania German dialect. That of his son Jacob, which starts in 1822, is in English, but the furniture forms fabricated by Jacob are generally the same as those his father produced.[51] Jacob, like his father, produced unpainted hardwood furniture and painted softwood pieces. On February 23, 1827,

he charged $1.25 for painting a kitchen dresser. The cost of his dressers varied considerably. In 1823 he made a walnut dresser for Jacob Rohrer for $24, whereas in 1824 and 1825 he made two, probably of softwood since he priced them at $14 and $15. In addition to walnut and poplar, Jacob used large quantities of cherry and pine. The cherry was used principally for desks and tables.

On at least one occasion Jacob seems to have made up a "recipe" of furniture. An entry on April 8, 1824, listed all of the following charged to Christian Bachman:

To one poplar kitchen dresser	$16.00
To one walnut dining table	6.00
To one highpost bedstead	7.50
To one open dresser	2.50
To one doetrough	1.75
To one wash trough	1.50
To two benches	1.50
To boxes and lampstand	1.25

Five months later, he sold Bachman a corner cupboard.

While the Bachman account books are the richest to survive from the Pennsylvania German community, the range of forms, prices, and productive capacity are probably representative of other rural Pennsylvania German joiners. As account books and inventories confirm, highly traditional patterns prevailed in the Pennsylvania German heartland from 1750 through at least 1840. Yet the process of acculturation was steady and inexorable, as Swiss, Palatines, and Württembergers became Pennsylvania Germans, and then Pennsylvanians. The pace differed with each family, each village, and each valley, and the marks of acculturation are visible in the material goods they chose to use. While we have concentrated on architecture and furniture, all material goods—tools and domestic items—reflect the cultural changes.

Material objects do provide valuable information on the process of acculturation, but they do not reveal the full nature and intensity of tensions beneath the surface. The English and German cultures rarely engaged in open political or physical strife in the history of Pennsylvania, but verbal struggles were common. While the transformation of Germans into Americans was generally smooth, ethnic tenacity enabled a minority of the Pennsylvania Germans to maintain their heritage. For this stubbornness they paid a price to a mainstream American culture that branded them "dumb Dutch."

[48] Snyder, "Chippendale Furniture," p. 23.

[49] Snyder, "Chippendale Furniture," p. 27, called the desk-and-bookcase the third most expensive item in the Bachman account, but there is a 1788 entry for a desk for Johann Bär at £20 which he apparently overlooked.

[50] Snyder, "Chippendale Furniture," pp. 18, 20–21.

[51] Jacob Bachman daybook, Joseph Downs Manuscript and Microfilm Collection, Winterthur Museum Library.

From Dumb Dutch to Folk Heroes

SCOTT T. SWANK

The image of the "dumb Dutch" may well antedate German migration to America, for every culture has its scapegoat for humor. Within the German states of the eighteenth century, Germans laughed at their fellow Swabians, a tradition that carried to America to the chagrin of the Swabians or "dumme Schwovve" who bore the brunt of it.

Bavarians and Pennsylvania Germans still tell the story of the thirteen Swabians who decided to venture beyond the boundaries of their region. The stolid Swabians set out one day to explore the land beyond the river near their village. Having crossed the river they became fearful and decided they must keep close watch on each other lest one of their group be lost. Stopping to count, their leader ticked off their number. "*Eens, zwee, drei, viere, fimfe*," and so on until he reached "*zwelfe*." Alarmed by the apparent loss of one of their number, each member of the group took his turn at counting. All counted twelve, but no one could pinpoint who was missing. As they milled about in confusion, chattering excitedly about their plight, a young Bavarian appeared on the road and asked if he could be of assistance. As they poured out their tale of adventure and woe, the Bavarian kindly offered to help. He pointed to a nearby dung heap and suggested that if the Swabians would lie face down on the dung heap and press their noses into it, then he could count noseprints and determine for certain if one of their party were missing. Eagerly the Swabians took his advice. As they rose, faces besmeared with Bavarian dung, they found to their astonishment that their noseprints numbered thirteen!

While the Germans, and those of German descent in America, have always enjoyed laughing at themselves and have not hesitated to poke fun at others, especially the Irish in Pennsylvania in the late eighteenth and early nineteenth

centuries, they have not appreciated being the brunt of ridicule by other ethnic groups.[1] Yet, because some eschewed modern developments, Pennsylvania Germans as a whole have been branded as stubborn and, in some cases, dumb.

The stereotype of the "dumb Dutch" emerged most clearly in Pennsylvania in the second half of the nineteenth century, was sustained through two world wars by anti-German sentiment, and is still vestigially alive in the Pennsylvania German community, with the Amish currently the chief victims of humorous barbs.

One source of the image may be Pennsylvania Germans' resistance to forced Anglicization of public schools in the 1830s and 1840s. Because of their opposition, Pennsylvania Germans were branded as being antieducation, a distortion of their true position. But many Pennsylvania Germans shared the general skepticism of nineteenth-century rural Americans toward higher education.

A second opportunity for misunderstanding lay in the rural and agricultural base of Pennsylvania German culture. Proponents of rapid urbanization often depicted farmers and rural townspeople as ignorant and unprogressive folk. A description of Lancaster, Pennsylvania, in 1876 provides the flavor of the conflict.

When it is remembered that the county, of which this old town is the center, is unsurpassed by any in the State for combined agricultural and mineral wealth, and that while the county contains over 125,000 people, this place has during the lapse of over one

[1]John J. Stoudt, *Sunbonnets and Shoofly Pies: Pennsylvania Dutch Cultural History* (South Brunswick, N.J., and New York: A. S. Barnes, 1973), pp. 22–236; Arthur D. Graeff, "Humor in Pennsylvania-German Almanacs," *American-German Review* 5, no. 5 (June 1939): 30–38; Abraham H. Rothermel, *The Dumb Dutch by One of Them* (Myerstown, Pa.: Church Center Press, 1948).

hundred and thirty years, only reached a population of 25,000 it will be surmised that the spirit of American enterprise has for some cause been discouraged, and rendered powerless to act in that vigorous manner commensurate with such surroundings and facilities, and can only be harmonized by the conclusion that during the past years which have witnessed, one by one, the bones of the original Dutch settlers drop into the earth, there must have reigned a disposition of what is now styled old-fogyism, to such an extent as to paralyze the growth of that enterprise so needful for the building up of great business centers.[2]

In addition to the animosity kindled over the school controversy and over the conservative orientation of the Pennsylvania German culture, the stereotypic image emerged from the mode of thought dominant in the writing of American history in the late nineteenth and early twentieth centuries—New England bias that allowed little room for the appreciation of non-Yankees. Ironically, the same authors that held the dumb Dutch up for ridicule also criticized the zealousness of New England's Puritans. An article entitled "Puritanism of the Pennsylvania-Germans" in *Harper's Monthly* in 1910 swiped at both groups with one stroke of the pen. "[The Pennsylvania Germans'] dimmer minds were not stirred in . . . a continual torment of self-question; but their lives were ordered with as rigid an ideal of conduct, and their ways were involved in a minuter and more constant sense of the mystery of the world." The author conceded that the theology of the Pennsylvania Germans was warmer than the Calvinism of New England, but he averred that the Pennsylvania Germans lacked the saving sense of humor that evolved out of Puritan New England culture. As historian Richard Shryock explained, "historians apparently projected their own ignorance of the culture into the culture itself. If they [Shryock means Francis Parkman, George Bancroft, and Albert B. Hart, among others] were not familiar with German theology, or art, or artisanship, there just wasn't any. Ergo, the 'Dutch' were just 'dumb.' "[3]

Fourth, and last, the image was rooted in ethnic bias. In the dominant English culture there was little disposition to ascribe positive qualities to ethnics who clung stubbornly to their language, customs, and identity. Ethnicity in the late nineteenth and early twentieth centuries was perceived as more of a threat to democracy than a stimulant, as immigration restriction laws of the 1920s attest. With the excep-

tion of Phebe Earle Gibbons, popular writers extended no more compliments to the Pennsylvania Germans than the academic historians did.[4]

Trends in popular literature in the late nineteenth and early twentieth centuries encouraged the development of regional and ethnic writers. Novels and short stories on the quaint, rural life of the Pennsylvania Germans appealed to the national audiences of New York's publishing industry. One of the most prolific of these Pennsylvania German popularists was Helen Reimensnyder Martin, who published at least thirty-eight novels between 1896 and 1939.

Martin, born in the heartland of the Pennsylvania Germans, rendered folk traditions into silly anachronisms and reduced life to a pat formula in all of her novels and short stories. To a degree the formula was her own, but, more important, it codified the values of the "progressive" forces she endorsed. Because her literary formulas are cultural products that achieved popularity, they deserve attention even though her novels' literary qualities might not.[5]

In most of her works, Martin used an attractive, sensitive young female as her central character. Usually this innocent child is being reared in a repressive and culturally deprived Pennsylvania German home—repressive because of male domination, culturally deprived because of the traditional rural distrust of book learning and city life. In the stifling environment, the heroine struggles with her burgeoning desire for freedom, her repressed sexuality, and her feelings of loyalty to family and home. A small supporting cast of stylized "significant others" are introduced to impede and / or assist the heroine in her dilemma.

Martin's classic novels are *Tillie, the Mennonite Maid* (1904) and *Maggie of Virginsburg* (1918). Tillie is a child in a Mennonite family in Lancaster County. The significant others are Miss Margaret, a college-educated teacher from Kentucky who lands a job in Tillie's school district; Doc, a blaspheming eccentric who provides medical service to the community and takes open delight in shocking and outwitting his stubborn, slow-witted Dutch neighbors; and Walter Fairchilds, an orphan reared in New England by an Episcopal bishop. As a Harvard student Walter had embraced agnosticism and was cast out of his home by the angry bishop. He migrates to Lancaster County where he becomes a teacher and Tillie's liberator. Maggie of Virgins-

[2] E. C. Hussey, *Home Building: A Reliable Book of Facts, Relative to Building, Living, Materials, Costs* (New York: Leader and Van Hoesen, 1876), pp. 326–27.

[3] James Truslow Adams, *The Founding of New England* (Boston: Atlantic Monthly Press, 1921); "Editor's Easy Chair," *Harper's Monthly* 121, no. 723 (August 1910): 473–75; Richard Shryock, "The Pennsylvania Germans as Seen by Historians," in *The Pennsylvania Germans*, ed. Ralph Wood (Princeton: Princeton University Press, 1942), pp. 239–58.

[4] Phebe H. Earle Gibbons, *"Pennsylvania Dutch" and Other Essays* (Philadelphia: Lippincott, 1872). Reprinted in 1874 and 1882. Gibbons, a Philadelphia-born Hicksite Quakeress, lived in Lancaster County while writing articles for *Atlantic Monthly* in the 1860s and 1870s. Her book remains a useful examination of Pennsylvania German culture.

[5] John Cawelti, "Literary Formulas and Their Cultural Significance," in *The Study of American Culture: Contemporary Conflicts*, ed. Luther S. Leudtke (Deland, Fla.: Everett / Edwards, 1977), pp. 186–87.

burg is similarly reared among the "church" Germans of rural Berks County, and her story follows the same general formula as Tillie's.[6]

As early as the 1890s a few Pennsylvania Germans began to retaliate against the stereotype. The most notable of the first efforts was the organization of the Pennsylvania German Society on April 15, 1891, in that notorious center of "old-fogyism," Lancaster. The minutes of the organizing session are replete with concern over the slighting of Pennsylvania Germans in the writings of the nation's history. The organizers expressed resentment over the "Puritanizing" of the past at the expense of other regions and different ethnic and religious groups.[7]

The men who founded the Pennsylvania German Society began by building on foundations laid by Pennsylvania German antiquarians earlier in the century. These pioneer amateur historians, men such as Israel Rupp, Morton L. Montgomery, and Abraham Harley Cassel, had already gathered records and documents and begun to call attention to important material relics of their heritage.

The Pennsylvania German Society was also part of a national trend. The 1880s and 1890s witnessed a proliferation of patriotic and hereditary societies. By 1895 there were at least forty-seven. The emphasis on patriotism was especially strong among upper- and middle-class elements of the population. The lure of genealogy was equally strong, perhaps in response to fears and insecurities engendered by the influx of new and largely poor immigrants from southern and eastern Europe and the Far East. "Ancestor hunting" was common sport as early as the 1840s and 1850s for members of the New England Society, but by the 1890s the search for family pedigree became a favorite pastime throughout the country. The waving of flag in one hand and family crest in the other was no longer confined to the Yankee Northeast.[8]

One of the immediate stimuli for the founding of the Pennsylvania German Society may have been the rejection of prominent Pennsylvania Germans by organizations such as the Sons of the American Revolution (SAR). All of the

hereditary groups placed social considerations on a par with heredity in screening for membership. The first level of screening was obviously genealogical. One had to be a descendant of a *Mayflower* passenger, an officer of the Revolution, or a revolutionary war veteran or had to belong to other qualifying categories; however, disputes raged over whether or not one had to be a direct or a collateral descendant. The second level of screening was more arbitrary; the applicant had to possess an "acceptable" level of achievement to merit membership. The organizations wanted an elite constituency.[9]

Whatever the reasons, the SAR rejected Pennsylvania State Librarian William H. Egle, an accomplished historian and genealogist, and Julius Sachse, a Philadelphia photographer and illustrator.[10] These two resented their exclusion and joined with others who identified more closely with their Pennsylvania German heritage than with their Anglo-American background. It should be added, however, that this group of men, too, exercised their right of exclusion and banned from membership in the society descendants of more recent nineteenth-century immigrants.

In 1893 the newly formed Pennsylvania German Society boasted seventy-three distinguished members. Among the company were at least fifteen lawyers and judges and as many ministers, the two principal occupations of members. The membership rolls also included several active and retired state and local politicians, bankers, newspapermen, college and seminary professors, physicians, pharmacists, merchant-businessmen, and a college president. A few were also members of the SAR, and many were members of distinguished Pennsylvania German families—Keim, Hiester, Levan, Weiser, Muhlenberg, and Pastorius.[11]

One of the most important members of the society from the outset was Julius Sachse (1842–1919). He, more than any of the other organizers, was intrigued by the material aspects of Pennsylvania German culture. He joined the tiny group of men that met on February 26, 1891, in J. Max Hark's Moravian parsonage in Lancaster to lay the groundwork. At the organizational meeting a month and a half later, Sachse was elected treasurer, a post he held until he stepped up as president in 1913/14. He also served on the executive committee from 1891 until his death in 1919.[12]

[6] For a broader analysis of Martin's fiction see Beverly Seaton, "Helen Reimensnyder Martin's 'Caricatures' of the Pennsylvania Germans," *Pennsylvania Magazine of History and Biography* 104, no. 1 (January 1980): 86–95.

[7] *Pennsylvania-German Society Proceedings*, vol. 1 (Lancaster, 1891), pp. 9–25.

[8] Wallace Evan Davies, *Patriotism on Parade: The Story of Veterans and Hereditary Organizations in America* (Cambridge, Mass.: Harvard University Press, 1955), pp. 43–44, 48, 72–73, 218–19; David D. Van Tassel, *Recording America's Past: An Interpretation of the Development of Historical Studies in America, 1607–1884* (Chicago: University of Chicago Press, 1960), p. 109.

[9] Davies, *Patriotism*, pp. 85–86, 77–78.

[10] Homer T. Rosenberger, *The Pennsylvania Germans, 1891–1965: Frequently Known as the "Pennsylvania Dutch"* (Lancaster: Pennsylvania German Society, 1966), p. 74.

[11] "List of Members of the Pennsylvania German Society," in *Pennsylvania-German Society Proceedings*, vol. 3 (Lancaster, 1893), pp. 149–88.

[12] "Obituary of Julius Sachse," in *Pennsylvania-German Society Proceedings*, vol. 31 (Meadville, Pa., 1925), pp. 40–46.

Sachse exerted strong influence on the society's publications program. During the late nineteenth and early twentieth centuries the society attempted to publish the monumental "Narrative and Critical History of Pennsylvania: The German Influence in Its Settlement and Development." The concept was primarily Sachse's, based on Justin Winsor's highly regarded eight-volume *Narrative and Critical History of the United States* (1884–89). The Pennsylvania series began with Sachse's own treatise, "The Fatherland, 1450–1750," in volume 7 (1897) of the society's proceedings, and continued through volume 33 (1929), long after Sachse's death.

Sachse was an illustrator, a photographer, and a first-rate scholar. His efforts insured that the Pennsylvania German Society would not become primarily a social fraternity but instead would make a permanent contribution to Pennsylvania German and American culture as a publishing society. As important as his many writings were, Sachse's illustrations were more significant. For some twenty years nearly every important publication on the Pennsylvania Germans carried some of his sketches or photographs. Many of the pictures captured the remnants of a disappearing culture and communicated a particular view of the past to a sympathetic audience. They also recorded and documented architecture, artifacts, customs, and people.[13]

The Julius Sachses of the Pennsylvania German culture attracted little attention outside the southeastern Pennsylvania German heartland, and then mostly in pockets of early German migration such as Ontario, Canada, the Shenandoah Valley, and western Pennsylvania. Nonetheless, he and others of similar persuasion worked tirelessly to redress the biases of the existing historical record and to preserve for posterity the records and relics of their heritage. In one sense these efforts were an attempt to maintain a degree of social control in a rapidly changing society. But in another sense, these efforts were an attempt by the leadership of a minority to halt the erosion of ethnic identity. In the late nineteenth and early twentieth centuries a constellation of organizations, publications, and cultural props were assembled to foster ethnic loyalty. In addition to the Pennsylvania German Society, the most notable were universities and colleges, historical societies, civic celebrations, religious organizations, and family associations.

The University of Pennsylvania may have been the first American college or university to appoint a professor of German language, and in the late nineteenth and early twentieth centuries it contributed more to the promotion of Pennsylvania German studies than any other American university. The two scholars from the faculty who distinguished themselves were Oswald Seidensticker and Marion Dexter Learned. Both were present at the 1891 organizational meeting of the Pennsylvania German Society, Seidensticker as an aging professor from the University of Pennsylvania, Learned as a young, new faculty member then at Johns Hopkins University. In 1895 Learned was invited by the University of Pennsylvania to fill Seidensticker's faculty position, and he soon became chairman of the university's expanding German department.

Marion Dexter Learned was born into a non-Germanic family near Dover, Delaware. After graduating from Dickinson College in Carlisle, Pennsylvania, Learned received a Doctor of Philosophy degree in German from Johns Hopkins in 1887, the first doctorate granted in the subject by that institution. Learned is probably the most important non-German scholar to interest himself in the field of Pennsylvania German studies. By moving to the University of Pennsylvania in 1895 he located himself in a strategic position to pursue those interests. The university was engaged in a campaign to raise the level of its scholarship to keep pace with Johns Hopkins, Wisconsin, Harvard, and other aggressive universities. Under a sympathetic administration, Learned's ambitious publication projects found favor and financial support. In 1897 he launched *Americana Germanica*, a quarterly journal, which in 1903 severed its ties with the university and became known as *German American Annals*. *American Germanica* continued existence as a series of scholarly monographs under university auspices with Learned as editor. Subsequent plans to create Emperor William Institution of German-American Research at the university were authorized in 1909, but World War I and Learned's death in 1917 strangled any possibility of its establishment.[14]

Learned's arrival in Philadelphia was auspicious for a second reason. Even if the University of Pennsylvania had not provided a base for Learned's scholarship, he would still have been able to rely on the support of the German American community. German Americans in Philadelphia and elsewhere were riding the crest of a wave of enthusiasm for Germanic culture in the 1890s. In 1888 the German Society of Pennsylvania, which had been founded in 1764 as a charitable agency to assist impoverished German immi-

[13] For Sachse's photographs of Schwenkfelder log houses, meetinghouses, costume, and artifacts, see Howard W. Kriebel, "The Schwenkfelders in Pennsylvania, a Historical Sketch" in *Pennsylvania: The German Influence in Its Settlement and Development*, pt. 12, Pennsylvania-German Society Proceedings, vol. 13 (Lancaster, 1904), pp. 1–232.

[14] *Dictionary of American Biography*, 1933, s.v. "Marion Dexter Learned"; John J. Appel, "Marion Dexter Learned and the German American Historical Society," *Pennsylvania Magazine of History and Biography* 86, no. 3 (July 1962): 299.

grants, completed the most successful year in its history by erecting a new headquarters building at Spring Garden and Marshall streets. The new edifice housed the society's substantial library of more than 50,000 volumes and served a membership of about a thousand.[15]

Learned became an active member of the German Society of Pennsylvania after his arrival in Philadelphia, and he drew support from its membership to found the German American Historical Society in 1901. This new organization was devoted to the study of German American history throughout the United States. It also advocated the study of history as a means of cultivating German language study and spreading cultural ideals other than those fostered by German socialists.[16] The vice-president of the German American Historical Society was Georg von Bosse, pastor of the German Lutheran Paulus Church in Philadelphia. (Von Bosse later served on the editorial staff of the *Pennsylvania-German*, about which more will be said later.) Learned served as the English secretary for the German American Historical Society and headed its publications committee.

Learned's most ambitious project attempted to combine the support of the University of Pennsylvania, the Pennsylvania German Society, and the German American organizations in the formation of the Pennsylvania Association of the Ethnographical Survey. Starting with the Germans, Learned proposed a study of every major ethnic group in the state. He succeeded in funding the first survey, the 1902 Conestoga Expedition in Lancaster County, but the larger dream died from lack of financial support. The results of the expedition were summarized in the journal *German American Annals* in 1907 and then elaborately presented in a monograph. The journal and the *Americana Germanica* monographs contain much important research on the Pennsylvania Germans and reveal Learned's own bias, a bias that may have helped doom the publications to obscurity and the German American Historical Society to oblivion. Learned was operating as an Englishman between two worlds of German Americans. His emphasis on Pennsylvania German history was irrelevant to most enthusiasts of modern German culture, while his association with German American organizations limited his effectiveness among members of the Pennsylvania German community.[17]

Learned's chief contacts in the Pennsylvania German

community were leaders like Samuel W. Pennypacker, a fellow member of the German Society of Philadelphia; Julius Sachse; Martin Grove Brumbaugh, president of the Pennsylvania State Teacher's Association; and Nathan C. Schaeffer, state superintendent of public schools and president of the Pennsylvania German Society. With Brumbaugh and Schaeffer, Learned helped convene a meeting on April 9, 1898, to organize an association of the teachers of German in Pennsylvania, and he was elected secretary of the new group.[18] With Pennypacker, Learned collaborated in creating the first public exhibit of Pennsylvania German historical materials outside of Pennsylvania. The exhibit was part of the commonwealth's contribution to the national Jamestown Exposition of 1907.

The history of the exposition reveals how Learned effectively utilized the talents of a variety of people. On January 3, 1905, Learned's friend Pennypacker, who was then governor, delivered a speech to the Pennsylvania legislature in which he referred to several past and future national celebrations. After singling out Pennsylvania's role in the Louisiana Purchase Exposition of 1903 and mentioning plans for the Lewis and Clark Exposition in Portland, Oregon, he called for Pennsylvania's participation in the upcoming exposition celebrating the 300th anniversary of the Jamestown settlement, an exposition that would open as his term in office ended.[19]

The legislature passed a joint resolution to create a commission of twenty-three prominent Pennsylvanians and to appropriate $100,000 for exhibits and buildings at the exposition. Governor Pennypacker served as ex officio president of the commission. The commission created a nine-member executive committee to which Pennypacker appointed James H. Lambert of Philadelphia as president. Pennypacker, however, remained active on the executive committee until he left office in January 1907.[20]

The concept of a Jamestown Exposition had originated in 1900 in the hearts and minds of leaders of the Association for the Preservation of Virginia Antiquities. The idea received support from the Daughters of the American Revolution at state and national levels, from J. Hoge Tylor, governor of Virginia from 1898 to 1902, and eventually from

[15]Appel, "Learned," p. 290; Harry W. Pfund, *A History of the German Society of Pennsylvania* (2d ed.; Philadelphia: By the society, 1964), p. 9.

[16]Appel, "Learned," p. 293.

[17]Appel, "Learned," pp. 301, 317–18; Marion D. Learned, "The Conestoga Expedition," *German American Annals*, n.s. 5, no. 1 (January/February 1907): 30–53; Marion D. Learned, *The American Ethnographical Survey: Conestoga Expedition, 1902*, Americana Germanica Monographs, vol. 12. (New York: D. Appleton, 1911).

[18]Marion D. Learned, "Proceedings of the First Meeting of the Association of the Teachers of German in Pennsylvania," *Americana Germanica* 2, no. 2 (1898): 71–93.

[19]Samuel W. Pennypacker, *The Autobiography of a Pennsylvanian* (Philadelphia: John C. Winston Co., 1918), p. 542.

[20]James H. Lambert, *Pennsylvania at the Jamestown Exposition, Hampton Roads, Virginia, 1907* (Philadelphia: Pennsylvania Commission, 1908), pp. 3–4. See pp. 29–30 for a full list of the members of the Pennsylvania Commission.

the Virginia General Assembly. The result was the blue-blooded Jamestown Exposition Company led by Fitzhugh Lee, who took the idea to Washington, D.C. The persistent and powerful Virginians eventually convinced Congress to pass an authorizing bill on March 3, 1905 (two months earlier optimistic Governor Pennypacker had begun garnering support in the Pennsylvania legislature). President Theodore Roosevelt welcomed the opportunity for a national celebration. Since the exposition was to be held at Hampton Roads rather than at Jamestown, Roosevelt saw a golden opportunity for one-upmanship in international saber rattling. He immediately endorsed "an international naval, marine and military celebration" commemorating the founding of the nation and the great events of its distinguished history.[21]

Virginians, cognizant of previous Jamestown celebrations in 1807 and 1857, wanted Jamestown and Virginia in the national spotlight. Harry St. George Tucker, president of the Jamestown Exposition, espoused "a great historical and educational exposition" which would teach a history lesson to the nation, and thereupon steered the planning away from an industrial or commercial fair celebrating America's material progress.[22]

Nobody endorsed the aims of the Virginians any more enthusiastically than Governor Pennypacker of Pennsylvania. Pennypacker's distinguished professional life centered on law and politics, but his passion was history. Raised with a strong sense of family and ethnic identity, Pennypacker was a founding member of the Historical Society of Pennsylvania and the German American Historical Society and a key figure in the Pennsylvania German Society. As a historian Pennypacker was an exceptional antiquarian for his day, certainly more scholarly than most. His avid and rigorous reading schedule and legal orientation fostered this scholarly bent. At age twenty he began keeping a log of his reading, recording author, title, number of pages, and excerpts of ideas that impressed him. He even logged the number of pages read in various languages. By 1916 he had filled four folio volumes listing his reading.[23]

Although Pennypacker was the driving force behind Pennsylvania's participation in the Jamestown Exposition, the man responsible for the content of the state's historical and educational exhibits was Marion Dexter Learned.

Learned, in his own way, was as dedicated as the governor to the preservation and presentation of Pennsylvania German culture. Hired by the Pennsylvania commission to create the Commonwealth's historical exhibit for the exposition, Learned leaned heavily on his assistant, Albert Cook Myers.[24]

By the time of the exposition, Myers was situated in a strategic position. As Learned's assistant he could shape the Pennsylvania exhibit, and he was primarily responsible for writing its catalogue. Also, early in 1907 he had been appointed superintendent of historical exhibits for the entire exposition.[25]

The historical exhibits at Jamestown were housed in a special history building. The Pennsylvania exhibit conceived and implemented by Learned and Myers won a gold medal.[26] Its scope was the history and progress of Pennsylvania from settlement to 1907, and all of it was crammed into a small space, 861 square feet (fig. 16).

The exhibit was viewed by thousands of visitors, won its gold medal, and then was promptly and permanently retired and forgotten. Pennypacker's public career ended with his retirement from the governorship in 1907. Learned continued with his brilliant career until anti-German sentiment, World War I, and his death in 1917 stopped him and the German American movement. Myers went on to his own distinguished career but never again figured prominently in Pennsylvania German activities.

Excavation of this exhibit from the dust of seventy-six years is difficult but essential. First, the exhibit, which featured Pennsylvania's colonial history, symbolized the spirit of the exposition as an educational venture designed to rekindle enthusiasm for the colonial era, its heroes, and its enduring values. In this sense the exposition and the Pennsylvania exhibit, like the opening of the American Wing of the Metropolitan Museum of Art in 1924, were landmark national manifestations of the colonial revival movement. In addition to reinforcing the cultural values inherent in that movement, the Pennsylvania history exhibit was the largest, most diverse, and most important exhibit of American "colonial" material culture to date. The Museum of Fine Arts in Boston had produced an American silver exhibit in 1906. After Jamestown came the Hudson-Fulton Celebration in 1909 at the Metropolitan Museum, often considered the first major museum exhibit to display antiques as art.[27]

The first section of the Pennsylvania exhibit used large

[21] *The Official Blue Book of the Jamestown Ter-Centennial Exposition, A.D. 1907* (Norfolk: Colonial Publishing Co., 1909), pp. 26–28, 63–65, 49–50, 62, 75.

[22] *Blue Book*, p. 2.

[23] Pennypacker, *Autobiography*, pp. 145–46. In 1914 he read 28,190 pages: 26,684 in English and 1,506 in other languages, specifically French, German, Latin, Dutch, and Spanish.

[24] Lambert, *Pennsylvania at Jamestown*, p. 121.

[25] Lambert, *Pennsylvania at Jamestown*, p. 144.

[26] Lambert, *Pennsylvania at Jamestown*, p. 15.

[27] Elizabeth Stillinger, *The Antiquers* (New York: Alfred A. Knopf, 1980).

Fig. 16. Floor plan of the Pennsylvania State Historical Exhibit, James-
town Exposition, Hampton Roads, Virginia, 1907. From James H. Lam-
bert, *Pennsylvania at the Jamestown Exposition, Hampton Roads, Virginia,
1907* (Philadelphia: Pennsylvania Commission, 1908), p. 162.

maps, including distribution maps of religious and ethnic
groups, to portray the settlement of the colony and its devel-
opment. The second and larger segment of the exhibit fea-
tured objects illustrative of colonial life in Pennsylvania.
Vignettes spotlighted ethnic groups such as Swedes, Ger-
mans, and Britons. County exhibits, sectarian exhibits on
groups such as the Quakers and Moravians, and type exhibits
on costume, firearms, tools, lighting devices, and house-
hold furnishings filled remaining space in the cramped
alcove with Pennsylvania treasures.[28]

The historical exhibit treated all of Pennsylvania's groups
but featured the Pennsylvania Germans. It was the first
national exhibit of Pennsylvania German material, and
many of the documents, paintings, and artifacts have not
been exhibited outside their home institutions since. This
is especially true of objects in the extensive Schwenkfelder
and Moravian displays (fig. 17).[29]

In addition to national activities such as the Jamestown
exposition, local civic celebrations fostered the growth of
ethnic identity among Pennsylvania Germans and publicly
declared ethnic pride. Civic celebrations have long been
important in Western culture in reinforcing prevailing social
and political values, and Pennsylvania Germans used them.

Fig. 17. Exhibit of the Moravian Historical Society, Nazareth, Pennsyl-
vania, at the Jamestown Exposition, Hampton Roads, Virginia, 1907. From
James H. Lambert, *Pennsylvania at the Jamestown Exposition, Hampton
Roads, Virginia, 1907* (Philadelphia: Pennsylvania Commission, 1908),
p. 251.

[28] Learned used Conestoga Expedition material in the preparation of
these exhibits (see Learned, *Ethnographical Survey*, p. 37).

[29] Lambert, *Pennsylvania at Jamestown*, pp. 236–58.

They took special note of the anniversary of German settlement in Pennsylvania—1683—at least as early as 1906. In October 1908, Germantown celebrated its 225th anniversary. The historic Tulpehocken region, always one of the most self-conscious Pennsylvania German areas, celebrated the 200th anniversary of that settlement and established the Conrad Weiser Memorial Park Association in 1923. Even the Commonwealth of Pennsylvania entered the process in 1931 with efforts to acquire the property now known as Ephrata Cloisters. Restoration began in 1935 under the supervision of architect G. Edwin Brumbaugh, son of Martin G. Brumbaugh.[30]

Family associations, reunions, and picnics also became popular phenomena in the early twentieth century. Their proliferation coincided with the birth of the national patriotic and hereditary societies, and their beginnings no doubt owe as much to the enthusiastic American veneration of ancestors as to German tradition. While many family reunions date their first gatherings to the pre–World War I era, it was not until the 1920s and 1930s, with improved transportation, that these largely rural reunions reached their full development.[31] Often family gatherings were stimulated by sons who had to some degree left the Pennsylvania German culture to become educators or ministers. These sons were the same type of people who joined the Pennsylvania German Society. In other cases the family reunions represented a grass-roots popular culture beyond the reach of the Pennsylvania German Society. Whatever the inspiration, both types contributed to a renewed interest in a family's ethnic origins. Many reunions were quite elaborate. The *Pennsylvania-German*, a monthly journal, reported on the impressive Loucks (Laux) family reunion in York County in June 1910. Nearly a thousand descendants attended a formal program of music, speeches, and poetry, followed by a lavish family dinner. The day's festivities and family memorializations ended with a family minister pronouncing the Mosaic benediction in German.[32]

The Pennsylvania German clergy were more numerous and more zealous than any other segment of the culture in their efforts to provide sustenance for ethnic identity. They encouraged the writing of church histories and the celebration of the anniversaries of their congregations. They wrote for denominational and historical society publications,

became active members of historical and genealogical organizations, taught in colleges and seminaries, and by personal example demonstrated the importance and vitality of their ethnic heritage.

The Reverend Paul de Schweinitz of Bethlehem was secretary of the Moravian Missionary Society and one of fourteen founding members of the Pennsylvania German Society. Abraham Harley Cassel, lay minister of the Church of the Brethren (Dunkard), labored assiduously for decades to save Pennsylvania German manuscripts and German language publications from oblivion or destruction. And the Reverend Philip C. Croll, Lutheran pastor in Lebanon, compiled numerous historical tracts and founded the *Pennsylvania-German*, the leading journal of early twentieth-century Pennsylvania German ethnicity.

Croll founded the monthly in January 1900 and served as its first editor and publisher. It was a secular, filiopietistic trumpet of ethnic achievement that heralded pioneer heroes like Conrad Weiser and promoted appreciation of Pennsylvania German history, language, and social customs. Croll nurtured those who had "kept the faith" (and the dialect) and reached out to those who had not. To entice marginal Pennsylvania Germans he introduced readers to a part of the Pennsylvania German heartland in each issue. People were encouraged to visit historic sites such as Ephrata, Bethlehem, Germantown, and Schaefferstown, and to make pilgrimages to their own ancestral homes. Croll's era still depended on horse and buggy, nevertheless he wanted to capitalize on increased tourist interest within the region and to use these pilgrimages as a way of calling attention to the architectural treasures that were visible monuments to the past.[33]

Control of the *Pennsylvania-German* was transferred to Henry A. Schuler in 1905 and then in 1909 to Schwenkfelder antiquarian H. W. Kriebel. Kriebel nursed the journal through its most controversial phase, just prior to World War I when it became an organ of German-American sentiment in an effort to broaden its appeal to all American Germans. The journal's aggressive pro-German philosophical stance offended many Pennsylvania Germans who felt no kinship to Bismarckian Germany. With the rise of German imperialism, association with German Americanism

[30] Editorial, *Pennsylvania-German* 7, no. 7 (November 1906): 377; Rosenberger, *Pennsylvania Germans*, pp. 168–69.
[31] For a fascinating but all too brief discussion of these phenomena, see Rosenberger, *Pennsylvania Germans*, pp. 169–75.
[32] "The Laux-Loux-Lauck, Laucks, Loucks Family," pt. 1, "First Family Association Meeting," *Pennsylvania-German* 12, no. 5 (May 1911): 258–9.

[33] An example of the new tourist literature of the pre–World War I era is Henry W. Shoemaker's *A Week in the Blue Mountains* (Altoona, Pa.: Altoona Tribune Press, 1914). This illustrated guide implored tourists to see Pennsylvania as never before on an eight-day wagon trip from Reading to Lebanon County and back, averaging about thirty miles per day. The trip featured Crystal Cave, mountain hotels, good food, spectacular scenery, a plentiful supply of Indian stories, and many old buildings and cemeteries.

opened the way for others to see the "dumb Dutch" as the "dangerous Dutch."

Kriebel's editorial shift to German Americanism began in 1911 with the addition of Pastor Georg von Bosse to the editorial staff. In 1912 Kriebel renamed the journal *Penn Germania: A Popular Journal of German History and Ideals in the United States* and incorporated contemporary political material.[34] By 1913 the journal was in financial trouble, and by 1914, with sentiment rising against him, Kriebel tried to steer a neutral course in the murky waters of Anglo-American–German relations. In spite of his efforts the journal died in 1914. Nevertheless, the *Pennsylvania-German/Penn Germania* remains one of the most important documents of early twentieth-century Pennsylvania German self-consciousness.

With the end of World War I and the easing of German-American tensions, the Pennsylvania Germans entered an era of folk consciousness which continues to the present day. The antiquarians and clergy still figure prominently, but the new consciousness extends beyond the churches and amateur historians to the popular level and has been institutionalized in old and new organizations. Furthermore, the Pennsylvania Germans have attracted attention beyond the heartland. Most significantly, following World War I, the burgeoning world of folk art dealers and collectors and several major art museums discovered the artifacts of the Pennsylvania Germans.

What the dealers and collectors called "folk art" in the 1920s and 1930s often astonished the Pennsylvania Germans. With the exceptions of Edwin AtLee Barber, whose pathbreaking study of sgraffitoware appeared in 1903, and Henry Mercer, who had published works on Fraktur, iron, and tools before the 1920s, almost no one in the Pennsylvania German heartland had thought these material things important enough to write about.[35] Nevertheless, antiquarians, as we have noted, had been interested in old "things" since at least the 1840s, and many late nineteenth-century antiquarians such as Henry K. Deisher of Kutztown and George Danner of Manheim had collected artifacts. More important, many Pennsylvania German families prized and preserved the material possessions of their forebears; other families either still used the pieces or were too frugal to trash their attic junk.

[34] *Penn Germania: A Popular Journal of German History and Ideals in the United States*, n.s. 1, no. 1 (January 1912).
[35] Edwin AtLee Barber, *The Tulip Ware of the Pennsylvania-German Potters: An Historical Sketch of the Art of Slip-Decoration in the United States* (Philadelphia: Pennsylvania Museum, 1903); Henry Chapman Mercer, *The Bible in Iron* (Doylestown, Pa.: Bucks County Historical Society, 1914). Mercer's book began as a pamphlet on decorated stove plates in 1899.

Of all the early collectors of Pennsylvania German material culture, Henry Chapman Mercer is the best documented. Mercer's own writings, his extensive records and correspondence, and subsequent studies have helped fill in the details of his life. Nevertheless, Mercer remains an enigma, for he did not collect for the sake of art or historical association. His goals were akin to the leading eighteenth-century English antiquarians who studied natural history and to the nineteenth-century European ethnologists absorbed in folk culture, yet he did not adhere to either of these persuasions. Mercer, a Harvard undergraduate with a law degree from the University of Pennsylvania, had field training in prehistoric archaeology and was somewhat of an anthropologist at heart. For a time in the 1890s he served as a curator at University of Pennsylvania Museum, but he quit this post in 1897 in poor health and a state of disillusionment. He felt ill at ease in anthropology because of the discipline's lack of interest in historical materials.[36]

Mercer, like most great collectors and antiquarians, matched expansive ideas with substantial resources to fulfill strongly held personal goals. Like so many other collectors, Mercer wanted permanently to press his ideals and conceits on his collection, and like Henry Ford, John and Abby Aldrich Rockefeller, Electra H. Webb, Ima Hogg, and Henry Francis du Pont, Mercer eventually had to found his own institution to fulfill his dreams. Yet Mercer was not like any of the major collectors. He was not of their socioeconomic standing, and he did not collect "art."

In the beginning, after quitting the museum in 1897, Mercer collected what most people regarded as trash. His primary concerns were not the finest products of handcraftmanship, but the tools that produced them, the processes by which they were created, and the way of life that characterized these craftsmen in the preindustrial era. As an anthropologist, Mercer saw his own region—Bucks County—as a microcosm of the nation, and he wanted ordinary things and ordinary people to garner proper recognition as nation makers.[37]

With a zeal and focus rare even among collectors, Mercer collected and classified like a scientist. He stressed scholarly research and publication rather than what he described as the selfish motivations of most collectors. His fireproof concrete museum, containing more than 25,000 objects, was the fulfillment of his dream, "a classified record of human progress shown in the Tools of Industry." In spite

[36] Donna G. Rosenstein, "Historic Human Tools: H. C. Mercer and His Collection, 1897–1930" (M.A. thesis, University of Delaware, 1977), pp. 9–10.
[37] Rosenstein, "Historic Human Tools," p. 11.

of this, Mercer died in 1930 "a disillusioned and cynical man."[38] Because most people used his writings and his museum in ways he did not intend or approve, Mercer did not set many immediate trends in the world of material culture. His treatises on old houses, Fraktur, and iron stove plates stimulated the collection of Pennsylvania German antiques, but most collectors preferred to think of Mercer's artifacts as "folk art" and glorified the finished products rather than the tools and craft practices.

The collectors' concept of folk art was largely imported from two different traditions. The first was European ethnology, which as early as the 1860s and 1870s began to preserve and study the arts and crafts of many European countries. Especially strong in Scandinavian and Germanic regions, by 1900 this movement had spawned major museums, for example, Vienna's Austrian Museum of Folk Culture in 1888.

The second source of folk art inspiration was American but retained European roots. It owes much to New York–based artists, many of European descent, working between 1913 and 1930. Two of the most important were Elie Nadelman, born in Poland and educated in Munich, who between 1923 and 1938 amassed one of the largest collections of American folk art, and sculptor Robert Laurent, a native of Brittany and a collector in his own right who in 1922 inherited the entire estate of Hamilton Easter Field. Field was an American-born pioneer of the folk art movement, who in the summer of 1913 established the Ogunquit School of Painting and Sculpture at Ogunquit, Maine. The cottages he provided for resident artists and sculptors were furnished with part of his own extensive collection of American primitives such as decoys, weathervanes, hooked rugs, and paintings. His list of summer visitors was impressive: Robert Laurent, Marsden Hartley, Stephan Hirsch, Bernard Karfiol, William Zorach, Wood Gaylor, Niles Spencer.[39]

In addition to his direct impact on the artists at Ogunquit, Field exercised influence over the entire American art scene through *Arts*, a journal he edited and published. Field inaugurated it in 1920 as a trade paper, with the aim of reporting on the activities of artists, collectors, and museums. But *Arts* was primarily an outlet for Field's prophetic zeal. Field believed the arts (including drama,

music, and art) were inadequately appreciated in the United States, and he dedicated his journal to corrective measures and to heavy doses of European, Oriental, and American art.[40]

Arts was probably the first art journal in the world to carry feature articles on American folk art. Field himself wrote the first article of this genre, "American Hooked Rugs," which he identified as "one of the most characteristic arts of America." In it Field mentioned his own extensive collection of hooked rugs and expressed the hope that museums would begin to preserve them and to display them as legitimate expressions of American taste. A later issue featured "Pennsylvania German Pottery in the Jacob Paxson Temple Collection" in which the sgraffito technique and Pennsylvania German motifs were compared to related phenomena in early Muhammadan art.[41]

Discovery of American folk art coincided with the discovery of American antiques as art. While the first is probably related to the second, the linkage is unclear. Both were expressions of a new wave of American nativism, but the birth of "folk art" was part of a worldwide enthusiasm for primitive art. For "modernists" such as Yasuo Kuniyoshi, Alice Newton, Dorothy Varrian, and Frank Osborne, American primitives were counterparts to the ethnographic materials of Europeans who were drawing upon African and oceanic cultures for inspiration.[42]

All of this enthusiasm for American primitives might never have become a popular force in the 1920s and 1930s without the promotion efforts of Greenwich Village dealer Edith Halpert and of Newark Museum's Holger Cahill. Cahill in the early 1920s discovered European peasant art through a visit to leading European ethnographic collections and American folk art through a visit to Laurent's Maine home. Cahill opened major exhibits on folk painting and sculpture at Newark Museum in 1931 and the Museum of Modern Art in 1932. These established folk art as a major category of American art. Such a designation was certified by the acquisition of folk art by national figures like du Pont, Ford, Rockefeller, and Webb. Cahill continued to figure in the development of American folk art as head of the Federal Art Project's Index of American Design.[43]

Pennsylvania German material culture became collecti-

[38] Rosenstein, "Historic Human Tools," p. 36. Mercer purchased most of his objects between 1916 and 1930 at house sales and auctions. He also relied on dealers Abraham Rice of Bethlehem, Levi Yoder of Silverdale, and Henry K. Deisher of Kutztown.

[39] Beatrix T. Rumford, "Uncommon Art of the Common People: A Review of Trends in the Collecting and Exhibiting of American Folk Art," in *Perspectives on American Folk Art*, ed. Ian M. G. Quimby and Scott T. Swank (New York: W. W. Norton, 1980), pp. 13–53.

[40] *Arts* 1, no. 1 (December 4, 1920): 7.

[41] Hamilton E. Field, "American Hooked Rugs," *Arts* 1, no. 5 (May 1921): 28–31; "Pennsylvania German Pottery in the Jacob Paxson Temple Collection," *Arts* 2, no. 2 (November 1921): 75–80.

[42] Rumford, "Uncommon Art," p. 15.

[43] Rumford, "Uncommon Art," pp. 23–37; Holger Cahill, "Introduction," in Erwin O. Christensen, *The Index of American Design* (New York: Macmillan Publishing Co., 1950), pp. x–xi. For a description of the scope and procedures used, see *Index of American Design Manual* (Washington,

ble in the early 1920s with the realization that it was "folk art." With Halpert's promotional efforts what had been a limited business for a few dealers became a capitalistic scramble as prices soared. Old well-placed dealers profited, a class of new dealers sprang up, and collectors vied for choice items. A few art museums joined the fray, but most of the action took place in the world of private enterprise. The Pennsylvania German community saw many of its irreplaceable treasures snatched from its geographical and psychological boundaries.[44]

Several classifications of individuals and institutions figure prominently in the Pennsylvania German folk art story, namely collectors, dealers, art museums, and historical societies and agencies. Barber and Mercer deserve credit as the earliest major collectors of Pennsylvania German folk art, even though they preceded the American folk art phenomenon and did not perceive and describe their work and interests in folk art terms. Other early collectors, such as Jacob Paxson Temple, George Lorimer, Arthur J. Sussel, and Clarence Brazer, rarely published their collections and came to public attention only when their collections were sold at auction or donated to museums.

One of the most fascinating collectors was Cornelius Weygandt. Weygandt is intriguing because he represents a different strain of collector. Unlike Mercer, whose interests were scholarly and scientific, or those wealthy collectors who kept their treasures to themselves, Weygandt was a dedicated popularizer of folk art.

Weygandt's pedigree was rooted in Germantown. His namesake, Cornelius Weygandt, migrated from Germany to America in 1736 and settled in Germantown where in 1739 he married Maria Agneta Bechtel, the daughter of Johannes Bechtel, a turner by trade and a lay Reformed preacher.[45] Cornelius was a cabinetmaker, and the Weygandts eventually settled in Easton where descendants distinguished themselves as newspapermen. The woodworking tradition, however, was kept alive by Thomas Jefferson Weygandt, grandfather of the modern Cornelius, who moved to Philadelphia from Easton in 1820. Thomas was a musician, an instrument maker, an amateur inventor, and a cabinetmaker.

Thomas's son, Cornelius Nolan Weygandt (1832–1907), followed a more practical course than his father. He worked his way up the banking ladder to be president of Merchant's National Bank in Philadelphia. He married Lucy Elmaker Thomas in 1864, and together they reared two children, one of whom was the Cornelius of our story. Cornelius Nolan Weygandt, while a banker, kept alive family traditions and during his life joined organizations such as the New England Society, the SAR, and the Site and Relic Society of Germantown.[46]

Our Cornelius Weygandt was born in Germantown in 1871 to a history-conscious family living in a town of ancient associations and long-standing antiquarian interests. Surrounded by cultural relics, including family paintings, furniture, books, and documents from the Pennsylvania German Reformed and Welsh Quaker sides of the family, Cornelius was bombarded with images of the past. Theoretically he could have consciously rejected this heritage or treated it superficially, but Cornelius embraced it and gloried in it. He became absorbed into the very fabric of the place of his birth and the region of his heritage.

Weygandt received his formal education at Germantown Academy and University of Pennsylvania, receiving a Bachelor of Arts degree in 1891 and a Doctor of Philosophy degree in English literature in 1901. Between degrees Weygandt pursued the family tradition of journalism, working for the Philadelphia *Record* (1892) and the *Evening Telegraph* (1893–97). He returned to the University of Pennsylvania in 1897 as a graduate student and teaching assistant and did not leave until his retirement in 1935. In 1907 he was appointed professor of English literature, a position he held with distinction until his retirement.[47] As a graduate student and professor, Weygandt's scholarly proclivities were William Butler Yeats and the Celtic revival. He visited Yeats in 1902 and was responsible for a visit by Yeats to the university in 1903.

Weygandt's background and personality precluded a life of narrowly focused and intense scholarship. He was a teacher and popularizer who loved life and endeavored to convey his enthusiasm for it to others. If tributes by students in the *Daily Pennsylvanian*, the university newspaper, are accurate, he succeeded. He was described as being a great teacher because of his voracious reading and input of fresh material into his courses, his infectious enthusiasm for English literature, his prolific output, and his tangential interests. Students in his classes learned about life as well as

D.C.: Works Progress Administration, 1938). The complete catalogues of the index are now available on color microfiche.

[44] The story of the discovery and exploitation of Pennsylvania German folk art has been sketched by several different writers, most notably Rosenberger, *Pennsylvania Germans*, pp. 161–64, 261–67; and Earl F. Robacker, *Arts of the Pennsylvania Dutch* (New York: Castle Books, 1965), pp. 17–25.

[45] Cornelius Weygandt, *On the Edge of Evening: The Autobiography of a Teacher and Writer Who Holds to the Old Ways* (New York: G. P. Putnam's Sons, 1946), p. 50.

[46] Obituary of C. N. Weygandt (1907) in Cornelius Weygandt biographical folder no. 1, University of Pennsylvania Archives, Philadelphia.

[47] Weygandt, *Edge of Evening*, pp. 75, 101.

literature and were exposed to the life of Pennsylvania and New Hampshire as well as to that of the British Isles.[48]

Weygandt's scholarly interest in the Irish literary renaissance, of which he was considered the "American Apostle," probably derived from his intense Pennsylvania provincialism and in turn shaped his own concept of his Pennsylvania heritage. No one told Cornelius Weygandt that he should be an apostle of Pennsylvania German culture. It was a fairly logical—although clearly not inevitable—outgrowth of his background, which he explained in his autobiography:

I had been planning *The Red Hills* (1929) [his first book on Pennsylvania Germans] for nearly forty years before I wrote it. While I was a boy in college the hope came to me that someday I might write a book about the Pennsylvania Dutch as I knew them. I was about three-eighths Pennsylvania Dutch by blood. I had heard stories all my life about my father's people, of Easton and its Delaware and his old aunties who lived in the Forks City. I had gone to Lebanon [Pennsylvania] as a boy in days when you heard no English spoken on the streets. I had made many expeditions to various parts of Dutchland, both before and during and after my newspaper years. I had written an editorial on things Pennsylvania Dutch while I was on the *Evening Telegraph* that brought the paper letters of protest and of approval. I read Elsie Singmaster's stories from the date of their first publication. I had read Ulysses Koons about Ephrata. I had read Governor Pennypacker's articles. I knew Martin Grove Brumbaugh well. I had sat at college under Oswald Seidensticker. It was he who began the serious research into our origins.[49]

Weygandt's interest in the remnants of his Pennsylvania German culture, which he saw rapidly passing away, may have steeled him for criticism of his chosen field of study. Literature departments in the 1890s did not teach contemporary literature as a matter of course, and his excursion into the realm of contemporary poetry must have seemed risky at the time. But as risky as it might have been, the study of Irish literature certainly was more respectable than the study of Pennsylvania literature. From his study of Irish literature and the Celtic revival Weygandt gleaned principles he labeled "higher provincialism" and the "country heart" which he applied with vigor to his American interests and his own work.

In Weygandt's mind a culture's art and literature might be expressive of ideas and values derived from outside itself (cosmopolitanism) or be bound in its own limitations (lower provincialism). Either was less than the greatness achieved by a provincial culture informed but not dominated by wider movements. In the higher provincialism, exemplified by the

Wessex novels of Thomas Hardy and the American poems of Robert Frost, Walt Whitman, and Emily Dickinson, greatness developed from provincial roots.[50] Weygandt viewed Yeats as the product and premier expression of higher provincialism. He probably also thought of his own work in this way.

In Weygandt's writings, the rural core of his provincial bias is obvious. While born and raised in an urban environment and employed by an urban university, Weygandt rejected urban dominance. In this respect he was an urban exponent of the "country life / colonial revival" mind-set. He was a city boy with a bad case of country heart who lived for his weekend excursions into the Pennsylvania countryside and summers in New Hampshire.[51]

In his youth he had rejected the notions of the naysayers who prophesied moral decline and cultural decadence and mourned the loss of the good old days. In 1899 he professed great confidence in the future of Anglo-American civilization.[52] But in retirement, Weygandt turned to writing as solace from the intrusions of modern life. He lamented the loss of nineteenth-century ideals and devoted himself to reviving the half-forgotten and to perpetuating the best of the past.

Weygandt's three principal works on the Pennsylvania Germans are *The Red Hills* (1929), *The Blue Hills* (1936), and *The Dutch Country* (1939), the last two being published during his retirement. *The Red Hills* was the most popular and the most significant because it first expressed Weygandt's country-heart attitudes toward his beloved heritage and the objects he treasured. All three books convey the same values and celebrate Pennsylvania landscape and culture. In spirit they parallel Wallace Nutting's nostalgic portrayals of New England, written during the 1920s and early 1930s.[53]

In *The Red Hills*, Weygandt directly assaulted the image of the dumb Dutchman and celebrated the Pennsylvania Dutch, the term he preferred to use.[54] He later explained that by doing so he had accomplished more than had the "pedants" of the Pennsylvania German Society.

[48] *Daily Pennsylvanian* (April 23, 1937) in Weygandt biographical folder no. 1, University of Pennsylvania Archives.

[49] Weygandt, *Edge of Evening*, p. 166.

[50] Cornelius Weygandt, "The Higher Provincialism," *Barnwell Bulletin* 11, no. 46 (April 1934): 17–50.

[51] Cornelius Weygandt, "The Country Heart" (address to the University of Pennsylvania School of Veterinary Medicine, June 4, 1937), copy in Weygandt writings folder no. 4, University of Pennsylvania Archives.

[52] Newspaper clipping, April 11, 1899, C. Weygandt biographical folder no. 1, University of Pennsylvania Archives.

[53] Wallace Nutting, *Pennsylvania Beautiful* (*Eastern*) (Framingham, Mass.: Old America Co., 1924).

[54] Cornelius Weygandt, *The Red Hills: A Record of Good Days Outdoors and In, with Things Pennsylvania Dutch* (Philadelphia: University of Pennsylvania Press, 1929), pp. 5, 24–25.

Pennsylvania German is a term sired by pedantry out of an inferiority complex. My old friend Martin Grove Brumbaugh went around upstate telling folks that if we call ourselves Pennsylvania German everybody will respect us and no longer dismiss us as dumb Dutch. The change of name did not achieve the desired end. My own *Red Hills* (1929) has done far more to do away with the inferiority complex than that misnomer, Pennsylvania German, ever did. Pennsylvania German is a term with no roots in the soil. We call ourselves Pennsylvania Dutch and so our neighbors of other ancestry call us. There are deep roots to Pennsylvania Dutch. They are words of the people, not of the pedants. They are words that conjure up picturesque places and homey ways. They smack of the soil and have tang to them. They do not smell of the lamp as Pennsylvania German does, but of mint-bordered meadow streams, hills of clover, mountains of second growth above white-roaded valleys of limestone. . . .

. . . *The Red Hills* gave Dutchland heart. After the barn symbols were written of approvingly in *The Red Hills* they began to come back on the barns. Many more folk were interested in spatterware and redware and painted chests and illuminated writing after they read of them in *The Red Hills*. "The first book about us that does not laugh at us at all," said a Reformed clergyman to me. But the highest praise of all came from that scholar who said: "Weygandt, damn him, has put back for ten years the general acceptance of 'Pennsylvania German.' " Weygandt is proud to believe he has put that obnoxious term back for twenty years. Pennsylvania German reeks of the lamp—I would emphasize that again and again. There is no homeness about it, or picturesqueness, or romance, or earthy savor. If I say it who ought not, in *The Red Hills* we who are Pennsylvania Dutch put our best foot forward.[55]

Weygandt's fascination with Pennsylvania German culture had material as well as spiritual and ancestral roots. The objects he loved and collected were folk art of the higher provincialism. They were also tangible memory symbols. His interest went beyond aesthetic appreciation, but Weygandt did not possess the anthropological fanaticism of Henry Mercer. His objects encapsulated a thousand memories of past and present—memories of visits to traditional tradesmen such as Jacob Medinger, the "Last of the Old Potters"; memories of family history; memories of sights, sounds, and smells of the hills and valleys of Pennsylvania in different seasons; memories of the quest for the unusual and the excitement of the auction; and memories of the people whose spirits expressed the best of the world he loved.[56]

Weygandt was an avid collector of folklore and artifacts. He scoured the shops of Philadelphia and Germantown and when roads and automobiles made such excursions possible turned to the countryside. According to his son Cornelius and his daughter Ann, their father knew all the major dealers but relied heavily on Levi Yoder of Silverdale and Hattie Brunner of Reinholds. He especially loved the thrill of country sales but, since he did not drive, had to rely on friend William J. Phillips or daughter Ann.[57] Few collectors of Pennsylvania German folk art could exercise the influence Weygandt did through his writings unless they founded a museum, as did the Landis brothers at Landis Valley, Lancaster County, and Henry Francis du Pont at Winterthur, or donated their collection in whole or part to an established institution, as did Titus Geesey to the York County Historical Society and the Philadelphia Museum of Art. To Cornelius Weygandt belongs the honor of being the most influential popularizer of the Pennsylvania Dutch in the first half of the twentieth century.

The most ambitious scholarly interpreter of Pennsylvania German folk art in the twentieth century was John Joseph Stoudt. His *Consider the Lilies* was a bold and innovative book in 1937; however, at the time most readers considered it obtuse or dismissed it as eccentric. Even Stoudt recognized that his florid prose obscured his central theme, for he rewrote the book and republished it in 1966 as *Pennsylvania German Folk Art: An Interpretation*. In both versions Stoudt espoused the views of folk art advocates and asserted that folk art was an expression of the success of America's melting pot, testimony to the creativity of America's craftsmen, and evidence of America's uniqueness. However, Stoudt gave this an ethnic twist by proclaiming Pennsylvania German religious sectarians as his heroes and heroines.[58]

Stoudt contended that Pennsylvania German folk art owed nothing directly to European models but was a living product of the Pennsylvania German experience in the New World. He credited religious ideas, particularly the sectarian world view of the mystical minority of radical pietists, for the inspiration behind the Pennsylvania German visual

[55] Weygandt, *Edge of Evening*, pp. 49, 168. Weygandt's achievements as a popularizer were publicly recognized at the Kutztown Folk Festival in 1954. Saturday, July 3, 1954, was declared Weygandt Day, and Weygandt was feted with speeches by his friends. The Pennsylvania Dutch Folklore Center at Franklin and Marshall College, organized by Alfred Shoemaker, Don Yoder, and William Frey, announced the establishment of a fellowship in American folk art in Weygandt's name. Earl F. Robacker, perhaps the leading popularizer of "Pennsylvania Dutch stuff" in the 1950s and 1960s, credited Weygandt's *Red Hills* with his own conversion to antiques and Pennsylvania German culture in 1929, "Cornelius Weygandt Day," *Dutchman* 6, no. 2 (September 1954): 12–13, 37.

[56] Weygandt, *Red Hills*, pp. 70–71, 133–62, 181–91, 234–45.

[57] Interviews with Cornelius N. Weygandt, July 11, 1978, and Ann Weygandt, November 1978. Weygandt knew enough dialect to understand the people he visited, but he never spoke it.

[58] Stoudt (1911–81) was the son of John Baer Stoudt, a minister and an early Pennsylvania German antiquarian. The younger Stoudt utilized Frederick Jackson Turner's frontier thesis but rejected geographical determinism.

arts. The source of their art lay in the allegorical interpretation of the Scriptures that spread through the culture via hymns, devotional writings, and the Bible of Berleberg (1726–42). According to Stoudt the rich symbolism of the radical pietists that flowered in Pennsylvania German folk art antedated and influenced a similar phenomenon in the German states by fifty years.[59]

In Stoudt's mind, Pennsylvania sectarians possessed all the millennial fervor and hope of the New England Puritans but not the iconoclastic spirit. Because they were more susceptible to visual imagery than the Puritans, Pennsylvania Germans created folk art. Stoudt's celebration of Pennsylvania German folk art did have some caveats. He never could comfortably place decorated furniture, pottery, metals, and textiles within the confines of his theory, even though he tried in *Pennsylvania German Folk Art* as well as in *Early Pennsylvania Arts and Crafts*. He was most at ease with Fraktur and other graphic art, but here, too, he subordinated images and symbols to literary texts. The texts needed an iconographic key, which Stoudt found in the fourfold medieval method of interpreting the Scriptures.[60] The result was his iconographic index for the major symbols of Pennsylvania German folk art.

Once he plunged into the well of medieval mysticism, Stoudt never emerged. He may have successfully traced certain ideas and symbols to the origins of Christianity, but he never demonstrated that the ideas and symbols of a tiny band of sectarians permeated Pennsylvania German consciousness and were then transmitted in the material communications of an entire eighteenth-century culture.

Folk art for Stoudt was art of the unconscious, "undistorted by the conscious mind." It was intuitive and immediate as well as religious. In this sense Stoudt agreed with those who interpreted folk art as intuitive expressions of untrained folk. He also agreed with them that folk art was preindustrial and not therefore a phenomenon of bourgeois capitalism. His chief deviation lay in his insistence that folk art was the product of a group aesthetic rather than the unique and spontaneous work of individual artists.[61]

From our point of view, his principal errors lay in forcing all Pennsylvania German folk art into a sectarian religious mold, in denying the bourgeois character of most Pennsylvania German folk art, and in asserting that Pennsylvania German folk art antedated and inspired its European counterparts.

Stoudt's religious orientation led him to suggest Pennsylvania Germans built their great stone houses and barns to last until the anticipated millennium.[62] But there were other types of material he had to ignore because he could not fit them to his religious theory, such as sgraffito plates with earthy inscriptions. Stoudt also ignored the basic fact that most of what has been designated as Pennsylvania German folk art was probably produced by and for people of Lutheran and Reformed religious persuasion, not sectarians.

Stoudt throught in terms of a rural folk community, but, in fact, the townspeople, farmers, and craftsmen of the Pennsylvania German region were the products of a preindustrial capitalism rather than a feudal peasant society.[63] While rarely engaged in industrial activity in the modern sense, their attitudes and values were entrepreneurial, and the farmers in particular were absorbed in the process of capital wealth accumulation.

While Stoudt was aware of material culture in Europe comparable to Pennsylvania German folk art, his theory rationalized its existence. As old and new studies of French, Swiss, German, and Czechoslovakian folk art reveal, the flowering of folk art in these countries occurred at precisely the same time as in America, roughly 1750 to 1840. This chronological coincidence also fits with Scandinavian and Eastern European experiences and suggests a Continental European phenomenon that affected its European fragments in the New World. The explanation for this phenomenon most likely lies in the socioeconomic history of Europe and America and, if the American experience is indicative of the whole, in the embourgeoisiement of society in a preindustrial era.[64]

[59] John Joseph Stoudt, *Pennsylvania German Folk Art: An Interpretation*, Pennsylvania German Folklore Society, vol. 28 (Allentown, Pa., 1966), pp. 91–92.

[60] Stoudt, *Folk Art*, pp. 97–98, 126, 82, 119, 102–3; John Joseph Stoudt, *Early Pennsylvania Arts and Crafts* (New York: A. S. Barnes, 1964).

[61] Stoudt, *Folk Art*, pp. 124–25. For the latest in the ongoing debate on the nature and definition of folk art, see John Michael Vlach, "American Folk Art: Questions and Quandaries," *Winterthur Portfolio* 15, no. 4 (Winter 1980): 345–55; and Simon J. Bronner, "Investigating Identity and Expression in Folk Art," *Winterthur Portfolio* 16, no. 1 (Spring 1981): 65–83.

[62] Stoudt, *Folk Art*, p. 25.

[63] See Robert Redfield, *The Little Community: Viewpoints for the Study of a Human Whole* (Chicago: University of Chicago Press, 1955); and Robert Redfield, *Peasant Society and Culture: An Anthropological Approach to Civilization* (Chicago: University of Chicago Press, 1956), for a discussion of the characteristics of peasant societies.

[64] Jean Cuisenier, *French Folk Art* (Tokyo, New York, and San Francisco: Kodansha International, 1977); Robert Wildhaber, ed., *Swiss Folk Art* (Zurich: Pro Helvetia, 1971); David Baud-Bovy, *Peasant Art in Switzerland* (London: Studio, 1924); Vera Hasalova and Jaroslav Vajdis, *Folk Art of Czechoslovakia* (New York: Arco Publishing Co., 1974); Ernst Schlee, *German Folk Art* (Tokyo, New York, and San Francisco: Kodansha International, 1980); and George Kubler, "The Arts: Fine and Plain," in Quimby and Swank, *Perspectives*, pp. 234–46. Kubler described a similar phenomenon in nineteenth-century Latin America and hypothesized an "interlude of release" between the disintegration of an old order and the triumph of an urban, industrial order ("The Arts," p. 237).

Stoudt represents the articulate elite of the Pennsylvania German community and stands in the tradition of the antiquarians and leaders who struggled over a century to foster ethnic pride and counteract a negative stereotype. Cornelius Weygandt represents the spirit of the people who constituted the grass-roots strength of modern Pennsylvania Germans. Together, they and others helped rekindle the fires of self-consciousness.

Simultaneously, but outside of the Pennsylvania German community, unconnected but related forces began enhancing the image of the Pennsylvania Germans. Among the most important of these forces was the continued elevation of Pennsylvania German folk art and the presentation of the best of it to the general public through publications and museum exhibitions.[65]

The permanent installations of Pennsylvania German collections at major art museums lent great prestige to the folk art movement in the interwar years. The Philadelphia Museum of Art, with the installation of rooms from the House of the Miller at Millbach, became the first major American museum to recognize Pennsylvania German material culture as art.[66] The curator was a young man by the name of Joseph F. Downs. While not a Pennsylvania German, Downs has to be regarded as the most influential museum professional of the twentieth century in regard to public recognition and appreciation of Pennsylvania German folk art. His installation of these rooms at the museum was conceptually conventional in aesthetic focus and architectural treatment but innovative in subject matter. They were the first folk art period rooms in an American art museum.

Downs (1895–1954) graduated from the Boston Museum School in 1921 and, after a period of time on a traveling fellowship in Europe, took a position as an assistant at the Museum of Fine Arts, Boston. In 1925 he moved to the Philadelphia Museum of Art where, in 1928, he became the first curator of decorative arts and the next year supervised the Millbach installation.[67]

In 1932, Downs moved on to the Metropolitan Museum of Art in New York. The American Wing of that museum had not included Pennsylvania German rooms in 1924, but Emily Johnston de Forest, wife of the chief financial backer of the wing, had an abiding interest in Pennsylvania German folk art. She may have been the earliest major collector of Pennsylvania German material culture living outside of Pennsylvania. Her husband, Robert de Forest, was successively a board member, a secretary, and a president of the museum. In 1934 Emily de Forest's collection found a permanent home in new period rooms at the Metropolitan. The curator of the installation and author of the accompanying pamphlet was Downs.[68]

Downs's approach to the material was similar in concept to the installation in Philadelphia. He provided a sympathetic architectural setting for objects of masterpiece quality. The installation offered nothing new and was less successful than the Millbach one, largely because it could not match the quality of the Millbach architectural elements and interior spaces. However, Downs used the occasion to attract attention to the important de Forest collection, and, with the inestimable backing of America's premier art museum, he brought Pennsylvania German folk art to the center of the American folk art stage. With the permanent installation of the de Forest collection and the nearly simultaneous boost provided by the government-sponsored Index of American Design's choice of Pennsylvania German folk art as one of the three most original expressions of American creativity (along with the art of the Spanish southwest and that of the Shakers), the arts of the Pennsylvania Germans were enthroned. Pennsylvania Germans had suddenly become folk heroes.

During his Metropolitan tenure of seventeen years, Downs lived in New Guilford, Connecticut, where his home Cohabytation and his personal collection of early American furniture attracted the attention of knowledgeable collectors. Downs was invited to join the prestigious Walpole Society, and he became a close friend and consultant to several important collectors, including Henry Francis du Pont who gathered a sizable Pennsylvania German collection during the twenties and thirties. Du Pont maintained a steady correspondence with Downs through the 1940s, and in January 1949 Downs assumed the position of du Pont's first full-time curator.[69]

The matter of Downs leaving the Metropolitan was negotiated by du Pont over a long period of time. The negotia-

[65] Apart from the 1907 Jamestown Exposition and the 1926 Sesquicentennial held in Philadelphia, both of which were celebrations with Pennsylvania German exhibits peripheral to their central purposes, the first exhibit devoted to Pennsylvania German folk art was held at Central Moravian Church Sunday School Building in Bethlehem in 1936. A publication entitled "Catalogue of the Pennsylvania Folk Art Exhibition" was issued in the Pennsylvania German Folklore Society's first volume ([Allentown, Pa., 1936], pp. 125–35).

[66] Joseph F. Downs, *The House of the Miller at Millbach: The Architecture, Arts, and Crafts of the Pennsylvania Germans* (Philadelphia: Franklin Printing Co., 1929).

[67] Henry Francis du Pont, *Joseph Downs: An Appreciation and a Bibliography of His Publications*, reprinted from Walpole Society *Note Book*, 1954.

[68] Joseph F. Downs, *A Handbook of the Pennsylvania German Galleries in the American Wing* (New York: Metropolitan Museum of Art, 1934).

[69] Joseph Downs and Charles F. Montgomery to Henry Francis du Pont, September 27, 1948, H. F. du Pont Correspondence, Winterthur Archives.

tions also included Charles F. Montgomery, a mutual friend and prominent antiques dealer. Du Pont's general aims were to catalogue and publish his collection. Montgomery was to prepare a card catalogue, and Downs would be the principal author of the books. The plan called for a room-by-room catalogue within a general chronological framework. Both men would work 175 days a year in an effort to publish several volumes over a five-year period, at the end of which time Downs would become curator of the soon to be formed Winterthur Museum.[70] The agreement was reached on October 6, 1948, and Downs immediately notified the Metropolitan of his plans:

I took a secret pleasure yesterday in providing a shock to the vast bulk that is Francis Taylor; he did not relish the news of my leaving on January 1st, for more reasons than one, it appears. Roland Redmond (who was present) asked if I would continue as adviser to the Museum. Do you object to that? Taylor also does not wish to announce my leaving until next July, and will say I am on leave of absence from January until then, to do some writing. Your name will be suppressed, to avoid publicity.[71]

Once at Winterthur both Downs and Montgomery were immersed in more than cataloguing and writing about the collection. Indeed, during Downs's five years at Winterthur he completed only one major catalogue—on Queen Anne and Chippendale furniture—but assisted in the installation of a number of rooms and was working on a second book. Most germane for this study was Downs's role in the purchase and installation of one of the most important Pennsylvania German period rooms of his career, the Fraktur Room. With its completion in 1951, Downs had achieved a remarkable feat—he had engineered the public presentation of the three finest Pennsylvania German collections at a triumvirate of America's most important museums. This was not the end of the development of Pennsylvania German exhibits, but Downs's death in 1954 cut short the career of one of the culture's most important promoters.[72]

Joseph Downs's position as curator at three of the most prestigious institutions in the country had enabled him to exercise a leverage available to few other individuals. His career (1925–54) spanned a critical phase of the Pennsylvania German folk art phenomenon. At the time of his death, popular interest in Pennsylvania German folk art was reaching its zenith. This era of interest in the antiques of Pennsylvania German culture also stimulated the rebirth of folk consciousness within the community.

The Pennsylvania German community's discovery of itself was not simply a discovery of the past. It was creative shaping of the past by those who wanted to find either sustenance for contemporary attitudes or reinforcement for contemporary beliefs. Just as the entire history of this ethnic group has been the tugging and pulling of two worlds, so the discovery and exaltation of them as "folk" became a dialogue between past and present.

The external popular appeal of Pennsylvania German folk art lay in its perceived affirmation of American values, not in its Germanness, and those outside the Pennsylvania German community who were promoting its folk art were aiming not to bolster ethnic identity but to celebrate preindustrial *American* development.

Within the Pennsylvania German community the same phenomenon kindled ethnic pride. In one camp the concept of folk art became a tool of ethnic propaganda renewing the age-old struggle against total assimilation. In another camp it served as the latest weapon in the contributionist arsenal. In the latter arena the struggle for assimilation was over, and acculturated Pennsylvania Germans could point with pride to the art they gave to America.

[70] Although precise on many points, du Pont was vague as to the number of books he expected Downs to write (du Pont to Downs, October 6, 1948, du Pont Correspondence, Winterthur Archives).

[71] Downs to du Pont, du Pont Correspondence, Winterthur Archives.

[72] Du Pont was deeply affected by the loss of Downs and moved quickly to recognize his monumental role in the promotion of and appreciation for American decorative arts. He encouraged the Antiquarian and Landmarks Society of Connecticut, of which he was a member, to buy Downs's house and keep his collection intact. Both he and Alfred Bissell of Wilmington, Delaware, offered funds if the remaining money could be raised. Once this plan collapsed, du Pont, along with David Stockwell of Wilmington, was instrumental in having part of the Downs collection installed in the new American Museum in Bath, England. He also purchased some small items from the collection for Winterthur, established a Joseph Downs Manuscript and Microfilm Collection at Winterthur, and provided annual decoration for Downs's grave in Guilford. For details on these transactions, see du Pont's correspondence with Downs's sisters, Joseph Downs folder C, du Pont Correspondence, Winterthur Archives.

Henry Francis du Pont
& Pennsylvania German Folk Art

SCOTT T. SWANK

Henry Francis du Pont (1880–1969), the great-grandson of du Pont Powder Works founder Eleuthère Irénée du Pont, by his own account fell in love with American antiques on a trip to New England in 1923. On that occasion he experienced the "living with antiques" philosophies of Mrs. J. Watson Webb of Shelburne, Vermont, and Harry Sleeper of Gloucester, Massachusetts. Rather than copy their New England collecting preferences, du Pont shortly thereafter motored into Pennsylvania and bought a Chester County walnut chest of drawers with the inlaid date of 1737; he quickly became an avid collector of Pennsylvania things. Before this trip, like many other American collectors, he had been buying European antiques.

Recently, several writers have argued that New England was the fount of interest in collecting American antiques and set trends for other regions by spawning the first serious collectors. These collectors perceived certain objects as "morally and aesthetically superior to most new household goods then available."[1] New York collectors are given substantial credit in this developmental process, but those from Pennsylvania and Delaware are not. Possibly New Englanders and New Yorkers were the first to assign art values to American antiques, but the Pennsylvania-Delaware story is of major importance to the history of American decorative arts, and Henry Francis du Pont is one of its central figures. Like the other great collectors of his era, du Pont

collected New England antiques, but he specialized in Pennsylvania German folk antiques at a time when they were gaining popularity. In this latter area he and other Pennsylvania-Delaware collectors helped set trends in the collecting of American folk art.

Initially du Pont assembled his Pennsylvania German collection at Chestertown House, his Southampton, Long Island, home (figs. 18, 19). In 1926, upon the death of his father, he inherited Winterthur, a 2,500-acre estate in northern New Castle County, Delaware. Du Pont's ties to Winterthur were strong. Since 1902 he had been assisting his father in developing its naturalized gardens. In 1914 he had taken over management of its farms and had begun building up a prize-winning holstein dairy herd. The remaining task was the transformation of the house to accommodate his ambitious plans for his rapidly growing collection of antiques. Renovation and enlargement of the house began in 1929 and were completed in 1931. A new wing increased the interior of the house by 200 percent (fig. 20). During these years du Pont established the Winterthur Corporation, a charitable and educational foundation designed to administer the building and the collections when these became a museum in the then distant future.[2]

Having thrown himself into collecting decorative arts as enthusiastically as he had previously entered farming, cattle breeding, and horticulture, du Pont sought the best American antiques he could find. The competition for choice

[1] Elizabeth Stillinger, *The Antiquers* (New York: Alfred A. Knopf, 1980), p. xii; see also Richard H. Saunders, "American Decorative Arts Collecting in New England, 1840–1920" (M.A. thesis, University of Delaware, 1973).

[2] E. McClung Fleming, "History of the Winterthur Estate," in *Winterthur Portfolio 1* (Winterthur, Del.: Henry Francis du Pont Winterthur Museum, 1964), pp. 10, 23, 35, 45, 48–49.

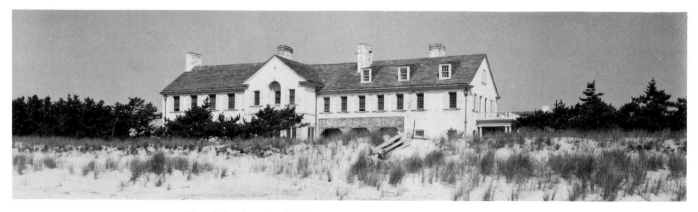

Fig. 18. Southeast facade, Chestertown House, Southampton, Long Island, N.Y. (Photo, 1969, Winterthur.)

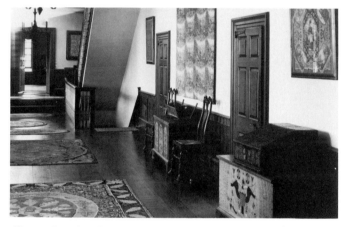

Fig. 19. First-floor hall, Chestertown House. (Photo, 1969, Winterthur.)

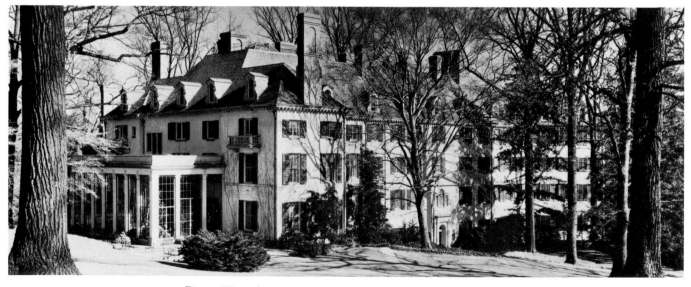

Fig. 20. Winterthur as it appeared in the 1930s. The 1929–31 addition is to the right. (Photo, Winterthur.)

high-style items was cutthroat in the late 1920s, a fact demonstrated by the establishment of long-standing record prices for American furniture at the 1929 Reifsnyder and 1930 Flayderman sales: the Van Pelt high chest, for example, went for $44,000.[3] The competition for American folk art was also heating to a boil by the late 1920s, and at the time one of du Pont's specialties was Pennsylvania German folk art. Over his lifetime he assembled the largest and most important single collection of this material now in a public institution.

Du Pont's collecting pattern was derivative. He discovered the lure of antiques through friends and was always strongly influenced by other important collectors, interior designers, and professionals. He, like the other great collectors of American decorative arts of the twenties and thirties, sought the most aesthetically pleasing antiques, the most firmly documented objects, and those also deemed collectible by his peers.

Like every collector du Pont also wanted his collection to be unique. Fortunately, few of his colleagues collected Pennsylvania German folk art. With the exception of Titus Geesey, also of Delaware, most of du Pont's counterparts did not collect folk art, acquired only folk paintings rather than decorative arts, or focused on New England rather than Pennsylvania.

While du Pont's interest in Pennsylvania German artifacts continued until his death in 1969, he collected most of them between 1925 and 1935. Twice during the 1950s he expanded his collection, but both times this resulted from the acquisition of architectural interiors and the creation of new rooms for his public museum.

Purchase records delineate the patterns of du Pont's collecting. He rejected many items of historical interest, whether the historical associations were firmly based or speculative, and many of aesthetic quality in favor of items that he liked and that were the right size and color for the space in the room he sought to fill. The records also reveal that du Pont's collecting tastes were not static. In the late 1920s and early 1930s he shied away from types of material that he later collected. He passed up much fine redware pottery, often due to a fear that it was late nineteenth- or early twentieth-century material, and turned down many choice dated and signed pieces of redware pottery in favor of the more sought after sgrafittoware. With tinware and Stiegel glass he exhibited a wariness that has proved to be a boon for the strength of his collection.

In each category du Pont collected individual masterpieces, but from the start he was blending an assemblage of

[3] Stillinger, *Antiquers*, 228–29.

objects into his home. Therefore, color, size, and an appropriate location in his house were critical to his decisions. Undoubtedly du Pont rejected many items of high quality which he could have afforded and, were he thinking only in terms of a museum collection, probably should have purchased. He chose what he liked if he thought it was fairly priced, if it fit his prevailing design for his home, and if he had space for it. The result was a creative harmony of color, texture, and form in the dozens of rooms in his house at Winterthur.

The skills of connoisseurship in the decorative arts were relatively undeveloped before du Pont turned Winterthur into a public museum in 1951 and created the Winterthur Program in Early American Culture in cooperation with the University of Delaware. Considering the total number of items collected by du Pont from 1923 to 1969 (some 50,000) and the number of items viewed but rejected (at least four out of five), he was rarely fooled. Of the more than 1,200 identifiable Pennsylvania German objects purchased by du Pont, few are fakes. The most significant of these is the 1793 dated Himmelberger chest which du Pont purchased in 1926 and was identified as a fake in 1977 (see fig. 21).

Over the entire span of his collecting, du Pont corre-

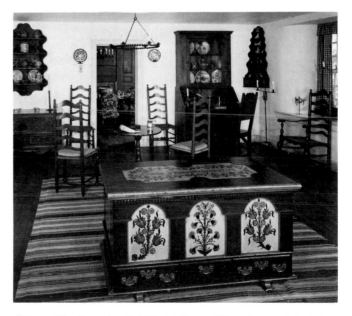

Fig. 21. The Pennsylvania Folk Art Room, Winterthur, as it looked in 1959. (Photo, Winterthur.) The chest featured in the room is the 1793 Sibilia Himmelbergerin chest which is now thought to have been made about 1900. Made of pine with uncharacteristic secondary woods (maple and walnut), the chest illustrates the full vocabulary of Pennsylvania German construction for the form. It is one of a school of furniture bearing the Himmelberger family name.

sponded with nearly every major dealer in Pennsylvania German antiques, the most important of whom were Clarence Brazer of Chester, Hattie Brunner of Reinholds, Charles M. Heffner of Reading, Joe Kindig, Jr., of York, A. H. Rice of Bethlehem, Ida Hostetter of Lancaster, and Charlotte and Edgar Sittig of Shawnee-on-Delaware. The story of these relationships is vital to an understanding of how he assembled a large and important collection of folk art in a short time.

Clarence Brazer was one of du Pont's earliest contacts for Pennsylvania German artifacts, especially furniture. In 1925 he had exhibited his Pennsylvania coverlets and chests at the Pennsylvania Museum (now Philadelphia Museum of Art), where they caught the eye of du Pont. Brazer specialized in signed and dated furniture, and nearly all his chests displayed the names of decorators or customers for whom they were made. He discovered the Jonestown school and in 1925 had cornered the market on chests made by Christian and John Selzer and John and Peter Ranck. In 1925 Brazer offered six dated chests to du Pont:

Christian Selzer	1793	$250.00
Christian Selzer	1777	$300.00
John Selzer	1808	$250.00
Johann Rank	—	$200.00
Jacob Schelli	1800	$250.00
Elizabeth Redelson	1815	$200.00
Maria Schlern	1788	$350.00[4]

The records are inadequate to determine exactly what du Pont purchased from Brazer and when, but they do reveal that in 1926 he bought several coverlets, a Pennsylvania walnut banister-back chair with leather slip seat, and two Christian Selzer chests dated 1785 and 1796. Brazer did some restoration work on these for du Pont: both chests had their lids repaired and their feet replaced before they were shipped to Winterthur.[5]

In 1925 when A. H. Rice of Bethlehem, discoverer of Mahantango Valley furniture, sold a dated pewter inkstand to Louise Crowninshield, du Pont's sister, du Pont indicated that if Rice ever found another like it he would buy it. But his first purchase from Rice appears to have been not an inkstand but a "painted Pennsylvania Dutch chest of drawers" in 1927. That same year Rice held a major sale of glass, ceramics, and books at his 519 North New Street shop

in Bethlehem, and the next day he offered du Pont first choice on additional items that had come in too late for the sale, among them glassware, transfer-printed ceramics, and three fine hanging cupboards (two of them corner cupboards) dated 1776, 1785, and 1792.[6]

Rice, like many other early dealers in Pennsylvania antiques, including Brazer, sought to enhance the market for his goods. One technique was to research and publish the collection then sell the newly documented material. In 1928, Rice offered his entire collection of Pennsylvania and Virginia earthenware (1,600 pieces) to du Pont, most of which were to be featured in a book Rice was completing. Du Pont rejected the offer and the opportunity to own the finest redware collection in the country, but he agreed to consider individual items and bought one sgrafitto plate. Rice's ventures were not always successful; by 1931 he was in serious financial trouble and sold his entire stock of antiques to Ira Reed, a dealer from Sellersville.[7]

Rice never succeeded in selling much to du Pont, largely because his prices were too high or he offered the wrong items at the wrong time. In 1931 he had offered a 5-by-7-foot Tintoretto entitled *Moses in the Land of Canaan*, forty iron eagle snow catchers, and a Northampton County Rothrock Pottery sgrafitto pie dish. The Italian painting would not have interested du Pont at any price, and the pie dish at $1,000 was too dear, but du Pont bought the eagle snow catchers. While du Pont did not buy in large volume from Rice, he did acquire a number of choice items, among them three pieces of Schwaben Creek Valley (Mahantango Valley) furniture now in the Winterthur Museum collection, including the above-mentioned chest of drawers. A desk and a bureau were purchased for $700 in 1929 in a special deal. Noting that they were "the only two pieces of this type of furniture left," for du Pont Rice reduced the asking price from $1,250 to $700.[8]

One of the most productive associations of the 1920s and one of the most long-lived contacts of du Pont's collecting career was his business friendship with Hattie Brunner, a

[4] Esther Stevens Fraser, "Pennsylvania Bride Boxes and Dower Chests," *Antiques* 8, no. 2 (August 1925): 79–84; Clarence Brazer to Henry Francis du Pont, December 16, 1925, H. F. du Pont Correspondence, Registrar's Office, Winterthur.

[5] Brazer to du Pont, February 23, May 4, 1926, du Pont Correspondence, Registrar's Office.

[6] A. H. Rice to du Pont, May 18, 1927, du Pont Correspondence, Registrar's Office.

[7] Rice to du Pont, March 21, August 23, 1928, July 29, 1931, and du Pont to Rice, April 10, 1928, du Pont Correspondence, Registrar's Office; A. H. Rice and John Baer Stoudt, *The Shenandoah Pottery* (Strasburg, Va.: Shenandoah Publishing House, 1929).

[8] Rice to du Pont, March 3, July 19, 1931, December 22, 1929, du Pont Correspondence, Registrar's Office. See Frederick S. Weiser and Mary Hammond Sullivan, "Decorated Furniture of the Schwaben Creek Valley," in *Ebbes fer Alle-Ebber, Ebbes fer Dich: Something for Everyone, Something for You*, Publications of the Pennsylvania German Society, vol. 14 (Breinigsville, Pa., 1980), pp. 333–34, for the reasons for renaming the Mahantango furniture.

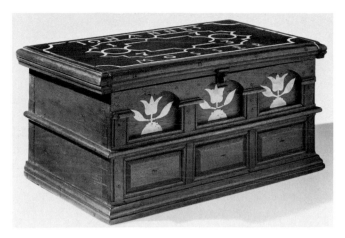

Fig. 22. Chest, Lancaster County, 1773, made for Johannes Mosser (Musser). Walnut and tulip with sulfur inlay; H. 7⅜", W. 14⅞", D. 8½". (Winterthur 65.2256.)

Pennsylvania German living in Reinholds. Brunner first appeared on the Philadelphia scene at the sesquicentennial celebration of 1926. That year du Pont purchased spatterware from her and in 1927 began buying furniture. Since he was buying large quantities of ceramics in these years, his first furniture purchases were of the storage or display variety, particularly corner cupboards and dressers. In 1927 he bought from her two corner cupboards (one with an inlaid star), one dresser, and two benches. In 1928 he purchased a walnut corner cupboard, in 1929 the Herr wardrobe ($800) and the small Johannes Mosser chest ($1,000) (fig. 22). During the next decade du Pont's purchases were largely limited to an occasional shelf, bench, and stool, until, in 1936, he made his last, major furniture purchase from Hattie Brunner—a decorated desk-and-bookcase (pl. 4).[9]

Most of du Pont's acquisitions from Brunner's shop were ceramics, especially spatterware, "gaudy Dutch," slipware, and sgraffitoware. On April 20, 1928, Hattie offered him a rare slipware platter for $575. He liked it, but he questioned its authenticity because of its pristine condition. She reassured him with the history of the piece, and du Pont purchased it. Hattie had gotten the platter from her sister-in-law's mother, "who had it packed away in a chest ever since her husbands death, who always prized it very highly. She always had kept it to revere his memory."[10]

Within a month Hattie was back with two sgraffito pie plates, one in "proof" condition which had a tulip motif

and an attribution to George Hübener. "I bought [it] from the great grand daughter of the original owner. Was always packed away in a chest. As they did not think it looked well in a cupboard with decorated china." The second she believed to be by the same hand as a plate illustrated on page 164 of Barber's *The Tulip Ware of the Pennsylvania-German Potters*. It had a Pennsylvania German inscription which she translated for du Pont as follows:

> A is a deacon sensible and wise.
> B is a farmer that loves his plough.
> C is a captain that protects this land.
> D is a blockhead that hates intelligence.
> Dated 1830.

Hattie then explained: "Mr. Barber was trying to buy this piece about 25 yrs. ago but the man would not sell it. He got hard up for cash and for that reason parted with it. I had to pay a stiff price for this piece. I must have $1500.00 for the two pieces."[11]

Du Pont and Brunner enjoyed a cordial relationship. She gave him right of first refusal on her choicest antiques, and he had her assurance that the items she was purchasing were of local origin. In the summer of 1930 Hattie and her mother-in-law visited Chestertown House at du Pont's invitation. Two years later, after seeing du Pont's greatly expanded house and collection at Winterthur, she wrote:

> Cannot begin to tell you just how much we enjoyed our visit to your house, seeing your magnificent collection.
> We fail to find suitable words in the English language to fully express our appreciation. We thank you heartily. Will always remember you as a most generous host.
> Sometime when you tour through this part of Pennsylvania, I wish you would let us know before hand, and we will serve you a Pennsylvania German dinner.

She paid a return visit in 1947, this time with a friend and fellow Pennsylvania Dutchman Cornelius Weygandt who by then was in ill health.[12]

The only dealer of Pennsylvania German folk art with whom du Pont enjoyed a comparable friendship to that with Hattie Brunner was Joe Kindig, Jr., of York. Kindig carried high-quality merchandise, and he offered du Pont more than Pennsylvania German antiques. The two men's business association dates from the 1926 sale of an English / German labeled John Elliott mirror.[13]

[9] Hattie Brunner to du Pont, June 18, 1926, and du Pont to Brunner, May 17, December 23, 1929, January 5, 1937, du Pont Correspondence, Registrar's Office.

[10] Brunner to du Pont, April 28, 1928, du Pont Correspondence, Registrar's Office.

[11] Brunner to du Pont, May 17 and 23, 1928, du Pont Correspondence, Registrar's Office.

[12] Brunner to du Pont, November 21, 1932, September 9 and 21, 1947, du Pont Correspondence, Registrar's Office.

[13] Joe Kindig, Jr., to du Pont, June 14, 1926, du Pont Correspondence. Registrar's Office. For biographical information, see D. Patrick Hornberger, "The Legend of Joe Kindig," *Antique Collecting*, pt. 1, 1, no. 12 (May 1978): 10–13; pt. 2, 2, no. 2 (July 1978): 10–15.

Because he had no place to put them, du Pont declined to buy some choice Pennsylvania furniture and architectural elements from Kindig until 1931. Du Pont's refusals included several clocks and a secretary desk-and-bookcase that Kindig in typical dealer fashion claimed was the best he had ever handled. The year 1931 marked a turning point in their relationship in several ways: du Pont visited Kindig's shop in York, and Kindig motored to Winterthur shortly after; the two became first-name-basis friends; and with his quarters at Winterthur greatly expanded, du Pont began to acquire in volume. A measure of their friendship can be seen in a Kindig offer in 1932 to trade some antiques for an old Buick. Du Pont liked the idea, but he reported that he had just traded in his old Buick for a new one.[14]

In addition to deliberating over cars and antiques, the two men swapped jokes and bantered cheerfully in their 1930s correspondence. Kindig often bemoaned the fact that quality merchandise was so hard to find. In 1933 he lamented, "Yesterday, I traveled 250 miles and saw nothing but junk, not even a good looking woman."[15]

Du Pont bought many choice Pennsylvania, Baltimore, and even New England items from Kindig in the 1930s. A 1937 sales receipt illustrates this point. Du Pont bought a Connelly clock, a New England pole screen, a Philadelphia Chippendale wing chair, a Queen Anne side chair, and a pair of New York Hepplewhite chairs for a total of $10,700. From 1931 through 1937 he rejected the finest Pennsylvania Dutch bedspread Kindig had ever seen, the best Christian Selzer chest Kindig had ever seen, and a rare view of the town of Lititz.[16] Clearly Pennsylvania German folk art was slipping in importance for du Pont by 1937.

Of all the dealers from whom du Pont purchased Pennsylvania German antiques, the most active in the 1930s was Charles M. Heffner in Reading. In 1930 Heffner began offering the handcrafted items of Lancaster County's Joseph Lane (Lehn), who died about 1890.[17] During the year du Pont turned down Heffner's offers of Fraktur, some Lehnware, six Leeds plates with German inscriptions, a miniature pottery rocker dated 1802 with a history from Chester County, and a pottery dog with a basket in its mouth. At the same time du Pont did buy some Lehnware and began buying iron candle stands with brass fittings, items of unspecified origin that Heffner continued to supply over the years.

In the correspondence with Heffner, which is voluminous, we have enough detail to understand some of du Pont's selectivity. While he no doubt bought and arranged according to his taste—a subjective judgment based on preferred quality, color, form, and design—du Pont also had more mundane reasons, which are often revealed in letters explaining why he was not buying offered items. All dealers received responses indicating that the proffered antique was too new, too large, too expensive, or the wrong color. Heffner received more rejections than anyone else because he offered more goods.

Du Pont was rarely fooled by dealer jargon or claims of attribution or authenticity. He did, however, want the dealers to commit themselves in writing. In Heffner's case typical dealer banter rarely helped make a sale, but it may not have lost one either. On April 19, 1933, Heffner offered a 12-by-16-inch cut valentine from John to Elizabeth Blundine—the "finest old valentine in captivity." Du Pont rejected it—"I think the valentine is a beautiful one, but I really cannot afford to buy valentines during these times." On December 19, 1935, du Pont received "the cutest little item, you have ever seen, in Pennsylvania Pottery," a 5-inch-tall pottery pepper shaker shaped like a man. Du Pont had the privilege of rejecting it not once but twice, for Heffner tried the same ploy about six months later. Possibly Heffner assumed that du Pont was buying in such quantity that he would not remember items after several months, or perhaps he hoped that du Pont would forget why he rejected it the last time. Similarly, three times in 1935 Heffner sent the "cutest" little Betty lamp and a trammel, which he claimed were craftsmen's models, to no avail.[18]

Heffner's cute merchandise tended to run in batches. He obviously liked unusual redware whimsies and hoped du Pont would also. All through the 1930s he offered such things as pottery whistles in the shape of dogs' heads, fish, monkeys, pigs, and frogs, a pottery bust of George Washington, and a miniature pottery lamp. He even offered a 1797 pottery bug whistle and a toy sgrafitto flute. Du Pont resisted all of these treasures except the bust of Washington.[19] The source and date of some of Heffner's material has recently come into question. Many of the items he handled—iron candle stands, tin sconces, pottery whimsies—were capable of being manufactured or reproduced without

[14]Kindig to du Pont, May 3, 1932, du Pont Correspondence, Registrar's Office.

[15]Kindig to du Pont, November 9, 1933, du Pont Correspondence, Registrar's Office.

[16]Kindig to du Pont, December 15, 1937, May 13 and 30, October 26, 1932, du Pont Correspondence, Registrar's Office.

[17]Charles M. Heffner to du Pont, June 3, 1930, and du Pont to Heffner, August 7, 1930, du Pont Correspondence, Registrar's Office.

[18]Heffner to du Pont, April 19, 1933, December 19, 1935, and du Pont to Heffner, April 20, 1933, du Pont Correspondence, Registrar's Office.

[19]Heffner to du Pont, September 11, 1935, and du Pont to Heffner, September 11 and 28, 1935, du Pont Correspondence, Registrar's Office.

detection in the 1930s. But he no doubt handled much good material, too.

Heffner was indisputably a very enterprising dealer. His prices were hefty for the quality he offered, and he is one of the few dealers with whom du Pont regularly bargained over price rather than merely turned down the offered item. A classic case occurred in July 1940 when Heffner offered a 1797 openwork pottery sugar bowl for $175. On August 10 du Pont indicated his interest at $125. Heffner claimed it was owned by a family who needed money. They would sell it for $125, but that would leave Heffner with no commission for locating the piece. He asked for $15 for himself; du Pont sent him $135, designating $10 for Heffner.[20]

Heffner invariably attributed undated objects to an eighteenth-century origin; he never offered anything less than the best he had ever seen; and he worked hard to link every object to a local family. While his exaggerations need to be balanced by healthy skepticism, Heffner did uncover some fascinating items. In 1947 he offered du Pont, for the second time, an "Amish woman" pottery bottle from Lancaster County. In this case Heffner's persistence paid off, for du Pont bought it. In the same year, du Pont bought the pottery bug whistle Heffner had offered several years earlier. On April 24, 1947, du Pont received one of Heffner's most intriguing items secured from an "old Lancaster County family"—a pair of wooden figures with brass shield. Heffner guaranteed that du Pont would "have fun" with the view that was offered when the lever was manipulated to lift the shield.[21]

Du Pont established a network of dealer contacts throughout southeastern Pennsylvania in 1925. In some instances his collecting helped launch a business. Such was the case with Ida Hostetter of Lancaster, whose collection he visited in June 1925. After the visit du Pont inquired about a large painted wardrobe he had admired. In making the decision to sell, Hostetter took the first step in establishing her own business, a business that continued until her death twenty-one years later in 1946.[22]

Ida Hostetter was the wife of the president of Lancaster's Conestoga National Bank. She was of Pennsylvania German descent, the daughter of Isaac and Susanna Kegerreis of Richland, Lebanon County. For many years she had collected glass and ceramics, specializing in what was then believed to be Stiegel glass.

Hostetter sold her collection of sgrafitto and slipware to the Pennsylvania Museum in the 1930s. Her Fraktur were the most notable items remaining in her collection at her death, but they were not generally of the finest quality. While she did supply several objects in the Winterthur collection, Hostetter's most notable sale to du Pont was her first one—the painted clothes cupboard she sold him in 1925 (pl. 7). This wardrobe spent a number of years at Chestertown House, but finally, in 1938, du Pont moved the wardrobe to Winterthur, fortunately before a major storm flooded his Southampton home. He wrote Hostetter, "I am glad to say that your green wardrobe had already been moved here in my new Pennsylvania German room [see fig. 21]. I also have a tiny little room where I show my glass, as well as several other new rooms I installed in the same section, which used to be the old squash court."[23]

Other dealers may have come on the scene earlier and offered more Pennsylvania German material to du Pont, but no Pennsylvania dealers offered better quality Pennsylvania German folk art than Charlotte and Edgar Sittig. The Sittigs began dealing with du Pont upon establishing their business in 1941. Charlotte was a native of the Pennsylvania German region, and her father had been a pioneer antiques dealer. Edgar, born in Germany and trained as a musician, entered the business after an injury ended his career as a cellist. Of all their many sales to du Pont, the most significant were the interior (walls and ceiling) from the Hottenstein house at Kutztown, installed at the museum as the Fraktur Room, and the Hottenstein clothespress. This dual triumph was their finest contribution to Winterthur, but not the only one.

Since 1941 the Sittigs have been responsible for numerous additions to du Pont's and Winterthur's Pennsylvania German collection. The Sittigs represented the new type of dealer of the 1940s who relied heavily upon antiques shows. With the rapid expansion of the pool of collectors, these shows proved to be popular and profitable. The Sittigs frequented a number of them in the 1940s, most notably Chicago; Morristown, New Jersey; White Plains, New York; and Wilmington, Delaware (fig. 23). Except for Chicago, du Pont regularly attended these shows and others at Reading, Harrisburg, Lancaster, and York. Business was not confined to the shows, however, and the Sittigs continued to sell choice items to du Pont until his death in 1969.

[20] Heffner to du Pont, August 12, 1940, and du Pont to Heffner, August 15, 1940, du Pont Correspondence, Registrar's Office.
[21] Heffner to du Pont, April 24, 1947, du Pont Correspondence, Registrar's Office.
[22] Ida Hostetter to du Pont, June 22, July 22 and 28, 1925, du Pont Correspondence, Registrar's Office; Ida Hostetter obituary, *Intelligencer Journal* (Lancaster) (May 27, 1946). After her death, her personal collection and business stock were dispersed over a five-day period in two separate sales.
[23] Du Pont to Hostetter, November 3, 1938, du Pont Correspondence, Registrar's Office.

Notable examples were the Jacob Graf clock, a Pennsylvania hanging cupboard, the famous so-called Bachman secretary, a long rifle from the Odenwelder collection, some Ephrata manuscripts, the Bachman account books, and important Fraktur.

Through many years and thousands of transactions with numerous antiques dealers, du Pont steadily erected a monumental collection of Pennsylvania German folk art. The records show that he conducted himself with integrity and remarkable efficiency throughout this period. While he never purchased an item without seeing it, du Pont made his decisions quickly, returned unwanted objects immediately, and paid promptly. Normally he did not bargain over price. Because of this and his stature as a du Pont and as a major collector, the objects offered to him were pushed to the upper limits of their market value. Because of his integrity and his ability to pay top dollar, du Pont helped to establish the market year after year and assisted a number of dealers in surviving difficult depression years. Nevertheless, except for sgraffittoware, du Pont assembled the bulk of his remarkable collection of Pennsylvania German folk art at reasonable prices, because from 1925 to 1935 he had relatively little competition.[24]

Du Pont collected Pennsylvania German antiques because fine material was so *convenient*. He could make jaunts into the Pennsylvania countryside to major dealers and antique shows with ease. Second, he wanted to create a large collection quickly, and Pennsylvania German material was available in *quantity*. Third, it was relatively *inexpensive*, especially when compared with the prices commanded by New England objects. Fourth, in all his collecting du Pont had a *regional bias*. He wanted to demonstrate that the mid-Atlantic area could hold its own when compared to New

Fig. 23. Charlotte and Edgar Sittig of Shawnee-on-Delaware, at the Chicago Antiques Exposition, ca. 1941. (Photo, courtesy Charlotte and Edgar Sittig.) The exposition, organized by O. C. Lightner, publisher of *Hobbies* magazine, was held annually for a week in November in the late 1930s and 1940s at the Stevens Hotel. The Sittigs' booth rented for $78 a week, with an additional $8.25 for the showcase.

England. Fifth, du Pont *liked* Pennsylvania German folk art. Its colorful contrast to high-style furnishings offered intriguing comparisons and reinforced the concept of the superiority of "colonial" over Victorian life.

FRAKTUR ROOM

Because Henry Francis du Pont had ample resources, an iron will, an abundance of creativity, and the wisdom to surround himself with skilled personnel, he was able to realize his dreams. He also had his full share of good fortune. These characteristics are generously evident in the circumstances surrounding the acquisition and installation of Winterthur's Fraktur Room in the 1950s.

The pace of du Pont's collecting of Pennsylvania German artifacts slowed in the late 1930s as his interests shifted. Having assembled a large collection, du Pont concentrated, after 1935, on the display and refinement of his collection. He began by selecting only items of exceptional quality or those that would enrich a particular room display. In 1938 he completed the Pennsylvania German Folk Art Room (fig. 21). Over the next dozen years he installed the displays now known as the Dresser Room, Lebanon Bedroom, Pennsylvania German Bedroom, Pennypacker Hall, Pottery Room, and Spatterware Hall (figs. 24, 25, 26, 27). All of these

[24]Du Pont grew up in a household filled with empire and late nineteenth-century furniture. Neither the furniture nor the interiors survived his 1929–31 renovations. In obtaining objects to refill his house, his chief rivals among Pennsylvania German folk art collectors were Wilmington's Titus Geesey, Philadelphia's J. Stogdell Stokes and George H. Lorimer. Other rivals were the many dealers who kept choice items for themselves, especially Arthur J. Sussel of Philadelphia. Geesey, secretary to Pierre S. du Pont, founder of Longwood Gardens, amassed a quality collection which now forms the core of the Pennsylvania German furniture collections at Philadelphia Museum of Art and York County Historical Society. Stokes, president of Pennsylvania Museum, 1933–47, was also an important collector of Pennsylvania German furniture. His collection was sold by Parke-Bernet Galleries on March 20, 1948. Lorimer was editor of *Saturday Evening Post*. His collection was sold at auction by Parke-Bernet March 29–April 1 and October 24–28, 1944. Du Pont made purchases at both sales. A third competitor in Philadelphia was Sussel, a German immigrant to the United States in 1905 and a collector by the end of World War I. Sussel died in 1958, and his collection was sold by Parke-Bernet Galleries October 23–25, 1958, and January 22–24, 1959.

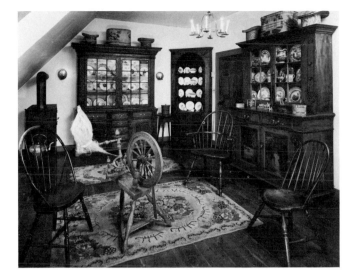

Fig. 24. Dresser Room, Winterthur, as it looked in August 1962. (Photo, Winterthur.) The room typifies du Pont's early collecting interests and is characteristic of the displays at Chestertown House prior to the transfer of much of du Pont's folk art to Winterthur. Hooked rugs, Windsor chairs, painted furniture, and colorful ceramics were thought to be natural companions. Many of du Pont's dressers were purchased in the 1930s as repositories for his burgeoning ceramics collection. While the dresser collection is the largest in any public institution, only a few match the quality of the architectural cupboard in the left background.

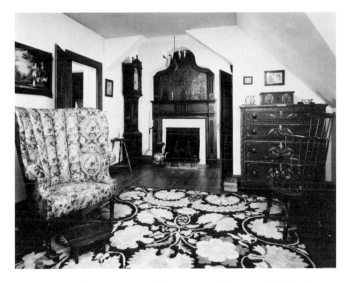

Fig. 25. Pennsylvania German Bedroom, Winterthur, as it looked in August 1962. (Photo, Winterthur.) Next to the Fraktur Room and the Kershner complex, the Pennsylvania German Bedroom contains the most important Pennsylvania German architectural elements at Winterthur. The raised panel doors are characteristic of large sections of German-speaking Europe and contrast sharply with the geometric paneling of eighteenth-century English doors. The origin of the fireplace mantel and overmantel is not known.

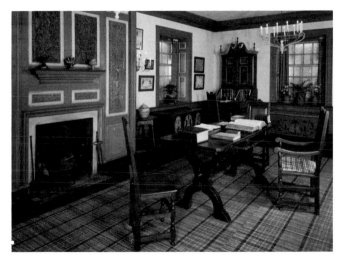

Fig. 26. Fraktur Room, Winterthur, as it appeared in February 1959. (Photo, Winterthur.) The Chester County wainscot chairs in this photograph were replaced with Pennsylvania ladderback chairs in 1981 (see pl. 1). The Hottenstein clothespress occupies the wall opposite the fireplace.

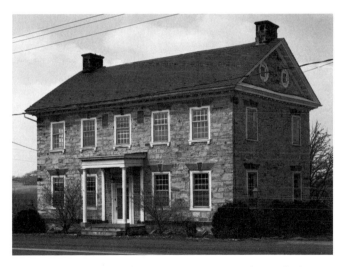

Fig. 27. David Hottenstein house, Maxatawney Township, Berks County. Built 1783. (Photo, Winterthur.) This limestone mansion is now owned and maintained by the Historic Preservation Trust of Berks County which kindly granted permission in 1981 for Winterthur to photograph the interior and make measured drawings. Much of the credit for the recent restoration of the house belongs to the late David and Mary DeTurk Hottenstein.

Pennsylvania German settings followed one pattern of display. In each, architecture was a sympathetic backdrop for a exhibition of objects. In the Pennsylvania German Folk Art Room the architecture was nondescript; in the Pennsylvania German Bedroom a dramatic overmantel served as the focal point of the display, but even so the architecture was subordinate to the objects, and the architectural instal-

lation had little or no historical integrity vis-à-vis the contents of the room.

With the Fraktur Room, du Pont and his curator, Joseph Downs, created a display space that had both historical integrity and architectural significance (fig. 26, pl. 1). While evidence suggests that du Pont still saw the room primarily as an aesthetic setting for his Fraktur, the architecture easily held its own stature once the furnishings and framed Fraktur were placed.

The presence of the Fraktur Room provides Winterthur with a historical fragment that is highly illustrative of the whole Pennsylvania German culture drama. The architecture of the David Hottenstein mansion is exceptional in its quality and ornamentation. It also provides documentation of the inner workings of cultural assimilation among the Pennsylvania Germans. In order to understand its importance, it is necessary to examine Hottenstein and his house in its original setting.

David Hottenstein built the house from which this room was taken in 1783 along the important Easton Road, two miles north of the village of Kutztown.[25] And that house has no surviving peer in Maxatawney Township, although the area boasts other fine eighteenth- and early nineteenth-century limestone houses built by other prominent families such as the Levans, Kemps, and Kutzes. Hottenstein, the prime taxpayer in the township, had erected a monument to his wealth and stature in the community.[26] As an edifice built by the second generation of Hottensteins in America, the house was a tribute to material success in the New World, and as a Georgian double-pile structure, the house provides nonverbal evidence of the degree of assimilation by one Pennsylvania German family (figs. 27, 28). The interior of the Hottenstein house features some of the finest architectural detail and one of the most elaborate painting schemes of any surviving Pennsylvania German house in southeastern Pennsylvania.

From a modern vantage point the Hottenstein house is an English house of classical inspiration. Its elaborate Georgian architectural ornament, often associated with urban centers, has led some local historians to believe that Philadelphia craftsmen were imported to build the house. In light of our recent research, there is, however, a more

Fig. 28. View of kitchen wing and some outbuildings, David Hottenstein house. (Photo, Winterthur.) In addition to the kitchen wing (*left*), enlarged about 1840, the house is supported by a flock of outbuildings, including a summer kitchen / washhouse (*right*) and a bakehouse (*center*). Not visible are the nineteenth-century doctor's office and the bilevel smokehouse.

plausible explanation.

First, the Maxatawney area had its share of masons, carpenters, and joiners. Surviving artifactual evidence reveals that its craftsmen were capable of producing a house of the size and quality of Hottenstein's mansion. Masons do not appear on the township's tax lists from the 1780s, but the number of stone houses in the area, and in the nearby Oley Valley, from which many of the families had migrated and where they still had relatives, prove that capable masons were practicing their trade in the area by the 1780s. Two surviving pieces of furniture from the Kutztown area, one made for Maria Kutz and the other for David Hottenstein, indicate the presence of a master cabinetmaker in the 1770s and 1780s who could have executed the fine corner cupboards in the house (fig. 29, pls. 2, 7). In 1779, two years before the Hottenstein clothespress was made, Maxatawney tax rolls listed only two joiners, Paul Hertzoge and Philip Heyman. A third joiner, George Essert (Esser), was present on the rolls, but no occupation was listed. By 1784 Esser was listed as a joiner, Hertzoge was gone from the tax rolls, and Christian Derr, joiner, had moved in from Greenwich

[25]*The Centennial History of Kutztown, Pennsylvania, 1815–1915* (Kutztown: Kutztown Publishing Co., 1915), p. 61.

[26]On the 1780 tax list, David "Huttenstone" was listed as operating a still and a farm of 442 acres. He had two Negroes, five horses, and five cattle and was assessed at £132.10. Only two other residents of Maxatawney were assessed at over £100, and they were at £120 and £114. The Kutz family who founded Kutztown had assessments ranging from £7.10 to £90 (*Pennsylvania Archives*, 3d ser., vol. 18 [Harrisburg, 1898], pp. 381–82).

Township. Philip Heyman was still plying his trade, and a Christian Heyman appeared on the lists as a joiner for the first time. Henry Shedeley was listed as a turner. Of these men, only Esser and Philip Heyman were longtime residents of the township. Esser, who was a Lutheran deacon in St. John's Union Church, is probably the master joiner who worked for the Hottensteins, since he lived only two miles away from David Hottenstein's farm and attended the same church (the Hottensteins were members of the Reformed congregation).

Second, the English Georgian features of the house did not require importing urban craftsmen. Although in 1783 Hottenstein's house was a highly fashionable statement in Maxatawney, the Renaissance vocabulary was already familiar to German as well as English craftsmen on both sides of the Atlantic. German craftsmen from urban centers in Europe or who trained in Philadelphia or Germantown could have carried these ideas to Maxatawney. In addition, both English and German carpenter manuals were available to craftsmen before the 1780s.

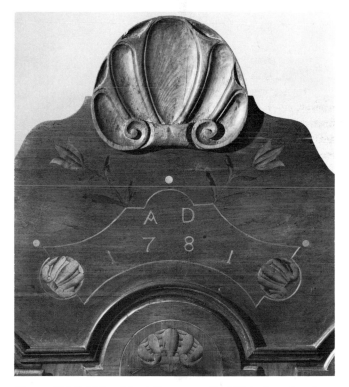

Fig. 29. Detail, Hottenstein clothespress, 1781. (Winterthur 58.17.6; see pl. 3, for an overall view.) The carving and ornamentation of this walnut cupboard is unmatched by any other Pennsylvania German furniture and combines marquetry, inlay, carving, and paint or stain. The last was used for accent purposes only. Traces of green are visible on the stems and leaves of the marquetry flowers in this detail, and traces of red are visible on the carved shell.

The fashionable and expensive house was predominantly English in style. Even its decoratively painted interior woodwork was not distinctly Germanic, for the painting of interiors was known and practiced in eighteenth-century New England and in non-Germanic areas of the South. The Hottenstein interiors are part of a larger story of architectural simulation. Simulation of marble, masonry, and expensive exotic woods had been common in seventeenth- and eighteenth-century England and on the Continent and had roots in the Italian Renaissance.[27] Central Europe had been more profoundly affected by the idea of simulation than England. In many parts of Germany, Austria, and Switzerland, wood had long been the preferred building material, and painted surfaces, whether decorative or simulative, had a revered history. Especially in south German baroque churches, painted wood was used in preference to the material being simulated and not just as a less expensive substitute.

American evidence of the paneled and painted interior is rare. The Hottenstein house takes on additional importance because it is one of the finest and most extensive painted American interiors that date from the eighteenth century. Although the architecture and the decoration, both interior and exterior, are predominantly Renaissance classical and more English than German, the house does have a Pennsylvania German accent, most notably in its front entrance and its double date stone. The existing porch is not original to the house and was probably added when the kitchen wing was built, but the door frame and door are original. The carving of the door frame presages the fine classical detail of the hall interior, while the door, of tripartite construction with massive strap hinges, is a traditional Germanic feature (figs. 30, 31, 32). The date stones are identical in size and flank the central window. They are carved sandstone and, being larger than more typical single date stones, resemble tombstones (fig. 33). The keystones of the semicircular arches echo the more boldly carved keystones of the jack arches of the window lintels. In sum, the most personal elements of the house—the date stones—and the most symbolic element—the front door—announced to visitors that the inhabitants were successful and important Pennsylvania Germans.

Architectural vocabulary and decoration are important indicators of house identity, but scholars of vernacular building traditions consider the structure of the house and

[27] See Margaret Jourdain, *English Interior Decorations, 1500–1830* (London: B. T. Batsford, 1950). Winterthur's Williams Room from Lebanon, Connecticut, is from a 1710 house. The interior painting may date from a slightly later time. Other examples are cited in Martha Van Artsdalen, "Architectural Simulation in America, 1725–1800," typescript, 1979.

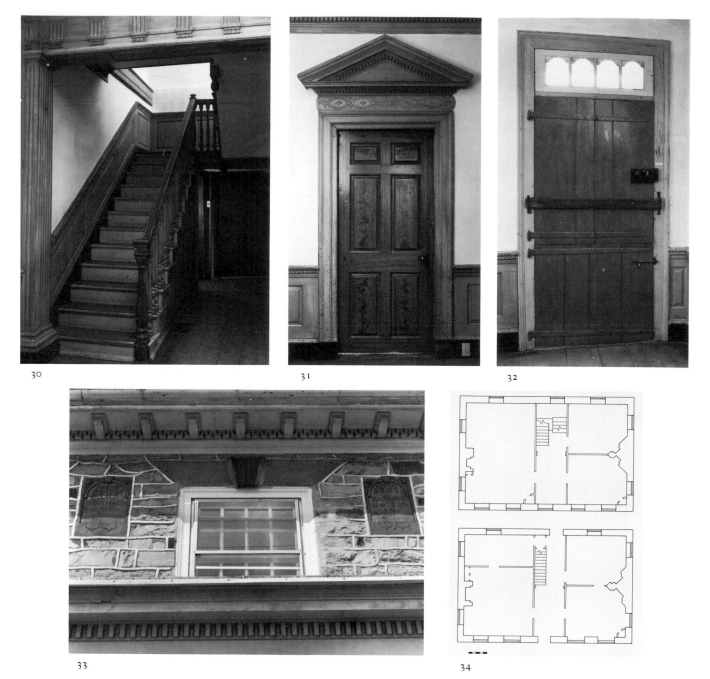

30

31

32

33

34

Fig. 30. Entrance hall, first floor, David Hottenstein house. (Photo, Winterthur.) The open, dogleg staircase with turned balusters, decorated face string, and paneled wainscoting extends to the third floor. The door to the right leads to the kitchen wing. Access to the cellar is under the staircase, and a passageway under the staircase leads to a small room off the first-floor great parlor. The staircase hall is set off from the front hall by the Doric pilasters and entablature visible in the foreground.

Fig. 31. Pedimental doorway, entrance hall, first floor, David Hottenstein house. (Photo, Winterthur.) The door frame, with denticulate cornice and carved pulvinate frieze, and the door, grained to resemble mahogany, con-

trast sharply with the treatment of the front door. The frame is similar to door frames and chimney breasts found in manuals by Batty Langley, Abraham Swan, and other British carpenters of the mid eighteenth century.

Fig. 32. Tripartite front door, interior, first floor, David Hottenstein house. (Photo, Winterthur.)

Fig. 33. Detail of facade, David Hottenstein house. (Photo, Winterthur.)

Fig. 34. Floor plan, first and second floors, Hottenstein house. (Drawing, courtesy Bernard L. Herman.) The partition in the first-floor great parlor is a nineteenth-century addition.

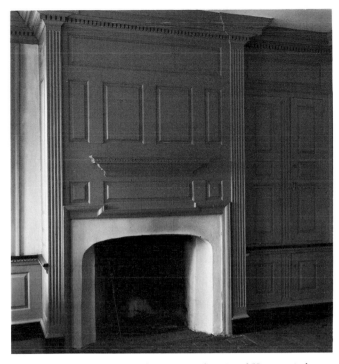

Fig. 35. Fireplace detail, first-floor great parlor, David Hottenstein house. (Photo, Winterthur.) Each fireplace in the house was executed differently, using a new variation on or combination of a basic set of classical characteristics and moldings. The geometry of each room is pronounced and distinct, an individualistic treatment that provides visual surprise for the modern visitor and presumably provided satisfaction to the original owner. In light of this classical geometric precision, the different number of flutes in the flanking pilasters is a puzzle.

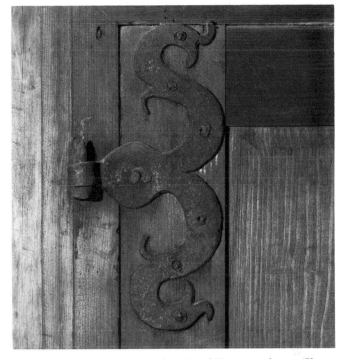

Fig. 36. Ram's horn hinge, attic door, David Hottenstein house. (Photo, Winterthur.) It probably was locally made.

its construction and floor plan to be the most significant features of any building. The three-room plan of the Hottenstein house can be interpreted as either a Germanic survival plus central hall or an adaptation of a central-hall English Georgian plan (fig. 34).

In construction the Hottenstein house has few Germanic details. The roof framing is a type of double-butt purlin construction found in English housing. The moldings utilized throughout the house were cut by planes readily available to both English and German woodworkers and have no specific German feature. The particular combinations of moldings and the use of freestanding cornice-type carpenter mantels give the interiors a conservative flavor and a provincial twist, but again nothing German emerges. The use of fireplaces throughout the house and their placement are characteristic of the well-to-do English houses of the period, while the asymmetrical fireplace paneling, the hardware, the construction of the corner cupboard cabinetry, and the placement of stoves into several of the fireplaces are German accents.

The asymmetry of the paneling suggests a certain unfamiliarity with the Georgian aesthetic. A few other points illustrate the workmen's unfamiliarity with English interpretations of classical detail. Many of these eccentricities are found in the two most elaborately treated spaces, the entrance hall and the large downstairs parlor. In the parlor, for example, the flutes in the fireplace pilasters number four on the left and five on the right (fig. 35).

The hardware in the Hottenstein house is one of its most conservative elements. The use of massive strap hinges on finely detailed interior doors is an anomaly, unless we see it as German preference. The locks are Germanic. The attic door sports an impressive pair of hinges that today would be collected as folk art (fig. 36). In 1783, they were old-fashioned but serviceable.

The cabinetry is of high quality. The house had fielded paneling and wainscoting throughout the first and second floors, and at least four of the six rooms had built-in floor-to-ceiling corner cupboards. The cupboards vary in size, in the number and treatment of interior shelves, and in door construction. Those that were upstairs have doors with glass panes, suggesting that display items were kept in sleeping chambers, whereas the downstairs cupboards have solid panel doors (figs. 37, 38, 39). The molded raised paneling

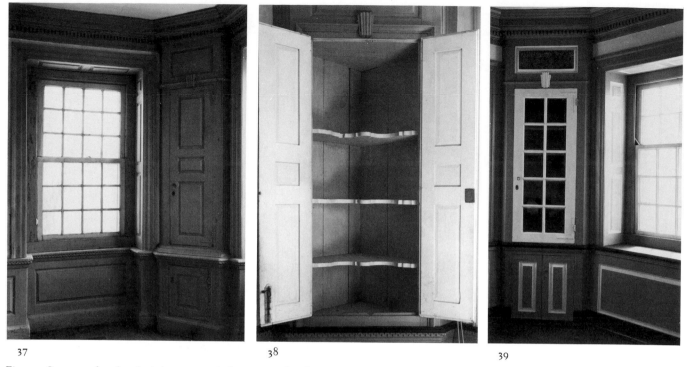

37 38 39

Fig. 37. Corner cupboard and window surround, front room, first floor, David Hottenstein house. (Photo, Winterthur.) All of the built-in cupboards of the first floor have solid, fielded panel doors with locks. The shelves of this cupboard have scalloped front edges.
Fig. 38. Scalloped shelves, corner cupboard with double doors, great par-

lor, first floor, David Hottenstein house. (Photo, Winterthur.)
Fig. 39. Corner cupboard, front chamber, second floor, David Hottenstein house. (Photo, Winterthur.) This cupboard, like its larger and more elaborate partner in the great chamber across the hall (see pl. 2), has glass panes. The original paints on the two cupboards were identical.

Fig. 40. Tombstone of Dr. David Hottenstein, family cemetery on a knoll overlooking the Hottenstein house and farm. (Photo, courtesy Charlotte and Edgar Sittig.) The inscription translates as follows: "Memorial to dec[eased] David Hottenstein. He was born February 8, 1766, and died July 3, 1848. He was 82 years, 4 months, and 25 days old ——— ——— ———."

on all the cupboards is identical to that on the doors and the wainscoting throughout the house.

The David Hottenstein who built the house was a son of Jacob Hottenstein, an immigrant who settled in 1729 in what is now the East Penn Valley of Maxatawney Township.[28] Jacob sired four sons and three daughters. Jacob, Jr., and William settled elsewhere in Berks County, Henry became a prominent physician / druggist in Lancaster, and David (1734–1802) bought out Henry's share of the family farm and remained in Maxatawney. David Hottenstein had three sons and three daughters. The eldest son, also named David (1768–1848), became a doctor, inherited the farm, and managed it from 1802 until his death. While a prosperous and well-educated American, doctor David also kept his Germanic heritage, as his tombstone attests (fig. 40).

The elder David Hottenstein changed the architectural landscape of Maxatawney. After 1783 he lived in the finest house in the region and projected his preeminence visually for all passersby, including Theophile Cazenove. Unfortu-

[28] Sara K. Brown, "Jacob Hottenstein, 1697–1753," *Historical Review of Berks County* 4, no. 2 (January 1939): 41–43. One of David Hottenstein's daughters married a Kutz.

nately, detailed returns of the 1798 Pennsylvania Direct Tax for the township do not survive, so descriptions of many buildings and their dimensions are lost. But the general assessment records are extant and show that even near the end of his long and distinguished life Hottenstein remained the principal taxpayer of his area, with a tax of $15.04 on property appraised at $7,920. Only two other residents of Maxatawney were taxed at $10 or more in 1798, George Kemp, with an evaluation of $7,822 and a tax of $14.86, and Abraham Zimmerman, with property valued at $7,340 and a tax of $13.94. The difference among these men's taxes is in their housing. Zimmerman's house was appraised at only $375, Kemp's at $1,312 (he also owned a few lesser houses which he rented), and Hottenstein's at $2,250.[29]

Although the Kutztown area was subsequently dotted with limestone farm complexes, most featuring two-story Georgian stone houses somewhat comparable to the Hottenstein house, in 1783 Hottenstein's mansion simply had no peers. Even in 1798 there were only a few two-story stone houses in Maxatawney and none with an appraised value comparable to Hottenstein's. The tax records reveal that a two-story stone house with barn rarely carried an evaluation less than $1,000 on the direct tax roster. A two-story log house with barn rarely exceeded $1,000. A one-story log house was usually valued at less than $400, and a one-story stone dwelling could range from approximately $300 to $700. Using these criteria, Maxatawney's architectural profile probably looked something like table 1.

David Hottenstein's house probably had a significant architectural impact on his region as others tried to emulate it in the wave of prosperity after 1783. But two thoughts must be kept in mind in evaluating Hottenstein's achievement. First, the building of such a house required a great amount of available cash or substantial borrowing power. As we have seen, only a few other men in the township had comparable assets in the 1780s and 1790s, and they may not have had resources to devote to housebuilding. Second, and more important, Hottenstein was probably the first man in the area to *want* to expend his resources in this manner. As suggested in chapter 3, many Germans chose not to sink capital into their own dwellings and personal household goods. Certainly a general correlation existed in Maxatawney between overall property value and house value, but the relationship was not always one to one. Obviously craftsmen who owned little or no land could have had substantial housing, but values of their houses did not exceed $700 in 1798. On the other hand, certain well-to-do resi-

dents lived in low-value houses. Abraham Zimmerman, who was in the township's top 1 percent wealth bracket, possessed a house valued in the bottom 50 percent. He was not alone in this disparity.[30]

As a general principle among Pennsylvania German farmers the higher the percentage of total assets invested in one's house, personal belongings, and household goods, the greater the likelihood that the family was assimilating. The lower the percentage, the more likely that the family was clinging to Germanic patterns of life. David Hottenstein's estate inventory tests this hypothesis.

David Hottenstein's inventory in 1802 totaled £10,812.18.11. When combined with the value of his home and large farm, the magnitude of his wealth is readily apparent. Yet he was still a Pennsylvania German. The value of his personal apparel (£21.18.6) was substantial but does not indicate a fashionable dandy. The specific entries in his inventory reveal a traditional cast of characters inside the house. Hottenstein had *more* textiles than most Pennsylvania German farmers, but not a larger variety. The Hottenstein clothespress may be the "Cloath Dresser" valued at £5.5.[31] We know that this particular clothespress was more elaborate than most clothespresses, but the form itself was very typical of prosperous Pennsylvania German households.

Most of the items in Hottenstein's inventory follow a traditional Pennsylvania German pattern, with Hottenstein possessing more of everything than the typical farmer and probably of better quality. For example, rather than one or two beds and bedsteads, Hottenstein had six, including two with curtains. He also owned at least twenty chairs and seven walnut tables. Like other Pennsylvania German farmers, he possessed a twenty-four-hour clock, a kitchen dresser, and a dough trough.

	TABLE 1	
Maxatawney Township's Architectural Profile 1798		
Valuation	Number of Dwellings	Probable house type
$ 100–400	68	one-story log
400–700	38	one-story stone, two-story log
700–1000	11	with barn, or two-story stone
1000–2250	12	two-story stone with barn
Source: 1798 Direct Tax, Schedule A.		

[29] Pennsylvania Direct Tax, 1798, National Archives, Washington, D.C. (microfilm). The following section is based on a study of the partial returns from Maxatawney Township.

[30] Another example is Balzer Gehr, with property valued in 1798 at $4,842.50 and a house valued at only $250.

[31] David Hottenstein Inventory, July 27, 1802, Office of the Register of Wills, Berks County Courthouse, Reading.

Indicators of English taste are evident in the inventory but not abundant. Because the house followed an English pattern and contained fireplaces (and andirons), only two ten-plate stoves were listed. Hottenstein also had a desk, a silver watch, six silver teaspoons, two silver sleeve buttons, an umbrella, and twelve pictures. In almost every other respect, Hottenstein's estate was like that of many Pennsylvania Germans. He had a large amount of cash (£1668.7.6) and had reinvested his liquid assets in notes and bonds. His farm and household goods totaled approximately £200, only 2 percent of the total value of the inventory. More than 80 percent of his inventory assets were in notes, bonds, and book debts in the names of several dozen neighbors and relatives. If the household inventory is to any degree an accurate reflection of what was in the house, then Hottenstein furnished his fine mansion sparsely in a traditional Germanic manner. Although the architecture expressed his aspirations, the furnishings reaffirmed the past.

Because of this complexity, the Hottenstein house and its museum fragment, the Fraktur Room, are exceptional examples of one phase of the process of ethnic assimilation. They represent a dramatic departure from Germanic tradition when viewed from a first-generation German American vantage. When perceived from the English end of the continuum, they speak English with a German accent. And when combined with all aspects of the David Hottenstein family history, the language is clearly Pennsylvania German.

The room from the Hottenstein house now at Winterthur fits into a larger plan that du Pont had. He wanted a suitable setting for his large collection of Pennsylvania German Fraktur. On August 11, 1950, Thomas Tileston Waterman, du Pont's chief architectural adviser since 1933, proposed a plan that called for installing a room made from old Germanic building materials to set the proper ambience, specifically a five-plate stove, sliding sash windows, a sheathed door with rebated cleats, and antique ceiling joists. While there is no record of du Pont's response to Waterman's proposal, the existing Fraktur Room shows no trace of Waterman's plan because two events served to sidetrack the original idea. On January 21, 1951, Waterman died after a lengthy battle with cancer.[32] A few months earlier

the Sittigs had discovered an elaborately decorated architectural interior near Kutztown, and it offered a more authentic and more spectacular backdrop for the colorful Fraktur.

The Fraktur Room had begun life in 1783 as the second-story chamber, or "Great Room," of David Hottenstein's fine new house. The house had remained in family hands, although not always in the direct Hottenstein line, for its entire history. (In 1980 it was deeded to the Historic Preservation Trust of Berks County on the death of its most recent owner, David F. Hottenstein [1906–80].) In 1950 it was owned by George Grim, a relative by marriage. For many years the house had been occupied by tenant farmers, the Hottensteins having long since left the farm, taking family possessions with them. One antique remained—a massive *Gleederschank*—imprisoned because one end of the upstairs long room had been partitioned to make a closet. The presence of this unusual clothespress (pl. 3) was sniffed out by Asher J. Odenwelder, Jr.

Odenwelder, scion of a distinguished Easton family, lived in the three-story family home in Easton, Pennsylvania, where he was an executive of Easton National Bank. According to Charlotte Sittig, who had known Odenwelder from the time she was a young girl and who was a close friend of the ebullient collector, Odenwelder loved life and its finest pleasures (fig. 41). (His penchant for fine food and drink need little attention here, but one cannot resist speculating what it must have been like to motor off antiquing with Odenwelder during the Prohibition era in a Pierce Arrow with its own stocked bar.)[33]

By the mid 1940s Odenwelder had assembled a fine collection of Pennsylvania German antiques, and in 1948 he published a pamphlet on his collection and collecting habits. As a serious collector he began with Washington flasks and moved on to Currier and Ives lithographs, spatterware, and Pennsylvania pottery, including sgraffitoware. Eventually he graduated to the installation of architectural elements to create a period ambience in his dining room. By the late 1940s he had amassed a small but admirable collection of furniture.[34]

Odenwelder also sold antiques, but on the day in 1950 that he set out for Kutztown to purchase the Hottenstein clothespress he was intent on buying for himself.[35] Because

[32] As a member of the firm of Perry, Shaw, and Hepburn, Waterman worked on early Williamsburg reconstructions and restorations, including the Governor's Palace. He was a prolific writer, principally on Southern architecture. From 1933 through 1950 Waterman advised du Pont on many new installations, including the Montmorenci Stair Hall, the Court, and the Marlboro Room. At the time of his death he had been fighting cancer for well over a year, and he was quite ill in the final months. His health may have prevented him from drawing up new plans for and working on the installation of the room the Sittigs found.

[33] The information on Odenwelder and the Hottenstein house is based on a series of interviews with Charlotte and Edgar Sittig in 1981. Odenwelder was featured in *Antiques* 51, no. 4 (April 1947): 246–49.

[34] Asher J. Odenwelder, Jr., *The Collector's Art, A and Z*, Home Craft Course, vol. 26 (Plymouth Meeting, Pa.: Mrs. C. Naaman Keyser, 1948), pp. 4, 5–7, 9.

[35] Interview with Charlotte and Edgar Sittig, 1981.

Fig. 41. Asher Odenwelder, Jr., and Charlotte Sittig, Odenwelder dining room, Easton, 1945 or 1946. (Photo, courtesy Charlotte and Edgar Sittig.)

of the size and expense of the antique wardrobe, he asked his friends, Charlotte and Edgar Sittig, to accompany him. Odenwelder was worried that the clothespress could not be removed from the small chamber, not realizing that it could easily be dismantled. He also wanted the Sittigs to see the remarkable interior of the Hottenstein house.

All three realized the value of their respective finds, but probably not their full significance. In one exciting trip Odenwelder and the Sittigs had discovered the most important single piece of Pennsylvania German furniture and the most important painted interior in the Pennsylvania German architectural repertoire. Odenwelder purchased the clothes cupboard from Grim, dismantled it, and reassembled it in his Easton home. The Sittigs began negotiating with Grim for the painted interior of the long southwest room on the second floor.

Grim, then superintendent of the Northampton County school system, sold the room for $1,000 with the stipulation that the Sittigs pay for repairs necessary for putting the room in order minus its original paneling, trim, and windows. Grim received $500 on October 17, 1950, and the remaining $500 on October 26 after the room had been removed. He stipulated on October 17 that Edgar Sittig was to replace the baseboard, install a flat chair rail, repair all plaster damage, and thoroughly clean the room, but it was agreed that paneling and cornice would not be replicated.

When the Sittigs discovered the room and negotiated its purchase, they had no buyer. A call to Charles F. Montgomery at Winterthur soon located one. Montgomery, always eager for fine architectural interiors, cognizant of du

Pont's desire for a Fraktur room, and undoubtedly aware of Waterman's proposal for one, wasted no time in traveling to see the room. He was accompanied by Joseph Downs, then du Pont's curator and the curator who had previously supervised the installation of Pennsylvania German rooms at the Philadelphia and Metropolitan museums of art. Sensing a real find, the two men promptly escorted du Pont to the site, and his dream of a Fraktur room came to the edge of realization.

Edgar Sittig sold the room to du Pont for $3,000 plus the cost of the repairs for which he was obligated. Du Pont also agreed to bear the cost of removal and to supply his own crew for the delicate process. In late October 1950 Howard Lattomus and a crew of five Winterthur carpenters began dismantling their treasure; they faced a difficult task and a hostile community (figs. 42, 43, 44, 45).

When word of the impending du Pont project reached the ears of the small, proud Kutztown community, people expressed concern and even invective. Unable to reach the principals of the drama, they focused on the actors close at hand, namely Edgar Sittig and the Winterthur crew. During the several days he was on the site supervising work, Sittig faced direct threats and considerable verbal abuse. The Winterthur crew was likewise made uncomfortable. They worked quickly and with great skill and each day returned to Wilmington with a truckload of material.

Grim, smarting under the double sting of local criticism and the fact that a du Pont was buying the room, tried to block the move during and after the fact of removal. He asked for more money, but the fee had been agreed upon in writing. After the work was completed, he argued that he had sold only the part of the room up to the later partition and that the partitioned area was a second room for which he had not been paid. Upon hearing of this, Lattomus wrote to Edgar Sittig:

I am surprised that Mr. Grim says we were not supposed to take woodwork from both sides of the partition in the southwest bedroom of his house near Kutztown. Since this partition is a later addition to the room, Mr. Grim told both of us it was unnecessary to put a new board in it but to patch the old one where it was cut out for the cornice molding. My five men were working on both sides of the partition at the time of this conversation, and Mr. Grim complimented us all on our good work, so I am sure they could verify the conversation.[36]

While the controversy swirled, du Pont and the staff of his soon-to-open museum made plans to install the new interior. Pleased with his latest acquisition, which cost him

[36] Howard Lattomus to Sittig, January 8, 1951, courtesy of Charlotte and Edgar Sittig.

42

43

44

45

Figs. 42–45. Removal of the corner cupboard from the great chamber, David Hottenstein house, by Winterthur carpenters. (Photos, courtesy Charlotte and Edgar Sittig.) The crew, as standing in the second photo, consisted of Earl Malford, Ben Johnson, "Pappy" Langford, foreman Howard Lattomus, John Alexander, and Tom Lattomus.

$3,000 for the woodwork plus $700 for repairs, he expressed his delight to Edgar Sittig in a letter:

The woodwork of the Hottenstein Room has arrived safely and I am delighted with it. I feel sure if it were not for you I would never have gotten it and I am very much obliged to you for all the trouble you have taken. My carpenter, Howard Lattomus, said that you smoothed out all his difficulties.

The room is just what I wanted as a background for my frakturs besides being full of interest in itself, and what I have been dreaming about for years and never expected to find.[37]

A week later Sittig responded:

Thank you very much for your kind letter. I am sending you herewith some snapshots I took, as the work progressed, and hope they will be of interest to you. I numbered each one on the back.

I want to compliment you on Howard Lattomus and his men. Their skill, teamwork and efficiency was superb, and I have never seen a finer bunch of men all working together.

I have been having a lot of trouble on this end, due to spite work. Fortunately I have some good friends in the contracting business here in Stroudsburg, who are helping me out, as I have to replace woodwork, windows and plaster, and there is a lot of it, and it is quite a distance to go from here.[38]

Naturally, the same crew that removed the interior installed it at Winterthur. The architectural drawings were prepared on September 18, 1951, by Leslie Potts, superintendent of Winterthur Farms and a draftsman who worked on numerous museum installations during the 1940s and 1950s. The Fraktur Room was one of Winterthur's most accurate installations to date and involved no major changes to the woodwork or original room dimensions except for a doorway that had to be cut through the north wall of the room in order to provide access to and from the rest of the museum.

The epilogue to the story occurred in 1958. After the death of Odenwelder in December 1957, the Sittigs were asked to help sell his collection. Many items were bought by public institutions, including Henry Ford Museum and Winterthur Museum. The Hottenstein clothespress was purchased from Odenwelder's estate by the Sittigs for Henry Francis du Pont. Thus, after a brief separation, the Hottenstein Gleederschank returned to the room that had housed it for 180 years, what is now the Fraktur Room at Winterthur, and two of the greatest monuments of Pennsylvania German culture were reunited.

The Fraktur Room was a significant departure for du Pont.

With the encouragement of the Sittigs and his museum's small curatorial staff, he had acquired an eighteenth-century interior and installed it with minimal alteration. He did not rearrange the architectural elements to suit his twentieth-century tastes, as had been customary for most private collectors and small museums heretofore. Instead, he attempted as faithful a recreation as was possible in the space available.

KERSHNER COMPLEX

Completion of the Fraktur Room by Joseph Downs and Charles F. Montgomery gave Winterthur a Pennsylvania German installation that rivaled those of the Philadelphia Museum of Art and Metropolitan Museum of Art. Because there were several other Pennsylvania German rooms at Winterthur and du Pont was no longer actively collecting Pennsylvania German folk art, there was no pressure at Winterthur after 1952 to plan new installations. However, just as du Pont was always receptive to a choice object, he also took notice of architectural discoveries that offered the possibility of building upon the strengths of his collection.

One such discovery was made in 1957 by Frank H. Sommer, at the time a novitiate at a Jesuit seminary near Wernersville, Pennsylvania. While on a stroll near the seminary, Sommer, a student of classical art and architecture, wandered into an abandoned stone farmhouse and discovered remarkable European baroque plaster ceilings. Sommer, a former faculty member at the University of Delaware, reported his find to his friend Montgomery. Montgomery and du Pont visited the site and quickly began to determine where the interiors could be placed in the nearly full museum and to negotiate the purchase of the rooms in the abandoned farmhouse.

Finding a location at Winterthur proved to be relatively easy. Montgomery and du Pont were somewhat dissatisfied with the Pine Kitchen, an early Winterthur assemblage of "Early American" antiques, which was already badly dated by its installation and had an amalgamated architectural setting that did not merit retention (fig. 46). Measurements of the space and the first floor of the Wernersville house revealed comparable dimensions. Since the house was uninhabited and in poor condition and had been relegated to the subservient status of a farm storage shed, negotiations for purchase proceeded quickly and smoothly. The interiors of the house and the nearby bakehouse were purchased for $1,800 in 1957.[39]

[37] Bill of October 19, 1950, for $3,700, marked paid on October 28, 1950, and du Pont to Sittig, October 21, 1950, H. F. du Pont Correspondence, Winterthur Archives.

[38] Sittig to du Pont, October 28, 1950, du Pont Correspondence, Winterthur Archives.

[39] Bill and correspondence with James Weber, June 1957, du Pont Correspondence, Winterthur Archives.

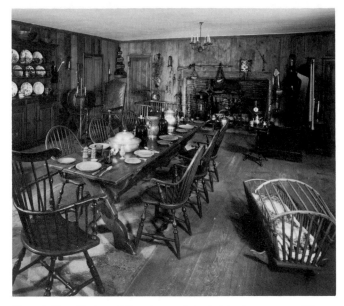

Fig. 46. Pine Kitchen, Winterthur, as it looked in August 1953. (Photo, Winterthur.)

Fig. 47. Hehn-Kershner house, Wernersville, Berks County, as it looked in 1957 when discovered by Frank H. Sommer. (Photo, Winterthur.) This view shows the ground-level entrance to the cellar of the house as well as the combination bakehouse and smokehouse (ca. 1840).

The house had been known as the Hehn-Kershner house, named after the two families who owned it during the eighteenth century. The Hehns of Heidelberg Township, Berks County, were a prominent and prosperous family. Primarily farmers, they owned large quantities of land around the church they helped to establish—St. John's Reformed Church. The house sits within easy walking distance of the hilltop site of the church.

The house was probably built by George Hehn (Hain), Jr., a Pennsylvania German whose ancestors had originally settled in New York's Schoharie Valley in the early eighteenth century. Many of this group of Palatines had followed Conrad Weiser to Pennsylvania, settling along Tulpehocken Creek, a tributary of the Susquehanna. Most of the settlement was along Tulpehocken Path, historically the major route from Reading to Sunbury on the Susquehanna. The tract of 122 acres, which George Hehn, Sr., bought in 1735 from the Penn proprieters and upon which his son George built the stone house in 1755, lay just off this path.

George Hehn, Sr., of Heidelberg was the son of John George and Veronica Hehn of Schoharie Valley. About 1729 the Hehns settled the Cacusi section of what is now eastern Lebanon Valley. As early as 1739 the Cacusi residents had a log church and were being served by a Reformed minister from Oley Valley.[40] George, Sr., apparently

assembled about 1,200 acres of land in this region before his death in 1746. Apart from the land donated to St. John's, his sons and daughters inherited or purchased portions of this tract and lived in a family enclave.

The date 1755 is scratched in the attic of the house, and the architectural fabric of the house supports this construction date. Tradition has it that the house, built of local limestone, was erected by two German redemptioners, a mason and a carpenter.[41] The house may have been built by two redemptioners, but not without abundant help, for the Hehn house was no simple farmhouse. In 1755 it was a lord-of-the-manor house of significant proportions and grand pretension. The dressed limestone of the facade and the elaborate plaster ceiling moldings with ornamental medallions are evidence of expensive and fashionable craftsmanship. Dressed limestone requires a skilled stonecutter, not just a mason, and, presuming the date of 1755 is accurate, the house constitutes one of the earliest and largest examples of such masonry in Berks County (fig. 47).

The scale of the house announced its pretensions. The Hehn house was built against a hill. It had a full basement, two floors, and an attic. In addition, the house was accompanied by en suite outbuildings, including a dressed limestone, two-story bakehouse and smokehouse, a storage cellar

[40]W. J. Kershner and Adam G. Lerch, *History of St. John's (Hain's) Reformed Church in Lower Heidelberg Township, Berks County, Pa.* (Reading, Pa.: I. M. Beaver, 1916), pp. 13, 25.

[41]Kershner and Lerch, *History of St. John's*, pp. 461–62; John A. H. Sweeney, "New Pennsylvania Rooms at Winterthur," *Antiques* 75, no. 1 (January 1959): 58.

built into the adjacent hillside, and a stable or barn. En suite construction was rare in 1755, and it is likely some of those buildings were erected at a later date.

The basement of the house, which was traversed by a spring, opened to ground level on the west side. An original sash window at this level provided documentation and a model for replicating other windows, all of which had been destroyed by 1957. The basement ceiling retained its original mud-and-straw plaster between the joists.

The first floor consisted of three rooms in 1957 because a nineteenth-century partition divided the parlor from the rear chamber. The kitchen had a massive stone fireplace on the interior wall and a closed staircase of nineteenth-century vintage. The entrance to the kitchen, and principal entrance to the house, opened from the south and faced the bakehouse situated 25 to 30 feet away. The first floor had suffered considerable damage by 1957 but no significant modernization. The five-plate stove had been removed, the doors and windows were gone, and much of the first-floor ceiling molding had been removed or had deteriorated beyond the possibility of restoration.

The second floor was more nearly intact. The baroque ceiling moldings and central medallions of the two upstairs chambers were in excellent condition; therefore, these were the ceilings removed and reinstalled with the first-floor interiors at Winterthur. The large upstairs hall, above the kitchen, had a fireplace which may have been used to feed a stove in an adjoining room.[42] The second floor also had an outside entrance, the third entrance to the house. It opened onto ground level on the east side of the building.

The three principal architectural mysteries of the Hehn house are its roofing material, the exact disposition of first-floor rooms, and the original position of the staircase. Unfortunately, the dwelling is presently a pile of overgrown rubble, with only a few partial walls standing, so further investigation will require archaeological excavation. The roofing material of the bakehouse was red-clay tile, and one of these tiles is part of the Winterthur collection.

The staircase could only have been located in two positions in such a traditional Germanic house, either to the right of the kitchen fireplace or in the location of the nineteenth-century one along the exterior kitchen wall. The dimensions of the niche to the right of the fireplace are sufficient for a closed winder staircase. In 1957 this area showed evidence of a former opening in the ceiling, which Winterthur curators speculated many have been for an original ladder-type access to the second floor; however, a ladder staircase, even of a permanent kind, would have been inappropriate for as ambitious a dwelling as the Hehn house. It would have been inconsistent with the fine construction detail of the remainder of the building. At the time of discovery, the second-floor chimney-stack niche was a closet, closed in with scraps of eighteenth- and nineteenth-century paneling. The quality of the eighteenth-century fielded paneling is evidence for an original winder staircase in the niche. Such a staircase would have had doors and paneling.

The argument for an earlier staircase on the site of the existing nineteenth-century one—on the exterior wall next to the kitchen entrance—although plausible, has problems. The staircase in its nineteenth-century location chops considerable working space from the kitchen. The niche location, on the other hand, occupies a corner that might otherwise have been difficult to use effectively, and thereby maximizes kitchen work space. Second, since the existing staircase is clearly nineteenth century in construction, one must ask why a new staircase was built. Staircases do not normally wear out in 75 to 100 years if the house is maintained, as the Hehn-Kershner house was; however, a winder staircase in a niche was clearly outmoded by 1830. An occupant might have decided to sacrifice some work space in order to gain a more commodious staircase.

Perhaps one of the most significant arguments for the original staircase being located in its later position is the existence of a small window to the left of the kitchen entrance. This window could not be included in the Winterthur installation due to the necessity of compressing the rooms into existing museum space, but its purpose was most likely to provide natural light for a stairway to the cellar. The crucial question is whether this window was original to the house or was added when the staircase was moved from the fireplace niche to its present location. In light of the architectural ambiguities, Winterthur's curators decided to accept the existing staircase rather than recreate on the basis of speculation.

The third mystery relates to the spatial organization of the first floor. The most typical Pennsylvania German house of the mid eighteenth century, whether one or two story, consisted of three principal rooms, although two- and four-room variations of the same plan were common. Conceptually, the Hehn house has three spaces on the first floor, for a summer beam divided the large area next to the kitchen (*Küche*) into two spaces, each with an ornamented ceiling. In Germanic architecture these spaces were the *Stube* (parlor) and the *Kammer* (sleeping chamber). And in fact, upon discovery in 1957, this area was divided into two rooms by nineteenth-century paneling. The evidence suggested that the house originally had two rooms on its first floor, not

[42] A comparable surviving example is Schifferstadt, Frederick County, Maryland, built in the mid eighteenth century.

three, so the installation at Winterthur presents only the Küche and Stube. The Hehn house may have had either a combination Stube-Kammer or two rooms separated by a board partition that was merely replaced in the nineteenth century.

The men who first owned this architectural masterpiece, George Hehn, Jr., was, like David Hottenstein, one of the most prosperous farmers of his township and region. He ranked in the top 10 percent of taxpayers and landowners in the township. In 1772 the house was purchased by Conrad Kershner (Kirshner) who was also wealthy.

The first Conrad Kershner (1687–1771) and his wife, Marie, arrived in New York in 1722 and eventually settled in Bern Township, Berks County. The Conrad Kershner who bought George Hehn's house, probably a grandson of the first Conrad Kershner, owned the house from 1772 to 1803. This Conrad Kershner is remembered in the Wernersville area as a captain in the local militia during the revolutionary war. A 1778 roster of Kershner's company reveals nine Hehns and several other relatives by marriage, especially Fishers. Church records show that eleven Kershners were baptised at St. John's Church between 1773 and 1803. All were designated as children of Conrad Kershner, but the listing of a Conrad Kershner as sponsor for the 1793 baptism of Jacob, son of Conrad Kershner, demonstrates that at least two generations of Conrad Kershners were represented in the records. After 1803 the entire Kershner clan moved from Heidelberg to Windsor Township.[43] The reasons for their departure are unknown.

Conrad Kershner's probate inventory may document the furnishings of the massive limestone house which he purchased from the Hehn family and lived in with his large family, but one must remember that it was taken a full decade after he had moved away.

Inventory of all the goods and chattles rights and credits late the personal estate of Conrad Kirshner late of Windsor Township deceased exhibited by the Administrators for said Estate and appraised by us the underwritten as follows this eleventh day of November A.D. 1813

	£	s.	d.
The cloths of the deceased	16	4	9
oast, rye and wheat in sheaves, corn in the ears	124	10	0
seed clover has first & 2d crop corn tops flax in bundles &c	97	6	6

[43] Kershner and Lerch, *History of St. John's*, pp. 55–57, 88–91. The children are Daniel, January 10, 1773; Jacob, June 11, 1775; Antoni, May 4, 1777; Catherine, April 16, 1781; Maria, May 30, 1784; John, March 20, 1789; Suzanne, March 20, 1789; John, October 7, 1792; Jacob, December 1, 1793; William, August 19, 1798; and Samuel, October 26, 1800.

	£	s.	d.			
Windmill, boards, straw, old timber, flax break, mill &c		7	19	3		
gears, strawbench barral baskets, buckets, scaffold board planks		6	11	10		
flails rakes forks boards in & on the barn wheelbarrow, applemill		5	11	0		
spades shovels hoes, saw grind stone bad[?] swingle trees		5	0	0		
tub sower crout, Tar, Barral vineager Tur chopping bench & sundry		3	15	6		
14 heads of horned cattle 7 sheeps 11 hogs 2 horses 1 Dog 18 geese & Turkey		90	10	0		
an ex earthen pots sifts Traps cradles waggon cover bags &c		7	3	0		
bee hives, chaff bags bushel measure, flax seed wheat salt		5	10	0		
an old saddle hamp plaister of paris scyths cutting tools leather		7	6	9		
cow chains heckets tow flax cowbell soap dough trough		16	17	9		
onions woman saddle man saddle bags flax yarn basket		6	3	6		
cotton, wollen yarn chest miror steel yard Coverlets		5	12	42		
chairs tables sheets chissel locks 4 beds rifle checks tow		25	13	3		
stuff table cloths sheets cloths towles sundries breadbasket		10	9	6		
Chest auger copper kittles linen potatoes hhd tallow lard		16	5	0		
a keg hammer tongue pan rails old tools iron pot split tools		3	0	0		
Copper tea kittle coffe pot saw auger frying pan iron pots tin ware		3	19	3		
A set of laddles tables bench pewer plates bar on Kitchen dressor		19	0	6		
Battles Candles sticks Knives & forks a lot of sundries reel wool wheel		3	11	3		
a lot of sundries bed & bedstead chairs Tables benches miror clok		26	7	6		
a bed and bedstead with cortains chairs 2 tin plate stove 2 pipes		20	2	6		
Books, bottles, fire tongue, garden drug & sundries		2	19	4		
1 Bond of Elias Furman with interest	£ 72	18	7			
1 Do "Wart. Kirstner" Do	21	18	0			
4 Do "Geo. Kutter" Do	195	8	4			
1 Do "Geo. Rotherend" Do	53	0	0			
1 note "Peter Kirshner" Do	10	19	4			
20 bonds of John Kirshner not due yet	1,000	0	0			
15 Do "Cond Kirshner" Do	600	0	0	1954	4	3
				2492	3	7

Book account unsettled	83	12	8
Do Do settled	115	13	8
a Lottery Ticket no 467 in Hamburg church	1	2	6
very probable lost 2 bonds ag. A. Sayer	19	6	0
Cash	12	10	6
	£2724	8	52

Michael N. Smith
Nicholas Gritt[44]

Kershner's position on the tax lists of Heidelberg and Windsor townships and an inventory of £2724.8.52, which does not include the value of land holdings, confirm that he, like Hehn, was one of the wealthier men in the region and prosperous by more widely applied standards. More than four-fifths of his liquid assets were in bonds, notes, and book accounts.

Naming and furnishing the rooms from this house posed a problem for the curatorial staff. Even at Winterthur there was a general paucity of Pennsylvania German household furnishings made prior to 1770. This meant the rooms could not be furnished as they had been furnished by George Hehn from 1755 to 1772. The next logical step was to furnish it as it had looked under the second owner, Conrad Kershner, and for this reason the rooms at Winterthur are called the Kershner rooms. Because Kershner's death occurred over a decade after his departure, the museum staff, led by curator John A. H. Sweeney and museum director Charles F. Montgomery, decided not to use the Kershner estate inventory. Instead they sent research assistant Charles F. Hummel to comb Berks County inventories filed between 1782 and 1796.[45] Hummel's survey provided the historical foundation for selecting the appropriate furnishings for the Kershner complex, such as large quantities of pewter and linen, and for eliminating inappropriate items such as window curtains, andirons, silver, candlesticks, and paintings. Some compromises had to be made for the sake of museum exhibition. For example, the parlor includes framed Fraktur and an assemblage of sgrafittoware. Other compromises were necessary because the museum did not own and did not have any prospect of buying appropriate objects, most particularly a bed and bedstead.

The architectural installation in the museum required adjustments, but this 1958 installation was clearly one of the most ambitious efforts toward historical accuracy ever undertaken by du Pont and the museum staff. In the end it

was not historically as authentic as the Fraktur Room of Joseph Downs, but only because the curators could not triumph over insurmountable physical and logistical obstacles. Today, it remains the most important Pennsylvania German architectural installation in any museum.

At the time Sommer found the Hehn-Kershner house it was owned by James F. Weber of Reading and had probably been last lived in about 1937 when the Kintzer family left the farm. The abandoned dwelling was being used partially as a storage facility for farm equipment but was in disrepair and deteriorating rapidly. On June 19, 1957, Winterthur contracted to buy the interiors of the house and the bakehouse.[46] Further arrangements with Weber allowed Winterthur to take stonework from around the kitchen entrance as long as Winterthur reinforced the doorway. Because the museum removed window frames, it also had to shore up the masonry in these areas, which it did by filling in the windows with cement blocks. Weber's chief concerns were that the structure of the building not be weakened and that the equipment lean-to next to the house not be disturbed.

Two days after Weber signed the agreement, Montgomery wrote to du Pont at Southampton, confirming plans to begin the dismantling. Russell Kettell, a noted New England antiquarian, was to arrive to prepare drawings, a photographer had been scheduled, and a master plasterer had been hired to assist in the removal and reinstallation of the ceilings.[47] The key Winterthur personnel were Montgomery, Sweeney, and Hummel.

The process of removal was supervised and documented by Sweeney and executed by Howard Lattomus and an expert Winterthur crew. Removal of the Kershner house proceeded smoothly but slowly, as did the installation. The location chosen for the Kershner installation was a space 29′ 6″ by 22′ 3″. The Kershner first floor measured 34′ 8″ by 22′ 3″.

The original plan called for replacing the Pine Kitchen with the two Kershner first-floor rooms. The first major problem was the lack of fit. The near-perfect match in width was a stroke of luck, but the length match showed a 5′ 2″

[44] Conrad Kirshner Inventory, 1813, Office of the Register of Wills, Berks County, Reading.
[45] Memoranda, Hummel to Montgomery, August 15 and 18, 1958, files of Charles F. Hummel, Winterthur Museum.

[46] Marie Graeff to Mary-Hammond Sullivan, July 9, 1978 (courtesy of Mary-Hammond Sullivan). "In return for $1800 received this day, June 19, 1957, I James F. Weber of Reading, Pennsylvania have sold to the Winterthur Museum, of Winterthur, Delaware all the interiors or parts of my old stone house in Wernersville, Pennsylvania which the Museum may wish to take, including doors, windows, plasterwork, framing, fireplace, etc. In addition to the above it is agreed that said Museum is to have the fireplace, its facing and bake oven from the bake house on the same property" (Contract, June 19, 1957, Hehn-Kershner architecture and house history file, Winterthur Archives).
[47] Charles F. Montgomery to du Pont, June 21, 1957, du Pont Correspondence, Winterthur Archives.

discrepancy. In their effort to achieve accuracy, du Pont and the Winterthur staff pushed out the exterior wall of the museum to gain precious inches, but in the end the kitchen and the parlor were shortened. In addition, the ceiling in that space of the museum was only 7′ 3″ and could not be increased to accommodate the rooms' original 8′ 9″ ceilings.[48]

Although the Kershner rooms kept their original relationship to each other, the changes in dimension altered the rooms in significant ways. The original dimensions of the parlor were approximately 22′ 3″ by 20′ 5″. This nearly square, traditional German parlor, was made more rectangular.[49] It is now 22′ 3″ by 19′. This loss of approximately 1′ 5″ in width combined with the structural limitations imposed by the museum's load-bearing exterior wall and by the existence of a window opening centered on the side wall created a symmetry not found in the original room. More serious was the unavoidable loss of ceiling height (fig. 48, and pl. 8).

Alterations to the kitchen were more drastic than those to the parlor, and once again they were inescapable. The Pine Kitchen had served as both a period setting and a principal museum throughway. The northwest kitchen corner of the Kershner house, and its window, were sacrificed to allow entry into the adjoining Wentworth Room and to provide a cross passageway to the rest of the museum. That corner, across from the far end of the fireplace and away from the front door, was the traditional location of the kitchen table and its benches and chairs. The kitchen also lost nearly 3′ in width. Combined with the greatly lowered ceiling these changes give the kitchen a cramped and narrow air. And while the magnificent fireplace hearth always dominated its kitchen, in the museum installation it overpowers the room.

In the process of installation, Sweeney and Montgomery hit upon the idea of displaying the south facade of the house. On March 18, 1958, Montgomery dashed off a letter to du Pont in Balboa, Panama:

Work on the Kirschner Rooms is coming along well, though there have been many problems. Only last night I got agreement from Mr. Weber, the owner of the house, to let us take the stone out of the whole front so that we can line the hallway of the old iron

room with it. In other words, as you walk along the hallway, you will see the exterior of that house and then walk in through the front door. I think it will add a terrific note of reality to it and though it will add some $2000 to the cost, both John and I are convinced it is worth it. I had to pay $750 for the stone, and the work of taking it out and putting it in will be $1200–$1500 more. I am sure this is going to be one of our great installations. The fireplace is simply overwhelming when you walk into the room and I think the realism of it will be perfect.[50]

The idea was well worth the price, for it added welcome textural relief and a note of authenticity to the museum's rooms (fig. 49).

The Kershner bakehouse was also moved at the same time as the other two rooms. It is the only installation of a functional outbuilding in Winterthur Museum. While the original position vis-à-vis the kitchen entrance was shifted to fit available space, its close proximity makes the central point that bakehouses were adjuncts to kitchen work space that were critical to the overall farm operation. In fact, this bakehouse was much larger than in the Winterthur installation; it was a two-story combination bakehouse and smokehouse.

The Kershner rooms were designed to illustrate eighteenth-century Pennsylvania German life and provide galleries for a range of late eighteenth-century Pennsylvania German furnishings. Most of the objects placed in the parlor and kitchen were already in the Winterthur collection in 1957. A few had even been in the Pine Kitchen. And one item, the bench, was found in the Kershner bakehouse when the Winterthur crew began work there. The installation of the Kershner complex in 1958 climaxed du Pont's long interest in the collecting of Pennsylvania German artifacts.

The Kershner complex, like the Fraktur Room, is an architectural setting serving as a gallery for historical and art objects. Also like the Fraktur Room, the Kershner rooms have an integrity and significance all their own. The Fraktur Room from the outwardly English-style house of David Hottenstein presents a persistence of Germanic forms, for example, the clothespress, in a wealthy, anglicizing German family. The Hehn-Kershner house represents the Germanic end of the continuum and in its museum fragment provides a glimpse of one of the largest and finest traditional Germanic houses erected on Pennsylvania soil.

The Kershner installation as a museum exhibit also merits special attention. It represents the last phase of development of H. F. du Pont's long career in creating period settings in his museum. The meticulous attention to histor-

[48] Drawings, 1957/58, Kershner Kitchen and Parlor Room files, Joseph Downs Manuscript and Microfilm Collection, Winterthur Museum Library.

[49] See chapter 2 above; see also Arthur J. Lawton, "The Pre-Metric Foot and Its Use in Pennsylvania German Architecture," *Pennsylvania Folklife* 19, no. 1 (Autumn 1969): 37–45; and Arthur J. Lawton, "The Ground Rules of Folk Architecture," *Pennsylvania Folklife* 23, no. 1 (Autumn 1973): 13–19.

[50] Montgomery to du Pont, March 18, 1958, du Pont Correspondence, Winterthur Archives.

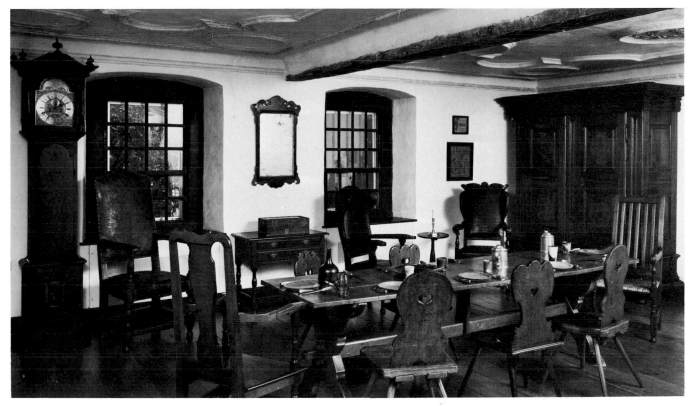

Fig. 48. Hehn-Kershner parlor as installed at the museum. (Photo, Winterthur.) The baroque plasterwork ceiling that characterized the principal rooms of the house is from the better-preserved, second-floor rooms. The walls and floor are from the first-floor parlor. See pl. 8 for the 1982 installation.

Fig. 49. Hehn-Kershner kitchen as installed at the museum. (Photo, Winterthur.) This view of the exterior facade and the kitchen, with its massive stone fireplace, reveals the magnitude of the task of removal and installation. The segmented discharging, or relieving, arch above the doorway is characteristic of central European and early Pennsylvania German construction. The parlor lies to the immediate left as one enters the kitchen door. (This windows of the Hehn-Kershner house were constructed in this manner also; see fig. 47.) For display purposes the bakehouse, the facade of which is visible to the right, is adjacent to the kitchen. In its original location the bakehouse door faced the kitchen door and was some 25′ away. The doorway visible on the far wall of the kitchen was not part of Hottenstein's house; it leads to another room of the museum.

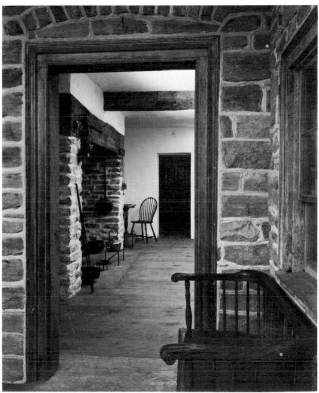

ical detail, the effort to incorporate an outbuilding and an exterior wall to provide context, and the research behind the project all signal that this period setting was special. It was the product of a highly trained professional staff. In a sense it marked the end of du Pont's very personal approach to his museum. It was the fulfillment of his effort to institutionalize his museum endeavor so that it could continue to realize his dreams by presenting his work to the American public long after his death.

German Influences
in Pennsylvania Furniture

BENNO M. FORMAN

One of the curiosities of American furniture history is that virtually no one has explored the possibility that the German influence on Pennsylvania furniture might be anything more than a rather minor theme in the colonial arts of the Middle Atlantic states. The popular view of the eighteenth-century furniture of Pennsylvania is that English craftsmen in Philadelphia made great furniture—the so-called Queen Anne chairs and Chippendale highboys—while their country cousins made Chester County chairs. A German "subculture," to use the sociological term coined a generation ago, existed somewhere west of Paoli, and craftsmen in the wide-open spaces there produced quaint, colorful, eminently collectible "folk art," whatever that is. Such an approach to the furniture of any area must inevitably hinder our understanding of both the furniture itself and the people who transplanted familiar cultures to new places, whether those people were English, Welsh, or German. The simplified overview is ludicrous in the light of our present knowledge that every group that settled in America was a subculture and every form of furniture in every style made in preindustrial America was taken from a European prototype or fashion.

The vastness of the Pennsylvania farming country gives the impression that all of the Germans who settled there must have been farmers or, at best, village folk. The furniture of these people, with tulips and hearts painted on Renaissance-style carcasses, is so colorful and so different from mainstream eighteenth-century American work in the English manner that the casual student can scarcely avoid the self-evident impression that the Pennsylvania Germans

were the *only* conservative group in colonial America. Sociologists now tell us that *all* agrarian groups, regardless of their ethnic origins, always were and still are conservative. The idea that the culture became ossified or "stunted," as Arnold Toynbee would have described it, and its furniture was essentially folk art ignores the facts of the complex interrelationships that make up the act of living. Oversimplifications have polarized thought about the significance of the German contribution to the arts of Pennsylvania and have made it difficult to conceive of, let alone unravel, the many strands of changing attitudes that constitute our present conceptions.

While much attention has been paid to recognizably ethnic Pennsylvania German furniture, little attempt has been made to study the furniture that shows the accommodation of German tastes to life in Pennsylvania. The Germans who settled in the midst of an English province, where very different traditions in furniture making had been established, had an opportunity to select from the forms and styles of two cultures—their own and those of their English neighbors. In this respect, they had a choice denied their brothers who remained at home. The towns that were predominantly settled by Germans, such as Reading and Lancaster, developed and prospered, and the burghers who lived there could demand and could afford something more than painted chests. No attempt has been made to show Germans becoming Americans, as the process is reflected in their furniture. Virtually no recognition has been accorded the German craftsmen who disembarked from the ships in Philadelphia and never left the town, and their influence

on the most sophisticated furniture-producing community in eighteenth-century America has never been considered a possibility. No one has even suggested that it might have been the presence of German craftsmen or German ideas in Philadelphia that made the furniture of that metropolis unique in colonial America. No search for the accommodations made by German-born and German-trained craftsmen who settled in predominantly English communities has ever been inferred from studying the artifacts they produced. Nor has anyone ever suggested that any German craftsmen came from cities and towns where they had made fine hardwood furniture or that the urban, woodworking craftsmen of Germany in the years immediately preceding the beginning of migration to Pennsylvania were among the most versatile and ingenious in western Europe. Most of all, no one has attempted to show or even suggest that German master craftsmen took apprentices of English extraction or how, bit by bit, the characteristics of construction and the woodworking techniques that originated in the German-speaking portions of western Europe became fused with English tastes and ideas about style and, in time, came to predominate in those places where these former apprentices settled, a fact that eventually enabled Americans to produce that great rarity in the decorative arts—something new under the sun. To unravel all of the possible strains suggested by these ideas is beyond the compass of this short essay. Such a work would involve the total commitment of a platoon of scholars for most of a working lifetime.

In the same way that Britain was a nation emerging from an amalgam of regions with their own different traditions—Scotland, Wales, Cornwall, East Anglia, Yorkshire, the southern counties—each with its own ancient ways of doing things, each speaking its own dialect, Germany at the beginning of the eighteenth century was not the unified nation that it was to be at the end of the nineteenth. In many ways, the area that we think of as modern Germany was considerably more medieval than England. At the conclusion of the Thirty Years' War in 1648, the population of Germany had declined from 30 million to 20 million; the Rhineland, where a considerable proportion of the Germans who came to Pennsylvania were born, was ravaged and virtually deserted. A hereditary peasant class lay at the bottom of a complex social hierarchy. Responsible historians have estimated that 1,800 independent states existed within the empire, including some 1,400 smaller territories known as the dominions of the knights; 51 free imperial cities responsible only to the emperor; 63 ecclesiastical principalities; and 170 to 200 temporal principalities and countships. All that can be said of this collection as "Germany" is that they spoke a common language, and even that was

articulated in a number of dialects. This great variety of different peoples—living in different circumstances, strongly regionalized and perhaps even localized, some Protestant and some Roman Catholic, some in agricultural hamlets and villages, some in towns and great cities, some accustomed to serving the local ruler at his opulent court, and some on the brink of starvation—have little in common. And neither does their furniture.

Unquestionably the most far-reaching and totally accommodated form of furniture introduced into colonial America by German craftsmen is the arched-top, slat-back, rush-bottom chair. This form, generally known to us today as the Delaware Valley slat-back chair, was very likely first made in Germantown, which was settled by groups of pietists and Quakers from the Rhineland in 1683. One of the earliest pictures showing a piece of American furniture is the portrait of Johannes Kelpius painted by Christopher Witt of Germantown prior to Kelpius's death in 1708 (fig. 50). The arched slats of the chair in which Kelpius is seated are easily distinguished from those of Anglo-Dutch slat-back chairs in that the slats here arch boldly upward on their lower as well

Fig. 50. Christopher Witt, *Johannes Kelpius.* Germantown, ca. 1705. Watercolor on paper. (Historical Society of Pennsylvania.)

as on their upper edges. The double cut under the arm, barely visible on the Kelpius chair but nonetheless present, is another feature that marks the Rhineland heritage of this chair form. The slat-back chair may have been introduced into Pennsylvania by a chairmaker who was a member of the Shoemaker (originally Schumacher) family of German-town. If the Shoemakers were the first makers of these chairs in the New World, then they are also the agents through which the style made its way to Philadelphia early in the eighteenth century, for Jacob Shoemaker, formerly of Germantown, moved there in 1714/15 and continued to practice his trade.[1]

In 1725, Solomon Fussell, a turner who may have been of German extraction, was at work in Philadelphia making such chairs as these.[2] Fussell's 1738–51 ledger book reveals that his shop produced thousands of chairs, most of them in the traditional slat-back form, with four turned legs that distinctively taper from large at the bottom to small at the top, and a few dozen in the stylish taste of this period with "crookt" feet or, as we call them today, cabriole front legs (fig. 51). Fussell's chairs show an extremely early accommodation of a German form to the English taste in Philadelphia and surroundings and have often been confused with the work of Philadelphia's most renowned chairmaker, William Savery, of English extraction, who we now know was Fussell's apprentice prior to setting up his own shop in 1743. Most of Savery's early rush-bottom chairs betray their lineage from his years with his master by a front leg that is quite close to the Fussell type but differs by having a less dynamic outline. The vast majority of Savery's identified work, however, is not in the slat-back manner, although a recently discovered bill reveals that his shop produced such chairs.[3]

One of the facts of chairmaking life in the history of Philadelphia is that both Fussell and Savery responded to the demands of the marketplace by modifying the traditional slat-back chair first by replacing the turned front legs with crookt legs, and then replacing the slat back with a "banister" (splat) to produce a distinctive chair type that scarcely reveals its origins in the German slat-back tradition and has

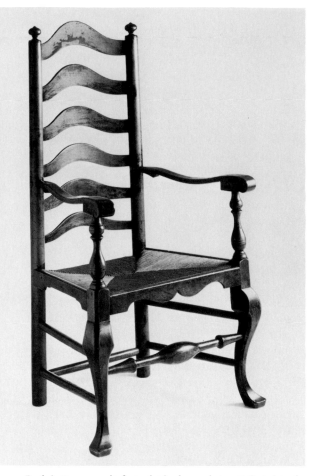

Fig. 51. Rush-bottom, crookt-foot, slat-back armchair, attributed to the shop of Solomon Fussell. Philadelphia, 1735–49. Maple; H. 45⅛", W. 25½", D. 21¼", seat height 15¾". (Winterthur 52.236.)

no counterpart in German furniture. Documentary evidence shows that after Fussell retired from chairmaking in 1751, craftsmen such as William Davis (d. 1767), who was probably of Welsh extraction, and William Cox (working 1767–96), who had come to Philadelphia from New Castle, Delaware, continued to make chairs in the Germanic slat-back manner in Philadelphia.[4] A chair of this type is illustrated in figure 52. It has the high degree of finish that we expect a Philadelphia slat-back chair to have. The elongated balusters of the front stretchers suggest that it was made at the end of the eighteenth century or early in the nineteenth.

The comfort and neat appearance that these chairs offered at an extremely modest price made this form one of the

[1] See Benno M. Forman, "Delaware Valley 'Crookt Foot' and Slat-Back Chairs: The Fussell-Savery Connection," Winterthur Portfolio 15, no. 1 (Spring 1980): 41–64.

[2] "Turner" is the ancient designation for a woodworking craftsman who performed his art at a lathe. His principal products were chairs, wheels, spinning wheels, treen plates, and tool handles.

[3] "8 mo 11th 1765. Isaac Howell to Wm Savery D[ebtor]; To 6 plain four Slatt Chairs @ 6 s.—£1-16-0. Recd. the above being in full of all Demands [signed] William Savery" (bill, Sill purchase [uncatalogued], Joseph Downs Manuscript and Microfilm Collection, Winterthur Museum Library [hereafter cited as DMMC].

[4] See Forman, "Fussell," figs. 1, 10, 15, 16, 20. American Furniture and Decorative Arts . . . Part Two of the Collection of the Late Arthur J. Sussell, Parke-Bernet Galleries, sale catalogue, January 22–24, 1959, no. 694.

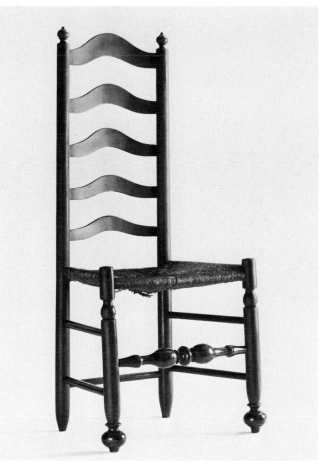

Fig. 52. Rush-bottom, slat-back chair, probably Philadelphia, 1775–1800. Maple; H. 44″, W. 20″, D. 16½″, seat height 17¼″. (Winterthur 59.2499.)

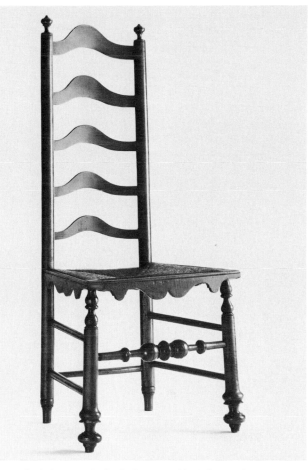

Fig. 53. Rush-bottom, slat-back chair, possibly Delaware County, 1775–1800. Maple; H. 46⅜″, W. 20¾″, D. 17⅞″, seat height 17⅜″. (Winterthur 59.2401.)

most successful in American furniture history. Benjamin Franklin, for example, bought twenty of them between 1739 and 1748. Davis may have trained another Quaker chairmaker of Welsh extraction from Burlington County, New Jersey, named John Laning (1738–1826), who then moved to Greenwich, New Jersey, and trained another craftsman of Welsh extraction, Maskell Ware (1766–1846). Ware's sons, grandsons, and great-grandsons continued to make these chairs in Roadstown, Bridgeton, Cedarville, Alloway, and other towns in southern New Jersey into the third decade of the twentieth century.[5] The Wares and their customers

[5] See Mabel Crispin Powers, "The Ware Chairs of South Jersey," *Antiques* 9, no. 5 (May 1926): 307–11. For a modern documentary study of the Ware chairmakers, see Deborah Dependahl Waters, "Wares and Chairs. A Reappraisal of the Documents," in *American Furniture and Its Makers: Winterthur Portfolio 13*, ed. Ian M. G. Quimby (Chicago: University of Chicago Press, 1979), pp. 161–74.

doubtless never realized that these chairs were a German form.

The slat-back chair is the ubiquitous turned chair of Pennsylvania, New Jersey, Maryland, and the Shenandoah Valley and was made by hundreds of craftsmen. The example in figure 53, although often attributed to Maskell Ware, was found in Media, Pennsylvania, and was probably made in that vicinity.[6] It could easily date from the last quarter of the eighteenth century and, in many ways, has a more purely Germanic feeling than the Philadelphia and South Jersey chairs. For example, the maker of this chair was not content to repeat the ogees that appear on the front casing of the seat in the Fussell chair. He elaborated them with an additional element consisting of a half round flanked by fillets,

[6] See Margaret E. White, "Some Early Furniture Makers of New Jersey," *Antiques* 78, no. 4 (October 1958): 323.

producing a scalloped figure that suggests the taste for the highly embellished line common on pediments and profiles of Pennsylvania German dressers. The transition from the strongly emphasized central elements of the front stretcher to the legs is accented by a turned ring that we would never expect to find in the more restrained Philadelphia approach to this turning. Perhaps it was put there for a market with more baroque tastes.

The great number of turned, slat-back chairs in the Germanic manner from Pennsylvania is in inverse proportion to the number of turned-chair makers whose names have been found in the records of the province. Almost none of the Pennsylvania German craftsmen whose account books are now in libraries and archives made chairs. Virtually no craftsmen were designated as turners in the inventories of Berks and Lancaster counties that we surveyed for this book. The only significant inventories of a turner's shop that have come to our attention are those of the craftsmen who worked in the shop owned by the *Unitas Fratrum* (Moravian community) at Bethlehem. The earliest, transcribed in full below, is dated 1758. It very likely contains more equipment than any village turner of the same period possessed.

Werckzeug der Dreherey	Tools in the turner's shop
3 Drehbänke	3 lathes
1 Hölzerner Schraubstock	1 wooden bench vise
6 Schneidzeuge	6 turning tools (probably gouges)
3 Bohrer	3 brace bits
8 Ausreiber	8 reamers
3 Handbeile	3 hatchets
1 Spalteisen	1 froe
1 Axt und 2 Keile	1 ax and 2 wedges
1 Schlägel	1 maul
12 Meistel	12 chisels
2 Paar Schraubstähle	2 pairs screw plates and dies
3 Bieg Zängel	3 pairs bending pliers
1 Grosse Beiss Zange	1 large pair pincers
1 Kleine Do	1 small ditto
2 Grade Zirckel	2 straight compasses
2 Krumme Do	2 calipers
6 alte Feilen	6 old files
3 Drehdocken	3 mandrels
4 Stemeisen	4 firmer chisels
1 Grosse Säge	1 large saw (two-handled?)
1 Kleine Do	1 small ditto
3 Hohlspindeln	3 hollow mandrels
3 Ringspindeln	3 ring mandrels
8 Zweyschnitter	8 two-edged grooving chisels
1 Einschnitter	1 one-edged grooving chisel
10 Löffelbohrer	10 spoon bits
5 Center Bohrer	5 center bits (English tools)

1 Feil Zange	1 saw vise
1 Kleinen Schraubstock	1 small bench vise
3 Hammer	3 hammers
11 Eiserne Stifte	11 iron pins (meaning not clear)
1 Messinger Dockenspindel	1 brass mandrel
1 Dexel	1 small adz[7]

The inventory shows that the turners who worked at Bethlehem—the name of only one, Johannes Bechtel, has so far emerged from the records—were well equipped to do virtually any sort of turning required of them, despite the absence of any chairs in the inventory. Bechtel, who may have come from Philadelphia or Germantown, was working at Bethlehem in 1762 and, in addition to the above tools, had the following completed work on hand:

7 fertige Räder	7 finished spinning wheels
800 Fälgen zu Spin Räder	800 fellies for spinning wheels
250 Bäncke	250 benches (bases for spinning wheels?)
600 Ausgeschrotene Spulen	600 cut-out bobbins
300 Wirkel und 300 Fliegel und 300 Naben	300 spindle rings and 300 flyers and 300 hubs
50 Geleimte Scheiben	50 glued-up wheels (e.g., flax-wheels).[8]

A mere recounting of the tools in a turner's shop does not give us a picture of the range of objects he was capable of making in addition to the chairs that constitute the product of most interest to students of furniture. The recently published translation of the daybook kept by Abraham Overholt (Oberholtzer) of Plumstead Township, Bucks County, between the years 1790 and 1833 reveals that although he made no chairs, he used his lathe to create spinning wheels, bedsteads, trundle beds (with wheels), butter molds, axles and bed screws of iron, clock reels, rolling pins, weavers' screws, bucket plugs, distaffs, warping reels, spooling wheels, quilling wheels, spouts and valves for pumps, tool handles, and legs for tables.[9]

[7]Inventarium derer Mobilien in Bethlehem, September 1758, Moravian Archives, Bethlehem, Pennsylvania. I am indebted to Vernon Nelson, archivist, for making available the inventories taken at various times between 1758 and 1837; to Jonathan P. Cox for his invaluable assistance in transliterating and translating them; and to William L. Goodman and Alan J. Keyser for their refinement and correction of our original translation of this and the following tool lists. Of course, the ultimate responsibility for the accuracy of these terms is mine.

[8]Inventarium, Dreher, 1762, Moravian Archives. Bechtel's presence in Philadelphia has now been documented (interview, Désirée M. Caldwell, June 9, 1981).

[9]*The Accounts of Two Pennsylvania German Furniture Makers: Abraham Overholt, Bucks County, 1790–1833, and Peter Ranck, Lebanon*

Chairs are not frequently itemized in the inventories of Pennsylvania Germans prior to 1770, and for this reason we cannot state with certainty that many of the surviving slat-back chairs from the counties primarily settled by Germans predate the Revolution. The dearth of chairs among the Pennsylvania Germans in the eighteenth century should not be ascribed to economic considerations, but rather to the custom of using benches instead. The Moravian community at Bethlehem, however, had a good quantity of turned chairs in the public rooms of the Sun Inn, as might be expected. In the 1772 inventory were:

6 Wallnuss Stühle [@] 4s.	6 walnut chairs
10 do mit geflochtenen Rohr [@] 6s. 8d.	10 ditto with twisted reeds (for rush bottoms)
40 geflochtene Stühle [@] 3s.	40 rush-bottom chairs.[10]

Doubtless most of these had been made in Bechtel's shop.

A chair that is quite different in appearance from those made by turners is the more recognizably Germanic type illustrated in figure 54. In modern Germany, this kind of chair is called a *Brettstuhl*, literally a "board chair." The usage has been given currency in America by repetition but so far has been found only in the 1802 inventory of the furniture at Bethlehem. This inventory, written by John Frederick Peter, the now famous composer who lived at Bethlehem and later at Salem, North Carolina, lists among the furniture in the "Conferenz Stube" of the "Gem[ein]haus":

2 Brettstühle	2 board chairs
2 stroh Stühle	2 straw (bottom) chairs
1 schienen Stuhl	1 splint (bottom) chair
4 Armstühle grün anges- trichen	4 armchairs painted green
8 geflochtene Stühle	8 braided (rush-bottom) chairs.

"In der Küche," that is, in the kitchen, Peter listed "1 Brettstuhl," and in his own quarters "1 hölzerner Stuhl mit polster Küssen" (1 wooden chair with stuffed cushion). Further, in the "Pilger Stuben" (pilgrim's parlor) was "1 hölzerner Stuhl."[11]

The singular rarity of the word *Brettstuhl* in non-Moravian documents does not mean that this form of chair did

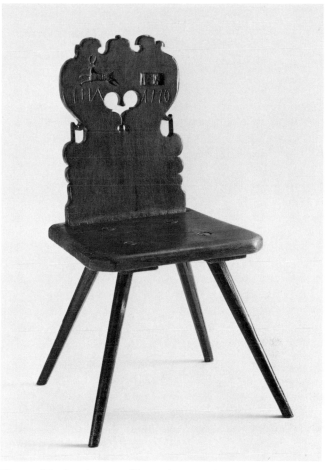

Fig. 54. Wooden chair, possibly Northampton County, 1750–75. Black walnut; H. 31¼″, W. 16¼″, D. 14⅛″, seat height 14¾″. (Winterthur 63.827.)

not appear elsewhere in Pennsylvania or that such chairs did not appear in the culture before 1802; it merely means that they were not called Brettstühle. The likelihood is that they were listed only as "wooden chairs" or as chairs made of some specific wood. For example, the 1766 inventory of Nazareth Hall, a large school for boys owned by the society in Nazareth some 10 miles northeast of Bethlehem, had:

Auf den Stuben	*In the parlor*
16 Nusb[aum] Stüle @ 3 / . . . £3.8	16 walnut chairs
7 alte Pine do @ 1 / . . .[7s.]	7 old pine ditto.[12]

Walnut chairs are common in Pennsylvania, but pine chairs are unknown except for board chairs. That those in this

County, 1794–1817, trans. and ed. Alan G. Keyser, Larry M. Neff, and Frederick S. Weiser, Sources and Documents of the Pennsylvania Germans, vol. 3 (Breinigsville, Pa: Pennsylvania German Society, 1978), pp. 3–20 (hereafter cited as *Overholt / Ranck*).

[10] Inventories, Sun Inn, 1772–1822, Moravian Archives, Bethlehem. The same room had "4 Bänke" (benches) at 2 shillings.

[11] Inventarium, Meubelen der Gemein, 1802, Moravian Archives.

[12] Inventarium, Mobilien und Handwerk, 1763–1770, Moravian Archives.

1766 inventory were further characterized as "old" indicates that the form was used in the Moravian settlement from the earliest years.

Microanalysis reveals that the chair in figure 54 is made of American black walnut (*Juglans nigra*), a native wood that, insofar as we know, was not exported to those parts of continental Europe where chairs of this type were made—happy confirmation of the fact that it was made in America, despite its close similarity to Germanic counterparts.[13] When Pennsylvania Brettstühle come on the antiques market, they are almost invariably said to have originated in Bethlehem, although it is likely that they were made earlier elsewhere in Pennsylvania and later at Ephrata and at the Zoar community in Ohio.

A chair with a date carved on it ought to be a furniture historian's dream come true because the date should place it in history for us. Good reasons exist, however, for suspecting that the date 1770 carved on this chair bears no relationship to the actual year in which the chair was made. The date and initials are shallow and crudely gouged into the back. They are crowded into a space where they do not fit, and it is difficult to believe that the same person who cut them designed and executed the back on which they appear. They are the work of an amateur; the chair is the work of a professional. They stand in stark contrast to the "stag in full course," as the heraldic writers of the eighteenth century termed the animal on the front.[14] The stag and the rectangular depression to its right are symmetrically placed with regard to the margins of the back. Careful scrutiny of the head of the deer under a microscope reveals that it is inlaid, which suggests that the inlay that formed its body and an inlaid plaque (possibly with date or initials), where now only the rectangular depression remains, have fallen out.

The craft practiced by the man who made this chair is not so easy to divide as was that of the craftsmen who made slat-back, turned chairs. In all probability, he did not call himself a "chairmaker" in any language. For all the world, this chair looks like the work of a talented carpenter, and it would pose no problem for the most finicky historian of the crafts were it not made of a hardwood.

European craft traditions in the seventeenth and eighteenth centuries arranged craftsmen in a strict hierarchy that is somewhat at variance with our modern conceptions of who made what furniture. Custom decreed that makers of the finest furniture worked in hardwoods—they are called

ébénistes in France. The makers of the lowest priced furniture worked in softwoods. They are called *witwerkers* in Holland.[15] A similar hierarchy of craftsmen existed in Germany, although we can only assume from the analogy to other countries what they did. Among furniture makers in Germany, the *Schreiner* and the *Kistmacher* stood at the head of the list. The former word is usually, but inadequately, translated as "joiner." The latter is translated as "chest maker." Judging from the furniture that survives, the Schreiner of eighteenth-century Germany displayed considerably greater versatility than the Anglo-American joiner did. Both the Kistmacher and the Schreiner in Germany worked in expensive hardwoods and used veneers, materials that made them the equivalent of what Englishmen and Americans called "cabinetmakers" in the eighteenth century. The Kistmacher's trade appears to have been essentially urban, or at least that which was patronized by the most affluent customers, since few provincial chests are veneered. The name of his trade certainly suggests his most popular product and thus the most popular form of storage furniture in his time. A nonurban Kistmacher might have done the same things a joiner in seventeenth- and eighteenth-century England and America did: fine interior woodwork and important, even complex, joined furniture.[16]

We would expect a seventeenth-century joiner to have built case furniture of hardwoods using the frame and panel technique that we associate with that trade. A *Zimmermann* (carpenter) may have framed wooden buildings out of hardwoods, such as oak, but when he made furniture, he probably worked in softwoods—pine, spruce, and fir (*Tannenholtz*)—in Europe. In America, he used pine and tulip (*Leriodendron tulipifera*). Tulip is anatomically a ring porous wood—what we commonly refer to as a hardwood— but it is actually softer and easier to work and paint than the indigenous, southeastern Pennsylvania yellow pine, which is botanically a nonporous softwood. Because tulip is not native to Europe, the Germans had no name for it. It was commonly called poplar by English craftsmen in Pennsylvania, and Germans transliterated this into *Bebler*, which is the way it appears in numerous Pennsylvania German documents.

The discussion of who could have practiced what trade, and therefore who could have made what furniture, may

[13] Hereafter, the listing of the botanical name of the wood in parentheses after mention of its common name in English indicates that a microanalysis of the piece of wood in question has been performed.

[14] John Guillim, *A Display of Heraldry* (6th ed.; London, 1724), p. 155.

[15] T. H. Lunsingh Scheurleer, "The Dutch and Their Homes in the Seventeenth Century," in *Arts of the Anglo-American Community in the Seventeenth Century*, ed. Ian M. G. Quimby (Charlottesville: University Press of Virginia, 1975), p. 14.

[16] Benno M. Forman, "Continental Furniture Craftsmen in London, 1511–1625," *Furniture History* 7 (1971): 99–117.

have no meaning in the context of life in eighteenth-century Pennsylvania for no system of craft guilds with their exclusive rights and privileges prevented any craftsman from making whatever kind of furniture he pleased; only custom and a man's training might incline him to work in certain woods and at a certain trade. A classic example of the mingling of crafts in America can be seen in the accounts of Abraham Overholt. Overholt not only made products that we associate with the turner's trade, but he did joiner's and carpenter's work as well. In addition to spinning wheels of oak and maple, examples of which have survived, Overholt made clock cases, chests of drawers, and chests out of hardwoods like walnut and cherry; numerous chests out of tulip, which he then painted; and dough troughs and tables, to which he added turned legs.[17] In doing this, Overholt was following European rural and village traditions, which numerous craftsmen from nonurban Europe continued in this country, for all we know even in urban areas like Philadelphia.

But this was not the way in every community established by Germans in America. The urban European tradition of strict separation of crafts becomes apparent when we compare the inventories of tools used by the Schreiner and Zimmerleuter at the Moravian community at Bethlehem in 1758. The joiner/cabinetmaker's tools are many and diversified, obviously intended to produce complex and fine work. The tools of the carpenter are few, appropriate to heavier, larger scaled, and relatively straightforward work.

Inventarium der Mobilien in Bethlehem:	*Inventory of the furnishings in Bethlehem:*
Werkzeug in der Schreinery	*Tools in the joiner (/cabinetmaker's) shop*
2 Fug Bänke	2 jointers (28–30 inches long)
6 Rauh Bänke	6 jack planes (22–25 inches)
5 Schlicht Höbel	5 smoothing planes (8 inches)
4 Schrop-Höbel	4 fore planes (8 inches)
5 Sims-Höbel	5 molding planes
2 Alte Nuthobel	2 old plow planes
2 Alte Grundhobel	2 old routers
1 Kurtzen Steilhobel	1 short plane (with a steep-pitched iron)
1 Eisernen Do	1 iron ditto
1 Messingnen Do gehört Bischoff	1 brass ditto belongs to Bischoff (bishop?)
3 Paar Spundhöbel	3 pairs tongue-and-groove planes
3 Kehl Höbel vor das Dach Gesims	3 Cornice molding planes
4 Do vor die Fenster Rahmen	4 molding planes for window sashes
2 Do vor Thüren	2 ditto for doors
39 Do davon die meisten vom Bruiss sind	39 ditto most of which belong to Bruiss
2 Grosse Hohlkehlen	2 large hollow molding planes
1 Grosser und 1 Kleiner Falz Hobel	1 large and 1 small fillister
1 Gradhobel [modern, Grathobel]	1 beveled rabbet plane (dovetail plane)
12 Stemeisen von 1½ bis ½ Zoll	12 firmer chisels from 1½ to ½ inch
23 Lochbeutel	23 mortise chisels
4 Stechbeutel	4 firmers
18 Dinne Stemeisen } davon gehören die meisten Bruis	18 paring of which chisels most belong
19 Hohleisen }	19 gouges to Bruis
2 Englische handsägen	2 English handsaws
3 Kleine Sägen mit Rucken	3 small backsaws
2 Teutsche Handsägen 1 sägen Blatt	2 German handsaws (and) 1 saw blade
3 Lochsägen	3 compass saws
3 Winkelbohr Hefter nebst ein paar Dozent Bohrer und	3 braces along with two dozen bits and
6 Center Bohrer	6 center bits
6 Grosse Bohrer u[nd] 3 Ausräumer	6 large (auger) bits and 3 reamers
8 Schraubzwingen	8 C-clamps
2 Hand Beile	2 hatchets
1 Texel [Dexel]	1 adz
1 Axt	1 ax
9 Raspeln	9 rasps
4 Grosse Zug Nägel	4 large draw-bore pins
3 Nägel zum Fusboden legen [Nägelversenker?]	3 flooring punches (?)
4 Winckel Maasse	4 squares
4 Streich Maasse	4 marking gauges
3 Schnitzer	3 carving tools
1 Banckhacken	1 bench hook
1 Zwinge die fenster Rahmen zu kehlen	1 clamp for molding window sashes
1 Schneid messer	1 cutting knife
6 Neue Hobeleisen	6 new plane irons
1 Zieh Klinge	1 scraper
1 Holzemer Schraubstock	1 wooden bench vise
1 Beiss Zange	1 pair pincers
1 Hammer	1 hammer
2 Neue unausgefeilte Pulsten vor Schrauben zu Bohren	2 new, unfiled ——— for boring screws (meaning not clear)
1 Kessel vor firnis zu Kochen	1 kettle to heat varnish in
2 Farbsteine einer davon ist	2 stones for grinding pig-

[17]*Overholt / Ranck*, pp. 6, 8, 9, 10, 13, 27, passim.

in Naz. Hall	ments, one of which is in Nazareth Hall
Glaser Werckzeug	*Glazier's tools*
1 Bleyzug in dem Kästgen	1 glazier's vise in the little chest
1 Forme zum Bleygiessen	1 mold in which to cast lead
1 Kriesel [Kreisen?]	1 circle cutter (?)
1 Demant	1 diamond
Obiges Glaser Werckzeug gehört Bruder Oneberg	the above glazier's tools belong to Brother Oneberg[18]

If an English craftsman of the time were to enter this shop, he would recognize most of these tools, although the forms of some would be unusual to him. Many of the planes, for example, had a handhold affixed to their front ends—a detail dropped from English planes by the end of the seventeenth century. Many of them were less sleek than their English counterparts, and some of them, such as the *Grundhobel* (entry 7), were fancifully carved and a totally unfamiliar form to an English workman. The Grundhobel, a plane that is pulled rather than pushed, is used to cut a recessed ground in the face of a board into which a craftsman can insert inlay. Likewise never found in a British joiner's kit—if we can accept Joseph Moxon as a reliable witness to English joinery methods—are the *Zug Nägl* (entry 36). This tool is used to pull the shoulder of the tenon of a mortise-and-tenon joint close to the face of the mortise before the joiner drives in the wooden pin that holds the joint together. According to Moxon, the English method was to pull the joint together by merely driving in the pin.[19]

The *Gradhobel* (entry 18) is the most characteristically German tool in the list. Seventeenth-century examples of this plane have survived. It is a side-cutting rather than a bottom-cutting plane that is designed to shape the side profile of a dovetail. It is used on the batten to be fitted into a dovetail-shaped groove and on the groove as well. A Gradhobel cut both the positive dovetail in figure 59 and the negative groove into which it fits. No exact duplicate of this tool was used by English craftsmen in the early and mid eighteenth centuries because they did not make joints this way.[20] The *Kleine Sägen mit Rucken* (entry 25) could also

[18] Inventarium, Schreinery, 1758, Moravian Archives.

[19] See Joseph Moxon, *Mechanick Exercises; or, The Doctrine of Handy-Works Applied to the Arts of Smithing, Joinery, Carpentry, Turning, Bricklaying* (1703; reprint ed., New York: Praeger Publishers, 1970), pp. 84–88.

[20] See Josef M. Greber, *Die Geschichte des Hobels* (Zurich: VSSM Verlag, 1956), p. 279, pl. 141, no. 21. I am indebted to William L. Goodman for calling this to my attention and clarifying the means of achieving the effect. In the absence of an English name for this German tool, he has suggested "bevelled rabbet or dovetail plane" (Goodman to Forman, August 16, 1981).

have differed considerably from the backsaws that English craftsmen were accustomed to. A saw of this type in Germany usually has an offset handle that is parallel to the cutting edge of the blade; the English model has the handle nearly perpendicular to the edge.

The more convenient shape and size of a few English tools available to craftsmen in Pennsylvania (Germans as well as Englishmen) is made clear by the reference to the two English handsaws (entry 24) in the inventory; the superior qualities of the "Center Bohrer" (entry 26) is also evident from its presence here. Every aspect of the crafts in Bethlehem does not appear to have been affected by the proximity to English ways of doing things. While the Bethlehem joiner/cabinetmakers were equipped to make sash windows (see entry 42), their glazier, Brother Oneberg, had a glazier's vise and a lead mold—sure evidence that he was equipped to make leaded casement windows of a type that had not been popular among Englishmen for a generation.

In contrast, the tools Bethlehem's carpenters used suggest that their craft was more limited in character. In the 1758 inventory are:

Werkzeuge der Zimmerleute	*Tools of the carpenters*
2 Winckeleisen	2 iron carpenters' squares
6 Bund Axte	6 felling axes
5 Breite Beile	5 broadaxes (side axes)
3 Hand Beile	3 hatchets
6 Klamhacken	6 carpenters' dogs
2 Hohleisen	2 gouges
5 Stemeisen	5 mortise chisels
1 Zange	1 pair of tongs
3 Quer Axte	3 twibils
3 Blattehammer	3 large mallets
4 Axte	4 axes
1 Schneide keil	1 splitting wedge
4 Handsägen	4 handsaws
2 Schrothsägen	2 two-man cross-cut saws
6 Pumpen Bohrer	6 pump (pipe?) augers
8 Bohrer	8 augers
4 Texel	4 adzes.[21]

The lists of the tools used by the turners, joiners, and carpenters of Bethlehem have been included here because the German names for tools are not readily available to American readers and because they illustrate the principles that underlie our assumptions about who could have made what Pennsylvania furniture in the eighteenth and early nineteenth centuries. It is clear that any craftsman called a Schreiner or a joiner/cabinetmaker was capable of making much more complex furniture than one called a Zimmermann or carpenter. Although either could have made Brett-

[21] Inventarium, Zimmerläute, 1758, Moravian Archives.

stühle, just as both made coffins, a Zimmermann would find it difficult to cut the profile of the back without a *Loch-säge* (compass saw).

Many of the forms of Pennsylvania German furniture come from a heritage that reaches back several centuries. The Brettstühle which became a potent symbol of German nationalism in the decades between the two world wars are a Germanic version of the board chairs of middle and northern Italy known as *sgabelli*. The most famous sgabello to survive from the early Renaissance is the example from the Palazzo Strozzi bearing the Strozzi family coat of arms (confirmed in 1489). It is now in the Metropolitan Museum of Art.[22] This deceptively simple and masterfully made walnut chair consists of a board seat and back, each outlined with inlaid geometrical stringing in a light colored wood. The back is surmounted by an architectonic scrolled pediment and a delicately carved medallion. The chair has three legs instead of the more common four. These legs are inserted into the seat bottom but do not project through the upper surface. Like those of their German descendants, the legs are chamfered. It is likely that the sgabello form made its way into southern Germany, by way of what are now Austria and Switzerland, prior to the sixteenth century. The back of the chair in figure 54 is essentially the outline of a baroque cartouche. In the expensive versions made in sixteenth- and seventeenth-century Italy and eighteenth- and nineteenth-century Switzerland and Germany, such backs are carved with leafy decoration.

Another example of the board-chair form in the Winterthur collection is pictured in figure 55. This chair is made of a so-called southern yellow pine of the genus *Taeda*, possibly *Pinus echniata*, which grows in southeastern Pennsylvania and was commonly used for drawer linings in early eighteenth-century furniture associated with the Germantown and Philadelphia areas. Yellow pine also grows in Lancaster County, New Jersey, Maryland, Delaware, and southward. The alternating light yellow springwood and dark orange red summerwood together constitute one annular ring and are clearly visible in the board that constitutes the seat of this chair (fig. 56). Although the craftsman who made the chair consciously chose a center-cut board for the seat to minimize warping, board seats of pine tend to break along the lines of the annular rings. The bottoms of chairs

[22] See August Schestag, *Die Sammlung Dr. Albert Figdor*, vol. 2 (Vienna: Artaria, 1930), no. 657. This form is usually referred to as a *sgabello* (joint stool) in Raffaella del Puglia and Carlo Steiner, *Mobili e Ambienti Italiani dal Gotico al Floreale*, vol. 1 (Milan: Bramante Editrice, 1963), pl. 63, passim. Sometimes they call it a *sedile* (seat, bench), as in fig. 62; other times they call it a *panchetta* (small bench), as in fig. 61. The distinctions that warrant these variations in terminology are not clear from the illustrations.

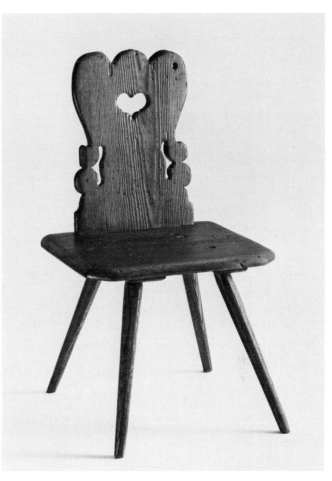

Fig. 55. Wooden chair, possibly Northampton County, 1750–75. Hard (yellow) pine; H. 32⅛″, W. 18⅛″, D. 14⅜″, seat height 15″. (Winterthur 65.2246.)

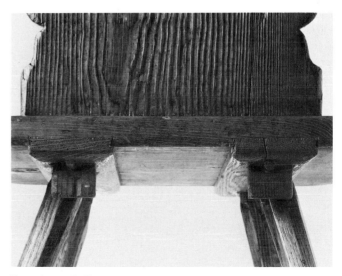

Fig. 56. Detail of bottom of chair shown in fig. 55.

of this type are therefore invariably reinforced by battens that are dovetailed into the board. Similar battens are used to keep the tops of tables from warping and to fasten them to their frames (see fig. 63). The battens of this chair are made of white oak (*Quercus alba*). The legs, also made of white oak, are chamfered on their long edges and are split on their upper ends. Each of them has a wedge driven into the split to hold the leg firmly in place. Two tenons are worked on the lower edge of the chair back and are inserted through mortise holes in the seat. The back is held in place by a pin driven through a hole in each tenon beneath the seat. All of these techniques are distinctively Germanic.

The raised grain of the wood in this chair, which gives it an unduly ancient look, was probably not caused by exposure to the weather but by some former owner who used a caustic paint remover to remove what may have been several coats of paint, including the original one. While we would not expect walnut chairs to be painted, at least one other board chair in the Winterthur collection (65.2247), made of tulip, still retains much of what appears to be an original coat of green paint.

We cannot be certain whether the original owners of the Italian antecedents of elaborately carved German board chairs actually used them or considered them an early Renaissance equivalent of eighteenth-century "hall chairs" in England. From the lack of wear on many of the Italian examples and their highly sculptural character, it could be argued that they were intended to be decorative pieces arranged along the walls of elegant rooms through which visitors would pass rather than tarry. Some, but not all, of the Italian examples have dished-out seats, which suggests that they were furnished with cushions and could have been sat upon, perhaps as was the English custom, by servants in attendance or by petitioners seeking favors. From Albrecht Dürer's 1514 copperplate engraving of Saint Jerome (fig. 57), it is apparent that more workaday versions of board chairs were used in Germany. The example illustrated by Dürer is furnished with a puffy cushion (as are the benches that line the wall). Nearly 300 years later, in 1802, John Frederick Peter's inventory of his own rooms at Bethlehem included "1 hölzerner Stuhl mit polster Küssen" (1 wooden chair with a stuffed cushion).[23] The condition of the board chairs in the Winterthur collection makes it abundantly clear that they have seen hard use during their lifetimes. That some owners did not use their furniture while most others obviously did is the sort of fact that continually emerges from the study of furniture history and makes sweeping generalizations fatuous.

Fig. 57. Albrecht Dürer, *Saint Jerome in His Study*. Nuremburg, 1514. Engraving on paper. (Metropolitan Museum of Art, Fletcher Fund, 1919.)

The bench, in German called a *Banck*, is closely related to the board chair. Benches, built into the wall and thus forming a part of the woodwork in a home rather than being a piece of movable furniture, were probably the most common form of seating furniture in the areas of Germany from which the majority of immigrants to Pennsylvania came. Benches were likely quite common here, too, although the fact that they were built into the wall means that they formed part of the house and, therefore, under English law, were not mentioned in inventories of household property. An instance in the remarkable daybook of Johannes Bachman, a furniture craftsman who lived near Lancaster in the second half of the eighteenth century, gives us a hint that, at least once, he built a bench into a house for a customer. In a list itemizing such work as laying floors and installing windows and doors for Andreas Fereres (Feree) in October 1783, we find the provocative entry "ein Banck . . . 3 / ."[24] A bench for only three shillings must have been a slight item indeed and in the middle of what is essentially joiner's housework may well have been built in.

A bench listed in a household inventory is more likely a free-standing example such as the one illustrated in figure 58. This particular piece of furniture was found in Germantown in 1956. It has an elaborate profile articulated on the

[23] Inventarium, Meubelen der Gemein, 1802, Moravian Archives.

[24] Johannes Bachman daybook, p. 96, DMMC.

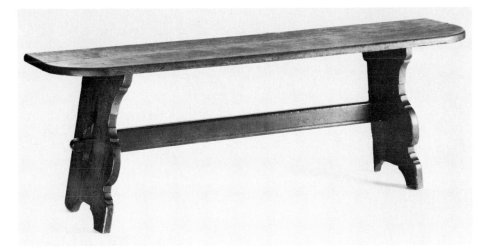

Fig. 58. Bench, probably Germantown, 1750–75. Maple; H. 20¾", W. 62¼", D. 14½". (Winterthur 56.49.2)

Fig. 59. Detail of bench shown in fig. 58.

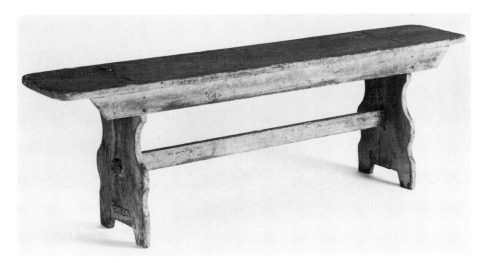

Fig. 60. Bench, Pennsylvania, ca. 1800. Tulip; H. 18¾", W. 60", D. 11⅞". (Winterthur 65.2828.)

Fig. 61. Detail of bench shown in fig. 60.

outward facing edge of its supports (can we call them legs?) which is the kind of outline we might expect to find on the back of a Pennsylvania board chair or, indeed, on the front and back legs of an Italian sgabello. The rear edges of these legs are not profiled which suggests that the maker intended this bench to be placed flush against a wall—the way it is at Winterthur and, indeed, as a related example is displayed in the German National Museum in Nuremberg. In the Winterthur example, a stretcher is affixed through rectangular mortise holes chiseled through the legs and is fastened in place with a wedge that goes through the tenons on the ends of the stretcher. The upper margins of the legs have been grooved on each side so that the top of each leg forms a positive dovetail (fig. 59) and the bottom side of the seat has been sawed, planed, and chiseled into a negative dovetail which does not carry through the front edge of the seat and is therefore not visible from the front. The upper edge of each leg is then slid into its groove on the bottom of the seat.

The tulip bench illustrated in figure 60 is also related to board chairs in style and has some features of the same construction. The legs have two tenons cut on their upper edges in the same manner as the backs of the chairs. These tenons are inserted into mortise holes cut through the seat and are wedged in place (fig. 61). A feature that is generally interpreted in American furniture as being somewhat later than

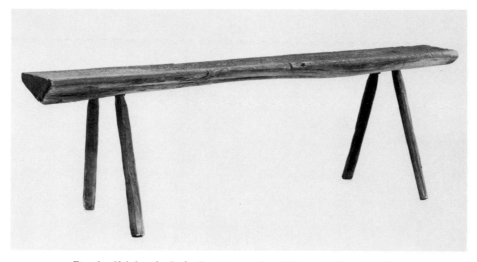

Fig. 62. Slab bench, Berks County, ca. 1840. White oak; H. 21¾", W. 70¾", D. 11¾". (Winterthur 65.2833.)

the construction of the Germantown bench is the skirtboard or apron which imparts additional rigidity. This detail is commonly found on footstools whose outlines are somewhat plainer than the present example. Such footstools, if held together with cut nails rather than wrought, were made in the nineteenth century. Henry Lapp (1862–1904), an Amish craftsman of Mascot, Leacock Township, Lancaster County, included outstanding illustrations of benches of this type in his drawing book. The wrought nails holding the skirtboard to the seat of the bench in figure 60 indicate that it could have been made in the eighteenth century, although advertisements in Philadelphia newspapers indicated that wrought nails were still being imported into this country from England in the 1820s.[25] This bench retains a considerable amount of what appears to be its original coat of red paint under a later coat of gray. Although the upper surface of the seat has completely lost its paint, its edges are red, suggesting that the top, too, was once painted. Simple and inexpensive benches of this type were not made exclusively for domestic use: the Bethlehem inventories indicate that they were used in churches and other public rooms, and a watercolor painting in the collection of the Abby Aldrich Rockefeller Folk Art Center, Williamsburg, shows such a bench in a schoolroom.[26]

The bench illustrated in figure 62 must appear to a refined taste to be the most crudely articulated piece of furniture in the Winterthur collection. It is actually a by-product of the most complex technological device used in colonial America—the sawmill. The seat is made from what mill sawyers call a "slab" and is the unusable part cut from a log when it first goes through an up-and-down, single-blade, water-power mill saw. Although Oliver Evans of Philadelphia had the distinction of being the first American to publish instructions on how to build a sawmill (1795), the works of his mill are the same as one published three quarters of a century earlier by Jacob Leupold in Leipzig.[27] Slab benches were not confined to Germanic cultures, but this example bears the unmistakable look of a German craftsman's hand because its legs are chamfered like those of Brettstühle.

The bench, made totally of white oak (*Quercus alba*), is undatable on the basis of style or technology; it consists simply of a slab into which four staggered holes have been drilled

[25] Henry Lapp, *A Craftsman's Handbook*, ed. Beatrice B. Garvan (Philadelphia: Philadelphia Museum of Art, 1975), pls. 8, 17. Cut nails were made in Philadelphia in 1797. See Lee H. Nelson, "Nail Chronology as an Aid to Dating Old Buildings," Technical Leaflet 48, *History News* 23, no. 11 (November 1968): 203–14.

[26] See, for example, *Schoolmaster and Boys* by an unknown artist, Pennsylvania, ca. 1815, in Nina Fletcher Little, *The Abby Aldrich Rockefeller*

Folk Art Collection (Boston: Little, Brown, 1957), pl. 77. According to the 1766 inventory of Nazareth Hall now in the Moravian Archives, the Gemein Saal (Society Room) contained "22 grosser Bäncke, 4 kleine" (22 large benches, 4 small ones). In the "house" at Nazareth Hall were "9 grosse Kasten Banke" (9 large chest benches) valued at 4s. and 4 small ones as well as "10 grosse Bänke" at 1s. 6d. each and "17 kleine D[itt]o" at 1s. each.

[27] The plan for the sawmill in Oliver Evans, *The Young Millwright's Guide* (Philadelphia, 1795), is by Thomas Ellicott. The mill saw was popular in New England long before Pennsylvania was settled, but the first mills there were built by northern Europeans and not by Englishmen. See Benno M. Forman, "Mill Sawing in Seventeenth-Century Massachusetts," *Old Time New England* 60, no. 4 (Spring 1970): 110–30.

and into which four legs have been inserted. The badly weathered surface indicates that it spent much of its life outdoors. The seat bears the marks of a knife or hatchet as if it had been habitually used as a surface upon which things were cut. The most ironic aspect of this simple bench is that it is one of three pieces of furniture at Winterthur that is displayed today in the actual architectural context in which it was once used. It was standing outside of the Hehn-Kershner bakehouse and was "thrown onto the truck" when the bakehouse was removed from Wernersville, Berks County, for installation in the museum in 1958.[28]

Tables made by German craftsmen in Pennsylvania are closely related to board chairs and benches in both style and techniques by which they are made. The profile of the support beneath the bench in the Dürer engraving in figure 57, for example, is similar to the profile of the backs of board chairs in that it is a sculpted outline. It differs from the examples made in America in that it is essentially medieval in conception, while the American ones are inspired by motifs associated with post-Renaissance ideas of style. But the Gothic flavor of the Dürer table persisted through the centuries to reappear in America as the notches on the legs of the example in figure 63 at the point where the stretcher passes through them. This type of table is genially referred to by collectors as a sawbuck table, a name derived from its resemblance to the X-shaped support used by sawyers called a *Sägebock* (literally, a ram for sawing upon; modern English, sawhorse).[29] While the name is descriptive, it does little to evoke the social customs and usage that help us understand the table.

Because each of the side supports of the Dürer table and its German descendants is cut from a single plank to which a superstructure and top are fitted, the Dürer table is not properly the direct ancestor of the American example illustrated in figure 63.[30] Although these tables share a superficial stylistic similarity, the legs of the American table cross diagonally and are made from much narrower pieces of wood. Such legs, pierced at their juncture by a stretcher, each end of which is in turn pierced and held in place by a wedge, recall an alternative type of table that was movable.[31] This form of table was not merely a piece of furniture that could be taken apart to make space in a room when necessary, but a camp or field table appropriate to a mobile society. In either event, the American table has descended from forms that were originally associated with the knightly class when they were first seen in Germany, and not with the farmers and burghers who eventually came to use them every day.

In addition to the ingenious engineering that went into working out the leg structure of this type of table, other details suggest portability. The upper ends of the legs are pegged into cleats that are dovetailed into the underside of the top which means that the top can easily be removed.[32] A groove has been planed into the inner side of each cleat, and a drawer supported by runners nailed to the upper margin of its sides slides neatly in the grooves. The directness of the construction and integration of the parts of this table have an economy that must appeal to any modern student of design; no element does only single duty.

Ironically, the drawer in this most recognizably Germanic table at Winterthur, has none of the characteristics we associate with German workmanship—wedged dovetails, lateral dovetails on the back and front, or wooden pins (pegs) fastening the bottom to the sides (as in fig. 71). The drawer has a knob at each end which permits access to its interior from either side. This feature also appears in Shaker furniture and may have been carried into that tradition by craftsmen of Germanic background. The illustration shows the rear side of the table. The dovetailed battens under the top are clearly visible; they do not show when the table is viewed from the opposite side.

Inventory references to tables in eighteenth-century Pennsylvania are frustratingly matter of fact and have not provided us with an alternative to the collectors' term for the sawbuck table. Indeed they reveal almost none of the kind of information we would like to have about table forms or uses. Some tell only the wood of which the table was made or its location in the house, such as the "two walnut tables below stairs" valued at 19s. that Martin Gerick of Exeter, Berks County, possessed in 1757, or the "Walnut Table in the upper Chamber" worth £1.5 owned by Samuel Hoch of Oley in 1762, or merely the "Walnut Table" valued at £1.2.6 in the inventory of Nicholas Kutz of Maxatawney Township in 1790. Sometimes they mention the use to which a table was put, such as the "dining and tea table[s]" valued with "½ dozn Chairs and Grittle" at £7.10

[28] Interview with George B. Colman, Winterthur staff, October 1975.

[29] Moxon, *Mechanick Exercises*, p. 150, calls this device a *trussel* (trestle) and illustrates one in pl. 5, item O.

[30] See Alexander Schöpp, *Alte deutsche Bauernstuben und Hausrat* (Elberfeld: Alexander Schöpp Verlags-Buchhandlung, 1922), pl. 20, for a table that differs from the American one only in that it has stretchers. See also Bernward Deneke, *Bauernmöbel: Ein Handbuch für Sammler und Liebhaber* (Munich: Keysersche Buchhandlung, 1969), pls. 80 (dated 1781), 81 (undated), 82 (dated 1832).

[31] Wedged stretchers were used in sixteenth- and seventeenth-century central Italian tables. See Puglia and Steiner, *Mobili*, pls. 44, 47, 89.

[32] For battens used to attach the top of an Italian table, see Puglia and Steiner, *Mobili*, pl. 63.

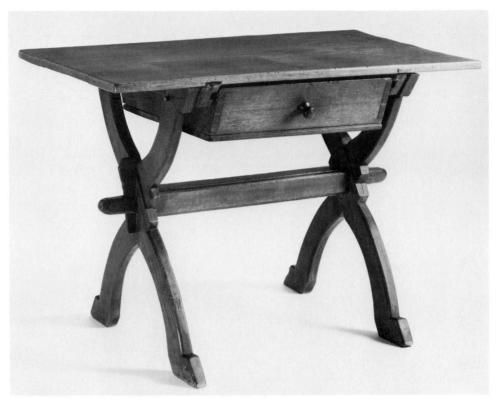

Fig. 63. Table, Pennsylvania, ca. 1800. Black walnut; H. 28⅛″, W. 41¾″, D. 23″. (Winterthur 61.1148.)

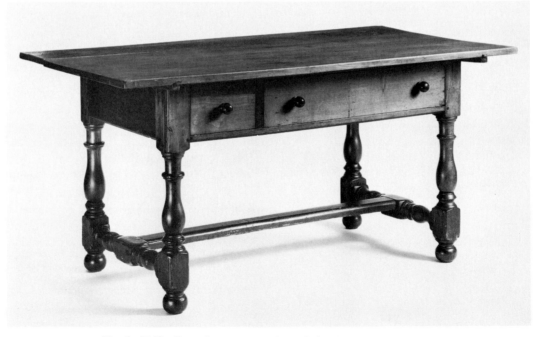

Fig. 64. Table, Pennsylvania, 1750–1800. Black walnut; H. 30½″, W. 63″, D. 32½″. (Winterthur 66.1209.)

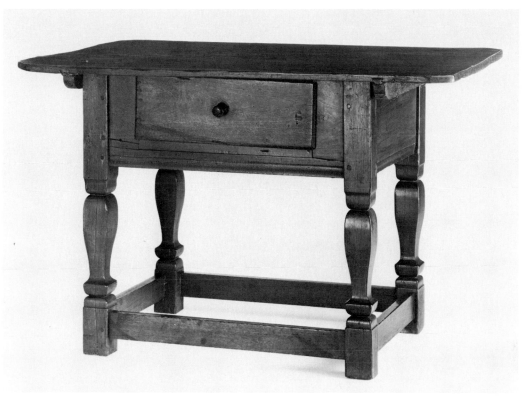

Fig. 65. Table, Pennsylvania, 1750–1800. Black walnut; H. 30″, W. 32″, D. 23¹¹/₁₆″. The top is not original. (Winterthur 65.2749.)

that Joseph Hirst of Kutztown owned in 1800; or sometimes the form, such as the "walnut wing table" worth 15s. in the inventory of John Klinger of Pinegrove in 1800.[33]

A better list of table types, although not a great deal more informative than the inventory listings, can be found in craftsmen's accounts. For example, Johannes Bachman of Lancaster made tables between 1771 and 1788 which he described in his daybook as follows:

ein Düsch [Tisch, a table]	12s.	(1771, p. 6)
ein bebler Düsch [a poplar, i.e., tulip, table]	15s.	(1772, p. 18)
Diesch blat geleÿmt [glued a table leaf]		(1772, p. 18)
ein Flıegel düsch [a wıng table]	£ 4.	(1777, p. 33)
ein Düsch mitt zweÿ schubladen [a table with two drawers]	£ 1.12	(1784, p. 98)
ein zümorganess Disch [literally, an "in the morning eat" table—a breakfast table]	£ 2.10	(1784, p. 99)

[33] Berks County Inventories are in the Office of the Register of Wills, Berks County Courthouse, Reading, and are filed alphabetically by year.

ein Düsch brägfäst Döbel [a table, then phonetically, the English in German, "breakfast table"]	£ 2.10	(1786, p. 99)
ein schreÿb düsch [writing table—desk]	£ 1.05	(1787, p. 126)
ein Däschck und Thö Disch [a desk and tea table]	£23.10	(1788, p. 133).

Some of these we can easily visualize. The table with two drawers was likely the common Pennsylvania form with drawers of different widths. It may well have been most used in a kitchen. The Winterthur example (fig. 64), whose exterior is made of black walnut, has little overhang at the top and a medial stretcher, both suggesting that it was designed to be used by someone who was standing. This form is rare outside of Pennsylvania but may or may not be of Germanic origin. One with square baluster legs of the type illustrated in figure 65 is in the collection of the open-air museum, Skansen, in Stockholm. A related table with baluster legs and two drawers was once displayed in the Hessian dwelling room at the German National Museum, Nuremberg, and another with a single drawer was displayed

Fig. 66. Plan for dining table, Montgomery County, 1820–30. Ink on paper. (Young drawings, 66 x 56, Winterthur Museum Library: Photo, Benno M. Forman.)

in the Oberrealschule at Elberfeld prior to World War II.[34]

Wing tables or, as we call them today, drop-leaf tables are relatively common in northern Germany, and many now in German museums are made in the style that was popular at the beginning of the eighteenth century.[35] Some of the nineteenth-century Pennsylvania examples differ from those of the early eighteenth century in that they have one leaf instead of two. A drawing, probably dating from 1820–30, by a German-speaking craftsman in Montgomery County, is of this type (fig. 66). The dimensions translate as follows: "Length 3 foot 8 inch. In width 3 foot. The leaf 20 inch. The wing 16 inch. In height 2 foot 5 inch. [The frame of the bed] 7 inch."[36] Neither the drawing nor its text indicates how the leaf is supported, but from the dimensions we may conclude that this is a dining table.

Drawings like this are deceptive and to a great extent unnecessary. They merely reveal in a sort of shorthand way how the piece of furniture is articulated, and for all practical purposes, the measurements without the drawing do that. Once a craftsman had seen a form that a customer might require—and he could hardly avoid seeing all of the forms that existed in his cultural area, if not in his master's shop then in the homes of his neighbors—all he really needed to

create it was a set of dimensions. Virtually every surviving account book of Pennsylvania German craftsmen has some notations to this end *without* drawings. A good example is in the daybook of Abraham Overholt of Plumstead, Bucks County, who wrote out for himself the dimensions for a clothespress as well as those required for a clock case.[37]

An English table form that became popular in Pennsylvania after the middle of the eighteenth century is similar to the dining table but much smaller in size. It was known as both a Pembroke table and a breakfast table. Bachman's accounts indicate that this table with two short wings had its charm for the generally conservative Mennonite settlers of Lancaster County who bought the vast majority of his furniture. The form is neatly described in *The Cabinet-Maker's Philadelphia and London Book of Prices.* The basic model to which many options could be added was "two feet three inches long on the bed, by three feet when open, one fly on each side, the framing four inches and a half deep, one drawer, scratch beaded, square edge to the top, and plain Marlbro' legs."[38]

Tables with crossed legs were probably made by craftsmen working at a trade that traced its antecedents to medieval carpentry, while tables with legs joined by a perimetric stretcher are clearly made with the pinned mortise-and-tenon joints that we associate with joinery. The same joiner's

[34] Schöpp, *Bauernstuben*, pls. 28, 25.

[35] Deneke, *Bauernmöbel*, pls. 70–72. See also footnote 58 below.

[36] This craftsman may have borne the family name, Young. See ms. 66 x 56, incorrectly catalogued as Michael Young Drawing Book (hereafter cited as Young drawings), DMMC. I am indebted to Jonathan P. Cox for calling this manuscript to my attention.

[37] *Overholt/Ranck*, p. 27.

[38] *The Cabinet-Makers' Philadelphia and London Book of Prices* (Philadelphia: Snowden & McCorkle, 1796), p. 46.

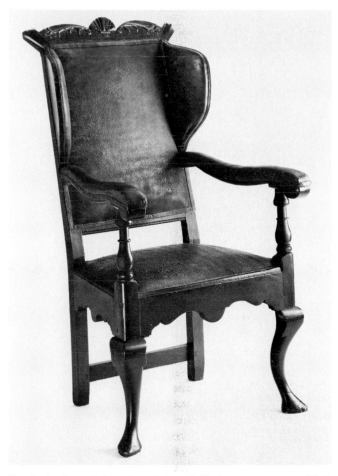

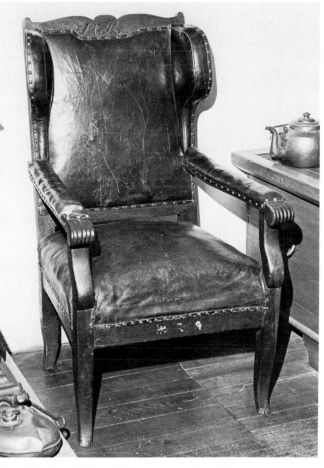

Fig. 67. Leather-upholstered armchair, probably Lancaster, 1752–73. Black walnut; H. 47″, W. 22⅛″, D. 18½″, seat height 17½″. (Winterthur 58.65.)

Fig. 68. Lederner Lehnstuhl, Germany, ca. 1800. Oak; measurements not available. (Hohenlohe Museum: Photo, Benno M. Forman.)

techniques were also used to construct the frames of those extreme rarities of village furniture, upholstered chairs. The chair in figure 67 is made of black walnut (*Juglans nigra*). The frame of its slip seat is red pine (*Pinus resinosa*). It was purchased for Winterthur in 1958 from the collection of Harold Donaldson Eberlein, a popular writer on decorative arts in the early years of the twentieth century and famous for a series of books for collectors whose titles all began *The Practical Book of* The chair is reported to have been found by Eberlein's father in the 1870s inside a chicken coop on a farm near Manheim, Lancaster County. The leather on the back was originally studded around its perimeter with brass tacks. The farmer from whom it was purchased said that his grandfather bought it at an auction of "Baron" Henry William Stiegel's belongings.[39]

Assuming the chair originally belonged to Stiegel (1729–85), who immigrated to America about 1750, it may have been purchased in 1752, the date of his marriage to Elizabeth Huber, or around 1758 when he married Elizabeth Holtz, but probably no later than 1774 when he was declared bankrupt. The chair has arm supports that are closely akin to those on an armchair with a tradition of ownership in the Weaver family of Lancaster.[40] Both chairs were probably made there. The upholstered chair illustrated in figure 68 is in Hohenlohe Museum, near Swäbisch Hall, Württemberg. It has overtones of the style practiced in Germany during the first quarter of the nineteenth century and shows the persistence there of the manner in which the Winterthur example is made. It suggests that we need look neither to the English chairmaking tradition for influences on the

39 Harold Donaldson Eberlein and Cortlandt Van Dyke Hubbard, "Baron Steigel, Ironmaker and Glassmaker," *American Collector* 6, no. 10 (November 1937): 6–8.

40 See Doris Devine Fanelli, "The Building and Furniture Trades in Lancaster, Pennsylvania, 1750–1800" (M.A. thesis, University of Delaware, 1979), p. 68; Forman, "Fussell," fig. 4.

Lancaster craftsman who made the Stiegel chair nor to the designs of Thomas Chippendale to find the origins of the style of its crest rail. References to chairmakers in Lancaster Borough are extremely rare, but one chairmaker—of German extraction—had business dealings with Stiegel's Manheim glass manufactory in 1765. His name was Jacob Vetler (Vetter?), and he was referred to as a "chairmaker of Lancaster" in the factory's accounts.[41]

Superficially the Stiegel chair might stimulate us to believe that the grandeur that surrounded Baron Stiegel has been exaggerated; a taste accustomed to the armchairs of Philadelphia in this period should have found this one less than urbane. If the chair was owned by Stiegel or his kindred, it was probably used in his more private rooms because it retains very old, possibly original, fittings for a close pan. This chair is considerably more elaborate than the usual closestool, or "closed stool," but the German name for the form, *Nachtstuhl* (night chair), suggests when it was customarily used.[42]

So few Pennsylvania German upholstered chairs have survived from the colonial period and so seldom are references to them encountered in the documents of the region that it is difficult to generalize about them. The frame of the example illustrated in figure 69 is made completely of American black walnut except for the seat rails, which are American red oak (*Quercus rubra*). The pins used to hold the chair together are, surprisingly, red oak instead of walnut to match the stiles. The chair is made in a style that preceded the style of the Stiegel chair in America by at least a quarter of a century. The arched crest rail of the back is commonly associated with the so-called Queen Anne style here, a fashion that appeared in French upholstered furniture in the last decades of the seventeenth century. The four-square stretcher arrangement that boxes in the lower section of the chair harks back to the mid-seventeenth-century leather chairs of northernmost Europe and is uncommon on leather chairs in seventeenth-century America. The anomalous turnings that support the arms convey no stylistic message at all. Oddly enough, the latest stylistic feature of the chair—the flat, outward-bowed arms—is rarely associated with English furniture made before the early 1730s, but it has a much longer history in Germany.[43]

[41] Stiegel Papers, Ledger A, no. 1, p. 76, Historical Society of Pennsylvania, Philadelphia (microfilm copy, DMMC).

[42] In the men's house at Bethlehem were: "1 zinnernen Nachttoph, 1s.; 1 Nachtstühl, 4s." (1 pewter night pot, 1s.; 1 night chair, 4s.) (Inventarium, Mobilien, 1758, Moravian Archives). *Cabinet-Makers' Prices*, p. 90, also calls it a night stool.

[43] See Schestag, *Figdor*, no. 694, said to be sixteenth century but very likely early eighteenth.

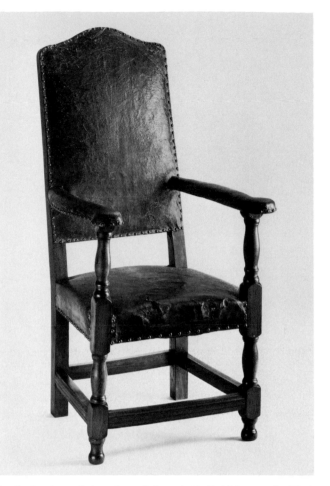

Fig. 69. Leather-upholstered armchair, probably Bethlehem, 1783. Black walnut; H. 54⅜″, W. 25⅜″, D. 21″, seat height 18½″. (Winterthur 65.2248.)

The strong tradition that suggests that leather upholstered chairs were made in Bethlehem is supported by the presence of leather chairs among the furniture owned by the Moravian community. In the 1802 inventory is "1 lederner Armstuhl" (1 leather [upholstered] armchair) for which, unhappily, no valuation is given. The 1837 inventory, written in English, lists "1 leather lined armchair old" and "1 leather lined old armchair from Adm[inistration?] house."[44] Neither is assigned a value.

For the connoisseur who would date a piece of furniture on the basis of stylistic attributes, the study of Germanic furniture is laden with traps. The chair in figure 60 is no exception. The rear of its crest rail is professionally carved with the initials PB and the date 1783. No good reason can

[44] Inventories, 1802 and 1837, Moravian Archives. The holdings of the society were considerably shrunken by 1837.

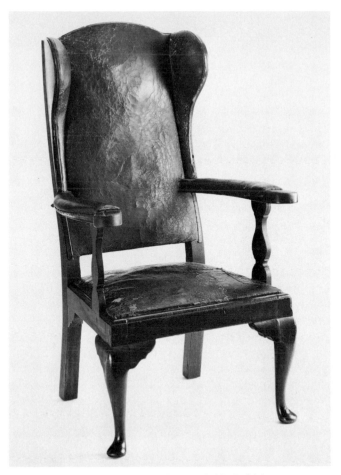

Fig. 70. Leather-upholstered armchair, probably Bethlehem, 1750–75. Black walnut; H. 46⅜″, W. 25¼″, D. 27″, seat height 14¾″. (Winterthur 66.695.)

labor and materials and the specialized tools and talent required to add textiles to a frame commercially, which is to say, profitably, we do not expect to find upholstered furniture being made outside of urban centers in colonial America. The chairs with Germanic overtones in the Winterthur collection are outstanding exceptions to that rule, but they are difficult to date on the basis of their style.

An additional chair said to have been found in Bethlehem (fig. 70) is made in a style that suggests it was conceived and executed sometime before the Lancaster example in figure 67. It also shows the assimilation of many ideas about what constituted a fashionable armchair in Philadelphia. This chair is of such a rare breed that its implications cannot be explored except in the broadest terms. It was illustrated in *American Furniture*, where Joseph Downs noted its "forward-standing ears" which "lend a whimsical air of arrested attention" and the distinctive arm supports in the shape of architectural balusters.[45] A chair with similar ears and arm supports, now in the Moravian Museum at Bethlehem, varies from the Winterthur example in two ways: its seat is half upholstered over the rail (however, the upholstery is not original to the chair), and it has square or Marlborough front legs in a style that we believe appeared in American furniture slightly later than the crook foot.[46] The

be found to challenge their originality. The chair was found in Bethlehem, Pennsylvania. And leather chairs in the inventories of that eighteenth-century community tempt us to dream that this could be one of them. The four-square design execution of the chair, whose stretchers are ornamented with planed moldings, suggests that the joiner who made the frame was seldom called upon to make frames for upholstered chairs. Normally, an upholsterer would be responsible for putting the fabric or leather on a chair frame, but since the upholstery of this chair is not original to it, we can draw no conclusions about that aspect of the chair's life by studying it. The records of the Moravian community at Bethlehem do not reveal that an upholsterer worked there, but since the process of upholstering a straightforward chair such as this one is more tedious than demanding of special skills, it could, with effort, have been accomplished by the joiner who made the frame. Because of the high cost for

[45] Joseph Downs, *American Furniture: Queen Anne and Chippendale Periods* (New York: Macmillan Co., 1952), fig. 14.

[46] The terminology here is taken from a printed Philadelphia price book which Benjamin Lehman of Germantown hand copied in 1786. A second manuscript version of this Philadelphia price book also exists, but no copy of the book itself has been discovered. The Lehman version was the first published and is the more nearly complete of these; see Harrold E. Gillingham, "Benjamin Lehman, A Germantown Cabinetmaker," *Pennsylvania Magazine of History and Biography* 55, no. 4 (1930): 289–306. The second manuscript version of this price book was published in a facsimile edition with comments by Martin Eli Weil in "A Cabinetmaker's Price Book," in Quimby, *American Furniture and Its Makers*, pp. 175–92. That manuscript carries an inscription revealing that it was copied from a book that had been printed in Philadelphia in 1772 by James Humphreys. Since the version that Weil found was copied by a craftsman whose orthography does not properly reflect the text as printed by James Humphreys, all references in this article were taken from the more accurate, careful, and complete Lehman version, which I have collated with the original manuscript in the collection of the Historical Society of Pennsylvania. Because the Lehman version contains material that the other version does not, it is possible that two editions of the price book existed. Whatever the case, Humphreys was merely the printer, not the author of the book. That two manuscript copies of the book exist and no printed copies survive suggests that this was a secret book, copies of which were in the hands of the master cabinetmakers / joiners of Philadelphia. The fact that the journeyman's wages are included in the entries, thus showing the markup the master craftsman was making, heightens this impression. A similar situation existed with the Carpenter's Company; see Carpenter's Company of the City and County of Philadelphia, 1786 *Rule Book*, ed. Charles E. Peterson (Princeton: Pyne Press, 1971), p. ix. It is also worth pointing out that Lehman

brackets at the tops of its legs relate Winterthur's chair to the Philadelphia school of chairmaking, as do the neatly wedged through-tenons of the side seat rails and the glue blocks at the juncture of the front legs and the seat rails. The leather bottom or slip seat, as we call it today, is also an uncommon feature in nonurban chairs.

Upholstered chairs made in Bethlehem could easily have been covered by the community's saddler, for the saddler's craft is really little more than that of an upholsterer working with leather. The 1762 inventory of the shop worked in by Bethlehem's saddler Gottlieb Lange reveals the following materials:

Leder	leather
Gurte	girth web
Leinwand	linen cloth
Schnure	cord
Zwirn	thread
Band	ribbon
Nägel	nails
Gelbe Nägel	brass tacks
Kuh Haare	cow hair
3 Körbe mit etwas Wolle	3 baskets with some wool

and the following tools to work them with:

3 Gurt zieher	3 girth pullers
1 Schnitt Messer	1 cutting knife
1 Bend zum zuschneiden	1 binding cutter.[47]

A comparison of construction details used in the Winterthur chairs from Bethlehem shows that two different people made their frames. The quarter round and fillet molded on the upper edge of the seat rails and the presence of a wedge under the bottom edge of each exposed tenon on the chair in figure 70 are mannerisms that we associate with the Philadelphia school of chairmaking. The unusual baluster that supports the arm was consciously chosen by the maker of the chair: the carving necessary to produce the very different arm support that characterizes Philadelphia chairs was within his capabilities, or he could not have carved the crookt leg. The habit of using such a baluster in this position is doubtless derived from a European tradition that has escaped our notice.[48] The rejection of a turned support for these arms is a further conscious choice because the mark of the still point of a lathe—the tool required to turn the round, pad feet—

is still visible on the bottom of each. These feet indicate not only that the maker of this chair possessed a lathe but also that he was capable of using it in a versatile way.

In the absence of any Pennsylvania German craftsman's accounts that talk about upholstered chairs, ideas about chairs can best be developed by comparing them with a document such as the price book printed by James Humphreys of Philadelphia in 1772. The few documents in American furniture history that permit us to compare equivalent products made in towns and in nearby cities show that their costs do not substantially differ. The basic price in Philadelphia for a walnut easy-chair frame with "plain feet and knees" and "without Casters" was £2.5. One with Marlborough legs, which ought to require less labor, was surprisingly the same price. One that was "Stuffed over the rails" and whose upholstery was finished with brass nails cost 8 shillings more. For "any arm chair made for a Close Stool with a cover to the pan" the price was 7s. 6d. not including the pan. Leather appears to have been the standard upholstery fabric of the time, but the alternatives—at added expense—were "Damask or [horse]hair Bottoms."[49] The seat of Winterthur's chair retains its original upholstery, and the saddler's girth web on the bottom is the narrow type, typical of the colonial period, and sparsely used, in the English manner. The tape that now edges the stuffed arms, the ears, and the back is modern. Brass tacks (gelbe Nägel?) which originally edged the upholstery were considered an indispensable decorative feature.

The stylistically later version of the chair with Marlborough legs still in Bethlehem suggests that it was made there sometime later than the Winterthur example. However, another way of looking at these two chairs exists: the 1772 price book and the copy by Benjamin Lehman of Germantown, dated 1786, show that alternative styles—chairs with either Marlborough legs or crookt legs—were simultaneously available to buyers in Pennsylvania and that either example could have been made at any time between 1772 and 1786 in either style.[50]

The recognizably ethnic character of Germanic furniture from the Pennsylvania hinterland has attracted so much attention over the years that furniture historians have neglected to look for German influence in the execution of

did not work in Philadelphia, and it may be presumed that the copier of the version Weil found (now in the Tyler Arboretum, Lima, Pa.) also lived and worked outside the city. Perhaps both sought to sell their goods at Philadelphia prices.

[47] Inventarium, Sattler, 1762, Moravian Archives.

[48] A similar baluster used to support a bench is illustrated in Schöpp, Bauernstuben, pl. 2.

[49] Gillingham, "Lehman," p. 296.

[50] As well as we can deduce from the terse descriptions in the price list, "chairs with crooked legs" do not have pierced banisters (splats), while those with Marlborough feet do. A crooked leg "chair with Plain feet, and [plain] Banister with leather bottoms" cost £1.14 in mahogany. A Marlborough-leg chair with "plain open [i.e., pierced] Banisters with Bases [on the feet] or Brackets [between the legs and seat rails] with Leather Bottoms" cost £1.12, only two shillings less (Gillingham, "Lehman," pp. 295, 296).

Philadelphia furniture and the accommodation of German craftsmen outside of Philadelphia to the styles popularized by Englishmen. That the chair in figure 70 and the one in the Moravian Museum have construction characteristics we are accustomed to seeing in Philadelphia chairs raises several important questions, not the least of which is how they got there. First and most obviously, and in the absence of better documentation, the Bethlehem chairs could have been made in Philadelphia, despite the fact that we do not usually associate the stylistic attributes of these chairs with that city. But we would be remiss if we did not explore a second possibility, namely that the structural attributes we associate with Philadelphia—the wedged tenon is one—are present in non-Philadelphia furniture not because of some mystical influence emanating from Philadelphia, but rather because these features are common techniques in German furniture making and are present in *Philadelphia* furniture because German craftsmen were working there.

The desk-on-frame in plate 6 is a classic example of a piece of furniture whose Philadelphia origin could scarcely be questioned but whose construction runs the gamut of Germanic furniture-making techniques. The tiny dovetails that fasten the top board to the sides are all wedged in a manner never encountered in English furniture. The drawers of the upper section are likewise held together with wedged dovetails (fig. 71); the dovetails that fasten the drawer back to the sides are worked on the back in the German fashion rather than on the sides in the English manner; the bottoms are held to the sides by wooden pins rather than the nails we find in Anglo-Philadelphia work; and the "bumpers" on the back of the drawers, designed to keep the drawer fronts flush with the partitions that surround them, are delightful, miniscule ogees worked on the rear edge of the drawer bottom itself rather than the added glue blocks of the English school. An X-ray photograph of one of the cleats that form the left and right edges of the boards that make up the writing surface (fig. 72) reveals that the boards are held in place by tenons worked on their inside edges—a refinement of one of the classic techniques used in Germany to hold the moldings of chest lids to the boards that compose their tops (see fig. 83). These tenons fit into blind mortises cut in the cleats and are held in place by wooden pins that transfix both mortise and tenon.

Stylistically, the overall appearance of the desk reveals little that suggests a German hand was at work: only the undulating fronts of the small drawers and the elaborate outline of the bottom of the skirt hint at the baroque line of German high-style furniture. The rest we accept as pure high-style Philadelphia—the engaged quarter columns at the

Fig. 71. Detail of a small drawer of desk shown in pl. 6.

Fig. 72. X-ray photograph of blind pinned tenon in bracket of writing surface of desk shown in pl. 6.

corners, the rounded balls of the claw feet, and the superior quality walnut from which it is made.

To get ourselves into the state of mind that permits us to look for the German aspects of a piece of Philadelphia furniture is not a simple matter. Most of the details that betray a Germanic hand at work either are hidden inside or are in the least obvious places, suggesting complete assimilation of German craftsmanship in Philadelphia into the English taste. Moreover, these techniques are found throughout Pennsylvania, Maryland, and New Jersey furniture of the eighteenth century, slightly later in the Shenandoah Valley, North Carolina, Ohio, Indiana, and the Niagara peninsula of Canada, and later still in Tennessee, Ken-

tucky, Missouri, and Texas after German craftsmen migrated to them.

Furniture from all parts of colonial America reveals that stylistic ideas find their way from a city to its hinterland. An obvious way this can happen is for a provincial craftsman to copy an urban example—an idea to which lip service is invariably paid but instances of which are hard to find because prototype and copy are difficult to identify, let alone bring together. A chairmaker in Bethlehem could be familiar with furniture shipped there from Philadelphia and might take his stylistic cue from it. But he would not *make* it with Germanic techniques unless he had been trained in the Germanic manner of workmanship.

Another self-evident way in which ideas made their way from city to village in the days in which design books did not exist was the migration of craftsmen. Examples of this can be seen in the furniture of Eliphalet Chapin and Benjamin Burnham, both of whom were born in Connecticut and made furniture there, but their known work betrays the fact that each of them had "sarfved his time in Felledlfey."[51] John Snyder has written the definitive study of how a little of both of these ways occurred in Pennsylvania. In a meticulous study of furniture from Lancaster Borough formerly attributed to Johannes Bachman, Snyder points out that much of the fine, Philadelphia-style furniture made in Lancaster, as well as the fixed woodwork still there, can be documented to the shops of Hans Jurig Burkhart, Peter Frick (b. Germantown), Michael Lind (arr. Philadelphia, 1750; in Lancaster, 1751), and Conrad Doll.[52]

We have been taught to believe that a non-English maker of a piece of furniture in America must invariably betray himself because the proportions and details of his work will differ from the proportions, execution, and details of work done by a craftsman trained in the English manner. This idea is reinforced by the armchair illustrated in figure 70 and more so by the desk-and-bookcase illustrated in figure 73. The brackets and the legs of the armchair are rather heavy for Philadelphia work, and the squatty top of the bookcase combined with the unusually tall desk perched on high and rather weakly articulated feet suggests a nonurban approach to style, despite the well-done quarter columns at

its corners. In the case of the chair, we are the victims of both the aesthetic assumption that all Philadelphia work is of a high order of accomplishment and its unavoidable corollary, that furniture made outside of Philadelphia is always inferior in design and execution. This prejudice is hard to overcome because we are unfamiliar with documented examples of inexpensive Philadelphia furniture and therefore cannot compare them to the more ambitious work of craftsmen elsewhere in the colony.[53]

If we assume that the desk-and-bookcase in figure 73 is awkward because it was made in the provinces by a German, we fall victim to appearances. A comparison of the very different turnings of the bookcase with those of the desk shows that these two parts were not made at the same time, nor even by the same school of craftsmen. The turnings of the upper section are fully round and stylistically somewhat later than the fluted, quarter-round, engaged columns of the base; the back of the desk is composed of two extremely wide boards, and the jointer (plane) that was used to smooth them had a nick in it. The four, narrower boards that compose the back of the top were smoothed with a plane that had no nick. The reeding at the bottom of the bookcase section is stylistically congruent with the turnings at the corners of its top, and this suggests that the bookcase is as much as a generation later than the desk. The desk is composed almost entirely of white pine (*Pinus strobus*), the bookcase of red pine (*Pinus resinosa*) which, as far as we can tell from our ex post facto reconstruction of the eighteenth-century forests of Pennsylvania, did not grow together in the same local stands. Both, however, appear to have been confined to the northernmost portions of the state.

The desk section seems unusually tall because it contains a chest rather than the conventional drawers we expect in this form of furniture. Access to the chest is obtained through a movable lid directly behind the wing that constitutes the writing surface (fig. 74). The craftsman who made this desk had to devise a special way of attaching the writing surface to the desk and had to have special hinges made for that purpose.

Many collectors would refer to this desk-and-bookcase by the damning word *married* and would remove it from their collections. Others will see it for what it really is: a piece of furniture whose useful life was extended by an addition that was never intended to deceive anyone. If we imagine the later bookcase away, the desk as it originally stood becomes somewhat more than merely a late eighteenth-century curi-

[51] Ethel Hall Bjerkoe, *The Cabinetmakers of America* (Garden City, N.Y.: Doubleday, 1957), pp. 54, 60.

[52] John J. Snyder, Jr., "Carved Chippendale Case Furniture from Lancaster, Pennsylvania," *Antiques* 107, no. 5 (May 1975): 964–75. If Lind was of Scandinavian extraction, as family tradition holds (Snyder to Forman, July 12, 1981), the style of carving on this bookcase can be shown to have analogues in Swedish furniture; see Sigurd Erixon, *Möbler och Heminredning I Svenska Bygder* (Stockholm: Nordiska Museets Förlag, 1925), pls. 278, 284, 286, 287, 362, 397, 414.

[53] See Nancy Goyne Evans's pioneering study, "Unsophisticated Furniture Made and Used in Philadelphia and Environs, 1750–1800," in *Country Cabinetwork and Simple City Furniture*, ed. John D. Morse (Charlottesville: University Press of Virginia, 1970), pp. 151–203.

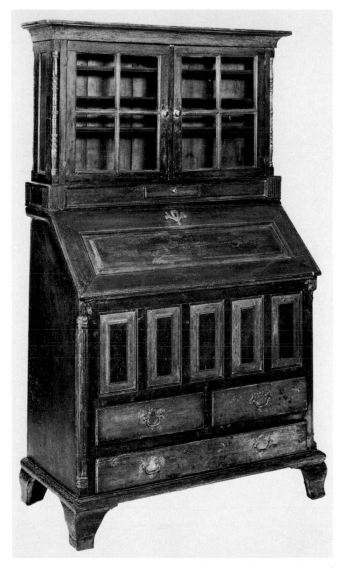

Fig. 74. Detail of desk shown in fig. 73.

Fig. 73. Desk with added bookcase, Pennsylvania. Desk: 1775–1800, red pine; bookcase: 1800–1825, white pine, tulip quarter columns, H. 73¾", W. 43⅜", D. 21⅜". (Winterthur 67.707.)

osity. It makes a stab at being a fashionable form, with attenuated bracket feet. As it presently stands, it links two cultures—that of the English settlers who liked to store things in desks with that of those continental Europeans for whom the chest was a preferred form of storage. We can only give this piece of furniture a fair viewing if we see it in this light rather than as an ill-conceived or misunderstood attempt to copy an English form.

The elegant desk-and-bookcase illustrated in plate 4 has a very different character. It is made totally of white pine, including its turned quarter columns, which indicates that it was always intended to have a painted exterior and suggests that it did not originate in southeastern Pennsylvania, always assuming that the wood of which it is made was procured locally. It was purchased for the Winterthur collection from Mrs. R. S. (Hattie) Brunner of Reinholds, Pennsylvania, in 1936. The legend that it had been found floating in the Susquehanna River near Sunbury came with it. Like Moses, it seems to have survived its immersion with equanimity: both parts are together and all of its original drawers are present. The finials and the fronts of the bracket feet are replacements.

Dean Fales described this desk-and-bookcase as a "Pennsylvania German production . . . 'gone English,'" a characterization that is worth exploring.[54] It is most certainly in the English manner insofar as its overall appearance is concerned. The style of the painting on the exterior is familiar to us from numerous painted chests and cupboards, but no detail immediately says "I was made by a German craftsman." The floral motif in the center of the pediment and the details of the execution of the "roses" at the peak of the scrolls are highly stylized but do not tell us that they were made by a German craftsman or that he did not understand what rococo-style carving was all about; they merely state that the maker was not trained to do carving. Not until we look very closely at the case and the bottoms of its drawers and see that every juncture is fastened with wooden pins rather than nails do we begin to perceive woodworking

[54]Dean A. Fales, Jr., *American Painted Furniture, 1660–1880* (New York: E. P. Dutton, 1972), p. 258, fig. 452.

characteristics that are umistakably Germanic. The multiple-pegged framing of the doors is Germanic as are the tenons of the horizontal rails protruding through the uprights, but most other German features are absent. The dovetails in the drawers, for example, are not wedged. The drawer linings throughout are sawn uncommonly thin, and, most delightful of all, the engaged quarter columns are made in the Philadelphia manner. Each one consists of three pieces of wood: capital, shaft, and base. The shaft was fluted with a plane prior to installation. The fluting was then carved up into the capital and down into the base with a small gouge after the case was assembled, a technique used throughout Pennsylvania by the end of the eighteenth century. Judging from the additional fluting on the front of the bookcase, the desk was made when the federal style was popular—probably in the early years of the nineteenth century. The slender attenuation of the pediment scrolls, which flare as they go from the roses toward the sides of the case, also suggest that date.

The task of reconciling the conflicting elements here is not easy. The same hand and eye that created the swept scroll pediment that makes this desk so distinctive also chose to stick door hinges on the surface of the facade. The same mind that controlled the hand that planed the drawer sides to a thinness which belies the conception that all Germanic work is "heavy" chose to make use of pine and paint it. The same eye that conceived the proportional relationships between the parts that make this desk so pleasing was a craftsman who brought a great deal of careful workmanship to bear in its creation and who had learned his trade in a well-supervised apprenticeship with a master whose own work had a Philadelphia flavor. The result is not a curiosity that we torture to fit our preconceptions, but another example of a kind of eighteenth-century taste we do not learn about from verbal documents, a taste that we rediscover only by engaging in aboveground archaeology.

The desire for English-style furniture by people whose tastes were formed in the northern European milieu was not confined to Pennsylvania. Many fine examples of northern European furniture in the English style, either veneered or made of hardwoods, are in this country. And they have often been mistaken for English furniture. An outstanding north German desk-and-bookcase, once thought to be English, is displayed at Carnegie Institute Museum of Art in Pittsburgh. Several others are in European museums.[55]

A desk-and-bookcase of a very different order, produced under very different circumstances, is pictured in figure 75. Instead of being joiner's work, as are the panels of the bookcase section in figure 72, it is made in the manner that has come to be commonly accepted as being the cabinetmaker's style in eighteenth-century America. This elaborate piece of furniture, whose show wood is American cherry (*Prunus serotina*), has a tradition of ownership in the Withers family of Strasburg, near Lancaster. It illustrates the assimilation of the English manner by at least two of the craftsmen who worked on it—the casemaker and his carver. As was the custom among collectors of a generation ago, this piece of furniture was attributed to Johannes Bachman. But Snyder's penetrating analysis of the Bachman account book shows that Bachman never specifically states that the furniture he produced had any carving on it. Snyder convincingly shows that this desk-and-bookcase and a number of related pieces of furniture did not originate in Lampeter Township, where Bachman worked, but rather in the borough of Lancaster. In the absence of documented case furniture known to have been made by Lancaster's leading joiner, Hans Jurig Burkhart, this desk-and-bookcase may tentatively be attributed to the shop of one of the Michaels Lind, father or son.[56]

The overall form of the Lancaster desk is virtually indistinguishable from the form it would have taken had it been made in Philadelphia. Its proportions, including the high ramp of the scroll pediment, are not notably different from late eighteenth-century Philadelphia work. We cannot, therefore, avoid asking why the maker chose cherry or why the purchaser accepted that wood. Light-colored woods were not considered fashionable in the period that the style of this desk evokes, nor would a light-colored wood have been considered appropriate for such an elaborate piece of furniture. If mahogany was unavailable in Lancaster at the time this object was made—say, during the revolutionary period when trade was interrupted—the easy, local alternative was walnut, as most surviving Lancaster work demonstrates. Clearly walnut was rejected and cherry chosen for a very specific reason. Only one such reason comes to mind and that is that a scarcity of mahogany forced the maker to select cherry because, from the moment of its conception, he intended to stain the desk to simulate mahogany. Were the desk-and-bookcase less elaborate, this notion would not be arguable. Imported mahogany, which might have cost as much as 50 percent more than local cherry or walnut,

[55]*The Furniture Collections of the Museum of Art, Carnegie Institute* (Pittsburgh: Museum of Art, 1980), [p. 3]. F. Lewis Hinckley, *Directory of Antique Furniture* (New York: Crown Publishers, 1953), nos. 205, 209, 256, 257.

[56]See Snyder, "Carved Furniture," figs. 6–8, pl. 2; see also John J. Snyder, Jr., "The Bachman Attributions: A Reconsideration," *Antiques* 105, no. 5 (May 1974), 1056–65. While the Bachman accounts never specifically mention carved work, much of his case furniture seems too highly priced for ornamented work.

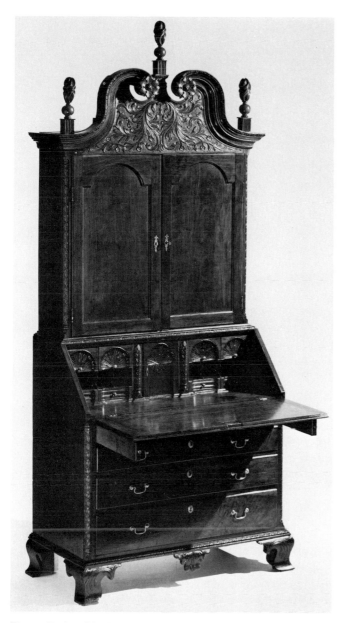

Fig. 75. Desk-and-bookcase, Lancaster, perhaps by the Michaels Lind, ca. 1780. Cherry; H. 103½″, W. 45″, D. 23⅝″. (Winterthur 51.56.)

relative provinciality of a piece of furniture based on what we can see of it after 200 years of changing fashions. Close examination of the desk indicates that it was indeed once stained and, like many other examples, stripped in modern times to reveal the beautiful wood Charles Eastlake taught us to admire, the wood that our ancestors were often at great pains to cover up.[57]

Can we then say that this piece of furniture is obviously provincial in nature and a misunderstood version of the Philadelphia high style because the carved work that outlines the quarter columns or the moldings at the top give it the air of exuberant overornamentation we associate with a provincial craftsman's mentality? The 1772 book of prices for cabinet work in Philadelphia shows that we cannot. There this specific form of a desk-and-bookcase is called a "winged desk."[58] All of the optional elements that we see on the Lancaster example are listed: "Skolloped Drawrs below and Shell drawers above [the scalloping here is distinctive] . . . Collum Drawers [document drawers] . . . a Prospect [the section including and behind the little door of the desk] & Swelled Brackets [ogee bracket feet]," and "Add for Quarter Columns 10 shillings" is specified. The bookcase portion has an architectonic "Scroll pediment head," "Arch Doors," and "columns."[59] Elsewhere in the price book we find that finials were then called, "blazes," rosettes were "roses," and moldings were carved ad libitum at extra cost. Any nouveau riche Philadelphian could pile up as much ornamentation as befit his taste and so could a Lancastrian: excess was available to anyone who could afford it.

Details betray that the Lancaster desk-and-bookcase originated somewhere other than Philadelphia. The intaglio carving on the pediment is the most obvious non-Philadel-

[57] Charles Eastlake, *Hints on Household Taste in Furniture, Upholstery, and Other Details* (1868; reprint ed., New York: Dover Publications, 1969), pp. 42–43, 66, 127, passim. Examination of numerous pieces of furniture made of cherry from both New England and Pennsylvania indicates that they were originally stained, although documentary confirmation of this is rarely found. In the daybook of Abraham Overholt, however, we find strong evidence that the staining of cherry furniture was on his mind. Immediately after writing about clock cases made of "wild cherry boards," Overholt notes that "you take guinea redwood [logwood—a dye wood used to obtain a red stain] and gum and 'merers' [mars?—a red oxide of iron] and alum and you cook this together but you do not put in the gum until it has nearly cooked enough and after that you add the gum and the color will become good" (*Overholt / Ranck,* p. 27).

[58] *Oxford English Dictionary* does not notice this exact use of *wing,* although several related uses appear. The daybook of Johannes Bachman seems, however, to confirm this sense of the word when it refers to a table with falling leaves as "ein fliegel düsch," literally, "a wing table" (July 5, 1777) (p. 33, DMMC). In 1800, John Klinger, Esq., a joiner of Pinegrove, Berks County, possessed "1 Walnut wing table" valued at 15s. and two others valued at 10s. and 7s. 6d. (Berks County Inventories).

[59] Gillingham, "Lehman," pp. 290, 292, 294.

does not ultimately affect the final price of a piece of furniture, after the labor is added, by more than 10 or 15 percent. This is the difference between a desk that cost the customer £30 in cherry versus £33 to £34.10 in mahogany—a negligible amount when a customer is intent upon making a show. After all, you can always *write* something at a table if writing is all you really want to accomplish.

The Lancaster desk-and-bookcase illustrates how easy it is to jump to an obvious but incorrect conclusion about the

phia detail. It is a fantasy placed as it would be on a Philadelphia desk or high chest, but the pattern itself is conceived in the strongly centralized manner of northern European vernacular carving in the late Middle Ages. The design is made mortal by an irrational, pendant tulip that serves as a bellflower. We would never mistake it stylistically for Philadelphia work, which is always much less free in conception and execution. Nor would we confuse the way it is done with Philadelphia work: in Philadelphia, pediment decoration was always carved from a separate piece of wood and applied to the surface of the pediment rather than carved into it. The carved shells and the unusual molded fronts of the drawers within the desk also lack the restraint that we like to believe is characteristic of the most elegant urban work. But neither of these exceptions to the general rule of what we find in Philadelphia makes it immediately apparent that the desk-and-bookcase was made by a craftsman trained in the German tradition: that becomes clear only when we perceive that the braces of the rear feet are dovetailed to the case, that the drawer bottoms and their runners were origidnally attached with wooden pins instead of nails, and that the upper rail of the doors are held in place by wedged tenons in cut-through mortises (fig. 76). Relatively small matters, for these details also appear in Philadelphia work.

The clear and complete descriptions in the 1772 price book, which had no illustrations, were in existence in that year, and the verbal information was doubtless in circulation prior to that date. Although proper measurements would have required some imagination, any skilled furniture maker could have made furniture in the manner and style the price book describes.[60] Verbal descriptions such as these must inevitably put the books of engraved designs favored by generations of furniture historians into a new perspective.

This is not to say that pictures of furniture did not play a role in conveying information about the forms and style of furniture. Indeed, more designs from eighteenth-century Pennsylvania have survived than all the rest of the places in which Americans made furniture. At least two manuscript books containing drawings of Philadelphia-style furniture were in the hands of German craftsmen. One, originally owned by Abraham Hover of Lancaster County, is at the Heritage Center in Lancaster. The other, containing the drawings of Daniel Arnd, is in the daybook once kept by Peter Ranck (Rank), joiner, of Jonestown (now Williams-

Fig. 76. Detail showing wedged tenon in door frame of desk shown in fig. 75.

burg), Bethel Township, Lebanon County, and is now in the manuscript collection at Winterthur.

The Hover book contains entries in two hands. The earliest are clearly in the hand of the person who wrote "Abraham Hover, his book, Mate It in the year of our lord 1796." These entries date from 1796 to about 1809. They are usually in German, but sometimes are in English with Germanic spelling—*th* for *d*, for example. A second group of memoranda, possibly by Abraham Hover but written in a somewhat more refined hand and better spelled (we should not preclude the possibility of practice leading to perfection) date from the 1820s and 1830s. The entry on page 2, however, definitely shows that the book was owned by Levy Huber in 1835.[61]

Hover's book is a fascinating document of a German training himself to write in an English hand. It has a hypothetical account entry dated 1790, in which he was teaching himself how to do double-entry bookkeeping. He also copied requests for payment, legal forms, promissory notes, receipts, and a letter from a coypbook. An abundant sense of humor runs through it. "If i onely gould rite as well as they master," he laments at one point; at another, after painstakingly copying a note four times in a big round hand, he wrote, "Abraham Hover is very sleapy."[62]

[60]This was not invariably coped with; see, for example, a related desk-and-bookcase with Germanic double-pinned door frames rather than wedged tenons in an Israel Sack advertisement in *Antiques* 81, no. 2 (February 1962): 137. This desk has an extremely short bookcase, perhaps made for a room with a low ceiling.

[61]Different branches of this family now spell the name differently. Among the variations are Hoover, Hoober, Huber, and Hover. Levy Huber could easily have been the son of Abraham Hover.

[62]Abraham Hover daybook, pp. 16, 17, 84, 85, 88, 89, 90. The citations here are to the photostatic copy in DMMC. The original manuscript is only partly paged. Some of the copybook maxims and the letter Hover copied on page 85 come from George Fisher, *The Instructor; or, Young Man's Best Companion,* a famous eighteenth-century self-improvement manual (London, 1740). Isaac Collins published an early colonial edition in Burlington, N.J., in 1775. Whether Hover was copying from a post-1790 edition of the book is not clear.

The Hover manuscript is one of the great records of an immigrant's determination to become Americanized, and our joy would be even greater if the accounts themselves revealed that Hover made any of the Philadelphia-style furniture so meticulously drawn in his book. Unhappily, his accounts show only that he did the kind of work associated with a carpenter / joiner—house building, flooring, shingling, making windows and perhaps an occasional chest. Close examination of five pages of entries which mention elaborate furniture forms reveal that the work described therein was done for Hover in 1805 and 1806 by a hired craftsman named Tichley Molloy or Checkly Melle or Checkly Miley or Chichely Milley—Hover entered the name in all of these spellings.[63]

Nonetheless, the drawings exist. The instructions for their dimensions are in Hover's handwriting and are in German. Perhaps he did them before going to Lancaster County in anticipation of making the furniture once he got there. Or, perhaps he made these forms at some time in his career other than the years covered in this book. But as far as we can tell, the opportunity did not present itself between 1796 and 1809.

It would be delightful if we could demonstrate that the drawings in Peter Ranck's book of accounts (1794–1817) were by Peter Ranck. As was the case with Hover, the Ranck accounts contain no evidence that he actually made any of these forms.[64] A half-dozen pages in the account book contain pencil illustrations with instructions for what the dimensions of the pictured objects ought to be. These instructions are written in a cultivated hand but contain words in dialect. Inside the front cover, in the same style of handwriting, is the legend "Daniel Arnd His Book" and a floral design in the rococo manner. This handwriting and that of the dimensions for the furniture illustrations are in a gray ink, as opposed to the brown ink of the entries, written in a mixture of Pennsylvania German dialect and Germanized English, that constitute the balance of the text. The handwriting of the brown ink entries is considerably less literate than the other, and it seems certain that the writing in this book is by two people. If so, the drawings and instructions with them are by one Daniel Arnd, and the accounts are by Peter Ranck.

Ranck was a joiner, who spent his working life in Jonestown, Lebanon County, Pennsylvania, but exactly who Daniel Arnd was has eluded us. At least two craftsmen by this name were living in Pennsylvania in the third quarter of the eighteenth century, but since they were members of the artisan class, we have been able to learn little about them. One was a silversmith in Philadelphia—apparently a minor one—whose inventory was submitted for probate on August 14, 1788.[65] The other was a joiner who worked in Lancaster County and by all rights is the more logical choice as the author of furniture drawings. That the drawings have some relationship to Lancaster County work is demonstrated by the curious panel with voluted corners on the base of the tall clock in this book and the presence of a similar treatment on several tall clocks found in Lancaster County.[66]

The Lancaster County joiner named Daniel Arndt was in Virginia in 1796 (two years after Peter Ranck made the first entry in his account book). We cannot avoid asking why, if the joiner was the author of the drawings, did he leave behind a perfectly usable book with 200 blank pages in it and a group of drawings that would be of use to him wherever he worked. If, on the other hand, the drawings are by the Philadelphia silversmith, we must ask why he made them. The only explanation is that he made them to sell to furniture makers who could use them to create Philadelphia-style furniture. Given *only* these two choices, I think it likely that the Philadelphia silversmith who died in 1788 was the author of these drawings.[67]

The drawings themselves are far more finished than any of the designs left us by any other American artisan of the eighteenth century. They are so unlike the usual sketches done by craftsmen for their own use that we can be tempted to believe that they could have been made by a man who was a trained silversmith, was capable of doing engraving, and hence must have been a draftsman as well.

Among the Arnd designs is an example of what the 1772 price book refers to as "a low chest of drawers" (fig. 77).[68] This form cannot be traced to a German origin. It was made in both Connecticut and Pennsylvania, but the majority of

[63] This craftsman also worked three months for Johannes Bachman beginning on January 9, 1804, and is listed as Kitchli Milli (Johannes Bachman daybook, pp. 353–54, DMMC). The name is probably not Melen or Mylen, both of which Hover spells correctly elsewhere in the manuscript (Hover manuscript, pp. 132, 133, 136, 140, 141, DMMC). For drawings from this account book, see Vernon Gunnion, "Country Furniture Designs . . . from Abraham Hover's Account Book," *Spinning Wheel* 31, no. 6 (July / August 1975): 32–35.

[64] *Overholt / Ranck*, pp. 33–227.

[65] Philadelphia Wills, 1788, no. 50, Philadelphia Courthouse Annex. The name is spelled Arnd, not Arndt. I am indebted to Désirée Caldwell for finding this inventory and recovering another craftsman from oblivion.

[66] John J. Snyder, Jr., "Chippendale Furniture of Lancaster County, Pennsylvania, 1760–1810," (M.A. thesis, University of Delaware, 1976), fig. 23.

[67] John Snyder to Benno Forman, July 25, 1981, quoting the records of the estate of Anna Arndt, widow of Charles Arndt, Lancaster County Deeds. I realize that others may disagree with my conclusion about the authorship of the drawings.

[68] Gillingham, "Lehman," p. 295.

surviving eighteenth-century examples were made in Pennsylvania. The low chest of drawers provides more usable space than the more fashionable bureau, which has only four shallow drawers, and its contents are easier to get at then those in the most fashionable high chest of drawers. The price book does not say how much low chests of drawers in mahogany should cost, which rules out the possibility that this form was intended for the most fashionable clientele. In walnut, it is unmistakably described and priced as follows:

Low chest of drawers with 3 long & 5 Small Dr[awers]	£4:10:00
D[itt]o with 4 long & 5 small Dr[awer]s	5:00:00
Do on Frame 18 Inches high without a drawer [in the frame]	5:10:00.[69]

The Arnd drawing clearly shows the four-long- and five-small-drawer version. The drawing also indicates that corners were to be finished with a fluted chamfer terminating with lambrequins (lamb's tongues), a fact which refutes the customary attribution of all furniture with this feature to Maryland. Many of the surviving examples have drawers whose wedged dovetails reveal that they were made by craftsmen trained in the German woodworking tradition, while others were obviously made by craftsmen who executed their drawers in the English manner.[70]

In most Pennsylvania German accounts and inventories, the low chest of drawers is merely called *ein draer* (a drawer). On March 19, 1784, Johannes Bachman entered in his daybook the fact that he made "ein draer mit 7 Reÿen schubladen" (a chest of drawers with 7 rows of drawers) worth £7.10 for Johannes Zimmerman. On May 1, 1786, he made one with 6 rows of drawers for £7.15. Either the latter had unmentioned additional ornament or inflation had caused him to raise his prices. Two years later, on August 4, 1788, he charged Johann Bärr "vor 2 göss of Draers . . . £26." At £13—twice as much as a low chest of drawers—a "göss" (case?) of drawers could very well be a high chest. The accounts of Bachman's son, Jacob, strongly suggest that he was making high chests. On April 16, 1822, he charged Christian Kindig $25 for a "high case of drawers."[71] Of course we can never be certain that the younger Bachman

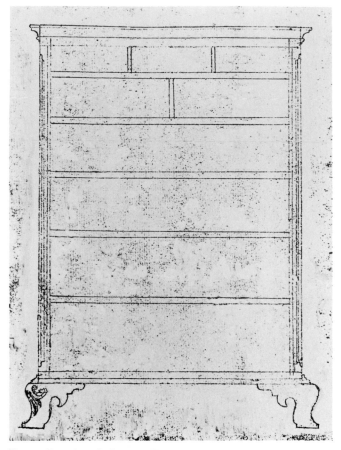

Fig. 77. Daniel Arnd, drawing of low chest of drawers. Philadelphia, prior to 1788. Pencil on paper. (Peter Ranck Account Book 67 x 23, Winterthur Museum Library: Photo, Benno M. Forman.)

was making Chippendale-style high chests so late as 1822, so unsure is our comprehension of the meanings of the words in period manuscripts. It could as well have been a chest-on-chest, or equally well what the 1772 price book called a "low chest of drawers." Numerous examples of this form, with turned feet in the so-called late Sheraton style, have been found in Lancaster County.

Documentary evidence that the high chest of drawers had been abandoned by the village craftsmen in Pennsylvania prior to the end of the second decade of the nineteenth century can be seen in the exuberant case furniture from Schwaben Creek Valley, Northumberland County. Among the several dozen pieces of decorated furniture made for textile storage illustrated in Frederick Weiser and Mary-Hammond Sullivan's extraordinarily meticulous study, "Decorated Furniture of the Schwaben Creek Valley," only a few inlaid chests, painted desks, and four- and five-drawer

[69] Gillingham, "Lehman," pp. 293, 295. Abraham Overholt also made this form in 1794: "I made a chest of drawers for Philiph Kratz, it was walnut with nine drawers . . . £5:10:0" (*Overholt / Ranck*, p. 8).

[70] An outstanding example of this form with federal-style inlay is in the collection of Berks County Historical Society, Reading, acc. no. 12. It is dated 1790.

[71] Johannes Bachman daybook, pp. 99, 120, 133; Jacob Bachman daybook, p. 4, DMMC.

chests of drawers are to be found. This distinctive body of work, now the best-documented group of Pennsylvania German furniture, was formerly known as Mahantango Valley furniture—a title that Weiser and Sullivan show is geographically too broad.[72]

Twenty-five surviving chests of drawers and four desks of the Schwaben Creek school are all associated with families from Upper Mahanoy Township, Northumberland County. All of the dated examples were made between 1828 and 1838, but undoubtedly some of the undated examples were made slightly earlier and slightly later. All are made with the panel-and-frame technique we refer to as "joined," and all have feet turned on the lower ends of the stiles. These feet are in the Sheraton style. When viewed in the light of the relatively narrow span of time in which they were made, these highly individual pieces of painted furniture can only be interpreted as a fad which took hold among this isolated group of settlers of German extraction at the moment the chest of drawers was replacing the chest as the preferred form for textile storage in rural Pennsylvania.[73]

The decoration on this furniture, much of it having religious, ritual, and symbolic content for its original owners, is a gathering of motifs from several centuries. Perhaps the most recent are the rosettes used here in a repeated, small-scale pattern that connotes the stenciling seen on contemporary empire-style furniture. The fanlike motifs in the corners of panels and drawers suggest neoclassical paterae, usually done in marquetry on veneered furniture in the Adam style. The hollow cornered border that usually outlines the face of a drawer is a classical treatment that was revived during the Renaissance. It appeared in northern Europe in the seventeenth century, continued there throughout the eighteenth century on urban-made veneered furniture, and was commonly inlaid or "strung" on English furniture in the third and fourth decades of the eighteenth century. The geometrical rondels, as Weiser and Sullivan point out, were probably forerunners of the painted "hex signs" that begin to appear in Pennsylvania in the second half of the nineteenth century.[74] Their roots lie in the inlaid or marquetry figures that appeared on northern European furniture at the end of the seventeenth century and were popular on English and American furniture made during the reigns of the first two Georges. The "tree of life" motif

traces its origin to medieval representations of floral subjects; birds intertwined in foliage to the grotesque style as practiced by the mannerist designers of northern Europe in the sixteenth century; and the jumping (*salient*) animals through heraldic representations to even greater antiquity.

Painstaking research in church and tax records enabled Weiser and Sullivan to put together a list of forty-five woodworking craftsmen active in the Schwaben Creek community during the first forty years of the nineteenth century. Close analysis of the list suggests that only eighteen of these craftsman are likely to have made this furniture, either because they were working in Upper Mahanoy, or because they were related to people whose names are painted on surviving examples.[75] The men and their known working dates are: Peter Albert (1806–38), called variously turner, carpenter, and schreiner; Nicholas Drumheller (1826–45), carpenter; John Geist (1821–35), joiner; George Geist, Jr. (1823–35), carpenter; George Haas (1835), joiner; Daniel Hennenliter (1826–35), carpenter and joiner; Jacob Hoffman (1829–43), carpenter and cabinetmaker; Daniel Kemble (1829–32), carpenter; John Kemble (1809–25), carpenter; John Mayer (1816–38), carpenter and joiner; Conrad Rebuck (1811–25), carpenter and joiner; Peter Rebuck (1821–35), joiner; Benjamin Reitz (1832–35), carpenter and joiner; Abraham Snyder (1810–21), carpenter and joiner; Daniel Snyder (1835), joiner; George Snyder (1820–25), joiner; Peter Snyder (1806–25), joiner and carpenter; and Peter Zerfink (1810–35), joiner. Were the list shorter, the interrelationships among these men clearer, and their relationships to the original owners of the furniture better documented, it might be an easy task to attach makers' names to some of the surviving furniture.

Weiser and Sullivan argue that the painted designs, while generically similar, differ in detail enough that at least twelve hands can be distinguished. Indeed, the three chests of drawers and two desks from Schwaben Creek Valley in the Winterthur collection are a representative cross section of the work done in Upper Mahanoy, and no two of them are by the same hand. One of the chests of drawers is undated, one is dated 1830, and another 1834. One desk is dated 1838; the other is dated 1834 and inscribed "Jacob Maser" (fig. 78).[76]

Jacob Masser (Maser, 1812–95), who lived near Line Mountain in Northumberland County, is said by family tradition to have been a furniture maker by avocation. He

[72] Frederick S. Weiser and Mary-Hammond Sullivan, "Decorated Furniture of the Schwaben Creek Valley," in *Ebbes fer Alle-Ebber, Ebbes fer Dich: Something for Everyone, Something for You*, Publications of the Pennsylvania German Society, vol. 14 (Breinigsville, Pa., 1980), pp. 332–94, esp. p. 341.

[73] Weiser and Sullivan, "Schwaben Creek," p. 335.

[74] Weiser and Sullivan, "Schwaben Creek," p. 356.

[75] Because of the vagaries of the records, it is likely that many of these men who owned considerable quantities of farmland and were no longer identified by a craft designation after about 1830 or so still continued to make furniture.

[76] Weiser and Sullivan, "Schwaben Creek," figs. 25, 1, 54, 30, 37.

was long believed to be the maker and decorator of the entire body of Mahantango Valley furniture. Weiser and Sullivan, however, demonstrate that this cannot be so since Masser was only fifteen years old when the earliest dated piece of the furniture was made. The inventory of Masser's estate and the list of items sold at the vendue following his death show that his woodworking activities were confined to carpentry. The absence of a lathe and gouges, essential tools for making the legs of his desk, suggests that Masser could not have made it.[77] Weiser and Sullivan found no independent documents confirming Masser to be a professional furniture maker, and the family tradition may be that he was little more than just that.[78] While the desk is the only example by the decorator they designate as D on their list of Schwaben Creek woodworkers, its many carefully articulated details of construction show that its carcass was made by a well-trained, professional woodworker.

The subtle ways in which craftsmen reveal their individuality is often most apparent from the parts of their work that are more laborious than artful. No body of related Pennsylvania German furniture at Winterthur illustrates this better than the Schwaben Creek group. For example, drawers can be made in dozens of different ways. All of the Schwaben Creek drawers are generically the same. A quarter-round and fillet molding runs around the front outside edge, with each part constituting about half the thickness of the entire molding. Wedged dovetails hold the sides to the front and back. The bottoms are composed of two pieces of wood, glued together and feathered on three edges to fit into a groove plowed on the inside of each drawer side and front. The fourth edge of the bottom is fastened to the lower edge of the drawer back. But no drawer in any of the Winterthur examples is exactly like that in any of the others. Each reveals the particular facets of the habits, tastes, attitudes, personality, and preferences in materials of the craftsman who made it. Their distinctness from one another can perhaps best be appreciated by comparing the same details in all of the specimens itemized in table 1.

One of the axioms of art historical method applied to furniture history is that details of workmanship that do not affect the expressiveness of a piece of furniture are usually done by rote and, therefore, are consistently the same and reveal the distinctive hand of an individual craftsman. For

[77] Pastor Frederick S. Weiser and Mary-Hammond Sullivan, "Decorated Furniture of the Mahantango Valley," *Antiques* 103, no. 5 (May 1973): 932–39. Vendue of Estate of Jacob Masser, January 15, 1896, no. 220, Office of Register, Northumberland County Courthouse, Sunbury, Pa. I am indebted to Frederick S. Weiser for making this document available to me.
[78] Weiser and Sullivan, "Schwaben Creek," pp. 348–49.

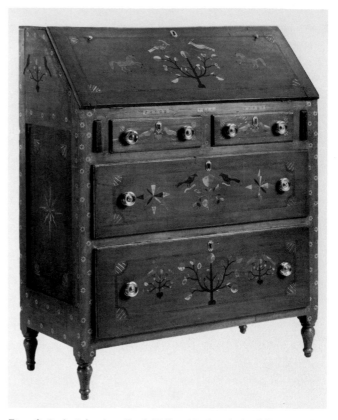

Fig. 78. Desk, Schwaben Creek Valley, Northumberland County, 1834. Tulip; H. 49⅛", W. 39", D. 19¾". (Winterthur 64.1518.)

example, the cleats mortised and tenoned to the edges of the wing of the Maser desk represent a technique that is strikingly similar to the one used by the maker of the Philadelphia desk in plate 6. Does this mean that the Schwaben Creek craftsman who made this desk was somehow aware of the technique used in Philadelphia? Probably not. The two differ sufficiently in detail to show that different craftsmen coming out of the same tradition can develop a similar solution to a problem. The tenoned batten appears in yet a different guise in a handsome desk in the federal style at the Schwenkfelder Museum, Pennsburg, Pennsylvania: the mortises are cut through the sides of the cleats, and the tenons have one further refinement, a wedge parallel to the sides of the tenon in them.

A piece of information that can be gleaned from table 1 but is not obvious from the exteriors of the Schwaben Creek furniture itself is the fact that the desk dated 1838 and the chest of drawers dated 1830, whose decoration is attributed by Weiser and Sullivan to decorator B, were in all likelihood made by different craftsmen. The presence of wooden pins in one and cut nails in the other and the fact that one

TABLE 1

Winterthur's Schwaben Creek Valley Furniture

Form	Desk	Desk	Chests of Drawers	Chest of Drawers	Chest of Drawers
Date	1834	1838*	1830	1834	undated
Weiser/ Sullivan decorator designation	D	B	B	C	L
Predominate wood	mostly tulip; some pine in drawers	all pine	mostly pine	mostly pine; tulip side, back panels	mostly tulip, some pine framing and drawer sides
Shape of framing pins	round to octagonal	quite round	square	round to octagonal	round to octagonal
Drawer-front wood	tulip	pine	tulip	tulip	tulip
Drawer dovetails	acute, almost tri-angular keys	rather close	widely spaced	widely spaced	perfectly spaced, widely spaced
Scribe lines	light at front, none at back	deeply incised	shallow	shallow	not inscribed
Chamfer at rear	not chamfered	2 strokes, rounded	1 stroke at shallow angle	1 stroke as deep as scribe for rear dovetails	not chamfered
Smaller piece of bottom	at rear	at rear	at front	at rear	at rear
Bottom nails	1 only (center) in large, 2 in small	3	3 square, wooden (pine) pins	2 cut nails	1 in center
Other details	Acc. #64.1518; writing wing framed on 3 sides, mitered, tenoned to side edges and pinned; front of loper thin & nailed on; front post's top angled to wing. Weiser/Sullivan figure 37.	#59.2974; wing not mitered, front of loper thick, mortised, pinned to tenon on loper; top of front posts cut off level with writing surface of wing. Weiser/Sullivan figure 30.	#59.2973; illegible pencil inscription side of second drawer: "——es Maser," above it, "84." Weiser/Sullivan, figure 25.	#64.1517; feather edge of drawer bottom more acutely angled than others; molding on case below lid is half round inside 2 fillets; has original drawer pulls/knobs, replacement feet. Weiser/Sullivan, figure 31.	#67.708; 3/16″ thick edging applied around edge of top; edging mitered; molding at top case is chiseled (i.e., carved) with gouge, pattern is hollows and rounds alternating. Weiser/Sullivan, figure 54.

* date is not part of the design and may have been added later.

has tulip in it while the other is all pine are differences that can be explained by time, technology, and available woods. The fact that the dovetails are laid out in very different manners, that the chamfers of the sides at the rear of the drawers are different, and, most of all, that in one the small piece of wood in the drawer bottom is placed to the rear while in the other it is placed to the front are evidence that they were made by different men, which would be difficult to dismiss. The fact that the wooden pins in the framing of one are square while those in the other are round further confirms this.

Documentary evidence that maker and decorator are not always the same man is in the accounts of both Johannes Bachman and his son, Jacob. On October 7, 1773, the elder Bachman billed Jacob Steiner 3 shillings for "ein küst angestrichen" (painting a chest). In October 1978 he wrote, "Hab ich dem Dewald Sphring ein küchen schank gemacht £8, . . . me[h]r ein küst angestrichen . . . 3 /" (I have made a kitchen cupboard for Dewalt Spring, £8, . . . also [I] painted a chest, 3s.). In 1825, Jacob Bachman charged Daniel Greider 50¢ for "painting one chest," and John King 25¢ for "painting one Beadstead," and in 1827, he charged Jacob Smith $1.25 for "painting one Kitchen Dresser," none of which he had made.[79]

But evidence survives to indicate the maker of a chest could also be its painter. Abraham Overholt noted in his daybook on March 17, 1791, "I made a poplar chest for Carl Zelner and painted it red with two drawers . . . £1:12:0"; March 31, 1791, "I made for Martien Oberholtzer a poplar chest with three drawers and blue speckled . . . £1:17:6"; March 28, 1797, "I made a chest with three drawers, I painted it blue and the mouldings red for Maria Sturd . . . £2:12:6."[80]

Pennsylvania German craftsmen excelled at the art of painting furniture, but their techniques, so obfuscated by time and changes in materials, are for the most part lost to us. The differences between then and now have caused much speculation about materials and techniques, some of it on target, much of it—especially that type that falls under the head of "if I were doing it, this is the way it would be"— cannot be demonstrated to be true.

Craftsmen used numerous painting techniques. On many floral-decorated examples, the design was scribed directly on the wood, with no undercoating, and painted in. The

colors are invariably discrete, that is, not mixed or blended on the work. All of the examples that are either wood-grained or "speckled" (sponge painted?) are undercoated. The Winterthur chests illustrated in this book were painted with pigments suspended in an oil-base vehicle, but this does not mean that all Pennsylvania German painted chests were decorated this way. It is possible that much Pennsylvania furniture was painted with casein tempera (called "distemper" in the eighteenth century), in which the pigments were suspended in a protein-base liquid, probably skim milk, curdled with quicklime. Examples of this paint survive on the ceilings of numerous eighteenth-century houses in Upper Bavaria and Tyrol.[81] Virtually all of the pigments on Pennsylvania German painted furniture—some of them organic—were commercially available in the eighteenth and early nineteenth centuries. None of them had to have been homemade from local materials.[82] Most of this furniture has been more or less "touched up" at one time or another, and virtually all of it now has a coat of modern varnish.

The means of attaining the two-toned effect that has most often appealed to modern collectors is described in numerous old books. Detailed instructions for doing it in both oil and distemper are contained in Nathaniel Whittock's *Decorative Painters' and Glaziers' Guide* (1827). First, Whittock instructs, completely and smoothly paint the surface with the ground color. This color should be the lightest tone that is desired in the finished work. When that coat has completely dried, apply a second coat, referred to in the trade as *megilp*. It is darker than the ground and usually has been mixed with an agent that prevents it from drying too quickly and from immediately binding with the ground coat. Whittock recommends white wax. He also says that oil-based megilp keeps moist longer than distemper, and that the finished work should be varnished to protect the paint.[83]

[79] Johannes Bachman daybook, pp. 25, 55, DMMC. More important are the questions of whether these chests were new or old and if Bachman's work amounted to repainting. Jacob Bachman daybook, pp. 3, 15, 29, DMMC.

[80] *Overholt / Ranck*, pp. 4, 10.

[81] Rutherford J. Gettins and George J. Stout, *Painting Materials, a Short Encyclopedia* (1942; reprint ed., New York: Dover Publications, 1966), pp. 7–8. I am indebted to Janice H. Carlson, Winterthur chemist, for testing Winterthur's chests. Samples of the paint were subjected to the protein-sensitive agent ninhydrin, with negative results.

[82] This conclusion is based upon analysis of several paint samples from chests in the Winterthur collection. Specific data is included with the pertinent item in the text. Further information about the pigments in Fraktur is contained in Janice H. Carlson and John Krill, "Pigment Analysis of Early American Watercolors and Fraktur," *Journal of the American Institute of Conservationists* 18 (1978): 19–32. Pigments included in the 1780 inventory of the Moravian's store were: "8 lb Prussian Blue 20s. 8d. [per lb.]; 6¼ ditto light ditto 12 / per lb.]; 364 lb Indigo 6 / 6 pr. lb.]; 89 lb Laque wood 1 / 2d.; 38 lb Brasille Ditto ld.; 28 lb. Allom 4d.; 70 lb. White Chalk 1d.; 166 lb. Red ditto —."

[83] Nathaniel Whittock, *Decorative Painters' and Glaziers' Guide* (London: Isaac Taylor Hinton, 1827), pp. 19, 21–28. Whittock was cognizant of the long tradition of decorative painting in England. He quoted Stalker

The tools that were used to attain the surface effects on speckled Pennsylvania German painted furniture have often been speculated on. Among the suggestions are corncobs and sponges. Few examples of this furniture reveal the minute patterns that characterize sponge painting on ceramics, and if corncobs were used, it was an instance of adopting a tool not available to a decorative painter in Europe. We do not need, however, to look too far for exotic tools; most of the rounded figures that appear on this furniture could easily have been made with conventional graining combs and graining brushes as well as with rags and that particularly supple material known as washleather. In short many tools could have been used to move paint into desired patterns, but it is now virtually impossible to tell what they were by merely looking at the 200-year-old results.[84]

Painted chests are by far the most conspicuous artifacts German craftsmen produced in eighteenth-century America. They are so striking in comparison to the unpainted hardwood chests in the English tradition that collectors have avidly sought them throughout this century. Popular collecting, unfortunately, separates furniture from its provenance with the result that few of the original owners can now be identified, but Monroe Fabian has made a pioneering effort to reestablish the ties in *The Pennsylvania-German Decorated Chest*.[85]

The obvious attractions of the painted chest have made it the icon that has come to represent German culture in eighteenth-century America. This is unfortunate in several ways. Painted chests represent only one aspect of one social and economic level of the German settlers, and the attention that they have attracted over the years has tended to overemphasize what is in reality only one episode. Further, the reduction of what actually were a number of German regional types of workmanship and iconography into a class that seems to speak with only one voice blends into one chaotic mass the many diverse regional themes and practices that Germans from widely separated geographical areas

brought to Pennsylvania. The one-note appreciation of the painted chest as a collectible requires it to remain a constant through the century and a half of its vital life in America, a point that is highly arguable.

The chests themselves may be grouped in several categories according to the way they are made. All of them are board chests. Some have drawers, others do not. A small group consists of board chests with additional pieces of wood applied to the facade, and many are dated. This group may be further subdivided into two types: those whose applied elements suggest architectonic forms and those very rare examples whose ornament consists of moldings applied to form a geometrical design. All of these have German antecedents.[86]

Structurally the carcasses of eighteenth-century Pennsylvania painted chests are much the same. The four boards that compose the case are dovetailed together at the corners. The detail from a Dürer engraving (fig. 79) shows that the basic technique was in use in southern Germany in 1506 and undoubtedly much earlier. The dovetails cut on the front and rear boards of the chests have wedges driven into them which spread them slightly, force them tightly against the dovetails of the side boards, and make as efficient a joint as it is possible to make out of wood. The technique does not require completely seasoned wood, an advantage since seasoned wood was not always available. The reason that many of these chests have lost so much of their original decoration can be traced to the fact that the oil-base paint used on them was not compatible with the high moisture content of the boards. Had distemper been used, the original paint would have survived in better condition.

With the exception of the lid of the chest in figure 80,

and Parker's *Treatises on Japanning* (1688), for example, which implies that many of the techniques Whittock described were used considerably earlier than the publication date of his book might indicate.

[84] Recent experiments carried out by Carolyn J. Weekley, curator of the Abby Aldrich Rockefeller Folk Art Center, Williamsburg, have suggested that a ball of putty, which can be shaped in various ways, is a good paint mover. The oil in putty repels the water in casein paint, and this would be advantageous if casein paint were used. Weekley has also had good results with a megilp consisting of casein paint to which vinegar has been added. Milk and beer also are reported to work well (interview, June 10, 1981).

[85] Monroe H. Fabian, *The Pennsylvania-German Decorated Chest*, Publications of the Pennsylvania German Society, vol. 12 (New York: Universe Books, 1978).

[86] It is likely that a few chests with turned spindles were made by immigrant German craftsmen who came to America in the nineteenth century. Such chests could have been made in the settlements at Old Economy in western Pennsylvania, at the Zoar community in Ohio, and in Texas and Missouri. Another category, chests made of walnut and decorated with inlay, also exists. The Winterthur collection is not rich in examples of this genre, but when the earliest Pennsylvania chests are dated, the dates are inlaid. These generally are not of Germanic origin, although inlay is an art that was practiced in Germany long before the settlement of America. One example in the Winterthur collection (acc. no. 57.1108) bears the initials ITI and has a tradition of ownership by Isaac Taylor of Gap, Lancaster County. This chest has none of the recognizable characteristics of German construction and is made and decorated in the manner we associate with Anglo-Welsh craftsmanship. The inventory of Isaac Taylor, dated August 18, 1756, in the files of the Lancaster County Historical Society, lists "one chest & drawers & box" valued together at £3. The inventory does not suggest that Taylor was a German. A related inlaid dressing table bearing the date 1724 and probably of Philadelphia origin is owned by the Philadelphia Museum of Art (acc. no. 40-16-28) and displayed at Cedar Grove in Fairmount Park.

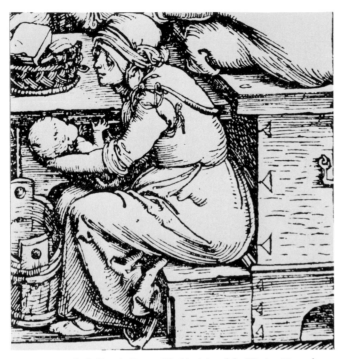

Fig. 79. Detail of Albrecht Dürer, *The Nativity of the Virgin.* Nuremberg, 1506. From Valentin Scherer, *Dürer, Des Meisters Gamälde, Kupferstiche und Holzschnitte* (Stuttgart: Deutsche Verlags-Anstalt, 1904), pl. 80.

the sides and lids of all of the Pennsylvania chests that have been examined for this book are made of a single board, usually cut from near the center of a log and easily recognized by its symmetrical pattern of annular rings (see fig. 81). Such boards shrink a bit toward their upper and lower edges but do not warp a great deal when they are rigidly dovetailed together as they are in these chests. The wedges compress the wood fibers in the dovetails so that when shrinkage occurs as the boards dry out, the joint does not loosen. The preferred woods are tulip and pine. Tulip, usually knot free, possesses a regular grain structure that is easy to work with hand tools and easy to paint. One of the yellow pines was the most common conifer used for these chests, although white pine was occasionally used when and where it was avilable. Spruce has never been found in a documentable Pennsylvania chest.

In Germany, painted chests were invariably made of conifers, either some members of the pine family (usually Scotch pine, *Pinus sylvestris*), or fir, or spruce, all of which are generally quite knotty. The boards in these chests are usually narrow, so fronts, backs, and lids are commonly composed of two or more of them. European chests are easily recognized by the end grain of the wood visible at the corners. The annular rings there usually form tight circles,

indicating that the boards came either from the tops of large trees or from much smaller trees than those of the virgin forest in Pennsylvania.

The earliest Pennsylvania German painted chest at Winterthur (fig. 80) is dated 1764. It was acquired in 1958 from Guy W. Walker, Jr., a New England collector. This chest has an applied architectonic facade, a feature that has been associated with Lancaster County, and it is made completely of tulip boards, dovetailed together.[87] The architectonic elements, of white oak, are pinned on and have been grained to look like one of the exotic woods sometimes used on German hardwood chests.

The feature that sets the 1764 painted chest and its relatives apart from the vast majority of Pennsylvania German examples is its compressed ball feet.[88] Judging by the stylistic ideas prevalent in the Anglo-American culture of eastern Pennsylvania, the feet look at least a generation behind the times. It is clear from their presence on this chest and the one in figure 79, dated 1774, that English notions of what was stylish had no effect on the maker or the owners of these chests. Ball feet had been introduced into southern Germany via Switzerland from Italy and into northern Germany by the sea route in the sixteenth century. They persisted on rural and village furniture in Germany into the nineteenth century. Therefore, their presence in Pennsylvania German furniture should be interpreted both as a convention and conscious choice that were totally independent of the time / style correlation of the English culture in Pennsylvania.

The same is true of the arches applied to the facade of this and the following chests. These arches reflect a touch of the mannerist phase of Renaissance design and appeared in high-style hardwood furniture of Germany at about the same time that ball feet did. The field of each panel on high-style German furniture in this manner is usually veneered with abstract floral intarsia (a kind of marquetry) whose origins in Italian furniture may be traced to the presence of Moorish craftsmen in Venice.[89] This lineage

[87] Three additional chests by this maker, dated 1764, 1765, and 1772, are illustrated in Fabian, *Decorated Chest*, figs. 53–55; Monroe H. Fabian, "Research on the Pennsylvania German Kist," *Der Reggeboge (The Rainbow): Quarterly of the Pennsylvania German Society* 6, no. 4 (December 1972): 3–6.

[88] An extraordinary ball-foot walnut chest made by a German craftsman, perhaps in Germantown, is in the collection at Wyck, the Germantown home of the Wister family. Pictures of numerous ball-foot walnut chests in the German manner are in the files of the Decorative Arts Photographic Collection at Winterthur.

[89] F. Hamilton Jackson, *Intarsia and Marquetry* (London: Sands, 1903), p. 8.

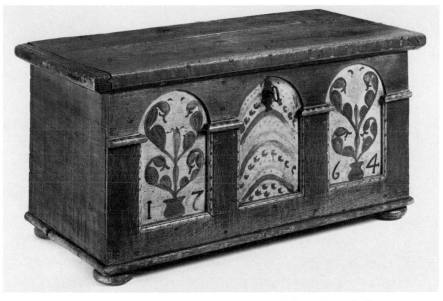

Fig. 80. Chest, perhaps Lancaster County, 1764. Tulip, white oak; H. 24¼″, W. 48¾″, D. 22¼″. (Winterthur 58.135.2)

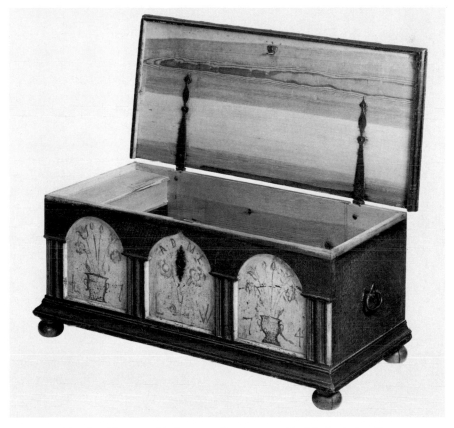

Fig. 81. Chest, possibly Lancaster County, 1774. Hard (yellow) pine; H. 21⅜″, W. 50½″, D. 23⅛″. (Winterthur 65.2255.)

immediately puts the Winterthur chest into its historical as well as its social and economic place: it is a work made not by a Schreiner working in veneers, nor a joiner using panel-and-frame construction, but rather by a craftsman working with boards, using paint the way a Kistmacher used marquetry. This craftsman provided his customer with a piece of furniture whose surface counterfeited, at small expense, the effect of intarsia.

The relationship of the 1764 chest to the tradition from which it comes raises an important question. Is it "folk art"? If the chest is a German form and was made for the use of a German in Pennsylvania, it is an artifact that speaks of German culture. In this respect, its maker, although living in an English colony and, therefore, living within an English culture, had not accepted English stylistic ideas. The same is true of the customer who bought it. Since the object is virtually the same in outward appearance as it would have been had it been made at the same time and for the same social and economic class in Germany, it cannot be judged by the standards of English ideas of what should be stylish when. Unless our definition of folk art includes the notion that a piece of furniture we would classify as folk art was made long after the high-style versions of it were first popular in the culture that produced it—a stricture that we have never placed on English-style furniture made in colonial America—then this piece of furniture is not folk art: it is merely inexpensive high art.

The allusion to veneer in the 1764 chest becomes stronger when we remember that the individual pieces of wood in an intarsia panel were usually stained to increase their verisimilitude. The resemblance is even more apparent when we compare the chest with its late sixteenth-century European antecedents. The design in the two flanking panels is floral, consisting essentially of what Randle Holme called "a flower pot, or a jug with two eares," from which emerges a central flower on a stalk.[90] The painting on the central panel does not appear to portray anything, unless, like the graining on the arches, it represents an exotic wood.

Because interest in the arts of Pennsylvania Germans has revived during a period in which scholars have begun to study the decorative arts more critically than they did a half century ago, looking at a chest without considering how to get at its meaning is no longer adequate. The idea that meaning is present here is not subject to argument. Decoration that carries a meaning comes from a tradition in con-

tinental Europe that predates the immigration of Germans to Pennsylvania. The characteristic of this tradition is that the decoration is appropriate to the form of furniture on which it appears. Eighteenth- and nineteenth-century painted furniture in German museums, particularly that which was made and used by Roman Catholic Germans, has decoration whose didactic intent is unmistakable. Who, for example, could ever think an impure thought in a *Himmelbett* (four-poster bed) decorated with religious painting? The painted decoration on furniture owned by Pennsylvania German Protestants may sometimes seem mild and ambiguous, a circumstance caused by the twofold effort of avoiding Catholic symbolism while of necessity hewing to the common cultural tradition from which both Catholic and Protestant Germans sprang.

The search for meaning in Pennsylvania German arts has followed different trends since the 1920s. One strain of investigation culminated in two books by John Joseph Stoudt, *Consider the Lilies, How They Grow* (1937) and *Pennsylvania German Folk Art: An Interpretation* (1966).[91] Stoudt's enthusiasm for his subject was, unfortunately, not coupled with the literary knack of disarming criticism in advance: he managed to offend virtually every segment of the Pennsylvania German community. What he had to say about some Pennsylvania Germans was not necessarily true of all Pennsylvania Germans. Most of all, the author of these ambitious and pioneering works tended to founder, as all writers about decorative arts subjects eventually do, when he tried to equate literary images with the physical ones that appear on the furniture. The criticism of this aspect of Stoudt's work is well taken; who can say for sure what an artist who did not keep a diary was thinking when he painted something? We are fortunate when we can learn how much he charged for it. Ideas about what the artist intended his design to mean will always rely upon argument rather than proof.

The reaction against what has been interpreted as Stoudt's excesses has left us in an age of relatively bland underinterpretation designed to offend no one. Regardless of whether time will prove that either or neither of these points of view is correct, the vigor of the decoration on Pennsylvania German furniture indicates that it was made and used by a vigorous society. It invites vigorous interpretation but cannot be addressed in detail in this essay.

Students of the arts know that the possible meanings that can be extracted from objects are not confined to the deco-

[90] Compare this with figs. 136–38 in Peter W. Meister and Hermann Jedding, *Das Schöne Möbel im Lauf der Jahrhunderte* (Heidelberg: Keysersche Verlagsbuchhandlung, 1958). Randle Holme, *The Academy of Armory*, vol. 1 (London, 1701), vol. 2 (London: Roxburghe Club, 1905), 2:2.

[91] John Joseph Stoudt, *Pennsylvania German Folk Art: An Interpretation*, Pennsylvania German Folklore Society, vol. 28 (Allentown, Pa., 1966). The storm of criticisms that Stoudt aroused is in inverse proportion to the legitimacy of the approach he took.

ration on their surfaces. The materials and the way they are handled by a craftsman also give insights into the social and cultural history of the place and time in which an object was made. The Pennsylvania German painted chest is no exception, for like every object made in a transplanted cultural tradition, it illustrates adherence to tradition and change. The most striking example of this principle at work can be observed by analyzing the construction of the lids of the American chests.

The lids of German chests are usually composed of two boards. Moldings attached to the front and two sides of the lid form a lip that effectively seals the inside. On the majority of eighteenth-century Germanic chests, these moldings extend above the surface of the top boards. An additional molding is applied to the upper surface of the lid along the rear side, and a fifth molding is added across the center of the lid from front to back. The additional moldings create the appearance of two joiner's panels and physically stiffen the lid. The American box in figure 82 has a lid that portrays this effect. Tenons cut on the corner edge of each of the two boards at their juncture are fitted into mortises in the two side moldings and are pinned and sometimes wedged in place as well. Both pins and wedges are visible on the joint of a German chest (fig. 83). The gap between the two boards is caused by shrinkage. It indicates that the boards of the top were not totally dry when they were assembled, which offers evidence that the technique of working conifers that had not been completely "seasoned" was brought to Pennsylvania from Europe.

Psuedojoined lids in the European manner have so far been observed on only two pieces of identifiable Pennsylvania German furniture, a small box (*Kästgen?*) in the Mercer Museum, Doylestown, and another in a private collection (fig. 80). Both are made primarily of tulip.

Lid moldings on the earliest of the American chests are pinned to the front and side edges of the top, and their upper surfaces are flush with the top surface of the boards. The edges of the lid usually have a tongue planed on them which fits into a groove on the inner edge of the molding. This tongue and groove is visible on the front of the side moldings of the lid in the overall view of the chest in figure 78. In addition, two tenons—instead of one found on the European examples—are cut on each lateral edge of the top board, and these fit into mortises on each side molding, where they are held in place by pins driven perpendicularly through the completed joint (fig. 84). Sometimes the tenons are wedged from the outside. The front molding is pinned onto the front edge of the lid. These moldings, which are often massive on early examples, serve as cleats, like those on tables, to stiffen the top and prevent warping. Chests

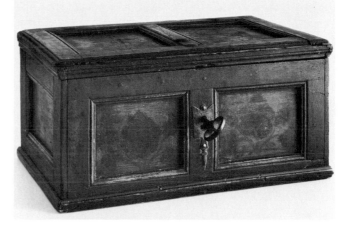

Fig. 82. Box, Pennsylvania, 1750–75. Tulip; H. 7⅞″, W. 16¼″, D. 10⅝″. (Private collection: Photo, Winterthur.)

Fig. 83. Detail of wedged and pinned tenon on German chest, Bavaria, ca. 1800. (Liechey Collection, Schwaben Hall, Bavaria: Photo, Benno M. Forman.)

Fig. 84. Detail of pinned mortise of chest shown in fig. 83.

made after the Revolution tend to have no lid tenons, and the moldings are generally smaller, often only as thick as the lid itself. The use of a lid that has a flush upper surface rather than being pseudojoined cannot be thought of as an American development, since numerous German examples have this feature. It should rather be seen as an alternative form which, for reasons that we have not yet discovered, became the rule in Pennsylvania.

The chest in figure 79 is dated a decade later than the one in figure 78. The identity of L. W., for whom it was made, is not known. The underside of its lid shows the grain pattern of a center-cut board. To the left inside the chest is what was properly referred to as a till in eighteenth-century English, or a *Kuffer* (cognate, "coffer") in German. Both of these words were used throughout the Middle Ages to describe a receptacle for money. When the till is built into a chest that could be locked, it was used for the storage of small articles of value. Doubtless such a till held the "cash in his Chest . . . £65" listed in the 1733 inventory of John Hess of Lancaster County.[92] The ogival arch above the center panel is a motif carried over from the Middle Ages and should not be construed as an idea derived from a piece of Pennsylvania William and Mary–style furniture. The painted design on the front of this chest evokes essentially the same ideas as that of the 1764 chest.

The rule of thumb that architectonic decoration added to the facade of a chest indicates that it originated in Lancaster County presents a problem when we attempt to apply it to the 1774 chest. Its provenance is unknown, but a closely related chest dated 1785, perhaps from this maker or one of his former apprentices, is in the collection of the Art Institute of Chicago. Christopher Hama, the man whose name is painted on the 1785 chest, lived in Pine Grove Township, Berks County, when the census of 1790 was taken.[93] This is not to say that the rule of thumb is wrong, but given the perambulatory habits of craftsmen, the possible exceptions to such rules tend to make them useless.

Is it possible that chests like the examples illustrated in figures 78 and 79 are the earliest ones made by Germans in Pennsylvania? Where, for example, are the early chests of Germantown and elsewhere that are comparable to the slat-back chairs discussed above? Could an entire generation have passed away before someone painted a date on a chest? After all, European furniture with carved or inlaid dates survives from the sixteenth century. The chest that was made in 1764 was probably made for a second- or third-generation settler. Since we know nothing of the chests of the first generation, how can we interpret this and even later ones intelligently? Our best ideas can be little more than surmises. Do the dated painted chests represent the continuation of a tradition, as the motifs that appear on them suggest? Are they chests made and used by a new wave of German immigrants who came to Pennsylvania after the middle of the

century? Or do they represent the first attempt to hold onto a tradition that the surviving first-generation settlers realized was slipping away? The answers to these questions will very likely be discovered by a social historian and not a historian of artifacts.

If the concept of the "dower chest" is correct, then, in a sense, a chest was the possession of a female and not a male. Certainly the 1747 will of Johannes Keim of Berks County suggests that this could be so. Keim specified that his wife "shall have her walnut chest, Spinning wheel and the Side Sadle and at least the Seat in the House were I live during her Life." Johannes Bachman specifically made chests for young Mennonite girls in the early 1770s. In the account of Abraham Neukom on March 5, 1772, he noted, "hab ich seiner Magd Maria ein Küst gemacht . . . £1:06:00" (I have made a chest for his daughter Mary), and on November 18, 1775, "Johann Martin bät . . . seiner magt ein küst gemacht . . . £1:18:00" (Johann Martin bade a chest be made for his daughter).[94]

Where, then, did eighteenth-century men keep their clothes? In their wives' chests? What if they weren't married? The answer is, of course, that all chests were not "dower" chests; men also had them and several mid to late eighteenth-century examples with men's names inlaid or painted on them can be found in the files of Winterthur's Decorative Arts Photographic Collection. The inventory of Johannes Gelbeck of Oley Township, Berks County, dated August 28, 1758, for example, reveals that Gelbeck possessed "a chest and Drawers" valued at £2.10. But chests appear in the inventories of men decades before 1758. Jacob Landes of Lancaster County had a chest, valued at 14 shillings, in 1730, as did Jacob Goot of Conestoga. Peter Holdiman of Donegal owned two, valued together at £1.4, in 1739.[95]

[92] Eighteenth- and early nineteenth-century Lancaster County Inventories are in the manuscript collection of Lancaster County Historical Society, Lancaster. They are filed alphabetically by year. Pennsylvania Germans used *Newekischt* rather than *Kuffer*.

[93] Fabian, *Decorated Chest*, p. 219, fn. 24; fig. 122.

[94] Will Book 1, pp. 8–9, Registry of Probate, Berks County Courthouse, Reading; Johannes Bachman daybook, pp. 17, 34, DMMC. The term *dower chest* does not appear in any eighteenth-century records, German or English. In addition to not being a period term, hence a source of confusion for students of history, the phrase poses a grammatical problem since both English and American dictionaries show *dower* as a verb and a noun but not as an adjective. *Dower* is "the part of or interest in the real estate of a deceased husband given by law to his widow during her life," a far cry from the concept that users of the phrase *dower chest* intend to convey. A *dowry*, on the other hand, can be "the money, goods or estate that a woman brings to her husband in marriage," and the phrase, *dowry chest* could be construed as grammatically correct, although it does not appear in contemporary records. It was customary in both English and German cultures for the husband to return such goods to the wife by will. Russell Weider Gilbert, *Pennsylvania German Wills*, Pennsylvania German Folklore Society, vol. 15 (Allentown, Pa., 1951), pp. 51–52, 76–77, lists many goods that would not fit in a chest.

[95] Berks County Inventories.

The general dearth of surviving chests that can be associated with men may be partially attributed to the fact that, in Pennsylvania, settlers of German extraction had an option that they did not have in Germany: the English-style chest of drawers and desks. Henry Willets, a tanner of Maiden Creek, Berks County, had a "case of drawers" valued at £3 in 1755. In that same year, John Wily of Maiden Creek left a case of drawers valued at £3.15. He also had a "chist" valued with a table at £2.10. The estate of the much honored and wealthy Conrad Weiser of Reading included "a chest of drawers with rubbish in it" valued at £3.7.6.[96] With the advent of an alternative form of furniture for use by men and mature, married women, it is possible that around the middle of the eighteenth century the chest to be filled in anticipation of marriage took on a new significance as a form of furniture appropriate to the daughters of the household.

The chest illustrated in plate 12 bears the date 1778. It has a legible but indecipherable inscription in the form of a rebus on its lid and is sufficiently related to a chest dated 1784 with the name Catherina Brumbrin painted on it to enable us to attribute it to a Berks County origin.[97] This is the earliest of the dated chests at Winterthur that, in addition to the obligatory floral motifs, is decorated with a geometrical design as well. The way in which the decorator handled this design suggests that he was counterfeiting in paint that particular kind of abstract marquetry known as parquetry. The details that suggest this are most apparent where the straight lines on the arched panels awkwardly meet the curved line of the arches. Many of the other corners are also handled in a similarly inexplicable manner. The mismatch of patterns is particularly noticeable on the side panel. The immediate temptation is to assume that these discontinuities came about because the maker did not plan well, an idea that is difficult to countenance in this otherwise professional work, or that he lacked training, an idea that is belied by the extraordinary delicacy of the rinceaux in the central panel of the lid, now badly faded, but one of the most brilliant passages in all of the chests. Another, perhaps more subtle, explanation can be argued: the painter intended to heighten his simulation of parquetry by purposely mismatching the pattern. The makers of geometrical parquetry in the urban areas of Germany, where it was most used, were specialists who made and sold it by the running foot to craftsmen who added it to their chests. Numerous pieces of northern European furniture show that these craftsmen applied this stock parquetry with no attention to matching up the patterns perfectly.[98]

The iconography of the chest contains several motifs that are not present on the earlier Winterthur chests. The central flower of the flanking facade panels, which may represent a fully opened tulip, has a coronal shape, complete with conventionalized triangular additions that in heraldic designs represent thorns, an image replete with secular and religious overtones. Although this rendering of a crown is not common on American furniture, it is present on painted furniture in the German National Museum and Stockholm's Nordiska Museum. The suggestion of a flower/crown is heightened by the man on horseback in the central panel. A Dauphin County Fraktur of circa 1790 with a horse and rider has the text "Ich iege nach der Crone des Gerechtigkeit" (I hunt for the crown of righteousness).[99]

In the same way that the crown is a universal symbol of authority, enriched by its association with Christ, the man on horseback is also an evocative image of great antiquity. When we delve into its ancient meaning, however, we find that it is more virile than the mere concept of a huntsman. Stoudt persuasively argues that this image alludes to Saint John's vision (Rev. 19:11–16) in which he "saw the heaven opened; and behold, a white horse, and he that sat thereon called Faithful and True; and in righteousness he doth judge and make war. . . . His name is called the Word of God. . . . Out of his mouth procedeth a sharp sword, that with it he should smite the nations: and he shall rule them with a rod of iron." The image is conventionalized here by placing the sword in the hand of the rider rather than in his mouth, and the eighteenth-century costume in which he is clad makes the figure appear quaint rather than vengeful. Nonetheless, the horse is and always has been a symbol of irresistible power. Beryl Rowland has shown that from the Middle Ages onward the horse alone, such as appears on the lid of the Jacob Masser bureau (fig. 78), was considered a phallic symbol and that the man on horseback multiplies this meaning. This combination can be further interpreted as teaching the opposite—that appetite or passion can be controlled by a virtuous mind.[100]

The reconciliation of opposites is also implied by the

[96] Berks County Inventories.
[97] *Pennsylvania Furniture of the Eighteenth Century: The Collection of the Late Stanley F. Todd*, Samuel T. Freeman, sale catalogue, May 23–24, 1966, p. 20, fig. 76.
[98] Forman, "Continental Craftsman," pp. 100–101, pls. 25–28a.
[99] Frederick S. Weiser, *Fraktur* (Ephrata: Science Press, 1973), frontispiece.
[100] Stoudt, *Folk Art*, p. 115; Beryl Rowland, *Animals with Human Faces: A Guide to Animal Symbolism* (Knoxville: University of Tennessee Press, 1973), pp. 103, 107–9. The tradition of rendering biblical and classical figures in the costume of the time of the artist rather than the time of the character or event depicted predates the Renaissance. For a European rendition of a rider on a dark horse, see Deneke, *Bauernmöbel*, pl. 54.

image of the unicorn, which figures prominently on the chest made for Margaret Kern (pl. 13), dated 1788. The chest is painted with flowers that have been associated with the manner and vocabulary of Fraktur artist Heinrich Otto, although the painting on the chest is not by the hand that painted the Fraktur. Otto worked in Lancaster County.[101]

The unicorn is a fabulous beast with a twisted horn emerging from its forehead, the bearded head, neck, and body of a horse, the legs and cleft hooves of a deer, and the tail of a lion. As it appears on this chest, the image was more readily available to a German in Pennsylvania than to one in Germany. It is taken from the "achievement or Sovereign Ensign Armorial of the Most High and Mighty Monarch, George, by the Grace of God of Great Britain, France and Ireland, King" and was added to the escutcheon of the English monarchs when the Stuarts of Scotland ascended the English throne.[102]

The unicorn of fable has all of the symbolic qualities associated with the horse. It varies from the horse in that it is supposed to be swifter and can be captured only by the scent or sight of a virgin, with whom it is usually associated in medieval paintings. Rowland notes that the authors of the medieval bestiaries equate the unicorn with Christ—the horn represents His unity with His Father, the animal's small size, His humility. She continues:

The phallic nature of the symbolism is particularly obvious in a fifteenth-century German engraving of the Annunciation. . . . Gabriel, as a huntsman, blows the angelic greeting on a hunting horn. The unicorn, pursued by dogs, flees to the Virgin, who is sitting in a state of ecstasy with upturned eyes and her hands folded across her breast as the horn is plunged in her lap. God the Father blesses the pair from above. Here the unicorn clearly represents the fertilizing breath of the Holy Ghost or *Logos*, the word of God made flesh.[103]

Such symbolism as the unicorn and many of the others discussed here should not be interpreted as belonging to pre-Protestant theology or having no place on a painted chest intended for the use of a young girl. Nor should the pagan aspects of the symbols that were made a part of Christianity as it spread through Europe be rejected as irrelevant to our topic. A symbol has meaning because it is rooted in traditions with which those who are being taught new ideas can associate. It owes its richness as a symbol to the fact that its meanings have continuity. Symbols are rooted in the needs of a culture. While the matter represented by the symbols on chests such as the one that belonged to Margaret Kern is something that our society prefers to leave for the sex-education classes in our schools, the agrarian society of the eighteenth-century Pennsylvania Germans dealt with those needs in a straightforward, certainly creative, way.

The chest illustrated in plate 13 A. H. Rice described in his 1926 *Antiques* magazine advertisement as "Chest with Birds, Tulips and Adam and Eve." It was not purchased for the Winterthur collection, however, until 1957. The feet had been replaced prior to its acquisition.[104]

A number of related chests with one or two painted panels consisting of an arch supported by baluster-shaped columns and a pot of flowers within each, have appeared in numerous publications over the years. Only one of these furthers our knowledge. It is dated 1803, which places the Winterthur example in the probable quarter century of its creation.[105]

The story of Adam and Eve is told on the Winterthur chest with a vitality and attention to detail that exceed the limited technical ability of the artist. Adam, whose name in Hebrew means man—the progenitor of all people—will forever symbolize the loss of innocence. Here he stands with Eve under the tree of knowledge at the moment before they

[101] Monroe Fabian to Elaine Eff, March 1 (1977?), Object Folder 59.2804, Registrar's Office, Winterthur Museum. The feet are not original; see Esther Stevens Fraser, "Pennsylvania Bride Boxes and Dower Chests, II: Country Types of Chests," *Antiques* 8, no. 1 (August 1925): 81, fig. 5. I am indebted to Charles F. Hummel, deputy director for interpretation, Winterthur, for this reference.

[102] Guillim, *Heraldry*, p. 83, describes the English version of the unicorn as "gorged [around his neck] with a Princely Crown; from which is a Chain turn'd over his Back, and between his Legs, [colored] Gold, of which Metal he is also hoof'd, main'd and tuff'd [bearded]." Since Guillim died ninety-three years before George I ascended the throne, the quotations cannot be attributed to him, although no other author's name is appended to the revised and enlarged text. The English edition of Caesar Ripa, *Iconologia or Moral Emblems* (London, 1709), by P. Tempest, says that "a gold chain hanging down from heaven . . . signifies . . . conjunction and the Chain whereby God is pleas'd to *draw* Men to himself, and *raise* the Mind to Heaven" (p. 16, fig. 64).

[103] Rowland, *Animals*, pp. 153–54. A difference between English and German imagery on this point can be illustrated by a single example,

although there are many. Num. 23:22 in the King James Version of the Bible, is rendered: "God bringeth them forth out of Egypt; He hath, as it were, the strength of the wild-ox." The same passage in Luther's translation reads: "Gott hat sie aus Egypten geführet; Seine freudigkeit ist wie eines einhorns." And the second line translates, "His joyfulness is like a unicorn's."

[104] Advertisement, *Antiques* 10, no. 5 (November 1926): 426. The sole item Henry Francis du Pont purchased from the advertisement was a chest of drawers, dated 1834 (acc. no. 64.1517). He subsequently purchased the Jacob Maser desk and an additional unidentified chest of drawers in December 1929. They were the only items left from the original offering. A. H. Rice to du Pont, May 18, 1927, H. F. du Pont Correspondence, Registrar's Office, Winterthur Museum.

[105] Israel Sack, Inc., *Opportunities in Antiques*, no. 27 (October 1975), no. P4136. Adam and Eve were popular subjects and at least fifty broadsides were printed for early nineteenth-century Pennsylvania German consumers; see Walter Boyer, "Adam und Eva im Paradies," *Pennsylvania Dutchman* 8, no. 2 (Fall/Winter 1956/57): 14–18.

taste the forbidden fruit and thus become mortal. The snake, the Old Testament incarnation of temptation and the guile of evil, sinuously winds about the tree trunk. The painter of this chest, however, used his art to tell us much more. The overall color of the background is green, suggesting the verdure of Eden, and for once, the conventional setting off of a subject within a panel has a telling effect, as if Adam and Eve, not yet having tasted the fruit, are still within the predictable safety of the garden.

The corners of the chest are decorated with stylized hearts, the motif most commonly used by Pennsylvania German craftsmen and Fraktur artists to suggest both the innermost feelings of man and the regenerated or saved soul. Perhaps the introduction of Christ into this Old Testament story suggests that the painter of Winterthur's chest intended to join the story of Adam's fall to the New Testament words of Saint Paul who described Adam as "the figure of Him that was to come. . . . For as through the one man's disobedience the many were made sinners, even so through the obedience of the one shall many be made righteous."[106]

The serpent, or snake, has not invariably been interpreted as a symbol of evil or treachery. Some exigetical writers saw in the fact that the snake sheds its skin a symbol of renewal, as Christ renewed the spirit of man. Saint Augustine, for example, interpreted the moment in which Moses lifted up the serpent in the wilderness as prefiguring "the death of the Lord on the cross."[107]

When we analyze a painting that was executed by an artist who did not take his system of symbolism from the culture that we know best, we are sometimes tempted to find in his work details that suggest literal meanings that he did not intend. Is the line painted in the center of Adam's chest meant to suggest hair, or is this the incision that remained after God removed his rib to create Eve?[108] The scar is portrayed in numerous post-Renaissance paintings, and perhaps the painter of this piece of furniture intended us to see this. And what are the dots at the ankles of Adam and Eve? Are they merely this artist's way of rendering ankles, or do they have a deeper meaning? They certainly could be interpreted as stigmata, signs of condemnation and disgrace in the Old Testament context and an unusually

vivid image in a Protestant painting. But, in the context of New Testament thought, they are signs of redemption and remind us of the idea that Christ resurrected Adam and Eve when he descended into Limbo.[109] These thoughts are graphically joined in popular Taufschein in the Winterthur collection commemorating the birth of Anna Mary Stauter of Swatara, Lebanon County, in 1819. It was "Eng[rave]d and sold by C[arl] F[riederich] Egelmann on Pennsmount near Reading," and among other images, has a picture of Adam and Eve in the Garden entitled *Paradise Lost.* Opposite is a picture of Golgotha with Christ and the two malefactors crucified, and under it is printed the legend *Paradise Found.*[110]

For the first time on the Pennsylvania German furniture at Winterthur we are able to see birds in a meaningful context. These colorful creatures, which add so much charm to Fraktur and painted furniture, are traditionally called distelfinks. If they are indeed intended to represent that bird, they have meaning on two levels. The distelfink, literally thistle finch, is not native to America. It is, in fact, a bird known in continental Europe as the siskin (*Spinus spinus*). An English ornithologist tells us that the siskin is a relative of the canary and informs us, with the typical reticence of a scholar whose mind should be on other things, that "his song is not unmelodious."[111] On the level of delight, then, the image of the bird evokes the happy recollection of his song.

On another level, the bird symbolizes the soul. The captive bird further enriches this idea. In 1506, Dürer rendered the siskin in the context of the Madonna and Child twice, once in oil and once in a copperplate engraving. Beryl Rowland has analyzed the engraving. "The vital movement of the illustration is in the child, who strains in his mother's lap to hold a bird, the symbol of the human soul. Below him, in contrast, sits a motionless, chained simian with some partially eaten nuts. Whereas the bird in the hand is the voluntary captive of Christ, the fettered monkey symbolizes the sinner enslaved by his own bodily lust."[112]

Not all of the chests at Winterthur deal with such heady subject matter. The makers of many of them appear to have

[106]Rom. 5:14, 19. In I Cor. 15:22, Paul writes: "For as in Adam all die, so also in Christ shall all be made alive."

[107]Rowland, *Animals*, p. 145; John 3:14. No serpents are borne by the noblemen in Guillim's *Heraldry.*

[108]A less ambiguous scar appears on the chest of Adam in a ca. 1810 Fraktur by Johann Valentin Unger; see Frederick S. Weiser, *The Pennsylvania German Fraktur of the Free Library of Philadelphia: An Illustrated Catalogue,* Publications of the Pennsylvania German Society, vol. 10 (Breinigsville, Pa., 1976), pl. 94.

[109]H. W. Janson, *History of Art* (New York: Harry N. Abrams, 1962), pp. 176–77, fig. 286.

[110]Taufschein, acc. no. 60.105. The engraving may postdate Egelman's arrival (1821) in the Reading area; see Donald A. Shelley, *The Fraktur-Writings or Illuminated Manuscripts of the Pennsylvania Germans,* Pennsylvania German Folklore Society, vol. 23 (Allentown, Pa., 1961), pp. 69–70, 156–63, 186. I am indebted to Nancy Coyne Evans, registrar, Winterthur, for this reference.

[111]*Encyclopaedia Britannica,* 1946, s.v. "Siskin."

[112]Rowland, *Animals*, p. 13.

been more concerned with beautifying a cumbersome form of furniture than dabbling in theology. The painted chests made by members of the Seltzer and Ranck families of Jonestown, Lebanon County, are a case in point. The central vase of the chest illustrated in plate 15 bears the inscription, in English, "Christian Seltzer his work 1796." Esther Stevens Fraser first wrote about chests by Seltzer (1749–1831), the founder of the Jonestown school of decoration, and his apprentice Johannes Ranck (1763–1828) and Ranck's brother, Peter (1770–1851), in 1927.[113] Fraser's articles caused great excitement because for the first time the names of a few men who decorated Pennsylvania chests emerged from anonymity. The chests have been popular collectibles ever since.

Fraser's interest—as it was in all of the articles she published—focused on the painted decoration of the chests, and she analyzed the relationship of the work done by these Jonestown craftsmen with a great deal of success. Subsequent research has shown that, in addition to being decorators, Seltzer and the Rancks were also joiners for a good part of their lives and very likely made the chests they decorated.[114] Comparison of the structures of the chests confirms the conclusions that Fraser drew on the basis of the painting: Christian Seltzer was a master of his craft whether you admire his work or not; Johannes Ranck, whose chest dated 1790 is illustrated in figure 85, was an attentive pupil; and Peter Ranck, whose chest dated 1880 is pictured in figure 86, practiced his trade in a fairly uninspired fashion.

The moldings around the edges of the lids of all three chests are merely pinned on, that is, no tenons were cut on the ends of the lids and no tongue-and-groove joints were used. The junctures of the sides with the fronts and backs of the Seltzer and Johannes Ranck chests are mitered—an elegant touch that required some extra effort—those of Peter are not. The dovetails on the Seltzer chest are things of beauty—neatly angled, perfectly spaced—those on Johannes Ranck's chest are irregularly spaced and have rather casually articulated angles. Peter Ranck's are about the same as his brother's. The painting on the Seltzer chest is done with assurance, and the outline of the floral design was not scribed before the painting was executed: in 1796 at the age of forty-six, Christian Seltzer knew what he was doing. The rough layout of the floral design on the Johannes Ranck chest was scribed before the paint was applied. Peter Ranck's work is similar to his brother's but less inflected.

The differences between these craftsmen may be explained by the degree of individual talent each possessed or by the amount of opportunity each had to practice his craft, for all of them gained a portion of their income from activities other than woodworking. The former is not easy to assess objectively but seems to be the logical choice because Peter Ranck's accounts for the twenty-three year period between 1794 and 1817 reveal that he made sixty chests—five chests every two years—a respectable number considering the size of Jonestown and the fact that at least three other joiners were working there. No diminution in demand occurred with the turn of the century. The chests themselves suggest that Johannes Ranck learned his trade from Christian Seltzer, and that Peter Ranck probably learned his from Johannes, who was old enough to be working on his own account by the time Peter reached the age at which he could begin his apprenticeship.

The central panel of the Christian Seltzer chest in plate 15 portrays the last gasp of the mannerist European high style in eighteenth-century America. The explicitly rendered female figure, emerging like a good-natured, wasp-waisted genie from a two-handled jug, is an echo of caryatids carved on European furniture in the sixteenth century, as are the asymmetrical leaves above the flowers in the upper quadrants of the panel. The tulips that dominate the flanking panels of the facade have undergone a remarkable metamorphosis. They now have a contrastingly painted central element which changes their appearance. This central element is further embellished with a row of vertical spots that are given additional emphasis by the circles painted around them. It is tempting to see these tulips as having been transformed into pomegranates. This image has not heretofore been encountered in Pennsylvania German iconography, although it is a common enough motif in eighteenth-century blue-resist-printed textiles, on late seventeenth-century painted furniture in Holland, and on German, delft-type plates, where it is casually referred to today as the Meissen onion. The pomegranate is mentioned in the Bible thirty times, always as a symbol of delight. In the Middle Ages it was variously interpreted as a symbol of hope, fruitfulness, and fertility, and, because of its numerous seeds and the fact that they break through the husk when the fruit matures, the Resurrection.[115]

[113] Esther Stevens Fraser, "Pennsylvania German Dower Chests Signed by the Decorators," *Antiques*, pt. 1, 11, no. 2 (February 1927): 119–23; pt. 2, 11, no. 4 (April 1927): 280–83; pt. 3, 11, no. 6 (June 1927): 474–76.

[114] *Overholt / Ranck*, pp. x–xi.

[115] William B. Honey, *Dresden China* (New York: David Rosenfeld, 1946), p. 92. I am indebted to Phillip H. Curtis, associate curator, Winterthur, for this reference. Michael Daves, *Young Readers Book of Christian Symbolism* (Nashville: Abingdon Press, 1967), p. 49; John W. Ellison, comp., *Nelsons' Complete Concordance of the Revised Standard Version Bible* (New York: Thomas H. Nelson and Sons, 1957), pp. 1497–98; Arnold Whittic, *Symbols, Signs and Their Meaning and Uses in Design* (2d ed.;

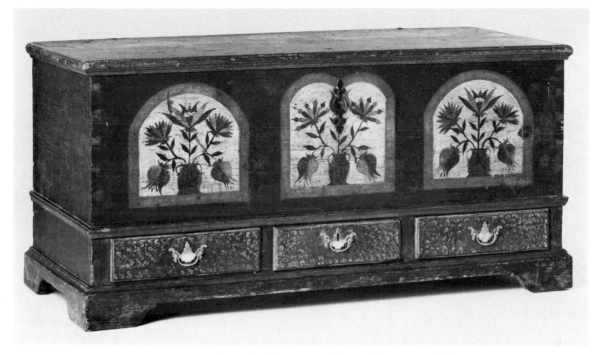

Fig. 85. Chest, Johannes Ranck, Jonestown, Lebanon County, 1790. White pine; H. 25″, W. 51½″, D. 22″. (Winterthur 67.783.)

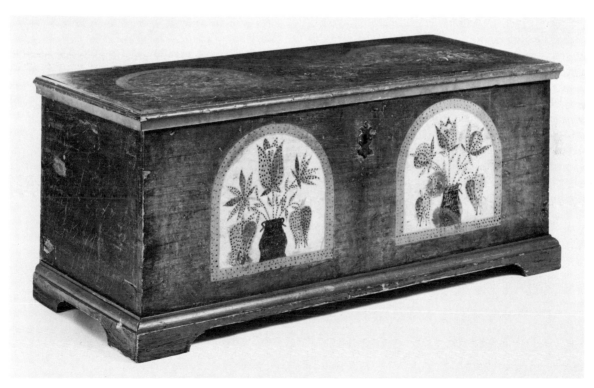

Fig. 86. Chest, attributed to Peter Ranck, Jonestown, Lebanon County, 1800. White pine; H. 22¼″, W. 51⅜″, D. 22¾″. (Winterthur 67.760.)

The Seltzer chest has little about it to suggest that it was made at the end of the eighteenth century. The transformation of the pots that appear on earlier Seltzer chests into jugs (not unlike the so-called bellarmine jugs of German origin) does not seem to represent an awareness of Anglo-American neoclassicism; it seems, instead, to be the substitution of one type of German jug for another.[116] The presence of the earlier style pot on the chronologically later chest by Peter Ranck suggests that he continued to use a form he had learned during his apprenticeship.

Because they are dated, the Seltzer and Ranck chests provoke another question. How did the makers of the Pennsylvania painted chests escape the European fashion of painting their chests in the rococo style? Numerous examples reveal that this style became quite popular in Germany in the third quarter of the eighteenth century and continued well into the nineteenth.[117] The only rococo touch on German American chests is an occasional assymetrical iron escutcheon, like the one on the Seltzer chest. A similar escutcheon appears on the earliest of the Winterthur chests (fig. 78) and could be classified as a rococo device only in the broadest terms: it is nothing like the elaborately asymmetrical work that was done in Germany after the middle of the eighteenth century.

This question raises another: Why, in contrast to European practice, is carved work virtually nonexistent on Pennsylvania case furniture made in the German styles? This question of carving is perhaps easier to deal with than rococo painting, for carving is a trade and not a style. The explanation could well be that few of the joiner/carpenters who established the various schools of case-furniture making in Pennsylvania were carvers. This, in turn, suggests an answer to the problem of the absence of rococo-style painting: the later eighteenth-century case furniture of the Pennsylvania Germans was made by second- and third-generation craftsmen who had learned their trades from earlier generations of craftsmen. Virtually no rococo decoration appears on middle-class German painted furniture prior to the 1780s, so we may assume that this style was not known to the masters of these second-generation craftsmen, and for that reason, the style of painted furniture made in interior

Pennsylvania continued to be based on ideas learned prior to the invention of the rococo style.

When new iconography appears on Pennsylvania German furniture, it is secular, indeed patriotic, in theme and neoclassical in style. The remarkable chest illustrated in figure 87 portrays a part of the Great Seal of the United States, adopted in 1782, and in doing so is somewhat more American than German. The cut nails that hold the drawer bottoms to the drawer backs suggest that the chest could have been made anytime in the nineteenth century. Its maker is unknown. It was purchased for the Winterthur collection in 1937, at which time Henry Francis du Pont was advised by the previous owner, A. J. Pennypacker, that the "Eagle chest came from the Mahantango Valley in Snyder County, Pennsylvania."[118]

The eagle and shield of the Great Seal also figure prominently on a remarkable clock (pl. 10) bearing the inlaid inscription on the frame surrounding its face "Leickens Taunschip Dauphin Caunty Verfertiget von Johanes Paul." Although a letter from Charles Bellows in the Winterthur files says that the clock was made for his grandmother's "maternal great grand parents, Benjamin and Catherina Eva Groff Hammer of Washington Township, Dauphin County," the clock was in all likelihood made by Paul for his own use. It probably remained in his estate until after his death in 1868, at which time it was sold at auction, possibly to Bellows's ancestors.[119]

The Paul clock movement is probably of British origin.[120] The case, however, may be classed among the half-dozen most extraordinary pieces of American woodwork at Winterthur. It is composed totally of joined panels, a rarity in itself, and is all the more remarkable because the small panels of the door (pl. 11) and base are hand carved and feather edged and inserted into the frames formed by the hand-carved and hand-plowed (there is no word in the language of English joinery to describe this technique) mun-

Newton, Mass.: Charles T. Branford Co., 1971), p. 297; Marie Leach, ed., *Funk and Wagnalls' Standard Dictionary of Folklore, Mythology and Legend* (New York: Funk & Wagnalls, 1972), p. 880. I am indebted to Elizabeth V. Forman, reference librarian, Newark (Del.) Free Library, for these references.

[116] Ivor Noël Hume, *A Guide to the Artifacts of Colonial America* (New York: Alfred A. Knopf, 1970), pp. 55–57.

[117] Deneke, *Bauernmöbel*, pp. 104, 174, 239, 241, passim.

[118] A. J. Pennypacker to du Pont, May 26, 1937, object folder 57.1105, Registrar's Office. The chest was illustrated without caption in *Antiques* 14, no. 3 (September 1928): 189.

[119] Charles Bellows to Charles F. Montgomery, November 28, 1958, Object Folder 58.2874, Registrar's Office. John Paul, Jr. (1789?–1867), was a calligrapher, "civil engineer, millwright, surveyor and conveyancer," and sometime carpenter, according to his will (Miles Miller, *History of Elizabethtown, Dauphin County, Pennsylvania, 1817–1967*, [n.p., 1967], p. 135). In support of the idea that Johannes originally made this clock for himself and not for sale is the fact that the will stipulates that his tools and furniture be sold at public auction. It is possible that the clock came into the Hammer family at the time of Paul's auction in 1868; Vicky Uminowicz to Forman, September 25, 1981.

[120] Edward Francis LaFond, Jr., "The Henry Francis du Pont Winterthur Museum Collection of American Clocks" (M.A. thesis, University of Delaware, 1964), p. 168.

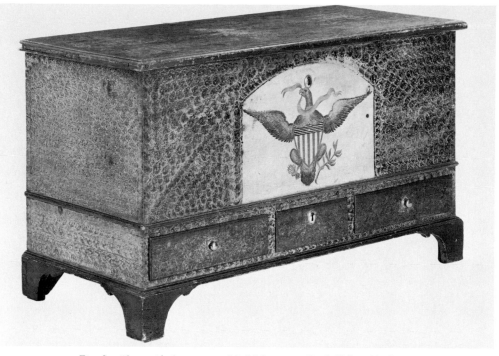

Fig. 87. Chest with drawers, possibly Mahantango Creek Valley, North-umberland County, ca. 1815. Pine; H. 29⅜", W. 51", D. 23". (Winterthur 57.1105.)

tins. The effect is similar to the geometrical designs used on seventeenth-century north German clothespresses.[121] The broken curve of the pediment, which emphasizes the counter curves of the ogee line, suggests Renaissance architectural style.

The curly maple case is in the narrow-waisted English manner of the mid eighteenth century. Despite the fact that the saw-toothed motif, the tessellation, and the alternating dark and light stringing of maple and walnut inlaid into the case are typical of north German marquetry patterns in late sixteenth-century furniture, the basic flavor of the Paul clock case is late eighteenth-century, Anglo-American neoclassical: the woods are all light in color, the finials are classical urns, and the feet, although of a typical Germanic pattern common in Pennsylvania furniture, are attenuated in the manner of French feet in the American federal manner. The feet and skirtboard were grained at a later date to disguise the fact that a small panel once pendent from the center of the skirt has broken off.

In addition to the federal eagle and shield inlaid on the base and, in ivory, as the keyhole plate on the door, a number of motifs from the seal of the Commonwealth of Penn-

sylvania are worked into the design. Among them are the two workhorses, minus their harness, three sheafs of wheat, incorporated from the 1701 arms of the City of Philadelphia, and a plow, originally used in the arms of Chester County. The word *Liberty*, from the state motto, is prominently featured, although the other two words of the motto, *Virtue* and *Independence*, are not included.[122] Birds and flowers abound, and at the bottom of the case is an inlaid dog chasing a fox carrying a goose in its mouth—perhaps an allusion to the Aesop fable that features similar characters.[123] The base is outlined with herringbone crossbanding

[121] Deneke, *Bauernmöbel*, pp. 215, 222, esp. 224.

[122] Whitney Smith, *The Flag Book of the United States* (New York: William Morrow, 1970), p. 187. I am indebted to Elizabeth V. Forman for this reference.

[123] The theme comes from the *Fables* of Jean de La Fontaine (1621–95), bk. 11, fable 3, *Le Fermier, Le Chien et Le Renard* (The farmer, the dog and the fox). I am indebted to Leslie Anne Greene for this suggestion. The moral of this fable is appropriate to the spirit of liberty manifest in the figures on the clock: "Couche-toi le dernier, et vois fermer ta porte. / Que tu quelque affaire t'importe, / Ne la fais point par procureur" (Be the last to go to bed, and be sure to close your door. / If something is important to you, / Don't leave it to be done by your proxy) (*Fables de La Fontaine* [Paris: Lebigre Frères, 1834], p. 135). The use of La Fontaine by Johannes Paul tends to support Miles Miller's contention that Paul was of Huguenot descent.

TABLE 2

Relative Value of Tall Clocks

Name	Township	Date	Total value of estate	Value of clock and case	Value of next most expensive item
John Gelbeck	Oley	1754	£ 234	£ 10	horse and furniture £8.5
Michael Ruth	Tulpehocken	1754	693	10	a chest 10s.
Martin Gerrick	Exeter	1757	665	5	chests and an old clothespress £1.15
Michael Albert	Tulpehocken	1774	192	9	wearing apparel £4.7
Valentine Kerber	Reading	1775	—	10	a desk £3
Herman Webber	Bern	1777	446	7	a chest 10s.
Thomas Kutz	Amity	1779	2,523	100	a bed and red bedstead with bolsters and pillows £110
Benjamin Weiser	Womelsdorf	1782	204	18 (walnut case)	walnut chest of drawers £5
Daniel Rieff	Oley	1783	1,718	10	desk and bookcase £5
Henry Dilbon	Rockland	1785	970	15	a walnut chest with three drawers and locks £1.17.6
Nicholas Kutz	Maxatawny	1790	—	7.10 ("30 ower")	a walnut "chist" £1.5
Frederick Hauman	Greenwich	1800	171	7.05	a "close copart" £3
John Klinger	Pinegrove	1800	—	15 and £2.10 for "a hang clock or watch"	20 chairs £3.15
Alexander Klinger	Reading	1802	69.10.3	4.10	desk £3.15

Source: Berks County Inventories.

of ash, common on Pennsylvania furniture in the Anglo-American William and Mary style. In such a monumental and laborious feat of inlay, Paul's Grundhobel doubtless required resharpening many times.

A clock case such as this one represents a tremendous investment of time and effort which, in preindustrial terms, translates into a considerable expenditure. What could a clock have meant to its owner to justify this expense? Without documents, we cannot hope to answer this question, but we can introduce considerable evidence to show that the ownership of expensive clocks was common among Pennsylvanians of German extraction throughout the eighteenth century. Indeed, expensive clocks are so prominent that, if one had to choose an icon on the basis of documentary research to represent that culture, the tall clock—not the painted chest—ought to be it.

Tall clocks begin to appear in the inventories of the successful Pennsylvania German yeomen at about the same time as chests of drawers. They are invariably the most expensive piece of furniture in the house. When we compare them with the next most expensive item in an estate, we get some idea of their relative value (table 2). When we further compare the values of these clocks with the total value of the estates of the testators, we see that the relationship is not constant. For example, Herman Webber's clock constituted 2 percent of his net worth. The clock of Daniel Rieff (Reiff, Rife) amounted to 0.5 percent of his estate. But

the value of Michael Albert's clock amounted to 4 percent of his estate, and Alexander Klinger's clock represented more than 6 percent of his.

To wealthy men, such as Thomas Kutz and Daniel Rieff, it is clear that the clock had about the same meaning that it did to their English neighbors: to possess one was a mark of worldly success, to display it, a form of conspicuous consumption. Yet, the other furnishings in Kutz's household show that he had disarmingly simple taste. For example, Kutz possessed only five chairs, whose total value was £1.17.06. At 7s. 6d. apiece, they could hardly have been anything more than rush-bottom slat-back chairs.

If we are committed to the idea that a colonial household contained only essential items rather than luxuries, clocks seem to fill an unduly important role in its furnishings. We cannot fail to ask if the clock had a significance for its owner that it does not have in our society today. What modern American would invest 6 percent of his net worth in a time-piece? And what need did a yeoman have to divide up his days into minutes? Clearly a farmer's life is not governed by a clock: he milks the cows when the cows need milking, not when the clock tells him to. The plowman's life is governed by the sun and the rhythms of nature and not by the striking of a chime.

German clockmakers in Pennsylvania were not accustomed to engraving mottoes on the dials of clocks as some of their English brethren were. We find no "Fugit Horae"

here, no injunctions to guard each hour of passing time as precious. But many Fraktur indicate, the clock was thought of as having a significance beyond its mere physical presence. The text of one such Fraktur (fig. 88) reads as follows:

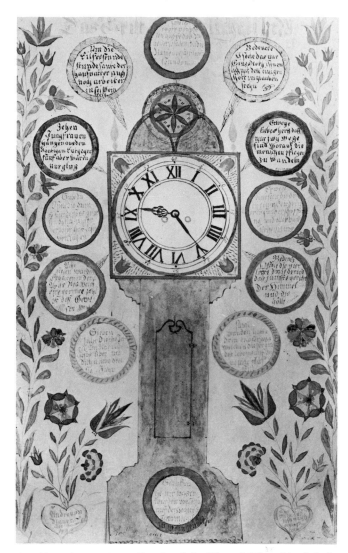

Fig. 88. Andreas B. Bauer, Das Geistlicher Uhrwerk [The spiritual clockwork]. Probably Montgomery County, 1832. Watercolor on paper. (Schwenkfelder Library, Pennsburg, Pa.)

Bedencke O Seele das nur Eines Noth ist nemlich mit dem einigen Gott im glauben stehn

Consider, O soul, that there is only one need, namely, believe in the only God.

Erwege liebes hertz dass nur zwy Wege sind Worauf die menschen pflegen zu wandeln

Ponder, dear heart, that man can walk only two paths.

Erwege liebe seele die drey einigkeit dein erlösung erschöpfung und aller werke ist heilig uns

Ponder, dear soul, the three unities: your salvation, your creation, and your works are holy unto us.

Bedenke o seele die vier letzte dinge den tod das jüngste gericht Der Himmel und die Hölle

Consider, O soul, the four finalities: death, the last judgment, heaven, and hell.

Fünf wunden hatte dein erlöser aus welchen die Ströme des lebens auf deine seele flüssen

Your Savior had five wounds, out of which the stream of life flows onto your soul.

Sechs krüge mit waser wurden von Jesu auf der Hochzeit zu Cana in galiläa zu wein gemacht

Six pots of water were made into wine by Jesus at the wedding at Cana in Galilee.

Sieben jahr Diente Jacob um Rahel dein Jesus aber um dich etliche dreisig Jahr

Jacob served seven years for Rachel; but your Jesus served some thirty years for you.

Acht seelen warden Erhalten in der Arge Noa Welch eine Geringe zahl ist des Gewesen

Eight souls were preserved in Noah's Ark, which is a small number.

Siehe du, O Seele, die neinte stunde ist es gewesen das ich unser Erlöser has lasen verklagen

See thou, O soul, that our Savior was accused in the ninth hour.

Zehen Jungfrauen hängen aus dem B[r]autigam Entgegen fünf aber waren nur glug

Ten virgins awaited the bridegroom, but only five were wise.

Um die Eilfte Stunde fante der hausvatter auch noch arbeiter in sei Weinberg

At the eleventh hour, the father of the house found his workers still in his vinyard.

Zwolff thore von perlen hatte das Neue Jerusalem da die Namen geschrieben stunden

The New Jerusalem had twelve pearly gates where the names were written.[124]

Of all the items found in museum collections none is approached in a more schizophrenic fashion than clocks. Horologists are fascinated by their movements; lovers of furniture are equally passionate about the woodwork of their cases. Much has been written about the former, little about the latter.[125] Many Pennsylvania German joiners did, indeed, make cases for clockmakers. On March 14, 1772, Johannes Bachman noted that he had "ein urkasten

[124] A related Fraktur by Bauer in the Schwenkfelder collection (acc. no. 2–31a) has this same text and is dated 1843; for another, see Weiser, *Fraktur*, pp. 18–19.

[125] A conspicuous exception to the rule is Edwin A. Battison and Patricia E. Kane, *The American Clock, 1725–1865: The Mabel Brady Garvan and Other Collections at Yale University* (Greenwich, Conn.: New York Graphic Society, 1973).

gemacht" (made a clock case) priced at £2.15 for Christian Forrer, a Swiss-born clockmaker then living in Lampeter. On the same day he charged Abraham Kündig £3 for one. In 1773 he made what must have been an estraordinary case for £5. He did not make another so expensive as that until March 14, 1778, when he charged Martin Meyli (Mellen, Mylin?) £5 for one and noted that it was at the "alt breiz" (old price).[126]

Not until we look at the accounts of his son Jacob, do we begin to get an insight into the variety of woods that such cases were made of. On April 5, 1836, Jacob made "one popler clockcase" for Adam Kindig at $12. On December 17, 1835, he sold one of "mehackeny" to Christian Herr for $25. On September 20, 1827, and January 31, 1828, he billed Anthony Baldwin (1783–1867), a Lampeter Township clockmaker, for two cherry clock cases at $19 each. The working arrangement between Bachman and Baldwin seems to have been one of trading goods for goods. On December 29, 1827, and on several other occasions, he credited Baldwin's account "by one clock," sometimes at $42, other times at $44. Bachman subsequently put the movements into cases and sold them, as we find in a typical entry dated July 15, 1831: "to Christian Brackbill, one Clock and case . . . $60."[127] Assuming the costs of these cases and movements are fairly consistent in proportion to one another throughout Pennsylvania, we may conclude that works were about twice as expensive as cases.

Numerous authors in their admirable zeal to point out what is uniquely American about American furniture have tried to see the cases of the earliest Pennsylvania German clocks as the amalgamation of English style and German woodworking techniques.[128] The idea seems cogent until we remember the essentially international character of style in the eighteenth century and look at northern European clocks—not the ones with straight sides and painted decoration that we see in the folk museums of Europe, but those with carved hardwood cases made in large towns for middle-class customers. These clocks differ little from their English counterparts except in details.

The earliest Pennsylvania German clock and case in the Winterthur collection that was made outside of Philadelphia (fig. 89) bears the inscription on its dial "Jacob Graff Machet Dieses" and is recognizably non-English in appearance (fig. 89 and pl. 33). Graff's earliest known work was done in Lebanon, and one example inscribed "1735—Jacob

126 Johannes Bachman daybook, pp. 18, 25, 52, DMMC.
127 Jacob Bachman daybook, pp. 49, 44, 26, 33, DMMC.
128 For example, see Marshall B. Davidson, *The American Heritage History of Colonial Antiques* (New York: American Heritage Publishing Co., 1967), p. 311.

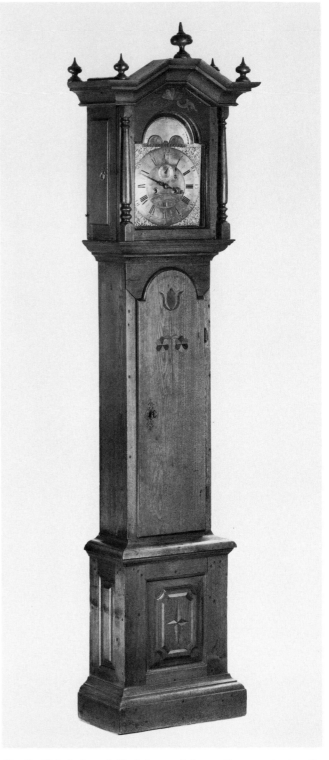

Fig. 89. Tall clock, probably Lebanon, Lebanon County, prior to 1760. Black walnut; H. 98″, W. 24½″, D. 12⁹/16″. (Winterthur 65.2261.) For a view of the clockface see pl. 33.

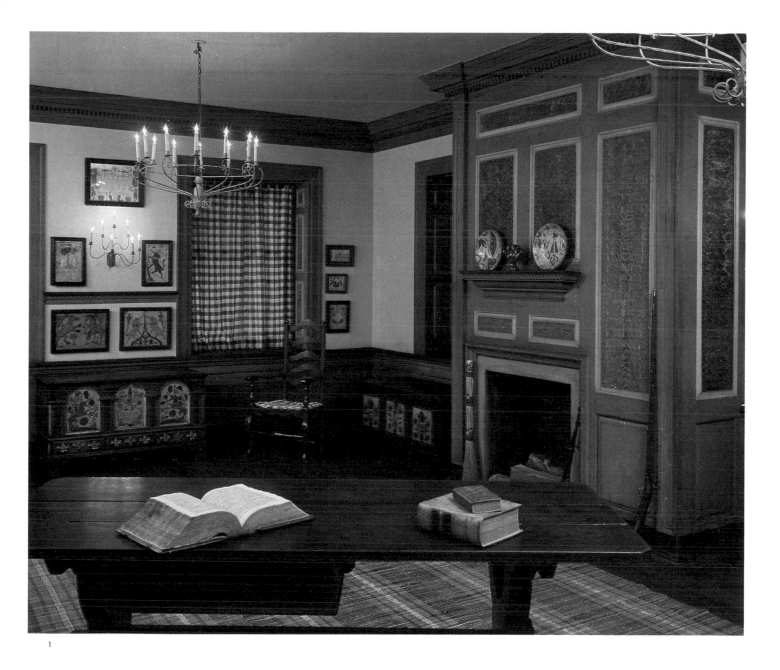

1

Pl. 1. Fraktur Room, formerly the great chamber of the David Hotten-
stein house, as installed at Winterthur. (Photo, Winterthur.) The stove
hole slightly visible on the right overmantel paneling probably dates to
1783. The mantelshelf, bolection fireplace surround, and fielded panel-
ing are characteristic of the chimney breasts in the rest of the house

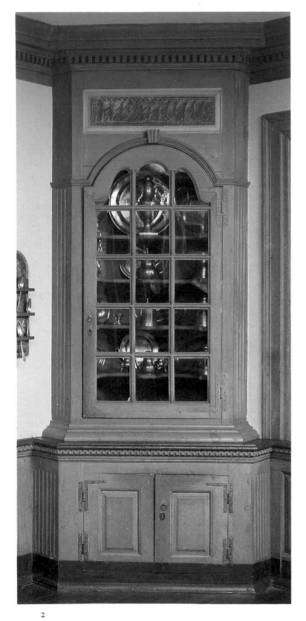

2

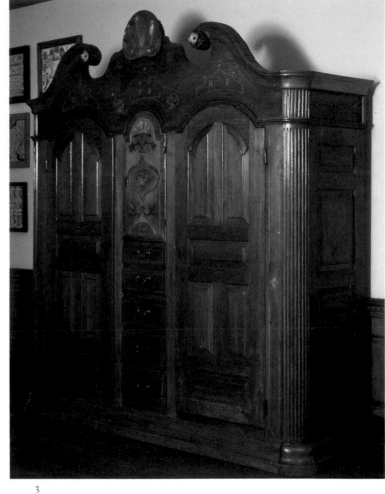

3

Pl. 2. Corner cupboard, great chamber, David Hottenstein house, as installed at Winterthur. (Photo, Winterthur.) This is the most elaborate of the cupboards built into the Hottenstein house.

Pl. 3. Clothespress, probably Kutztown, Berks County, 1781. Black walnut; H. 101″, W. 91¾″, 25¼″. (Winterthur 58.17.6.)

Pl. 4. Desk-and-bookcase, probably eastern Pennsylvania, ca. 1785. White pine; H. 100⅛″, W. 40¾″, D. 23⅝″. (Winterthur 57.502.)

Pl. 5. Dresser with glass doors, Pennsylvania, 1775–1800. Tulip; H. 84⅜″, W. 64″, D. 18½″. (Winterthur 64.1895.)

Pl. 6. Desk-on-frame, Philadelphia, ca. 1750. Black walnut; H. 42″, W. 38¼″, D. 24¾″. (Winterthur 58.2263.)

Pl. 7. Clothespress, possibly Lancaster County, 1740–80. White pine; H. 82⅛″, W. 66⅛″, D. 22″. (Winterthur 67.1165.) A similar piece, ownership now unknown, bears the date 1769.

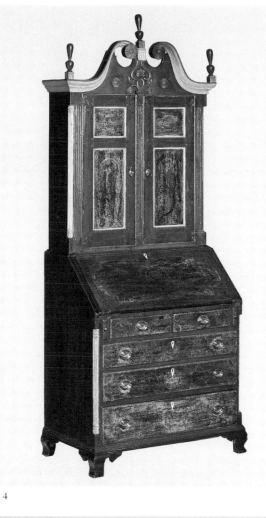

4

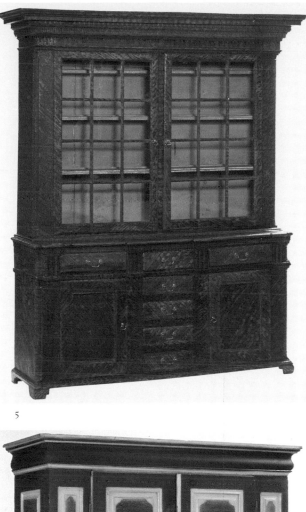

5

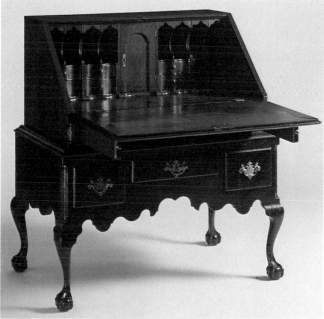

6

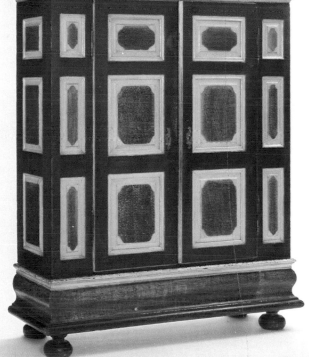

7

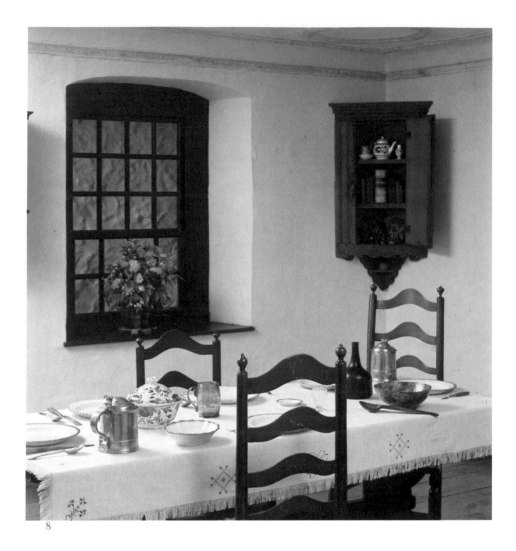

8

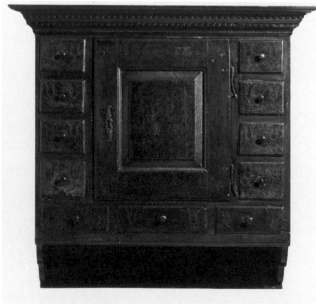

9

Pl. 8. Hehn-Kershner Parlor as it appeared in 1982. (Photo, Winterthur.)
Pl. 9. Hanging cupboard, Pennsylvania, 1775–1800. White pine; H.
36⅞″, W. 38⅝″, D. 18″. (Winterthur 64.1591.)

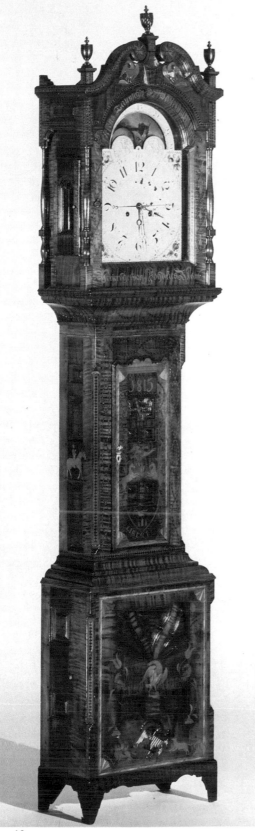

10

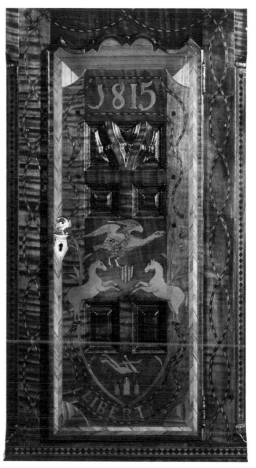

11

Pl. 10. Tall clock, Johannes Paul, Jr., Elizabethville, Dauphin County, 1815. Curly maple, tulip; H. 98″, W. 20¾″, D. 10¼″. (Winterthur 58.2874.)

Pl. 11. Detail of door on the Paul clock.

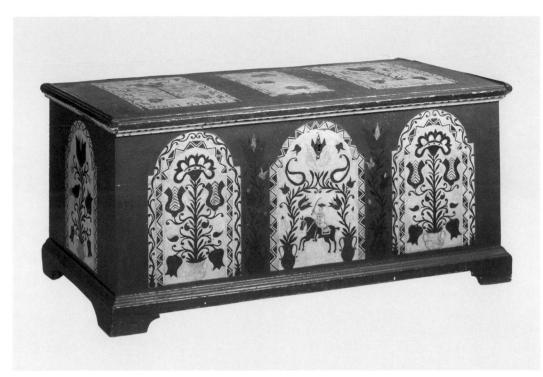

12

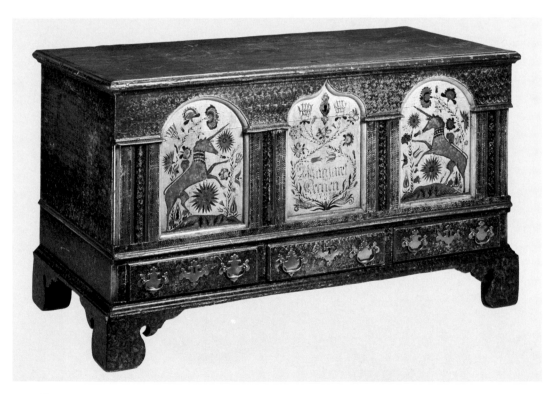

13

Pl. 12. Chest, Berks County, 1778. Tulip; H. 22″, W. 49½″, D. 18″.
(Winterthur 53.78.1.)
Pl. 13. Chest, Pennsylvania, 1788. Tulip; H. 28⅜″, W. 50″, D. 24″.
(Winterthur 59.2804.)

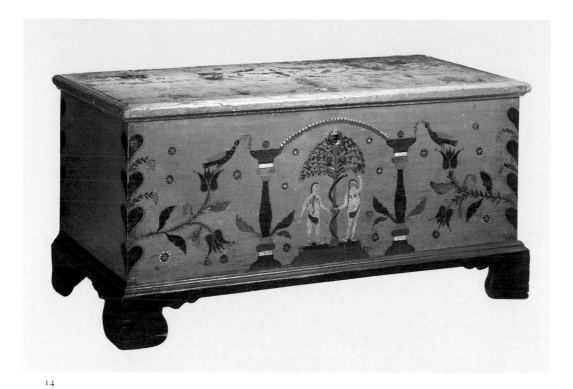

14

15

Pl. 14. Chest, probably Schwaben Creek, Northumberland County, ca. 1830. White pine; H. 24¾", W. 50", D. 17¾". (Winterthur 57.99.4.)
Pl. 15. Chest, Christian Seltzer, Jonestown, Lebanon County, 1796. White pine; H. 23⅝", W. 52⅛", D. 22⅛". (Winterthur 59.2803.)

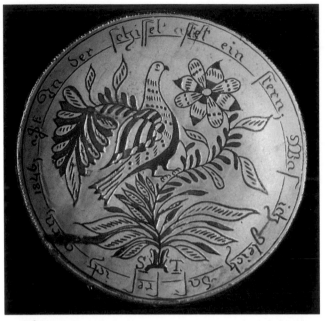

16

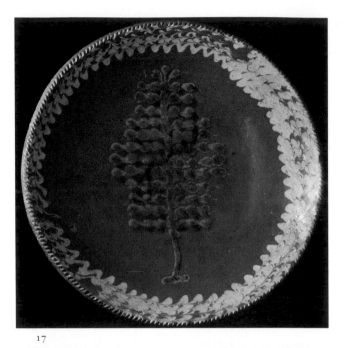

17

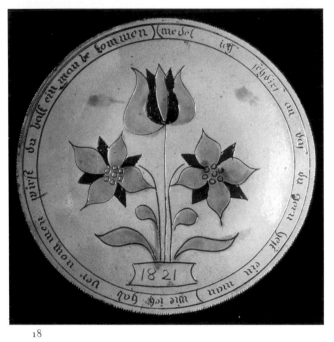

18

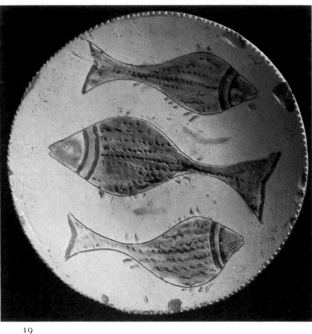

19

Pl. 16. Plate, drape-molded; sgraffito decoration; Samuel Troxel, Upper Hanover Township, Montgomery County, January 20, 1846. Incised: "In der schissel steht ein stern, Was ich gleich das fres ich gern, 1846 nSf[?] [and] ST." Potter's name, location, and date incised on reverse. Diam. 9¼". (Winterthur 60.625.)

Pl. 17. Large dish, drape-molded; white slip-trailed decoration, tree motif covered with green; Pennsylvania, 1820–50. Diam. 15⅞". (Winterthur 67.1506.) An unusual example of Pennsylvania slipware design.

Pl. 18. Plate, drape-molded; sgraffito decoration, green petals and leaves; Pennsylvania, 1821. Incised: "medel ich seh dirs an das du gern hest ein man / Wie ich hab ver nommen wirst du balt ein man bekommen." Diam. 11⁷/₁₆". (Winterthur 60.640.) Here copper oxide was not randomly

splashed but was carefully applied inside the outlines of the petals and leaves.

Pl. 19. Plate, drape-molded; sgraffito and combed decoration, green fish; Pennsylvania, 1800–1825. Diam. 12⅛". (Winterthur 55.109.5.) The potter incised the outlines of his fish, used a comblike tool for details, and carefully colored the bodies green. The distinctive combing is seen on two other plates at Winterthur. Fish occur only rarely in Pennsylvania German earthenware and probably designate the function of the plate as a serving or baking dish for fish.

Pl. 20. Plate, drape-molded; sgraffito decoration, green, brown, and blue coloring; attributed to Johannes Neesz (1775–1867), Tylersport, Salford Township, Montgomery County, 1800–1820. Diam. 12¾". (Winterthur

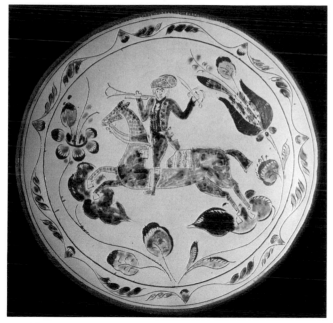

20

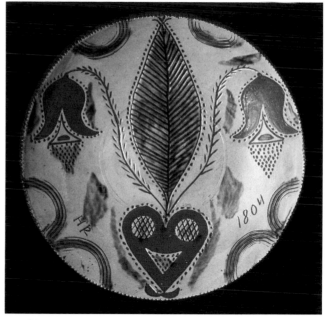

21

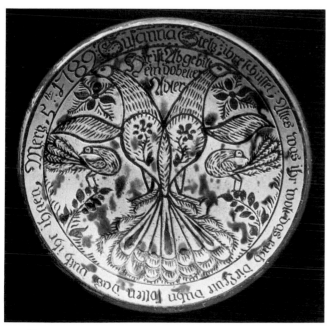

22

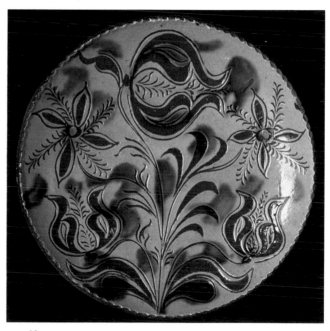

23

60.660.) Blue occurs on this Neesz plate and on the one in fig. 143 (Schwind, "Earthenware"), perhaps experimentally. Blue is also known on several pieces by Jacob Scholl.

Pl. 21. Plate, drape-molded; sgraffito decoration, splashes of green; Pennsylvania, 1804. Incised HR and date. Diam. 11¾". (Winterthur 60.687.) A similar plate also marked HR but dated 1805 is at Philadelphia Museum of Art. Henry Roudebuth is the potter with whom these initials have been associated. The HR of fig. 160 (Schwind, "Earthenware"), however, appears to be a different maker. The circular marks in the center of this plate resulted from the mold.

Pl. 22 Plate, thrown; sgraffito decoration, splashes of green; attributed to

George Hübener, Montgomery County, March 5, 1789. Incised around rim: "Susanna Stelz: ihre schüssel: Alles was ihr wolt das euch die Leute duhn sollen das duth ihr ihnen, Merz 5th 1789"; between bird heads: "Hir ist Abgebilt ein dabelter Adler." Diam. 13". (Winterthur 65.2301.) The name on the plate is clearly that of the owner, Susanna Stelz. The biblical verse around the rim bears no relation to the double-headed eagle depicted. Hübener described the creature as a "spread" eagle, and it is far more competently executed than the ones of figs. 111 and 191 (Schwind, "Earthenware").

Pl. 23. Plate, drape-molded; sgraffito decoration, splashes of green; Pennsylvania, 1825–35. Diam. 10⅛". (Winterthur 60.690.)

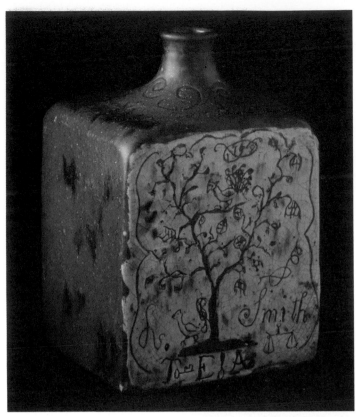

24

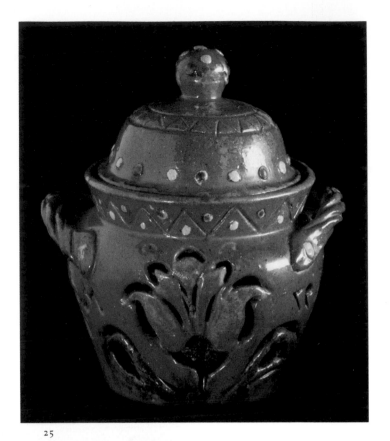

25

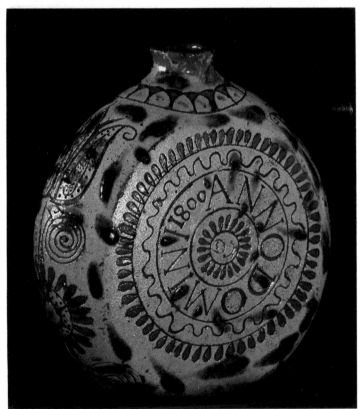

26

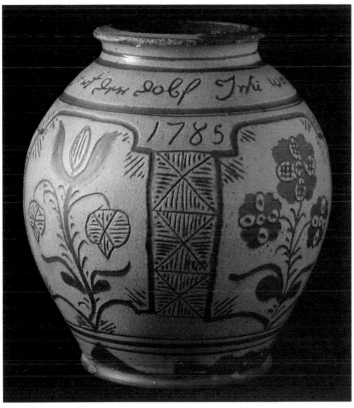

27

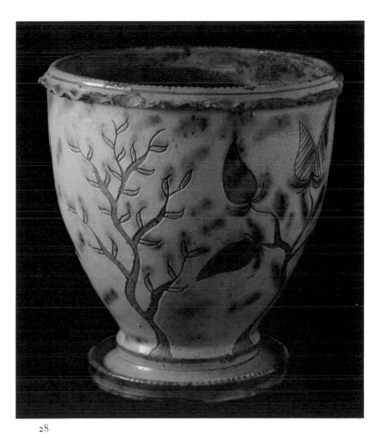

28

Pl. 24. Tea canister; sgraffito decoration, incised scrollwork, splashes of green and brown; attributed to Joseph Smith, Wrightstown, Bucks County, 1769. Incised: L. Smith / TEA. H. 8¼". (Winterthur 57.1390.) A very similar canister in Metropolitan Museum of Art is signed by Joseph Smith and also dated 1769. One made for Esther Smith is dated 1767. The canisters were inspired in form and decoration by English salt-glazed stoneware examples.

Pl. 25. Covered bowl; double-walled body with decoratively pierced outer wall, incised bands, and yellow slip dots, some covered with green; splashes of green; Pennsylvania, 1797. MJ and date pierced below handles. H. 6⅛". (Winterthur 60.630.) Applied dots of slip give the bowl a jeweled effect.

Pl. 26. Reverse of flask or pocket bottle shown in fig. 122 (Schwind, "Earthenware"). The initials DK(?) are incised within the smallest circle. The concentric rings, the border pattern, and the scrolls on the sides were accomplished by means of a compass.

Pl. 27. Jar, thrown; sgraffito decoration; Pennsylvania, 1785. Incised: "Elisabetha Sisholsin gehret der dabf. Jesu won in 1785." II. 8½". (Winterthur 60.666.) One of the few examples of inscriptions written in German script. Potters named Seisholtz worked in Adams and Northumberland counties.

Pl. 28. Flowerpot, thrown; sgraffito decoration, green coloring; Pennsylvania, 1810–40. H. 8¼". (Winterthur 65.2313.) An unusual example of uncluttered and highly effective decoration.

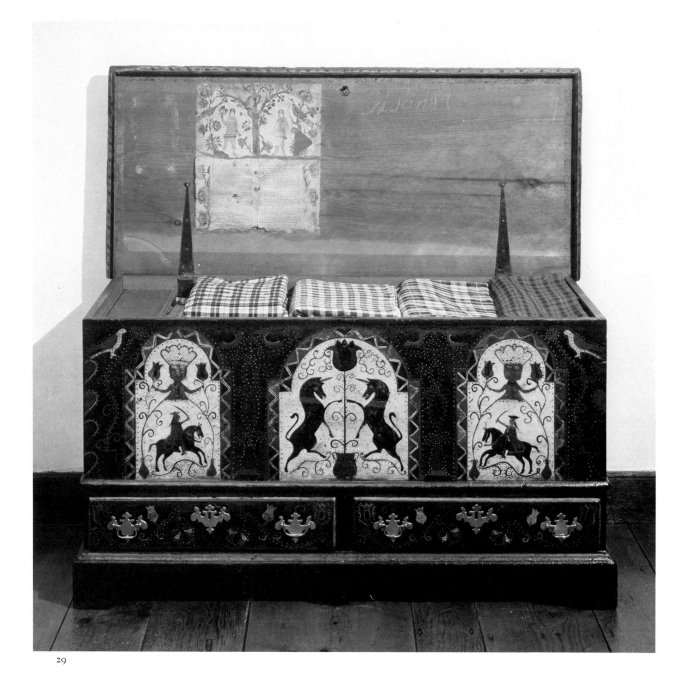

29

Pl. 29. A group of folded, checked mattress covers in a chest made in upper Berks County. (Winterthur 55.95.1.) A chest full of household textiles was the pride of a Pennsylvania German housewife.

Pl. 30. Sampler, Elisabeth Waner, possibly Salisbury, Lancaster County, dated 1817 and 1820. Linen with cotton and silk; H. 17¼″, W. 16 ⅜″. Red and blue yarns on natural ground. (Winterthur 80.60.)

Pl. 31. Reticule, Bethlehem, signed MG. Cream silk satin with polychrome silk, painted decoration, silver spangles; H. 10½″, W. 2″, L. 10¹/₁₆″. Inscription: "Where Lehi flows & feeds sweet flow'rs, 'Twas wrought in Bethlehem's pleasant bow'rs. 1807 / Friendship sweetens the cares of Life." (Winterthur 80.6.)

30

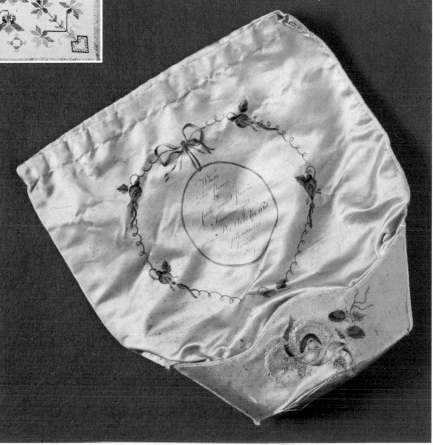

31

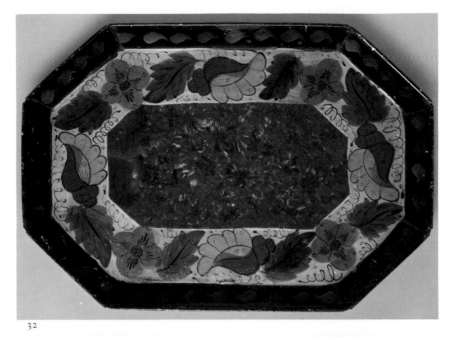

32

33

Pl. 32. Tray attributed to Frederick Zeitz, Philadelphia, 1874. Tinned sheet iron, asphaltum, and paint; L. 15⅛". Scratched into the back is 1874 / FZ / LZ. (Winterthur 65.1717.)

Pl. 33. Clockface, Jacob Graff (d. 1778), Lebanon, 1735–50. Brass, pew-ter, iron, and silver plate; H. 16⅞". Engraved on an arc within the chapter ring is JACOB GRAFF MACHET DIESE (Jacob Graff makes this). It is housed in an 8'2" walnut case (see Forman, "Furniture," fig. 89). (Winterthur 65.2261.)

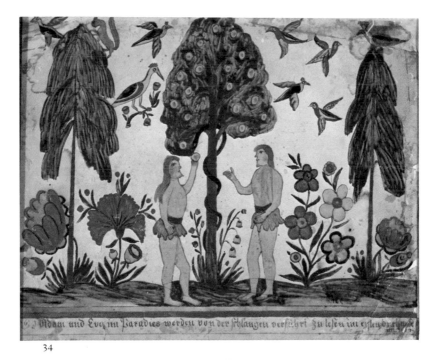

34

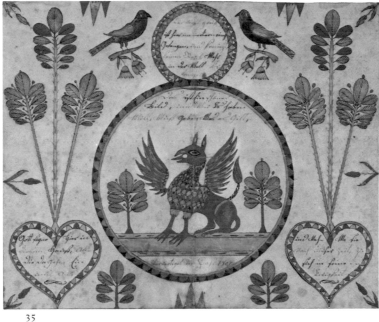

35

Pl. 34. Durs Rudy, Adam and Eve. Lehigh County, 1825–40. Hand drawn, lettered, and colored on paper; 19.7 x 24.45 cm. (Winterthur 55.37.) *Adam and Eve were tempted by the snake in Paradise. To be read in Genesis, chapter 3.* Organist and schoolmaster at Neff's Church in Lehigh County, Rudy prepared drawings of Adam and Eve, metamorphoses, and patriotic scenes as well as baptismal certificates. Durs Rudy, father and son, arrived on the *Commerce* in October 1803. Both men were artists; the son (1789–1850) did not do all the Fraktur attributed to the name, but the style of this one indicates that it is the younger Rudy's work.

Pl. 35. Anonymous artist, drawing with house blessing. Southeastern Pennsylvania, 1803. Hand drawn, lettered, and colored on paper; 32.6 x 39.5 cm. (Winterthur 57.1190.) *The griffin is trapped here in the lower circle and can achieve no more thievery in the world. / This is a beautiful picture and whoever wants it must pay what it is worth. Made in the year 1803. / God bless all who go out and in here in this house and take them after our time to himself in his eternity.* Unrelated apparently to other Fraktur, the drawing of a griffin is a document reminding us that Fraktur was done for sale.

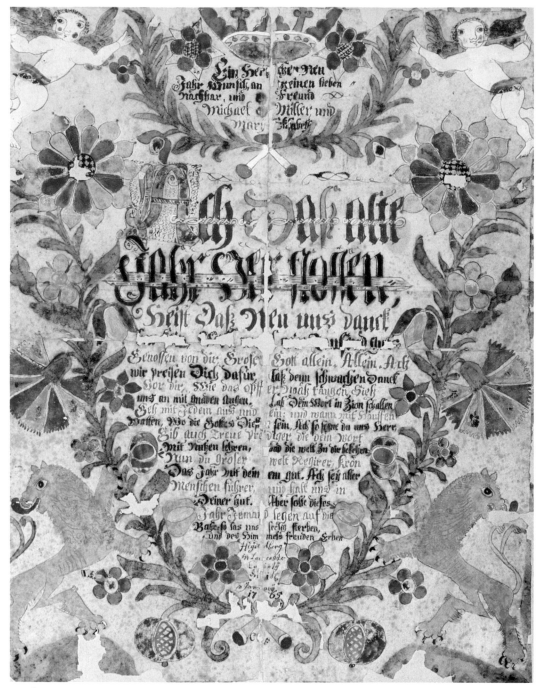

36

Pl. 36. C. F., New Year's greeting. Lebanon County, 1765. Hand drawn, lettered, and colored on paper; 50.75 x 40.65 cm. (Winterthur 57.1202.) *A cordial New Year's wish to my dear neighbors and friends Michael Miller and Marÿ [Maria] Elisabeth. / Ah, the old year passed away means for us to be thankful for the new ——— members [of the household and hired hands] from you, great God alone. Alone. O, we give you praise for it, let our feeble thanks count before you as Noah's sacrifice. Look upon us with gracious eyes. Let your word be of effect in Zion, leave and enter with each one: And if scores of weapons where the ——— of God are. O, thus bless us, Lord, and also give us faithful preachers who teach your word to good effect and turn the world to you. Now, you great ruler of the world, crown the year with your goodness. O, be the guide of all men and keep us in your protection. But should this year bring someone to the bier, grant us to die blessedly and to inherit heaven's joy. / Heÿdelberg in Lancaster County, January 1, 1765. / C. F. This large New Year's greeting was made for the miller at Millbach and his wife, from whose home other Fraktur has also survived. The text reflects the Pennsylvania German schoolmasters' role as ancillary to the ordained clergy.*

37

38

Pl. 37. Engraver artist, drawing. Southeastern Pennsylvania, ca. 1800. Hand drawn and colored on paper; 7.6 x 10.15 cm. (Winterthur 57.1245.) Engraver artist's precision and his habit of apparently stamping a die or woodblock onto paper to give an outline for his pen to trace later have given him his nickname. A similar drawing (Mercer Museum) contains a note that it was given to a child during her schooling.

Pl. 38. Reading-Berks artist, Taufschein. Schuylkill County, ca. 1820. Hand drawn, lettered, and colored on paper; 19.35 x 31.75 cm. (Winterthur 58.120.19.) *Benjamin Zimmerman was born in the year of our Lord Jesus Christ 1820, January 28, in the state of Pennsylvania in Schuylkill County, in West Penn Township. His father was the honorable Samuel Zimmerman and his mother, Susana, née Miller; this son Benjamin mentioned above was born to them into the world and was also baptized the 14th day of May 1820 by Pastor Scheffer. Sponsors were Johannes Zehner and his wife, Barbara.* This artist's work is so close to that of Conrad Gilbert, in both style and locale, that it is natural to seek a relationship. The logical possibility is that he is Peter Gilbert, Conrad's son, who also was a schoolmaster.

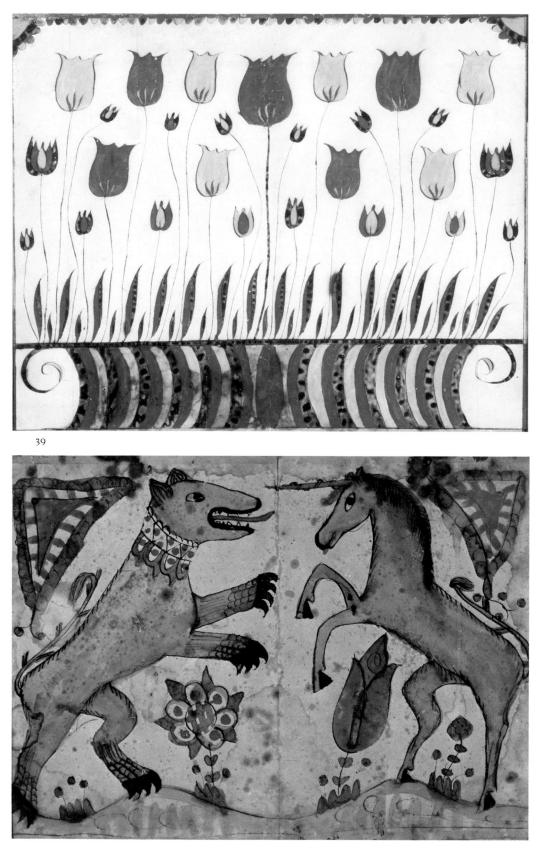

39

40

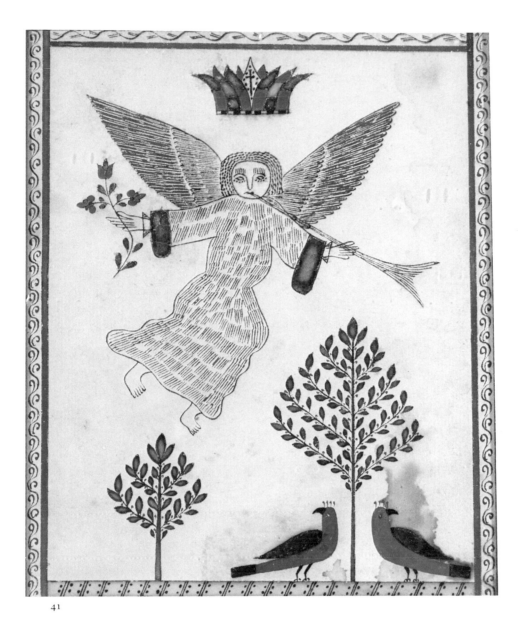

41

Pl. 39. Anonymous artist, drawing. Southeastern Pennsylvania, post-1820. Hand drawn and colored on paper; 31.9 x 39.2 cm. (Winterthur 58.120.12.) The watermark on this paper is King, which points to the King papermill in southwestern York County, but the provenance of the drawing is unknown.

Pl. 40. Friedrich Krebs, drawing. Probably Dauphin County, ca. 1810. Hand drawn and colored on paper; 29.55 x 39.70 cm. (Winterthur 61.1112.) Although it lacks text and penmanship to aid in attribution, this drawing is clearly the work of Krebs, whose total production was phenomenal. The lion and the unicorn have been taken from the arms of Britain and drawn as sparring partners. More frequently artists drew pairs of each animal facing one another, a monument to the Pennsylvania German fetish for symmetry.

Pl. 41. Rudolph Landes, drawing. Bucks County, ca. 1800. Hand drawn and colored on paper; 19.7 x 16.2 cm. (Winterthur 64.1532.) The angel descending with a trumpet and a floral branch is a designation of the Last Judgment. So, too, is the floating crown marked with a cross, but the latter is a religious device rarely found on Pennsylvania German art. Both symbols are from the book of Revelation.

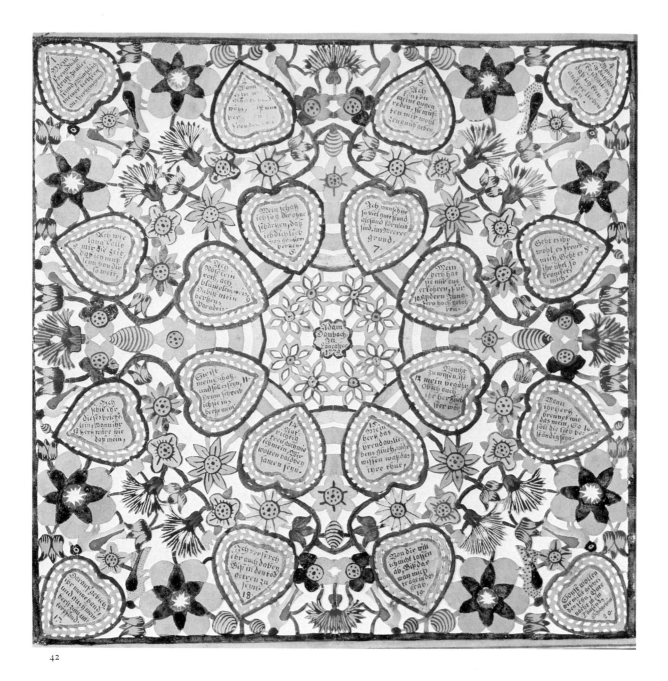

42

Pl. 42. Anonymous artist, love letter. Lancaster County, 1779. Hand drawn, lettered, and colored on paper; 31.4 x 31.1 cm. (Winterthur 65.1339.) [Center:] *Adam Dambach in Lancaster 1779.* [Hearts:] 1. *My friendly greeting at all times I wish my dearest from the bottom of my heart.* 2. [Illegible.] 3. *Oh if only my eyes could speak, they would testify for me,* 4. *that when I look at you, most beautiful, I can love no other.* 5. *Oh how long must the time be for me that I must be so far from you.* 6. *My treasure, I tell you without joking that I love you with all my heart.* 7. *I wish you as many good hours as there are grains of sand at the bottom of the sea.* 8. *If all is well for her, it makes me happy. If things are bad for her, it makes me sick.* 9. *Oh little rose red, oh little flower white, you are my heart's paradise.* 10. *My heart selected her for me above other highborn maidens.* 11. *She is my treasure and shall be it, so I will write* her name in my heart. 12. *It is my desire to know from her if I am also her most beloved.* 13. *I send her this little letter, if only her heart were like mine.* 14. *Upright, true, just as I intend, we want to be together soon.* 15. *My heart burns out of love's passion [and] wants to know what hers does.* 16. *If her heart burns like mine, then our love will endure.* 17. *Thereupon I give her my hand and also my heart as security.* 18. *I promise her also thereby to be true until death.* 19. *I will not forsake you until they carry me into the grave.* 20. *Otherwise we do not want to be parted: Good night my thousand treasure!* Adam Dambach, most likely the donor and not the maker of this piece, was born in Lancaster in 1754. On August 29, 1780, he, a Lutheran, married Susanna Funk, a Mennonite. Dambach died in 1803.

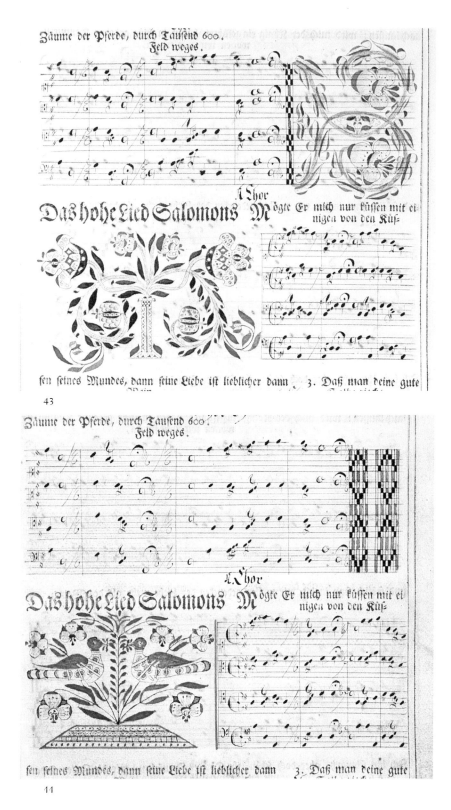

Pls. 43, 44. Das hohe Lied Salomons. From two different printed and illuminated copies of Johann Conrad Beissel, *Paradisisches Wunder-Spiel* (Ephrata, 1754), p. 72. (Joseph Downs Manuscript and Microfilm Collection 65 x 558, 65 x 559, Winterthur Museum Library.)

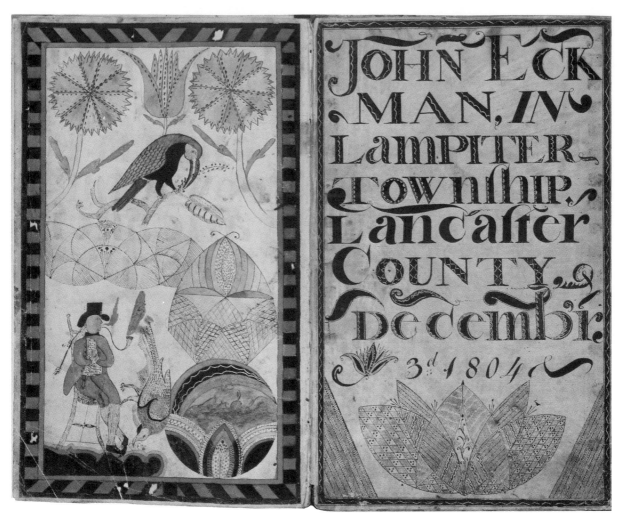

45

Pl. 45. Decorative endpapers. From John Eckman's exercise book, Lampeter Township, Lancaster County, 1804. (Joseph Downs Manuscript and Microfilm Collection 78 x 182, Winterthur Museum Library.)

Pl. 46. Title page. From manuscript of Johann Conrad Beissel, "Paradisisches Wunder-Spiel" (Ephrata, 1754). (Joseph Downs Manuscript and Microfilm Collection 65 x 560, Winterthur Museum Library.)

Pl. 47. Resurrection diptych. From manuscript copy of Johann Conrad Beissel, "Paradisisches Wunder-Spiel" (Ephrata, 1754), unpaged. (Joseph Downs Manuscript and Microfilm Collection 65 x 560, Winterthur Museum Library.)

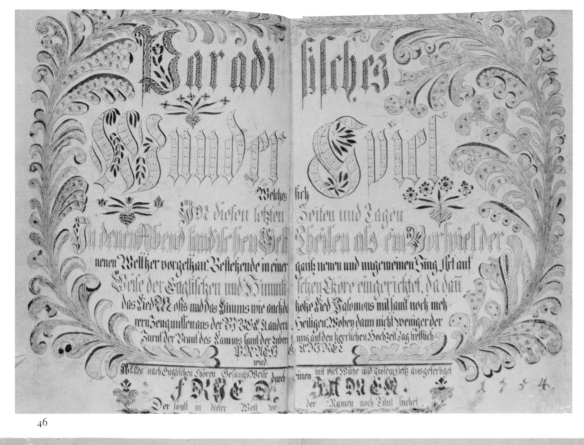

46

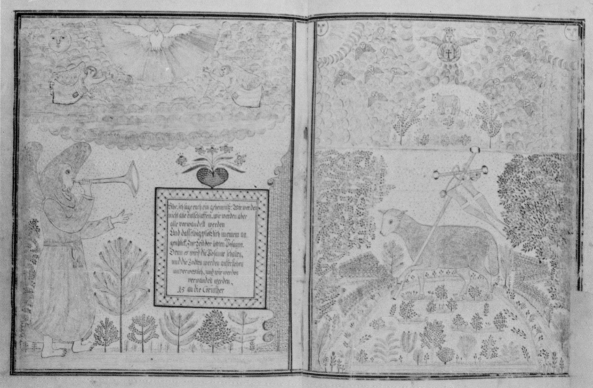

47

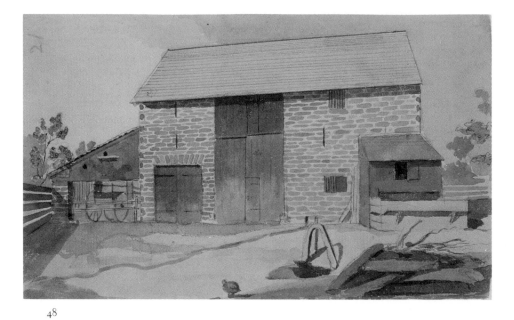

48

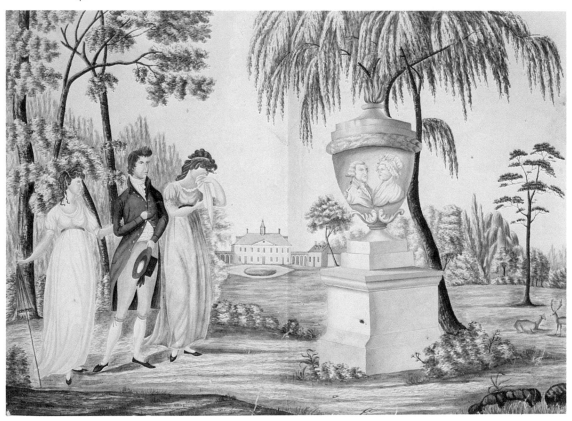

49

Pl. 48. John Lewis Krimmel, stone barn. Pennsylvania, 1819. Pencil and watercolor; H. 11.75 cm., W. 18.1 cm. (Joseph Downs Manuscript and Microfilm Collection 59 x 5.6.33, Winterthur Museum Library.)

Pl. 49. Charles F. Kluge, *In Memory of Genl George Washington and his Lady.* Nazareth Hall School, Nazareth, 1816. Watercolor; H. 33.66 cm., W. 41.59 cm. (Joseph Downs Manuscript and Microfilm Collection 71 x 211, Winterthur Museum Library.)

Graf—in Lebanon" has survived. Judging by the style, the Winterthur clock and its case were probably made before 1760.[129] The details of the case represent the northern European version of the international style. The joined base with its fielded panel is not in the English manner. Indeed, the hollow corners of the panel are a decorative detail we do not expect to find on Anglo-American furniture until the last decade of the eighteenth century, and then it is done in stringing. The molding that forms the transition between the base and the waist is not in the English classical style, derived from the moldings that appear on classical columns, but is a northern European treatment. The floral inlay on the door is Germanic, as is the door in the side of the hood that allows access to the works. The pintle hinges are of a typical German type, rather than the butt hinges common on English furniture. The tang that attaches to the door is fitted into a mortise, and a rivet is inserted through the door and the hinge in the German manner. The case is pinned together, rather than nailed, and the pins are of the characteristic oval shape that we associate with German workmanship seen on chests.

The pediment molding is not the ogee scroll that is a trademark of the Anglo-American style; it consists of a straight molding, run with a cornice plane, sawed apart, mitered, and glued back together in the manner we most often see in this country on eighteenth-century courting glasses (looking glasses) of painted or veneered European pine or spruce. The looking glass in figure 90 is of this type and is one of many in American collections. The advertisements of James Reynolds, a Philadelphia merchant, specifying "Dutch" and "German" looking glasses in 1784 and 1794 clearly indicate that looking glasses such as this one were imported into this country during the colonial period.[130]

What, then, does the Graff case have about it that says it was made in America? Other than the fact that it is made of American wood, nothing. But the Graff case is an exception among those at Winterthur made by Pennsylvania German craftsmen, for the majority have cases that are in

Fig. 90. Looking glass, northern Germany, probably 1750–75. Alternating conifer and walnut veneers on a conifer frame, ebony inserts; H. 32″, W. 22¾″. (Winterthur 66.1314.)

the English manner. The drawing of a clock case by Daniel Arnd (fig. 91) emphasizes the point. True, all tall clocks must be of a certain height to accommodate the pendulum, which is always one meter long (fractionally more or less), and the height of the bonnet is determined by the height of the movement and the size of the bell upon it, if any. The width and shape of the waist and the base, however, can take on a number of forms, and do in European cases. But the clock cases made after 1760, whose workmanship reveals that they were constructed by German craftsmen, have the slender proportions and understated relationship among base, bonnet, and waist that connotes the Anglo-American style.

Evidence of English orientation in the style of clock cases scarcely emerges from Pennsylvania German account books. In the book kept by Abraham Hover, we find only the dimensions for the one he might be called upon to make. They tell us little about style. Wrote Hover: "Die Hoch von Einem uhrkasten das understa stuck 23 zoll de Leib 3 fuss 2 Zoll" (the height of a clockcase the lower part 23 inch the

[129] George H. Eckhardt, *Pennsylvania Clocks and Clockmakers* (New York: Devin-Adair Co., 1955), p. 213. The inscription on the clock is probably not contemporary.

[130] Judith Coolidge Hughes, "Northern European Export Mirrors: The Evidence and Some Suggestions," *Antiques* 89, no. 6 (June 1966): 856–61; Wallace Nutting, *Furniture Treasury*, 2 vols. (Framingham, Mass.: Old American Co., 1928), 2:3148–51, 3154–55, 3158, 3160. The word *Dutch* occasionally appears in Berks County Inventories as a corruption of *Deutsch*, meaning German; for example, Bernhard Wommer, 1755, "2 German Sickles," 6d.; Dietrich Weinig, a Reading merchant, 1761, "thirty nine duche Sichels," £6.10; Daniel Rieff, 1783, "three small Dutch Scythes," 15s.; Barbara Wenzer, 1797, "Large Dutch Bible," £1.10.

Fig. 91. Daniel Arnd, drawing of tall clock. Philadelphia, prior to 1788. Pencil on paper. (Peter Ranck Account Book, 67 x 23, Winterthur Museum Library: Photo, Benno M. Forman.)

body 3 foot 2 inch). The price book of 1772 sets forth the numerous variations available to a customer.

CLOCK CASES

	Mohogany £	Wallnut £	Jurnyman £
Clock Case with Square head & Corners	6	4	1.15
D[itt]o with Scroll pediment head (without fret Dentil or Carved and [with] Square Corners)	8	5	2. 5
Do, with Column Corners	10	7	3
Do, with fret Dentils Shield Roses & Blases	12	9	4
Do without fret or Dentils	11	8	3. 5

N.B., The above prices without Glazing.[131]

The verbally indicated variations constitute the attributes of the style and the look of the case. The very fact that Benjamin Lehman of Germantown meticulously copied the price book indicates that the craftsmen of Germantown were also making clock cases in this manner. The price book clearly demonstrates the effect that embellishment has on style and on the consequent price of an item. For £4 in 1772 (and in 1786), a customer could commission a flat-topped walnut clock case without columns on the corners. According to the normal rules of dating by style, such a case would say "William and Mary" and perhaps today be priced accordingly in the shop of a dealer in antiquities. At the other extreme, a customer who wanted to spend money could order a case—from the same maker on the same day—with turned columns at the corners of the hood, a scrolled pediment with roses (rosettes) at their volutes, a fancy rococo shield (cartouche) in the center, turned and carved blazes (flame finials) at the corners, a dentil molding under the hood, and fretwork (in the Chippendale style) cut out and glued on, for only twice as much in walnut or three times as much in mahogany, N.B., glazing extra.

It should come as no surprise to us that the taste for the Philadelphia style extended to the growing and thriving town of Reading where Daniel Rose (1749–1827) (fig. 92), an extremely successful Pennsylvania German craftsman, furnished clocks to local burghers and to gentry of the surrounding countryside. Rose, who represented Reading in the legislature and was an officer in the Continental army, made the works of the clock illustrated in figure 93.

Rose must have been a remarkable man. His portrait reveals him in all his glory as he was in 1795, the year that

[131] Gillingham, "Lehman," p. 303.

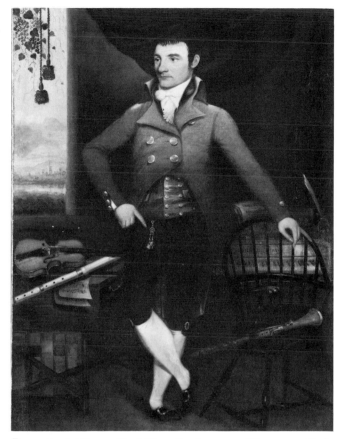

Fig. 92. Jacob Witman, *Daniel Rose*. Reading, 1795. Oil on canvas (Berks County Historical Society: Photo, Winterthur.)

Jacob Witman (d. 1798) worked in Reading. Rose was considered something of a dandy in his time, an impression the painting would convey even more strongly had not the powdered wig that he wore in the first version of it been overpainted.[132]

Although the knee and shoe buckles and possibly the silver buttons in his portrait were out of style and had doubtless long been converted into something else by this talented man before his death in 1827, much of the impedimentia of his life that surrounds him in the painting is listed in his inventory. Present are the "Breakfast table Mohogonay" valued at $10, the piano—which incidentally has the name of the artist who painted the portrait on its fascia rather than

[132] George C. Groce and David H. Wallace, *The New-York Historical Society's Dictionary of Artists in America, 1564–1860* (New Haven: Yale University Press, 1957), p. 683. I am indebted to Joyce Hill Stoner, paintings conservator, Winterthur, for the information that the paint of the hair has the same pigments in it that the black and browns of the rest of the painting have, which suggests that the wig was immediately overpainted (Stoner to Forman, August 22, 1981).

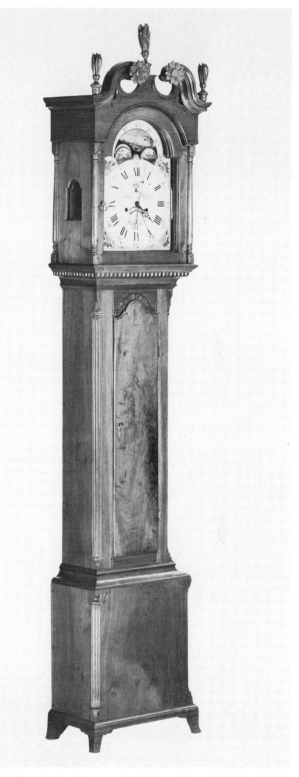

Fig. 93. Tall clock, Reading, ca. 1785. Walnut; H. 100¾″, W. 19¾″, D. 11″. (Winterthur 65.2.)

the name of its maker—valued with one of Rose's two organs at $60, the "glass ink-stand" valued at 50¢, books valued at $5 from his bookcase, the "clarinet flute," "Hoboy" (hautbois or oboe), and some of the music which consumed much of his leisure. The only indications that he possessed a $25 "musical timepiece" are the "sundry watch Keys, Seals and Chains" valued at $3 protruding from under his silk waistcoat. This remarkable watch played a hymn on the hour and is in the possession of descendants.[133]

Singularly absent from the image of Daniel Rose as he wished posterity to remember him is any allusion to the fact that he was a clockmaker. The transformation of a second-generation Pennsylvania German artisan at the age of forty-six into Gentleman was complete.

The case of the clock in figure 93 is typical of those from the Reading area, despite the fact that a handwritten label alleging that it was made by John Bachman is pasted in the right side of the hood.[134] The painted dial and the French feet in the federal manner combined with the earlier style shell and bonnet suggest that it was made at the turn of the century either by a craftsman or for a customer who was not totally ready to embrace neoclassicism. (The "forte piano" in Rose's portrait indicates that the full-blown federal style was known if not particularly fancied by everyone in Reading in 1795.) From a distance the clock case does not suggest that it was made by a German craftsman. Close examination reveals that it is put together in the Germanic fashion with wooden pins, that the tenons of the glazed door of the hood protrude through the uprights, and that the brackets on the feet carry a lingering suggestion of the brackets of painted chests from Berks and Lebanon counties. Superficially, the finials atop the case are in the Philadelphia manner, but only the center one—rather stiff by Philadelphia standards—can rightly be called a blaze: the other two are carved to suggest leaves. Similarly, the turnings at the corners of the hood are not really classical columns such as we usually find on ambitious Anglo-American clock cases. They round out at the bottom into vaselike forms

that have precedents in German mannerist supports.

The most novel touch about the case is the treatment of ornamentation at the sides of the waist. From a distance, the case appears to have turned quarter columns of the type common on Philadelphia case furniture. In actuality, they are worked directly on the edge of the boards that frame the front of the case (fig. 94). These boards, which are not unusually thick, have been rounded, perhaps with a quarter-round plane, and fluted with a gouge. The "rings" at the top and the bottom of each column have also been carved into the boards. The effect, which can be seen on a number of similar clock cases from the Reading area, is appealing to a connoisseur of woodworking techniques because it was not done on the lathe—the easiest way possible (which is the way it was done in Philadelphia)—and is totally unexpected. We cannot interpret the fact that the corners were done this way to mean that turning was not available to the maker of the case since this craftsman did turning; the roses on the pediment reveal the mark left by the point of the lathe in the center of each flower, indicating that they were turned prior to being carved. The molding on the pediment directly above the door is also turner's work. Inasmuch as the maker did not choose the easiest way to accomplish the effect, one interpretation remains: the case was made by a man who loved woodworking, a man who wanted to show

Fig. 94. Detail of tall case clock shown in fig. 93.

[133] Berks County Inventories, 1827. The portrait, "in the third story front room," was valued at $10. See also Mary P. Dives, "Reading's First 'First Citizen,' " *Historical Review of Berks County* 1, no. 2 (January 1936): 51–54.

[134] The secondary wood of the case is white pine, a common wood in clock cases from Reading and Berks counties and virtually unknown in Lancaster County cases, where tulip is used. I am indebted to Edward F. LaFond, Jr., for this information which will appear in his forthcoming book on the Winterthur clock collection. The label may be spurious; its maker could not distinguish between an eighteenth-century *f* and the long *s*. In the former, the serif crosses the vertical line, in the latter it does not. The "label" consistently uses *f*'s for *s*'s, giving us such words as "Cheftf and Bedfteadf."

off his ability, a man who wanted to make a joke in the European tradition of trompe l'oeil work, and did.

It seems a pity that having admired a clock case such as this one, its maker's name should elude us. But that is the common situation when it comes to clock cases—the woodworker who gives us such delight remains anonymous, and all the credit goes to the fellow whose name is on the dial. The inventories surveyed for this book suggest two men as candidates for making clock cases. One is Alexander Klinger, a woodworker of Reading whose estate amounted to £69.10.3 in 1802 but included a tall clock valued at £4.10. (Perhaps the movement in it was received in trade from Daniel Rose.) What sets Klinger apart from the mass of joiner/carpenters is the fact that he possessed "1 turning bench" valued at 10 shillings and a "Chest with Joyner and Turner tools" in it valued at £3. Another craftsman who could have made fine cases is John Crush of Lancaster Borough, whose inventory is dated December 9, 1776. Crush's name sounds as if he were of English extraction, but the presence of "Sundry German books" valued at £2.10 and a German stove plus the fact that his inventory was taken by three Germans, shows that he, too, was of German extraction. This inventory contains a splendid array of tools, many fine household goods, including "a case and clock" valued at £8. Happily for us, the appraisers also noted, "a Clock Case (half finished)" in his shop.[135]

Prior to the middle of the nineteenth century the only form of furniture as expensive as a clock in the homes of Pennsylvanians of German extraction was an occasional fine cupboard of hardwood. For many years it has been the custom at Winterthur to refer to the largest of these cupboard forms by the high German word *Schrank*. Schrank merely means cupboard, and like the English word, falls far short as a description of the myriad types of storage furniture that were referred to by this name in the eighteenth century.

Prior to the sixteenth century, a cupboard was just that—a board (really the top of a table) on which you put or kept drinking cups. Perhaps late in the sixteenth century, certainly early in the seventeenth, an enclosed section was integrated into the cupboard—as a place in which to lock up cups of plate (silver) or gold—and the word began to mean a form of furniture that had a door on it.

Although inventories of estates offer us our best insight into the way colonial homes were furnished, the inventories of the Pennsylvania Germans present a special problem. According to a law that was passed shortly after the arrival

of the first English settlers in Pennsylvania, all court records had to be written in English.[136] While this makes it easy for scholars with imperfect German to learn from household inventories the sort of furniture that Pennsylvania Germans owned, the nuances of the forms that the words describe are lost.

A classic example of this kind of problem is presented by the piece of furniture that is referred to in inventories as a dresser. This is a well-understood form in Anglo-American culture. As it was made by Germans in Pennsylvania, it is a tall piece of furniture with several rows of recessed shelves, upon which plates are displayed, over an enclosed cupboard. The lower section of the case is usually about twice as deep from front to back as the upper shelves, so its top forms a handy, waist-high table on which plates can be stacked before they are stored on the shelves. The British version of this form is called a Welsh dresser, although it was made in many places in England besides Wales. It usually consists of several shelves resting atop an updated version of the late seventeenth-century form known as a sideboard or a side table. The base, instead of being a cupboard, is more like a table with drawers in it. When the inventory of a person with a name like Josiah Rees contains "a Dresser" with "4 pewter dishes and plates," we assume that this piece of furniture was made in the British and not the German style.[137]

Dressers are common in the inventories of Pennsylvanians of German extraction as well. Martin Gerick of Exeter, Berks County (1757), had a "Dresser and Dresser ware" valued at £4, £1 less than his "clock and case." It is likely that this dresser was not in the room used for dining, but rather in the kitchen, as was the one in the 1771 inventory of Catherina Gerick, perhaps his widow, perhaps the same

[136] "The Great Law or Body of Laws of the Province of Pennsylvania . . . enacted at Upland (Chester) . . . December 7, 1682. . . . Chapter XXXVII, And be it etc., That all pleadings, processes and Records in Courts shall be short and in English and in an ordinary and plain Character that they may be easily read, and understood and justice speedily rendered" (*Charter to William Penn and Laws of the Pronvince of Pennsylvania* [Harrisburg: Lane S. Hart, 1879], p. 117). The law seems directed at court documents in Latin and the possibility of keeping them in the modern Roman or Italic hand as opposed to the customary writing of the superliterate classes, the Secretary or Court hand. Although the law was repealed in 1693 (along with many others), it was reenacted in the same year. In 1683, the law affected the Dutch and Swedish settlers, as well as the Germans at Germantown, who had preceded the English in Pennsylvania. Although the law does not seem to have been reenacted prior to 1713, the custom was established and generally (although not invariably) conformed to until well after the Revolution. See John D. Cushing, ed., *The Earliest Printed Laws of Pennsylvania, 1681–1713* (facsimile ed.; Wilmington, Del.: Michael Glazier, 1978).

[137] Berks County Inventories.

[135] Lancaster County Inventories.

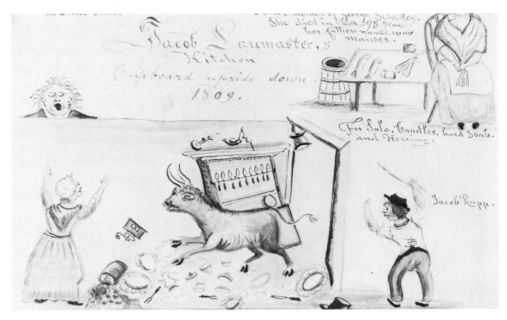

Fig. 95. Lewis Miller, *Jacob Laumaster's Kitchen Cupboard upside down.*
York, 1809. Watercolor on paper. (Historical Society of York County.)

dresser, then listed as "1 Kitchen Dresser" and valued at 7s. 6d. This form may also have been referred to as a kitchen cubbart, as was one valued at 6s. in the 1775 inventory of Bernhard Wommer, perhaps of Swiss extraction, who lived in Bern, Berks County. In it were "9 wooden tranchers and one Earthen Bason" valued at 1s. 6d. Ludwick Huett of Cumru Township, Berks County, had "a Kitchen Dresser and whats derein" valued at £6 in November 1799, while "all the Pewter in the Corner Cupboard" was valued at only £1.2.6. This second cupboard, elsewhere in his house, was apparently built into the wall since it was not appraised.[138]

An illustration in one of the books of drawings by the irrepressible Lewis Miller of York shows a dresser of this type on a day in 1809 when Jacob Rupp's cow got out of hand and turned "Jacob Laumaster's Kitchen Cupboard upside down" (fig. 95). This unhappy incident for Frau Laumaster is a happy one for us because it gives us a rare insight into how such a cupboard was furnished. Atop it was a hog-scraper candlestick with the candle burning; hanging from the top was a fat or grease or Betty lamp. Nine pewter spoons were arrayed in the notches on the front edge of one of the shelves. Two-tine forks, queensware dishes, a coffee mill, a coffeepot, spilled coffee, and dishes lie everywhere.[139] That Miller calls it "a kitchen cupboard" suggests

that the word *dresser* in the German inventories, and the variations of it that we find, such as *tresser* and *tressor*, are the English word being Germanized.

When Pennsylvania Germans spoke to each other, they often referred to the form as a *küchen schank.* Johannes Bachman made this form in expensive as well as inexpensive versions. On March 7, 1776, he billed Peter Cornitz, for whom he had "ein küchen schank gemacht" (made a kitchen cupboard), for £4.12. In contrast, fifteen months earlier, he billed Elizabeth Gutie for one that cost only £1.17.[140] These pieces of furniture could have been different in size, or one could have had doors while the other had none, or the cheap one could have been of pine or poplar, the expensive one, walnut—all of these variations exist.

The black walnut kitchen cupboard or dresser in figure 96 is one of the most prepossessing collector's items at Winterthur, largely because of an exciting upper profile. The presence of what we now call trestle feet, a medieval or at the latest an early Renaissance treatment, suggests that it is a fairly early effort by a German immigrant. The cupboard

[138] Berks County Inventories.

[139] *Lewis Miller, Sketches and Chronicles: The Reflections of a Nineteenth Century Pennsylvania German Folk Artist,* intro. Donald A. Shelley (York: Historical Society of York County, 1966), p. 72. "One Dresser,

Coffee Mill, Coffee Pot and Strainer" valued at £1.7.6, together with "6 Pewter Dishes, 2 Basons, 9 Plates and 10 Spoons" and "6 Tin cups 1 funnel 1 Keg 1 tin quart and Sugar holder" valued together at £3.7.6. constituted the furnishings of the "dresser" owned by Peter Andrews, a blacksmith of Union Township, Berks County, on November 11, 1766 (Berks County Inventories).

[140] Johannes Bachman daybook, pp. 39, 37, DMMC.

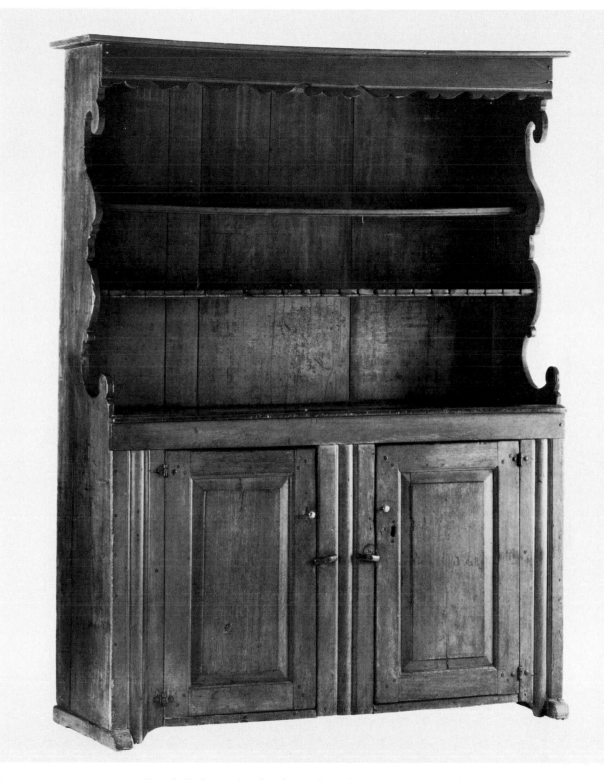

Fig. 96. Kitchen cupboard or dresser, Pennsylvania, 1750–1800. Black walnut; H. 81¾″, W. 63″, D. 21⅜″. (Winterthur 65.2750.)

was illustrated in Nutting's *Furniture Treasury* and had found its way to New England somehow, for it was then in the stock of Shreve, Crump, and Low, a Boston department store.[141] Like all of the eighteenth-century dressers that have been examined for this book, its backboards run the full height of the cupboard. The turn fasteners that now hold the doors of the lower section closed and give this cupboard a rather more folksy look than it had when it was new, are not original, although they have been there many years.

Numerous touches of workmanship indicate that a German craftsman made this cupboard. The boards that form the top of this and many similar cupboards overhang the sides and have a molding run along the front and returned on the side edges across the grain. The English method is to dovetail the top board to the sides and apply a molding around the top of the case. The fascia board across the front is a fascinating compound molding. The rounded upper portion was run with the round plane that could be found in any joiner's or carpenter's toolbox, whether he was German or English. The lower part of the molding, however, was run with a *Grathobel*, a German tool. After this molding was run, the fanciful ogee curves that enliven this profile were laid out and then sculpted with a *Lochsäge*. The double pinning of all the tenons on the doors is a further characteristic of German workmanship. The right door was originally fitted with an English-style lock, which could be interpreted to suggest that this side of the cupboard may have been used to store food and was locked between meals. An equally likely possibility is that this side of the cupboard was used to store valuable plate when the householders were away from home in the same fashion that the English court cupboard came to be used when it got an enclosed section in the seventeenth century. The fact that the hinges are riveted on, as they are on chests, and cannot be removed from the outside for unauthorized entry, heightens this impression.

The dresser continued to be a favored form of furniture in the nineteenth century. John Bachman settled an account with his brother Jacob by "making a Kitchen Dresser," and John was duly credited with $8.50 on April 15, 1822. On February 23, 1827, Jacob Bachman charged Jacob Smith $1.25 for "painting one Kitchen Dresser." In 1823, Bachman made "one walnut kitchen dresser" for Jacob Rohrer, for which he charged $24.[142] The last entry suggests that by this date the kitchen dresser was more than a mere cupboard with open shelves.

The account book of another craftsman of the Lampeter

[141] Nutting, *Furniture Treasury*, 1:573.
[142] Jacob Bachman daybook, pp. 1, 2, 4, DMMC.

Fig. 97. Detail of dresser shown in pl. 5.

Fig. 98. Detail of drawer from dresser shown in pl. 5.

region also named Jacob Bachman shows what that form was. On April 21, 1823, this craftsman billed the same Jacob Rohrer $23 for "one Walnut Dresser with glass D[oo]rs."[143] The monumental example in plate 5 shows the extent that elaboration could reach in a relatively short time. The case, made totally of tulip, has a simple mahogany-colored stain under its present fancifully painted mid nineteenth-century surface. Its present federal-style brasses replace original ones

[143] Jacob Bachman (II), Ledger B, p. 6, DMMC. He was possibly a cousin or nephew of Jacob who was the son of Johannes (Snyder, "Chippendale Furniture," p. 13).

of similar size that were very likely the same type. Its fluted frieze is in the late eighteenth-century, Anglo-American joiner's style. The traditional form has been enriched by the addition of a row of drawers between the lower cupboards. The utilitarian role played by the shelf above the lower section has disappeared along with the shelf itself. The form has been redesigned to emphasize the upper section where vessels can be displayed with maximum effect. The supporting role of the lower section has been accentuated by the architectonic fret and triglyphs added to its facade. The pediment of the lower section has further been emphasized by being brought forward. The whole display is heightened by neatly turned and fluted engaged quarter columns at the corners.

Despite its massive size, the delicate treatment of every detail—such as the frames of the doors and their muntins, the use of English-style butt hinges, and the precise care with which the carving of the applied moldings is done (fig. 97)—indicates the presence of a master joiner. The drawer construction—wedged dovetails, pinned-on bottom (fig. 98)—shows that he was trained in the German manner. We have but to contrast this work with the chest made by Peter Ranck at about the same time (fig. 86) to refute forever the notion that traditions decline: only the individual workman loses interest in what he is doing.

If our notion of when fashion first dictated that the upper part of a freestanding Pennsylvania German kitchen cupboard have glazed doors on it is correct, few of the examples now in American museums date earlier than the last quarter of the eighteenth century. Since the idea is not found in German furniture of this class any earlier, we must conclude that the form takes its cue from the practice of enclosing the buffet (beaufait) that was built into the corner of a room in English-style houses. Our means of determining when this event took place is little more than impressionistic because built-in furniture was rarely inventoried. Richard Hodgkins of Lancaster, whose 1731 inventory is among the earliest of those filed in Lancaster County, possessed a corner cupboard. It was probably built in since it was not assigned a value at the time of his demise. Josiah Rees, a Welshman in Reading who owned a dresser in 1770, also had a corner cupboard valued at £1.2.6, which was probably freestanding because it was appraised.

Few corner cupboards appear in Pennsylvania German inventories earlier than the first one mentioned in the accounts of Johannes Bachman in Lancaster County who billed Jacob Masd (Mast) £2 for "ein eck schang" (one corner cupboard) in 1775.[144] A corner cupboard worth so little

[144] Johannes Bachman daybook, p. 92, DMMC.

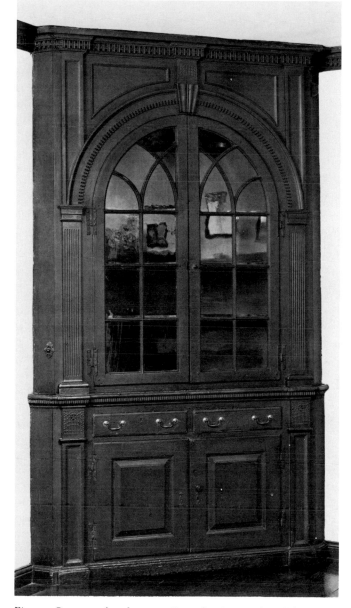

Fig. 99. Corner cupboard, eastern Pennsylvania, ca. 1800. White pine; H. 102⅞″, W. 61⅛″, D. (inside) 29½″. (Winterthur 59.1126.)

might have been built in, for Bachman also did joiner's work in houses, but the low value indicates that even among the conservative Mennonites, it was time for a few items worthy of formal display to be moved out of the kitchen. An example of this built-in form dating from about 1815 is illustrated in figure 99.

Other forms of cupboards made for the kitchen had particular names defining their specific uses. For example, in

1758 the institutional kitchen run by the Moravians at Bethlehem contained "1 schrank [cupboard] 8/," "1 schüssel schrank [dish cupboard] 4/," and "1 zinn schrank [pewter cupboard] 3/." In 1762 the Sun Inn at Bethlehem had a "küchen schrank mit schüssel brett . . . 12/" (a kitchen cupboard with a dish board). Dozens of examples of the form known as a *Milchschank* (milk cupboard), for the storage of dairy products, were made by Johannes Bachman. In inventories, these are usually inexpensive, utilitarian pieces of furniture, but a plan of one of these suggests that they could sometimes be very modishly decked out in federal-style detail (fig. 100).[145]

Hanging cupboards were also found in the kitchen but were doubtless used elsewhere in a household as well. On March 22, 1782, Johannes Bachman made two of them for Abraham Kägi. He billed each at £1.15, but he listed one as "ein hönck schönkleyn" (a little hanging cupboard) and the other as merely "ein hönck schank," without the diminutive.[146] One set of drawings illustrates this form and refers to it as a "Wandt Schranck" (wall cupboard). The example of this form with a small shelf at the bottom in plate 9 is typical of the group. Such cupboards have been found in Pennsylvania as well as in piedmont North Carolina, where many Germans settled in the late eighteenth century. This cupboard, which probably dates from the last quarter of the eighteenth century, first came to light in 1925 when it was in the collection of E. S. Youse of Reading. The presence of white pine in it, as well as tulip, suggests that it might have originated in that area. The most unusual feature of this cupboard is that its drawers all have holes in them that correspond to holes in the interior of the case. These holes permit the insertion of pegs, now lost, to secure the drawers so that they cannot be opened without unlocking the door to gain access to the pegs. A similar German example in Heimatmuseum at Villingen im Schwarzwald is dated 1835.[147]

The richest and most complex form of furniture in Pennsylvania German inventories was generally referred to in English as a clothespress. The problem of translation that we have encountered before presents itself once more: to call this expensive and elaborate form of characteristically

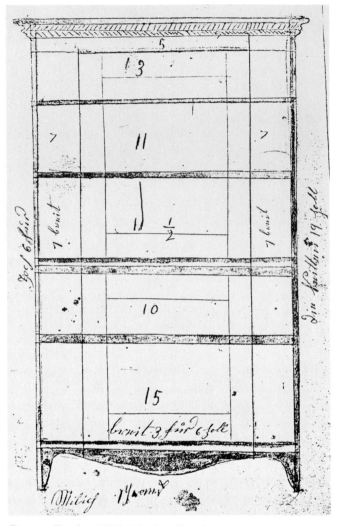

Fig. 100. Plan for a *Milch Schank* (milk cupboard), Montgomery County, 1820–30. Ink on paper. (Young drawings, 66 x 56, Winterthur Museum Library: Photo, Benno M. Forman.)

Germanic furniture, known in high German as the Kleiderschrank, by an English name evokes none of the distinctive connotations of form, proportion, and ornamentation that graphically demonstrate the differences between the German and English cultures in America. Because German houses in the eighteenth century were built without closets in which to hang clothing, virtually every home had a clothespress, and like all forms of furniture it could be anything from a few boards pinned together and painted, like the "poplar clothes press" valued at £1.13 in the 1776 inventory of Conrad Keim of Oley, Berks County, to the "Cloath Press" valued at £12 in the inventory of John Crush of Lancaster in the same year. Crush's press is not otherwise described, but since his tall case clock was appraised at £8

[145]Inventarium, Mobilien, 1758, and Sun Inn, 1762, Moravian Archives. Johannes Bachman daybook, p. 34, and Young drawings, p. 7, DMMC.

[146]Johannes Bachman daybook, p. 92, DMMC.

[147]Object Folder 64.1591, Registrar's Office. It is illustrated in Howard Pain, *The Heritage of Country Furniture: A Study in the Survival of Form and Vernacular Styles from the United States, Britain, and Europe Found in Upper Canada* (Toronto: Van Nostrand Reinhold, 1978), p. 313. I am indebted to Jonathan P. Cox for this reference.

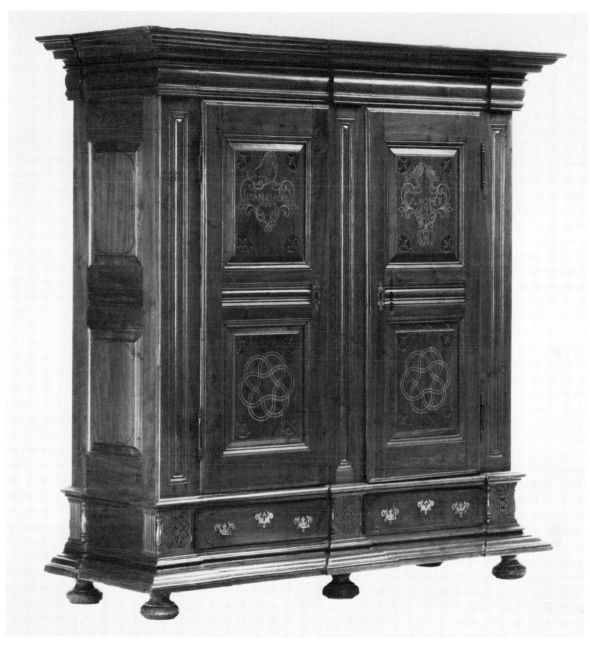

Fig. 101. Clothespress, Lancaster County, 1768. Black walnut; H. 89½″,
W. 85¾″, D. 30⅝″. (Winterthur 65.2262.)

and his desk-and-bookcase at only £5, his press must have
been quite grand.

The European tradition of using clothespresses in social
classes lower than the nobility or upper reaches of the mer-
chant class could not have been more than a century old at
the time the first Germans came to America. Few domestic
examples in European museums predate the middle of the
sixteenth century. In size and general form they do not
greatly differ from their American counterparts, such as the
one pictured in figure 101. This Kleiderschrank bears the
inscription EMANUEL HERR MA HER FEB D[EN] 17 1768. Three
additional closely related presses probably by the same Lan-
caster maker as the Winterthur example, are known. The
earliest is in William Penn Memorial Museum Harrisburg.

It bears the names of I. M. and A. M. Kauffman and is dated 1776. Another, privately owned, has the names Abraham and Elizabeth Reist and is dated March 8, 1776. The most elaborate of all is the press in Philadelphia Museum of Art with the name "Georg Huber" and the date "Anno 1779" on it.[148]

Perhaps the most intriguing fact to emerge from the resurgence of interest in things Pennsylvania German was the discovery in 1976 by Monroe Fabian and the conservation staff of Smithsonian Institution that the material used to create the inscriptions and designs on these presses and the related furniture of this group is sulfur and not *Wachseinlagen* (wax inlay), as was reported in an article in *Antiques* in 1960. Fabian has subsequently identified twenty-two pieces of furniture—boxes, chests of drawers, and presses—that have it.[149] In the absence of literary references to how the technique was used, experiments at Winterthur indicate that the desired pattern is first carved in the wood, and molten sulfur is poured into the channels. When it has solidified, any excess is removed by scraping. This ingenious technique, which simulates ivory or bone inlay, effectively saves a great deal of labor and produces a handsome result. The sulfur apparently loses much of its yellow color with age. No European precedents for "inlaying" sulfur into wood have so far been discovered, but the use of molten sulfur for making castings from molds is described in Cennino Cennini's *Libro dell' arte*, written in the first quarter of the fifteenth century.[150]

The designs on the doors of the Herr press are among the most elaborate in all of the Pennsylvania German hardwood furniture. The lower cartouche was laid out with a compass, the mark of the still point of which is ingeniously hidden by another line in the design itself. The pattern is a variation on the intertwining lines known as "love's true knot," symbolizing of the union of two persons.[151] The design on the upper panel of the left door consists of a baroque floral cartouche surmounted by a large bird. The cartouche on the upper section of the right door consists of leaves growing out of a pot, beneath which is an angel's head and wings, in the manner of an *amore*. Surmounting the design are two birds, one larger than the other, in a pose that can best be described as rubbing beaks. These round-headed birds have been labeled "parrots" when they appear on Fraktur, but here they appear to be turtle doves. According to Stoudt, *The Song of Songs* conveys essentially this same image. He also quotes and translates a couplet from a Germanic bottle in William Penn Memorial Museum, Harrisburg, with the legend "Schnabeln müss man erlauben / Zwei verliebten Turtle-tauben" (Billing must be permitted / Two beloved turtle-doves).[152] The cartouches strongly suggest that this press commemorated the marriage of an Emanuel Herr, the large bird in both doors, with the smaller bird, Ma(ry?), on the date indicated. The right panel, with its pot, lily / tulip, and *amore*, perhaps evokes a blessing of fertility and children.

Hattie Brunner advised Henry Francis du Pont in 1929 that the Emanuel Herr who owned the press was the son of Hans Herr, a minister living in what is now Lancaster County in 1720. The Herr family genealogy reveals that Emanuel, son of Hans Herr of Lampeter Township, was born in 1689 and died in 1740. He could not have been the original owner of this press. The second son of this Emanuel, also named Emanuel, was born in 1722 and married Mary Smith in 1747. Although the initials of his spouse are correct, the date on the press has little or no relationship to the known biographical facts of this couple's life. A more likely owner is Emanuel Herr of Lancaster, great-grandson of Hans and grandnephew of the first Emanuel. This Emanuel Herr (b. 1745), the son of Christian and Barbara, had a wife named Mary (née Martin) who is mentioned in the Lancaster County will of her father in 1792.[153] Since the iconography of the facade suggests that this press celebrates a marriage and this Emanuel is the only person of that name in Lancaster County who was of marriageable age in 1768, he seems to be the most likely candidate to have been its original owner.

In addition to its sulfur inlay, the Herr clothespress possesses relief carving rarely found on Pennsylvania German furniture, as well as turned, engaged, quarter spindles flanking the carved medallions of the base. The appearance

[148] Research notes of Deborah Dependahl Waters, Object Folder 65.2262, Registrar's Office.

[149] X-ray fluorescence of a sample from the press revealed a substantial quantity of pure sulfur, which was confirmed by differential scanning calorimetry (Winterthur Museum Conservation Laboratory report, June 14, 1977). For *Wachseinlagen*, see Frances Lichten, "A Masterpiece of Pennsylvania German Furniture," *Antiques* 77, no. 2 (February 1960): 176–78; Monroe H. Fabian, "Sulphur Inlay in Pennsylvania German Furniture," *Pennsylvania Folklife* 27, no. 3 (Fall 1977): 2–10.

[150] See Daniel V. Thompson, Jr., trans., *The Craftsman's Handbook: The Italian "Il Libro Dell Arte"* (New York: Dover Publications, 1933), p. 130. I am indebted to Barbara Roberts, furniture conservator, J. Paul Getty Museum, for this reference.

[151] Holme, *Academy*, 1:bk. 3, p. 8.

[152] Stoudt, *Folk Art*, pp. 107–8.

[153] Theodore W. Herr, *Genealogical Record of Reverend Hans Herr and His Direct Lineal Descendants* (1908; reprint ed., Lancaster: Lancaster Mennonite Historical Society, 1980), pp. 1–4. I am indebted to Vicky Uminowicz for the reference to the 1792 will of Christian Martin, Lancaster County Abstracts of Wills, Lancaster County Courthouse, Lancaster.

of the doors is unusually clean because the tenons of the crosspieces are wedged rather than pinned in the mortises of the uprights. The tori planed in the pillars flanking the doors are a common feature on presses that originated in southern and eastern Germany, although the finest European examples are veneered rather than made of hardwood. This example is notable because it retains its original feet.

In contrast, the clothespress that came from the house owned by David Hottenstein of Kutztown, Berks County (pl. 3), was designed to sit directly on the floor. In Hottenstein's 1802 inventory, this press was valued at £5.5 and was the most expensive piece of furniture in his estate. Further, it was called a "Cloath Dresser"—not a Kleiderschrank or a Gleyder Schonk or a wardrobe or a clothespress.[154]

This press is by far the largest piece of movable furniture in the Winterthur collection, but like all cupboards of its type, it can be disassembled into a package that will fit into a small wagon. The base and the cornice come apart from the rest of the carcass. Both are secured by ingenious tenons that extend up from the base and up into the cornice and are held in place with removable wedges (fig. 102), such as were used on the table in figure 63. The doors lift off, the center flattens out. The lap-jointed pine boards of the back and the shelves can all be dismantled in a relatively short time.

Figure 102 shows that the sides of the carcass are joined panels, but the shop in which this piece of furniture was made was more than a mere joiner's shop. Someone in it was a carver, as the shell at the center of the pediment illustrates. And someone there was also capable of painting, for the background of the lobes in the shell was painted black, as was the fluting in the quarter columns at the corners. The long molding that forms the pediment scroll and the molding at the foot of the case were painted a deep earth red. The flowers that adorn the voluted scroll were painted a light yellow ocher and shaded black around the edges. In addition, the stems and leaves on the central door panel bear traces of green stain and suggest that other parts of the flowers on the facade may have been stained. The whole effect of the rich color that this piece of furniture must have originally displayed is lost to us today because of the unusually hard cleaning that was given to its surface sometime before du Pont acquired it (see pl. 3).

Inlaying was a fairly common decorative technique among the German craftsmen of Pennsylvania and its presence on an elaborate piece of furniture like this one is expected.

[154] Berks County Inventories. More than half the presses in the first volume of Heinrich Kreisel, *Die Kunst des deutschen Möbels* (Munich: Verlag C. H. Beck, 1970), have feet that appear to have been added in modern times.

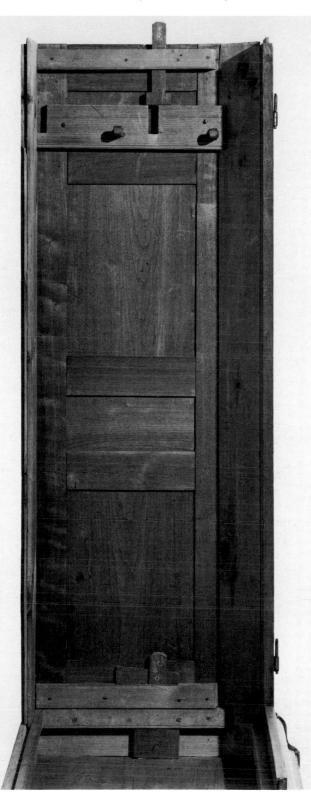

Fig. 102. Detail of right interior side panel of clothespress shown in pl. 3.

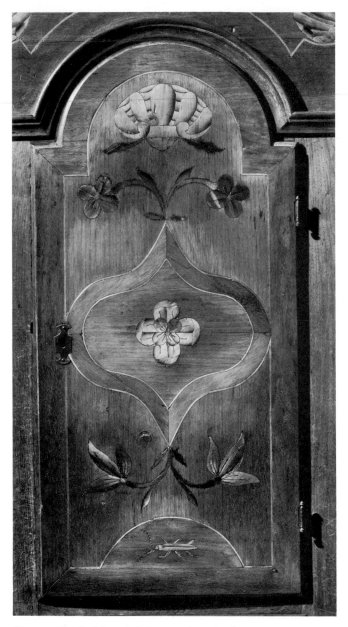

Fig. 103. Detail of door of clothespress shown in pl. 3.

that particular kind of saw, similar to the modern coping saw, known as a *Laubsäge*. This saw has an extremely thin blade, capable of cutting intricate shapes. It was also used to cut out the flowers that were applied to the pediment scroll. Its kerf mark can easily be seen there and is also visible on the interior of the petals of the flower at the center of the door.

The arches of the flanking doors combine with the central door to suggest the appearance of the classical arches that were so much a part of late Renaissance design in seventeenth-century Europe. The design on the small door is ambiguous. It seems to be derived from a recessed niche with a shell at the top, but the floral decoration compromises the effect. In the center of the panel at the bottom sits a grasshopper. Those of us raised on the fables of Aesop as popularized by La Fontaine immediately associate the image with joyful insouciance. However, J. Osborne informed us in *The Art of Heraldry* (1730) that "*Solomon* reckoneth the Grasshopper for one of the four small things in the Earth that are full of Wisdom."[155]

The grasshopper also appears as a decorative device on a chest dated two years after the Hottenstein press. It bears the inlaid name Maria Kutz. The chest, owned by Philadelphia Museum of Art, and the Hottenstein press probably originated in the same shop, and the logical place for that shop to have been was Kutztown. Although earlier records have not survived, the Kutztown tax list of 1817 has five cabinetmakers and four carpenters. The most prominent among them were Jacob Essert (b. 1758), who was assessed at $1,384, and Adam Kutz, assessed at $1,762.[156]

Germanic techniques of construction appear throughout the press. The door hinges are of the two-part type which permit the doors to be removed by simply lifting them off of the pintle, which is affixed to the case. The part of the hinge that is attached to the door fits into a groove cut in

What separates this example from all others that have been examined in preparation for this book is the fact that the design on the door above the row of drawers (fig. 103) is *not* inlaid but is a true piece of intarsia composed of several kinds of wood, meticulously sawed out, singed, stained, and glued together on a solid piece of wood to form the door. Because of the small, tightly rounded shapes that compose the pattern, we may also infer that the master craftsman who made this complex piece of furniture also possessed

[155] J. Osborne, *The Art of Heraldry* (London, 1730), pp. 186, 198. I am indebted to Gail Dennis for this reference. The allusion comes from Prov. 30:24, 27. In the Luther Bible, this section reads: "Vier sind klein auf erden, und Klüger denn die weisen: . . . Heuschrecken haben keinen König; dennoch ziehen sie aus ganz mit hauffen." In the King James Version these are "the words of Agur the son of Jakeh," not Solomon, and are rendered "There are four things which are little upon the earth, But they are exceeding wise: . . . The locusts have no king, Yet they go forth all of them by bands." If we read the inlaid insect on the press literally, its long antennae suggest that it is a grasshopper and not the Old World short-horned locust.

[156] Morton Montgomery, *Historical and Biographical Annals of Berks County, Pennsylvania* (Chicago: J. H. Beers, 1909), pp. 240–41, 872. I am indebted to Nancy L. Restuccia for this information. A clock case in the federal style by Jacob Essert or one of his sons is in the hands of direct descendants living in Kutztown. It cannot be related to this cupboard in any way.

Fig. 104. Detail of cloak pins in clothespress shown in pl. 3.

the edge of the door frame. The leaf of the hinge extends within the door and is nailed in place. Such hinges are neat, and the means of fastening them to the door are elegant. The back side of the small door is stiffened with two long, slightly tapered, dovetail-shaped battens that fit into tapered, negative-dovetail slots sawed and planed across the grain into the back of the single board that composes the door. A series of cloak pins consisting of rounded hangers affixed to wedged pegs (fig. 104) are attached to a bar that extends across the inside of the right cupboard. The pegs are in essence round tenons and are wedged to hold the hangers in place. The drawer fronts have wedged dovetails, and the drawer bottoms are held in place with wooden pins. The Hottenstein clothespress contains the entire vocabulary of woodworking techniques used by German furniture makers in Pennsylvania.

And yet, I would argue that this is a piece of furniture that could only have been made in America. We have but to compare it with the German Kleiderschrank in figure 105 to see the difference. True, the continental example is veneered and has rococo keyhole escutcheons. True, the German press has doors whose shapes reflect the influence of French stylistic ideas on southern German craftsmen in the latter part of the eighteenth century. But the American example expresses the culture in which it was made and the house in which it stood to perfection; its row of drawers marching down the middle represents the integration of an English chest of drawers into an otherwise easily recognized German furniture form. It illustrates the blending of English and German cultures in the same way that the Hottenstein house itself does. It is one of those pieces of furniture that is not a poor copy of a European form but instead represents

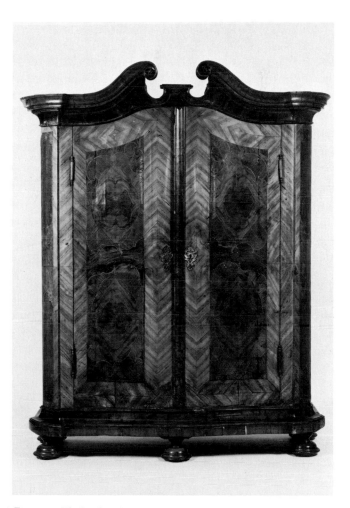

Fig. 105. Kleiderschrank, probably north German, 1750–75. Measurements not available. (Southeby Parke Bernet Galleries.)

a wedding of ideas that could not have occurred in quite this way anywhere else in the world in the eighteenth century. We can say, with pride in the phrase, that this is a piece of American furniture.

EPILOGUE

The student of furniture deals with materials that offer a means of getting at truths about human personality, beliefs, and customs not quite matched by any other historical technique. However, unlike most types of historical research, furniture history is complicated by the dual nature of these materials. Like any historian, the furniture historian seeks out those verbal documents that have survived from the times and places that concern him. He must also deal with the furniture, which is a document of equal validity but one that only grudgingly reveals its innermost secrets.

Attempts to learn about the life and thought of the German settlers in Pennsylvania by studying their furniture have been carried out over a long period of time by individuals with widely divergent aims using widely divergent techniques. Many of the ideas that have emerged from this research have been distilled into generalizations which in turn have hardened into axioms that are rarely subjected to critical examination. New research must inevitably take as its point of departure the ideas advanced by past researchers, but the very nature of the process—to search again—guarantees that whatever assumptions we begin with will be altered by new information we find. Regardless of where we begin or end, the question that all types of historical investigation asks is the same: How do the ideas that were thought in the past affect our understanding of ourselves today?

When we survey the materials that form the bulk of this essay, the easy conclusion that all German furniture makers who came to America continued to make recognizable furniture with strong traditional and ethnic overtones must fall by the wayside. This idea has gained credence because many people who have written about the arts of the Pennsylvania Germans confined their investigations to the sort of furniture that would lead to that conclusion. The conclusion was foreordained. We can now see the German craftsman and his customers in a broader perspective because we can now identify a considerable quantity of furniture that does not "look" Germanic but was made with techniques that could only have been brought to America by craftsmen trained in Germanic Europe. Further, when we look closely at the furniture we have been pleased to think of as being made in the European "folk" tradition, we find that it has changed in America with the passage of time in response to particu-

lar needs within the culture that the settlers established here. These changes do not parallel the changes that the same forms underwent in Europe during the same period. A third idea quickly emerges. We find that the techniques with which craftsmen made furniture in Germany, while of necessity brought to America by emigrating furniture makers, changed in response to materials found here.

We have been aware for decades that a large class of furniture made by Pennsylvania Germans borrowed both forms and details from English-style furniture and wedded them to a Germanic taste for the way the surface of a piece of furniture should look. The desk-and-bookcase in plate 4 is a classic example of this impulse. A variation of this theme is equally important: craftsmen of German background integrated into their traditional forms some ideas that they would not have encountered had they not come to America. The Hottenstein clothespress (pl. 3), for example, incorporates an English chest of drawers into an otherwise purely Germanic Kleiderschrank. The result is a new form that did not exist before anywhere else in the world. To my mind, combinations like this show that American colonial furniture is more than a watered-down version of European ideas, can be exciting to collect and analyze, is worthy of a place in the furniture history of the western world, and graphically reveals the impulses that matured in American culture in the following centuries.

Because our minds are so often absorbed with the stylistic aspects of objects, we forget that a piece of furniture owes as much for the way it looks to the techniques that are used to make it as it does to the stylistic ideas it represents. When we remember this, we can pass from an understanding of furniture like the Lancaster desk-and-bookcase in figure 75 and the Reading clockcase in figure 93, both of which show German-trained craftsmen assimilating the Philadelphia English style, to a comprehension of pieces of furniture like the desk in plate 6, which shows something far more difficult to get at: the German craftsman who had assimilated English culture to such an extent that he was, in effect, assimilated *by* it. This degree of assimilation in the eighteenth century is most apparent in Philadelphia. Unlike Lancaster or Reading, where German settlers very quickly established a community whose cultural life was as strong as that of the English community, in Philadelphia the traditions and taste of the English community overshadowed those of the Germans. Philadelphia's Germans were a true subculture in the sociological meaning of the term. Because Philadelphia set the tone for all of Pennsylvania in the eighteenth century a German furniture maker who chose to settle there before 1750 had to make furniture that he could sell to all colonists and not merely to an ethnic minority.

If furniture made with Germanic construction but designed for an English taste was being produced in Philadelphia, German craftsmen had to be present to make it. Who might these craftsmen have been? In the spring of 1978, a hearty group of Winterthur Fellows in Early American Culture set out to examine the Philadelphia inventories and emerged with a list of 275 craftsmen engaged in the woodworking trades between 1725 and 1760.[157] As expected, the vast majority bore English names, although we have no idea yet how many of them were Germans who had anglicized their names. Among those obviously of northern European origin were John Behrent, Johannes Clemen, Johannes Gebhard, Henrick, Jacob, and John Heilig, Johannes Keim, Garrat Keteltas, Johann Gotlob Kleem, George and Jacob Knorr, Henry Maag, Augustin Neisser, Christopher Sauer, Joseph Saul, Heinrich Schmitt, and Jacob, Peter, and Jonathan Shoemaker.

Since chairs are relatively inexpensive in relation to case furniture, and therefore are more frequently replaced in households than larger forms, experience suggests that we might most profitably look at them anew to see if they offer a clue to the Germanic presence. When we look at those most desirable objects of the furniture collector's affection, Philadelphia chairs in the Queen Anne style, we perceive that they are not in fact a monolithic group but can be divided into three distinct stylistic strains. The first group, whose date of appearance has so far eluded our best efforts, is what we may call the English strain, for want of a better term.[158] These chairs are characterized by a simple compass seat, the usual crookt back and feet, and have an indented crest rail, the type commonly called a yoke top. The earliest examples probably had stretchers as well. They do not differ materially from contemporary English chairs and probably appeared in Philadelphia between 1725 and 1730. A second group is related to these. They too are in the English manner but seem to be derived from New England versions of this style rather than English prototypes. Among these are the rush-bottom, crookt-leg chairs labeled by William Savery, which cannot have been made earlier than 1743.[159] Neither of these groups concerns us here.

A third group has features that do not seem to represent an organic elaboration of the stylistic attributes of the first two strains. A few of the characteristics of the style do not commonly appear in English chairs, and some of them never appear at all. The front legs of these chairs tend to be relatively heavy, the knees are decorated with foliated leaves,

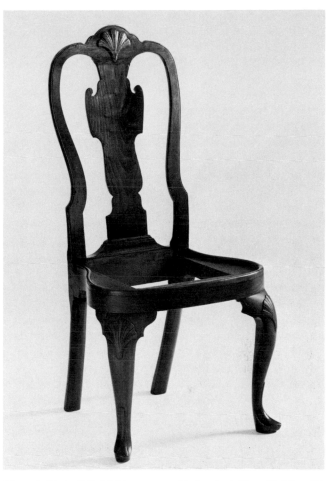

Fig. 106. Chair, Philadelphia, ca. 1735. Black walnut; H. 42⅛″, W. 19½″, D. 19½″, seat height 17″. (Winterthur 59.2509.)

and the front feet with carved claws grasping balls. The features that are common in Philadelphia examples but rarely appear in English chairs are the so-called trifid, sock, and slipper feet—we have no period names for them—the volute-enriched crest rail that projects upward instead of being indented, and the increasingly complex outline of the banister (splat) and compass seat, sometimes with an extra outward bowing curve on each side rail.[160] The front rails of these chairs are often indented and ornamented with a shell. A simple example of this third group, which I have denominated the "German strain," is illustrated in figure 106.

So long as our minds are clouded by our irrational habit of referring to *all* chairs with crookt front legs by the handy sobriquet, Queen Anne, we cannot dissociate chairs of type three from those of type one or mentally place either in its proper time. Queen Anne, toward the end of her life, may

[157] The fellows were Cynthia Baldwin, Doris D. Fanelli, Peter H. Hammell, Wendy A. Kaplan, and Sandra F. Mackenzie.

[158] Downs, *American Furniture*, figs. 28, 111, 112.

[159] Forman, "Fussell," fig. 1.

[160] Downs, *American Furniture*, figs. 28–30, 116.

have seen a type-one chair with a crookt leg, rounded stiles, and a yoke top. But the datable examples of the type-three style that we find in the museums of England, when we find them at all, were made during the reign of the second Hanoverian George. We cannot say when the chairs of the first type appear in Philadelphia, but it would be surprising if chairs of the third type appeared there much before 1735.

When we look, without emotional involvement, at a type-three chair such as the one illustrated in figure 106, what can we enumerate as its English characteristics? The rear stiles are related to the English style of the first group mentioned above because both are derived from Dutch models. The same is true of its crest rail. But the front feet, which do not present themselves to us in the pristine condition that they had when they left their maker's shop, are not a common English type. (They were originally about a half inch higher and more conical toward the bottom than we see them today, more closely related to the French treatment of this leg form than the English.) Likewise, the famous Philadelphia "stump" rear leg, either chamfered or rounded, is not related to the usual English rear leg on a chair of this class; English chairs in this manner continued to have squared rear legs, refined from the William and Mary style.

The relationship between the crest rails of chairs in types one and three is complex. The upward projecting style of type three appears chronologically earlier in continental Europe. It is essentially a type of crest rail, somewhat reduced in scale, that was popular in Holland during the first decade of the eighteenth century. The style enjoyed a brief vogue in England and is to be seen on the famous chair in the Dutch manner at the Victoria and Albert Museum attributed to Richard Roberts of London and believed to have been made between 1715 and 1720.[161] The motif continued to be used on the continent and continued to change, but the indented crest rail of the type-one chairs was far more common on English chairs made between 1715 and 1730.

The confusion that arises in our minds between the type-one and type-three chairs is caused by our habit of thinking of them as contemporary with each other in Philadelphia. While type-one chairs may have continued to be made after the type-three crest was introduced—persistence being a characteristic of provincial furniture making, and taste being an imponderable we can deal with only obliquely—it is probable that the indented crest rail was made here earlier than the upward-projecting style.

Having said what the stylistic features of type-three chairs are, can we say what the origins of chairs in this manner

Fig. 107. Detail of inside front corner of chair shown in fig. 106.

Fig. 108. Detail of juncture of seat rail and rear stile of chair shown in fig. 106.

are? It is quite possible that the means of getting at their origins have been staring us in the face all along. The answers do not lie so much in the chairs' aesthetic appearance, which is, after all, styled to make them marketable to people with English tastes, but rather in the way the chairs are made. This is what makes the Philadelphia compass-seat, crookt-leg chairs unique as a group in American furniture. The seat frame does not consist of vertically oriented rails of rather small size, tenoned and pinned into the front

[161] Ralph Edwards and Margaret Jourdain, *Georgian Cabinet-makers* (rev. ed.; London: Country Life, 1946), fig. 9.

legs, in the conventional English manner. Instead, they are large pieces of wood oriented horizontally. This simple difference enables the maker to achieve a wonderfully bold compass seat. The chair does not need stretchers, as chairs with weaker frames do, because a round tenon on the upper end of the leg fits into a hole drilled through the mortise-and-tenon joint at the front corners of the seat frame (fig. 107). And what do we find when we look down at the end of this tenon? A wedge, in the German manner. This technique, familiar to us from Brettstühle and benches (figs. 54, 55, 60), and the cloak pins in the Hottenstein clothespress (fig. 104), known to all collectors of Philadelphia Windsor chairs, has also been found on an unmistakably German chair in the State Dressing Room at Chatsworth, Derbyshire.[162]

When we look at the back of the rear stile of the Philadelphia chair (fig. 108), we see the famous Philadelphia "through-tenon." This technique was used on the lids of chests as well as the writing surfaces of desks and the frames of countless doors made by craftsmen trained in the German tradition. It is not found on Philadelphia furniture made by Englishmen prior to the arrival of the Germans. Does this not tell us something?

In Germany, the round, wedged tenon does not appear to have been widely used in high-style chair construction. Its probably very local place of origin awaits discovery. The wedged through-tenon is ubiquitous. It was used by northern European craftsmen working in the German manner in Salem, North Carolina, where the chair in figure 109 was made between 1764 and 1775. This extraordinary chair is made of American black walnut and shows no Philadelphia influence in its design, but its crest rail comes unmistakably from the same source as those of the early type-three Philadelphia examples. It, too, possesses a wedged seat-rail tenon that protrudes through the rear stile (fig. 110).[163]

The question of the ubiquitous presence of these tech-

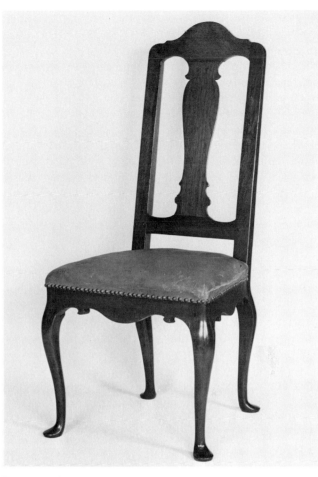

Fig. 109. Chair, Ennert Ennerson or Andreas Brösing, Salem (now Winston-Salem), North Carolina, 1764–75. (Old Salem, Restoration: Photo, Bradford L. Rauschenberg, Museum of Early Southern Decorative Arts.)

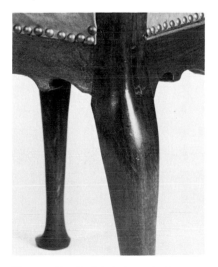

Fig. 110. Detail of chair shown in fig. 109.

[162] I am indebted to Jane Wright of the Winterthur guiding staff for calling this chair to my attention.

[163] I am indebted to Bradford L. Rauschenberg of Museum of Early Southern Decorative Arts, Winston-Salem, for calling this chair to my attention. His colleague, John F. Bivins, suggests that the chair could have been made by either Ennert Ennerson, a joiner who came to Salem from Sweden around 1764, or Andreas Brösing, who came to Salem via Bethlehem ca. 1770. The half upholstery over the seat rail, common in Swedish furniture made in the French manner, makes Ennerson a strong candidate. A desk at Salem Tavern has wedged dovetails and wedged tenons holding the end battens of the writing surface in place. Bivins attributes this desk to Thomas Wohlfahrt (Welfare) and dates it in the mid-1790s. Wohlfahrt was the former apprentice of Johannes Krauss (w. Salem 1775–96) who emigrated directly to Salem from Germany by way of Charleston, S.C.

niques in Philadelphia Queen Anne chairs, most of which were undoubtedly made in shops that had English masters, is important. How could the presence of a mere handful of German craftsmen so completely dominate the way in which chairs were made by craftsmen of English traditions? The answer is that we are probably not looking for a handful of craftsmen, but one.

Few of the German craftsmen who elected to breathe the urban air of Philadelphia were in a position to set up as masters of their own shops when they arrived. Most worked in English shops, and doubtless the master of at least one such shop was happy to learn how he could make his chairs more stylish by eliminating the stretchers, for the more stylish design attracts the more fashion-conscious customer. Competition assures the popularity and rapid dissemination of a better idea. The plentiful supply of walnut in Pennsylvania made it possible to construct chairs in this manner, a manner that fully exploits the strength and beauty of walnut and enabled the maker to create a compass seat of generous and exciting proportions, full of the movement that we see on German chairs and so often absent on English examples. The horizontal orientation of the wood enables the maker to attain one more unique feature common on German chairs, indeed, to carry it further, and that is the indented front seat rail, usually decorated with a carved shell—one more fillip to increase our admiration for the design of these chairs.

The fact that we recognize Germanic construction techniques in Philadelphia chairs does not mean that we yet understand their significance. That must come with further research. But their existence cannot be denied and cannot help but make us wonder if those qualities that make Philadelphia furniture distinctive among all of the furniture made in the American colonies cannot as much be traced to the presence of German craftsmen in the community as to Thomas Chippendale's *Director*.

Pennsylvania German Earthenware

ARLENE PALMER SCHWIND

<div style="columns:2">

Aus der ert mit ver stant
macht der häffner aller hand.
gluck glahs und erd
ist sein gelt ehrlich wert.

Out of clay such skill he brings.
The potter makes all kinds of things.
Luck, glass, and earth
Are all their money's worth. [*Fig. 111*]

</div>

Decorated earthenware objects were among the first of the arts of the Pennsylvania German community to gain widespread attention and admiration. Ceramics historian and museologist Edwin AtLee Barber published a book on the subject in 1903, and collectors, particularly in the Middle Atlantic states, soon began to seek the remarkable wares he described.[1] Henry Francis du Pont was one of the early enthusiasts of Pennsylvania German pottery: during his lifetime he accumulated 77 examples of the coveted sgraffito or scratch-decorated wares and over 100 other redware objects of Pennsylvania origin. As a result, Winterthur's collection is one of the two largest and most important assemblages of Pennsylvania German earthenwares in the country, yet most of the 94 pots included in this catalogue have never before been illustrated or discussed.

Pottery appeals to people on different levels. To those interested in the life-styles of the past, ceramics stand as expressive witnesses because they are closely associated with cooking, eating, drinking, and the toilet. Connoisseurs respond to pottery in the here and now, assessing shape and proportion, glazing and color, and decorative techniques. What has been most appreciated about Pennsylvania German earthenwares is their decoration, whether slip-trailed or sgraffito, often exuberantly colorful. Barber set the tone

with the subtitle of his book: "An Historical Sketch of the Art of Slip-Decoration in the United States."

Slip, clay mixed with water to a creamlike consistency, was used to embellish earthenwares made throughout America. Potters of no other region, however, produced slipwares of the pictorial, and often didactic, content that is found in Pennsylvania. The styles of the Pennsylvania German earthenwares can be traced to German, Swiss, and Bohemian pottery of the seventeenth and eighteenth centuries, yet those potters of central European backgrounds who settled elsewhere in America are not known to have carried on the Old World traditions with the same fervor as did the artisans who worked in Pennsylvania. However, little scholarly attention has been given the eighteenth-century German potters working outside of Pennsylvania and North Carolina.

In 1751 Edward Annely advertised in New York City that he had "set up the Potter's Business, by Means of a Family of Germans he bought, supposed by their Work, to be the most Ingenious in that Trade, that ever arrived in America . . . he has Clay capable of making eight different sorts of Earthen Ware."[2] Also in the 1750s, Johann Heinrich Penner produced earthenware goods in Germantown (now Braintree), Massachusetts, a planned community for Ger-

[1] Edwin AtLee Barber, *Tulip Ware of the Pennsylvania-German Potters: An Historical Sketch of the Art of Slip-Decoration in the United States* (Philadelphia: Pennsylvania Museum, 1903); a second edition was published in 1926. In 1970 Dover Publications republished the 1926 edition.

[2] *New York Gazette* (May 20, 1751), as quoted in Rita S. Gottesman, comp., *The Arts and Crafts in New York, 1726–1776: Advertisements and News Items from New York City Newspapers* (1938; reprint ed., New York: Da Capo Press, 1970), p. 84.

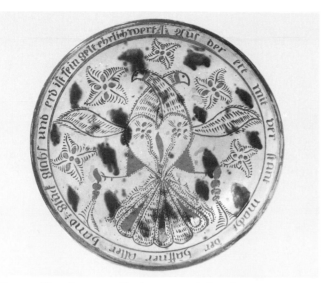

Fig. 111. Plate, thrown; sgraffito decoration, splashes of green. Jacob Joder, possibly Berks County, 1800. Incised: "Aus der ert mit ver stant macht der häffner aller hand: gluck glahs und erd ist sein gelt ehrlich wert." Name and date incised on reverse. Diam. 12⅛". (Winterthur 60.688.) The Berks County census for 1800 includes three Jacob Joders and one Jacob Joder, Jr. Joder may have been associated with the Hübener pottery in Montgomery County (see pl. 22). The same verse is on plates by other potters.

man immigrants. Two pots survive from his later operation in Abington, Massachusetts.[3] It was a potter from Neuweid, Germany, Johan Willem Crolius, who may have introduced the manufacture of salt-glazed stoneware in America shortly after his arrival in New York in 1718. Another German potter named Johannes Remmi (Remmey) made stoneware in New York in the 1730s. The descendants of both Crolius and Remmi carried on the stoneware business through the nineteenth century at potteries in Philadelphia and Baltimore as well as New York. In the Shenandoah Valley, encompassing parts of Pennsylvania, Maryland, Virginia, and West Virginia, a distinctive style of pottery was developed in the nineteenth century by the craftsmen who lived there, many of whom were of German origin. Slip decoration was for them, as for others, an important technique.[4]

[3] Petition of Johann Heinrich Penner of Germantown, Documents and Correspondence Relating to the Boston Fire of 1760 (microfilm), Joseph Downs Manuscript and Microfilm Collection, Winterthur Museum Library (hereafter cited as DMMC). A John Henry Benner had previously been documented from 1765 in Abington; see Lura Woodside Watkins, *Early New England Potters and Their Wares* (1950; reprint ed., Archon Books, 1968), pp. 45–46 and figs. 30, 31.

[4] William C. Ketchum, Jr., *Early Potters and Potteries of New York State* (New York: Funk and Wagnalls, 1970), chap. 2; W. Oakley Raymond, "Remmey Family: American Potters," 4 pts., *Antiques* 31, no. 6 (June 1937): 296–97; 32, no. 3 (September 1937): 132–34; 33, no. 3 (March

The products of the Moravian potters in North Carolina are most closely related to the traditional earthenwares made by Pennsylvania Germans. The Carolina Moravians maintained ties with the Moravians in Bethlehem, Pennsylvania, and some potters traveled between the two communities. Gottfried Aust, who had learned the potter's craft abroad at Herrnhut, worked at the Bethlehem pottery for ten months before moving to North Carolina and building a pottery there at the end of 1755. One of his apprentices, Peter Stotz, took over the Salem, North Carolina, brickworks in 1767 so that brickmaker Charles Culver could go to Pennsylvania. Four years later Stotz himself left for Pennsylvania "to take charge of the pottery at Lititz." A further commercial connection was the Moravian potters' reliance on Philadelphia sources for red lead. Philadelphia also became a market for their clay tobacco pipes.[5]

Although documented Pennsylvania Moravian earthenware is scarce, Pennsylvania German wares in general differ from the southern products in several ways. Large redware dishes were consistently thrown on the wheel in North Carolina; bat molds came into use there only in the middle of the nineteenth century. In Pennsylvania, however, molded dishes began appearing in the last quarter of the eighteenth century. Colorful slip-trailing, often on a brown slip ground, was the favored method of Moravian decoration, but sgraffito, popular in Pennsylvania, is virtually unknown in the South. Designs seen on North Carolina wares are generally floral and are less stylized than those of Pennsylvania, and human and animal representations are rare. Inscriptions, too, are not found on the southern pottery.

Because of their remote location, the Moravian settlers of North Carolina could not easily acquire fine European ceramics. Several foreign potters visited the community, however, and shared their knowledge of the manufacture of fine-bodied wares. As a result, creamware, tin-glazed earthenware or delftware, and probably even salt-glazed stoneware were produced there in the styles of the imported ceramics. While Pennsylvania German potters occasionally made fineware *forms* such as teapots (fig. 112), attempts at creamware and other fine bodies were limited to Philadelphia manufacturers, mostly of English heritage.[6]

1938): 142–44; 34, no. 1 (July 1938): 30–31. A. H. Rice and John Baer Stoudt, *The Shenandoah Pottery* (Strasburg, Va.: Shenandoah Publishing House, 1929); William E. Wiltshire III, *Folk Pottery of the Shenandoah Valley* (New York: E. P. Dutton, 1975).

[5] John Bivins, Jr., *The Moravian Potters in North Carolina* (Winston-Salem: University of North Carolina Press, 1972), pp. 16, 54, 80, 174.

[6] Queensware (creamware) was offered by Philadelphia potter Valentine Standley in the *Pennsylvania Journal* (May 3, 1775). In the nineteenth century the Columbian Pottery of Alexander Trotter, Archibald Binny, and James Ronaldson, and the Washington Pottery of James Mullowny

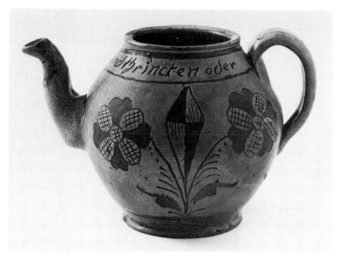

Fig. 112. Teapot (lid missing), thrown; sgraffito decoration; Pennsylvania, 1799. Incised: "Gott seyne euch in esen und thrincken oder 1799." H. 5½". (Winterthur 60.633.) A rare Pennsylvania imitation of an imported fineware form. Possibly by the same maker as figs. 131, 156, and pl. 27.

In spite of the collecting interest in Pennsylvania German pottery, the literature on the subject is sparse. Barber's *Tulip Ware of the Pennsylvania-German Potters* remains the authoritative work. His material, although published without footnotes, has been generally accepted as accurate. Barber scoured many sources for the names of potters, he traveled to pottery sites, and he pursued relatives or descendants of potters for information and objects. *Tulip Ware* is nonetheless only a beginning: additional information must be unearthed about both pots and potters before their roles in American ceramic history can be fully explained. A start has been made in the last few years with new research published and welcomed as important contributions to the study of Pennsylvania pottery: Lester Breininger's booklet on the potters of the Tulpehocken area of Berks County; Jeannette Lasansky's exhibition catalogues on redwares and stonewares of central Pennsylvania; and Susan Myers's study of the Philadelphia ceramics industry to 1850.[7]

The search for data about German potters and their wares in Pennsylvania can be difficult. Records are scanty, and few official documents such as census and probate regularly note occupations. Moreover, for many potting was not the primary vocation. Even when the name of a potter is known, his specific background and training cannot always be traced, whether in Pennsylvania or in his European homeland. Although the colony passed laws in 1717 and 1727 requiring ship captains to provide lists of their non-English passengers, complete with occupations and places of origin, few did so. Of the surviving lists only a handful contain any mention of occupations. While there are other, relatively complete lists of the names of the adult men who made the voyage, these are replete with problems. The English-speaking officials who recorded many of the German names often had little idea of how to spell them, thus they contributed mightily to the language problems that permeate all aspects of research on the subject. Finally, personal manuscripts, such as diaries, letters, or account books, that would amplify the bare facts have been discovered for very few potters.

The earthenwares themselves remain a major source of information about the men who made them. Winterthur's collection contains many signed and dated pots, reflecting the classic concern of collectors and curators with documentation. While it may not be considered truly representative of the Pennsylvania industry, Winterthur's collection provides valuable guidelines for the attribution and dating of unmarked examples. Included in this catalogue are forty-eight dated objects. Thirty-one objects bear a name or initials believed to be that of the maker, while nine carry the name or initials of the original owner. Many unmarked vessels can be attributed to known potters because of their close relationship to documented pieces at Winterthur or in other collections.

Few Pennsylvania German potters were as thorough as Samuel Troxel, who signed the backs of two plates at Winterthur with his name, township, county, state, and the date (figs. 113, 114, and pl. 16). Troxel put his initials on the front surface of the plates as well. Andrew Headman was similarly disposed when he made an extraordinary flowerpot (fig. 115). His name is incised in script on the bottom and is also stamped—with several inverted letters—on a relief lozenge on the lower row of decoration. Aside from these objects of ornamental function, there are in the Winterthur collection several utilitarian forms that bear the maker's mark. Joseph S. Henne of Upper Tulpehocken Township,

were among the producers of refined earthenwares. See Susan H. Myers, *Handcraft to Industry: Philadelphia Ceramics in the First Half of the Nineteenth Century*, Smithsonian Studies in History and Technology, no. 43 (Washington, D.C.: Smithsonian Institution Press, 1980). The porcelain factory built by Bonnin and Morris in 1770 was certainly operated by English artisans (Graham Hood, *Bonnin and Morris of Philadelphia: The First American Porcelain Factory, 1770–1772* [Williamsburg, Va.: University of North Carolina Press, 1972]).

[7] Lester P. Breininger, Jr., *Potters of the Tulpehocken* (Robesonia, Pa.: Taylor Mansion Publications, 1979); Jeannette Lasansky, *Central Penn-*

sylvania Redware Pottery, 1780–1904 (Lewisburg, Pa.: Union Co. Oral Traditions Projects, 1979); Jeannette Lasansky, *Made of Mud—Stoneware Potteries in Central Pennsylvania, 1834–1929* (Lewisburg, Pa.: Union Co. Bicentennial Commission, 1977); Myers, *Handcraft to Industry*.

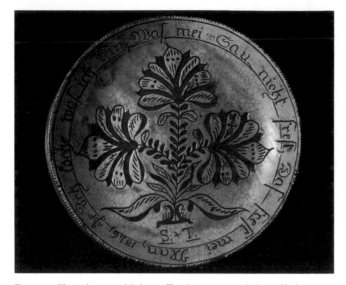

Fig. 113. Plate, drape-molded; sgraffito decoration, splashes of light green. Samuel Troxel, Upper Hanover Township, Montgomery County, January 20, 1846. Incised: "Ich koche was ich kan; Was mei Sau nicht frest, Das frest mei Man, 1846; nSf[?] / S.+T." Potter's name, date, and location incised on reverse (see fig. 114). Diam. 9⅜". (Winterthur 60.626.) Fig. 113 and pl. 16 are among the latest dated examples of Troxel's work, yet they are extremely similar to his work of the 1820s and 1830s.

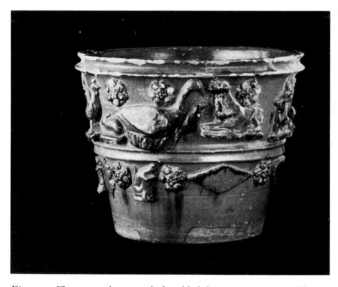

Fig. 115. Flowerpot, thrown; relief-molded decoration, green and brown highlights. Andrew He(a)dman, Bucks County, or possibly Philadelphia, 1851. Name stamped (with several inverted letters), and date incised on diamond lozenge on side of pot; name and date incised on bottom of base. H. 8⅜". (Winterthur 59.1846.) Potters named Headman operated potteries in Philadelphia and in Bucks County. An Andrew Headman is listed in the Philadelphia directory for 1837. A five-fingered flower vase with relief decoration was made by Charles Headman in 1849 and is in Philadelphia Museum of Art. The decoration here is reminiscent of English Fulham stonewares of the eighteenth and nineteenth centuries.

Fig. 114. Detail of signature incised on reverse of fig. 113.

Berks County, sometimes stamped his storage crocks several times with his name (fig. 132). A number of pie plates and cooking pots are known with the mark of Willoughby Smith of Womelsdorf (figs. 116, 140). The rather ordinary sander in figure 117 has the name of John Licht, probably the maker, scratched in the bottom along with the date 1826. Many potters' molds have signatures, and some include a place name and date, because they were valued tools of the trade, and the marks denoted ownership (figs. 118, 137).[8]

Written and material sources indicate that several hundred potters practiced their craft in Pennsylvania during the eighteenth and nineteenth centuries. In his first survey of America's manufactures, undertaken between 1787 and 1794, Tench Coxe found only "coarse earthen or potters ware" and "very little stone-ware" made in Pennsylvania. The manufacture of ceramics and glass throughout the country, he concluded in dismay, were in an "infant state." "From the quantity and variety of the materials which must have been deposited by nature in so extensive a region as the United States, from the abundance of fuel which they contain, from the expense of importation, and loss by fracture, . . . from the simplicity of many of these manufactures, and from the great consumption of them, impressions of surprise at this state of them and a firm persuasion that they will receive the early attention of foreign or American cap-

[8] At Winterthur there are ten potter's molds made of biscuit earthenware. Two are signed by John Wirth and dated 1817 (see fig. 118); one is signed B. B. Mershon, 1848; one is signed W. A. Lowe, New Jersey, 1874; one is signed Samuel Nusser, 1846; two are signed Daniel Strawn, 1843 and 1845; one has the name Shaun(?), 1845; one has IS, 1797; and one is unmarked.

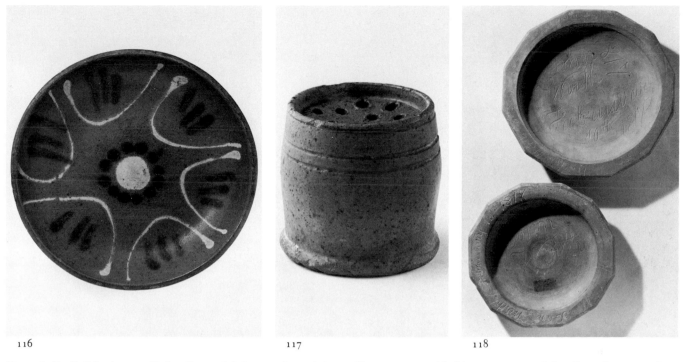

116 117 118

Fig. 116. Small dish, drape-molded; yellow and dark green slip-trailed decoration. Willoughby Smith (1839–1905), Womelsdorf, Berks County, 1864–1905. Stamped on reverse: W. SMITH. / WOMELSDORF. Diam. 7¼". (Winterthur 59.2224.) Smith by age eleven was apprenticed to potter John Shaner of Montgomery County. In 1864 he bought Feeg Pottery in Womelsdorf.

Fig. 117. Sander, thrown; brown glaze. John Licht, Pennsylvania, October 1826. Name and date incised on bottom. H. 2" (Winterthur 60.605.)

Too many men with this name are recorded in Pennsylvania records to permit specific identification of this potter.

Fig. 118. Twelve-sided dish molds, unglazed earthenware. John Wirth, Pennsylvania, February 10, 1817. Diam. (larger one) 9⅜". (Winterthur 69.391.3, .5.) Clay was thinly rolled, cut into bats, and slapped or draped onto the convex sides of molds such as these. On the concave surfaces, potters often wrote their names and other information. The location of Wirth's pottery is not known.

italists, are at once produced." As Coxe predicted, the situation did improve by 1810, with the manufacture of "ordinary ware of common potters' clay" being "very much extended in the United States." For Pennsylvania he recorded 164 potteries producing $164,520 worth of goods annually. Lancaster County, with only 3 potteries in 1787–94, had become the potting center of the state with 15 potteries in operation in 1810.[9]

The 1820 Census of Manufactures records only twenty-four potteries in Pennsylvania in the ten counties for which returns survive. The low number may also be explained by the part-time nature of many of the establishments. Many traditional potters were farmers first and foremost: they potted part of the year as a way of supplementing their incomes. Potter Michael Fillman demonstrated this concern with land

when he described his new situation in Clarion County to his former Montgomery County employer, Jacob Scholl (fig. 119). He wrote, "I A good Farme have goad [got] of 123 Ackers of Lime Stone Land aboud 40 Acker glire [clear]. First dread [rate] Medo [meadow] Land and a first dread orghert [orchard]."[10]

These potters-farmers were often assisted in their work by family members, and some had the additional help of an apprentice or journeyman. Fillman asked Scholl to send him a good potter, saying he would "Pay him a good brice [price]." In 1820 John Kendall of Lower Bern Township, Berks County, paid his employee $120 per year in wages.[11]

[9] Tench Coxe, *A View of the United States of America in a Series of Papers Written . . . between . . . 1787 and 1794* (Philadelphia: William Hall, 1794), pp. 62, 278; Tench Coxe, *A Statement of the Arts and Manufactures of the United States of America for the Year 1810* (Philadelphia: A. Cornman, Jr., 1814), pp. xliii, 65.

[10] Michael Fillman to Jacob Scholl, July 25, 1848, Photostat, DMMC (also published in Breininger, *Potters*, pp. 3–5). All Fillman quotes in this essay are derived from this letter. According to Barber (*Tulip Ware* [1970 ed.], p. 161), Fillman, while a journeyman, was responsible for "some of the best designs produced at [the Scholl] pottery."

[11] United States Bureau of the Census, "Record of the 1820 Census of Manufactures, Schedules for Pennsylvania," National Archives, Washington, D.C. (microfilm, DMMC). Questions posed concerned raw material

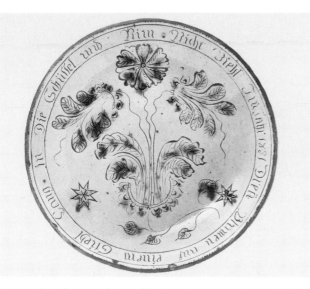

Fig. 119. Plate, drape-molded; sgraffito decoration, green coloring; attributed to Jacob Scholl, Tylersport, Salford Township, Montgomery County, 1831. Incised: "Im Jahr 1831 Dreii blumen auf einem Stiehl Lang in Die Schüssel und Nim Nicht Viehl." Diam. 11 ³/₁₆". (Winterthur 60.661.) This plate appears to be the one illustrated by Edwin AtLee Barber in *Tulip Ware of the Pennsylvania-German Potters: An Historical Sketch of the Art of Slip-Decoration in the United States* (Philadelphia: Pennsylvania Museum, 1903), fig. 61, although incorrectly described as unglazed and credited to Philadelphia Museum of Art. In the text Barber notes the piece belonged to the grandson of Jacob Scholl. A jar attributed to Scholl is shown in fig. 135.

Workmen may have received other benefits in the form of lodging and food.

Traditional earthenware potteries were characteristically owned and operated by a single master potter who controlled all aspects of production and marketing. Outside entrepreneurial capital was usually interested in the more complex and costly manufacture of fine earthenwares, stonewares, and porcelain. One Bucks County pottery, however, seems to have been owned by a nonpotter, presumably as an investment. Richard Moore notified the public in 1825 that he had taken over Quakertown Pottery, formerly owned by Abel Penrose, but he had retained the same workman "who, for some years past, by his superior knowledge in the

business, has given a preference to the ware wherever it is known."[12]

The amount of capital needed to erect a pottery did not have to be great and varied according to the size of the undertaking. Small-scale, two-man operations, such as those in Northumberland and Montgomery counties run by Adam Gudekunst, John Leisenring, and John Leidy, were established with $300 to $350 capital. Isaac English, on the other hand, had invested $3,000 in the Philadelphia County pottery where he employed four men.[13]

The 1777 household inventory of Jacob Roat, a Philadelphia potter of German background, lists the typical equipment in a traditional earthenware pottery.

a Quantity of Earthen Ware	£52.11.9
1.0.0 [pounds?] of Red Lead	7.10.
5 1/2 Cords of Wood for the Pothouse @ 20s	5.10.
1 Six plate Iron Stove & Pipes in the Pothouse	5. .
2.0.0 of Magness [manganese]	1. 4.
3 Pottery Turning Wheels & Frames	7.
1 Iron bound bucket & 2 glazing Tubs	.10.
1 Glazing Mill	3.
1 Clay Mill	7.
1 Ax	3.9
70 Pot boards	1.10.
a Quantity of blue Clay	1.

These tools and materials, excluding the earthenware on hand, amounted to £41.11.9, or approximately 6.4 percent of his inventoried estate.[14]

Pennsylvania potters fashioned their wares of local clays which, whether gray, blue, red, or yellow when dug, turned a red color when fired. They established themselves near clay banks. Michael Fillman's clay was "very henty [handy] it is about 18 Rods to Hall to the Clay mill." In the often horse-powered clay mill, air bubbles were removed and the clay rendered into a uniform consistency. Veins of the white clays needed for decorative purposes were uncommon, so most potters had to purchase their supply.

Much of the ware was thrown on a potter's wheel, although many potters did rely on molds to shape, and occasionally to ornament, certain forms. Other decoration seen on Pennsylvania German earthenwares was accomplished by means of slip cups (fig. 144), stamps, and other

employed (kind, quantity annually consumed, cost of the annual consumption); number of persons employed (men, women, boys, girls); machinery (whole quantity and kind of machinery, quantity of machinery in operation); expenditures (amount of capital invested, amount paid annually for wages, amount of contingent expenses); production (the nature and names of the articles manufactured, market value of the articles that are annually manufactured, general remarks concerning the establishment as to its actual and past condition and demand for and sale of its manufactures).

[12] *Bucks County Patriot and Farmers' Advertiser* (May 2, 1825). Moore's workman may have been Zachariah Mast, a German. Moore was previously identified as a potter who started Quakertown Pottery (Guy F. Reinert, "Pennsylvania German Potters of Bucks County, Pennsylvania," *Bucks County Historical Society Papers* 7 [Allentown, 1937], pp. 584–85).

[13] Nos. 994, 1011, 765, 601, "1820 Census of Manufactures."

[14] Philadelphia County, Probate Court Records (1777), no. 37, City Archives, Philadelphia (microfilm, DMMC).

tools that were devised by the individual potter. Touches of color were supplied by oxides of manganese (brown), copper (green), iron (black), and, rarely, cobalt (blue). Once decorated, the wares were set on wooden planks—pot boards—to dry.

Earthenwares had to be glazed, at least on the interior surface, in order to be nonporous. Glaze formulas varied but basically included red lead, flint, and clay. Because the red lead was costly the Pennsylvania German potter glazed sparingly. Pie dishes, bowls, and pans were routinely glazed only on the inside. Both interior and exterior walls of the vessels seen in figures 120 and 190 were glazed, but the interior of the lid was left unglazed. After pots were glazed they were placed into protective cases made of unglazed earthenware, called saggers, which were then stacked within the kiln.

Firing took up to a week in the wood-fueled kilns. Each kiln would be filled and fired several times during a year. John Leidy reported that during 1815 he had "burned" eleven kilns.[15] At John MCrea's pottery in Norrington twenty-four cords of wood were consumed during 1819 at a cost of $5 per cord. The size of the kilns varied. Fillman claimed to have built at his new Richland pottery "tha Biggest kill . . . tha I have Saw." He measured its size to Scholl only in dollars, however, noting that it held about $120 worth of earthenware. Like all potters, Fillman experienced disappointments in the "burning"; when he opened his kiln on July 12, 1848, "Half was goen." Because of the rudimentary methods of controlling the flames, vagaries of weather, and unforeseeable accidents in the kiln, a potter never had assurance of success.

The market could also be uncertain, although a universal need for utilitarian earthenwares, especially in kitchens, larders, and dairies, was a strong guarantee of sales. Replacing broken objects also kept the pottery busy: as the maker of one plate reminded the customer, "when it breaks the potter is happy" (fig. 191). As one of the few potters in Clarion County, Fillman found he sold ware faster than he could make it: "the People Does many times pay me for Crocks before th[e]y Ere Borned [burned] for the Seek [sake] of giden [getting] them." But nearly thirty years earlier, in 1820, craftsmen in more populous areas of the state had reported a decline in business because of foreign imports.

The 1820 Census of Manufactures indicates fairly uniform market values for Pennsylvania earthenwares. Adam Gudekunst's wares ranged in price from 3¢ to 37½¢ per piece. John Leisenring's were priced from 3¢ to 40¢, while Daniel and John Bogar of Northumberland County sold

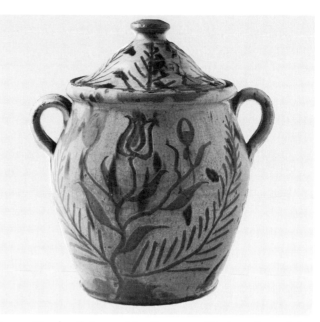

Fig. 120. Two-handled covered jar, thrown; sgraffito decoration, splashes of brown; Pennsylvania, 1796. H. 9½″. Repaired finial. (Winterthur 62.642.) The interior of the lid of this and other covered vessels was left unglazed. A tulip decorates the other side.

earthenwares from 2¢ to 33¢. Fillman's letter offers some insight into the relative costs of crockery in 1848. He mentioned that pots sold from 8¢ to 25¢ and explained to Scholl that a day's labor in Clarion County was worth 50¢ except at haymaking time when it rose to 62¢. To extend the comparison, Fillman's farmland had cost him $3.33 an acre.

Information about the pricing of individual vessels can be gleaned from both the 1848 Fillman letter and the Swank account book of the early 1850s.[16] Retail cost, not surprisingly, depended on the size of the object, that is, the amount of raw materials required and the time needed to make it. The most expensive items Fillman described, selling at 25¢ each, were his largest: "big" cream crocks and one-gallon jugs. Half-gallon jugs were 15¢, and a quart one brought 10¢. Swank's highest priced jug, probably of a gallon capacity, was also 25¢. He apparently offered two sizes of cream crocks and sold them for 20¢ and 25¢. Crocks and dishes of unspecified purpose ranged in price at the Swank pottery from 4¢ to 25¢ and from 3¢ to 18¢. Pound-cake molds cost the buyer 18¾¢; chamber pots could be had for 12½¢ and 15¢. Lamps and sugar bowls could be bought for 12½¢ each, while pitchers came in 10¢ and 12¢ varieties. A "spiting-box" sold for 6¼¢.

[15]No. 765, "1820 Census of Manufactures."

[16]Daybook of Samuel or possibly Josiah Swank, Upper Turkeyfoot Township, Westmoreland County, DMMC.

Prices also varied somewhat according to the potter's market and competition. Noting that "good Corcks [sic] is very Skears [scarce] here," Fillman discussed the higher prices earthenware commanded in the western part of the state. A crock that would have been sold in Montgomery County for 5¢ and 6¢ brought 8¢ and 10¢ in Clarion County. Although the wares were usually described in terms of cost, for example, a "five-cent pie dish," Pennsylvania potters, like many artisans of the time, would accept goods in payment for their products. In Westmoreland County, potter Samuel Swank received such things as sugar cakes, chestnuts, varnish, and whiskey in lieu of or in addition to cash.

An earthenware potter's market in Pennsylvania was more or less "local." According to Johan David Schoepf, who traveled in the state in the 1780s, the Bethlehem pottery supplied the neighborhood "far around." One Chester County potter told the census taker in 1820 that he sold to "storekeepers throughout the county." Nearby, Daniel High claimed the entire state was his market.[17]

Eighteenth-century potters of Philadelphia had enjoyed the widest market, selling their wares thoughout America. "Philadelphia earthenware," apparently distinctive in style or quality, was advertised in many newspapers north and south. Two platters of Philadelphia ware were even recognized by appraisers of a merchant's estate on Nantucket Island in 1801. In 1767, Providence, Rhode Island, potter Joseph Wilson notified the public that he made earthenware "in the best Manner and glazed the Same Way as Practised in Philadelphia." Jonathan Durell had learned the pottery trade in Philadelphia and then opened his own business in New York City. He advertised there in 1773 that he was "now manufacturing" Philadelphia earthenware: "The ware is far superior to generality, and equal to the best of any imported from Philadelphia, or elsewhere, and consists of butter, water, pickle, oyster and chamber pots, milk pans of several sizes; jugs of several sizes; quart and pint mugs, quart, pint, and half pint bowls of various colours; porringers, and smaller cups of different shapes, striped and-clouded dishes of divers colours, pudding and wash hand basons, with sauce pans, and a variety of other sorts of wares."[18] Current research indicates that the styles of English Staffordshire pottery were closely copied by colonial Philadelphia potters. Some potters of German background, such as Matthias Meyer, Jacob Roat, and Jacob Udery, are known to have worked in early Philadelphia, but the exact role of the Germanic craftsmen in the production of the famed Philadelphia earthenware has not been ascertained. One of the early stoneware potters in Philadelphia was Anthony Duché. Born in England to Huguenot parents, he produced wares that closely imitated both English and Rhenish imports of the period.[19]

As Durell's advertisement implies, most of the traditional potter's wares were utilitarian, associated with eating and drinking and the preparation and storage of food. Additional forms mentioned in the Swank accounts are crocks, dishes, pie dishes, jars, flowerpots, cream crocks, stovepipes, sugar bowls, night pans, spitting boxes, cake molds, lamps, and pitchers. Besides these forms, there are in the Winterthur collection cooking pots, a flask or pocket bottle, a salt cup, whistles, and toys (figs. 121, 122, 123, 124, 125). For use on desks, Pennsylvania German potters created inkstands and sanders (figs. 126, 117). The washbasin shown in figure 127 would have served in a bedroom. The puzzle jug (fig. 128). designed to sprinkle the unwary drinker, was a form popular in both English and Continental pottery. A teapot and two tea caddies (figs. 112, 129, and pl. 24) are rare redware versions of fine-bodied English imports. The bulbous jars of figures 130 and 131 are reminiscent of Dutch delftware interpretations of early China trade porcelains, both in their shapes and in the distinctive panels framing the decoration of the sides.

For many of the forms recorded in Pennsylvania German pottery it is difficult to pinpoint characteristics that are specifically German. Certain shapes are universal and almost timeless, and a potter would rarely embellish the most utilitarian pots. Probably the sander attributed to John Licht (fig. 117), the crock by Joseph S. Henne (fig. 132), and a mug and pitcher made by a Hessian-born potter of York, illustrated in *Antiques*, best demonstrate what would have been the bread-and-butter ware of the Pennsylvania German potters.[20] Yet few of these plain objects survive, and it is only in the highly decorated earthenwares, often made

[17] Johann David Schoepf, *Travels in the Confederation* (1783–1784), trans. and ed. Alfred J. Morrison, vol. 1 (Philadelphia: William J. Campbell, 1911), p. 142.

[18] Inventory of Christopher Hussey, 1801, Nantucket County, Mass., Probate Court Records, Book No. 4 (citation courtesy of Nancy Goyne Evans); *Newport Mercury* (June 22, 1767), as quoted in Charles D. Cook, "Early Rhode Island Pottery," *Antiques* 19, no. 1 (January 1931): 38; *New York Gazette and the Weekly Mercury* (March 15, 1773), as quoted in Gottesman, *Arts and Crafts*, pp. 84–85.

[19] For a discussion of the industry in the eighteenth century, see Beth Ann Bower, "The Pottery-Making Trade in Colonial Philadelphia: The Growth of an Early Urban Industry" (M.A. thesis, Brown University, 1975); and Elizabeth Cosans, "Catalogue and Remarks" (typescript), in United States Department of Interior, National Park Service, "Franklin Court Report," 6 (1974), on deposit at Independence National Historical Park, Philadelphia. Robert L. Giannini III, "Anthony Duché, Sr., Potter and Merchant of Philadelphia," *Antiques* 119, no. 1 (January 1981): 198–203.

[20] The products of Henry Miller are described in "Collectors' Notes: Pennsylvania Potter," *Antiques* 88, no. 2 (July 1965): 101.

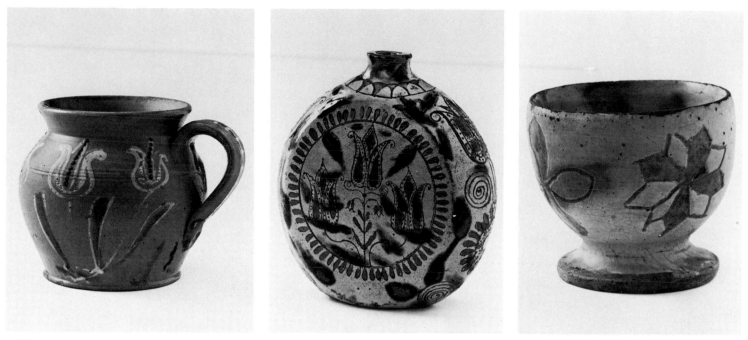

121

123

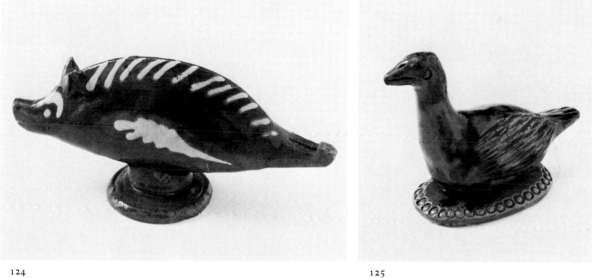

124

125

Fig. 121. Cooking (possibly bean) pot (lid missing), thrown; yellow, green, and brown slip-trailed decoration; Pennsylvania, May 24, 1837. Date incised on bottom. H. 5⅝". (Winterthur 60.617.) The blackened bottom indicates its use in cooking.

Fig. 122. Flask or pocket bottle, press-molded; sgraffito decoration, splashes of green; Pennsylvania, 1800. H. 5⅛". (Winterthur 60.644.) Reverse shown in pl. 26. The initials DK(?) on the reverse of this rare flask may be those of the maker. A mug dated 1809, featuring a mermaid, was probably by the same potter (see advertisement of Mrs. Lawrence J. Ullman, *Antiques* 31, no. 1 [January 1937]: p. 4).

Fig. 123. Salt cup, thrown, sgraffito decoration, splashes of green; Penn-

sylvania, 1785–1825. H. 2⅞". (Winterthur 65.2308.)

Fig. 124. Hedgehog whistle; white slip decoration; Pennsylvania, 1825–50. L. 5¼". (Winterthur 59.2282.) One of two in the Winterthur collection. A similar whistle is in Mercer Museum, Bucks County Historical Society.

Fig. 125. Figure of a goose; incised and stamped decoration, mottled olive and brown glaze; probably Pennsylvania, 1825–75. H. 2 13/16". (Winterthur 59.2236.) One of many goose figures at Winterthur, some of which may have been intended as rattles. Related geese with topknots have been attributed to the Maize pottery, Centre County.

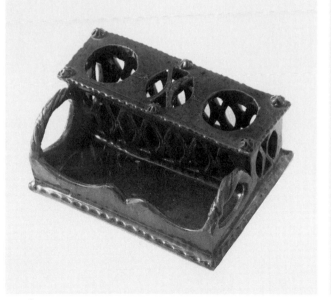

126

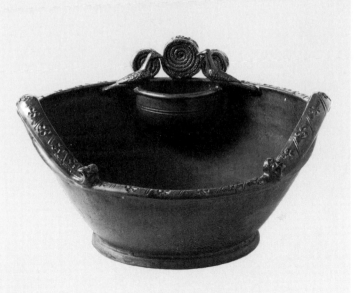

127

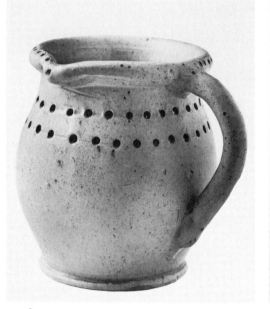

128

129

130

Fig. 126. Inkstand, slab built; openwork decoration; Pennsylvania, 1780–1820. L. 6½″. (Winterthur 55.589.) A typically Germanic form.

Fig. 127. Washbasin with strap handles, thrown; stamped details, brown glaze; Pennsylvania, 1850–1900. W. 15⅛″. (Winterthur 67.746.) Wadsworth Atheneum has a similar basin.

Fig. 128. Puzzle jug, thrown; punched decoration, green yellow glaze; attributed to David B. Huber (1845–1916), Niantic, Montgomery County, 1865–70. H. 6″. (Winterthur 80.66.) The handle of the puzzle jug has a hole which the drinker must cover in order to drink from the spout without having the liquid spill out. The jug was acquired from the potter's grandson.

Fig. 129. Tea caddy, thrown; sgraffito decoration; Pennsylvania, 1794. WH and date incised on bottom. H. 6″. (Winterthur 52.55.) A bird decorates the other side of this earthenware version of a fineware form.

Fig. 130. Jar, thrown; sgraffito decoration, splashes of green and brown; Pennsylvania, October 5, 1788. Incised: "Phillib Süssholz den 5 ockdomer 1788." H. 8⅛″. (Winterthur 65.2706.) In the layout of the design in panels as well as in the overall shape, this jar is reminiscent of Dutch delftware in the Chinese taste. Süssholz was probably the owner of the jar, although there were potters named Seisholtz in Pennsylvania.

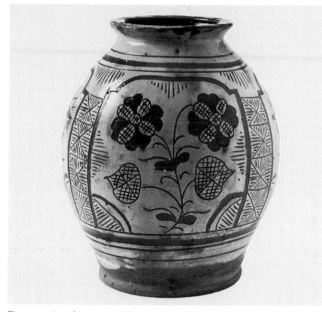

Fig. 131. Jar, thrown; sgraffito decoration, Pennsylvania, 1780–1800. H. 9½″. (Winterthur 60.656.) The panel arrangement of the design is also similar to Dutch delftware jars. The piece is closely related in form and decoration to fig. 156 and pl. 27. The teapot in fig. 112 may be by the same hand.

Fig. 132. Storage jar, thrown; variegated green and brown glaze. Joseph S. Henne (1820–1901); Upper Tulpehocken Township, Berks County, 1846–65. I. S. HENNE is stamped three times and surrounded by a garland of impressed ovals. H. 10⅝″. (Winterthur 67.1582.) The mottled surface color results from atmospheric conditions in the kiln during firing.

solely for ornamental purposes, that the hand of the German potter is evident.

It is rarely a "pure" hand because the potters of Pennsylvania were by no means a homogeneous group. Craftsmen of Swiss and Bohemian origin have been identified as well as those from virtually all the principalities of Germany. Many of them were the offspring of immigrants and had not known Europe firsthand. Moreover, potters, like other artisans of the Pennsylvania German community, were exposed to outside influences, specifically, imported ceramics and the work of non-Germanic potters in Pennsylvania.

As in the other regions of America, English ceramics dominated the Pennsylvania market in the eighteenth and nineteenth centuries. Into the port of Philadelphia came everything from tureens to toys in a variety of ceramic bodies: delftware, stoneware, creamware, porcelain, and common red and yellow earthenwares with slip decoration. That these wares did indeed spread inland is suggested by the Philadelphia importers' advertisements of assortments of ceramics "suitable for the country," and by surviving shop inventories.[21] Archaeological investigation may provide clues as to what designs and bodies, if any, found particular favor

among the German settlers, but as yet there have been few excavations of Pennsylvania German sites.

Commonly associated with the Germans in America are English painted and sponge- or spatter-decorated white earthenware of the early nineteenth century. Indeed, it has been thought that spatterware and the so-called Gaudy Dutch wares were designed exclusively for sale to the Pennsylvania Germans. The latter ware is gaudy to some twentieth-century eyes, but it does rest firmly in the mainstream of English ceramic styles of the period. With their oriental-inspired motifs in the bright Imari palette of red, gold, and blue they relate closely to the bone and stone chinas of Spode, Mason, and other English manufacturers. Because they were less expensive earthenware versions, they were probably considered export goods, but their restriction to the Pennsylvania German market has not been satisfactorily proved.[22]

German-made ceramics were also imported for sale in Pennsylvania. Documented earthenware imports are scarce,

[21] Mary Marjorie Gilruth, "The Importation of English Earthenware into Philadelphia, 1770–1800" (M.A. thesis, University of Delaware, 1964); Lititz shop inventory, 1774, DMMC.

[22] One writer responsible for this theory is Cornelius Weygandt, *The Red Hills: A Record of Good Days Outdoors and In, with Things Pennsylvania Dutch* (Philadelphia: University of Pennsylvania Press, 1929), pp. 149–50. For stylistic analysis of Gaudy Dutch ware, see Karin Calvert, "The Origins of the Iconography of Gaudy Dutch," typescript, 1978, Winterthur Museum Library.

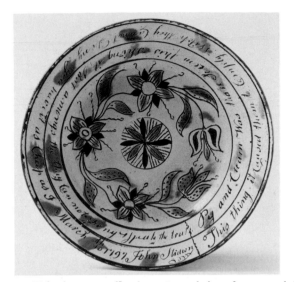

Fig. 133. Dish, thrown; sgraffito decoration, splashes of green; probably Bucks County, March 10, 1797. Incised: "Py and Cream Was thare Sceem this Thing it Past amongs the youth thay Can not Deny & Speak the truth / This thing it Caused them to Comply Witch they Cannot Deny you have it as Cheep as I March 10th 1797 John Strawn." Diam. 14 5/16″ (Winterthur 65.2302.) There were several John Strawns among the English Quaker family of potters named Strawn in Haycock Township, Bucks County. The most likely maker or owner of this dish is the John Strawn (1744-ca. 1809), son of Jacob, who had moved west to Greene County by 1790. Philadelphia Museum of Art has a plate that appears to be by the same hand and is dated 1793 and has the initials TS.

so the exact impact of the trade cannot be determined. However, pottery sent from the Continent may well have reinforced the Old World styles of the emigrant potters and inspired their descendants. Stoneware bellarmine jugs and other forms made in the Rhineland were marketed throughout America from the beginning of the seventeenth century. Many eighteenth-century examples, decorated with emblems of the British monarchy, were sent to England and her colonies. Fine German porcelains also came to Pennsylvania. John Penn's effects, inventoried in 1788, included a "set of elegant Dresden china" (Meissen porcelain). That the market for this famous ware was broader is seen in the 1790s inventories of "Dresdner" teawares in a Lititz shop.[23]

Besides the competition and influences of imported ceramics, the Pennsylvania German potters were also exposed to the work of non-Germanic potters in their midst. In Chester County, Arthur James has discovered potters of English, Irish, and Welsh origin, some of whom had Ger-

mans in their employ. Abraham Weaver, Joseph Smith, and Ephraim Thomas were among the non-Germanic potters in Bucks and Montgomery counties. That Germans patronized these "foreign" potters is seen in the record of merchant Jacob Hause's purchase of ware from John Vickers, a potter of English background. By the same token, customers of English extraction must have bought items, perhaps designed to their special order, from the German potters. Thus David Spinner's fanciful plates inscribed in English may have been made for English clients.[24]

The extent to which non-Germanic potters in Pennsylvania were influenced by the art of their German counterparts—or their German customers—is difficult to measure. The pieces known to have been made by Henry McQuate, a Lebanon County potter, are in a style neither strongly English nor German. Although he was of Scots Irish parentage, McQuate married a German girl who spoke no English, and in 1864 joined the German Baptist sect, the Dunkards.[25] The large dish shown in figure 133, with the name John Strawn, was probably the work of one of the Strawn family of potters of English Quaker background. The inscription is in English, but style and design of the plate parallel that of Pennsylvania German pottery.

A tea caddy (pl. 24) demonstrates a situation where a potter of English origin rendered in Pennsylvania redware an English fineware form with English decoration. Made for L. Smith in 1769 the canister was modeled on Staffordshire tea caddies of white salt-glazed stoneware, circa 1740 (fig. 134). The English examples were small and slip-cast and often featured a tea plant molded in relief on one side. The Pennsylvania redware version is much larger and slabbuilt. A tea plant with birds appears on one side, but it was executed in the sgraffito manner, incised on a wash of white slip. Like the English caddies, the Pennsylvania one has the word *tea* on it. Symbols displayed between the letters are not exactly paralleled in England but are clearly associated with tea: scales for weighing the leaves; a spoon for serving and stirring; a key indicating that the value of tea often resulted in its being locked up. The owner's name and date further embellish the Pennsylvania piece as they often do on English stoneware with scratch-blue decoration.[26]

A 1767 caddy owned by an Esther Smith, virtually identical to Winterthur's, had been attributed by Barber to the Joseph Smith pottery in Wrightstown, Bucks County.

[23] Ivor Noël Hume, "Rhenish Gray Stonewares in Colonial America," *Antiques* 92, no. 3 (September 1967): 349–53. Penn inventory, DMMC; Lititz shop inventories, 1791–1792, DMMC. There is no way of knowing if the wares so described were truly Meissen porcelain.

[24] Arthur E. James, *The Potters and Potteries of Chester County, Pennsylvania* (West Chester: Chester County Historical Society, 1945), pp. 95–96; Barber, *Tulip Ware*, pp. 129–33.

[25] Rhea Mansfield Knittle, "Henry McQuate, Pennsylvania Potter," *Antiques* 8, no. 5 (November 1925): 286–87.

[26] Two scratch-blue stoneware tea caddies with the names of the owners and dated 1768 are in Winterthur's collection (58.940, 71.193).

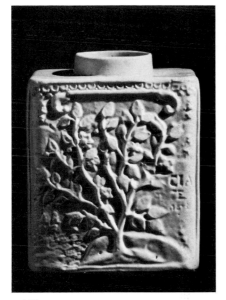

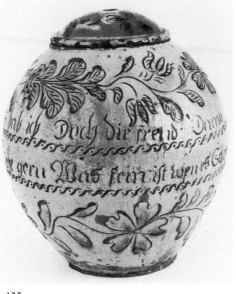

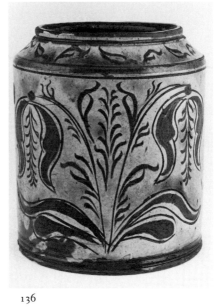

134 135 136

Fig. 134. Tea canister, slip-cast, salt-glazed stoneware; Staffordshire, England, 1740–60. H. 3⅝″. (Private collection.) Imported stoneware canisters of this sort served as models for the Smith pottery redware versions.

Fig. 135. Covered jar (finial missing), thrown; sgraffito decoration, splashes of green; attributed to Jacob Scholl, Tylersport, Salford Township, Montgomery County, 1825–35. Incised: "Ich Liebe gern Was fein ist wen es Schon nicht mein ist / Und mir nicht werden kan So hab ich Doch die

Freud Daran." H. 8⅞″. (Winterthur 60.665.) The decoration is similar to that of fig. 119. Jars of the same shape but with some blue coloring bear the floral mark of the Scholl pottery.

Fig. 136. Jar (lid missing), thrown; sgraffito decoration, splashes of green; Pennsylvania, 1820–40. H. 7¼″. (Winterthur 60.637.) Possibly from the same pottery as fig. 168 and pl. 23.

Recently this attribution has been confirmed by a third canister with Joseph Smith's name on it.[27]

Regardless of his training or inclination, the traditional earthenware potter of Pennsylvania operated within a relatively limited range of shaping and decorating techniques.[28] Clay could be freely modeled by hand but this was generally reserved for small toys and figures. The coil method of shaping vessels is not found in Pennsylvania German ware except as an occasional decorative device, as on the back of the washbasin in figure 127. The L. Smith tea caddy and the inkstand (fig. 126) were slab-built, fashioned from flat slabs of clay luted together at the edges.

Most hollowware forms and many of the pans and dishes were thrown on the potter's wheel. A lump of clay positioned in the center of the turning wheel could be transformed by the potter's hands into a thin-walled pot of elegant and bold proportions (fig. 135) or into ordinary cylindrical shapes (fig. 136). Tools of special profile, called ribs, aided in the final shaping and smoothing of a pot on the wheel.

Many large dishes, usually described as pie plates, were not thrown but molded. Clay was rolled with a rolling pin into a sheet and then cut into pancakelike circles or bats of the proper sizes. The bats were then slapped or draped over the convex sides of wood, plaster, or pottery molds (figs. 118, 137), removed, and then dried. Often the edges of a drape-molded plate were coggled, like a piecrust, while the edges of a thrown piece were usually thickly rolled (fig. 138). Although used by the Pennsylvania German potters from the 1770s and 1780s (figs. 160, 172), drape molding was not a practice of Continental European craftsmen but was peculiar to the English industry. Potters of English origin working in Philadelphia apparently introduced drape molding by midcentury.[29] It was probably through them that the

[27] Barber, *Tulip Ware*, pp. 108–9. The Esther Smith canister was featured in an article by Rawson W. Haddon ("Early Slip Decorated Canister," *Antiques* 9, no. 3 [March 1926]: 166) and is now in the collection of Yale University Art Gallery. The third canister, listed in Sotheby Parke Bernet, *American Heritage Auction of Americana* (Sale 2549 Y, January 28–30, 1981, item no. 690), is now in the collection of the American Wing, Metropolitan Museum of Art.

[28] For well-illustrated discussions of technology, see Elizabeth A. Powell, *Pennsylvania Pottery: Tools and Processes* (Doylestown, Pa.: Bucks County Historical Society, 1974), and Guy F. Reinert, "Slip-Decorated Pottery of the Pennsylvania Germans," *American-German Review* 2 (March 1936): 12–14, 49.

[29] Cosans, "Catalogue and Remarks."

Fig. 137. Mold for loaf dish, unglazed earthenware. B. B. Mershon, probably Pennsylvania, March 3, 1848. Name and date incised on concave surface. L. 13¾". (Winterthur 68.161.) Thin bats of clay were draped over the convex sides of molds such as this.

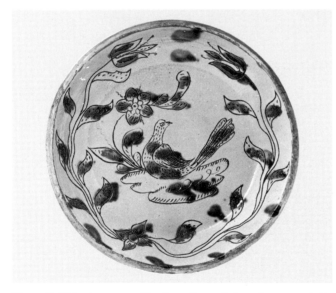

Fig. 138. Dish, thrown; sgraffito decoration, splashes of green; probably Bucks County, 1790–1810. Diam. 11½". (Winterthur 60.655.) This dish relates closely to the Strawn piece shown in fig. 133. Scratched lightly on the reverse are G x A 1854 and E x A 1862 which probably refer to later owners.

rural Germanic potters learned the technique.

Another method of production was press-molding, where clay was pressed by hand into the concave side of a mold. A convenient way to make figural forms, press-molding is illustrated by a bird whistle made by John Drey in 1809 (fig. 139). The flask shown in figure 122 and plate 26 was also shaped in this way.

For variation in color and texture, potters added colorants to the glaze, sometimes for a random, mottled appearance (figs. 140, 141) and sometimes for a monochromatic effect

(fig. 190). Unusual variegations of surface color were inadvertently achieved on account of the atmosphere within the kiln (fig. 132), but such kiln-induced coloration is more often seen in New England pottery.

As mentioned earlier, the Pennsylvania German artisans favored decoration with slip. White or cream-colored slip, derived from the pipe clay and kaolin banks of Chester County, provided the most striking contrast on the red body of the earthenware, but slip was also colored green, black, or brown. An overall slip coating formed a ground suited to pictorial decoration, but if the slip was not of the proper consistency or was not applied carefully enough, the body would show through. Several plates at Winterthur illustrate this problem (figs. 142, 143).

Slip could be brushed on, but it was more commonly trailed onto a dried, "leather-hard" vessel by means of a cup fitted with one or more quill spouts (fig. 144). It was a medium particularly suited to inscriptions and simple, linear motifs (figs. 145, 170). The more ambitious or dextrous potter could also accomplish complex pictorial and geometric designs with the slip-trailing method (fig. 146 and pl. 17). For a jeweled look, slip was applied in dots, as on the bowl in plate 25. This dotting technique had been popular among Staffordshire and Kent potters of the seventeenth and eighteenth centuries. Some pottery made in Sussex, England, in the late eighteenth century featured inlaid slip, a technique of slip decoration seen on one example at Winterthur, a multinecked flowerpot of Continental form (fig. 147).[30] Here the initials and the date were inlaid with slip.

For elaborate pictures, several craftsmen treated slip like paint, spreading it over the body in broad, thick areas (fig. 148). Mineral colorants could be added on top of the slip for contrasting details, as in the dark hair and coats of the historical portaits of figures 149 and 174. This slip painting was unsatisfactory. The thick slip did not adhere well to the body surface and cracked and peeled over the years.

Intaglio decoration is seen in Pennsylvania German as in other traditional American earthenwares. To make impressions in the soft clay, potters used simple household utensils as well as specially designed stamps. The maker of the jar shown in figure 150 struck the clay repeatedly with a round punch. Bands of rings and flowers encircle the bases of several animal figures (figs. 125, 180), while distinctive rosettes embellish the edge of a washbasin (fig. 127). Like the Sussex potters, Absalom Bixler found printers' type a conve-

[30] For examples of dotted slipwares, see Geoffrey A. Godden, *British Pottery: An Illustrated Guide* (New York: Clarkson N. Potter, 1975), p. 22, no. 7, and p. 25, nos. 13–14. Godden illustrates Sussex wares with inlaid slip on pp. 108–9.

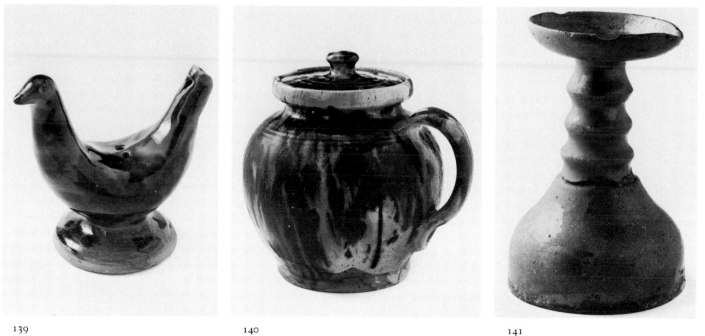

139 140 141

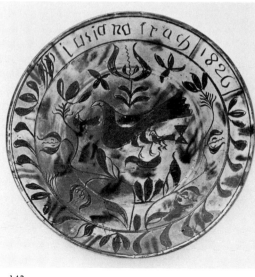

142

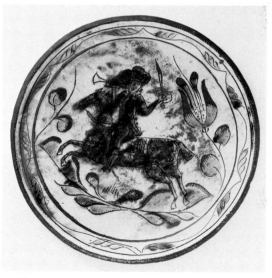

143

Fig. 139. Bird whistle, press-molded; mottled brown glaze. John Drey (Dry) (1785–1870), Dryville, Rockland Township, Berks County, 1809. Name and date incised on bottom. H. 3⅜". (Winterthur 62.658.) Dry took over the Melcher pottery in 1804.

Fig. 140. Covered pitcher, thrown; white slip coating with green and dark brown mottled coloring. Willoughby Smith (1839–1905), Womelsdorf, Berks County, 1864–1905. Stamped on bottom: WILLOUGHBY SMITH / WOMELSDORF. H. 7⅛". (Winterthur 67.1678.) Manganese and copper oxide in the glaze created the mottled appearance. For another marked Smith pot, see fig. 116.

Fig. 141. Grease lamp, thrown; splashes of dark brown; Pennsylvania, 1800–1840. H. 6⅛". (Winterthur 61.1138.) At the Swank pottery lamps sold for 12½¢.

Fig. 142. Plate, thrown; sgraffito decoration; attributed to Rudolph Drach (Trach), Bedminster Township, Bucks County, or possibly Hamilton Township, Northampton County, 1826. Incised: "iuliana [iusiana?] trach 1826." Diam. 10¾". (Winterthur 67.1608.) No mention of a Juliana Drach was found in Bucks County records. Rudolph Drach did have a daughter named Susanna (b. 1795). Attribution to Drach is based on the surname incised and the relationship of the decoration to that seen in fig. 162.

Fig. 143. Plate, drape-molded; sgraffito decoration, splashes of blue and green; attributed to Johannes Neesz (1775–1867), Tylersport, Salford Township, Montgomery County, 1800–1820. Diam. 12¾". (Winterthur 69.604.) Both Neesz and Rudolph Drach failed to put a sufficient amount of white slip over the body surfaces.

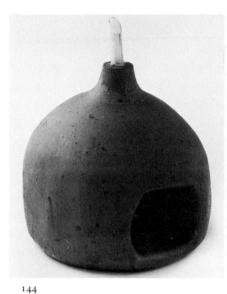

144

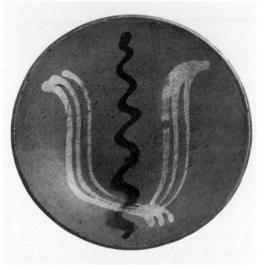

145

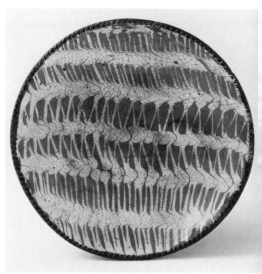

146

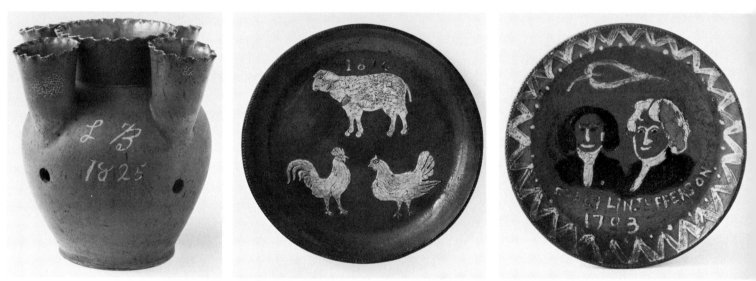

147

148

149

Fig. 144. Slip cup, thrown; clear glaze; probably Pennsylvania. 1846. Incised date and undecipherable words on bottom. H. 3″. (Winterthur 60.535.) The slip—liquid clay—was trailed through the quill spouts onto the pieces being decorated.

Fig. 145. Plate, drape-molded; yellow and brown slip-trailed decoration; attributed to John Dry pottery, Dryville, Rockland Township, Berks County, 1810–40. Diam. 10³/16″. (Winterthur 67.1505.) A slip cup was used to apply the slip decoration on this plate. Attribution based on a similar example marked D. Dry in the collection of William Penn Memorial Museum, Harrisburg.

Fig. 146. Large dish, drape-molded; white slip-trailed decoration, splashes of green; Pennsylvania, 1775–1825. Diam. 13¼″. (Winterthur 66.1246.) This plate demonstrates one potter's masterful control of the slip-trailing technique.

Fig. 147. Flowerpot, thrown; inlaid slip initials LB and date; Pennsylvania, 1825. H. 9 ¹/16″. (Winterthur 67.1614.)

Fig. 148. Large plate, drape-molded; applied white slip with incised detail; Pennsylvania, 1814. Diam. 14⅜″. (Winterthur 67.1558.) Another plate at Winterthur, featuring two horses and also dated 1814, is attributed to the maker of this object. In both cases slip was applied very thickly like paint. They bear a stylistic relationship to the work of Absalom Bixler, illustrated in figs. 151, 175, 176, and 177.

Fig. 149. Large plate, thrown; applied white slip, some colored dark green; probably Pennsylvania, 1793. Inscribed: FRANKLIN. JEFFERSON/1793. Diam. 13⅞″. (Winterthur 67.1671.) The potter depicted heroes of the day in thick white slip which has not adhered well to the body. Its mate is shown in fig. 174.

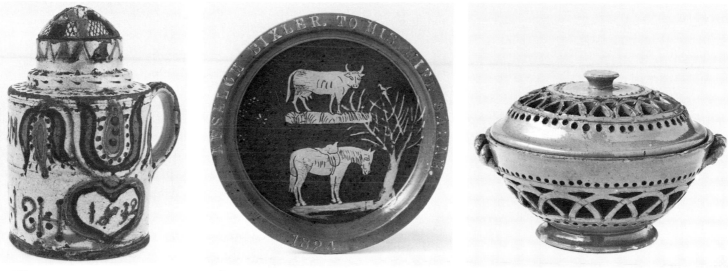

150 151 152

Fig. 150. Covered jug (finial missing), thrown; sgraffito, slip-trailed, and punched decoration on white slip ground, brown and green coloring; Pennsylvania, 1832. Initials SM and HSH as well as date on side. H. 8". (Winterthur 60.631.) This piece exhibits an unusual combination of decorative techniques.

Fig. 151. Large plate, thrown; applied white slip with incised detail. Absalom Bixler, Lancaster County, 1824. Type letter impressed inscription, partially filled with slip: ABSALOM BIXLER. TO HIS WIFE SARAH. 1824. Diam. 14¹/₁₆". (Winterthur 67.1661.) Another signed plate of sim-

ilar decoration is at Beauport, Gloucester, Massachusetts. Several flowerpots are known with relief decoration and the same inscription, also impressed in type letters. The historical subject plates in figs. 175, 176, and 177 are attributed to Bixler.

Fig. 152. Covered bowl; double walled with decoratively pierced outer wall; Pennsylvania, 1800–1850. H. 3¾". (Winterthur 60.693.) This bowl closely follows German prototypes. The piercing was done with the aid of a compass.

nient way of making intaglio inscriptions (figs. 151, 175, 176, 177). For the plate in figure 151 he filled the letters with slip.

Pierced or openwork decoration occurs on some hollowware forms of Pennsylvania German manufacture. Although the technique is a universal one, it is possible that some examples were inspired by English pierced creamwares that were so popular in America in the federal period. The inkstand and covered bowl in figures 126 and 152, however, are more closely tied to Continental prototypes.[31] These openwork pieces are among the most elaborately conceived of the Pennsylvania German earthenwares, yet they are crudely cut—in spite of the potters' reliance on a compass. The interlocking circles of the bowl in figure 152, for example, are irregular and the lid is ill-fitting.

Potters sometimes ornamented their wares with designs in relief. Filling small molds, called sprig molds, with clay for individual motifs, Andrew Headman produced a remarkable carousellike band around his flowerpot (fig. 115), reminiscent of the Fulham stonewares of London. A single,

overall mold both shaped and decorated the octagonal dish of *figure 153* with tulips, crossed swords, and seed pods in low relief as well as the potter's initials and the date 1794. In the Mercer Museum of Bucks County Historical Society there is a mold for a dish of very similar design, made by Andrew Headman in 1793. This method of shaping and decorating was used by Staffordshire potters.[32]

The type of decoration considered by collectors to be most characteristic of Pennsylvania German production is known as sgraffito. With few exceptions, the technique has not been recorded in American pottery outside of Pennsylvania.[33] This is a perplexing historical fact because sgraffitoware was

[31] See, for example, Erich Meyer-Heisig, *Deutsche Bauerntöpferei: Geschichte und landschaftliche Gliederung* (Munich: Prestel verlag, 1955), pl. 56.

[32] See Godden, *British Pottery*, pl. 3 and pp. 62, 63, 67. The Headman mold is illustrated in Shirley Martin, "Craftsmen of Bucks County, 1750–1800," *Bucks County Historical Society Journal* 1, no. 9 (Spring 1976): 39, fig. 4. For an English example of a mold and matching plate by William Bird, see Manchester City Art Gallery, *The Incomparable Art: English Pottery from the Thomas Greg Collection* (Manchester, Eng.: 1969), pp. 20–23, figs. 24–25.

[33] A sgraffito plate made in New Jersey in 1793 by Phillip Durell is shown in New Jersey State Museum, *New Jersey Pottery to 1840* (Trenton, 1972), fig. 16. The pottery trade sign made by Gottfried Aust in Salem, N.C., 1773, was decorated with a type of sgraffito where incised motifs were highlighted with pipe clays (Bivins, *Moravian Potters*, pp. 224–25).

made throughout Europe, not just in Germany. In fact, quantities of sgraffito made in Barnstaple and Bideford in North Devon, England, were exported to the American colonies, especially to New England, in the seventeenth and early eighteenth centuries. Potters in Somerset and Staffordshire continued the practice on a smaller scale until about 1800.[34] Central European decorated dishes often show a combination of sgraffito and slip-trailing: a central motif executed in sgraffito was often surrounded by a slip-trailed inscription. Pennsylvania German potters, on the other hand, generally employed only one of the methods on a single vessel.

In the sgraffito process, a layer of slip is applied over the body clay and is scratched through to reveal in a decorative manner the contrasting body color beneath. In Pennsylvania the body was invariably red, the slip skin usually white. The lead glaze on top gave the white slip a yellowish cast. In several examples at Winterthur the red color of the body appears to have been intensified by the addition of red slip to the exposed areas. Sometimes the areas within incised outlines were carefully filled with copper oxide for green coloring, as in the petals and leaves of plate 18 and the fish of plate 19. Occasionally, mineral colorants carried a design on their own, independent of the sgraffito pattern, as in the case of the green rosettes on two JK plates (figs. 154, 155). Most often, however, copper oxide and manganese dioxide were applied for random tones of green and brown. Blue is seen only on a few Pennsylvania German sgraffitowares (fig. 143 and pl. 20).

Large, shallow plates and dishes were the most common shapes to be decorated in the sgraffito manner, no doubt because they provided a broad, flat, canvaslike area. Few bear evidence of cooking or other usage, so they were probably intended to ornament the home like pictures. Sgraffito hollow forms do occur, but rarely; the Winterthur collection contains many of the known examples.

Examination of the seventy-seven sgraffito-decorated pots at Winterthur reveals that a variety of tools was employed to incise the clay. Some potters scratched with a thin, sharply pointed implement for a linear effect (fig. 129). Others used a wider, almost chisellike blade to carve out large sections

of their designs (figs. 166, 172). One as yet unidentified potter relied on a distinctive combing tool. In the example of his work included in this catalogue (pl. 19), the device was used effectively to delineate the fins and scales of the fish. The sgraffito process naturally lent itself to certain techniques, such as cross-hatching, that can be seen in the products of many potters (fig. 156). Similarly, many potters filled in or emphasized large shapes of their pattern with dots and dashes (pl. 21).

Although much of the Pennsylvania German sgraffito decoration appears to have been executed freehand, the artisans did have their shortcuts. Circular and semicircular motifs were frequently laid out with a compass. Telltale points are clearly seen, for example, on the rare flask of plate 26, where a compass was used to space the large circles, the border of interlocking semicircles, and the scrolls on the sides. The craftsman responsible for the plate in figure 157 depended on his compass for the outlines of the urn, the stars, and the balloonlike blossoms. Even stencils may have been used: the punched band of stylized flowers and leaves around the jar in figure 158 was probably accomplished with a stencil. Conrad Ranninger tried a resist-type method known to Sung potters when he laid tree leaves on the damp clay and surrounded them with slip (fig. 159). Some decorative details were also the result of special, time-saving tools. For example, the potter who made the plate in figure 160 punched the bird's body and the heart with a stamp or roulette that had a row of five tiny squares.

Although the designs of different sgraffito potters can be quite similar, and although an individual craftsman may have formed a flower or leaf in more than one way, the details of execution can still provide a potter's "signature" and lead to specific attributions. The letters and flower in figure 164 and plate 22 are so close, for example, that we must conclude they were done by the same hand. Comparison with signed objects in other collections suggests an attribution to George Hübener.[35] In the same way, the shallow dish of figure 161 is attributed to Samuel Troxel, and figure 171 is believed to be the work of David Spinner. Attributions must be given cautiously, however, until more documentary evidence is discovered about the potters and their shops, their apprentices, journeymen, and successors.

The survival of many Pennsylvania German sgraffitowares was assured by their commemorative nature. Several Winterthur pieces carry dates—month, day, and year—implying the memory of a special event (fig. 130); others bear the name of the person for whom the object was made.

[34] C. Malcolm Watkins, "North Devon Pottery and Its Export to America in the 17th Century," *United States National Museum Bulletin*, no. 225, Contributions from the Museum of History and Technology (Washington, D.C.: Smithsonian Institution, 1960), pp. 17–59. A Staffordshire example, ca. 1760, is illustrated in Ronald G. Cooper, *English Slipware Dishes, 1650–1850* (London: Alec Tiranti, 1968), fig. 290; and in Jo Draper, *Dated Post-Medieval Pottery in Northampton Museum* (Northampton, Eng.: Museums and Art Gallery, 1975), p. 20, pl. 12. A 1766 fuddling cup incised with tulips and made in Donyatt, Somerset, is shown in Manchester City Art Gallery, *Incomparable Art*, p. 29, no. 42.

[35] Documented Hübener articles are illustrated and discussed in Barber, *Tulip Ware*, pp. 112–17.

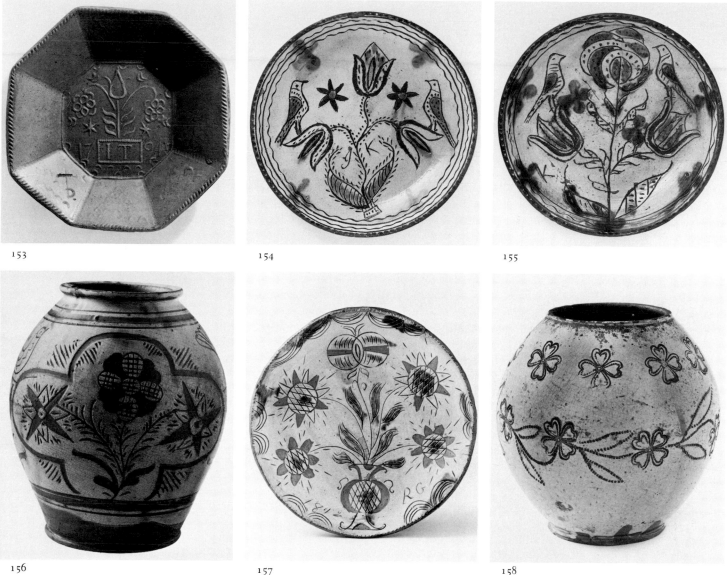

153

154

155

156

157

158

Fig. 153. Dish, form and decoration both from the drape mold; possibly Bucks County, 1794. Incised: IT and date. W. 8 13/16″. (Winterthur 65.2306.) The initials are believed to be those of the maker, identified by Edwin AtLee Barber as Jacob Taney of Nockamixon Township, Bucks County. Plates from the same mold are in the collections of Philadelphia Museum of Art and Smithsonian Institution. A related one from a different mold is in Mercer Museum, Bucks County Historical Society. A Jacob Taney owned land in Philadelphia County, but no one of that name appears in the 1790 census.

Fig. 154. Plate, drape-molded; sgraffito decoration, green coloring; Pennsylvania, 1790–1840. Incised JK. Diam. 12″. (Winterthur 67.1804.) In this and the following example copper oxide was applied to form four-petaled flowers above the birds' heads. JK has been associated with Jacob Kintner of Bucks County, but documented plates have not supported that attribution.

Fig. 155. Plate, drape-molded; sgraffito decoration, green coloring; Penn-

sylvania, 1790–1840. Incised K below left tulip. Diam. 11 7/16″. (Winterthur 67.1805.)

Fig. 156. Jar, thrown; sgraffito decoration; Pennsylvania, 1780–1800. H. 8 5/8″. (Winterthur 60.664.) Cross-hatching as seen in the flower petals on this jar was a common way for sgraffito potters to embellish their motifs. The piece relates to figs. 112, 131, and pl. 27.

Fig. 157. Plate, drape-molded; sgraffito decoration, splashes of green; Pennsylvania, 1812. Incised RG and date. Diam. 10 3/4″. (Winterthur 60.654.) The potter, possibly RG, relied on a compass to form the stars, vase, and flowers. A plate dated 1811 that appears to be by the same hand is also in the Winterthur collection.

Fig. 158. Jar, thrown; pricked sgraffito decoration; possibly by Jacob Scholl, Tylersport, Salford Township, Montgomery County, 1820–40. H. 7″. (Winterthur 65.2311.) Friedrich Hildebrand is known to have pricked designs through a stencil; however, in shape and design this pot bears a strong resemblance to the work of Jacob Scholl, figs. 119 and 135.

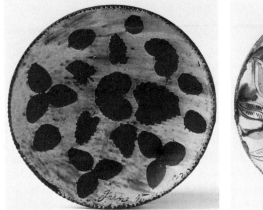

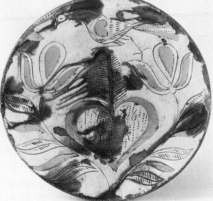

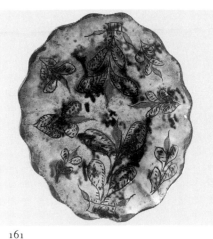

159

160

161

162

163

164

Fig. 159. Dish, drape-molded; leaves used as stencils on while slip ground, splashes of green. Conrad R. Ranninger (b. 1809); Montgomery County, June 23, 1838. Name and date incised on reverse; date incised on front surface. Diam. 9¹¹/₁₆″. (Winterthur 67.1612.) The use of tree leaves is unusual. Another Ranninger leaf dish with the same date is also at Winterthur. A Conrath Renninger was baptized July 4, 1809, in the New Hanover Lutheran Church, Montgomery County. A potter of this name was working in New Berlin, Union County, between 1849 and 1852.

Fig. 160. Plate, drape-molded; sgraffito decoration, green coloring; Pennsylvania, 1776. Incised HR in heart below date. Diam. 12⅜″, (Winterthur 55.109.4.) An early example of drape-molding in Pennsylvania German production. The bird's neck and tail and the heart were punched with a five-hole tool. Plates by the same HR are dated 1778 and 1793, but one dated 1804 (pl. 21) appears to be by a different potter.

Fig. 161. Shaped dish, drape-molded; sgraffito decoration, splashes of green; attributed to Samuel Troxel, Upper Hanover Township, Montgomery County, 1825. L. 8″. (Winterthur 60.627.) The attribution is based on a signed Troxel dish of the same form and similar decoration, dated 1823, in Philadelphia Museum of Art. Comparison with signed Troxel plates at Winterthur (fig. 113 and pl. 26) and an attributed one (fig. 165) support the attribution.

Fig. 162. Plate, thrown; sgraffito decoration, splashes of green. Rudolph Drach (Trach), Bedminster Township, Bucks County, or possibly Hamilton Township, Northampton County, 1798. Incised: "liewer wilt ich l[e]dig

leben als / der frau die hosen geben; 1798 / lieb mich allein oder laes gar sein / borgen m[a]chd sorgen meich / drach." Diam. 11½″. (Winterthur 67.1609.) The Art Institute of Chicago owns a plate signed Rudolph Drach, Bedminster Township, 1792 (illustrated by Edwin AtLee Barber). Two men of that name lived at that time in Bucks County, but the 1800 census records only one, and he lived in Northampton County. Drach's practice of writing inscriptions in horizontal lines is uncommon. The plate in fig. 142 was apparently made in the same pottery, probably for a family member.

Fig. 163. Plate, drape-molded; sgraffito decoration, olive green coloring; attributed to Johannes Neesz (1775–1867), Tylersport, Salford Township, Montgomery County, 1800–1820. Incised: "Ich bin geritten vihl stunt und Dag und Doch noch kein metel haben mach." H. 12¼″. (Winterthur 60.619.)

Fig. 164. Plate, thrown; sgraffito decoration, splashes of green; attributed to George Hübener, Montgomery County, September 14, 1787. Incised: "Wann das maenngen, und das hengen nicht wehr, so staenden die wiegen und hickel heusser Lehr:, September 14tm 1787." Diam. 13¹¹/₁₆″. (Winterthur 65.2300.) The attribution of this plate is based on its strong similarity to a signed plate of 1792 illustrated by Edwin AtLee Barber and another of 1789 marked GH. Hübener may have been related to potter Ludwig Hubner who worked for the Moravian community at Bethlehem from 1742. Another Hübener plate is shown in pl. 22.

Fig. 165. Plate, drape-molded; sgraffito decoration, splashes of green; attributed to Samuel Troxel, Upper Hanover Township, Montgomery County, 1830. Incised: "A ist ein amtmann verständig und klug; B ist ein bauer und liebet den pflug; C ist ein captain und schützet auf das land; D ist ein dumkopf und hasset verstand; 1830." Diam. 11¼". (Winterthur 60.659.) Documented Troxel plates are shown in fig. 113 and pl. 16.

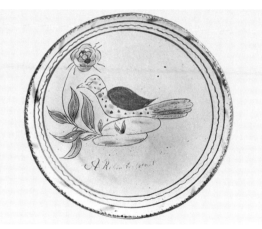

Fig. 166. Plate, drape-molded; sgraffito decoration, splashes of green; Pennsylvania, 1790–1830. Incised below bird: "A Robin Red breast." Diam. 11⅞". (Winterthur 60.658.) One of the few sgraffito objects with inscription in English.

Inscriptions were written in sgraffito around the edge of a plate, sometimes spiraling into a second row. Only Rudolph Drach is known to have written in horizontal lines across the face of a plate (fig. 162). Of the Winterthur examples discussed here, three have English-language inscriptions. The remainder are written in German, usually in block letters but occasionally in cursive.

The sayings immortalized on these earthenwares run the gamut from the religious to the profane—the selection being of either the potter's or the customer's choosing. Many were drawn from the proverbial lore of the community and recur on pots made in different shops. "God bless you in eating and drinking" appropriately encircles a teapot of 1799 (fig. 112), while the inscription on the jar in plate 27 translates: "This pot belongs to Elizabeth Sishols. Jesus dwells in 1785." A variation of Matt. 7:12, "Everything you want people to do to you, you should do to them," surrounds the dish made for Susanna Steltz (pl. 22). Potter Jacob Scholl expressed a bit of poignant philosophy on his jar in figure 135, saying, "I like what is fine, even when it's not mine and never can be yet its joy is with me."

Courtship, marriage, and the battle of the sexes were popular themes. A plate dated 1821 is inscribed, "Maiden, I can tell that you would like a husband. As far as I can see you shall soon be getting one" (pl. 18). Less optimistic is the horseman in figure 163 who proclaims, "I have been riding night and day and no girl wants me anyway." A boastful verse surrounds the peacock in figure 164: "Were there no men or roosters left, empty would be cradles and also chicken pens." In a similar vein is Rudolph Drach's

statement, "Rather would I singly live than to my wife the breeches give" (fig. 162). A feminine customer might have derived comparable pleasure from her pie plate inscribed, "I only cook what I can cook still, what the pig won't eat my husband will" (fig. 113). An unusual "alphabet" plate of 1830 offers one view of the German settlers' legendary resistance to formalized education: "A stands for the magistrate [Amtmann] sensible and wise, B stands for the farmer [Bauer] at home with the plough, C stands for captain who protects the land, D stands for blockhead [Dummkopf] who cannot stand learning" (fig. 165).

With few exceptions, the inscriptions on sgraffitoware bear no relation to the pictorial motifs, often with humorous effect. For example, paired with the rather serious-looking musicians in figure 172 is the obscure verse, "Good morning, cousin Schnitz. You kissed the mouth for nothing, didn't you." Samuel Troxel wrote, "On the platter is a star; what I like I gladly eat," yet he pictured a bird and flower, not a star (pl. 16).

Words or names were sometimes added as identifying features on objects. The tea caddy of plate 24 might have been classified merely as a large bottle of indeterminate function had not the word *tea* been included. The handsome bird shown in figure 166 is titled a "robin red breast," a necessary clue to the potter's intention because the bird as rendered has a red wing, not a red breast. Hübener, almost as an afterthought, dispelled any doubts as to the nature of the beast he created in plate 22 by squeezing in the phrase, "Here is pictured a spread eagle."

The eagle exemplifies the difficulties in interpreting the

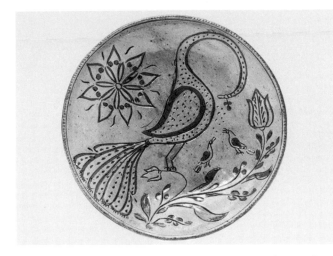

Fig. 167. Plate, drape-molded; sgraffito decoration; Pennsylvania, 1800–1830. Diam. 11³/₁₆″. (Winterthur 60.698.) The pelican "in her piety," a symbol of Christ the savior, is found on early English slipware as well as on Pennsylvania German decorative arts.

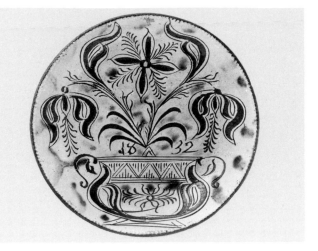

Fig. 168. Plate, drape-molded; sgraffito decoration, splashes of green; Pennsylvania, 1832. Diam. 11¾″. (Winterthur 67.1236.) The urn holding flowers is found in many variations on Pennsylvania German earthenware. This plate probably came from the same pottery as fig. 136 and pl. 23.

designs of Pennsylvania German earthenwares. Perhaps best known as the heraldic animal of the Holy Roman Empire until 1806, the double-headed eagle also represented the royal house of Spain and the czars of Russia and appears in the coats of arms of individual European cities. In a recent catalogue of north German folk pottery, Gerhard Kaufmann offered a less exalted explanation of dishes featuring this emblem. He believes that many were intended as prizes for marksmen, because from the eighteenth century the target bird (*Schützenvogel*) of shooting matches in Germany was the two-headed imperial eagle. It is doubtful Hübener's eagle dish served this purpose, made, as it was, for a woman. The motif here was probably only of decorative significance, just as on slipware dishes by Ralph Toft and other Staffordshire potters.[36]

Religious symbols occur on Pennsylvania sgraffito, but they, too, may have lost the impact of their original meanings. The pelican "in her piety" plucks her breast to feed her young and so symbolizes Christ as the savior of the world (fig. 167). At least five Staffordshire dishes made in the late seventeenth century have the same design.[37] Urns or vases containing three spreading flowers, as in figures 168 and 169, are said to represent the Incarnation. While the three fish on the plate in plate 19 bring to mind the sign of the early Christian community, they may have been intended only to designate the function of the piece as a fish platter.

Masonic motifs appear frequently on early American decorative arts but only rarely in the Pennsylvania German pieces. Whether to indicate his own or his client's inclinations, Simon Singer, emigrant from Baden, slip-trailed the masonic square and compass onto a plate (fig. 170).

Among the most interesting designs on Pennsylvania German earthenwares are those incorporating human figures. People are usually depicted in some activity. Hansel and Gretel (fig. 171) are about to dance or walk. Plaid-suited musicians intently play their instruments (fig. 172). A favorite subject was soldiers on horseback, captured on the clay in midstride (figs. 140, 163, 173, pl. 20). In the eighteenth and nineteenth centuries, rulers and military leaders were commonly portrayed in an equestrian pose. Engravings of their portraits were widely circulated and doubtless served as models for potters. Frederick the Great of Prussia and Emperor Josef II appear on horseback on central European pottery, while several English monarchs and dukes are on English delftwares.[38] The subject of one Pennsylvania

[36] Gerhard Kaufmann, *North German Folk Pottery of the 17th to the 20th Centuries* (International Exhibitions Foundations, 1979/80), p. 123, no. 101; Cooper, *English Slipware*, figs. 200, 201.

[37] Cooper, *English Slipware*, figs. 185, 195.

[38] Frederick the Great decorates a wall tile of 1772 shown in Kaufmann, *German Folk Pottery*, p. 26, no. 2; Josef II is shown in Mechthild Scholten Neess and Werner Jüttner, *Niederrheinische Bauerntöpferei 17–19 Jahrhundert* (Dusseldorf: Rheinland-verlag GMBH, 1971), no. 29. For other horsemen, see Museum fur Kunst und Gewerbe, *Alte Deutsche Bauernschüsseln: Ausstellung der Sammlung Dr. Konrad Strauss* (Hamburg, 1963), fig. 6; and Robert L. Wyss, *Berner Bauernkeramik* (Bern: Paul Haupt, 1966), figs. 9, 47, 58. For English delftware examples, see Ross E. Taggart, *The Frank P. and Harriet C. Burnap Collection of English Pottery* (rev. ed.; Kansas City: Nelson Gallery–Atkins Museum, 1967), p. 45, no. 82; p. 48, no. 100; and Anthony Ray, *English Delftware Pottery* (Boston: Boston Book & Art Shop, 1968), pl. 11.

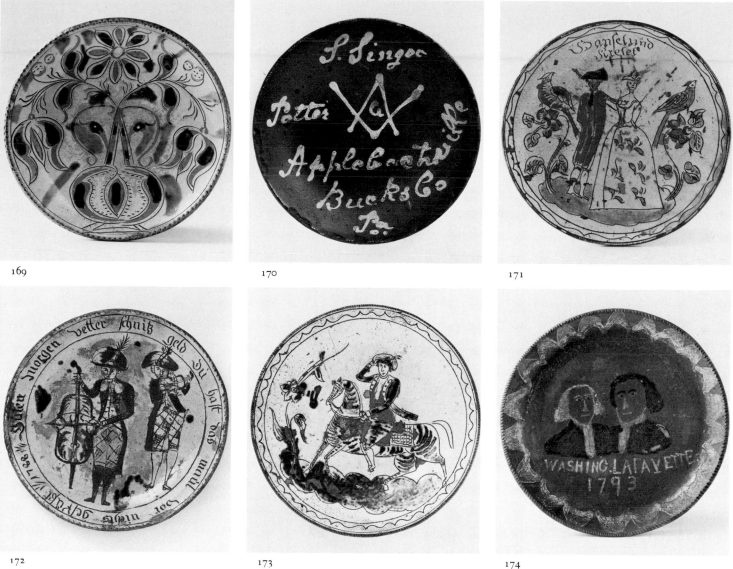

169

170

171

172

173

174

Fig. 169. Plate, drape-molded; sgraffito decoration, brown slip and splashes of green; Pennsylvania, 1820–40. Diam. 11⅞″. (Winterthur 60.695.)

Fig. 170. Plate, drape-molded; white slip-trailed decoration. Simon Singer (d. 1894), Applebachville, Haycock Township, Bucks County, 1870–90. Diam. 8¼″. (Winterthur 55.559.) After working in New York as a brick-maker, the emigrant Singer potted for the Herstines in Nockamixon Township, Bucks County, before buying the John Mondeau (Monday) pottery in Haycock Township. Two Singer plates of similar form inscribed "1810 pattern" imply a conscious revival of older styles. The masonic symbol may indicate Singer's beliefs or those of a customer.

Fig. 171. Plate, drape-molded; sgraffito decoration, brown slip and splashes of green; attributed to David Spinner (d. 1811), Milford Township, Bucks County, 1785–1800. Incised: "Hansel und Kretel." Diam. 12″. (Winterthur 60. 652.) Parrots, fuschias, and human subjects are characteristics of Spinner's work, several documented examples of which are known.

Fig. 172. Plate, drape-molded; sgraffito decoration, splashes of green; Pennsylvania, 1788. Incised: "Guten morgen vetter schnitz geld Du hast das maul vor nichts geküsst 1788." Diam. 11½″. (Winterthur 60.651.) The inscription bears no obvious relation to the scene depicted.

Fig. 173. Plate, drape-molded; sgraffito decoration, green and brown coloring; attributed to David Spinner (d. 1811), Milford Township, Bucks County, 1780–1800. Diam. 11¾″. (Winterthur 55.109.3.) Such equestrian portraits were probably copied from engravings. One Neesz-type horseman is identified as Washington.

Fig. 174. Large plate, thrown; applied white slip, some colored brown; probably Pennsylvania, 1793. Inscribed: WASHING.LAFAYETTE / 1793. Diam. 15¹/₁₆″. (Winterthur 67.1670.) A rare example of American pottery with historical portraits, probably inspired by English imports designed for the American market. Its mate celebrating Franklin and Jefferson is seen in fig. 149.

175

176

177

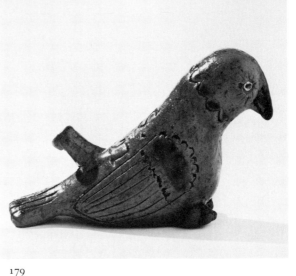

178

179

Fig. 175. Large plate, thrown; applied white slip, some colored dark green; attributed to Absalom Bixler (1802–84), Lancaster County, 1820–30. Type letter impressed inscription: DER FRIHIDE. GLUG. 1776. WASHING-TON. Diam. 14³/₁₆″. (Winterthur 67.1660.) Washington is posed as if to strike the Liberty Bell. The Bixler attribution for this and figs. 176 and 177 is based on the signed plate of fig. 151. Another plate with the same inscription and a different scene of the Liberty Bell is at Beauport, Gloucester, Massachusetts.

Fig. 176. Large plate, thrown; applied white slip, some colored blue and dark green; attributed to Absalom Bixler (1802–84), Lancaster County, 1820–30. Type letter impressed inscription: 1732. INDEPENDENCE. HALL. 1741. E.WO.OLEY. Diam. 14⅛″. (Winterthur 67.1662.) The structure depicted is Independence Hall, Philadelphia, which was constructed between 1732 and 1741. Edmund Wooley was chief carpenter of the project.

Fig. 177. Large plate, thrown; applied white slip; attributed to Absalom Bixler (1802–84), Lancaster County, 1820–30. Type letter impressed inscription: DAUNAE.L. BOON. DES. FANKNESS. INDAUNAS. 1787. Diam. 15⅛″. (Winterthur 67.1659.) The legendary Daniel Boone had been raised in Berks County. His death in 1820 may have prompted this commemorative plate.

Fig. 178. Plate, thrown; sgraffito decoration, green coloring; Pennsylvania, 1790–1820. Diam. 11⅜″. (Winterthur 60.657.) The peacock is a popular subject of Pennsylvania German pottery but is only rarely shown with spread tail.

Fig. 179. Whistle or bird call, probably freely molded; incised detail, splashes of brown, white and black slip eye; probably Pennsylvania, 1821. Incised above mouthpiece: J. S. / 1821. L. 4¾″. (Winterthur 60.639.) With its incised rather than modeled detail, this whistle was probably the work of a sgraffito potter, possibly J.S.

German sgraffito horseman plate is identified as George Washington, but most bear no name.[39] Some riders brandish swords, trumpets, or pistols; others merely salute. David Spinner illustrated a horse race and a deer chase in the manner of mid-eighteenth-century English fox and hound plates.[40] His male and female riders convey a sense of action by riding off the edges of the plates. Spinner and Johannes Neesz are the potters credited with most of the Pennsylvania horseman plates.

A unique group of Pennsylvania German earthenwares at Winterthur features people and scenes of American historical significance. The inspiration for such wares came from English imports. Before the Revolution, the American colonies provided English potters with a natural and protected market. After independence, when the products of other countries flooded the ports of the new republic, England sought to retain its hegemony, in part through the introduction of pottery decorated specifically for American consumption. Patterns included American landscape views, battle scenes, and tributes to a variety of political and military heroes. These designs were transfer printed, most often in underglaze blue on refined white earthenware, on dinner, tea, and toilet sets as well as miscellaneous individual forms. Certain Pennsylvania German potters, immune neither to this competition nor to the chauvinism of an independent America, created their own versions.

A remarkable pair of large and heavy shallow plates, dated 1793, have thickly applied slip portraits of four heroes of the age. Washington and Lafayette are grouped on one, while portraits of Franklin and Jefferson decorate the other (figs. 174, 149). The potter probably copied engraved images of the men, but the slip medium allowed for little distinguishing detail, making the identification of the subjects impossible without the inscription. In their caricature quality, the plates are reminiscent of earlier English slipware and delftware chargers featuring royal personages.

Of related size and impact are four dishes attributed to Absalom Bixler, a man of diverse talents who was born in Lancaster County in 1802. The attribution is based on figure 151 which has the inscription, "Absalom Bixler to his wife Sarah 1824." A similarly inscribed plate of related decoration is in Beauport, Gloucester, Massachusetts. Peculiar to Bixler was his practice of impressing printers' type for his inscription instead of lettering by hand—and type is listed in the inventory of his estate. While the plate dedicated to his wife shows a rather finely drawn cow and horse, the others have patriotic themes more crudely rendered in thin slips. Entitled "Der Frihide Glug 1776" (roughly, the Liberty Bell 1776), the dish in figure 175 shows a soldier, identified as Washington, holding aloft his sword—almost as if to strike the Liberty Bell. Another Washington-like figure stands before the building depicted in figure 176, recognized as Independence Hall not by the architectural details but by the rim inscription. (This structure was curiously neglected by the potters of Staffordshire who specialized in wares for American consumption.) On the rim are the dates 1732 and 1741, defining the period in which most of the construction was done; Bixler probably made the plate in the 1820s. The name of the chief carpenter of the Independence Hall project, Edmund Woolley, is also impressed on the lower rim. The third of the Bixler historical plates dramatically celebrates Pennsylvania-born Daniel Boone and his struggles to protect the American frontier from hostile acts of the Indians (fig. 177).

Such designs of specific American subjects are most unusual in Pennsylvania German production. Usually, potters composed scenes bustling with birds and flowers. The peacock, a bird often associated with the Pennsylvania German arts, appears on several sgraffito plates in the Winterthur collection, generally with tail feathers closed. On the plate attributed to Hübener (fig. 164), the peacock symbolizes the vanity expressed in the surounding verse. More whimsical is the giant peacock with spread tail who rides upon a rooftop in figure 178, although the peacock here may represent Death carrying off a soul. Parrots flank Hansel and Gretel (fig. 171), and an unusual owl dominates the plate of figure 188. In figure 189 two birds perch upon their egg-filled nest. Many pottery whistles and birdcalls were fashioned in the shapes of birds (figs. 139, 179, 187).

Farm and domestic animals occasionally decorate plates (figs. 148, 151), but they more commonly occur as three-dimensional ornaments. An unidentified potter modeled the appealing deer, dog, and fox illustrated in figure 180, lavishing attention on their coloring and on the features of their faces. More anatomically detailed and sculptural in effect are the cow and suckling pig, made in 1837 (fig. 181). A dog whistle (fig. 182), the blowhole positioned at the base of the tail, demonstrates the earthy humor that is sometimes found in Pennsylvania German pottery.

Undoubtedly the motif most closely associated with Pennsylvania German pottery is the tulip: because of its prevalence, Barber titled his book *The Tulip Ware of the Pennsylvania German Potters*. Allegedly Persian in origin, the tulip is found on pottery from many areas of Europe. American colonists' first exposure to the flower on clay may have been on the sgraffitowares sent from Devonshire.

[39] Illustrated in Mitch Bunkin, "Rare Pottery Stirs the Market," *Maine Antique Digest* (April 1978): p. 1-B.

[40] One is shown in Manchester City Art Gallery, *Incomparable Art*, p. 28, no. 41.

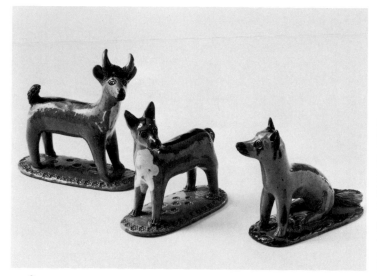

180

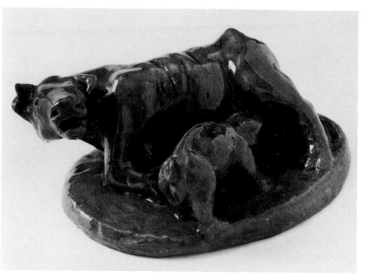

181

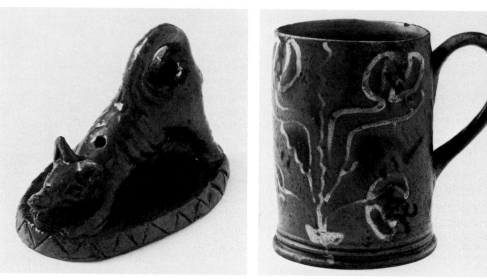

182

183

Fig. 180. Figures of deer, fox, and dog, probably all freely molded; white slip details, brown coloring, stamped and incised decoration; probably Pennsylvania, 1825–75. H. (deer) 5$\frac{1}{16}$″. (Winterthur 59.2280, .2288, .2205.) The distinctive details on these animals, notably the double-ring eyes, indicate a common maker. Such toys were popular items in a pottery.

Fig. 181. Figure of cow and suckling pig, probably freely molded; Pennsylvania, 1837. Incised on bottom: GB 1837. L. 5 $\frac{7}{16}$″. (Winterthur 59.2207.)

Fig. 182. Dog whistle, probably freely molded; incised detail; Pennsylvania, 1810–50. Incised on bottom: "Jakie." L. 3$\frac{13}{16}$″. (Winterthur 61.176.)

Fig. 183. Mug, thrown; brown and white slip-trailed decoration, splashes of brown; Pennsylvania, 1750–1800. H. 5$\frac{1}{16}$″. (Winterthur 60.634.) Figs. 183 and 184 and pl. 23 illustrate just three of the ways in which a tulip could be delineated.

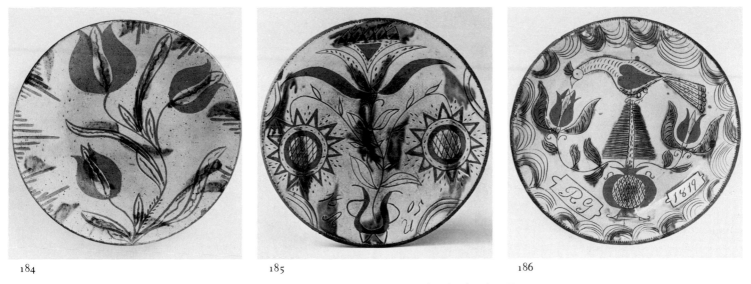

184 185 186

Fig. 184. Dish, thrown; sgraffito decoration, splashes of green; Pennsylvania, 1775–1800. Diam. 10½″. (Winterthur 65.2857.)
Fig. 185. Plate, drape-molded; sgraffito decoration, splashes of green; Pennsylvania, 1805. Incised date and A U flanking vase. Diam. 10 9/16″. (Winterthur 67.1524.) Plates by potter Andrew U range in date from 1801 to 1810. Although they exhibit strong similarities of design and detail, the potter had several ways of forming the same motifs. Some plates by RG

seem to be related to the AU group.
Fig. 186. Plate, drape-molded; sgraffito decoration, splashes of green; Pennsylvania, 1819. Incised: R G 1819. Diam. 12″. (Winterthur 60.699.) The pattern is very reminiscent of one used forty-three years earlier by HR (fig. 160). It has been thought that Rudolph Graber of Montgomery County was this RG potter.

Fragments excavated from Jamestown and elsewhere feature tulips.[41] As seen in the Winterthur collection, there were within the Germanic idiom many different approaches to the problem of drawing a tulip, from the bold bloom in plate 23 to the timid sprout of figure 183. Some are curvaceous (fig. 184), some are angular and geometric. Examination of six plates marked by the potter A(ndrew) U, one of which is at Winterthur (fig. 185), proves that a single potter did not always form his tulips in the same way, piece after piece.[42] Besides the tulip, fuschias and other flowers have been recognized on Pennsylvania German pottery, but often the stylized character of the blossoms makes botanical identification impossible.

On the whole, the designs as well as the shapes of Pennsylvania German earthenwares exhibit little stylistic development over time. The pottery was produced chiefly between 1780 and 1840, yet it can be difficult to distinguish the early from the late. The apprenticeship system, not as yet fully documented, probably accounts for some of the enduring similarities in individual motifs and in overall design concepts that are seen in dated wares spanning the period. The four-petaled flower Hübener drew in 1789 is essentially the

[41] Watkins, "North Devon Pottery," pp. 32, 37.
[42] Dated between 1801 and 1810, "AU" plates are in the collections of Metropolitan Museum of Art, Reading Museum, and Philadelphia Museum of Art.

same as that found in 1832 (fig. 168 and pl. 22). The 1819 plate of figure 186 reflects the 1776 plate of figure 160 in both the delineation of the peacock and the general layout. There is nothing about the bird whistles of figures 139 and 187 that reveals the forty-six years that separate them. Jacob Scholl's jar of the 1830s (fig. 135) is as boldly proportioned as those of the 1780s (fig. 189 and pl. 27). A similar lack of development characterizes the work of an individual potter. Samuel Troxel's products range in date from the 1820s to the 1840s yet they are extremely homogeneous in style and quality (figs. 113, 161, 165, pl. 16).

The quality of Pennsylvania German earthenwares varied, of course, from potter to potter. Some were skillful at the wheel; others were proficient at one or more types of decoration. Again, more documentary information about the pottery shops is needed before interpretations concerning quality can be formulated. The crude draftsmanship seen on the 1794 caddy (fig. 129) or the owl plate (fig. 188) may, for example, be the work of beginning apprentices, the potter's children, or even visitors to the pottery.

A potter's lack of experience with the raw materials or processes probably led to some of the technical flaws found in Pennsylvania pottery. A layer of slip that was too thin detracted from the sgraffito pattern, as on the jar shown in figure 189 or the plates in figures 142 and 143. Bixler's historical plates fail to create a very strong impression because

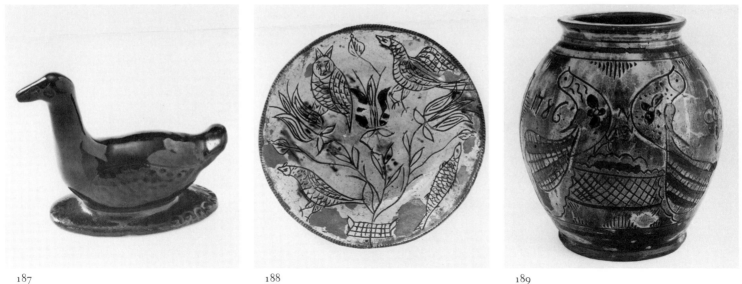

187 188 189

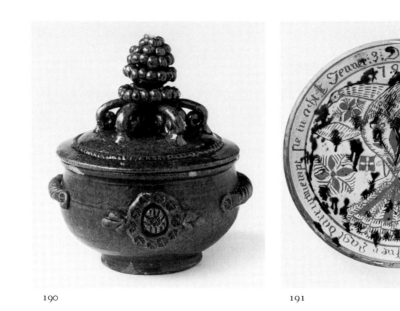

190 191

Fig. 187. Figure of a duck, incised detail, dark brown glaze. John H. Snyder, probably Mohrsville, Berks County, 1855. Incised name and date on bottom. H 2 5/16″. (Winterthur 62.656.) The identity of John H. Snyder is not certain. Potters named John Snyder are recorded in Mohrsville from 1835 to 1873, in Womelsdorf from 1876 to 1900, and in Lewisburg, Union County, in 1835.

Fig. 188. Plate, drape-molded; sgraffito decoration, splashes of green; Pennsylvania, 1800–1840. Diam. 10 13/16″. (Winterthur 67.1604.) The owl is an unusual subject in Pennsylvania German earthenware. Another plate at Winterthur drawn with a double-headed eagle appears to be decorated by the same, rather unskilled, hand.

Fig. 189. Jar, thrown; sgraffito decoration; Pennsylvania, 1786. H. 7 9/16″. (Winterthur 61.1133.) The two birds appear to be perched over a stylized nest filled with eggs. Too little slip was applied to the surface, so

the red body shows through creating a splotchy effect.

Fig. 190. Covered bowl, thrown; applied and stamped decoration, light brown glaze; Pennsylvania, 1780–1830. H. 5⅜″. (Winterthur 60.621.) Virtually identical bowls are in Mercer Museum of Bucks County Historical Society and Metropolitan Museum of Art. Their form and elaborate finials recall Swiss vessels.

Fig. 191. Plate, thrown; sgraffito decoration, splashes of green; possibly Montgomery County, January 3, 1792. Incised: "Jenner: 3: Die schüssel ist von ert gemagt wan sie verbricht der heffner lagt darrum nempt sie in acht / 1792." Diam. 12⅞″. (Winterthur 65.2299.) Although the motifs relate to those found on the Hübener plates (fig. 164, and pl. 22), the lack of skill apparent here suggests the hand of another potter, possibly in the same shop.

the slip was applied too thinly. Designs on other plates have flaked and crackled from the other extreme of too much slip. Colorants were sometimes put on carelessly so that areas of a design appear to be smudged, as in the flower drawn beneath the rider in figure 163. The maker of the covered pot (fig. 150) punched the clay so hard that the surface seems almost torn. The Robin Red Breast potter (fig. 166), on the other hand, incised his phrase so weakly that it became filled with glaze and difficult to read.

The decoration of many objects does not match the quality of the actual potting. The bowl in figure 190 was thinly and firmly thrown, but its decoration—of Swiss derivation—was sloppily done. The balls and scrolls of clay that form the finial are irregular in size and shape, and the stamped circles on the bowl are poorly spaced. Because none of the decorative devices of the bottom are repeated on the lid, the piece lacks cohesion. More successful in this respect is the covered bowl in plate 25.

Few would deny that much of the Pennsylvania German earthenware is overdecorated: sgraffito and slip-trailed designs seem to cover every inch of space. Small geometric shapes and flowers act as fillers around the main themes; border lines and swags, intended to enhance the central design, sometimes suffocate it instead. Only occasionally was a motif allowed room to breathe, as on the flowerpot of plate 28. Many potters failed to plan their decorating, with the result that inscriptions had to be squeezed in, as on the Singer plate where *Applebachsville* runs up the side (fig. 170). On figure 167, the head and neck of the pelican were so constricted in order to fit the available space that they are almost grotesque. Animal and human figures posed special problems in drawing for some potters. Compared to Hübener's very competent rendition (pl. 22), the necks of the double-headed eagle in figure 191 are long and ungainly, while those in Jacob Joder's version are too short (fig. 111). In portrait and genre plates anatomical details and perspective are often incorrect or absent. Nonetheless, the results, however accidentally achieved, are often charming.

It is this very lack of sophistication that collectors of Pennsylvania German pottery have found so appealing. The decoration has a spontaneity and vigor unmatched by other American ceramics. Although they hark back to the European backgrounds of the potters and their customers, the Pennsylvania wares have a distinct flavor of their own. Finally, through the variety of their shapes and pictorial designs, the Pennsylvania German potters vividly evoked in their products many aspects of their life in a unique early American community.

Pennsylvania German Glass

ARLENE PALMER SCHWIND

Potters, cabinetmakers, and other craftsmen of German backgrounds who worked in Pennsylvania nurtured a distinctive style there, but glassmakers produced nothing that can be distinguished as "Pennsylvania German" glass. Because immigrant glassblowers of German origins populated glasshouses from New Hampshire to Maryland and not just in Pennsylvania, early American glasswares reflect a widespread German tradition. At the same time, English-made glass dominated the import trade, providing the standard of quality to be emulated. These two factors, however divergent, inhibited the growth of strong regional styles and created instead a certain homogeneity of American glass production. This was reinforced by the habitual migration of artisans from one glasshouse to another.

Glassblowers of English heritage are believed to have operated only two of the approximately twelve glass factories built in the colonial period. One of these was in Pennsylvania. It was also a Pennsylvania glassworks, one located in the heart of the Pennsylvania German settlements, that pioneered in the manufacture of fine table glass modeled after English imports.

The ubiquitous presence of German-trained glassblowers in the early American industry was the result of several factors. First, the economic difficulties in eighteenth-century Germany that prompted the general emigration to America extended to the glass business, encouraging the highly skilled workmen to embark for the New World where their talents might be in greater demand. Many came as indentured servants. In some cases, entire families of active glassblowers emigrated together. Second, American entrepreneurs of every generation recognized that glass of all kinds was needed by settlers. In order to undertake the local manufacture of

glass, however, they required workers with special skills, who were available only from abroad. Third, the *Wanderschaft*, or migratory tradition, of Continental glass craftsmen made it natural for them to consider employment overseas.

The experience of John Martin Griesmayer illustrates this last point. He first blew glass at Herrenberg and left in 1702 to work at the Klosterwald factory. After seven years there he moved to Zwiefalten; by 1712 he had relocated at the Mattsthal glasshouse in Alsace. Between 1715 and 1723 Griesmayer was employed at the Rodalben works. From there he went to Hassell in Nassau where he was glasshouse superintendent until 1730. Within a few years he had traveled to the Forbach glasshouse in Lorraine, and then he ended his career at Amblève in Belgium. With a background of such mobility, his son Simeon (b. 1718) was, not surprisingly, willing to emigrate to America in 1738 to help start a glasshouse for Caspar Wistar in southern New Jersey.[1]

Although glasswares of English manufacture controlled the early American market, glassblowers from Great Britain were not easily persuaded to go to America. The eighteenth century was the golden age of English glass: the industry and its employees prospered. Glassmakers were discouraged from emigrating because if English-quality glass were produced in America, the home industry would have been

[1] Léon-Maurice Crismer, "Origines et Mouvements des Verriers Venus en Belgique au XVIIIe Siècle," *Annales du 7e Congrès International d'Etude Historique du Verre, Berlin-Leipzig, 15–21 août 1977* (Liège: Edition du Secrétariat Général, Association Internationale pour l'Historiè du Verre, 1978), p. 351. Arlene M. Palmer, "Glass Production in Eighteenth-Century America: The Wistarburgh Enterprise," in *Winterthur Portfolio 11*, ed. Ian M. G. Quimby (Charlottesville: University Press of Virginia, 1976), p. 78.

threatened.[2] The situation had been different, however, in the seventeenth century when England herself depended on glass imports from Venice and other Continental centers. Thus the glasshouse at Jamestown, Virginia, was an attempt in 1608 by Englishmen to supply the home country with glassware and reduce her dependence on foreign goods.

In spite of England's disapproval of American manufactures, an interest in glassmaking recurred periodically during the entire colonial era. The actual number of glass factories erected was small, only twelve or so, probably because the manufacture of glass required a considerable capital investment in a large facility and a team of skilled workmen. Glasshouses could not be erected anywhere; sites had to be carefully selected on the basis of the availability of fuel and raw materials of very specific properties. The financial and technical considerations of glassmaking were such that most of the colonial glass factories lasted but a short time.

Pennsylvania was chosen by many glass manufacturers. One glassworks was built there in the seventeenth century; at least six followed in the eighteenth. These early endeavors were mostly located in the eastern part of the state, but at the end of the eighteenth century the focus began to shift to Pittsburgh, which remained a center for glassmaking throughout the nineteenth century. In 1843 there were twenty-eight glasshouses and fifteen glasscutting establishments in the state, employing 835 men and producing goods valued at $772,400. When Joseph D. Weeks conducted a survey of the industry for the 1880 census he discovered that "Pennsylvania [stood] first as a producer of glass in the United States, its percentage in value being more than three times that of any other state."[3]

Pennsylvania's first glasshouse was conceived in 1682 as part of the economic plan of the Quaker settlement of Philadelphia. For this undertaking an English broad-glass (window) maker from Newcastle-on-Tyne, Joshua Tittery, was hired by the Free Society of Traders. Contemporary records imply that Tittery had been something of a troublemaker, perhaps explaining his willingness to emigrate. Four other

English glassmakers agreed to come as indentured servants. The Quaker founders envisioned a glass factory not only to supply the demands for window and table glass within the colony but also to provide goods for commercial trade with the West Indies. How successful they were in this venture is not clear. No glass is known that can be ascribed to the works. Tittery was still described as a glassmaker in 1688, but by at least 1699 he had abandoned the trade to become a potter.[4]

The first glasshouse to flourish in the American colonies was owned by Caspar Wistar and, after his death in 1752, his son Richard, both of Philadelphia.[5] Caspar Wistar was a German, having traveled to Philadelphia from Hilspach, near Heidelberg, in 1717. After his arrival he learned the trade of brass-button making but soon became involved in the import trade. Wistar's correspondence shows that he maintained connections with German merchants and consequently sold German-made fabrics, toys, and books, among other items. When he decided to engage in the manufacture of glass in the late 1730s, he turned to German sources. Indeed, the partnership arrangement he shared with his first four blowers (gaffers), in what he called the United Glass Company, suggests that the initiative for the business may have come not from Wistar but from the glassblowers themselves, probably through German merchants of Wistar's acquaintance.

The Wistarburgh glassworks closed down in 1776 or 1777 after nearly forty years of operation. Although situated in southern New Jersey, eight miles from Salem, the factory exerted an important influence on the glass industry within Pennsylvania. Until 1763 Wistarburgh was the only major glassworks in the Delaware Valley. As such, it was considered by Philadelphians such as Benjamin Franklin to be "our" glasshouse. Wistar's store on Market Street, Philadelphia, was the prime outlet for his glass. From there it was sent to wholesale and retail customers in New England and the South, as well as inland Pennsylvania.[6]

Wistarburgh's influence on Pennsylvania glassmaking extended beyond the presence of its products. Some Wis-

[2] For example, when Philadelphia entrepreneurs sought the aid of Benjamin Franklin, in London, in obtaining glassblowers, he replied that "it is always a Difficulty here to meet with good Workmen and sober that are willing to go abroad" (Franklin to Messrs. Tower and Leacock, August 22, 1772, Franklin Papers, American Philosophical Society, Philadelphia). In 1815, five English glassmakers were arrested in Liverpool as they boarded ship for America (*Raleigh* [N.C.] *Star* [December 22, 1815]).

[3] Charles B. Trego, *A Geography of Pennsylvania* (Philadelphia, 1843), p. 115. Joseph D. Weeks, *Report on the Manufacture of Glass*, 10th Census, 1880, as quoted in Lowell Innes, *Pittsburgh Glass, 1797–1891: A History and Guide for Collectors* (Boston: Houghton Mifflin Co., 1976), p. 73.

[4] The Tittery glasshouse is discussed in Arlene Palmer, "Aspects of Glassmaking in Eighteenth-Century America," *Annales du 8e Congrès International d'Etude Historique du Verre, Londres-Liverpool, 18–25 Septembre, 1979* (Liège: Edition du Centre de Publications de l'A.I.H.V., 1981), pp. 307–19.

[5] For an account of the Wistar glass business, see Palmer, "Glass Production," or Arlene M. Palmer, *The Wistarburgh Glassworks: The Beginning of Jersey Glassmaking* (Alloway, N.J.: Alloway Township Bicentennial Committee, 1976).

[6] Arlene Palmer, "Benjamin Franklin and the Wistarburg Glassworks," *Antiques* 105, no. 1 (January 1974): 207–10; Palmer, "Glass Production," p. 96.

tarburgh artisans, in the Wanderschaft spirit, left South Jersey to work for glasshouses in Pennsylvania. Christian Nasel, for example, worked for the Wistars for at least twelve years, but in 1763 he moved to Lancaster County to blow glass at the new works established by Henry William Stiegel.

Throughout the years of its operation, window glass and bottles were the chief products of the Wistarburgh blowers. Window glass was fabricated by the cylinder technique, the common method of production practiced in the glasshouses of Germanic Europe. In this process, glass, often of greenish tint, was blown into hollow cylinders. These were slit lengthwise, put onto wide iron shovels, and placed in the flattening or spreading ovens where the heat caused the cylinders to unfurl into flat sheets of glass. After cooling, the sheets were cut into panes of the desired sizes. The bottles attributed to the Wistars' glasshouse clearly follow the shape of the typical English imported wine bottles of the time, but they differ in that they are thinly blown of a light green glass rather than the heavy, almost black glass in English bottles.[7]

Although the emphasis at Wistarburgh was on bottle glass and windowpanes, tableware was also commercially manufactured there, albeit on a limited scale. Many of the extant hollowwares were blown of the same green glass as the bottles. In form and decorative detail they relate closely to German prototypes. Among the objects that descended in the Wistar family, for example, is a dog-shaped drinking vessel that is modeled after the whimsical *Schnapshunde* of seventeenth- and eighteenth-century German origin. Covered sugar bowls (fig. 192) have the domed and inset lid and the elaborately tooled finial often seen in central European glass.

Paradoxically, the Wistars imported English glasswares and sold them in their store along with glass of their own manufacture. That the Wistarburgh gaffers were influenced by the strong colonial taste for English styles is seen in a remarkable group of blue and colorless objects attributed to the Wistar works. Two cream buckets, in particular, reflect an English form popular in silver, pottery, and glass.[8]

During the Wistarburgh period several glasshouses are known to have been undertaken in Pennsylvania. There is some evidence that one, and possibly two, factories were set up in Bucks County in the 1750s, but as yet little is known about them. Gottlieb Mittelberger noted in the early 1750s

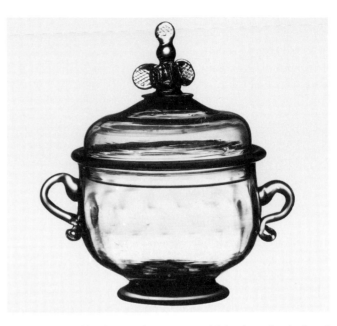

Fig. 192. Covered bowl, green glass, pattern molded with 20 ribs. Attributed to Wistarburgh Glassworks, Salem County, New Jersey, 1739–77. H. 7¼". (Winterthur 59.30.2.) In its concept and ornament the bowl reflects the German origins of the Wistarburgh craftsmen. Although situated in southern New Jersey, the glasshouse of Philadelphians Caspar and Richard Wistar influenced the glass industry in Pennsylvania.

that "several glass works have already been built in the region [of Pennsylvania]." Associated with one of them was Johan Georg Musse, a man described at his death in 1760 as "the old glassmaker."[9] Interestingly, Musse landed in America in 1750, having traveled on the same ship as Henry William Stiegel, who later became the most important glassmaker in colonial Pennsylvania. Perhaps it was Musse who implanted in Stiegel the interest in glassmaking, although it was not until 1763 that Stiegel's glasshouse materialized.

Stiegel is unquestionably the glassmaker most closely connected with the Pennsylvania German community, yet in no other colonial glassmaking enterprise were German and English traditions more interwoven. In 1763, when he first added a glasshouse to his ironworks at Elizabeth Furnace, Elizabeth Township, Lancaster County, Stiegel concentrated on bottles and window glass. Employing a staff of German craftsmen, at least one of whom had come from the Wistar factory, he very likely produced wares that paralleled those of Wistarburgh. Unlike Richard Wistar, however, Stiegel determined with his second and third factories

[7] A Wistarburgh bottle is illustrated in Palmer, "Glass Production," p. 86; another is shown in Robert Lewis Giannini III, "Ceramics and Glass from Home and Abroad," in *Treasures of Independence*, ed. John C. Milley (New York: Main Street Press, 1980), p. 66.

[8] Palmer, "Glass Production," pp. 95–96; an English glass parallel is illustrated in *Historic Glass from Collections in North West England* (St. Helens, Lanc.: Merseyside County Museums, 1979), p. 69, fig. E18.

[9] Gottlieb Mittelberger, *Journey to Pennsylvania*, trans. and ed. Oscar Handlin and John Clive (Cambridge, Mass.: Harvard University Press, Belknap Press, 1960), p. 76; Rudolf P. Hommel, "Hilltown Glass Works," *Montgomery County Historical Society Bulletin* 6 (1947): 25.

at Manheim, Lancaster County, to compete with the fine English table glass that was so widely imported. Spurred by the Townshend Acts of 1767 that levied high duties on imported glass and the general economic tension of the times, Stiegel by 1769 offered an extensive line of table forms, and this continued to be his focus until the works closed in 1774. Most significantly, these glasswares not only followed English shapes and ornamentation, but some were also fashioned of a lead-glass composition.

A century earlier English chemist George Ravenscroft, at the commission of the London Glass Sellers Company, developed a glass superseding the Venetian product that dominated the British glass trade. Ravenscroft's secret was adding oxide of lead to the glass batch.[10] Lead increased the density and weight of glass and gave it a brilliance unknown in the Venetian glass. His silica source was flint, giving rise to the term *flint glass*. Unfortunately, the term came to be applied indiscriminately in the eighteenth century to high-quality glass whether it was of a lead or a soda-potash composition. Ravenscroft's lead glass formed the basis for the tremendous surge of glassmaking in eighteenth-century England, creating a market for English table glass throughout Europe. Although several Continental factories duplicated the lead oxide formula in the 1750s, most Continental glass of the eighteenth century continued to be blown of nonlead glass.

The technology of lead glass first reached America when it was transmitted to the Stiegel business by English artisan John Allman sometime before 1771, possibly by 1769, when Stiegel began to advertise his product as "flint" glass. The factory books, preserved in the Historical Society of Pennsylvania, contain purchase records of red lead and mention hooded melting pots, a type of pot required only in the melting of lead-formula glass. In 1771 Stiegel petitioned for and received a monetary premium from the colonial Pennsylvania legislature for successfully introducing the manufacture of flint glass. Allman counterpetitioned for recognition of his role in the "Assistance and particular Management of American materials at the Glass Work of Henry William Stiegel," without which "the Manufacture of White Flint Glass could not have been brought to its Present Degree of Perfection."[11] Failing in his petition, Allman took his skills to a rival firm in Philadelphia.

A wide range of table forms was produced at Stiegel's American Flint Glass Manufactory at Manheim after 1769. In his advertisements and factory records the following are mentioned: decanters; tumblers, from half gill to quart sizes; mugs and cans; beer, wine, cider, and water glasses; salts, some with feet; three-footed cream jugs; candlesticks; sugar boxes with covers; bowls; vinegar and mustard cruets; jelly and syllabub glasses, with and without handles; ink glasses; pocket and smelling bottles; toys; apothecary and chemical ware. Blue is the only color recorded. Descriptions of ornamentation are few, but molding was clearly an important technique.

With the Stiegel works as with other glasshouses, it is difficult, if not impossible, to match the written records with extant objects. The key question affecting the recognition of Stiegel glass and its interpretation within the Pennsylvania German community is the matter of style. Were the products close facsimiles or merely Germanic versions of English styles? Or do they reflect a combination of traditions? It was the opinion of members of the American Philosophical Society in June 1771 that Stiegel's glass was "equal in beauty and quality to the generality of Flint Glass, imported from England."[12] Such forms as syllabub glasses and three-footed cream jugs were certainly copied from English ones, but other forms were common on the Continent as well. "German" cans with covers are specified in the accounts, and because the majority of Stiegel workers were of German background it seems likely that many products may have had a German flavor in their shape or decoration. On the other hand, there is little doubt that Stiegel's main purpose was to compete with English imports.

The complications of this matter of style are illustrated by a group of pattern-molded pocket bottles that is attributed to the Stiegel enterprise (figs. 193, 194, 195). In the first four months of 1770, Stiegel's gaffers produced more pocket bottles—6,214—than anything else. The Winterthur collection contains 39 examples and over 70 more are known in other collections. Of a small and fairly uniform shape, these flasks are all blown of a high-quality glass, usually purple in color, although a handful of blue and colorless ones are recorded. Spectrographic analysis of Winterthur's and a number from the Philadelphia Museum of Art show them to be of a rather homogeneous composition.[13] Significantly, they are blown of a nonlead glass in the Continen-

[10] See D. C. Watts, "How Did George Ravenscroft Discover Lead Crystal?" in *Glass Circle 2*, ed. R. J. Charleston, Wendy Evans, and Ada Polak (Old Woking, Surrey: Unwin Brothers, 1975), pp. 71–84; and R. J. Charleston, "George Ravenscroft: New Light on the Development of His 'Christalline Glasses,'" *Journal of Glass Studies* 10 (1968): 156–67.

[11] T. Kenneth Wood, "A Gratuity for Baron Stiegel," *Antiques* 7, no. 1 (January 1925): 30.

[12] News of the American Philosophical Society judgment was carried in many colonial newspapers, for example, *South Carolina Gazette* (July 8, 1771), and even was published in England in the *Felix Farley's Bristol Journal* (August 31, 1771).

[13] The analysis of these glasses was conducted by Victor F. Hanson and Janice Carlson at Winterthur's analytical laboratory.

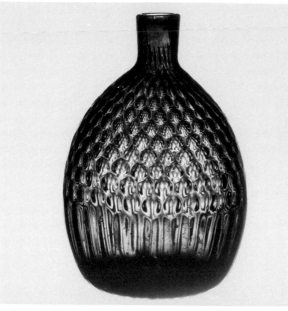

193

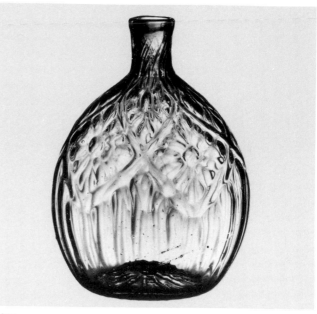

194

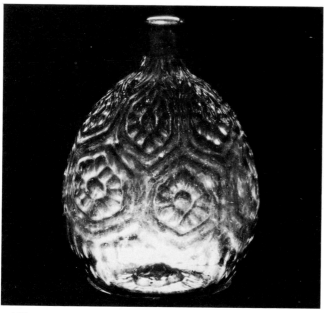

195

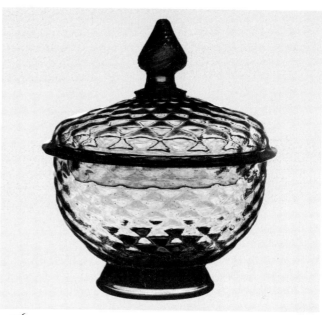

196

Fig. 193. Pocket bottle, purple glass, pattern molded with 28 diamonds over 28 flutes. Possibly H. W. Stiegel Glassworks, Lancaster County, ca. 1770. H. 5¼″. (Winterthur 59.3081.) Blown of nonlead glass, pocket bottles of this type may represent Stiegel's early efforts at quality ware. A limited number of molds seem to have been used, and they could have been carried to other factories by migrating workers.

Fig. 194. Pocket bottle, blue glass, pattern molded, diamond-daisy over flutes. Possibly H. W. Stiegel Glassworks, Lancaster County, ca. 1770. H. 5¼″. (Winterthur 59.3131.) Most of the pocket bottles mold blown in these patterns are of a purple color. This is the only blue example of the diamond-daisy pattern, although Stiegel is known to have made blue glass.

This flask was found in Morgan County, Ohio.

Fig. 195. Pocket bottle, colorless glass, pattern molded, daisy-in-hexagon type. Possibly H. W. Stiegel Glassworks, Lancaster County, ca. 1770. H. 5⅜″. (Winterthur 59.3147.) This is the least common pattern of the Stiegel-type flasks and especially rare in colorless glass.

Fig. 196. Covered bowl, blue glass, pattern molded with rows of 20 diamonds. America or England, 1760–1800. H. 5½″. (Winterthur 59.3299.) Stiegel and successive firms in Philadelphia set out to imitate English imports. Because they used a lead-glass composition, it is difficult to distinguish American from English production.

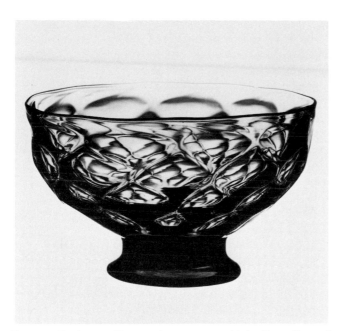

Fig. 197. Bowl, emerald green glass, pattern molded with 11 diamonds over flutes. England, 1760–1810. Diam. 4¼". (Winterthur 59.3137.) Glassware of this pattern had been believed to be of Stiegel manufacture, but the discovery of English objects blown from the same mold has altered the attribution.

tal manner; because of their refinement and color, however, they may have been described in the period as flint glass.

The pocket bottles have a style of their own. The purple color occurs in English export glass of the second half of the eighteenth century as do diamond-molded patterns. The floral-molded designs, however, are very reminiscent of central European glass, although no exact prototypes for some of the patterns have been found. These include the flasks molded with rows of petaled flowers contained within diamonds (diamond-daisy) arranged above flutes (see fig. 194) and an allover floral pattern known to collectors as daisy-in-hexagon (see fig. 195). Less complex patterns are those with twenty vertical ribs, an allover twelve-diamond design, and ones with rows of twenty-eight diamonds over twenty-eight flutes (see fig. 193). A few plain, free-blown flasks are also recorded.

Over the years, many other pattern-molded forms have been attributed to Stiegel's manufactory. Like the pocket bottles, a group of fourteen-rib colorless and blue cream jugs, also of nonlead composition, may represent Stiegel's early efforts at fine tableware before the lead-glass technology was perfected.[14] The attribution of pattern-molded ware

of lead glass is more problematical. A large number of diamond-molded sugar bowls, salts, and cream jugs blown of lead glass and often in blue (fig. 196) have been thought to be Stiegel's work. These are English in style, and through the careful study of the molded patterns, specifically the defects in the pattern resulting from imperfections in the molds, several of the designs are now definitely known to be of English, not American, manufacture.[15] Among these is the eleven-diamond-over-flute motif (fig. 197) which occurs in footed bowls, covered bowls, salts, and cream jugs. Furthermore, this style continued to be produced into the nineteenth century in both England and America. For example, a diamond-molded salt was pictured in an 1821 advertisement of Boston Glass Manufactory.[16]

The study of colored, pattern-molded glass of the eighteenth century has been inhibited by several factors. In the first place, it is only recently that English glass of this type has received attention from historians and collectors.[17] It is known to have been manufactured extensively in such centers as Bristol and Newcastle-on-Tyne in the 1760s and 1770s, and much of it was intended for the export trade. If Stiegel's claims of quality were accurate, it will be difficult, if not impossible, to separate his products from the imported goods. Finally, much of the English molded glass that was not sent to America in the eighteenth century came over in the early twentieth and brought high prices in the marketplace when sold as "Stiegel" glass.

The attempts to identify Stiegel's Germanic styles have been no easier. Ever since the publication of Frederick William Hunter's monograph on Stiegel in 1914, the greatest controversy has centered on the interpretation of his "enameled" glass.[18] The word appears in Stiegel's July 6, 1772, advertisement in the *Pennsylvania Packet* in connection with several forms. Salts were available in "blue and plain enamelled," servers were "common and enamelled," cream jugs were "enamelled and plain," smelling bottles came in "enamelled, common and twisted" varieties, and

[14]For an example of this type of cream jug, see Frederick William Hunter, *Stiegel Glass* (1914; reprint ed., New York: Dover Publications, 1950), fig. 73.

[15]The study of mold defects was pioneered by Dwight P. Lanmon while he was associate curator at Winterthur. For an application of his research in this area, see Dwight P. Lanmon, Robert H. Brill, and George Reilly, "Some Blown-Three-Mold Suspicions Confirmed," *Journal of Glass Studies* 15 (1973): 143–73.

[16]Illustrated in Kenneth M. Wilson, *New England Glass and Glassmaking* (New York: Thomas Y. Crowell, 1972), p. 203, fig. 157.

[17]For English pieces see *The Seddon Collection of English Coloured Glass* (Manchester: Cultural Services Dept., 1976).

[18]Publications on the topic include James H. Rose, "Eighteenth Century Enameled Beakers with English Inscriptions," *Journal of Glass Studies* 1 (1959): 94–102; and Axel von Saldern, "Baron Stiegel and Eighteenth-Century Enameled Glass," *Antiques* 80, no. 3 (September 1961): 232–35.

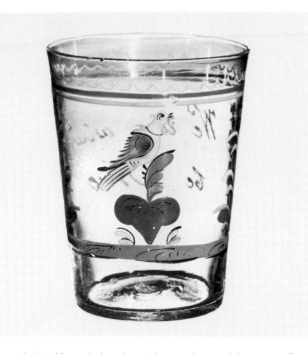

Fig. 198. Tumbler, colorless glass with enamel-painted decoration. Continental Europe, 1775–1825. Inscribed: "We two. will / be True." H. 3¾". (Winterthur 56.71.) Stiegel's enameled glass was probably not of this enamel-painted type, fashioned of nonlead glass and decorated in the Continental folk manner. Similar glasses known with inscriptions in other languages suggest the wide market for which they were made.

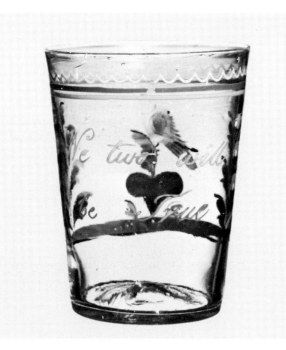

Fig. 199. Reverse of tumbler in figure 198.

wineglasses of plain, "enamelled and twisted" types were made. The assumption has been that these descriptions refer to polychrome, enamel-painted glasswares typical of continental European production, examples of which have come to light in the Pennsylvania area (figs. 198, 199). In other documents of the eighteenth century, however, the term *painted*, not *enameled*, describes what has to be glass of this type. A "large painted beer glass," for example, occurs in a 1744 household inventory taken in Maryland, and appraisers of Daniel Dulany's estate in 1753 listed "3 painted Dutch tumblers." The last reference reinforces the style as "Dutch"—Deutsch.[19]

While the term *enameled* may have been applied in the period to such painted ware, there is also documentation for its meaning as glass blown entirely of opaque white glass. However, *enameled* in an English context was most commonly used to denote glasses with opaque white enamel-twist stems. Among the goods advertised by English importers were "most fashionable plain and enamelled wine glasses" and "enamel'd Shank Wine glasses."[20] Such descriptions refer to the most popular form of stem decoration in English glass between 1750 and 1775, namely stems containing elaborately twisted patterns of opaque white, and occasionally colored, enamel rods. Stiegel's widely circulated newspaper notices were intended to promote his high-style glass in the urban centers where English imports prevailed, so it is probable that he offered products that could compete favorably with English fashions. It is reasonable to assume, therefore, that he imitated the twist-stem styles and that the stemmed forms he listed as enamel were enamel twisted. The nonstemware shapes said to be twisted were probably pattern molded in a swirl-rib design, while those described as enameled—cream jugs, smelling bottles, salts—may have been blown of opaque white glass. White glass smelling bottles, in particular, were popular.

It is important to note that the quantities of enamel-painted glasswares that have been traditionally associated with Stiegel over the years are of nonlead compositions, yet Stiegel was producing lead glass during the time he promoted enameled glass. Moreover, most are in the form of mugs, tumblers, or pewter-capped bottles, *not* in the shapes specified in the Stiegel documents and advertisements.

Stiegel's extensive advertising program across the colonies

[19] Probate Inventories, 1744, Liber 29, folio 120, Maryland Hall of Records, Annapolis; Dulany inventory, 1753, box 55, no. 42, Maryland Hall of Records.

[20] R. J. Charleston, "Opaque-White Glass of the Third Quarter of the Eighteenth Century," in *Gilding the Lily: Rare Forms of Decoration on English Glass of the Later Eighteenth Century* (London: Delomosne & Son, 1978), pp. 4–10; advertisements of merchants James Gilliland and George Ball, *New York Mercury* (April 4, 1763, and May 17, 1762).

began with his introduction of lead glass.[21] In 1767 Lieutenant Governor Penn had reported to the Lords Commissioners for Trade and Plantations that Stiegel's Lancaster County works was carried to "very inconsiderable Extent, there being no other Vent for their Ware, which is of very ordinary Quality, but to supply the small demands of the Villages and Farmers in the adjacent inland Country."[22] Penn's report, although designed to affirm the insignificance of American manufactures, was probably somewhat accurate in its assessment of Stiegel's market at that time.

It would be unwise to assume that Stiegel ever overlooked his local, Germanic clientele and failed to provide them with glass that met their demands and taste. Certainly the German cans with covers listed in the factory records were intended for regional consumption. A shop in Lititz, Pennsylvania, had six glass German cans in stock in 1774, valued at 1s. 3d. each, and these may have been of Stiegel manufacture.[23] How German these were in terms of decoration is not known. As yet, no direct documentary evidence of enamel painting—the purchase of colors, presence of a muffle or enameling kiln, identification of an enameler—has come to light in connection with either the factory or an independent decorating shop.[24] In short, there is no reason to believe enamel-painted wares of Continental styles are anything but Continental in origin. Examples with English inscriptions were simply made for export to the English-speaking market.

It is known that the importation of German and Bohemian glasswares increased dramatically after the American Revolution.[25] Generally less expensive than English goods, these nonlead Continental glasswares found a ready market throughout the country, not just among the Pennsylvania Germans. It was this "cheap German glass" that offered stiff

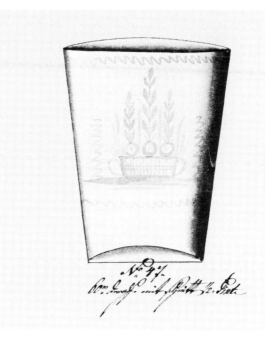

Fig. 200. "Tumbler, common, with cut." Ink and wash on paper. From manuscript catalogue inscribed "Gardiner's Island Suffolk County, New York," vol. 1, ca. 1800, no. 47. (Joseph Downs Manuscript and Microfilm Collection, Winterthur Museum Library.) Pictured in a Bohemia, Germany, glass manufacturer's trade catalogue used by New York merchants, this pattern proves that Continental engraved glass of the kind long attributed to Stiegel was exported to America in the post-Revolutionary period.

competition to Pittsburgh-area glass in the New Orleans market and probably to other American glass in other ports.[26] The structure and extent of the trade can be inferred from a Bohemian glass manufacturer's trade catalogue used in New York state in the federal period. Much of the glass is engraved and cut with delicate neoclassical motifs, but a few feature less sophisticated engraved designs of the sort that have long and erroneously been attributed to Stiegel (fig. 200).[27]

Nonetheless, Stiegel was probably the first glass manufacturer in America to embellish his glass with wheel engraving. In the June 20, 1771, issue of the *Pennsylvania Gazette* he notified the public that "a Glass cutter and flowerer, on application will meet with good encouragement," but it was not until June 1773 that he was able to hire one. Lazarus Isaac had sailed from London and set up shop in

[21] Stiegel had agents to sell his glass in New York, Boston, Philadelphia, and Baltimore as well as in lesser towns in Maryland and Pennsylvania. Advertisements for his glass also appear in the South, for example, in *South Carolina Gazette* (July 8, 1771) and *Virginia Gazette* (September 5, 1771). Southern notices courtesy of the Museum of Early Southern Decorative Arts.

[22] *Minutes of the Provincial Council of Pennsylvania* in *Colonial Records*, vol. 9 (Harrisburg: Theo. Fenn, 1852), p. 354.

[23] Shop inventory, Joseph Downs Manuscript and Microfilm Collection 69 x 126.1, Winterthur Museum Library.

[24] Hunter's designation of "enamelers" at the Stiegel factory and the attribution of works to them are not based on factual data (Hunter, *Stiegel Glass*, pp. 203–6). In Continental practice, enamel painting was generally done outside the factory by independent decorators.

[25] Dwight P. Lanmon, "The Baltimore Glass Trade, 1780 to 1820," in *Winterthur Portfolio* 5, ed. Richard K. Doud (Charlottesville: University Press of Virginia, 1969), pp. 15–48. Among the Philadelphia merchants who carried German glass was Jacob Sperry who advertised in the *Pennsylvania Aurora* (October 21, 1802).

[26] Albert Gallatin to Matthew Lyon, May 7, 1816, Gallatin Papers, New-York Historical Society.

[27] The catalogue is in the collection of the Winterthur Library and is discussed in Lanmon, "Baltimore Glass Trade," and in Francis N. Allen, "The Gardiner's Island Glass Catalogs: A Question of Attribution," *Glass Club Bulletin*, no. 123 (July 1978): 3–7.

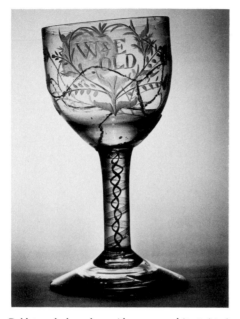

Fig. 201. Goblet, colorless glass with opaque white twists in stem and wheel-engraved bowl. Attributed to H. W. Stiegel Glassworks and engraver Lazarus Isaac of Manheim, ca. 1773. Inscribed: W & E / OLD. H. 7″. (Private collection: Photo, Sheldon Butts.) The evidence of Stiegel's advertisements suggests that he was anxious to make glass in the current English taste. This glass, made to commemorate the marriage of Elizabeth Stiegel to William Old in 1773, illustrates the popular English twist-stem style that was often known as enameled in the period. English-trained engraver Lazarus Isaac joined Stiegel in 1773 and was probably responsible for the English-style decoration of the bowl.

Philadelphia as an independent glass engraver for at least one month before joining Stiegel. It is clear from the advertisement he published in May 1773 that Isaac, who may have trained in Bristol, decorated glass in the current English mode: "He undertakes to cut and engrave on glass of every kind, in any figure whatsoever, either coats of arms, flowers, names, or figures. . . . He cuts upon decanters a name of the wine, &c. for 1s. tumblers for 6d each, wine glasses for 2s per dozen, and the stems cut in diamonds at 2 / 6 per dozen."[28] Isaac undoubtedly continued to engrave in this manner after he went to Manheim, yet none of the engraved glass that has been called Stiegel bears any relation to Isaac's own description of what he could do. Instead, it has shallow engraving of the Continental peasant style and, again, is glassware of nonlead compositions. For the engraved glass, as for the enameled glass, a formulated Pennsylvania German style has been assumed, and this has dictated the course of Stiegel attribution with no concern for the facts of his operation: Stiegel manufactured lead glass; he imitated

English styles; his market went well beyond Lancaster County; and he employed an English-trained engraver.

A goblet has recently been discovered in the possession of Stiegel descendants that may well exemplify the glass made at Manheim during the Stiegel-Isaac collaboration (fig. 201). Blown of colorless lead glass it is completely in the English style of the early 1770s with an ovoid bowl, a straight stem, and a conical foot. The stem contains twists of opaque white enamel in the pattern of a nine-ply spiral band enclosing a pair of heavy spiraled threads, a pattern similar to that seen in the stem fragment Hunter excavated from the Manheim site.[29] The quality of the goblet is not the best; the bowl is of awkward, if generous, proportions, and the central threads of the stem spiral unevenly. The feature that links the glass to Stiegel and Isaac is the wheel-engraved decoration of the bowl; it is believed to commemorate the 1773 marriage of Stiegel's daughter, Elizabeth, to William Old. The English background of the engraver is revealed in the floral motifs; the rose and buds exactly parallel those found on English wineglasses of the period and differ in concept and execution from those engraved on Continental glasswares. Although the design of the Old goblet relates to English glasses of Jacobite significance, the rose here is unlike the usual Jacobite rose in the number and arrangement of its petals.[30]

The documentary and material evidence of Stiegel's glass business suggests that glass usually described as Stiegel-type probably bears no relation to the objects actually manufactured at his Lancaster County establishment. The types of glass that do warrant further scrutiny for possible attribution to Stiegel's venture are table-glass forms of English style but fashioned of nonlead glass, English *and* German shapes blown of a lead-formula glass, and lead glass wheel engraved in the English manner.

Stiegel was not the only Pennsylvania glassmaker who set out to produce fine-quality table glass in the English

[28]*Pennsylvania Packet* (May 17, 1773); Stiegel's contract with Isaac is reproduced in Hunter, *Stiegel Glass*, after p. 72.

[29] The goblet was tracked down by members of the Christian Dorflinger Glass Club, Montgomery County, Maryland, particularly Sheldon Butts and Kenneth Lyon; see Sheldon D. Butts, "The Stiegel Old Wedding Goblet, *Glass Club Bulletin*, no. 139 (Winter 1983): 1, 2; Hunter, *Stiegel Glass*, fig. 159.

[30] For detailed illustrations of English rose engraved glasses, see G. B. Seddon, "The Jacobite Engravers," in *Glass Circle* 3, ed. R. J. Charleston, Wendy Evans, and Ada Polak (Old Woking, Surry: Gresham Books, 1979), pp. 40–78, esp. pp. 74–75, figs. 14a–d. The Old goblet is alluded to in Hunter, *Stiegel Glass*, p. 221, where he mentions he was told by Stiegel's great-granddaughter, Annie L. Boyer, that the rose motif was first made for the marriage of Elizabeth Stiegel and William Old. The covered tumbler engraved with a rose that Hunter illustrated (*Stiegel Glass*, fig. 135), however, is unlike the Old goblet and typifies the Continental style.

taste. After John Allman left Stiegel's employ, he took the lead-glass secret to Robert Towers and Joseph Leacock who opened a glassworks in the Kensington section of Philadelphia in 1771. The factory changed hands several times, but under the various owners a surprising range of forms was produced, from "dishes for sallad" to "bird cisterns and boxes." In 1775, advertisements give the first notice of American-made cut glass. Like Stiegel, the Kensington proprietors enjoyed a market beyond Pennsylvania.[31]

The second owner of the Kensington works, John Elliott, carried the concern with English styles one step further than Stiegel with his desire to make crown window glass, a method that had become, by the eighteenth century, the standard technique for making windowpanes in British glasshouses. In December 1774, Elliott advertised for a worker who could make window glass "in the English method." No one apparently applied to the factory at that time because no further mention of crown glass appears in the newspapers. Crown glass was probably not manufactured in America until 1780–83 when Robert Hewes opened a glasshouse for that purpose in Temple, New Hampshire. Although some of the Hewes blowers were Germans, or "pipe-smoking Dutchmen" as the townspeople complained, recent archaeological excavations of the site have proved that crown glass in the English manner was one of their products.[32]

In Pennsylvania in the 1770s there was considerable glassmaking activity besides the Kensington factory. Stiegel glassblower Felix Farrell left Manheim in 1771, and in 1777 he teamed up with George Bakeoven to open a small tableglass works in Philadelphia.[33] In Hilltown Township, Bucks County, a glassworks operated for the war years, 1776 to 1781. Peter Mason (Maurer), of German extraction, was the proprietor. This may have been the same location where J. G. Musse had blown glass in the 1750s and where a Jacob

Barge had intended to build a glasshouse in 1769.[34] The documentary history of the site is not clear, but fragments gathered there indicate the manufacture of green bottles and possibly window glass.

Paralleling the influx of German glass imports during the post-Revolutionary period was the continued immigration of German glassblowers. Among those who influenced the direction of the industry in Pennsylvania was Saxon-born Peter William Eichbaum who claimed to have been a glasscutter at the French court. Together with six other glassworkers he fled the French Revolution and sailed to Philadelphia in 1794. His arrival coincided with the plans of entrepreneur John Nicholson to begin glassmaking at his manufacturing complex at Falls of the Schuylkill.[35] Eichbaum was hired as the glasshouse superintendent, and seven German glassblowers worked under him blowing claret, mustard, and snuff bottles as well as apothecary ware. During the three years the factory was operated, Eichbaum apparently introduced coal-fired furnaces to America, but it was only in Pittsburgh, to which Eichbaum removed in 1797, that the coal-fuel technology was fully developed.

There were other glassmakers like Eichbaum who traveled to America without advance plans for employment. John Godlieb Götz, for example, was a native of Wurttemburg who came to Philadelphia in 1804, but where or if he found work as a glassmaker has not yet been ascertained.[36] At the same time, glassblowers of Germanic origin continued to migrate to Pennsylvania from other American glasshouses. The failure of the Maryland glassworks of John Frederick Amelung in 1795 led glassblowers Charles Erhard, Christopher Triepel, and Francis Sietz to seek employment with Nicholson. Other former Amelung workers traveled to Fayette County in western Pennsylvania to start a glasshouse in 1797 for Albert Gallatin, a Swiss native who became secretary of the treasury in 1801.

Among the gaffers at this New Geneva works was Balthaser Kramer whose American glassblowing career had begun over twenty years before at Stiegel's works. After Manheim shut down, Kramer and several others opened a glasshouse of their own in Frederick County, Maryland, that was subsequently taken over in 1784 by Amelung. Another New Geneva worker, George Reppert, also went there from Amelung's New Bremen glasshouse but by way

[31]Joseph Leacock to John Nicholson, December 23, 1794, John Nicholson General Correspondence, 1772–1819, John Nicholson Collection, Manuscript Group 96, Division of History and Archives, Pennsylvania Historical and Museum Commission, Harrisburg; *Pennsylvania Packet* (February 27, 1775). A Newport, R.I., merchant sought glass from the Kensington factory (Stanley F. Chyet, *Lopez of Newport: Colonial American Merchant Prince* [Detroit: Wayne State University Press, 1970], p. 133).

[32]*Pennsylvania Journal* (December 7, 1774); Henry Ames Blood, *History of Temple, New Hampshire* (Boston: George C. Rand & Avery, 1860), as quoted in Electa W. Kane, "Interim Report on Historical Research Concerning the New England Glass Works," typescript, Department of Archaeology, Boston University, p. 7. The glassworks site was excavated in 1975–77 under the direction of David R. Starbuck, James Wiseman, and Frederick Gorman of Boston University.

[33]*Pennsylvania Packet* (November 4 and 11, 1771) as quoted in George S. and Helen McKearin, *American Glass* (New York: Crown Publishers, 1941), pp. 95–96; *Pennsylvania Gazette* (August 27, 1777).

[34]Hommel, "Hilltown Glass Works," pp. 25, 28.

[35]For an account of the Nicholson glassworks, see Arlene M. Palmer, "A Philadelphia Glasshouse, 1794–1797," *Journal of Glass Studies* 21 (1979): 202–14.

[36]Ralph B. Strassburger, *Pennsylvania German Pioneers: A Publication of the Original Lists of Arrivals in the Port of Philadelphia from 1727 to 1808*, ed. William J. Hinke, vol. 3 (Norristown, Pa.: Pennsylvania German Society, 1934), p. 156.

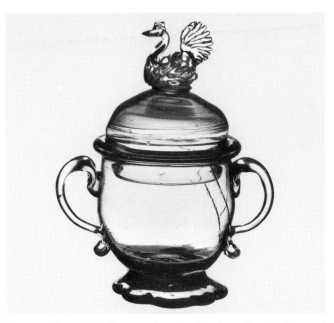

Fig. 202. Covered bowl, green glass. Attributed to Albert Gallatin and Co., New Geneva, 1797–1807. H. 7¾″. (Winterthur 59.3032.) German workers at Gallatin's western Pennsylvania factory produced hollowwares like this of nonlead glass in Continental styles.

of the Albany glassworks.[37] Typically, the emphasis of production at New Geneva was on bottles and windows. "Black" bottles were made for the French colonial market along the Mississippi. Some hollowwares blown of green glass are also believed to have been made there. That these were decorated is seen by the survival of three molds from the factory equipment, two with ribbed patterns and one with diamonds.[38] The sugar bowl in figure 202, reminiscent of the Wistarburgh one in its shape, is one of the German-style objects currently attributed to the Gallatin enterprise. Although the most sophisticated quality glass of German style that was made in America emanated from Amelung's glass establishment, there is no evidence that Amelung workers continued to create glass in these styles at New Geneva or other glass factories in Pennsylvania.[39]

Elsewhere in the state, as in the rest of America, a large force of German artisans labored in the glass industry. The Bethany window glasshouse in Wayne County, erected in 1816, was staffed with Christopher and Christian Faatz, both from Frankfort, as well as Adam and Nicholas Greiner and Jacob Hines, who were also of German heritage.[40] Philadelphia city directories reveal a large percentage of Germans employed in the many nineteenth-century firms there.

German glassworkers also populated the Pittsburgh glasshouses. As late as 1850, a visitor to one of the city's glassworks remarked, "we heard hardly any language but German spoken."[41] Many craftsmen, however, are known to have come to Pittsburgh glass manufactories from England and France. Their influence and that of the competitive English and French imports are clearly seen in Pittsburgh glasswares, especially the cut and engraved wares of the Bakewell firm, but it is difficult to pinpoint Pittsburgh glass that has comparable Germanic characteristics. Although the mid nineteenth century brought new waves of immigrants and craftsmen skilled in the latest Bohemian styles of fancy tablewares, a style of American-Bohemian glass developed in New England, not in Pennsylvania.

The specific attribution of glasswares in the nineteenth century, however, is often impossible because of the extent of the industry, the technological improvements shared by many factories, and the widespread distribution of products. New technologies of mass production promoted the standardization of form and ornament with moldmakers, not glassblowers, directing the course of style for inexpensive ware. At the same time, independent glasscutters and engravers established shops in many cities where they decorated glass blanks from many glasshouses and led the fashion in expensive glass. A truly national style of glass had begun to emerge from the dual influences of Germanic and English traditions. In their reconciliation of these influences the Pennsylvania glassmakers of the eighteenth century to a great extent paved the way for this American glass of the nineteenth century.

[37] Albany Glassworks, "Expences Building of the Last Furnace, 1797," Library, Corning Museum of Glass, Corning, N.Y. Dwight P. Lanmon and Arlene M. Palmer, "John Frederick Amelung and the New Bremen Glassmanufactory," *Journal of Glass Studies* 18 (1976): 18–19.

[38] Illustrated in Harry Hall White, "Pattern Molds and Pattern-Molded Glass," *Antiques* 38, no. 2 (August 1939): 64–67.

[39] For a catalogue of known Amelung wares, see Lanmon and Palmer, "Amelung," 9–136.

[40] L. G. Van Nostrand, "The Glass and China Cupboard: The Bethany, Pennsylvania Glass Works," *Antiques* 43, no. 5 (May 1943): 226–28.

[41] Lady Emmeline Stuart Wortley, *Travels in the United States,* . . . *1849 and 1850* (New York: Harper & Brothers, 1851), p. 89. Reference courtesy of Donald C. Peirce.

Metalwork

DONALD L. FENNIMORE

Copper and wrought iron are perhaps the metals most frequently associated with Pennsylvania German households. The straightforward utilitarian nature of objects such as stills and kettles bespeaks a culture that relied on simple metals for the most necessary and thankless of tasks, the mundane chore. Yet a substantial body of metalwork created by the Pennsylvania Germans exists which must be seen as something beyond everyday utility. The metalwork of these people represents a rich area of study. The objects they fashioned and used from iron, copper, brass, pewter, and silver filled needs in the lives of all Pennsylvanians from the most humble to the most ostentatious.

Winterthur Museum owns 114 objects that are documented or firmly attributed to Pennsylvania Germans and over 200 more objects, such as domestic utensils and hardware, that there is good reason to believe were used by them. Most of these pieces were and are extraordinary objects. They were saved (and later collected) because they were unusual or valuable. For example, the 31 tinned sheet-iron coffeepots at Winterthur were not a common household item for most Pennsylvania German families, and the four pewter candlesticks were made for a church. Such items, although not representative of the range of objects used in the average Pennsylvania German home, are indicative of the range of talents among Pennsylvania German metalworkers. These objects also reveal much about why these metalworkers chose to work where they did and the effect these choices had upon their work.

The English orientation of the colony had some influence on every Pennsylvania German craftsman. This influence was greatest upon those who settled in Philadelphia. The city was the hub for most affluent Anglo-American immigrants and their descendants. Their hands guided the colony's economic activities, and their pockets contained its wealth. The sphere of influence created by these Philadelphians affected all who entered or passed through the seaport regardless of nationality. Those who remained in the city found the tastes of English-oriented fashion tempered considerations of need most directly. The strength of this English influence diminished with increased distance from Philadelphia, but it never disappeared. In inland towns like Lancaster and York, German and English influences mingled in nearly equal parts, and the craftsmen working there produced hybrid objects that freely mixed elements from both traditions. In more rural areas the signs of the English culture were less apparent in the goods Germans made, yet even in the most basic of industries, iron, the Anglo-Americans had a hand.

Iron served in myriad capacities from the most humble and anonymous, as with wagon rims, horseshoes, and nails, to the more ceremonial and decorative. The metal was of particular significance because Pennsylvania had vast reserves of ore. Its quantity and ease of access led to the opening of 39 furnaces (for the smelting of iron ore and casting of objects) and forges (for the working of refined iron into tools and implements) by 1750. This number grew more than threefold to 145 by 1800, many of which were located in the Pennsylvania German region of the state. Most of the furnaces were founded by English entrepreneurs like Anthony Morris, one of the twelve original investors in Durham Iron Works in Bucks County in 1727 and, two years later, Spring Forge in Berks County, and George Ross, who with George Stevenson and William Thompson founded Mary Ann Furnace on Furnace Creek in York County in 1762. But German entrepreneurs also owned and operated furnaces and forges. Valentine Eckert, who had been active in Penn-

sylvania politics and the Revolution, founded Sally Ann Furnace in Berks County in 1791. Forty-one years earlier John Jacob Huber had begun Elizabeth Furnace on Middle Creek in Lancaster County. This furnace is perhaps the best known because Huber's son-in-law, Henry William Stiegel, acquired it in 1757 and ran it in a flamboyant manner until his bankruptcy in 1773.[1]

While we know something about the furnace owners, the many individuals who labored at the day-to-day production of iron remain anonymous. Every furnace employed a number of men, each with specific tasks: colliers (charcoal burners); fillers, who kept the furnace charged with charcoal, limestone, and ore; guttermen, who had charge of the sand molds; potters, who cast hollowware; and founders, who had overall responsibility for casting. A large number of these workers and their families were Germans, and many had come to Pennsylvania as redemptioners who sold their labor for a number of years in return for passage across the Atlantic.

Most of the products of furnaces and forges were heating devices and cooking implements—firebacks, jamb stoves, draft stoves, Franklin stoves, pots, pans, skillets, and kettles. Some of these products, identifiably Germanic in origin, were made for rural areas and towns in which the German element predominated. An example of this is illustrated by the cast-iron jamb stove (fig. 203), many of which were made in Pennsylvania's iron furnaces. This type of stove is traceable to the sixteenth century, when it is believed to have been developed in central Eruope. It consists of five cast-iron plates held together at one end with a wrought-iron bolt and at the other by the masonry of a fireplace wall against which it is placed. Fagots and embers inserted in it through the open end heated the plates which then acted as radiators. Such stoves were widely used in Germany, but not in other areas of the continent. The Lowlands, for example, preferred the draft or free-standing ventilated stove, while England relied on the fireplace, a more primitive form of heating.[2]

In Germany cast-iron jamb stoves were embellished with moralistic and biblical scenes and inscriptions. This tradition, like the stoves themselves, was transferred to Pennsylvania with the German immigrants. Judging from the hundreds of individual stove plates that remain today, it retained a great deal of vitality in the New World. Uncounted thousands of jamb stoves were cast and sold throughout the Delaware Valley, but today few can be traced to the houses in which they were originally installed.[3]

The furnaces and forges that produced jamb stoves were the heavy industry of metalworking, but the majority of metalworkers were self-employed, or at least self-proclaimed specialists. Of the many professions represented among the German arrivals in Pennsylvania, about "7 percent [were] smiths of various sorts": blacksmiths, braziers, cutlers, edge-tool makers, farriers, gunsmiths, locksmiths, nailers, pewterers, silversmiths, tinsmiths, wheelwrights, and whitesmiths.[4] They settled in every community, large and small, throughout Pennsylvania and on rural farms. In the aggregate they were probably the single largest body of craftsmen in the colony.

The smiths worked with wrought iron. Indeed, the need for wrought iron of every description was pervasive. Some smiths tried to remain specialized, like nailsmith Nickles Emig in Manheim Township, York County, but most produced a general line of work and repaired countless broken and damaged objects. Heinrich Siesholtz, for example, did considerable business in straightening scythes. A gauge of how essential these artisans were to the lives of Pennsylvanians is the fact that more than 1,500 blacksmiths worked in Lancaster County alone between 1729 and 1840.[5]

Blacksmiths produced a tremendous quantity of work, and their markets were localized. Yet little wrought iron can be identified as the product of a particular blacksmith because these men rarely marked their work. That their output tended to be straightforward and utilitarian in nature—wheel rims, door hinges, grubbing hoes, manure forks, crowbars, and twibils (a double-headed ax used for cutting mortises in architectural elements)—may in part explain this anonymity. The marked pieces are frequently household implements. For example, Peter Derr of Tulpehocken Township, Berks County, stamped his name into fat lamps, dough

[1] Arthur Cecil Bining, *Pennsylvania Iron Manufacture in the Eighteenth Century* (Harrisburg: Pennsylvania Historical Commission, 1938), pp. 187–92, 132, 136, 141–42.

[2] Henry C. Mercer, *The Bible in Iron: Pictured Stoves and Stoveplates of the Pennsylvania Germans*, ed. Horace M. Mann and Joseph E. Sandford (3d ed., Doylestown, Pa.: Bucks County Historical Society, 1961), pp. 12, 5, 6.

[3] Mercer, *Bible in Iron*, pp. 181–82.

[4] Don Yoder, ed., "Emigrants from Wuertemberg: The Adolf Gerber Lists," in *Pennsylvania German Immigrants, 1709–1786: Lists Consolidated from Yearbooks of the Pennsylvania German Folklore Society*, ed. Don Yoder (Baltimore: Genealogical Publishing Co., 1980), p. 28. This figure is based on those individuals from about 150 Württemburg communities, not from all of the German and neighboring states.

[5] *Friedrich Heinrich Gelwicks, Shoemaker and Distiller: Accounts, 1760–1783, Manheim Township, York County, Pennsylvania*, trans. and ed. Larry M. Neff and Frederick S. Weiser (Breinigsville, Pa.: Pennsylvania German Society, 1979), p. 63; Jeannette Lasansky, *To Draw, Upset, and Weld: The Work of the Rural Pennsylvania Blacksmith, 1742–1935* (Lewisburg, Pa.: Union County Historical Society, 1980), p. 26; Elmer Z. Longenecker, *The Early Blacksmiths of Lancaster County* (Lancaster: Lancaster Theological Seminary, 1971), pp. 30–44.

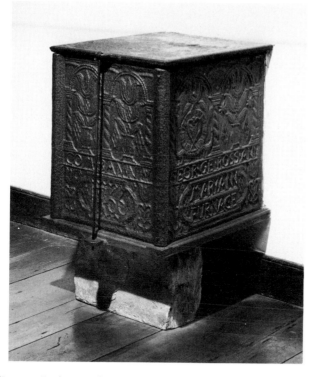

Fig. 203. Jamb stove, Mary Ann Furnace, Manheim Township, York County, ca. 1766. Cast iron and wrought iron; H. 23⁵/₁₆". Cast into the side and end plates is GEORGE ROSS ANN / MARYANN / FUR-NACE / COMBANNI / 1766. (Winterthur 60.773.) The bottom plate and wrought-iron rod are replacements.

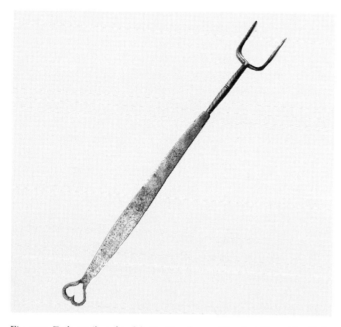

Fig. 204. Fork, attributed to Martin Eisenhauer, Hereford Township, Berks County, 1776. Wrought iron and brass; L. 15⅛". (Winterthur 60.792.)

scrapers, and bleeders during the mid nineteenth century. Some smiths simply engraved their names into the iron they made. A few marked their wares by insetting brass or copper, as did one Martin Eisenhauer. He reportedly inlaid his own name on the front of a fork and the date 1776 on the reverse (fig. 204). Although several Martin Eisenhauers lived in Pennsylvania at this time, the maker of this fork is probably the smith who resided in Hereford Township, Berks County.[6]

The decorative technique Eisenhauer used was uncommon. It appears almost exclusively on forks, ladles, skimmers, spatulas, and tasters, which were usually made in sets and given to Pennsylvania German women as marriage gifts. Although very few of the inlaid initials and names are traceable to individuals, it is likely they were those of the young women who owned the utensils, rather than the makers of these utensils.[7]

Tinsmithing is another area of iron manufacture in which Pennsylvania Germans were quite active. Although very little eighteenth-century tinned sheet iron has survived, there were many tinsmiths who transformed it into domestic utensils. (These men usually referred to themselves as tinsmiths, although the material with which they were working was largely sheet iron coated with a very thin layer of tin to retard rust.) Johann Henrich Krausz, tinsmith, worked on Second Street in Philadelphia as early as 1755 and advertised in the *Pennsylvanische Geschichts-Schreiber;* Philip Alberti provided fellow Pennsylvania Germans with tinware from his shop on Arch Street as early as 1768. Johann Christoph Heyne, a notable eighteenth-century Pennsylvania German pewterer, also advertised himself as a tinsmith, working on "King St., 3 houses below Dr. Kuhn and opposite Georg Graf, Lancaster," in the November 10, 1772, issue of the *Wochentlicher Pennsylvanicher Staatbote.*[8] A close inspection of four pewter candlesticks he made while working in Lancaster reveals candle cups and bobeches of tinned sheet iron, a rare, documented eighteenth-century example of tinned sheet iron and proof of Heyne's

[6] Lasansky, *To Draw, Upset, and Weld,* p. 72, discusses methods of insetting; *Pennsylvania Archives,* 3d ser., vol. 18 (Harrisburg, 1898), p. 370.

[7] *The Account Book of the Clemens Family of Lower Salford Township, Montgomery County, Pennsylvania, 1749–1857,* trans. Raymond E. Hollenback, ed. Alan G. Keyser (Brenigsville, Pa.: Pennsylvania German Society, 1975), records numerous gifts of forks, ladles, spatulas, skimmers, and tasters to the young women of the family on the occasion of their marriage. See also Jeannette Lasansky, "Unusual Pennsylvania Ironware," *Antiques* 119, no. 2 (February 1981): 440.

[8] Edward W. Hocker, ed., *Genealogical Data Relating to the German Settlers of Pennsylvania and Adjacent Territory from Advertisements in German Newspapers Published in Philadelphia and Germantown, 1743–1800* (Baltimore: Genealogical Publishing Co., 1980), p. 118.

dexterity with two quite different metals (see fig. 207).

Tinned sheet iron reached its greatest popularity in the nineteenth century with the advent of machine production, and most plain and decorated tin in museum collections dates from that time. As in the eighteenth century, little of it can be identified as having been made by a specific tinsmith, although manuscript material yields the names of many men plying the trade. Among the few tinsmiths who have left marked examples of their work are George Endriss and Frederick Zeitz of Philadelphia, Charles Snell of Reading, John Ketterer of Bucks County, and Willoughby Shade of Montgomery County, Philadelphia, and Bucks County.[9]

Frederick Zeitz is believed to have made the japanned tray in plate 32. The tray is one of more than 100 japanned pieces at Winterthur. Most of these are unsigned, and they may or may not have been made or decorated by Pennsylvania Germans. The tray, however, bears the date 1874 and Zeitz's initials. It has a black ground, a copper-colored center, and a border of white, red, yellow, blue green, and green. Of all the colors commonly used on nineteenth-century tinned sheet iron found in Pennsylvania, the most common ground colors were black and red, with an occasional yellow. Although other colors are virtually never seen today, records indicate that blue, green, orange, and purple grounds were also used.[10]

Another piece of tinned sheet iron at Winterthur is a coffeepot marked W. Shade (fig. 205). While it has been stated that the Shade family of tinsmiths worked in Berks County during the nineteenth century, this pot was probably made by Willoughby Shade, who worked in Marlborough and Towamensin townships, Montgomery County, in the 1840s and 1850s and was one of nearly 200 tinsmiths listed in the Philadelphia directories during the 1860s. He retired to Bucks County.[11] The coffeepot is one of many that are generally thought of as having folk or naive decoration, yet a close examination of the punched design on each side of this pot reveal that the dominant motif is a careful and academically rendered lyre, a neoclassical element largely associated with urban designs. Other pots that Shade decorated have equally sophisticated devices, thus supporting their attribution to an urban tinsmith and an urban clientele.

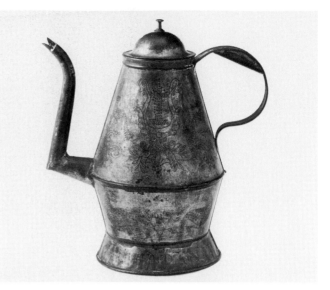

Fig. 205. Coffeepot, Willoughby Shade, Montgomery County or Philadelphia, 1840–70. Tinned sheet iron and brass; H. 11⅞". Stamped on the top of the handle is W. SHADE; punched around the footrim is CATHARENA H. MOYER. (Winterthur 65.2152.)

Philadelphia tinsmiths had long enjoyed a patronage from far beyond city limits. In 1792 Gerhard Clemens of Lower Salford Township, Montgomery County, spent over £25 in Philadelphia for "copperware, iron ware, pewter, tinware and feathers" to give to his daughter Elissabetha for her marriage. About fifty years later, Shade punched Catharena H. Moyer's name into the footrim of the coffeepot he made, which implies it, too, was a wedding gift. (Although her name is clearly German, it is not presently possible to determine which of the twenty-five Catharine Moyers recorded in the census records of Berks, Bucks, Clinton, Columbia, Cumberland, Lebanon, Lycoming, Montgomery, Northampton, Schuylkill, Union, and York counties was the fortunate recipient.)[12]

Most brass and copper workers, like tinsmiths, provided a broad range of objects. In the *Pennsylvania Gazette* of February 13, 1753, George Orr claimed the ability to provide prospective customers with copper "stills, furnaces and kettles of all sizes, Dutch ovens, stewing pans, frying pans, kettle-pots, ship-kettles, sauce pans, coffee-pots, chocolate-pots, dripping-pans . . . brass kettles of all sizes, beams and scales, lead weights" as well as to repair and tin "all sorts of

[9] Winterthur owns a cookie cutter by George Endriss and three coffeepots by John Ketterer. A second cookie cutter by Endriss and one by Snell are in a private collection in Pennsylvania.

[10] Henry J. Kauffman, *Early American Ironware, Cast and Wrought* (New York: Weathervane Books, 1975), p. 144.

[11] Margaret Coffin, *The History and Folklore of American County Tinware, 1700–1900* (New York: Galahad Books, 1968), pp. 150–51; the Philadelphia city directory of 1860 alone lists 180 tinsmiths.

[12] *Clemens Account Book*, p. 73; *Pennsylvania Census Index*, vol. 2 (Bountiful, Utah: Accelerated Indexing Systems, 1976), p. 1137; Jeannette Lasansky, *To Cut, Piece, and Solder: The Work of the Rural Pennsylvania Tinsmith, 1778–1908* (Lewisburg, Pa.: Union County Historical Society, 1982), pp. 37–38.

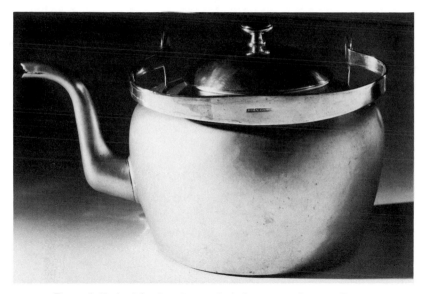

Fig. 206. Kettle, John Getz (1790–1842), Lancaster, 1810–42. Copper, brass, and iron; H. 12″. Stamped on the top of the handle is JOHN GETZ. (Winterthur 68.404.)

braziers work."[13] John Getz, another coppersmith of German extraction, provided the same products and services in Lancaster during the early nineteenth century. The teakettle in figure 206 is an example of his work and one of the most frequently made forms by Pennsylvania coppersmiths. Stills used for making alcohol were perhaps the only other copper implements that were more popular; few remain today because of heavy use.

Among the finer metals—gold, silver, and pewter—pewter was the most affordable and enjoyed a degree of popularity in Philadelphia and southeastern Pennsylvania. One of the best-known Pennsylvania German pewterers is Johann Christoph Heyne. He was born in Saxony, an area between the Elbe and Mulde rivers north of the Ore Mountains, in 1715. At the age of fourteen he was apprenticed to a pewterer. Upon completing his four-year term in 1733, he traveled through Stettin, a northern German port, to Stockholm, where he worked as a journeyman in the pewter shop of Maria Sauer. On May 8, 1742, Heyne arrived in Philadelphia aboard the British snow *Catherine* as a member of the *Unitas Fratrum* (Moravian Church). Soon thereafter he settled in its small religious community at Bethlehem, forty-eight miles north of Philadelphia on the Lehigh River. There he established a pewterer's practice in the integrated communal metalworking shop, which also included a brazier and a blacksmith. Silver objects may have also been produced under the same roof, since one of the shop supervisors was a working silversmith and engraver.[14]

In 1750 Heyne left the community but did not sever ties with the church. He moved to his wife's home in Tulpehocken Township near Reading, about sixty miles northwest of Philadelphia. By 1757 he had moved to Lancaster, sixty-five miles west of Philadelphia, and in that city he established a pewtering business which he continued to operate until his death on January 11, 1781. Heyne was apparently a full-time pewterer and applied his talents as a tinsmith. In addition, he devoted considerable time to church activities. He served as supervisor to several schools established by the church and became a missionary and assistant minister to communicants, both in outlying areas of Pennsylvania and, for a period of two years, in Ireland.[15]

Eighty-seven pieces of Heyne's pewter have survived. Many are ecclesiastical in nature—altar candlesticks, flagons, and chalices.[16] Others could have been used in either a domestic or an ecclesiastical context—plates (patens),

[13] Henry J. Kauffman, *American Copper and Brass* (New York: Bonanza Books, 1979), p. 34.

[14] Eric de Jonge, "Johann Christoph Heyne: Pewterer, Minister, Teacher," in *Winterthur Portfolio 4*, ed. Richard K. Doud (Charlottesville: University Press of Virginia, 1968), pp. 171, 175; I. Daniel Rupp, *A Collection of Upwards of Thirty Thousand Names of German, Swiss, Dutch, French and Other Immigrants in Pennsylvania from 1727 to 1776* (Philadelphia: I. G. Kohler, 1876), pp. 152–53.

[15] De Jonge, "Heyne," pp. 175–76.

[16] John H. Carter, Sr., "A Checklist of the Extant Pewter of Johann Christoph Heyne," *Pewter Collectors Club of America Bulletin* 7, no. 1 (December 1974): 26–33.

beakers (communion cups), and sugar bowls (pyx or ciboria). The remainder are canteens, nursing bottles, porringers, pint and quart cans, basins, and chamber pots.

Winterthur owns four altar candlesticks that bear Heyne's ICH mark and "Lancaster" (fig. 207). They are probably from a set of six once owned by the Most Blessed Sacrament Church (Catholic; organized 1741), in Bally, Berks County. These candlesticks are of a type frequently found on central European church altars. They can be traced to at least as early as 1689 in pictorial material, over half a century prior to Heyne's arrival in America.[17] (Similarly, Heyne made tall trumpet-shaped flagons with cherub-head feet that are almost unchanged in form and detail from those used in German churches and guildhalls as early as the seventeenth century.)[18] The candlesticks illustrate Heyne's tenacious concern for tradition. They retain the full baroque curves and volutes popular in Europe during the seventeenth century. Even more telling is the presence on all three sides of each candlestick of the six symbols of Christ's passion: the cross on which He was crucified, the hammer used to drive the nails, the crown of thorns, the scourge with which He was beaten, the vinegar-soaked sponge on a hyssop stalk, and the spear used to pierce His side. This remarkable statement made by a Moravian for a Roman Catholic church in the midst of the overwhelmingly Protestant Delaware Valley bespeaks the persistence of an ancient tradition established in Europe long before the American continent was known to exist.

Heyne's decisions about where to work undeniably affected his products and his style. He passed through Philadelphia when arriving in Pennsylvania and apparently returned there periodically during the course of his career, but he chose to settle elsewhere. Subsequent relocations from Bethlehem to Tulpehocken and finally to Lancaster scribed an arc around, but never into, Philadelphia. Certainly Heyne had the talent and acumen to vie with the best of Philadelphia's craftsmen, but he chose not to, preferring instead, judging from what we know about his life, to devote his abilities to pre-

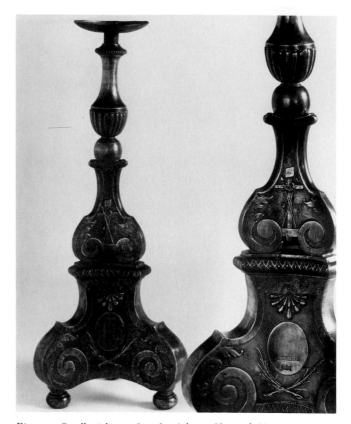

Fig. 207. Candlesticks, attributed to Johann Christoph Heyne (1715–81), Lancaster, 1757–81. Pewter and tinned sheet iron; H. 21⅞". Marked on the outside of the base on each is ICH/LANCASTER. (Winterthur 65.1602.1, .2.)

[17] Charles F. Montgomery, A History of American Pewter (New York: Praeger Publishers, 1973), pp. 90–91. In an engraving by Nicholas Dorigny dated 1686 similar candlesticks are on the altar of Santa Maria in Vallicella in Rome; see Erich Hubala, Propyläen Kunstgeschichte, vol. 9, Die Kunst Des 17. Jahrhunderts (Berlin: Propyläen Verlag, 1970), fig. 385a.

[18] A flagon came into the Winterthur collection with a history of original ownership by Evangelical Lutheran Church of the Holy Trinity in Lancaster, Pennsylvania. A spoutless flagon made in Vienna, Austria, which dates about 1600, is pictured in Ludwig Mory, Schönes Zinn; Geschichten Formen und Probleme (Munich: Bruckmann, 1961), fig. 112, and relates to Heyne's flagons. Another, with spout, made in Strasburg, France, and dated 1692, is pictured in Hans Ulrich Haedeke, Zinn; ein Handbuch für Sammler und Liebhaber (Braunschweig: Klinkhardt & Biermann, 1963), p. 325.

serving the churches and life-style with which he had been familiar in Germany. This is circumstantially evident through the partial knowledge we have of his life and activities in Pennsylvania. It is graphically underlined by the surviving artifacts, the bulk of which are ecclesiastical and basically unchanged in form, ornament, and function from those that he had been familiar with in Europe and that had been familiar to Europeans well before Heyne was born.

Pewterer William Will preferred Philadelphia. He was a second-generation Pennsylvania German and son of a pewterer. Like many of his colleagues he enjoyed the patronage of his countrymen outside the city limits as well as that of Anglo-Americans and Pennsylvania Germans living in the city. He made the pewter chalice and flagon that Andreas Morr and his wife, Catharina Elisabetha, presented to Evangelical Lutheran Zion Church in Penns Township, Northumberland County, in 1795. The chalice (fig. 208) is recognizably Protestant in form, but otherwise it is a simplified interpretation of a type used throughout Europe and England in the late eighteenth century. The inscription and

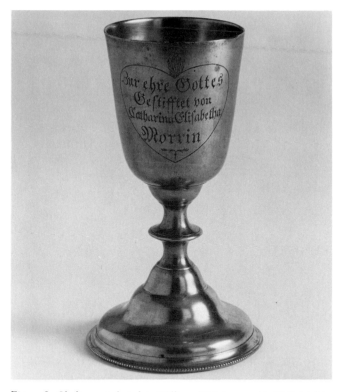

Fig. 208. Chalice, attributed to William Will (1742–98), Philadelphia, ca. 1795. Pewter; H. 7⅞″. Engraved on the cup within a flaming heart is "Zur ehre Gottes / Gestifftet von / Catharina Elisabetha / Morrin" (To the Glory of God the gift of Catharine Elizabeth Morr). (Winterthur 58.24.)

Fig. 209. Quart mug, attributed to William Will (1742–98), Philadelphia, ca. 1780. Pewter; H. 5¾″. Marked on inside bottom is PHILAD. Engraved on the barrel is the figure of an equestrian with upraised sword under two banners which read LIBERTY OR DEATH and HUZZA FOR CAPT. ICKES. (Winterthur 67.1369.)

the flaming heart (symbolizing religious zeal) are Germanic. The Morrs had settled in Northumberland County at least as early as 1771 and by 1795 were moderately prosperous. They owned over 300 acres and operated a sawmill, a gristmill, and a distillery.[19]

Will also made the quart mug in figure 209, which, although marked only with the word *Philadelphia*, is identical to another in the Winterthur collection that bears Will's name. The elaborate engraving on it honors Peter Ickes (b. 1748). Ickes, a Pennsylvania German, lived in Limerick Township, Montgomery County, at the time of the American Revolution and served as Captain of the Fifth Company of the Sixth Pennsylvania Battalion.[20]

Many of the metalworkers were dependent on each other, and the two Will pieces illustrate one of the simplest of these relationships. A comparison of the engraving on the chalice and on the mug indicates that they were done by two different artisans. That on the chalice is crisp and professionally executed; that on the mug is more naive, possibly done by an individual who was not formally trained and who was not working in an urban environment. It is doubtful that Will himself was an engraver. No engraving tools are listed in the inventory of his estate; neither is there any evidence of an ability at engraving on his part to be derived from what we know of his self-proclaimed activities. For the Morr commission he may have suggested or turned to a fellow Pennsylvania German such as engraver Anthony Armbrüster, located in Moravian Alley, who was conversant with the German language and alphabet and probably with the symbolism.[21]

Cooperation among specialists in complementary profes-

[19] Montgomery, *American Pewter*, pp. 73, 76, 78, 81, 82; Morr family notes, Gearhard Collection, Historical Society of Pennsylvania, Philadelphia; *Pennsylvania Archives*, 3d ser., vol. 19, pp. 452, 739.

[20] Charles V. Swain, "Interchangeable Parts in Early American Pewter," *Antiques* 83, no. 2 (February 1963): 212–13; Frederick S. Weiser to Donald L. Fennimore, May 1977.

[21] Suzanne C. Hamilton, *William Will, Pewterer: His Life and His Work, 1742–1798* (M.A. thesis, University of Delaware, 1967), pp. 73–99, 114–18; Alfred Coxe Prime, *The Arts and Crafts in Philadelphia, Maryland and South Carolina, 1721–1785: Gleanings from Newspapers* (Topsfield, Mass.: Walpole Society, 1929), p. 15.

sions, although rarely documented, was not uncommon. One fortuitously documented example of artisan symbiosis is a pair of pistols made by Frederick Zorger. The iron barrels and lock plates as well as the silver ramrod pipes, trigger guards, side plates, escutcheons, and butt caps are competently engraved. While Zorger may have done the engraving, the presence of "& I.F." below Zorger's name on the lock implies it was more likely done by the celebrated York clockmaker, carver, painter, organ builder, and engraver, John Fisher.

Born Johannes Fischer in Germany, he arrived in Philadelphia on October 4, 1759, and anglicized his name to John Fisher. He continued westward, finally settling in York, where he built a number of fine clocks, the best known of which is an astronomical clock with an "elegantly engraved" face now in the collection of the Yale University Art Gallery. At his death in 1808, seven years before Zorger, Fisher, nicknamed Pabeldoctor by the "old German citizens of York," was interred in the graveyard of Christ Lutheran Church.[22]

Clocks are the best-documented objects of brass and copper that were made in Pennsylvania, and clockmakers are perhaps the metalworkers who were most frequently involved in cooperative efforts, inasmuch as every clock they made had to be housed in a wooden case, the product of a cabinetmaker. The daybook of Lancaster cabinetmaker Jacob Bachman records that he routinely exchanged his clock cases for works by clockmaker Anthony Wayne Baldwin.[23] Such a barter system was mutually advantageous in that it provided both craftsmen with a finished product to sell and it freed each from additional cash outlay for the other's product.

Jacob Graff's fine brass eight-day clock (pl. 33), is also illustrative of symbiosis. It is housed in an anonymously made inlaid walnut case. We know nothing of the casemaker and little of this clockmaker beyond the fact that he lived in Lebanon and died in 1778. The clock's works, utilizing a standard anchor-recoil escapement and a rack-and-snail striking system, are faced with an engraved brass plate. The moon-phase disk and chapter ring are silvered, the spandrels are cast pewter. The clock face is unusual in two respects: there are engraved tulips in the hemispheres behind which the moon dial rotates, instead of the more commonly encountered continental features, and there was a day-of-the-week dial (now missing), which was rotated by hand (it was not tied into the clock's gear train), located to the right of the seconds dial. The meaning of the letters AN and IM flanking the window displaying the day of the month are presently unknown, but the inscription on the arc within the chapter ring translates as "Jacob Graff makes this." The clock was acquired from a member of the Illig family in 1946 and may have been originally made for a member of that family; the Illigs settled in the Millbach-Richland area of Lancaster (now Lebanon) County in the eighteenth century.[24]

The Zorger pistols (figs. 210, 211, 212, 213) to which we alluded above are a singular example of Pennsylvania German craftsmanship. Their maker, Frederick Zorger, was a well-known gunsmith and metalworker in eighteenth-century York. And these pistols, a rare survival, represent a singular contribution, ascribed to the Germans in Pennsylvania, in the annals of gunsmithing.

Firearms had been made and used in Europe and England for centuries before the settlement of Pennsylvania. The craft of making guns was among the first to be pursued in the colony because the need for efficient, accurate, and lightweight firearms was acute both for warfare and for hunting. Out of these multiple needs the "Kentucky" came into being. It refined the heavy, large-bore, relatively unwieldy, difficult-to-load, poorly sighted European firearm into a lightweight, small-bore, efficient, and deadly accurate weapon, perfectly suited to use in the heavily wooded, game-rich, and Indian-populated areas of Pennsylvania, Maryland, Virginia, Kentucky, and Ohio.[25] This development is normally associated with rifles but pertains to pistols as well.

This brace of pistols is the best example of Zorger's talent yet discovered. Stocked in walnut, the tapered cylindrical barrels are smooth bore and 60 caliber. The pistols flaunt ramrod pipes, trigger guards, side plates, escutcheons, and butt caps all in silver. This furniture (now called mounts) is elaborately cast and engraved and is virtually identical to that found on contemporary English pistols. Additionally, the carving on the stock surrounding the breech imitates the English style. It is possible that the mounts were imported from England. Indeed, the open trade between London and Philadelphia encouraged the movement of finished English goods such as these to America.[26] And the absence of mak-

[22] Brooks Palmer, *The Book of American Clocks* (New York: Macmillan Co., 1950), p. 192; Edwin A. Battison and Patricia E. Kane, *The American Clock, 1725–1865: The Mabel Brady Garvan and Other Collections at Yale University* (Greenwich, Conn.: New York Graphic Society, 1973), p. 134; *Lewis Miller, Sketches and Chronicles: The Reflections of a Nineteenth Century Pennsylvania German Folk Artist* (York, Pa.: Historical Society of York County, 1966), p. 70.

[23] Jacob Bachman daybook, Joseph Downs Manuscript and Microfilm Collection, Winterthur Museum Library.

[24] Mercer, *Bible in Iron*, p. 182.

[25] John G. W. Dillin, *The Kentucky Rifle: A Study of the Origin and Development of a Purely American Type of Firearm* (Washington, D.C.: National Rifle Association, 1924), pp. 11–16.

[26] W. Keith Neal and D. H. L. Back, *Great British Gunmakers, 1740–*

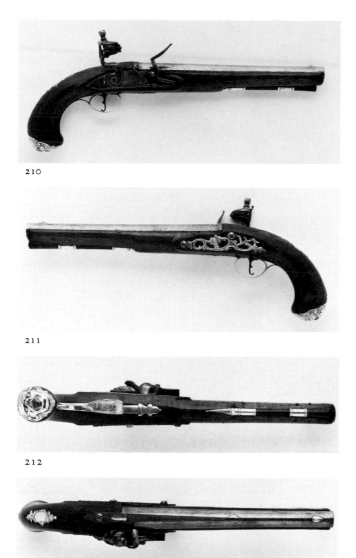

210

211

212

213

Figs. 210–213. One of a pair of flintlock pistols, Frederick Zorger (1734–1815), probably engraved by John Fisher (d. 1808), York, 1765–80. Walnut, iron, silver, and flint; L. 14½". Engraved on the lock plate is F. ZORGER/& I.F., and on top of the barrel is YORK TOWN. (Winterthur 61.857.1.)

er's marks on the silver furniture renders it difficult to state with certainty their place of origin. They could have been made in Pennsylvania by Zorger himself, who is known to

have worked with the precious metals, or by any one of myriad Pennsylvania silversmiths.[27] In either event, their sophisticated urban character relates them directly to furniture on marked English pistols and provides an important stylistic tie and possibly an economic one between the creators of Pennsylvania's Kentucky firearms and England.

The silver mounts also point up one other important fact: silver had the greatest appeal for urban inhabitants. Some stylish pieces did emanate from Bethlehem, Lancaster, Reading, and York, but most Pennsylvania silver is traceable to Philadelphia. Silversmith John Christian Wiltberger was a second-generation Pennsylvania German, born and raised in Philadelphia. His Evangelical Lutheran father, John Peter Wiltberger, was a hatter by trade who was born in 1731 at Offenbach on the Main River, near present-day Frankfurt. By 1755 he had immigrated to Philadelphia and married Anne Catarina Meminger. John Christian, the seventh of nine children, was born in 1766. It is not known to whom Christian was apprenticed, but he learned the trade of silversmithing and by 1793 was advertising his abilities as "goldsmith, jeweller and hair worker" at 33 South Second Street in Philadelphia. He continued in business at various addresses in the city, both on his own and in partnership with Samuel Alexander, until 1819, at which time he is presumed to have retired from active silversmithing.[28]

Slightly fewer than 100 pieces of Wiltberger's silver are known to exist, much of it flat silver.[29] The known examples of hollowware relate closely to the sugar bowl illustrated in figure 214, and demonstrate that Wiltberger was making fashionable silver for Philadelphia's elite. He was one of about 100 silversmiths doing so. His competitors included Anglo-Americans like Joseph and Nathaniel Richardson, Joseph Lownes, Richard Humphreys, Samuel Richards, and John McMullin; Franco-Americans like John Tanguy, Daniel Dupuy, Jr., Abraham Dubois, and John Le'Tellier; and other Pennsylvania Germans like Godfrey Shiving, Joseph Shoemaker, William Haverstick, Sr., and George Dowig.[30] Wiltberger and his colleagues strictly followed the design formula established by London craftsmen and tastemakers. The result was a remarkable stylistic

1790: The History of John Twigg and the Packington Guns (London: Sotheby Parke Bernet Publications, 1975), pls. 118, 198, 540, 162, 238. William Ball, Philadelphia silversmith, offered similar goods that he specified were imported (*Pennsylvania Gazette* [May 26, 1761, and November 13, 1766]). Another silversmith, John Carnahan, placed a similar advertisement in the *Pennsylvania Journal* (August 1, 1771).

[27] *Lewis Miller,* p. 45.

[28] Ellen Samson Magorn, *Wiltberger Family Notes* (Groton, Mass.: Privately printed, 1936); Philadelphia city directories, 1793–1820; Samuel W. Woodhouse, Jr., "Two Philadelphia Silversmiths," *Antiques* 17, no. 4 (April 1930): 326–27.

[29] This figure is derived from the objects recorded in the Decorative Arts Photographic Collection, Winterthur.

[30] Maurice Brix, *List of Philadelphia Silversmiths and Allied Artificers from 1682 to 1850* (Philadelphia, Pa.: Privately printed, 1920), p. v; *Philadelphia: Three Centuries of American Art* (Philadelphia: Philadelphia Museum of Art, 1976).

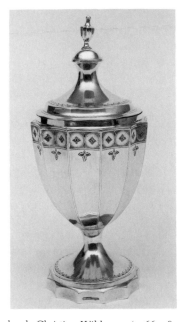

Fig. 214. Sugar bowl, Christian Wiltberger (1766–1851), Philadelphia, 1793–1819. Silver; H. 10¼″. Engraved on the side is MM; stamped twice on the base is "C. Wiltberger" in a conforming rectangle. (Winterthur 56.98.2.)

coherence in silver made in Philadelphia and environs from the late seventeenth century through the early nineteenth century, despite the cosmopolitan character of the populace. There were identifiable groups of English, French, German, and even Swedish, Italian, and Dutch immigrants in the Philadelphia area, yet these people quickly eschewed whatever previous stylistic preference they had in favor of the Anglo-Philadelphia taste.

Christian Wiltberger, a Philadelphian by birth, accepted English taste as his own and became a competent practitioner, supplying fashion-conscious Philadelphians, re-

gardless of familial origins, with stylish silver artifacts. Frederick Zorger blended style and practicality in a different way in Lancaster. And Johann Christoph Heyne, pewterer and tinsmith in Germany, Sweden, and the arc of Pennsylvania German counties surrounding Philadelphia, consciously chose not to immerse himself in the Anglo-American urban environment, but chose instead to nourish the Germanic attitudes, values, and life-styles of fellow immigrants who sought to maintain their Germanness.

In sum, the range of metals produced by the numerous and varied Pennsylvania Germans is vast, as were the ways in which they worked them. Yet while these craftsmen produced a vital contribution in all these metals, neither they nor their products can be seen as existing separately and apart from the history of Pennsylvania. The strength and richness of their tradition stems from its involvement and interaction with the historical circumstances that caused Pennsylvania to be so attractive to a wide variety of Europeans. Only in such an environment where multiple influences coexisted could such an innovative hybrid as the Kentucky firearm evolve. Similarly, the encouragement of tolerance as espoused by William Penn surely helped foster an attitude that allowed a devout Moravian pewterer to make objects so antithetical to his beliefs as the Romish candlesticks, an unlikely occurence in central Europe where religious feelings ran high during the period of immigration to America. On a different but related level, Germans became an integral part of every community throughout the colony. Cities were attractive to some and provided a setting in which they produced the best to be had for a sophisticated clientele, while others felt drawn to semiurban and rural settings where they made singular contributions. Their metalwork is a useful index of this innovative and culturally rich people and of their success at adapting to the variety of demands of the New World.

Household Textiles

SUSAN BURROWS SWAN

Throughout the eighteenth century the value of household textiles in both Pennsylvania German and Anglo-American homes accounted for a high percentage of the total estate inventory. One study of estate inventories found that in Philadelphia from 1700 to 1775 the median valuation of fabric furnishings, exclusive of apparel, included about one-twelfth of the median of the total of an individual's personal property holdings. A fully hung bed often represented a person's largest single household investment.[1]

Judging from the prominence and total values in household inventories of wearing apparel, bedding, and other fabrics, Pennsylvania Germans also took great pride in their textile stock. Working in a hierarchical order, Pennsylvania German inventory makers grouped the decedent's apparel first when taking an inventory. Other household textiles such as towels, sheets, and pillowcases were usually grouped by form, with specific values accorded to each item, and listed later in the inventory. Often the apparel constituted the highest single value. For instance, innkeeper Adam Witman from Reading in Berks County died in 1781, leaving wearing apparel valued at £67. His most valuable "one Bed Bedding and Curtain" was worth £22.14. Witman's eight-day clock was listed as worth £21.[2] While urban residents in the eighteenth and early nineteenth centuries purchased most of their fabrics, rural settlers usually raised, spun, and at times wove their own textiles. Although the men of the Pennsylvania German households planted and harvested the fibers and did some of the harder labor of processing them, or sheared the sheep, the spinning of threads was a woman's task. Some wealthy Pennsylvania German families hired girls or women to do this for them. Weaving, on the other hand, was always done by professionals—men and a few women—in their own shops. The women of the household created garments and other domestic textiles from the cloth and decorated them when appropriate and when leisure permitted. Thus all but the weaving of most household textiles, in rural areas and in small towns, took place at home, and nearly all of it was the work of the women there. Of the various technologies discussed in this book, the textile industry was the one learned at home and practiced at home and the one that was overwhelmingly women's domain.

Two major fibers, linen and wool, predominated among the Pennsylvania Germans in the eighteenth century. Hemp, cotton, and silk played smaller roles until the nineteenth century. For linen production farmers reserved about a fourth of an acre of flax for each member of the family. Quality flax required careful attention and heavy fertilization, but flax was a remarkable plant that produced multiple products. Farmers profited from both the fibers and the seeds. Some took the seeds to port cities for export; others sold the seeds to local millers to be made into linseed oil. After mills extracted the linseed oil, still another product remained, oil cake, which could be used for cattle feed. In 1760 on an average farm (125 acres) in Lancaster and Chester counties, 2 acres of flax yielded 300 pounds of hackled flax or hemp and 10 bushels of seed.[3]

Wool was the other major fiber in the eighteenth cen-

[1] Susan Prendergast Schoelwer, "Form, Function, and Meaning in the Use of Fabric Furnishings: A Philadelphia Case Study, 1700–1775," *Winterthur Portfolio* 14, no. 1 (Spring 1979): 36, 38.

[2] Berks County Office of the Register of Wills, Berks County Courthouse, Reading (hereafter cited as Berks County Inventories).

[3] James T. Lemon, *The Best Poor Man's Country: A Geographical Study of Early Southeastern Pennsylvania* (Baltimore and London: Johns Hopkins University Press, 1972), pp. 158, 152–53; Ellen J. Gehret and Alan G. Keyser, "Flax Processing from Seed to Fiber," *Pennsylvania Folklife* 22, no. 1 (Autumn 1972): 13.

tury. One sheep per family member usually produced enough wool to fill the needs for a year, but not every farmer kept sheep. Fortunately, between 1713 and 1790, the average number of adult sheep per farm varied from 15.6 to 12.4.[4]

Hemp, a plant very similar to flax, produced a coarser and darker fiber than flax. Weavers used its fibers for sturdier fabrics such as tick covers or grain bags, but its major use was rope. The Pennsylvania Germans of Lancaster County, especially those along the Susquehanna River, produced the largest quantity and the finest quality of hemp in Pennsylvania.[5]

Cotton fibers were not commonly worked in the eighteenth century because of the difficulties in processing them, thus cotton was considered a luxury fabric. However, occasionally we do run across an inventory that lists the tools for processing the fibers. In 1802, for example, David Hottenstein of Maxatawny Township, Berks County, owned a "spinning wheel and reel and two wool wheels" valued at £1.12 and "some cotton flax and yarn" worth £1.[6] And undoubtedly his cotton was worked on one of the wool wheels. Certainly, after the invention of the cotton gin in 1793, the use of cotton expanded. The increased ease in processing cotton stimulated production and brought down the price. Correspondingly, the demand for linen declined, and by the mid nineteenth century flax production had dropped drastically.

Pennsylvania Germans were but one of numerous groups who attempted to grow silk in America. All met with limited success, and one by one various schemes were abandoned. The Moravians at Bethlehem persisted well into the nineteenth century and at times may have processed enough silk to use for their own embroidery. The Harmonites, who created a settlement at Economy in western Pennsylvania, remained one of the last and most successful producers of silk. Hoping that their location could more cheaply offer western Pennsylvania and Ohio towns this luxurious fabric, these Pennsylvania Germans not only cultivated silkworms but by the 1840s also wove the fibers into complex fabrics like cut and uncut velvet. Such advanced weaving technology was not practiced elsewhere in the United States that early; however, sales were slow, and by 1855 they had all but abandoned silk growing and weaving.

Pennsylvania German tools for transforming the fibers into yarns and fabrics were typical of tools found in most western European cultures. Winterthur owns examples of three tools commonly found in Pennsylvania German households: the hetchel, the spinning wheel, and the tape loom. The simplest but most essential tool in the preparation of flax fibers was the hetchel, through which the women repeatedly dragged the flax fibers handful by handful. Its long, naillike projections combed the flax into parallel and smooth fibers that could be gathered into hanks and later spun into thread (fig. 215). Hetchels are occasionally listed in inventories (for example, in 1761, Dietrich Weining of Reading, Berks County, left a "heghel" valued at £1).[7] The one that Winterthur owns has an additional piece of brass with punched decoration, a name, and a date that contributes only to its attractiveness, not to its utility or serviceability. It is unusual because it bears a man's name, Michel Zimerman, and an early date, 1749.

The next tool, the spinning wheel, transformed the fibers into thread. Whether working with a large or small wheel, the work was repetitive. The small wheel, usually used only for flax, allowed the spinner to sit while she worked. The large wheel, primarily for wool or occasionally for cotton, required her to walk backward and forward while the shorter wool or cotton fibers twisted onto the spindle. (The use of the simplest spinning tool of all, the spindle, did not appeal to the Pennsylvania Germans, although it was common in other areas of Pennsylvania and the country.)

Spinning occurred in most households. By 1810 Montgomery County had one spinning wheel for every three people, a ratio that is probably typical of the other Pennsylvania German rural counties.[8] Women were taught to spin at a young age and some, especially those who never married, fell heir to that household task throughout their lives.

Catharine Wengert was one young girl who was to receive a spinning wheel in exchange for her labor. In 1811 she was apprenticed to Thomas Kurr, a weaver of Tulpehocken Township, Berks County, for eight years and nine months, presumably until she reached the age of majority. Her indenture described her as a "Farmers Maid," but like many girls who were similarly indentured she probably also expected to "learn the art and mystery of housewifery." Upon the completion of this unpaid and lengthy service she was to receive "2 suits of cloths, 1 new, 1 riding coat or cloak, 1 new bed—value of 10 pounds, 1 new bedstead, 1 new chest, [and] 1 new spinning wheel."[9] If, indeed, she served the entire term, her clothes, bed, and spinning wheel

[4] Lemon, *Poor Man's Country*, p. 162.

[5] Lemon, *Poor Man's Country*, pp. 215–16.

[6] My examination of inventories in Lancaster and Berks counties revealed that those with one wheel usually had a second one as well. Unfortunately, their size or use was rarely specified. Berks County Inventories.

[7] Berks County Inventories.

[8] Rudolf Hommel, "About Spinning Wheels," *American-German Review* 9, no. 6 (August 1943): 4.

[9] Indenture of Catharine Wengert, 1811, Joseph Downs Manuscript and Microfilm Collection, Winterthur Museum Library.

Fig. 215. Hetchel and cover, Pennsylvania, ca. 1749. Beech, steel, brass, and iron; H. 5¼", W. 4", L. 15⅜". Brass border punch decorated with scallops. Inscribed "Michel Zimerman / 1749." (Winterthur 67.1267.)

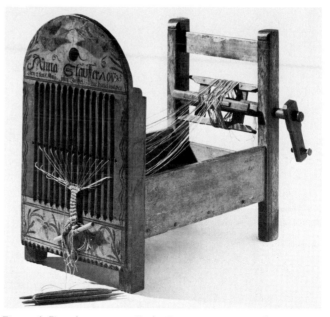

Fig. 216. Tape loom, upper Bucks County, ca. 1795. White pine; H. 17½", W. 9¾", L. 16¾". Inscribed: "Anna Stauffer AD 1795 / Den 2ten Maÿ John Drissell / his hand and pen." (Winterthur 59.2812.)

undoubtedly constituted either the total or the major part of the goods she possessed at marriage.

Although most households were not equipped to weave fabrics, spun threads or yarns could be woven on a variety of looms. Among Pennsylvania Germans the most common household loom was a boxlike tape loom placed on a table. It was on this sturdy loom that women wove tapes for fastening clothes, aprons, bedding, and shoes. Some of the surviving Pennsylvania German tape looms are painted, and one of the more fancily decorated looms is that made for Anna Stauffer (fig. 216). It and several others were painted by John Drissell of Bucks County.[10]

Yet the tape looms remain an enigma. Numerous such looms survive, and a few are shown in portraits, but little contemporary written material exists. Rarely do they even appear in inventory records. The inventory of Daniel Hoch, Oley Township, in 1789 is notable because it includes "1 Large Wheel, 3 Spinning Wheel, 1 Reel, Tape Loom and Wool Cards," valued at a total of £1.1.6.[11] In most cases we have no idea of how such looms were passed down from generation to generation or of how soon women turned this task over to their daughters.

Fabrics that Pennsylvania German women stitched at home included clothing and bedding. In 1789 Benjamin

[10] Winterthur owns two, and Mercer Museum, Doylestown, Pa., owns others.

[11] Berks County Inventories.

Rush of Philadelphia categorically stated that "the apparel of the German farmer is usually *homespun*." This is difficult to document because inventories usually lumped all clothing together as apparel. Furthermore, working garments received hard wear and had little sentimental value, so they rarely survived. However, contemporary drawings indicate that farmers and their wives wore clothing of simple and probably home manufacture.[12]

In contrast to the paucity of evidence about clothes, we know a great deal about bed furniture. A typical Pennsylvania German bed was composed of a bed (mattresslike bag), bedstead (wooden frame), and bedding (pillows, bolster, sheet, feather bag, and coverlet) and differed considerably from Anglo-American beds. Ropes stretched tightly around the bed-rail pegs acted as springs. (Elegant and expensive beds had "sack bottoms.") On top of the ropes lay the mattresslike bag of coarse linen, hemp, or tow stuffed with goose feathers, straw, or even corn husks. (The fillings were

[12] Benjamin Rush, *Manners of the German Inhabitants of Pennsylvania* (Philadelphia, 1789), pp. 22–23; *Lewis Miller, Sketches and Chronicles: The Reflections of a Nineteenth Century Pennsylvania German Folk Artist*, intro. Donald A. Shelley (York, Pa.: Historical Society of York County, 1966), pp. 32–33, 37, 45, 54, 80, 82, 90–92; Ellen Gehret, *Rural Pennsylvania Clothing: Being a Study of the Wearing Apparel of the German and English Inhabitants Both Men and Women Who Resided in Southeastern Pennsylvania in the Late Eighteenth and Early Nineteenth Century* (York, Pa.: Liberty Cap Books, 1976), p. 128.

replaced once or twice a year.) Tucked around this mattress was a sheet, usually made of linen until the middle of the nineteenth century, when commercial cotton became more affordable. Instead of a top sheet, Pennsylvania Germans used a bag filled with feathers. The geese of Pennsylvania had to donate sixteen to nineteen pounds of their feathers to keep each bag properly filled. Plump pillows—either two or four lay atop one long bolster—with matching covers completed the bedding.[13]

Colors or patterns of the fabrics used on bedding were rarely specified in inventories, but surviving examples display an extensive variety of checks in white, blue, tan, and brown (pl. 29) with an occasional bold blue-resist pattern. Pennsylvania German resist prints are easy to discern. They have the design defined in white and the background in blue, just the reverse of those made in England but the same as those made in Germany. In Pennsylvania most of these fabrics were prepared by blue dyers who advertised in local papers.

Many of the bed linens were initialed and numbered by hand. This numbering system helped the housewife insure that she had not mislaid a valuable item. It also aided in rotating fabrics for wear, for the quality and quantity of linens added stature to a woman's role. To own such an excess supply that many beautiful examples could remain in chests unused, and yet ready for display to visitors, was one goal of a "good" housewife.

The woven coverlets that Pennsylvania Germans used are similar to those made in Germany.[14] Perhaps a few skilled householders wove their own simple coverlets since a rather high number of looms are listed in inventories; however, the great majority were ordered or purchased from a local professional weaver.[15] Pennsylvania Germans selected the most decorative coverlets of wool and linen or cotton they could afford, but they chose within a limited range. Certain techniques and motifs recur regularly, such as detailed point twills and expanded point twills in striking color combina-

tions (fig. 217). Throughout the eighteenth century only the owner's initials were stitched, or marked, on a coverlet, but with the invention of the jacquard attachment (1801) it became possible for the weaver to add an identifying square or border often with his or the owner's name, location, and date.[16] One small coverlet that demonstrates one of the Pennsylvania German jacquard weaver's favorite borders is shown in figure 218.

In order to transform fabrics into household textiles and clothes, young women learned "plain sewing," which included the most basic running, back, and hemming stitches. To mark all household textiles properly, a girl also learned how to do the cross-stitch and how to form numbers and letters with it. All young girls learned this essential skill, but they did so in a variety of ways. Girls with non-Germanic backgrounds learned formally by working a marking sampler at home or in a dame school. In contrast Pennsylvania German girls learned the placement of stitches by studying printed charts, sampler designs, Fraktur drawings (those that showed charted letters), or an alphabet stitched on a friend's sampler or hand towels.[17]

Fancy needlework required more work but also began with samplers. Some prosperous Pennsylvania German families desirous of assimilation sent their daughters to a "young ladies' school." Almost all of these private schools were run by mistresses with non-Germanic names such as Mrs. Armstrong of Lancaster, Miss Robbins of Stouchsberg, and Mrs. Buchanan of Wrightsville.[18] Advertisements and existing samplers from these schools show that these teachers taught pretty much the same subjects that were taught at Anglo-American schools up and down the east coast, so it is only the German name on a sampler or mourning scene from one of these schools that differentiates its maker from the scores of Anglo-American girls attending that or another school.

[13] Alan G. Keyser, "Beds, Bedding, Bedsteads and Sleep," *Der Reggeboge (The Rainbow): Quarterly of the Pennsylvania German Society* 12, no. 4 (October 1978): 10–20.

[14] Weavers in Pennsylvania sometimes owned pattern books published in Germany. For example, the copy of Johann Michael Frickinger's *Weber-Bild-Buch* (Neustadt and Leipzig, 1783) was owned by J. Harburn, a weaver in either Lebanon or Dauphin county, Pennsylvania, ca. 1834; a copy of Johann Michael Kirschbaum's *Neues Bild und Muster-Buch* (Heilbroom, 1793) in a private collection is inscribed "Henry Clairs Book Bought in August in the Sitty of Lancaster in the year of our Lord Dn 1825 price $5."

[15] My survey of some Lancaster and Berks county inventories, 1760–1816, found twenty-five looms listed. Rarely did these inventories list the deceased as a weaver (although he may have done weaving part time).

[16] Joseph-Marie Jacquard invented the jacquard attachment and by 1806 perfected it; however, no Pennsylvania German examples of coverlets made in this process are known prior to the late 1820s; see Ellen J. Gehret and Alan G. Keyser, *The Homespun Textile Tradition of the Pennsylvania Germans* (Harrisburg: Pennsylvania Historical and Museum Commission, 1976), p. 6.

[17] For an example of one of these published charts, which is labeled "For Marking Linen," see Carl Frederick Egelmann, *Deutsche & Englische Vorscriften für die Jugend* (Reading [1821?]).

[18] Of the twenty-one teachers' names I have found in contemporary newspaper advertisements or seen stitched on samplers, only one is Germanic: Jemima Hartzell. She taught both in Pittsburgh and Somerset, Pennsylvania; see Davida Tenenbaum Deutsch and Betty Ring "Homage to Washington in Needlework and Prints," *Antiques* 119, no. 2 (February 1981): 419. I have seen several samplers done by Pennsylvania German girls at the schools.

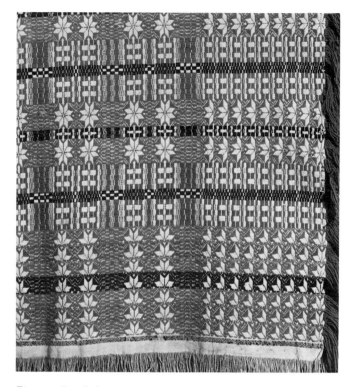

Fig. 217. Detail of woven coverlet, southeastern Pennsylvania, 1820–40. Wool and cotton; H. 96″, W. 78″. Point twill woven with 16 harnesses and 4 shafts; navy blue, pink, gold, and white. (Winterthur 69.1650.)

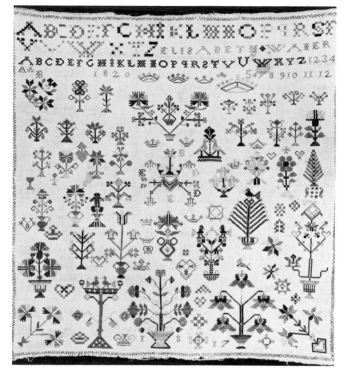

Fig. 219. Sampler, Catharin Martin, probably southeastern Pennsylvania, 1835. Linen with silk; H. 18″, W. 13¹/₁₆″. Blue, rose, brown, and gold yarns on natural ground; double threads intentionally woven in the ground to create guidelines for stitching. (Winterthur 81.6.)

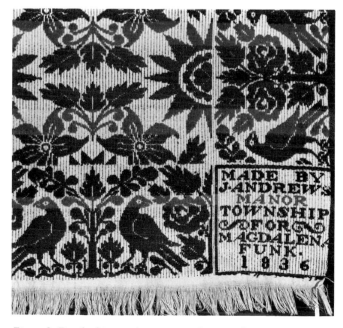

Fig. 218. Detail of jacquard-woven coverlet, J. Andrews, Manor Township, 1836. Wool and cotton; H. 47″, W. 43¼″. Two shades of blue and two shades of red on natural cotton ground. (Winterthur 69.1648.)

Fancy samplers that can be identified as typical Pennsylvania German ones are not numerous (pl. 30). The great majority date from 1800–1845 and were done with the cross-stitch almost exclusively (fig. 219). Most are worked on homespun linen with cotton or silk yarns (merino yarns appeared only after the 1830s). The upper part of these samplers usually contains the maker's name, printed alphabet, numbers, date, and occasionally a verse. Below this the young woman stitched between twenty and ninety individual geometric designs that are unlike those made elsewhere in America; however, samplers worked in Germany also show a random placement of many of the same elements and surely were the source for their Pennsylvania counterparts. These small designs, dubbed "spotty" elements today, are sometimes only a half inch high while others may be four or more inches tall. Characteristically, they are arranged randomly without regard to balance or symmetry. Quite possibly, the young needleworker, on seeing a new design, copied it in the next open space before she forgot it. The most prevalent design is a plant growing on a central stalk from a large pot or basket, but crowns, birds, tables, chairs, wineglasses, dogs, deer, and peacocks also enliven these

samplers. A popular motif appearing in many variations on Pennsylvania German samplers and hand towels is a central heart topped by a crown or a flower. Radiating from the heart are six branches that end in stylized flowers. Completing the whole are the initials OEHBDDE spaced between the armlike branches (see pl. 30). The letters stand for "O edel Herz bedenk dein End" (Oh noble heart consider your end), a frankness that is typical of sentiments worked in many Anglo-American samplers of the same period.[19]

Charting embroidery or lace designs on squared paper was an old tradition in Germanic culture that immigrants brought to Pennsylvania, and hand-drawn Pennsylvania German paper patterns still exist for samplers. Most include an alphabet, numbers, a girl's name, and a date, plus typical random designs.[20] They are drawn on finely squared paper (resembling today's graph paper) with the colors carefully painted in each tiny square of the design. By counting each color on the chart and translating it as a cross-stitch on the appropriate thread of her linen, a girl could recreate the pattern exactly. (Today this is called counted thread work.) In the same tradition, the work known as Berlin work was a Germanic idea: about 1804, A. Philipson, a Berlin printseller, began making hand-colored paper patterns of flowers, animals, and scenes for women to transfer in yarn to canvas.[21] But Berlin work shares only the charting concept with Pennsylvania German samplers; the designs are radically different.

Pennsylvania Germans rarely framed their samplers. Indeed, the treatment of their edges is evidence that they were not intended to be framed. Some have minute turned-under hems, while others show a row of crossed or diagonal stitches to prevent the unraveling of deliberately fringed areas. A few are bordered with a silk ribbon sewn flat, pleated, or gathered (called quilling). The ribbon treatment, however, is a regional characteristic found at times on both Germanic and non-Germanic samplers of the Delaware Valley. Most Pennsylvania German samplers retain their original brilliant colors because, instead of being framed in the Anglo-American tradition, they remained in drawers, in chests, or on shelves protected from the sun's harmful ultraviolet rays.

If we can judge from surviving examples, young Pennsylvania German women probably made more hand towels than samplers (popularly called show towels today, perhaps that best describes their function). Never meant for drying hands or dishes, many a hand towel hung on the inside of the parlor door, where it could be viewed by all. While most samplers and hand towels were made before marriage, a few are known to have been worked after marriage as gifts, and some women made them professionally.[22] The most commonly found needlework technique on towels, besides the cross-stitch, is reembroidered drawnwork, which in bands or squares gives an elegant lacy quality to a towel (fig. 220).

The evidence indicates that girls picked out their favorite sampler motifs to use on hand towels, but unlike on samplers, they carefully balanced the elements. Where we have found dated samplers and towels by the same girls, in every case the sampler was made before the towel and every design element in the towel appeared in the maker's or her sister's sampler. Many towels contained alphabets. A rarity is one showing the Schyfer family genealogy (fig. 221). The towel in figure 220 is unusual for two reasons: first, it is a miniature, and second, it displays scrolled rather than angular designs, worked with whip, satin, and seed stitches.[23]

Other fancily decorated household textiles in eighteenth-century Pennsylvania German homes were tablecloths. These were usually long and thin to fit their trestle-based tables, and everyday cloths tended to be pattern woven. The large quantities of tablecloths listed in many inventories imply that certain families probably insisted on a cloth at all meals. Prosperous David Hottenstein in 1802 owned ten tablecloths valued at £2.10 and five at £1.5. Other inventories list none.[24]

For special occasions, a woman might have a tablecloth she had decorated with cross-stitch designs, possibly includ-

[19] Ellen J. Gehret, "O Noble Heart: An Examination of a Motif of Design from Pennsylvania German Hand Towels," *Der Reggeboge (The Rainbow): Quarterly of the Pennsylvania German Society* 14, no. 3 (July 1980): 2.

[20] The first known dated pattern book showing this technique was published in Augsburg in 1524. Margaret Abegg, *Apropos Patterns: For Embroidery Lace and Woven Textiles* (Bern: Stamphli & Cie. AG, 1979), pp. 1, 3, 6. Several hand-drawn patterns are in Reading Public Museum and Schwenkfelder Museum.

[21] Susan Burrows Swan, *Plain and Fancy: American Women and Their Needlework, 1700–1850* (New York: Holt, Rinehart and Winston, 1977), pp. 205, 222, 224.

[22] Keyser, "Beds," pp. 1–2; Ellen Gehret gave an informal talk about this at the Goshenhoppen Festival, East Greenville, Pa., August 9, 1980.

[23] Fancy towels are difficult to identify in inventories. They may have been labeled as towels or perhaps they were considered the wife's property and were not inventoried in the husband's estate. Ellen Gehret is soon to publish a definitive study of hand towels. She has already charted over 600 towels.

[24] Berks County Inventories. My argument here is bolstered by visual evidence. Although others may argue that all of the tables in Miller's sketches have tablecloths—some extending to the table edge, others hanging over the edge—I believe this is not the case. The tables on pages 67, upper 68, and 95 clearly have tablecloths. Those tables on pages 25, 26, 57, lower 68 have a white top but no cloth. Miller left the tops white so he could show the dishes and utensils on the tables, which would be indistinguishable against a brown (that is, wood) surface in his drawings. See *Lewis Miller*, pp. 25, 26, 57, 67, 68, 95.

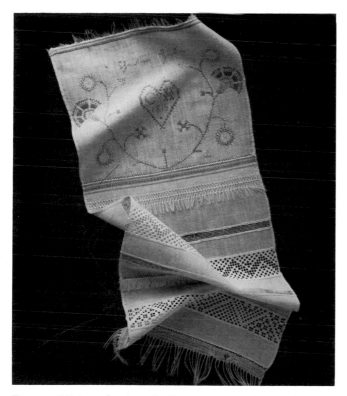

Fig. 220. Miniature hand towel, Christina Hess, probably Millersville, Manor Township, Lancaster County, 1815. H. 23½", W. 8¾". Embroidery worked in pink and green in an unusual curved design using satin, whip, and seed stitches; four bands of drawnwork and three fringes in the lower section. (Winterthur 67.1266.)

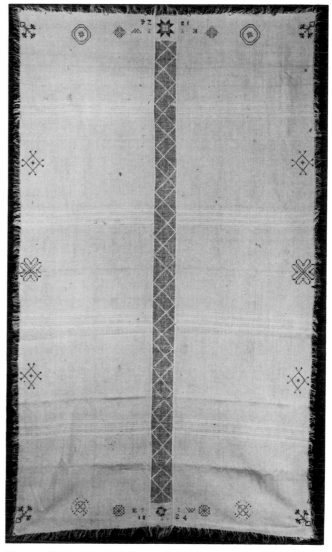

Fig. 222. Tablecloth, probably southeastern Pennsylvania, signed: EW 1824. Linen with cotton; H. 70¼", W. 41¾". Blue, red, and yellow cross-stitches; drawnwork panel reembroidered in diamond pattern. (Winterthur 60.355.)

Fig. 221. Genealogical hand towel, probably made by Martha Schyfer (Shaffer), New Holland area, Lancaster County, 1839. Natural linen with red cotton yarns; H. 55 9/16", W. 18⅛". (Winterthur 57.117.)

ing her name, initials, and a date. In some cases a drawnwork panel joined the sections of the linen. These techniques were the same ones that young women had practiced on their hand towels (fig. 222). Women also purchased or made covers—plain, pattern woven, or embroidered—for smaller tables. Other embroidered items included kerchiefs, aprons, sheets, and even pillowcases embellished with cross-stitched touches.

Inventory references to window and bed hangings are less common, but presumably some of these items, too, were embroidered. Innkeeper Adam Witman had one set of

"Calico Window Curtains" valued at £4. That valuation is quite high for simple curtains; possibly this was an elaborate set prepared by an upholsterer in town, rather than by Witman's wife.[25]

Surprisingly few Pennsylvania German quilts made before 1850 still exist, although inventories taken earlier occasionally list them. The popularity of quilts grew enormously in Pennsylvania German areas during the late nineteenth century, and they came to replace woven coverlets as the top coverings on beds. Since quilts, unlike coverlets, could be readily made at home, they offered women a creative outlet, much in the way samplers and decorated hand towels had, for there were endless varieties of pieced and appliquéd motifs that women could adopt or adapt for each quilt.

Exactly the reverse trend occurred in urban areas. Quilts were more popular there in the eighteenth century. By the 1850s quilts no longer retained the element of fashion in upper-class homes. These beds were covered by more elegant damask, velvet, or satin bedspreads.

Before closing the discussion of Pennsylvania fancy needlework there are two areas that must be briefly explored, Moravian needlework and Philadelphia needlework. While the Moravians constituted a small percentage of Germans in Pennsylvania, their impact on needlework and women's education was substantial. Before Pennsylvania passed an act supporting free public schools on April 1, 1834, schools were run primarily by various religious denominations. Two of the most notable, the Moravians and the Schwenkfelders, developed sophisticated school systems as early as the 1740s. Both denominations pioneered in offering young women considerable academic training.

After the American Revolution, Moravians opened their schools to nonmembers, and many prominent Anglo-American families sent their children there. The girls received a wide-ranging education for the time. They could take reading, writing in English and German, arithmetic, geography, some history, a little botany, music, and drawing, and they could also acquire superior needlework skills. At this juncture what concerns us is the needlework, for which the Moravian sisters and their pupils were widely known. Unfortunately, few of the small items made by the pupils were signed, so only a few of the mourning and scenic pictures can be identified. Often a familiar phrase like "where the Lehigh flows" helps to identify a Moravian piece. As a rule samplers were not made at the school. Most girls who enrolled already possessed plain sewing abilities, and the teachers emphasized more advanced techniques in silk embroidery on silk. The Moravian work featured delicate

[25] Berks County Inventories.

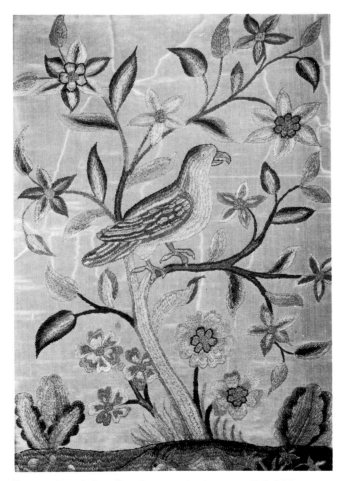

Fig. 223. Detail of needlework picture, Sarah Wistar, Philadelphia, 1752. White silk moiré taffeta ground with polychrome silk; H. 9½"; W. 7". (Winterthur 64.120.2.)

naturalistic flowers intricately shaded in silk satin stitch (pl. 31). This stood in vivid contrast to the cotton cross-stitch done in angular designs by the majority of Pennsylvania German needleworkers.

In contrast to Moravian needlework, distinctive needlework done in Philadelphia by Pennsylvania Germans is difficult to find. That done by the daughters of German emigrant Caspar Wistar, a glass manufacturer and prominent Philadelphia merchant, is quite unlike the needlework found in the Pennsylvania German heartland. Sarah and Margaret Wistar's pieces belong to a group of twenty mid eighteenth-century pieces done with silk threads on a silk ground (fig. 223). The only known Pennsylvania Germans among this group of needleworkers were the Wistars, the remaining young ladies were Anglo-Americans.

In conclusion, the textiles that Pennsylvania German women worked with ranged from coarse grain sacks of hemp

to elaborate cut and uncut velvets. Woven textiles could be turned into essential articles (like a mattress cover in linen, hemp, or tow) at home or could be a status symbol (for example, the blue-resist fabric ordered for exterior bedding).

Needlework skills varied from simple seaming to sophisticated embroidery with silk and metal threads. Basic needlework was an essential part of every woman's educa-tion. It taught her discipline as a child and provided essential household products throughout her life. It also served as a socializing mechanism, whether she was a young girl working alongside her sisters on a sampler or an adult meeting with other women while she worked on a quilt or other large sewing projects. Finally, there was a lasting benefit, that of the pleasure and praise of the finished object.

Fraktur

FREDERICK S. WEISER

Any cultural group can be distinguished from its neighbors by its own ideas and institutions. That is, a group of people who belong to a definable social entity, whether a folk culture or a mass-media society, will have a common body of thought. They will also have created individual-life-transcending establishments within the cultural group which are designed to preserve the thoughts from one generation to the next. There was such a common body of thought and institution among the Pennsylvania Germans, or Pennsylvania Dutch as they are popularly called, and wherever we find their folk culture—from Ontario to mountain valleys in West Virginia, as well as southeastern Pennsylvania—we find life was organized in essentially the same way. Some of the Pennsylvania Germans, thus, may have been English or Welsh by national origin, but folk culturally they were not.

The basic cultural binding force was the dialect, an almost purely German dialect spoken today both in America and in the southeastern corner of the Rhenish Palatinate. Until electronic media invaded every home, those who spoke the dialect used only a small percentage of non-German loan words. But beyond the dialect, the family farm, the union church or meetinghouse, the crossroads tavern and country store, the parochial (and then one-room) school were the essentials of the group. As these have died out or undergone major change, the culture has had to adjust.

Very little study has been given the role of the parochial school in the folk life of the Pennsylvania Dutch. Its days were numbered when, in 1834, the Commonwealth passed a free-school act which empowered townships, upon vote, to create free schools within their jurisdiction. Although it would take three and a half decades for the last strictly parochial school to close, there is no question but that the

1830s were years of major change in Pennsylvania German life in other respects as well. Major cracks began to develop then in the solid wall of German preaching and German press. An old institution—baptismal sponsorship—died out; not unrelated, confirmation became more important in church life than baptism. Industrialization eclipsed the small-town craftsman and the art that craftsman had often used totally un-self-consciously to make his product more salesworthy. While economic factors undoubtedly played important roles in these major revisions in Pennsylvania German life, the decline of the parochial school dare not be underestimated in what really amounted to a great wave of acculturation of the Pennsylvania Germans to their English-speaking world.

The parochial school was, however, only one of two methods of elementary instruction in the Pennsylvania German folk culture prior to the mid nineteenth century. The other was a similarly operated but less securely founded neighborhood school. We know slightly more about the parochial school than we do about the neighborhood school, but we do not know much about either. A congregation (or in the case of a union church of Lutherans and Reformed, usually both congregations together) erected a school building and outfitted it with table and benches and such other accoutrements as were needed. Part of the schoolhouse contained an apartment for the schoolmaster—usually a kitchen and a bedroom, with additional sleeping area for his own children on the second floor or loft. From the exterior, the school, as, for that matter, the earliest churches, were hardly distinguishable from residences in the countryside. The schoolmaster was hired by the congregation to be its organist, if blessed with an organ, or *Vorsinger* (precentor) if not. The salary for this service was paid by the con-

gregation. In 1819, for instance, Andreas Fleischer (1770–1842) was paid $30 by the Lutheran and $30 by the Reformed congregations of the Muddy Creek church in northeastern Lancaster County.[1] He kept the parish registers and church account books, represented the Lutherans, since he was one, at their synod meetings, and tended the church grounds. In some instances, the Schulmeister also farmed the *Karricheland*, or *Parrland* (glebe). But as schoolmaster the man also received income from his students, whose parents paid tuition directly to him. Fortunately, Johann Adam Eyer (1755–1837) kept a record of these sums in the 1780s, and from it we know that in a good year he earned £70 from teaching.

Living rent free, having land for crops and income from both church and families, schoolmasters nevertheless engaged in a variety of other income-supplementing activities. These included cupping or bleeding the sick, singing at funerals, writing wills and deeds, clerking at sales, and carving tombstones. One schoolmaster apparently even took flowers to market to sell. And more than one of them made his living more ample by making baptismal certificates and other decorated documents. In comparatively modern times the name *Fraktur* has been given to the phenomenon of these decorated texts. This appears to have happened because the Pennsylvania Dutch made a verb meaning, "to write fancily," out of the name of one of several elaborate penmanship styles current in eighteenth-century German life. (The writing style called Fraktur was distinguished by letters broken horizontally at their center.)

The parochial school was the bosom of the phenomenon of Fraktur, something as widespread as the Pennsylvania German dialect was at its height. We now have examples of it known from New York, New Jersey, Pennsylvania, Maryland, Virginia, North Carolina, South Carolina, Ohio, West Virginia, Kentucky, and Ontario.

Schoolmasters used Fraktur initially as part of the educational process. They gave smaller drawings of birds, flowers, scripture, or hymn texts to faithful students, larger music-notation booklets or writing-example booklets to older students, and one-sheet writing examples, called *Vorschriften*, to students at the close of the term. All of this both rewarded and encouraged the learners, but it also ingratiated the teacher to the students' parents. Since teachers were frequently hired for a year at a time, contract renewal was at the mercy of the *Karricheraad* (vestry, consistory, or church council, as the congregations' governing bodies were variously named) and reflected the good or bad will of the parents.

But in the second place, schoolmasters used Fraktur even more directly to enhance their income. This was the most widespread use of Fraktur, and in a truncated form it survived nearly to our day. Originally it consisted of drawing and penning in the significant data to a *Taufschein* (baptismal certificate). From the 1780s on, printed forms were available with stock woodcuts awaiting color and a stock text needing only names and dates. By 1835 practically no one drew a Taufschein entirely by hand any more; until the early part of this century a few vagabond scriveners—now no longer schoolmasters, but more likely footloose German emigrants—were still making their rounds and entering dates on mass-produced, color-printed documents and in family Bibles. For all of this a fee was paid, so that only a few of the persons making a Taufschein or completing entries on one felt the work merited a signature or even initials.

It is impossible at this point to determine what percentage of his income a schoolmaster could garner from Fraktur, and surely that figure varied tremendously from one individual to the next. But we can give some figures that might really be more surprising than the prices to which modern collectors push the stuff at auctions today. An anonymous artist whose work can be grouped by attribution under the nickname Engraver, working in south-central Berks and northeastern Lancaster counties through much of his career, put the price in a corner of his work. For a Taufschein measuring 8 by 13 inches he charged 25¢. Small flower drawings, a quarter of that size, were 6¢ or 6½¢. When Friederich Krebs died in 1815—a man who was extremely active in using both hand-drawn and printed Taufscheine, as well as other drawings—his estate contained several lots of "papers for birth Dayes" and other "picters" and "paper pictered" valued at various prices.[2] William Otto (1761–

[1] Schoolmaster Johannes Fleischer (1719–87) and his wife Eva Margaretha arrived in Pennsylvania on September 24, 1753. Fleischer served as schoolmaster of Augustus Lutheran Church at Trappe to 1761 and then of Trinity Church in Reading until his retirement in 1783. At least two of his sons, Johann Jacob (b. June 22, 1761) and Andreas (b. April 13, 1770), became schoolmasters, but of the three men, only Jacob seems to have done Fraktur. Andreas may have begun teaching after his fortieth birthday; he is listed as yeoman in deeds prior to that time. He and his wife Margaret Kreider Fleischer (1758–1831) are buried in the Muddy Creek Lutheran graveyard. According to his will, he was a resident of Adamstown when he died; he left his residence to Catharine Zenn (Zinn), with whom he had been living, providing she kept her maiden name.

[2] Inventory of Friedrich Krebs taken July 29, 1815, by Jacob Zeitter and Peter Heffelfinger and exhibited at the Registrar's Office of Dauphin County, August 2.

	[£	s.	d.]
By a lot of paper	—	5	—
By a second lot of clean paper	—	9	—
By a lot of picters and clean paper	—	6	—

[continued on next page]

1841), son of the great Fraktur artist Johann Henrich Otto (ca. 1733–ca. 1800), died with a good stock of "Daufshines and profiles," as Peter Stutzman and Johannes Minig who took his estate inventory termed them, worth $2. In Otto's case we may be even more specific about the then current prices, because the vendue list from the auction of his goods survives. Twenty-four lots of two "Dauf-schein" each were sold at prices ranging from 15¢ to 30¢, with the vast majority falling around 25¢ per lot. The only William Otto Taufscheine known are completely hand done, although it is possible that the ones sold were incompleted printed examples.[3] Thirteen cents for a blank Taufschein and a quarter for a completed one appears to have been average in the decades at the start of the nineteenth century.

Lest it be falsely concluded that the motive of the persons who prepared Fraktur was purely commercial, there is ample evidence that the schoolmaster-organist-scrivener-Fraktur artist could have earned a better salary had he done almost anything else, including entering the ministry (which together with the printery was the only occupation among the Pennsylvania Dutch that was in any way literary). In fact, some schoolmasters did enter the ministry. And no wonder, while Andreas Fleischer was earning $30 a year from each of two congregations in 1819, to which must be added his income from tuition, of course, and his housing, his pastors were receiving $50 to $60 a year from each of five or six congregations in their parishes, plus the use of a house, as well as perquisites for funerals, weddings, and the like, *and* the full take of produce used to decorate the church for the *Aern* or *Ernte Predigt* (the sermon at the harvest festival). Moreover, the surviving quantities of Fraktur show us that schoolmasters not infrequently took a stab at composing poetry for their texts, but it surely earned the scriv-

ener no more than a verse copied from the hymnal would earn. Fraktur text and embellishment provided creative channels to persons with artistic impulses, even as the whole procedure enhanced the income of the maker.

Finally, many of the Fraktur artists emerge as men of profound religious conviction who regarded themselves as servants of the church. But, because so many others of them were troublesome souls, Henry Melchior Muhlenberg could lament to his diary, "How rare and precious in this part of the world are Christian schoolmasters who out of love for Christ are able and willing to feed his lambs!"[4] When he recorded a detailed imbroglio in one of his congregations in 1776, he described the mediations of one Conrad Gilbert (1734–1812) without mentioning that Gilbert was or would soon be a parochial schoolmaster. Gilbert did some of the finest eighteenth-century Fraktur made (fig. 250). A closer look at his career reveals something of the mentality of the schoolmaster.

Johann Conrad Gilbert was born April 29, 1734, at 6921 Hoffenheim in the Kraichgau in Baden, the son of Hans Georg Gilbert (1698–1753) and wife Elisabeth Gruber (1702–66).[5] The Gilberts arrived at Philadelphia in 1750 on the *Nancy* and settled in Douglass Township, Philadelphia (now Montgomery) County, where Gilbertsville, a village near Pottstown, survives. They were active members at New Hanover Lutheran Church at Falckner Swamp, the oldest German Lutheran congregation in Pennsylvania. Conrad married Anna Elisabetha Steltz (1738–1818) on April 19, 1757, and together they were parents to a dozen children, including son Johann Peter (b. 1766) who seems to have followed his father's footsteps as a schoolmaster and probably made related Fraktur. After revolutionary war service, Conrad became the schoolmaster of Zion ("Red") Lutheran Church in Brunswick Township, Berks (now Schuylkill) County, from circa 1778 to circa 1780; then at Altalaha Lutheran Church, at Rehrersburg, Berks County, from 1780 until 1783; and next at Christ ("Little Tulpehocken") Lutheran Church near Bernville from 1783 to 1793. He eventually returned to Schuylkill County, perhaps to teach, although he was then over sixty years of age.

Gilbert's Fraktur consisted chiefly of Taufscheine, but a small drawing of rampant horses with a text from Psalms prepared for Anna Maria Gerhard (1787) is clearly a didac-

By a third lot of clean paper and paper for birthdays		—	11	—
By a lot of papers pictered and papers for birth Dayes	1	10	—	
By a lot of paper pictered—Dito	2	5	—	
By stampt paper		—	11	—
By a box of paint stuff		—	5	7½
By a chest with stampt paper and sundries		—	15	—
. . .				
By two band Boxes		—	1	—
By two small boxes		—	2	—
. . .				
By a lot of ruff paisbord	1	—	—	
By a lot of ruff Bandboxes		—	10	—

The last four entries reveal another of his activities, that of making boxes from cardboard and covering them with decorated paper.

[3] For examples of William Otto's work, see Robert M. Kline and Frederick S. Weiser, "A Fraktur-Fest," *Der Reggeboge (The Rainbow): Quarterly of the Pennsylvania German Society* 4, nos. 3–4 (September–December 1970): 12.

[4] Theodore G. Tappert and John W. Doberstein, trans., *Journals of Henry Melchior Muhlenberg*, vol. 3 (Philadelphia: Muhlenberg Press, 1958), p. 374.

[5] For a more complete biography, see Frederick S. Weiser, "His Deed Followed Him: The Fraktur of John Conrad Gilbert," *Der Reggeboge (The Rainbow): Quarterly of the Pennsylvania German Society* 16, no. 2 (September 1982): 33–45.

tic piece. The text translates, "Remain blameless and keep yourself upright, for it will go well for such a person in the end" (Ps. 37:37). He also prepared a poem about Paradise, dated 1793 (in a private collection). And, best of all, Abby Aldrich Rockefeller Folk Art Center, Williamsburg, possesses a drawing of the Easter rabbit, 1780–95, attributed to Gilbert.[6] This last drawing is the earliest known pictorial representation of the fabled bringer of Easter eggs, but true to Pennsylvania German folklore, he carries a harness of eggs below his abdomen: Pennsylvania Dutch children were taught that the Easter rabbit *laid* the eggs.

Gilbert's stature in his community is also disclosed by a bequest from his comparatively meager estate to each of the Lutheran and Reformed congregations in Brunswick Township (he died January 26, 1812) and by the text for his funeral sermon—a scriptural passage chosen by Pennsylvania German pastors very carefully to reflect the decedent's best virtue—Rev. 14:13. "And I heard a voice from heaven saying, 'Write this: Blessed are the dead who die in the Lord from henceforth,' 'Blessed indeed,' says the Spirit, 'that they may rest from their labors, for their deeds follow them.' " Gilbert, whose forte was angels, exotically attired, would no doubt have approved of a text from Revelation, because of its visual imagery, but the congregation at his *Leicht* (funeral) was commemorating a man in its midst distinguished by his goodness. His handwritten will—with its heading in Fraktur-type penmanship, the key to identifying his work—specified the disposition of his Bible "with the writings therein" and his sermon book. The latter he used when he conducted a *Lese-Gottesdienst* (worship in which a sermon was read in the absence of an ordained clergyman).

If producers of Fraktur were primarily schoolmasters, poorly paid and driven to a variety of activities to increase their living, but at least sometimes highly motivated, and frequently whether as artist, poet, or musician, the one person in the community to whom the arts belonged, what can we say of their customers? And how important to them was the Fraktur once they received it?

Since a Taufschein is a document with names, dates, and places, one generalization thrusts itself out at once when the texts are read: the Taufschein and likely almost all Fraktur are primarily a rural phenomenon. Only from the town of Hanover, in southwestern York County along the great colonial north–south road, do we have an extensive num-

ber of Fraktur for children born in a village. These date from the 1790s, by which time the Pennsylvania German countryside had spawned dozens of villages, chiefly residences of craftsmen for the surrounding countryside, of innkeepers for the sake of transients, and of retired farmers. If the Taufschein had achieved its popularity in villages, then perhaps we would have many examples from "Schaeffersschteddel" or "Lengeschder," but nearly everyone is for a child born in this or that "Daunschib." Were the urban schoolmasters sufficiently well paid that they did not need to make Fraktur to meet ends? Were they, that is, did they consider themselves, too sophisticated for such drawing? Did the pietistic clergy, who gravitated to the urban congregations, sweep away the old folk custom of a sponsors' gift at baptism in their emphasis on one's religious feelings and edification at the expense of a more objective baptismal grace? Did urban fathers simply feel that such a document smacked too much of the country mouse to get one for their children? Or was this German birth custom lost in the shuffle of acculturation, which proceeded more rapidly in town than in country? And what sort of people were among the rural children and adults who acquired Fraktur? We have seen that the Taufschein was a purchased commodity—and anything like that comes out of luxury funds, restricting it at once to purchasers with capital to spare. We cannot say, therefore, that everyone had a Taufschein, by any means; and if we take the texts on the Vorschriften and on what few records we have of Fraktur in the classroom literally, it was used to reward good (*fleißig*—diligent) pupils, which probably points to children from more aggressive households. We can imagine that only rarely would the day laborer, who hired out when others needed him, have bought Fraktur for his whole family at one sitting.[7]

How a person keeps what he has reveals its worth to him, of course. Fraktur was almost always an individual's possession (the exception being family group lists popular among the Mennonites, who did not baptize infants). Thus it is not at all surprising to find clear evidence for its storage in the one piece of furniture in a household that was clearly personal: the *Kischt* (chest) given to or acquired by many persons, male and female, during adolescence in anticipation of marriage, and the *Draar* (chest of drawers) which gradually supplanted it. The inside lid of the chest frequently contained Fraktur pasted to it: and the rolled Taufschein

[6] The reverse of the rabbit drawing bears the text: "Johannes Bolich, Braunschweig Daunschib, Bercks Caundi" which locates this in the county and the township where Gilbert served. (After 1812 this portion of the county became part of Schuylkill County.) A close comparison of the animal's eye and fur on this piece with those on similar pieces he did confirmed the attribution.

[7] Schumacher marked the list of baptisms he performed between 1754 and 1773 to indicate those who had also received a Taufschein or a Confirmationsschein. Of the more than 1,500 individuals, 233 received a Taufschein. See Frederick S. Weiser, *Daniel Schumacher's Baptismal Register*, Publications of the Pennsylvania German Society, vol. 1 (Allentown, Pa., 1968), p. 205.

found its way into the *Newekischt* (till). Moreover bits of paper, large and small, were also placed between the pages of books and Bibles, and these too were kept in chests and drawers. Owners almost never framed and hung Fraktur drawings, thank Providence, for they would long since have faded; but people did roll Taufscheine up and place them in the right hand of the deceased just before the coffin lid was nailed into place. Conceivably the choicest Fraktur drawings have long since rotted into Pennsylvania soil.

To make mute objects speak about the value system of their owners is the challenge to students of material culture. Fraktur is not quite mute, but its highly religious texts cannot be taken at face value, as if every Dutchman spent his life on his knees. A Taufschein almost never fails to give the child's name, parents' names, birthdate, and birthplace, but fewer than half the early ones state the date of baptism and the name of the pastor or those of the *Pedder* (male sponsor) and the *God* (female sponsor). This may be only partly because making a Taufschein could postdate a birth by decades. It may also reflect the individualistic concern for one's own name, birthdate, and parentage—a secular concern, especially when viewed against the failure to know or have a record of the particulars of the religious transaction, baptism, that gave the document its name.

Moreover, the plethora of secular objects introduced into the design of the Taufschein's border or the playfulness of faces in flowers, letters, and vines on the "Mennonite" Vorschriften, many of which were actually prepared by non-Mennonite schoolmasters, reveals sheer delight with the world and its things, both natural and man made. The bright color, *how* bright evident in those few pieces which have seldom been exposed to much light, show us that in this case religion did not stifle a polychromatic impulse—even among the plainly attired Mennonites.

———

In 1829 a young Pennsylvania Dutch, Lutheran woman moved with her family from Lampeter Township, Lancaster County, to another part of the county, and her friend Anna Koufs made her a drawing of birds, tulips, and a heart as a keepsake, a remembrance. In the 1890s, when the woman, who had by then moved several more times, was contemplating death, she divided her few keepsakes among her family. Susanna Tanger Harnish (1800–1895) was like many another Pennsylvania German of her day. She had made the transition from dialect to English; most of her grandchildren could neither speak nor understand her mother tongue. She had lived through industrialization, but when she taught her granddaughters to sew, she brought the standards of the apprentice system to bear: she rapped their knuckles when they made too large a stitch. She had lived through a moral revolution that changed the behavioral contour of America, yet she had been married to a Mennonite man who had operated a still with her brother—and after supper, as countrywomen of her generation did, she sat on a chair in back of the stove and smoked a pipe. Her estate amounted to only a few dollars, but her treasures became the treasures of the next generation by her choice. One granddaughter who bore her name received her scissors, the youngest grandchild a china figurine that she had had all her life. Her Bible, its pages interleaved with cutouts and folk drawings and some of the births entered in flowers and hearts, remained with the daughter who cared for her. The drawing Anna Koufs made for her in 1829 was carefully marked for a little great-grandson who caught her fancy. Her world was still full of stylized birds and tulips—neither Plato's ideal nor Daguerre's mirror—and that was the world she wanted a youngster born in the 1890s to remember her by. No one would remember her today, however, because she was simply one more Pennsylvania German woman, her life stamped by the notions and institutions of her culture.

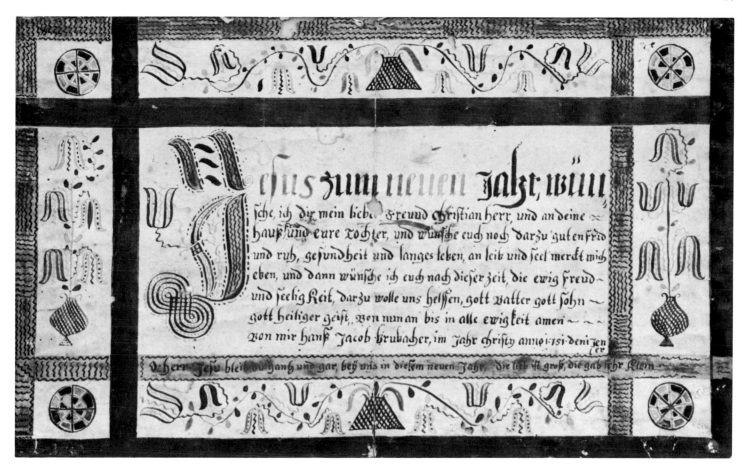

Fig. 224. Hans Jacob Brubacher, New Year's greeting. Lancaster County, 1751. Hand drawn, lettered, and colored on paper; 20 × 31.9 cm. (Winterthur 52.102.)

I wish you Jesus for the new year, my dear friend Christian Herr, and to your wife and daughter; and I wish you good peace and quiet, health and a long life in both body and soul, and then I wish you after this time eternal joy and blessedness, to which God the Father, God the Son and God the Holy Spirit may help us from now on into all eternity. Amen.
From me Hanss Jacob Brubacher, in the year of Christ 1751, January 1.
Oh, Lord Jesus, stay with us completely, in this new year. The love is great, the gift very small.

Hans Jacob Brubacher (d. 1802) made Fraktur for half a century among Mennonites in Lancaster County. When he died he owned a few pieces of furniture and books valued at more than £3, a remarkable amount for its day. Pennsylvania Germans extended greetings to one another at the New Year. The poem on this document is similar to the New Year's wish chanted by one of a group of men who went from farm to farm with rifles loaded with blanks to shoot out the old year and wish in the new. Brubacher made similar greetings until shortly before his death. This is one of the oldest pieces of Fraktur known.

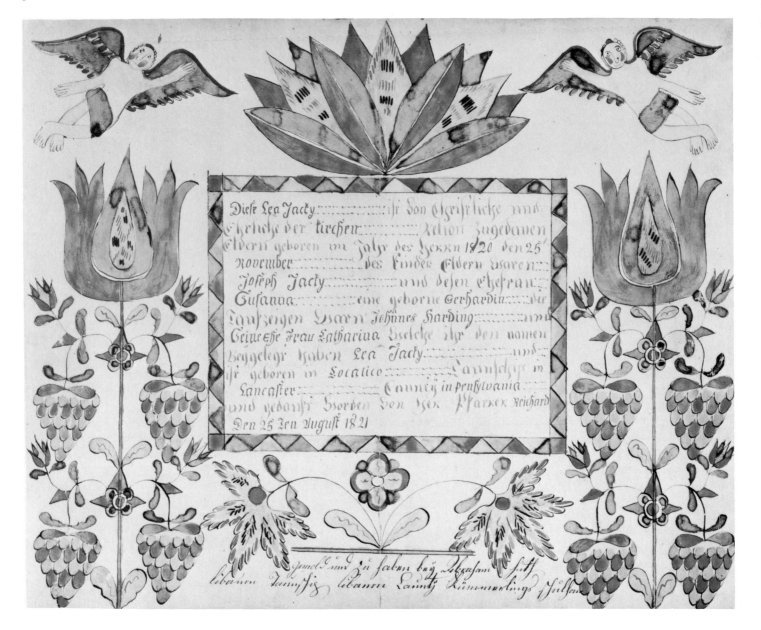

Fig. 225. Abraham Huth, Taufschein. Lebanon County, ca. 1825. Hand drawn, lettered, and colored on paper; 32.7 × 39.35 cm. (Winterthur 52.84.)

This Lea Jacky was born to Christian and honorable parents belonging to a church religion in the year of the Lord 1820, November 25. The child's parents were Joseph Jacky and his wife, Susanna, née Gerhard. The sponsors were Johannes Harding and his wife, Catharina, who gave her the name Lea Jacky, and [Lea] was born in Cocalico Township, Lancaster County, in Pennsylvania, and baptized by Pastor Reichard August 25, 1821. Drawn and to be had from Abraham Huth, Lebanon Township, Lebanon County, Kimmerling's Schoolhouse.

Perhaps as advertisement to prospective customers who might have seen Lea Jacky's Taufschein at her parents' home, Huth gave his precise location, no doubt the school at which he was teaching at Kimmerling's church, northeast of Lebanon. Huth erred when he wrote *Kirchen* (church) in the religion blank.

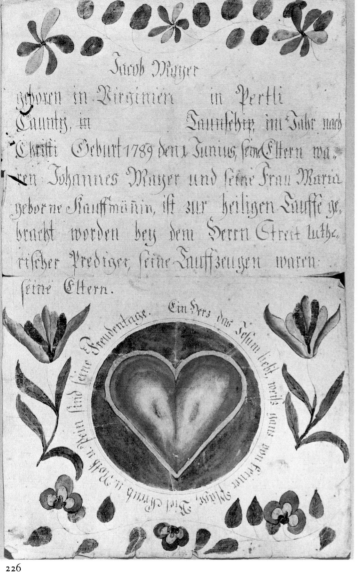

226

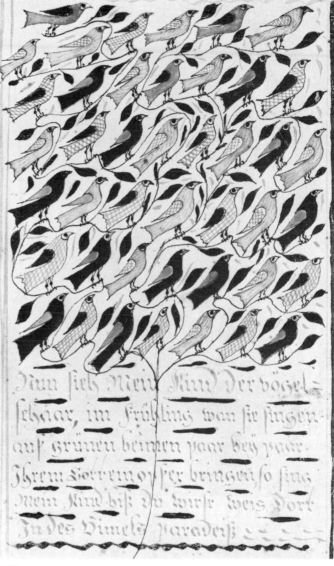

227

Fig. 226. Ehre Vater artist, Taufschein. Shenandoah Valley, Va., ca. 1790. Hand drawn, lettered, and colored on paper; 32.05 × 19.23 cm. (Joseph Downs Manuscript and Microfilm Collection 65 × 557, Winterthur Museum Library.)

Jacob Mayer was born in Virginia in Berkeley County in the year after Christ's birth 1789, June 1. His parents were Johannes Mayer and his wife, Maria, née Kaufmann. [He] was brought to holy baptism by Mr. Streit, Lutheran preacher, his sponsors were his parents. A heart that loves Jesus knows nothing of trouble. Much cross and need and pain are his daily joys.

The identity of the Ehre Vater artist remains unknown. His activity was staggering for his day: pieces by his hand are known from nearly every German-settled county in Pennsylvania, Virginia, North Carolina, and South Carolina. A sufficient number have been found in the Niagara peninsula settlement of Canada to raise the possibility that he worked there.

Winterthur also has a Taufschein that he made while working in southeastern Pennsylvania to commemorate the 1770 birth of Hanna Schön.

Fig. 227. Anonymous artist, drawing with text. Southeastern Pennsylvania, ca. 1800. Hand drawn, lettered, and colored on paper; 17.15 × 10.15 cm. (Winterthur 57.1.)

> *Now see, my child, the flock of birds*
> *In spring when they are singing*
> *On branches green, pair by pair,*
> *To God an offering bringing.*
> *So sing, my child, till you are white*
> *There in heaven's eternal light.*

This important small Fraktur has a verse related to its pictorial material. Like much Fraktur, its content is preoccupied with death. Not obvious from the picture is the folk belief that a bird carried the soul away at death.

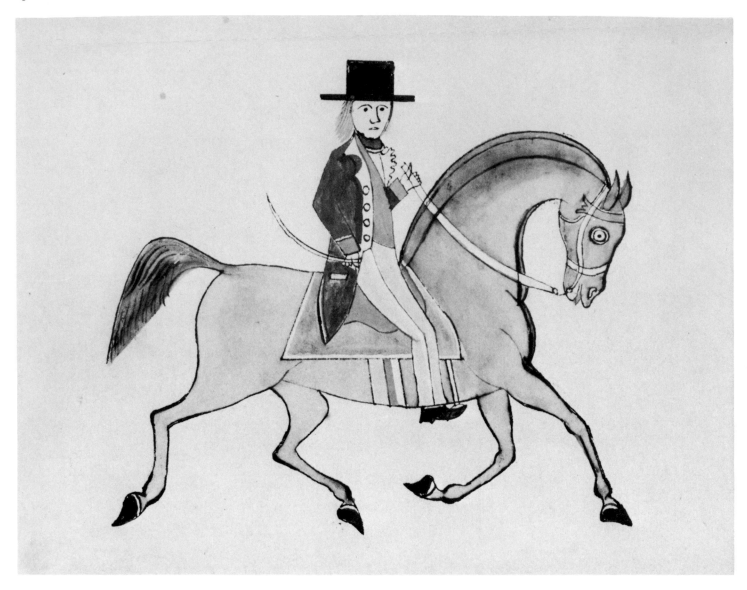

Fig. 228. Anonymous artist, drawing. Southeastern Pennsylvania, ca. 1810. Hand drawn and colored on paper; 14.75 × 19.45 cm. (Winterthur 57.1166.)

Heroes mounted on steeds may have served as the source of inspiration for many similar drawings of the Pennsylvania Dutch—but the heroes lose their glamor at the hand of the folk artist.

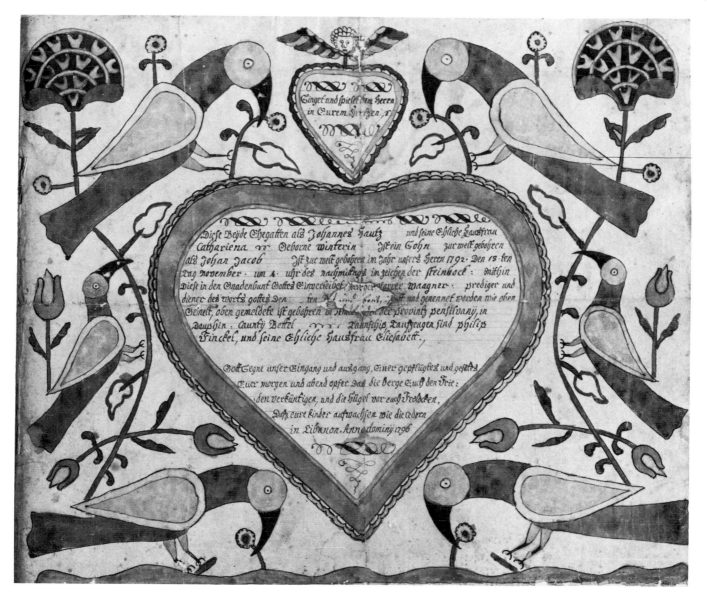

Fig. 229. C. M. Taufschein. Lancaster County, 1796. Hand drawn, lettered, and colored on paper; 31.1 × 37.45 cm. (Winterthur 57.1188.)

Sing and make melody to the Lord in your hearts.
To these two married persons, namely Johannes Hautz and his lawful wife, Cathariena, née Winter, a son was born into the world namely Johan Jacob. [He] was born into the world in the year of our Lord 1792, the 18th day of November at 4 o'clock in the afternoon in the sign of Capricorn. He was baptized and named into the covenant of grace of God [by] Pastor Wagner, preacher and servant of the Word of God the [blank] day of ——— as above named. The above-named was born in Am[erica] in the province of Pennsylvania in Dauphin County, Bethel Township. Sponsors were Philip Finckel and his lawful wife, Elisabett.

God bless our coming and going, your planting and plowing, your morning and evening sacrifice, so that mountains proclaim peace to you and the hills dance for joy before you, that your children grow up like the cedars of Lebanon. In the year of our Lord 1796.

C. M., a schoolmaster in northwestern Lancaster County, made a variety of forms of Fraktur, some with lions and unicorns, some with castles, and others with birds or fish. The motif at the top with a verse from Eph. 5:9 is related to the cover of an edition of the Marburg hymnal printed in Germany and sold in Philadelphia. The handsomely worked cover contains these words and many of the design motifs found over and again on Pennsylvania folk drawings.

230

231

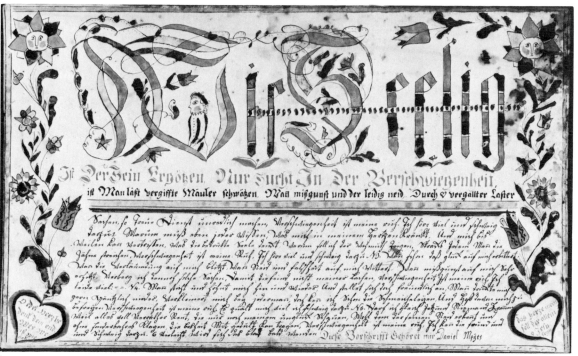

232

Fig. 230. Conrad Trevits, Taufschein. Berks County, ca. 1790. Hand drawn, lettered, and colored on paper; 20 x 33.35 cm. (Winterthur 57.1209.)

Johann Adam Griechbaum was born to Christian parents March 24 in the year of Christ 1780 in Bethel Township in Berks County. The sponsors were Adam Emrich and his wife, Eva, baptized by Pastor Schulz the 28th of March—the parents are the honorable Adam Griechbaum and his honorable wife named Barbara, née Germannin. To God alone be glory, to no one else ever.

Conrad Trevits (1750–1830) was a schoolmaster in several parts of Pennsylvania. He emigrated on the *Crawford*, landing in Philadelphia in October 1773, and enlisted in the Revolutionary armies three years later. In 1800 he was a resident of Mahantango Township, Northumberland County; he died in Snyder County. He produced large amounts of Fraktur, and Winterthur has three examples of his work.

Fig. 231. John Whisler, Vorschrift. Southeastern Pennsylvania, 1816. Hand drawn, lettered, and colored on paper; 20.35 x 32.35 cm. (Winterthur 57.1222.)

Christ speaks:
Give unto the Lord honor and praise out of a joyful heart, all spread the glory of God and praise his goodness. Up! Praise, praise God everyone, who frees us from distress and give thanks unto his name. Praise God and at all time exalt the great wonders, works, the majesty and glory, wisdom, power, and might which He bestows in all the earth, whereby [He] preserves all things, wherefore give thanks unto his name. Praise God who created for us body, soul, spirit, and life out of pure fatherly love and grace and has given them to us all, who protects us through his angels and daily gives us what we need, wherefore give thanks unto his name. March the first in the year 1816. [There follows the alphabet, with most possible combinations of letters, and the numbers.]
Christian Wagner his Vorschrift. To the glory of God alone. John Whisler.

Fig. 232. Anonymous artist, Vorschrift. Southeastern Pennsylvania, ca. 1800. Hand drawn, lettered, and colored on paper; 20.35 x 33.7 cm. (Winterthur 57.1233.)

[No. 1]. How blessed is the man who only takes delight in keeping silent, and lets poisonous mouths prattle and do unending service in envy and loathsome jealousy through the marring consequences of depravity. In keeping silent I have my rest. I hear much and hold my peace.
[No.] 2. Why does everyone need to know what sickens me at the heart and how my distressed soul affects me at times? Why should I show signs of melancholy when at once it will be made the point of gossip? In keeping silent I have my rest. I hear much and hold my peace.
No. 3. Though misfortune makes me bitter and I am struck with slander, though envy and falsehood wear upon me and jealousy burns against me, I conceal such things so that my enemies do not have a good laugh on me. In keeping silent I have rest. I suffer much; [and hold my peace].
No. 4. I am constantly jeered and bullied by those who show me a pleasant face. Others would gladly have me go down and belittle me in front of everyone. But I know their vain flattery and hope to be free of it myself. In keeping silent is my rest. There is much to torment me, I hold my peace.
No. 5. Even if I may trust no one, because only betrayers exist who prepare misfortune for me, I say, good for him who can put away envy and without overdue complaint can bear such malice with patience. In keeping still I have my rest. I am happy and keep silent about it.
No. 6. Perhaps the sheet[?] will take a turn.
This writing belongs to me, Daniel Meyer. ["Daniel Meyer" is in a different hand from the body of the text.]
[Left heart:] O noble heart, contemplate thine end who knows how near.
[Right heart:] This heart of mine shall be yours alone, O Jesus.

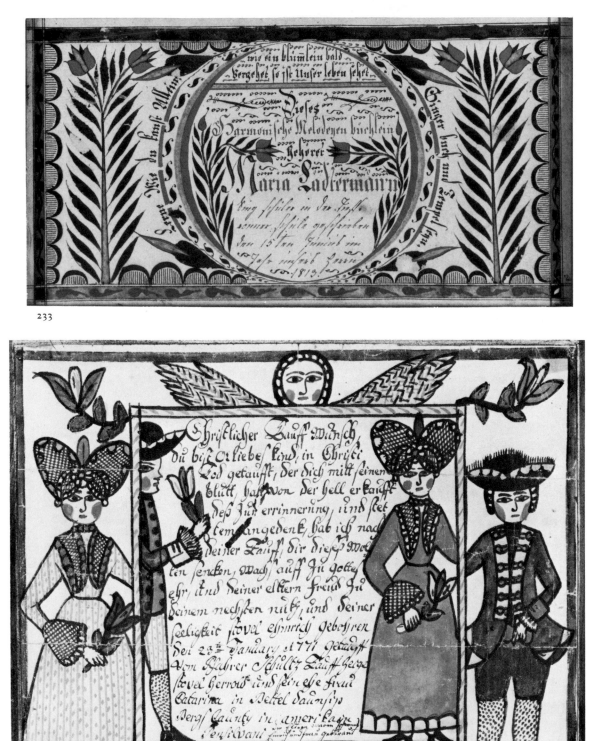

233

234

235

Fig. 233. Music Book artist, music notebook cover. Bucks County, 1813. Hand drawn, lettered, and colored on paper; 10.5 x 20 cm. (Winterthur 57.1242.)

> As a flower quickly dies,
> So our life from us flies.
> Learn to sing that you may be
> Singer, church, and melody.

This harmonious melody booklet belongs to Maria Lädterman, singing student in the Deep Run school. Written June 15, in the year of our Lord 1813.

An unknown artist working in the tradition of Johann Adam Eyer and teaching in one of the schools in which Eyer taught produced so many music booklets that he is dubbed the Music Book artist.

Fig. 234. Sussel-Washington artist, Tauf-Wunsch. Probably Berks County, ca. 1775. Hand drawn, lettered, and colored on paper; 18.75 x 23 cm. (Winterthur 58.120.15.)

Christian baptismal-wish.

O dear child, you were baptized into the death of Christ, who purchased you from hell with his blood. As a reminder of this and as constant memorial, I give you this drawing after your baptism. Awake to God's honor and your parents' joy, to your neighbor's benefit and bliss. Stovel [Christopher] Ehmrich was born January 23, 1771, baptized by Pastor Schultz. Sponsors Stovel Herrold and his wife, Catarina, in Bethel Township, Berks County, in America in Pennsylvania. The parents were Johannes Emrich and wife, Gertraut.

About two dozen pieces by this artist are known, from at least six counties, making the problem of identification especially complex. The fanciful attire

of the human figures must not obscure the fact that he intended them to be representations of the baptismal sponsors, as they are clearly labeled on a number of pieces. Nor should the very European wording of the texts be ignored. They are called Tauf-Wunsch (baptismal wish) in contrast to the more common Taufschein (baptismal certificate). They begin with a religious prayer-greeting addressed to the child by sponsors: the child and the sponsor are named, but sometimes the parents are not. In this instance someone added their name to compensate for the failing. The figures in the drawing are undoubtedly copied loosely from a printed source. If any Pennsylvania Fraktur artist could also have made such drawings before he emigrated, it may have been this one, but repeated searches in public and private collections in Alsace and the Palatinate have failed to find a piece by the same hand.

Fig. 235. Anonymous artist, Taufschein. Southeastern Pennsylvania, ca. 1800. Hand drawn, lettered, and colored on paper; 20 x 32.7 cm. (Winterthur 57.1251.)

To these two married people, namely Johan Jacob Fissler and his lawful wife, Eva, née Kobin, a daughter was born into the world in Europe, in Lossburg village, so named, in the year of our Lord Jesus Christ 1736, the 10th of October, and received holy baptism thereby and sponsors were the honorable Johan Georg Rechfänss and Chadarina Waltern, they were both in their single state, and was baptized therein by Johan Michael Kübler, preacher in Europe or Germany as it is called. Commit your ways unto the Lord and hope in him. He will do well. Fear God and keep his commandments, for that belongs to all men.

Many Pennsylvania German pioneers brought with them statements of their baptism from their pastors in Germany. Using the data in that sort of document, Taufscheine were sometimes drawn for these immigrants.

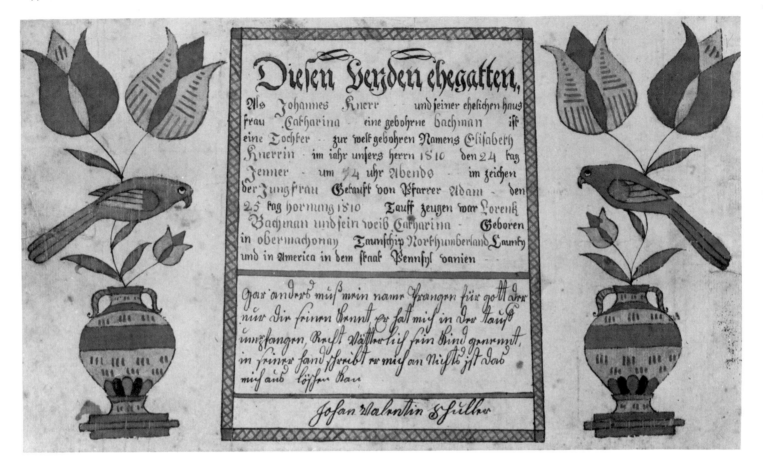

Fig. 236. Johan Valentin Schuller, Taufschein. Northumberland County, ca. 1810. Hand drawn, lettered, and colored on paper; 19.5 x 31.7 cm. (Winterthur 58.120.18.)

To these two married people, namely Johannes Knerr and his lawful wife, Catharina, née Bachman, a daughter was born into the world named Elisabeth Knerr in the year of our Lord 1810, the 24th day of January, at 4 o'clock in the afternoon, in the sign of the Virgin. Baptized by Pastor Adam the 25th day of February 1810. Sponsors were Lorentz Bachman and his wife, Catharina. Born in Upper Mahanoy Township, Northumberland County, and in America in the state Pennsylvania.
My name glitters quite differently to God who knows only his own. He received me in baptism, named me his child in a right fatherly way, recorded me in his handwriting, and there is nothing that can destroy me. Johan Valentin Schuller

Johan Valentin Schuller borrowed his vase and flowers from Taufscheine printed in Hanover shops. Continuing research into his life has virtually assured that the artist was the younger of two men (father and son) by this name who lived in the same area.

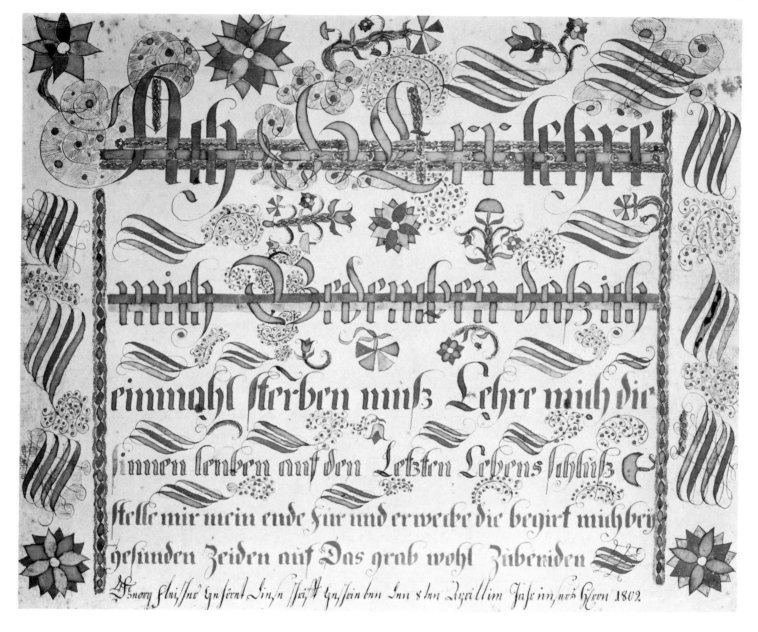

Fig. 237. Jacob Fleischer, Vorschrift. Lancaster County, 1802. Hand drawn, lettered, and colored on paper; 31.75 x 39.35 cm. (Winterthur 61.44.)

O lord, teach me to think upon this, that I must sometime die. Teach me to turn my thoughts to the final close of life. Set before me my end and awaken in me the desire at all times to be found ready for the grave.
This writing belongs to George Fleischer, written April 8 in the year of our Lord 1802.

The discovery of a will written by Jacob Fleischer, a Berks, Lebanon, and Lancaster counties schoolmaster, in the same hand as this identifies him as the artist of this and similar pieces. Fleischer, his father, and his brother were schoolmasters for many years.

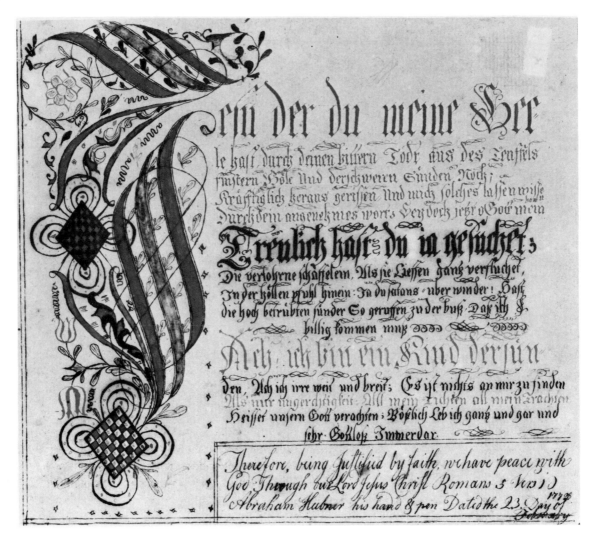

Fig. 238. Abraham Hübner, religious text. Montgomery County, 1773. Hand drawn, lettered, and colored on paper; 19.05 × 20.65 cm. (Winterthur 57.1183.)

Jesus, by your Cross and Passion,
By the bitter pain You bore,
When the Evil one would hold me
Deep in hell to suffer sore,
Mightily away You bore me
With a haven safe before me;
Through your word, contentment sweet,
You art still my sure retreat.

Truly have you searched
For the lost sheep,
As they wander away completely cursed
Into the hole of hell.
Yes, you conqueror of Satan
Have called the highly burdened sinner
So to repentance that I simply must come.

Ah, my failings sorely grieve me;
Ah my sins are very great;
There is nothing to be found in me
Except unrighteousness.
All my deeds, all my thoughts
Are bent on despising God.
I live evilly completely
And always very Godless.

[In English:] *Therefore, being justified by faith, we have peace with God through our Lord Jesus Christ. Romans 5:10. Abraham Hubner his hand and pen, dated the 23d day of February 1773.*

Schwenkfelders, members of a small Protestant religious colony, immigrated to northern Montgomery and eastern Berks counties en masse, where they produced relatively large amounts of written documents of many kinds, much of them now housed in their library at Pennsburg. Abraham Hübner was one of the earliest practitioners in this group. His bilingual pre-Revolutionary Fraktur includes a German hymn by Johann Rist and an English scripture citation of a standard Protestant text.

Fig. 239. Anonymous artist, Taufschein. Probably New Jersey, ca. 1780. Hand drawn, lettered, and colored on paper; 21 × 33.65 cm. (Winterthur 57.1189.)

In the year of the Lord after the birth of our Lord and Savior Jesus Christ, on November 19, 1772, was born to the two married people, namely Valtin Beitelman and his lawful housewife, Maria Barbara, née Rau, their 8th child and 6th son, Abraham. Because now the same Abraham, as well as all Adam's children, were conceived and born in and with original sin, they as Christian parents had him brought to baptism. The sponsors were Johan George Raub and his wife, Catarina. These two have gladly and willingly assumed the Christian task of sponsorship, brought the child before the Lord Jesus in baptism, and washed him with the pure baptismal water, as with the blood of the Lord Jesus, from original sin and had him recorded in the covenant of grace of God, and gave him therewith the handsome name Abraham. In America, in the state of New Jersey, Sussex County, Greenwich Township.

This is a Taufschein for a child born in New Jersey, or as the text states it, "Nu Schatzis, Sosicks Conty, Crinitz Taunschip." The border of this piece is a pattern for a cross-stitch embroidery design.

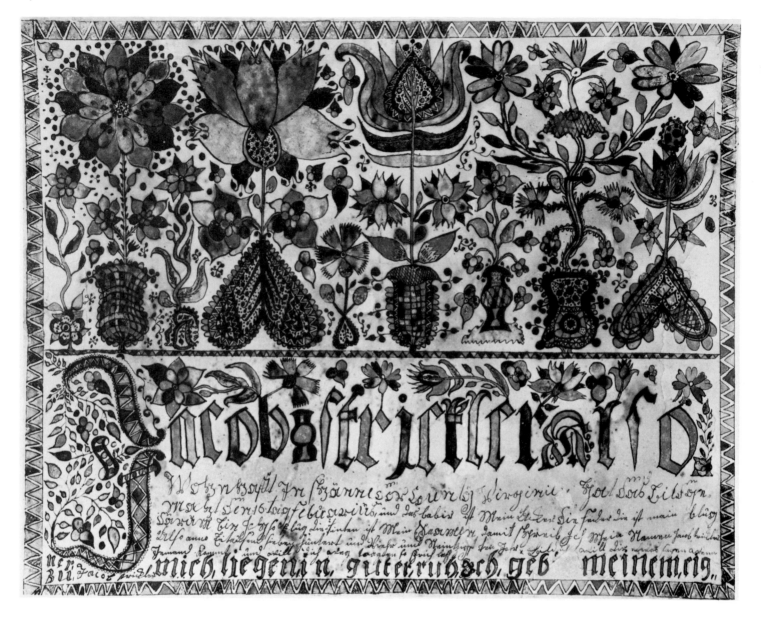

Fig. 240. Jacob Strickler, Vorschrift. Shenandoah County, Va., 1794. Hand drawn, lettered, and colored on paper; 30.85 x 38.45 cm. (Winterthur 57.1208.)

Jacob Strickler, residing in Shenandoah County, Virginia, made this picture the 16th day of February. The paper is my field and the pen is my plow, that is why I am so clever. The ink is the seed wherewith I write my name Jacob Strickler. One thousand seven hundred and ninety four. Pic- *ture. This is what I want to say to you: If anyone come and wants to carry you away so say: let me alone in good peace. I give myself to Jacob Strickler.*

A Mennonite and very likely a preacher, Jacob Strickler (1770–1842) has become better known through a large collection of his papers recently discovered and described by Donald R. Walters in "Jacob Strickler, Shenandoah County, Virginia, Fraktur Artist," *Antiques* 110, no. 3 (September 1976): 536–43.

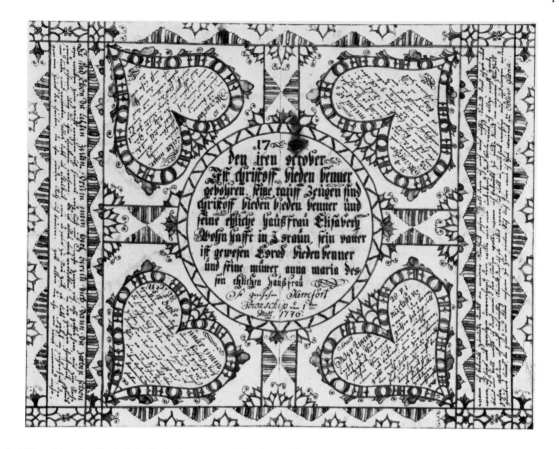

Fig. 241. Hereford Township artist, Taufschein. Berks County, 1776. Hand drawn and lettered on paper; 32.4 x 40.35 cm. (Winterthur 61.186.)

[Circle at center:] *1750, the first of October, Christoff Biedenbenner was born. His baptismal sponsors were Christoff Biedenbenner and his lawful wife, Elisabeth, residing in Istaum[?]. His father was Corad [Conrad?] Biedenbenner and his mother Anna Maria his lawful wife. Done Hereford Township, March 1, 1776.*

[Lower right heart:] *Sirch 29:1* [Ecclesiasticus, or the Wisdom of Jesus the Son of Sirach, a book of the Apocrypha]. *He that shows mercy will lend to his neighbor, and he that strengthens him with his hand keeps the commandments. Lend to your neighbor in the time of his need; and in turn, repay your neighbor promptly. Confirm your word and keep faith with him, and on every occasion you will find what you need.*

[Upper right heart:] *v. 4. Many persons regard a loan as a windfall, and cause trouble to those who help them. A man will kiss another's hands until he gets a loan, and will lower his voice in speaking of his neighbor's money, but at the time for repayment he will delay, and will pay in words of unconcern, and will find fault with the time.*

[Upper left heart:] *v. 10. [v. 7 in English translations]. Because of such wickedness, therefore many have refused to lend; they have been afraid of being defrauded needlessly. Nevertheless be patient with a man in humble circumstances and do not make him wait for your alms. Help a poor man for the commandment's sake and, because of his need, do not send him away empty.*

[Lower left heart:] *v. 20 [v. 22 in English translations]. Better is the life of a poor man under the shelter of his roof than sumptuous food in another man's house. Be content with little or much. It is a miserable life to go from house to house, and where you are a stranger you may not open your mouth; you will play the host and provide drink without being thanked.*

[Left border:] *The last times are already here; therefore, my heart prepare yourself, for the signs point from a distance to the judgment. Heaven, earth, air, and sea show themselves as God's army, showing themselves for vengeance, over those who dwell in windows. Everything is almost spoiled in all Christendom, belief and love have died out, everything that lives is vanity, as it was in Noah's time, so there lives now in safety the common house of Christians, who pride themselves on their sins' needs. To God alone be glory and to no one else.*

[Right border:] *When I concerned look back on my childhood years, then I make myself truly sick, that I was so vain. I walked in great misunderstanding, thy will was unknown to me, evil had me all too completely, blind and foolishly I filled the measure of sin. When I concerned think back on my childhood steps, then I make myself truly sick, that I was so vain. I should have grown in wisdom and have begun the path of faith, in grace and age increase, for the soul's rest, but, Lord, what I did you know. To God alone be glory.*

This dated but unsigned Taufschein is probably the earliest in the Winterthur collection. The extensive text of the document with quotations from the Apocrypha is an indication of the religious significance some artists felt these papers had. The supplemental data on the reverse, a common feature, reveals that the Taufschein was prepared when its owner was twenty-five years old and had been married two years, which reminds us that these records are frequently not contemporaneous to the events they describe. The artist, incidentally, also did some work in Albany Township in the northernmost corner of the county.

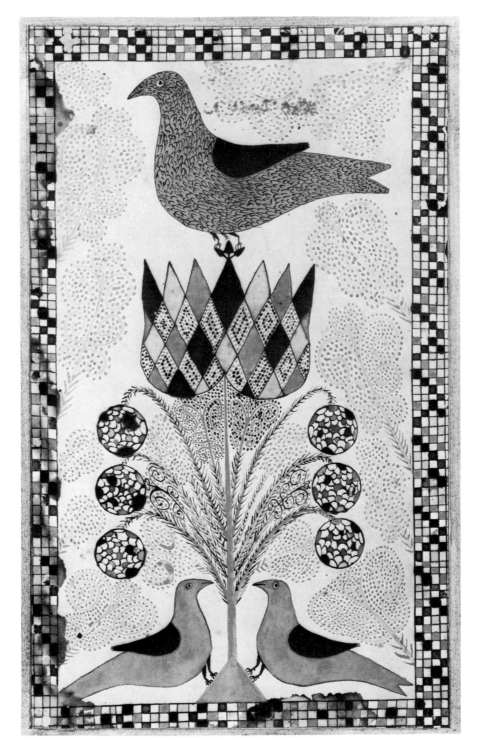

Fig. 242. Anonymous artist, drawing. Southeastern Pennsylvania, ca. 1810. Hand drawn and colored on paper; 32.35 x 19.05 cm. (Winterthur 61.45.1.)

The border of this drawing is a pattern for cross-stitch embroidery.

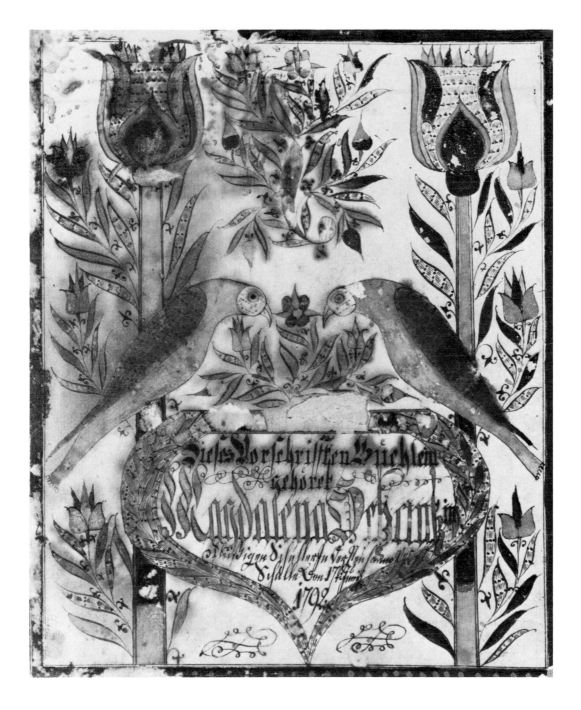

Fig. 243. Earl Township artist, Vorschrift book cover. Montgomery County, 1792. Hand drawn, lettered, and colored on paper; 20 x 16.2 cm. (Winterthur 61.308.)

This writing example booklet belongs to Magdalena Schantz, diligent student in the New Hanover school, June 17, 1792.

The shadow of one Fraktur artist on another is illustrated in this work. Johann Adam Eyer appears to have originated the Vorschrift booklet—in a four-page leaflet with penmanship examples for students—in Pennsylvania. Eyer and his brother Johann Friederich both taught in schools in northern Chester County in the late 1780s and early 1790s, presumably among Mennonites. A teacher in a neighboring Mennonite community across the Schuylkill in Montgomery County took the notion of the booklet from one of them. Later he moved to Earl Township in Lancaster County (hence his nickname; no signed piece is known) and made these booklets there, too.

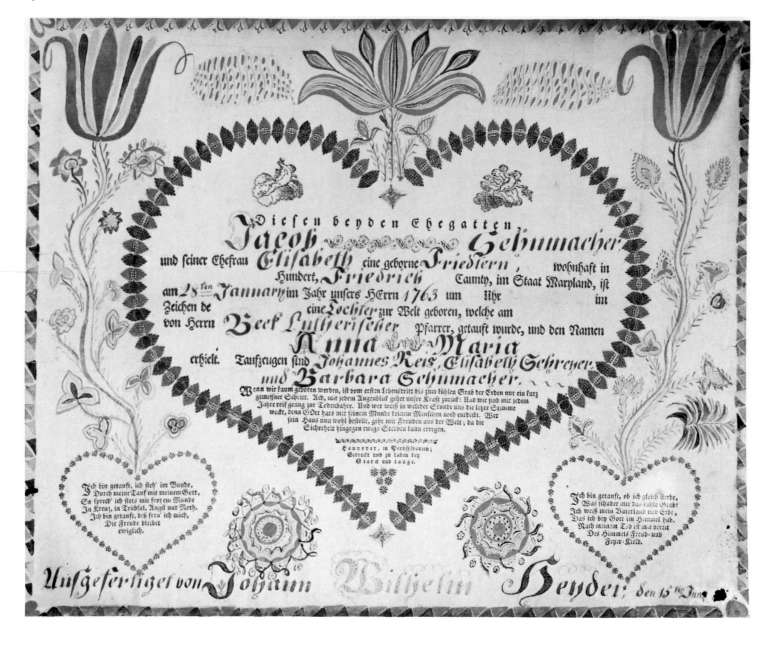

Fig. 244. Johann Wilhelm Heyder on a Taufschein form printed by Starck and Lange, Hanover, ca. 1810. Hand drawn, lettered, and colored on a printed form; 32.35 x 40 cm. (Winterthur 61.1103.)

Printing baptismal certificates became big business from the 1780s. Early centers were Ephrata, Reading, and Hanover. Here one of many varied formats printed by Starck and Lange in Hanover was decorated by Johann Wilhelm Heyder (1756–1813), former British mercenary and schoolmaster in the area for many years. The text records the birth and baptism of Anna Maria, daughter of Jacob Schumacher and his wife, Elisabeth, née Friedlern, born January 28, 1763, in Frederick County, Maryland, baptized by Pastor Beck, a Lutheran clergyman. Sponsors were Johannes Reis, Elisabeth Schreyer, and Barbara Schumacher. The typical baptismal hymns on printed certificates are found here.

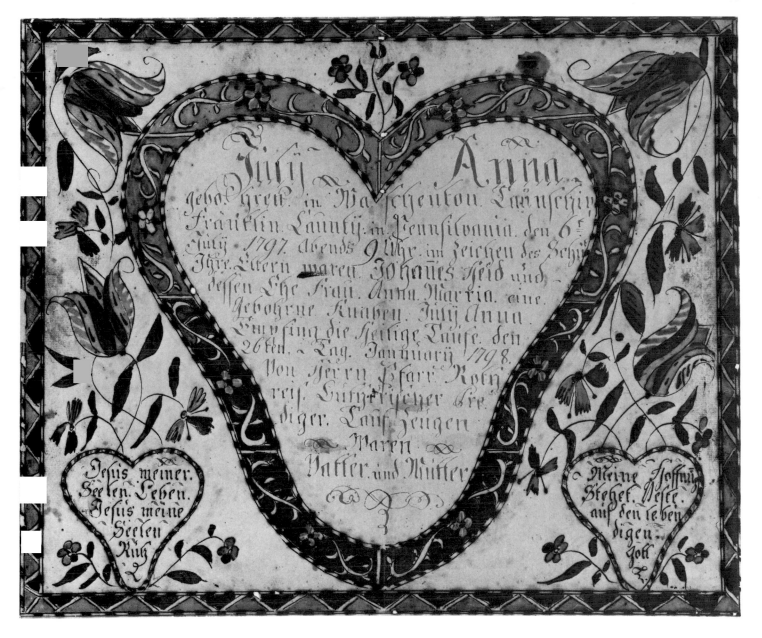

Fig. 245. Anonymous artist, Taufschein. Franklin County, ca. 1800. Hand drawn, lettered, and colored on paper; 31.75 x 38.7 cm. (Winterthur 61.1107.)

Julÿ Anna was born in Washington Township, Franklin County, Pennsylvania, July 6, 1797, at 9 o'clock in the evening in the sign of Sagitarius. Her parents were Johannes Heid and his wife, Anna Maria, née Knaben. Julÿ Anna received holy baptism the 26th day of January 1798 from Pastor Roth, traveling Lutheran preacher. Sponsors were the father and the mother. [Lower left:] *Jesus, my soul's life, my soul's rest.* [Lower right:] *My hope stands fast on the living God.*

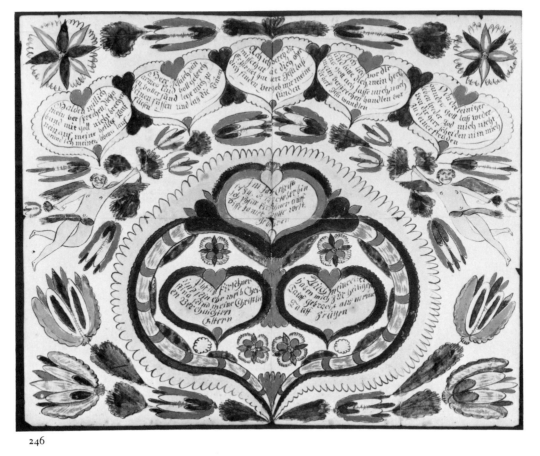

246

247

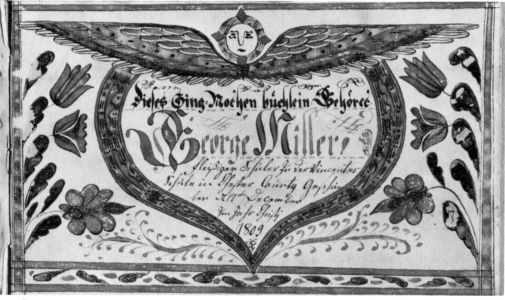

248

Fig. 246. Joseph Lochbaum, Taufschein. Probably Franklin County, ca. 1810. Hand drawn, lettered, and colored on paper; 32.35 x 39.35 cm. (Winterthur 61.189.)

[Five hearts, left to right:]

[1] *I will keep my promise not to break this covenant with God. No, on my holy baptism I want to establish my course of life.*

[2] *Lord Jesus, I your poor child am full of weakness, full of sin. Lay me at your feet and let the tears flow.*

[3] *Oh, I repent the misdeeds which have angered you or him. Lord Jesus, let [me] find you. Forgive me my sins.*

[4] *I lie before you and ask you, God of my heart, oh let me live according to my promise to walk before you, Lord Jesus.*

[5] *O you triune united God, let neither life nor death divide me from you, Lord take me to your joys.*

[Three hearts enclosed in a circle:]

[Top:] *In the year of Christ* A.D. *1784 October 14 was I, Philip Kirshner, born into this world full of woes.*

[Left:] *Philip Kirschner and his wife, Christina, are my Christian and married parents.*

[Right:] *And my parents brought me to holy baptism as my sponsors.*

Two signed examples of work by the "nine hearts" or "Cumberland valley" artist have directed us to Joseph Lochbaum, parochial schoolmaster of Solomon's Church in Franklin County. Lochbaum drew Taufscheine for children in Adams, York, Cumberland, Franklin, Perry, Bedford, and Somerset counties in Pennsylvania and in Washington County, Maryland. The baptismal hymn in the five hearts is not the usual one found on the borders of such papers. We know little about the recipient because Lochbaum, as often was his custom, gave no indication of where the family lived.

Fig. 247. Anonymous artist, Vorschrift. Montgomery County, 1815. Hand drawn, lettered, and colored on paper; 19.35 x 31.45 cm. (Winterthur 61.209.)

[Banner:] *Behold I bring you tidings of great joy which shall be to all people, for unto you is [born] this day the Savior.*

[Text:] *He to whom this Jesus is given has a treasure better than Arabian gold. He who remains virtuous is happy. He can stand firm and go through all kinds of weather.*

Whoever wishes to find Jesus must cleanse himself from sins which he has committed from youth on into old age, and ply himself in virtue, love God and also man. If we are not thus minded, we are still spiritually blind. May God illumine our hearts with tapers of true love and faith. Show us in faith thy son, who is given by thee, O Father, from thy throne of grace to us to be the way, the truth, and the life who brings us salvation. Lord Jesus true source of life, O cleanse us in body and soul and purify us in thy blood, so that everything may become right and good. To the labors of my hands, Lord Jesus, lend thine increase; grant me in my station to spare no toil or care, for my vocation comes indeed from thee; therefore, Thou wilt give me thy blessing. If in my station I should be met with affliction, ah as much as I am able, I will patiently bear. In this, O Jesus, grant that I be found true, and that uprightness and truthfulness be my portion in every hour, until at last I hear the joyous words, devout servant enjoy forever the glory and praise of thy Lord. 1-2-3-4-5-6-7-8-9-10-20-30-40-60-70-80-90-100-200-300-400-500-6000-A-b-c-d-e-f-g-h-i-k-l-ll-m-n-o-p.

Written in Skippack, Montgomery County, on December 31, A.D. 1815.

The Vorschrift enjoyed more popularity among Mennonites than among other Pennsylvania German groups, perhaps because Mennonites baptized adults and the Taufschein, rooted in infant baptism practices, was inappropriate. This Vorschrift, from the old Mennonite congregation at Skippack, is done in the tradition of Andreas Kolb, a schoolmaster there, about whose work little is known. The date on the Vorschrift and the quotation of the angel's greeting to the shepherds make obvious its secondary role as a Christmas / New Year's greeting to a young Pennsylvania German.

Fig. 248. Anonymous artist, music notebook, Chester County, 1809. Hand drawn, lettered, and colored on paper; 10 x 16.5 cm. (Joseph Downs Manuscript and Microfilm Collection 65 x 550, Winterthur Museum Library.)

This singing-note booklet belongs to George Miller, diligent student in the Vincent School in Chester County. Written December 17, in the year of Christ 1809.

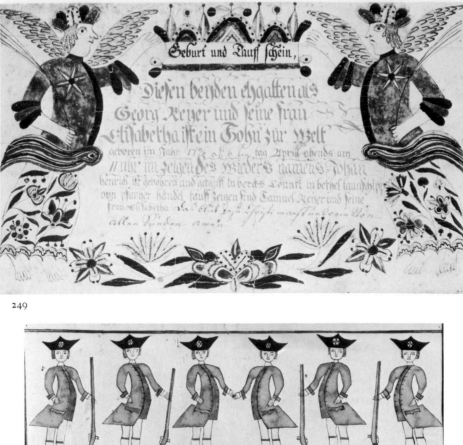

249

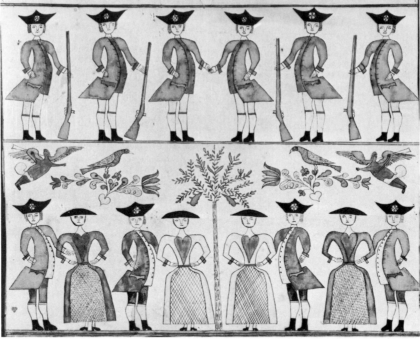

250

Fig. 249. Conrad Gilbert with an anonymous scrivener, Taufschein. Probably Berks County, ca. 1800. Hand drawn, lettered, and colored on paper; 20.65 x 33.35 cm. (Winterthur 61.1121.)

Birth and baptismal certificate.
To these two married persons, namely Georg Reyer and his wife, Elisabetha, was a son born into the world in the year 1796, the 6th day of April in the evening about 11 o'clock in the sign of the ram, with the name Johan Henrich. [He] was born and baptized in Berks County, in Bethel Township, by

Pastor Hendel. Sponsors were Samuel Reyer and his wife, Elisabetha. The blood of Jesus Christ makes us clean of all sins. Amen.
Fig. 250. Johann Adam Eyer, drawing. Probably Bucks County, ca. 1780. Hand drawn and colored on paper; 31.4 x 39.4 cm. (Winterthur 61.1124.)

Johann Adam Eyer was schoolmaster in various counties. He made this drawing of a double wedding of soldiers and their ladies—perhaps to amuse his younger twin brothers.

Fig. 251. Anonymous artist, New Year's wish. Southeastern Pennsylvania, 1816. Hand drawn, lettered, and colored on paper; 32.55 x 19.7 cm. (Winterthur 61.1144.)

I wish you a blessed New Year, you and your dear wife, sons and daughters, manservants and maidservants, and all those belonging to your household included. Forth, forth in the name of Jesus Christ the New Year is at hand. We beseech thee, thou eternal Son of the Father in highest heaven that it please thee to preserve thy poor Christendom continuously at all times, take not thy healing word from us the whole year through or ever. This we wish from the bottom of our hearts at this hour of the New Year that they may live joyfully and carry both love and sorrow. There is one flesh, one heart, one spirit. May the grace of God prosper in them that we may all fear God and keep his holy commands and grow up in uprightness and wisdom to your benefit and God's praise. Whoever has taken this to heart and with us desires to have work that we may be rightly brought up by God, him shall God reward. To the government, that it may receive its power from God and correctly administer it, may God give much seriousness and industry, that it may be upright, devout, and wise and deal as is pleasing to God and his son Jesus Christ and hold unfailing to his words, that it may have no remorse for its work. To each and every home and what is therein we wish a proper mind to God's honor and praise at all times, to house, lot and all time. The young men one and all, the daughters, too, may God keep pure and give a chaste mind and will to overcome flesh and blood. All this we wish from the heart, to be a people pleasing to God, a holy city founded upon God. Christ, moreover, is your servant. Whoever believes this can properly serve. That you may make the best of your years, think often upon your end and destination. To God be praise and thanks we have passed our time in rest and joy. He grants it with the New Year, to be totally renewed. So I wish good fortune to your house and on my hat a bunch of ribbons. But listen to me further. I wish you this blessing: that, as many as are the stars in heaven, as many as are the doors that open on earth, as many as are the leaves on the trees, as many as are the fish in the water, as many as are the blades of grass that shoot forth out of the ground, as many as are the drops that fall in the rain, as many as are the birds in the world, that many goods and that much money, that much fortune and that much blessing may God will to give you. All this Thou dost will to give, O thou source of my life, to me and all the Christian host, for a blessed New Year. For the New Year is not far away. The New Year is today. Today the dear New Year has begun, and the old is already completely passed away. The sun had hardly set before the New Year entered. To the son of the house we wish that he may be steadfast on his own, have a long life, a healthy body, a warm bed, and a pretty wife. You maidens one and all assembled in the house, be still and hear what I wish you—a young man of handsome stature as is pleasing to the maidens. If one happens to be too few, then I wish one for each of them. Then, too, a house finely built, prettier than pearls, with walls of marble and precious stone and crystal windows in it, so that it is handsomely decorated outside and nothing lacking inside. Herewith I commend this house into God's hand that all harm may be kept afar from it as the morning is from the evening. Think with us as is proper, how Christ was a servant for our sake and fulfilled the law to still his father's wrath. Today He first paid the ransom for all the sins of the whole world, so we desire now to entreat the Lord, that He shield us from sin and grant us new life. Think no more on the old sin, that we may strive to fill all his will.

Listen to me further and hear what I am able to wish for you. I wish you all a long life free from distress. God grant you many years, and that we live in faith, love, and hope, unto death, and be of service to our neighbor. For we wander along from one year to the next. We live and prosper from the old to the new. Should this year bring with it the end, so let it graciously

come. We commit ourselves into God's hands, for in life and in death we are his. Let this be your guide: Lord, as Thou wilt, so let it be unto me. Now I ask the father of the house or all together, whether you would like to hear our shooting. We shoot to your honor. We have our rifles and pistols in our hands and have the cocks pulled to set off the powder. However, if pistols and rifles should cause you dismay, you must say so before we shoot, in order that we may preserve our honor and spare our powder. Now I perceive no objection, so you shall hear the shot of joy. We are all ready now to shoot with mirth. Now, brothers, pull back the cocks and let go with the shots.

[In heart:] *In the year 1816 on the 25th day of April.*

This New Year's wish begins with the traditional chant given by the various itinerant groups of shooters making the rounds of the neighborhoods, continues with hymns and other verses, and concludes with more of the shooters' chant. This makes the remarkable document an entire collection of New Year's greetings, profane and spiritual, the more unusual because it is dated in April.

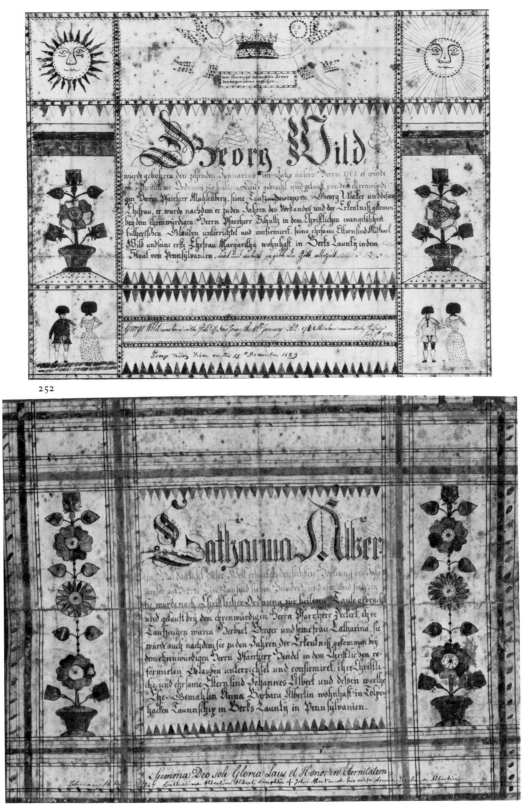

252

253

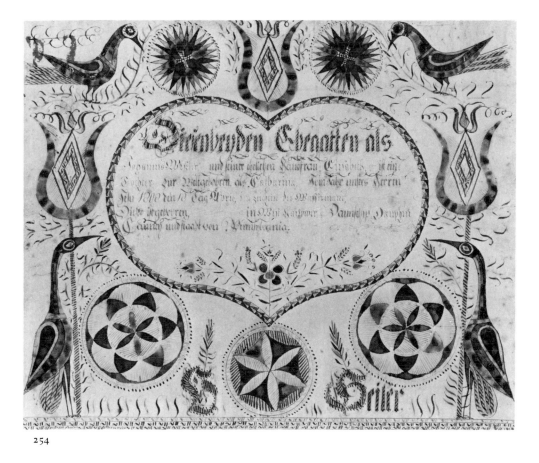

254

Fig. 252. Henry Dutge, Taufschein. Berks County, ca. 1784. Hand drawn, lettered, and colored on paper; 31.9 x 40.5 cm. (Winterthur 62.185.)

[Banner:] *Whoever persists will receive the crown of life.*
Georg Wild was born the tenth of January in the year of our Lord 1761. He was brought to baptism according to Christian ordinance and was baptized by Pastor Muhlenberg. His sponsors were Georg Waker and his wife. After he reached the years of understanding and wisdom he was instructed and confirmed by the honorable Pastor Schultz in the evangelical Lutheran Christian faith. His honorable parents were Michael Wild and his first wife, Margaretha, residing in Berks County in the state of Pennsylvania. Pray and work God gives you at all times.
[Same hand in English:] *George Wild was born in the state of New Jersey the 10th January* A.D. *1761. The above was written by H. Tutye[?] July 9th, 1784.*
[Another hand in English:] *George Wild died on the 15th December 1829.*
[On reverse:] *Baptismal certificate for George Wild is married to Catharina Albert October 18, 1784.*

The Taufscheine in figures 253 and 254 are probably contemporary with one another. They were produced by one of the more eccentric penmen, as the rear views of the couple in figure 253 hint. The marriage date—1784—written on the back of each certificate probably coincides with the date the documents were made, drawn no doubt in anticipation of matrimony.

Fig. 253. Henry Dutge, Taufschein. Berks County, ca. 1784. Hand drawn, lettered, and colored on paper; 31.75 x 40 cm. (Winterthur 62.186.)

Catharina Albert saw the light of this world the 6th of February in the year of our Lord one thousand seven hundred and sixty four. According to Christian ordinance, she was brought to holy baptism and baptized by the honorable Pastor Deckert, her sponsors were Herbert Berger and his wife, Catharina. Also, after she came to the age of accountability, she was instructed and confirmed by the honorable Pastor Hendel in the Christian reformed faith. Her parents were the Christian and honorable Johannes Albert and his worthy wife Anna Barbara Albert residing in Tulpehocken Township, in Berks County in Pennsylvania.
All Glory, Laud, and Honor be to God alone in eternity.
[Another hand in English:] *February 16th, 1764, Catharine Albertin Albert, daughter of John Albert and his wife, Anna Barbara Albertin.*
[On reverse:] *George Wald [sic] married Catharina Albert October 18, 1784.*

Fig. 254. H. Seiler, Taufschein. Probably Dauphin County, ca. 1810. Hand drawn, lettered, and colored on paper; 33 x 40 cm. (Winterthur 65.603.)

To these two married people, namely Johannes Wissler and his lawful wife, Elisabeth, a daughter was born in the world, namely Catharina, in the year of our Lord Jesus 1808, the 18th day of April in the sign of Aquarius. She was born in West Hanover Township, Dauphin County, and state of Pennsylvania.
H. Seiler.

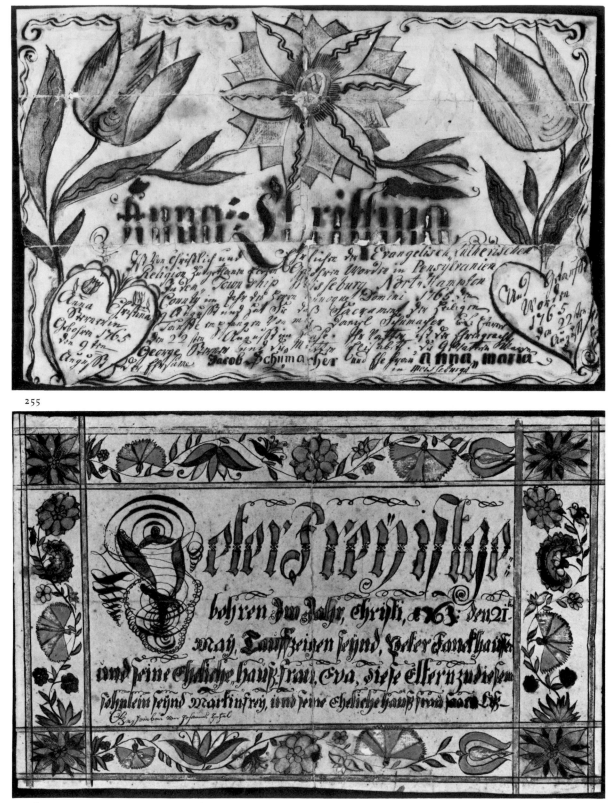

255

256

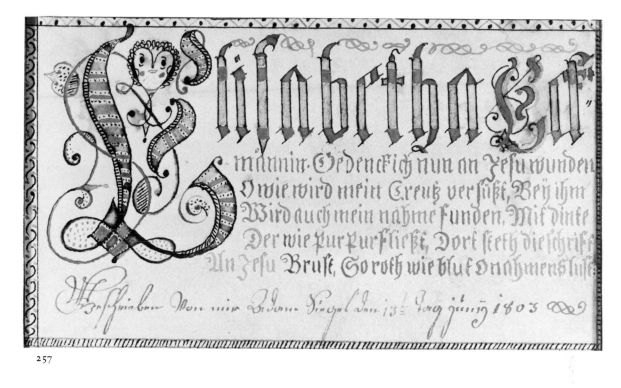

257

Fig. 255. Daniel Schumacher, Taufschein. Lehigh County, ca. 1765. Hand drawn, lettered, and colored on paper; 20.8 x 32.7 cm. (Winterthur 67.917.)

Anna Christina was born to Christian and honorable parents who hold the Evangelical Lutheran religion in Pennsylvania in Weissenburg Township, Northampton [now Lehigh] County in the year of the Lord, 1765, August 9, and she received the sacrament of holy baptism from me, Daniel Schumacher, E[vangelical] L[utheran] Pastor the 22nd of August, at home. Her father is his honorable magnificence George Sterner and the mother Elisabeth. The sponsors were the honorable Jacob Schumacher and wife Anna Maria in Weissenburg.
[Left heart:] *Anna Christina Sterner born on August 9, 1765.*
[Right heart:] *And baptized August 22, 1765.*

Daniel Schumacher (ca. 1729–1787) functioned as a Lutheran pastor without university training or ordination. One of the ways he seems to have authenticated his ministry (and supplemented his income) was by drawing Taufscheine for the children he baptized or confirmed, of which this is one of his earliest. His influence on Fraktur, as one of the first to make records of baptism, has not been adequately assessed.

Fig. 256. John Hetzel, Taufschein. Lancaster County, 1789. Hand drawn, lettered, and colored on paper; 19.7 x 31.3 cm. (Winterthur 67.920.)

Peter Frey was born in the year of Christ 1763, May 21. Sponsors were Peter Fanckhausser and his lawful wife, Eva. The parents of this little son are Martin Frey and his lawful wife, Saar Liss [Sarah Elizabeth]. Written by Johannes Hetzel.

John Hetzel (b. 1760) was a son of Heinrich Hetzel (d. 1786), schoolmaster at Hain's and later Muddy Creek churches. The senior Hetzel called himself a Reformed clergyman in his will, but there is no other record of him as such. Younger Hetzel probably followed his father as a schoolmaster.

Fig. 257. Adam Siegel, religious text. Lancaster County, 1803. Hand drawn, lettered, and colored on paper; 8.85 x 14.9 cm. (Winterthur 69.596.)

Elisabetha Eckmann. Now I think on Jesus' wounds. O, how my cross is sweetened. My name is also found with him, with ink which flows like purple. There stands the writing on Jesus' breast, as red as blood, O heart's delight.
Written by me, Adam Siegel, the 13th day of June 1803.

Adam Siegel served a number of Lancaster County schools during the time he lived in America. He arrived in 1774 and died in 1809.

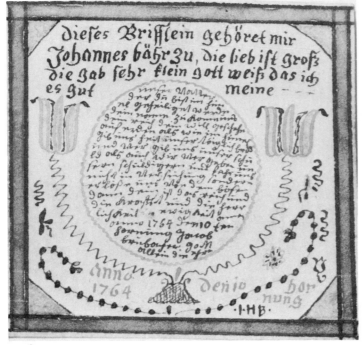

258

259

Fig. 258. Hans Jacob Brubacher, religious text. Lancaster County, 1764. Hand drawn, lettered, and colored on paper; 5.55 × 5.70 cm. (Winterthur 61.1127.)

This note belongs to me Johannes Bähr. The love is great, the gift very small. God knows that I intend it well. Anno 1764, February 10. I. H. B. [In circle: The Lord's Prayer.] Anno 1764, February 10. Jacob Brubacher. To God alone be glory.

Hans Jacob Brubacher no doubt made this for his grandson, the child of his daughter Elisabeth and her husband, Jacob Bähr. (A New Year's greeting to Elisabeth also has survived.) This is one of the smallest Fraktur known and one of many attempts made in Western civilization to write the Our Father in as small an area as possible.

Fig. 259. Christian Strenge, love letter. Lancaster County, ca. 1800. Hand drawn, lettered, colored, and cut out of paper; diam. 31.75 cm. (Winterthur 67.781.)

1. *My dearest one, I can no longer keep the feelings of my heart from you.*
2. *If it should please you, I have chosen you for my own.*
3. *I will truly promise you my heart, if I find you willing to do the same.*
4. *In my thoughts I have often kissed you, because you are such a pretty maiden.*
5. *You mean more to me in the world than all riches, possessions, and money.*
6. *If from your heart you will be mine, and always love me and no one else,*
7. *then my heart will be so devoted to you, that I will love you unto death.*
8. *Love, ah, that noble shoot is built on trust alone.*
9. *Love is founded on trust, through mistrust it soon passes away.*
10. *If you remain true to me, no one shall separate us but death alone.*
11. *My heart at all times thinks on you, and trust alone delights me.*
12. *My desire is only to make you happy and be genuinely bound to you.*
13. *In my heart I love you and wish to be with you constantly.*
14. *I have truly given you my heart and think about you every hour.*
15. *My dearest treasure, so let it be, I will be faithful to you, you be faithful to me.*
16. *Faithful is [name not given]. O, dearest one, do not forget.*
[Circle at center:] *Loving without possessing is harder than digging stone; loving without being together is most certainly the greatest pain.*

Christian Strenge (1758–1828), a Hessian soldier who remained in America and a member of the German Reformed Church, was justice of the peace, scrivener, and schoolmaster among his Mennonite neighbors near Lancaster.

Fig. 260. Johann Ernst Spangenberg, Taufschein. Northampton County, ca. 1810. Hand drawn, lettered, and colored on paper; 19.05 x 16.5 cm. (Winterthur 61.1126.)

[Heart at top:] *I give my heart to Jesus, in Jesus I constantly live. And Jesus is my refuge, Jesus my last word. [In Hebrew: JHWH pointed with the vowels of Adonai.]*

This baptismal certificate is an acknowledgment that Elisabetha was born on the 18th day of September in the year of our Lord Jesus Christ 180[2] in Willi[ams] Township, North[ampton] County in the state of Pennsylvania. The father was Nicalaus Wagner and the mother Susana. After the birth the dear parents let holy baptism be instituted according to the command of Jesus Christ and accordingly [she was] baptized by Pastor Endres and joined to the holy covenant of grace in Jesus Christ, to which Georg Henr. Miller and his wife, Rosina, were witnesses.

[There follow three verses of a baptismal hymn.]

[Lower right heart:] *May God give you good fortune and blessing, and health on all your paths, your protection be Jesus, Jesus alone your strength.*

This is one of Spangenberg's more modest certificates (others include entire orchestras and even family pets). His pedantic use of Hebrew (the letters of the divine name) may have impressed naive Pennsylvania Germans with their schoolmaster's erudition, but it may well be all the Hebrew he could write.

Fig. 261. Francis Portzline, Taufschein. Snyder County, ca. 1845. Hand drawn, lettered, and colored on paper; 38.75 x 31.45 cm. (Winterthur 65.602.)

Birth and baptismal certificate.
To these two married persons, namely Johan Hachmeister and his legal wife, Wilhelmina, née Portzline, a son was born into the world May 4, in the year of our Lord Jesus 1845 at 11 o'clock in the evening. This son was born in Chapman Township, Union County, in the state of Pennsylvania and was baptized by the honorable preacher Ellemeyer and received the name Samuel. The sponsors are Elizabeth Hachmeister.
This is the red baptismal flood, colored with Christ's blood, which heals all sins, inherited from Adam, and committed by us.
Francis Portzline

Francis Portzline (1771–1857) ended his long career as a shopkeeper, schoolmaster, and farmer as an old man in Snyder County. He faithfully made Taufscheine for members of his family as well as for many residents of his neighborhood.

German Language Books, Periodicals, & Manuscripts

FRANK H. SOMMER

Introduction

Henry Francis du Pont's early American books and manuscripts were assembled as an integral part of his collection of craft objects made in or imported to North America for the use of its early citizens. Beginning in 1963 the books and manuscripts were transferred from the museum's rooms to the closed stacks of the library. As a result, they became more useful to the scholar but were lost to the general public as a fundamental part of the panorama of American craftsmanship as it had been planned originally by the museum's creator.

The following essay is intended to draw the attention of scholars to the existence of these now hidden treasures at Winterthur; its illustrations should also make it possible for the visitor to the exhibition rooms to experience some of the visual pleasures he can no longer enjoy as part of his tour of the museum. It is hoped that through the use of this printed guide's reproductions the reader will gain some of the aesthetic and intellectual excitement visitors used to experience when du Pont, acting as their personal guide, showed them his books and manuscripts in their period settings.

The early American German-language imprints and manuscripts collected by du Pont are the specific subject of the following essay. It is intended as a general survey of this part of his collection. It does not attempt to paint a complete portrait of Pennsylvania German literary culture and graphic arts. That is a task that must be based on a more thorough knowledge of the culture's language, calligraphy, visual art, and the many other related collections owned by other institutions.

At Winterthur we have begun the work of surveying related collections other than our own as part of the Decorative Arts Photographic Collection (DAPC). Initiated in 1958, the original purpose of DAPC was to create a photographic catalogue raisonné of documented works of American decorative arts. A parallel collection of photographs of early American paintings, drawings, and prints called the Photographic Index of American Art (PIAA) was begun in 1963 and now is housed in the library with DAPC. In 1975 we made a proposal for a two-year photographic survey of objects made in the Delaware and Ohio river valleys. Funds were granted by the National Endowment for the Humanities Research Materials Program. Work on the Delaware Valley started June 1, 1976, and was officially concluded on December 31, 1977. The result was a group of 15,740 catalogued negatives of objects of Pennsylvania German material culture in other institutions.

Another course we are taking in building a broader base for a sound picture of Pennsylvania German culture is microfilming documents in other institutions and private, family papers. A major example of recently filmed manuscripts is that of the family papers of Leon E. Lewis, Jr. Frederick S. Weiser kindly brought the collection to our attention. Peter I. Lewis, the present owner, with even greater kindness, allowed us to borrow his entire collection and film it. The microfilm is now available for study purposes at Winterthur. We hope that other owners will be

willing to follow the splendid example of Lewis and let us microfilm similar collections. To do so will not only enhance our library's holdings in the field but also ensure the preservation of important collections of documents for future research in German American history which might be lost, stolen, or broken up.

Pennsylvania German Printing, Graphic Arts, and Book Trade

One of the greatest contributions of German culture to the West was the invention of printing. When Germans immigrated to Pennsylvania they brought with them the art of printing and the ancillary skills for making paper, woodcuts, engravings, bookbindings, and, finally, type. They also brought booksellers, almanac makers, newspaper editors, scholars, and literate clergy with at least partially literate congregations. The early German immigrants to Pennsylvania were in stark contrast to the Spanish in the southwestern and western United States, not only in their predominant Protestantism but also in their literacy and cultivation of the graphic arts.

WILLIAM McCULLOCH AND THE GRAPHIC ARTS IN PENNSYLVANIA

Isaiah Thomas, Massachusetts printer and publisher, was our first historian of American printing. In 1810 he published a classic of American literature and historiography, *The History of Printing in America, with a Biography of Printers, and an Account of Newspapers.* It touched on a good deal more than the topics of his title but stressed his major interests. His history was truly American in its coverage. It surveyed his subject in all the states and territories up to the time of publication. But, in an age before travel grants by private foundations and federal funding, it is not surprising that Thomas found most of his material in New England.

One of the early readers was Thomas's prominent Philadelphia counterpart, William McCulloch. Like Thomas, McCulloch was a successful printer and was extremely interested in the history of his craft and that of all its related arts. Like Thomas he set out to collect documentation for his subject. He pursued his subject by collecting written information and physical specimens to illustrate his annals. He also set out to collect oral history by interviewing the oldest people he could find connected with the graphic arts and the book trade in general. In 1812 and 1814/15 McCulloch sent Thomas suggestions for revision of the 1810 edition of *History of Printing,* and a large body of additional information collected on his subject in Philadelphia and adjoining parts of Pennsylvania. McCulloch's notes constitute the earliest and most detailed body of information collected on any of the arts and crafts of Pennsylvania. They cover the history of the graphic arts among the English-speaking population and the Pennsylvania Germans.[1]

PRINTING

When the first German group of immigrants established Germantown near Philadelphia in 1683, they brought with them a great tradition of learning which they had inherited from their ancestors in the Palatinate. They brought books with them as part of their intellectual baggage. But it was not until fifty-five years later that their successors began to print and publish books and periodicals in German, many of which were illustrated.

For most Americans, the study of German culture in the United States presents a very real initial problem—a language barrier. Furthermore, the systems of communication by the printed or written word are very different from the typefaces and handwriting with which we are familiar in the twentieth century. Since so much Pennsylvania German art bears printed or written inscriptions, a strategic place to begin a study of that subject is with the history of the arts and crafts of German typography and calligraphy.

GERMAN TYPOGRAPHY

The history of printing is fundamentally a history of the development and use of alphabets. Before turning to our examination of Winterthur's collection of German American printed books and periodicals, it may be helpful to commence with some brief remarks on the origin of their typefaces.

All modern Western alphabets grew out of that developed by the Romans. The Roman alphabet took two forms, lapi-

[1] Clarence S. Brigham, "William McCulloch's Additions to Thomas's History of Printing," *Proceedings of the American Antiquarian Society,* n.s. vol. 31, pt. 1 (April 1921): 89–247.

dary capitals used by monumental masons to cut inscriptions on monuments and buildings and manuscript lettering. Modern printing derived from both sources.

The history of the evolution of the alphabet from the Romans is complex. But, by the late Middle Ages, all writing used one or another form of gothic lettering and cursive script. Historian of printing Warren Chappell explained: "This so-called gothic script underwent numerous transitional [and regional] forms. It was known in fourteenth-century Germany as *Textur*, in France as *lettre de forme*, and in England as *black letter*. It was a *lettre de forme* of the following century that served as a model for the type used in Gutenberg's 42-line Bible and in the Mainz Psalter."[2] The Bible is dated to 1453–56, the Psalter to 1457. The printing of Gutenberg's day was designed in imitation of contemporary manuscript lettering and script.

In the late fifteenth and early sixteenth centuries "certain ameliorations were taking place in the German *lettre de forme*. The *Textur* of Gutenberg's time began to develop in two directions—the pointed gothic, called *Fraktur*, used in the prayer book of Emperor Maximilian I [fig. 262], printed by Johann Schoensperger in 1513—and a rounder, more cursive black letter, with *bâtarde* characteristics that became known as *Schwabacher*. The dictionary calls *Schwabacher-schrift* 'German italics.' "[3] Fraktur was a face commonly used by Pennsylvania German printers.

PRINTING AND THE MIND OF THE PENNSYLVANIA GERMAN

The illustrated and unillustrated books and periodicals of the Pennsylvania Germans give us clues to their thought. In both cases, it is quite clear that the majority of their printed—as opposed to oral—literature centered around two major points, Protestant Christianity and the affairs of daily life. They were primarily a Bible- and practically oriented people. But within this pattern there was a strong minor stream which stressed the unworldly and an interest in the occult.

The major forms of Pennsylvania German printed literature were the Bible, the almanac, and the newspaper. Closely correlated with their concern with the Bible were their modes of worship. These were reflected in a very large

Fig. 262. Johann Schoensperger and Albrecht Dürer, Fraktur text with pen and ink drawings, for the *Prayer Book of Maximilian I*. From Wolfgang Hütt, *Albrecht Dürer, 1417 bis 1578: Das gesamte graphische Werk; Handzeichen*, vol. 1 (Munich: Rogner & Bernhand, 1971), p. 758.

body of hymnody and pious literature. Around the almanac and the newspaper we can conveniently group most of the rest of their practical publications such as those for home medicine. There was also a small body of occult publications, partly practical and partly magical. This is not to say that the Pennsylvania Germans had no literature in the sense of poetry and fiction.[4] But the weight of the evidence of their printed artifacts shows that in the facet of their lives devoted to reading, their primary concerns were pious and practical, not literary.

Martin Luther's passionate concern with the Bible and with music were transferred to Pennsylvania. One of the results was that it was in Germantown in 1743 that the first

[2] Warren Chappell, *A Short History of the Printed Word* (Boston: Nonpareil Books, 1970), p. 31.

[3] Chappell, *Short History*, p. 108. For a more detailed account of the origin of Fraktur type see Walter L. Strauss, ed., *The Book of Hours of Maximilian the First* (New York: Abaris Books, 1974), p. 328. His footnote 2 and bibliography give references to recent discussions of the subject by Heinrich Fichtenau and Carl Wehmer.

[4] See Earl F. Robacker, *Pennsylvania German Literature: Changing Trends from 1683 to 1942* (Philadelphia: University of Pennsylvania Press, 1943).

Bible to be published in the North American colonies in any European language was Luther's translation into German. It also is no accident that music played such an important role in Pennsylvania German minds and hearts. Germans in America were no different from their relatives in Europe in their concern with music, both as audience and performers. Music both secular and sacred was part of the pattern of culture they brought intact from the Old World.

PUBLISHING AND PRINTING

Historical background. Andrew Bradford and Benjamin Franklin initiated printing in Pennsylvania for the German readers. Their earliest work was religious. Then in 1730, 1731, and 1732 Bradford published the first three Pennsylvania German almanacs. Franklin followed rapidly on his heels with the first German American newspaper (1732). Both publications soon failed.

It was also during the 1730s that the Pennsylvania Germans began to publish for themselves. Christoph Sower began his career as printer and publisher in 1738. In that year he published a broadside, described as "the earliest specimen of printing in German type in America," and began publication of the first successful German almanac printed in North America. On August 20, 1739, he initiated the first successful German American newspaper.[5]

Franklin attempted to dam the victorious flood of publication by the Germans. He failed. Other aspects of German life in the colony soon greatly annoyed him. In 1751 he began to use his pen to vent his spleen. In "Observations Concerning the Increase of Mankind" he made some remarks which he later allowed to be published.

And since Detachments of English from Britain sent to America, will have their Places at Home so soon supply'd and increase so largely here; why should the Palatine Boors be suffered to swarm into our Settlements, and by herding together establish their Language and Manners to the Exclusion of ours? Why should Pennsylvania, founded by the British, become a Colony of *Aliens*, who will shortly be so numerous as to Germanize us instead of our Anglifying them, and will never adopt our Language or Customs, any more than they can acquire our Complexion.[6]

Needless to say, Franklin's open expression of hostility did not inhibit the growth of German printing and publishing in Pennsylvania.

Franklin's irritation continued to grow. On May 9, 1753, he drew a precise picture of the state of the German press in Pennsylvania:

Few of their children in the Country learn English; they import many Books from Germany; and of the six printing houses in the Province, two are entirely German, two half German half English, and but two entirely English; They have one German News-paper, and one half German. Advertisements intended to be general are now printed in Dutch and English; the Signs in our Streets have inscriptions in both languages, and in some places only German: They begin of late to make all their Bonds and other legal Writings in their own Language, which (though I think it ought not to be) are allowed good in our Courts, where the German Business so encreases that there is continual need of Interpreters.[7]

The English printers to whom Franklin referred probably were Franklin and Hall and William Bradford III; the Germans were Christoph Sower I and possibly one or both of the Armbrüster brothers, Anton and Gotthard. The German English printers were probably Henrich Miller (or Müller, who also called himself Henry Miller in his bilingual *Lancastersche Zeitung / Lancaster Gazette*) and Franklin's sometime partner, Johann Boehm. Beginning with Christoph Sower, German printers had rapidly taken over the market of their fellow "Boors." And when Franklin most unwisely allowed "Increase of Mankind" to be published, German unity was further tightened.

In the development of human cultural patterns there usually can be found major points or centers of organization around which structure and function begin to develop. The published literature of any culture may not be profoundly integrated with its less articulate levels, but in the study of historical anthropology we must begin with firm facts. They may be only superficial evidence of profound complexities, but they give us a solid perch on the edge of the unknown from which we can safely explore its more murky depths.

Such significant points in the organization of early Pennsylvania German culture are the Bible, the literature of piety or devotion, the how-to-do-it books, and the popular press. We open with a survey of examples of those media published with few if any illustrations. The more complex questions raised by illustrations to printed Pennsylvania German texts will be discussed in a later section.

[5] Felix Reichmann, comp., *Christopher Sower, Sr., 1694–1758, Printer in Germantown: An Annotated Bibliography* (Philadelphia: Carl Schurz Memorial Foundation, 1943), p. 13. The statement that the "first 'Fraktur' type used in the New World" was employed in Sower's newspaper is from Karl J. Arndt and May E. Olson, eds., *German Language Press of the Americas* (Munich: K. G. Saur), vol. 1, *History and Bibliography, 1732–1968: United States of America* (3d ed., 1976), p. 523.

[6] Benjamin Franklin, "Observations Concerning the Increase of Man-

kind," *The Papers of Benjamin Franklin,* ed. Leonard W. Labaree, vol. 4 (New Haven: Yale University Press, 1961), p. 234.

[7] Franklin to Peter Collinson, May 9, 1753, *Papers of Benjamin Franklin,* p. 484.

The Bible. The primacy of the Bible among Protestants, from Jan Hus in the early fifteenth century through Luther, John Calvin, and the Anglicans of the sixteenth and early seventeenth centuries, needs no particular development here. The Sower Bible of 1743 was the first to be printed in North America in a modern European language, the first to be printed in Pennsylvania, and the first major monument of Pennsylvania German printing. For sheer size it was exceeded only by *Der Blutige Schau-Platz oder Martyrer Spiegel* (commonly known as *Martyrs' Mirror*) which was printed in 1748/49. Since there is reason to think that the printers of Ephrata, the press that produced *Martyrs' Mirror,* may have assisted with the production of Sower's 1743 Bible, it may be that some of the technical problems of printing *Martyrs' Mirror* were first solved in the production of Sower's book.

Biblia, Das ist: Die Heilige Schrift Altes und Neues Testaments, Nach der Deutschen Uebersetzung D. Martin Luthers, Mit jedes Capitels kurtzen Summarien, auch beygefügten vielen und richtigen Parallelen; Nebst dem gewöhnlichen Anhang Des dritten und vierten Buchs Esrä und des dritten Buchs der Maccabäer. Germantown: Christoph Sower I, 1743.

The title page of Winterthur's copy of Sower's Bible is the earliest variant. The clergy of Pennsylvania objected to the phrase "*Nebst dem gewöhnlichen Anhang*" ("with the usual appendix"). In order to please them, Sower changed the title page for a second impression by substituting the phrase "*Nebst einem Anhang*" ("with an appendix").[8] The title page of the Winterthur copy has been reinforced, but it appears to be original to the book.

Although smaller, the calf binding on the Winterthur *Biblia* closely resembles that on its copy of *Martyrs' Mirror* (see fig. 282). Both books have a central stud in each cover and corner mounts in brass with embossed floral and leaf designs. Both originally had two straps fastened with three rivets and with hooks which clipped into clasps on the upper board of the binding. The straps and hooks are missing from the Bible; the clasps are intact.

Literature of piety. In addition to the Bible, the religious literature of the Pennsylvania Germans consisted of Biblical commentaries, discussions of doctrine ranging from catechisms to full-size theological monographs, psalm books, and hymnals (with or without printed or engraved music), religious music per se, and works of personal devotion.

The majority of the printed religious literature at Winterthur consists of works of piety, the genre that formed the basis of Henri Bremond's magnificent study, *Histoire littéraire du sentiment religieux en France.* Bremond's major concern was with French writing of this kind. But some of the literature he studied was translated from French and printed in Pennsylvania in German and/or English by German printers. Our primary concern is the literature printed in German, but it cannot be understood except in the context of related French, English, Dutch, and even Spanish, Italian, and Latin writing in the same field. One of the best means of understanding some of the intellectual complexities of Pennsylvania German culture is to study its literature of devotion. The religious publications of those people in the eighteenth and early nineteenth centuries were both highly eclectic and international in origin.[9]

The majority of German language devotional works printed in eighteenth-century America consisted of reprints, some of them translations from English and French. Even the orthodox among the Germans shared with the Quakers an interest in reading Catholic devotional works such as the *Imitation of Christ* of Thomas a Kempis and the quietist writings of Archbishop Fénelon and Madame Guyon. Judging by the number of surviving copies, one of the most popular books published by Christoph Sower was an English translation of Fénelon called *The Archbishop of Cambray's Dissertation on Pure Love* [*of God*].

Finally, we can point to a minor note in Pennsylvania's pious literature. Some of it, at least, was characterized by a tone that New Englanders, had they known about it, would have condemned as frivolous. Early in the eighteenth century the religious emblem book had become in New England a thing for children. In Pennsylvania it was popular among adults until the mid nineteenth century. It is true that in seventeenth-century New England emblem books were taken seriously, so seriously that their pictures were used as a source of decoration for gravestones. But who in New England would have put out as Sower did in Pennsylvania a devotional book—*Der frommen Lotterie* (1744)—in the form of playing cards for a game?

Although religious literature was published among the Pennsylvania Germans in large quantity, the curious fact is that the most monumental book printed in eighteenth-century Pennsylvania was not published by or for the orthodox. It was printed on the Ephrata press for the Mennonites. It was designed to inspire its readers with the examples of holiness set by the lives of its subjects.

[8] Reichmann, *Christopher Sower, Sr.*, pp. 22, 23. In this and the book headings that follow the capitalization and spelling reflect that found on the title page of each work. The standardized spelling of publishers' and printers' names is based on Roger Patrell Bristol, *Index of Printers . . .* (Charlottesville: Bibliographical Society of the University of Virginia, 1961), and his *Supplement . . .* (Charlottesville: University of Virginia Press, 1971).

[9] E. Ernest Stoeffler, *Mysticism in the German Devotional Literature of Colonial Pennsylvania,* Pennsylvania German Folklore Society, vol. 14 (Allentown, Pa., 1950), pp. vii–xii, 1–171.

[Tieleman Janszoon van Bracht]. *Der Blutige Schau-Platz oder Martyrer Spiegel der Tauffs Gesiñten oder Wehrlosen-Christen, Die um des Zeugnuss Jesu ihres Seligmachers willen gelitten haben, und seynd getödtet worden, von Christi Zeit an bis auf das Jahr 1660.* Ephrata: Drucks und Verlags der Brüderschafft, 1748/49.

The history of the making and publication of one unique monument of early American printing fortunately is preserved by a near-contemporary source. *Chronicon Ephratense* (1786) by Brothers Lamech and Agrippa is the official history of Ephrata and its founder, Johann Conrad Beissel. Although opinion is divided on the identification of its authors, *Chronicon* was published while Peter Miller (Müller) was superintendent of Ephrata. He had been a member of that community since the early 1740s; therefore, the probability that *Chronicon's* account is substantially correct is high.

Martyrer Spiegel, or *Martyrs' Mirror*, is a history of those who were martyred for their faith in Christ. It is the Continental Protestant equivalent of John Fox's *Actes and Monuments* which was published in sixteenth-century England. It was compiled by Mennonite clergyman Tieleman Janszoon van Bracht, a Dutch follower of Swiss Protestant Reformer Menno Simons. A priest who left the Roman Catholic Church in 1536, Simons helped organize the remnants of the Anabaptists left after the attacks on them by both Catholics and Lutherans. A separatist group believing in adult (as opposed to infant) baptism, the Mennonites were an object of particular persecution in Europe. Van Bracht published his history of martyrs, which was primarily concerned with the sufferings of the members of his own faith, in Holland in 1660.

Among the first Germans to settle in Pennsylvania were the Mennonites. Since *Martyrs' Mirror* was the major publication of their sect and was in Dutch, these early German settlers—many of whom did not read Dutch—felt the need for a German translation of van Bracht's book. In the 1740s they approached the community at Ephrata as possible publishers. For in spite of many differences and difficulties between the two groups, there were still many ties between them.

With the above brief sketch as background we can turn to the history of the printing and publication of the book as given by Brothers Lamech and Agrippa.

The Mennonites in Pennsylvania agreed that their great Book of Martyrs, which was printed in the Dutch language, should be translated and printed in German. No one in the whole country was considered better able to do this than the Brotherhood in Ephrata, especially since they possessed a new printing press and a paper-mill, and moreover were able to put a sufficient number of hands to work. The contract was very advantageous for the above-mentioned Mennonites, for it was agreed on both sides that the Brethren should translate and print the book, but the Mennonites should afterwards have liberty to buy or not to buy.

. . . The printing of the Book of Martyrs was taken in hand, to which important work fifteen Brethren were detailed, nine of whom had their work assigned in the printing department, namely, one corrector, who was at the same time the translator, four compositors and four pressmen; the rest had their work in the paper-mill. Three years were spent on this book, though not continuously, for there was often a want of paper. And because at that time, there was little other business in the Settlement, the household of the Brethren got deeply into debt, which, however, was soon liquidated by the heavy sales of the book. The book was printed in large folio form, contained sixteen reams of paper, and the edition consisted of 1300 copies. At a council with the Mennonites, the price of one copy was fixed at twenty shillings, (about £1), which ought to be proof, that other causes than eagerness for gain led to the printing of the same.

That this Book of Martyrs was the cause of many trials among the Solitary, and contributed not a little to their spiritual martyrdom, is still in fresh remembrance. The Superintendent [Beissel], who had started the work, had other reasons than gain for it. The welfare of those entrusted to him lay near his heart, and he therefore allowed no opportunity to pass which might contribute anything to it. Those three years, during which said book was in press, proved an excellent preparation for spiritual martyrdom, although during that time six failed and joined the world again. When this is taken into consideration, as also the low price, and how far those who worked at it were removed from self-interest, the biographies of the holy martyrs, which the book contains, cannot fail to be a source of edification to all who read them.[10]

The physical evidence of the book adds further detail. The text of the Dutch original was translated at Ephrata, and the physical makeup of the book was also reproduced in an adapted form. The adaptation was not slavish. An Ephrata style was imposed on the original. For example, the Dutch original of 1660 and the Ephrata translation had two title pages, one engraved and pictorial, the other printed. The original title page was decorated with vignettes showing a selection of historical martyrdoms. The American engraved title page (if not engraved in America for the community, probably done for the press from an American design) was elaborately allegorical. Even the Ephrata-printed title page was an adaptation of the original (fig. 263). The elaborate, highly decorated Fraktur type used at Ephrata was new and different, and the printer's mark at the foot of the original printed title page was reproduced in a simplified and adapted form: in the edition of 1660 the emblem had the Latin motto *Fac et Spera*, at Ephrata it was translated into *Arbeite und Hoffe* ("work and hope").

Literature of daily life: How to do it. The English-language how-to-do-it collection at Winterthur primarily consists of what may be called self-help books of the natural world.

[10] Brothers Lamech and Agrippa, *Chronicon Ephratense: A History of the Community of the Seventh Day Baptists at Ephrata, Lancaster County, Penn'a.*, trans. J. Max Hark (Lancaster: S. H. Zahm, 1889), pp. 209–14.

Fig. 263. Title page. From Tieleman Janszoon van Bracht, *Martyrer Spiegel* (Ephrata: Brüderschafft, 1748). (Collection of Printed Books and Periodicals, Winterthur Museum Library.)

The majority deal with the realities of everyday urban life. Instruction is offered in eighteenth-century equitation and dance. The books describe rules for handwriting and etiquette. They tell what to say in letters on a variety of occasions. The nineteenth-century volumes were particularly concerned with the playing of respectable games—croquet and baseball. In an age when trained servants were already beginning to become scarce, proto-Victorian volumes also laid down a code for training the valet and footman.

In contrast, the how-to-do-it books in German at Winterthur, although printed in urban centers, for the most part deal with rural life. The major topics are medical—medicines for the human body and mind and for the farm ani-

mal. Both medicines were intimately involved with magic among the Pennsylvania Germans.

Magic is a subject on which one must be very careful when discussing the Pennsylvania Germans. Part of the sensationalism of the subject is due to journalism. Unfortunately, a good deal of it also is due to romantic historians of the nineteenth and the early twentieth centuries who overemphasized the occult strains of the Pennsylvania Germans. No one has ever produced evidence that anything comparable to the Salem witch trials occurred in seventeenth- or eighteenth-century Pennsylvania. But there can be no doubt that some of the eighteenth-century Pennsylvania Germans early acquired a reputation for a concern with the occult, specifically with alchemy and witchcraft.

William McCulloch sent Isaiah Thomas notes on the Pennsylvania Germans that show how early the occult label was attached to some of those people. Of Charles (Carl) Cist, a German immigrant printer who worked in the 1770s and 1780s, McCulloch wrote: "Cist tried many an earnest endeavor to discover the philosopher's stone; but with no other effect than rendering himself extremely poor. He at last turned his attention solely to printing, which he found much more profitable than cabalistic scrutiny."[11]

Anton Armbrüster was the printer brother of Gotthard, a man we shall meet in the discussion of the history of the illustration of Pennsylvania German almanacs. Anton's fear of witches and his attempts to force the devil to divulge the secrets of the buried treasure of Captain Kidd and the pirate Blackbeard "in the vicinity of Philadelphia" amused McCulloch. But what McCulloch wrote to Thomas about Armbrüster's dabbling in witchcraft, he obviously thought true—even if laughable.

The subject of Pennsylvania German magic is only touched on by printed evidence in the Winterthur collection. Although there is nothing new about the evidence in our holdings, it is important that we point out that the evidence exists and that it is part of the total portrait of the culture we are trying to sketch.

In our holdings of Pennsylvania German how-to-do-it manuals are two books written by Johann Georg Hohman (Hohmann, Homan). Both are medical handbooks. The first combines medicine with the tradition of the grimoire, the grammars of magic. The second covers medicine for both the human and his livestock. And even in animal husbandry Hohman's books apply some of the grimoire to veterinary medicine.

The grimoire, unlike the Hermetica, the Cabala, or the fifteenth- and sixteenth-century philosophical works of

[11]Brigham, "McCulloch's Additions," p. 203.

Marsilio Ficino and Agrippa von Nettesheim, is a practical book of spells, a cookbook of the occult. Some of them contain recipes of great antiquity. Other material belongs to the age of the occult in the sixteenth and seventeenth centuries. One contains fresh practices from early nineteenth-century Pennsylvania.

Hohman and his wife arrived in Philadelphia from Hamburg in 1802. He first worked in Bucks County but soon moved to Northampton County. By 1805 he was working in Berks County, and he continued to work there for the rest of his known life. Evidence indicates that he was a Catholic. He published a considerable variety of books including a Catholic catechism which appeared in 1819. In the preceding year he published *Die Land- und Haus-Apotheke* [The farm- and house-apothecary]. In 1819 he first published *Der lange verborgene Freund* [The long hidden friend]. He published several other works before 1836, when he disappeared from the records.[12]

We are concerned with *Freund* of 1819 and *Apotheke* of 1818. Of the two, the better known is the former. It was reprinted many times and was published in an English translation. It is the classic Pennsylvania German "powwow book," a grimoire of white magic. It reproduces the *Sator/Arepo* formula for an amulet which may date to ancient Rome. It carries a charm that involves the three kings, or magi, Caspar, Melchior, and Balthasar, whose supposed shrine was in Cologne—a city extremely important in the history of medieval and Renaissance German magic. The book is clearly based on a belief in the reality of powerful black (evil) magic, and, although the magic recipes given by Hohman are beneficent, he makes clear that he believes his charms have great power over evil. The book begins with a long account of illnesses successfully treated by Hohman and his wife between 1815 and 1819. It ends with a claim that the book itself is a charm, which may explain why a considerable number of early copies of the book have survived.

Johann Georg Hohman. *Die Land- und Haus-Apotheke, oder getreuer und gründlicher Unterricht für den Bauer und Stadtmann . . . Erste americanische Auflage*. Reading: Carl A. Bruckman, 1818.

The first part of *Apotheke* is devoted to cures for human ills such as frostbite, children's worms, rheumatism, fistulas, and cuts. Although the author brought up the subject with professed reluctance, he included a discussion of venereal diseases. He also presented rather heterogeneous recipes for homemade wines and other

beverages, salves, and hair dyes.

The majority of the rest of the book deals with veterinary medicine. The horse holds first place. Although there is no illustration of a vein horse parallel with the almanacs' vein man, Hohman gave an account of equine bloodletting and listed the correlations between the parts of the horse and the signs of the zodiac. Cows and pigs are given separate sections. The book concludes with a long section on dyes and dyeing, covering a wide range of colors for a variety of textiles.

Hohman's *Apotheke* is just as much a practical handbook as the *Freund*. But, unlike the latter, it has no Latin formulas, has no spells or charms, and makes no claims as an amulet. In part it is a simple handbook for home medicine, like the book attributed to John Tennant, *Every Man His Own Doctor* (Williamsburg, 1734), which Benjamin Franklin republished in Philadelphia. Although Franklin published a German translation of the book in 1749, it could have had little effect on a large German market. There was a definite demand for Hohman's book by 1818, as its eleven-page list of Pennsylvania German subscribers attests.

Newspapers. The world's first newspaper was the *Avisa Relation oder Zeitung* published by Johan Carolus of Strasbourg in 1609. "Earlier efforts in this line had taken the form of single sheets devoted to special events and had appeared irregularly, as occasions warranted," Warren Chappell explained. "England's first news publication of substance was issued the year before the First Folio, in 1622, by Nathaniel Butter, Nicholas Bourne, and Thomas Archer." The Pennsylvania Dutch of the nineteenth century developed an extraordinary number of German-language newspapers, but the eighteenth-century beginnings were slow.[13]

The first American newspaper was the one and only issue of *Publick Occurrences*, published in Boston September 25, 1690. It was printed by Richard Pierce for Benjamin Harris at Boston's London Coffee House. Its demise was due to its immediate suppression by the governor and council of Massachusetts.[14]

The fourth newspaper published in the mainland colonies was Pennsylvanian. *American Weekly Mercury*, printed and sold in Philadelphia by Andrew Bradford, began pub-

[12] Wilbur H. Oda, "John George Homan, Man of Many Parts," *Pennsylvania Dutchman* 1, no. 16 (August 18, 1949): 1.

[13] Chappell, *Short History*, p. 127; Karl John Richard Arndt and May E. Olson, *German-American Newspapers and Periodicals, 1732–1955: History and Bibliography* (n.d.; reprint ed., New York: Johnson Reprint Corp. 1965). For more information, see Arndt and Olson, *German Language Press*, vol. 1, *History and Bibliography*, and vol. 3, *German-American Press Research from the American Revolution to the Bicentennial* (1980).

[14] Clarence S. Brigham, *History and Bibliography of American Newspapers, 1690–1820*, 2 vols. (Worcester, Mass.: American Antiquarian Society, 1947), 1:340.

lication December 22, 1719, well after the beginning of German immigration. It was an English-language newspaper which paid little or no attention to the German inhabitants of the colony.

In 1732 Franklin attempted to catch the interest of the German-speaking community with *Philadelphische Zeitung*. We know of only two surviving issues, numbers 1 and 2, May 6 and June 24, 1732.[15] The paper was in the German language but, like all Franklin's German publications before the mid 1750s, was in a roman typeface. Although unsuccessful, it was the first German-language newspaper to be printed in Pennsylvania.

The first successful Pennsylvania German newspaper was published by Christoph Sower. It began under the title *Hoch-Deutsch Pennsylvanische Geschicht-Schreiber* on August 20, 1739. In 1745 its title changed to *Hoch-Deutsch Pennsylvanische Berichte*. Under the title *Germantowner Zeitung*, it was published from 1766 to 1776.[16] The publishers were three generations of Sowers.

The first German-language newspaper published in Lancaster was *Lancastersche Zeitung*, a bilingual paper published by Henrich Miller in 1752 and 1753. Its successor was *Pennsylvanische Zeitungs-Blat*, published by Francis Bailey under the name of Frantz Bailey. It lasted from February 4 to June 24, 1778. On August 8, 1787, Anton Stiemer, Johann Albrecht, and Jacob Lahn started a weekly newspaper under the title *Neue Unpartheyische Lancäster Zeitung, und Anzeigs-Nachrichten*.[17]

In the section of his *History of Printing* (1810) devoted to Pennsylvania and for that devoted to the American newspaper, Thomas published some remarks on the publishers of *Neue . . . Zeitung*. McCulloch corrected them, giving many biographical details.

Neue Unpartheyische Lancäster Zeitung, und Anzeigs-Nachrichten. Lancaster, 1787–90.

After a statement of editorial policy, the weekly paper opens number 1 on August 8, 1787, with a letter from a well-wisher and a "history of troglodytes" (fig. 264). A headline is given to European news on page 2. American news from Pittsburgh, Philadelphia, and Lancaster follows on page 3. Philadelphia market prices are given for twenty-two items. This is followed by an unsigned

Fig. 264. First issue of Anton Stiemer's *Neue Unpartheyische Lancäster Zeitung* (Pennsylvania) (August 8, 1787). (Collection of Printed Books and Periodicals, Winterthur Museum Library.)

poem and a signed letter to the editors. Advertisements begin on page 3. The entire fourth page is devoted to advertisements for the almanac of 1788 being issued by the publishers and a list of stationery and English and German books available from their bookstore. (The majority of the books offered are German titles.)

The Winterthur holdings of this important weekly newspaper run from August 8, 1787, to July 14, 1790, except for numbers 21, 38, 98, and 106.

THE BOOK ARTS IN

GERMAN PENNSYLVANIA

Like the English printers in America, the Germans lacked a constant supply of paper and type, but they were the first to fill those needs adequately by American manufacture. We have chosen examples from the Winterthur collection to show how Pennsylvania Germans solved these fundamental challenges and made other important contributions to the history of the graphic arts in America.

PAPER MANUFACTURE

In 1810, Thomas wrote of the origin of papermaking in the British colonies of North America: "Whether the European method of making paper has ever been introduced into Spanish America, I am not competent to say; but, in some of the English colonies, making paper from rags of cotton

[15] C. William Miller, *Benjamin Franklin's Philadelphia Printing, 1728–1766: A Descriptive Bibliography* (Philadelphia: American Philosophical Society, 1974), pp. 29–30.

[16] Edward Connery Lathem, comp., *Chronological Tables of American Newspapers, 1690–1820: Being a Tabular Guide to Holdings of Newspapers Published in America through the Year 1820* (Barre, Mass.: American Antiquarian Society and Barre Publishers, 1972), p. 3.

[17] Brigham, *History*, 2:873–95.

and of linen, has long been practised. Papermills were erected in Pennsylvania many years before the revolution. There were several in Newengland, and two or three in Newyork."[18]

In 1812 McCulloch wrote to Thomas from Philadelphia. One of the first topics on which he offered information was the origin of papermaking. "Mr. Wilcox . . . was the first paper maker in Pennsylvania," and "Mr. Rittenhouse, brother to the philosopher, erected the second mill in Pennsylvania (some short time after the Wilcox) near Germantown."[19]

McCulloch had confused the seventeenth-century papermaking Rittenhouse with David, eighteenth-century scientist and clockmaker, but early in 1815, McCulloch sent Thomas 296 pages of further information. He said that he was "totally wrong with respect to what I before sent you respecting the first paper mills erected in Pennsylvania." He attributed his errors to his mistake in oral history techniques, for his original account had been based on information obtained from young informants. "I have since been at the spots and conversed with the elders, some of whom have arrived at a very advanced age." "The first paper mill in Pennsylvania was erected on Paper Mill run, a small stream of the Wishahicon creek, 6 miles north of Philadelphia, by Nicholas (or Klaus, as it was then spelled) Rittenhouse."[20] McCulloch went on to quote his informants at length on the appearance of the mill, to correct his genealogical errors and his mistakes in dates, and to cite the manuscript evidence he had found in a Rittenhouse family Bible.

Much research has been done on the subject of the origin of papermaking in America since 1815, and it has confirmed, with minor corrections, most of McCulloch's statements. It has now been established that William (Wilhelm), the father of Nicholas, commenced the industry. Also, the family name was Rittinghuysen; the father and son were born in Mülheim-an-der-Rhur and emigrated from Holland to New York City and then to Roxborough near Germantown.[21] McCulloch also gave a great deal of information on later German American manufacturers in the commonwealth, data that has not yet been exploited to the full.

At Winterthur we have long been collecting early manuscripts written in the United States. They were inscribed on both imported and American-made paper. Thus, we found that in the natural course of events we had accumulated documents valuable not only for their inscriptions but also for their watermarks. We have strengthened this collection by buying paper for its watermarks alone and have built an important reference file of American-made paper. The watermarks used by more than fifty Pennsylvania Germans have been identified, one of which is reproduced as figure 265.[22]

TYPEFOUNDING

In addition to his contributions to the subject of Pennsylvania German paper manufacture, McCulloch tried to help Thomas revise his material on the history of American typefounding. Thomas had stressed—inaccurately—the priority of the German introduction of the art in Pennsylvania: "A Foundry, principally for Gothic, or German types, was established at Germantown, Pennsylvania, several years before the revolution; but that foundry was chiefly employed for its owner, Christopher Sower, who printed the Bible, and several other valuable works, in the German language. Some attempts were made about 1768, to establish foundries for types—one at Boston by mr. Mitchelson, from Scotland; another in Connecticut by a mr. Buel; but they were unsuccessful. In 1775, dr. Franklin brought from Europe to Philadelphia, the materials for a foundry; but little use was made of them."[23]

In his first letter to Thomas, McCulloch discussed the history of typefoundries. He brought to the attention of Thomas the work of Justus Fox, a typefounder in Germantown. Then he went on to discuss Christoph Sower II and his son Samuel. Like many people since, McCulloch managed to confuse the various Sowers with each other (and with others). As in the case of papermakers, when McCulloch again wrote to Thomas in 1815, he confessed that he had been confused, tried to straighten out the Sower-Fox question, and discussed other Pennsylvania German typefounders. In this case, McCulloch was only partially successful. Both he and Thomas were inaccurate about German primacy in typecasting in this country, but they were not far off target. David Mitchelson and Abel Buell had made English types in this country as early as 1769. Christoph Sower I made no type at all, but he did employ as a craftsman Justus Fox soon after Fox arrived from Germany circa 1750.

[18] Isaiah Thomas, *The History of Printing in America: With a Biography of Printers, and an Account of Newspapers; To Which is Prefixed a Concise View of the Discovery and Progress of the Art in Other Parts of the World*, 2 vols. (Worcester: Isaiah Thomas, Jr., 1810), 1:213.

[19] Brigham, "McCulloch's Additions," p. 92.

[20] Brigham, "McCulloch's Additions," pp. 111, 112.

[21] Dard Hunter, *Papermaking by Hand in America* (Chillicothe, Ohio: Mountain House Press, 1950), p. 15.

[22] Thomas L. Gravell and George Miller, A *Catalogue of American Watermarks, 1690–1835* (New York and London: Garland Publishing, 1979).

[23] Thomas, *History of Printing*, 1:213–14.

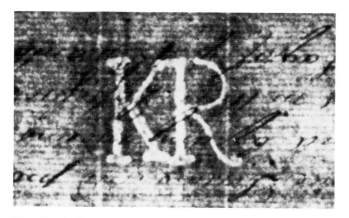

Fig. 265. Third watermark of the Wilhelm and Klaus Rittinghuysen papermill, Germantown, used in 1734 and earlier. The watermark is on a letter of administration to Mary Webb, 1731. (Richardson Family Papers, Joseph Downs Manuscript and Microfilm Collection 53.165.562, Winterthur Museum Library: Photo, Thomas L. Gravell.)

In 1743, the elder Sower had published the first Bible printed in this country in a European language. His son, Christoph II, printed a second issue in 1762, and a third in 1776. Christoph II imported all the equipment for typecasting from Germany in 1770. In 1771 and 1772, he printed the text of a religious periodical with what may have been the first German typeface cast in America.

Fox, kept on as a Sower employee by Christoph II after the death of Christoph I, "cast a complete font of German letters for the Bible that Sower printed in 1776."[24] Although not the first to make the effort, Christoph II was the first to succeed in the commercial production of American type.

Although Winterthur Museum Library contains no examples of the Sowers' printing with type cast from imported German molds or of the work Christoph II produced with type made by Fox, we have so many examples of work by Fox, Christoph I, Christoph II, and the latter's son, Samuel (himself the first typecaster of the Sower family), that it seemed worthwhile to insert this note on the family's close involvement with the introduction of German typecasting to Pennsylvania.

ILLUSTRATIONS

One of the most intriguing aspects of the publications imported and / or printed by the Pennsylvania Germans is their obvious emphasis on illustration. Of the imported books the principal evidence is biblical.

Artist Albrecht Dürer was, at the very least, sympathetic to Luther and his reforms. Some of Dürer's late work is Lutheran in inspiration. Luther himself was much addicted to the use of pictures in his own publications. He used them for propaganda warfare, both offensive and defensive, and for purposes of devotion: he fought Roman Catholic fire with fire derived from Roman Catholic sources. He was also a patron of artists. The text of Luther's New Testament (1522) was richly illustrated by his follower Lucas Cranach the Elder and his followers. The Cranach illustrations to the Luther Bible established a long tradition for printed German Bibles. Illustrated examples were imported to Pennsylvania as early as the beginning of the eighteenth century. They were not only read but, as Henry Mercer demonstrated in 1914, also used as a source for the decoration of German American cast-iron stoves.[25]

As will be discussed in more detail in connection with Johann Arndt's *Wahren Christenthum*, the genre of the emblem book, popular throughout sixteenth- and seventeenth-century Catholic and Protestant Europe, began publication in Augsburg in 1531. The text of the first edition of the first emblem book was written by humanist Andrea Alciati of Padua, but its illustrations, to the best of our knowledge, were supplied by artists employed by the book's Augsburg publisher.[26] The emblem book became a favorite form of Pennsylvania German literature printed in the state well into the second half of the nineteenth century.

The most widespread form of Pennsylvania German illustrated literature was the almanac. It was characterized by three contributions which flourished among German almanacs and also spread to English-language versions—illustrated covers, labors of the month, and vein man.

Illustrated covers were used in British-printed almanacs of the sixteenth and seventeenth centuries. How common they were and the variety of form they took are subjects that need more investigation. The earliest evidence of American illustrated almanac covers are publications by the Sowers. The first was the full-page woodcut cover of *Der Hoch-Deutsche Americanische Calender* for 1743.[27] For lack of other evidence, its design has sometimes been attributed to Sower himself, but the craftsman who cut the woodblock is unknown.

[24] Maurice Annenberg, *Type Foundries of America and Their Catalogs* (Baltimore and Washington, D.C.: Maran Printing Services, 1975), p. 27.

[25] Henry C. Mercer, *The Bible in Iron: Pictured Stoves and Stoveplates of the Pennsylvania Germans,* ed. Horace M. Mann and Joseph E. Sandford (3d ed., Doylestown, Pa.: Bucks County Historical Society, 1961).

[26] Mario Praz, *Studies in Seventeenth-Century Imagery* (2d ed., Rome: Edizioni di Storia e Letteratura, 1964).

[27] Sinclair Hamilton, *Early American Book Illustrators and Wood Engravers, 1670–1870* (Princeton: Princeton University Library, 1958), p. 8.

Fig. 266. October. From Benjamin Franklin, *Poor Richard Improved* (Philadelphia: B. Franklin and D. Hall, [1763]), unpaged. (Collection of Printed Books and Periodicals, Winterthur Museum Library.)

The craftsman who cut the woodblock for the second known American illustrated cover signed it "Leech." It was made, at the latest, for Christoph Sower II's *The Pennsylvania Town and Country-Man's Almanack* for 1755. That Sower I or II may have been the designer is completely possible since it is unlike anything English known at this time. The second almanac's text itself is a hybrid product of the fusion of German and British cultures. The principal author was John Tobler, a Reformed (Calvinist) minister from Saint Gall, Switzerland, the publisher, Sower II, was an immigrant from Germany, and the language of the almanac was English.[28] We know little about the artist, but his name implies he was of English origin, so the cover, like the text, may be a hybrid.

The use of a cover illustration was taken up in Pennsylvania by other German publishers. Eventually it became a common feature of the American almanac in general.

In 1748 and later, Philadelphia printer Gotthard Armbrüster used Labors of the Month cuts in his German almanac for 1749. These cuts were also used in 1748 by Benjamin Franklin to adorn the calendar in *Poor Richard Improved* for 1749. The evidence assembled by Elizabeth Carroll Reilley indicates that these are the first cuts of Labors of the Month used in any American almanac printed in either English or German.[29]

The fact that the harvest of grapes and the manufacture of wine were represented by Armbrüster and Franklin as characteristic activities for the month of October is sound evidence that, no matter where the blocks for these small prints were cut, the inspiration was Continental (fig. 266). For example, in a Florentine calendar dated 1464/65, like the Armbrüster calendar, October is characterized by the making of wine. A difference is that the earlier Italian print does not show the harvest of the grapes. A further difference is that in the Italian print the process of winemaking stops at treading, while in the Philadelphia print the winemaker is shown standing in the middle of his vat drinking must from an extremely large jug. In both German and Pennsylvania German almanacs the name for October is *Weinmonat* (wine month). The making of wine is a traditional activity associated with October in Italy and Germany. Although America had been noted since Vinland days for its grapes, the making of wine from them in 1748 was not a North American custom nor was it British.

The woodblock print, a fourteenth-century invention, was used to illustrate almanacs and medical texts with prints of several major types to assist the surgeon. Two of these today are widely known in English as Man of Signs and Vein Man.

The first type, usually represented as seated on what the contemporary sources identified as a "pumpkin," was used in seventeenth- and early eighteenth-century English-language almanacs in British America as a whole. The second type, almost invariably in a standing position, appeared first in Philadelphia in 1730. It was published in the earliest known Pennsylvania German almanac which, although printed in the German language in roman type, was issued by Andrew Bradford.[30]

[28] Hamilton, *Illustrators*, p. 12.

[29] Edwin Wolf 2nd, "Franklin and Other Philadelphians," *The Annual Report of the Library Company of Philadelphia for the Year 1977* (Philadelphia, 1978), p. 9; Elizabeth Carroll Reilly, *A Dictionary of American Printers' Ornaments and Illustrations* (Worcester, Mass.: American Antiquarian Society, 1975), pp. 413–32.

[30] Reilly, *Dictionary*, p. 455.

In German publications, Vein Man was usually the illustration for a chart that told how to use the figure as a guide *vom Aderlassen und Schröpfen* ("for bloodletting and cupping"). The chart told when the operations were to be performed and what the results would look like, serving as both an instruction manual and a guide to diagnosis for the amateur or professional barber-surgeon. The times set by the chart depended on the relationship of the moon to the zodiac. These variables were accounted for by the text of the chart. A constant factor in operations was the fixed astrological relation between the zodiac and the parts of the body recommended for bleeding and cupping. The woodcut of Vein Man was coded to show the different qualities of that relationship: an optimal relationship was indicated by a *G*, standing for *gut* ("good"); an unfavorable one was indicated by *B*, for *böse* ("evil"); an indifferent relation was symbolized by *M*, for *mittel* ("middling").

In 1748 Franklin published a Vein Man in *Poor Richard Improved* for 1749 (fig. 267). The fact that *B*, *G*, and *M* were used in the cut demonstrates that, as in the Labors of the Month, Franklin borrowed the figure from a German source. Unlike the German almanacs, *Poor Richard* did not have a bloodletting and cupping chart, even in translation.

Presumably as a result of the prestige of *Poor Richard*, other American English-language almanacs followed Franklin's example. The standing Vein Man even penetrated New England and replaced the seated Man of Signs. Outside the German-language almanacs the initial letters on Vein Man, meaningless to English readers, soon were dropped. But today Vein Man and Labors of the Month remain part of the decoration of current American English-language almanacs.

Illustrators. One of the major streams of German art consists of prints and book illustrations, especially woodcuts and copperplate engravings. Printing of pictures from woodblocks began in western Europe with the printing of cloth before the fourteenth century. Print specialist A. Hyatt Mayor explained: "As early as 1395 a German was printing holy images on paper in Bologna. Since the Italians made paper a century before the Germans, and also dominated painting, they would logically have been the first Europeans to print woodcuts. But if so, they did not preserve theirs, unlike the Germans, by pasting them inside book covers and boxes." The plot thickens. Engraving began in the techniques of the silversmith. "In the time and the region of Gutenberg's experiments, an engraver marked the earliest surviving date—1446—on any intaglio print."[31] The picture

[31] A. Hyatt Mayor, *Prints and People: A Social History of Printed Pictures* (New York: Metropolitan Museum of Art, 1971), figs. 5, 112.

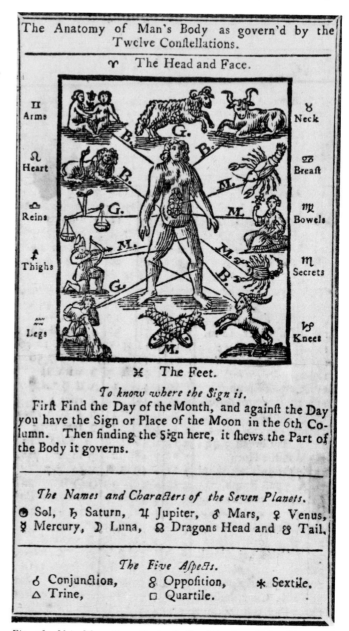

Fig. 267. Vein Man. From Benjamin Franklin, *Poor Richard Improved* (Philadelphia: B. Franklin and D. Hall, [1763]), unpaged. (Collection of Printed Books and Periodicals, Winterthur Museum Library.)

is a *Flagellation of Christ*. That it is not merely an impression taken from the decoration of a silver object is demonstrated by the fact that the numerals have been printed from the metal plate on which they were engraved in reverse.

German-speaking immigrants to Pennsylvania brought woodcutting and engraving with them in the form of completed prints and illustrated books; they also brought with

them the techniques of woodblock cutting and engraving. Finally, the later immigrants brought with them the much more recent art of lithography invented in Munich in the 1790s.

To represent the Pennsylvania German woodcut artist we have chosen Justus Fox (1736–1805). McCulloch, again, is our major source. Although the following passage by no means includes all of McCulloch's information about Fox's career, it contains the heart of the facts he gathered on Fox's work as an illustrator. The reader will be quite correct if he infers that a great deal of research remains to be done on Fox, whose work certainly merits the effort.

Justus Fox was born March 4, 1736, in the city of Manheim, Germany. His father, a cabinet maker there, was in circumstances affluent enough to give Justus a good education. . . .

He arrived at Philadelphia, with his father, in the beginning of September, 1750. . . . The next day after his arrival, Justus was carried out to Germantown [by Christoph Sower]. He was immediately put in the printing office. . . .

Justus served 6½ years, till he was of age with Sower. He afterwards worked with Sower 1st till the old man died, and then with Sower 2d. . . .

Fox cut in wood the bust of Gen. James Wolfe, and the plan of Quebec and its environs, which were inserted in one of Sower's almanacs shortly after the city was captured from the French. I have seen these engravings, and they are really well executed. Fox cut numbers of things in that way for almanacs and other works. . . .

Justus Fox possessed a ready talent in drawing heads and designs on wood. Every thing of the kind he cut was on apple wood. . . .

Fox was nice, to a hair, in all his work, and displayed great patience and pains in its execution. . . .

Justus Fox possessed a versatile turn. He was employed for many years by Sower 2d in making lampblack. He was an excellent bleeder, and cupper, and tooth drawer. And he never used any fleams, or other instruments necessary in these lines, but those of his own making; and they were of the very best kind. He also kept an apothecary shop, as well as Sower 2d; and did a little in the practice of medicine. He was, at one and the same time, a farrier, an apothecary, a bleeder and cupper, a dentist, an engraver, a cuttler, a turner, a lampblack manufacturer, a maker of printer's ink, a typefounder, and a physician. Like Sower 1st and 2d he was jack of all trades.[32]

The Pennsylvania German illustrator whose work is most extensively represented in the Winterthur collection is Carl Friederich Egelmann (1782–1860). We have chosen him as the most interesting figure among Pennsylvania German engravers. He was an astronomer and mathematician, an author of both poetry and prose, a newspaper editor and

[32]Brigham, "McCulloch's Additions," pp. 164–68.

Fig. 268. Carl Friederich Egelmann, The Writing Master with a *Warning to Youth.* From C. F. Egelmann, *Deutsche & Englische Vorschriften für die Jugend* (Reading, [1821?]), unpaged. (Collection of Printed Books and Periodicals, Winterthur Museum Library.)

publisher, and a businessman.[33]

Egelmann, born in Neuenkirchen, Germany, on May 12, 1782, reportedly arrived in Baltimore in 1802. He worked there as a coachmaker and made chairs. He then became a schoolteacher in Chester, Pennsylvania. Later he moved to Heidelberg Township (now Wernersville), Berks County. He became organist and choirmaster and taught German at Hain's Church, near the Kershner house (three of whose rooms are now at Winterthur). By 1815 he held the same posts in Alsace Township. During the 1820s he was drawn to urban life, and he lived in or near Reading, Berks County, until his death. Egelmann may have begun his teaching career as an instructor in English. His almanacs and many of his publications show that he was bilingual and took an active part in both German-speaking and English communities of early America. He contributed astronomical calculations to one or more issues of seventy-six American almanacs. Of these, only twenty-six were published in German.

[33]Louis Winkler, "Pennsylvania German Astronomy and Astrology VII: Carl Friederich Egelmann," *Pennsylvania Folklife* 23, no. 1 (Autumn 1973): 2–12.

Unlike most Pennsylvania German graphic artists, Egelmann worked on copperplate engravings more often than on woodcuts. He did both prints and book illustrations, and in at least one case, that of his copybook, he produced an entire book by engraving alone. Very probably the largest collection of Egelmann's work as an engraver is in Berks County Historical Society, Reading, but Winterthur has a representative collection of his birth and baptismal certificates, almanac work, and book illustrations (fig. 268).

The third of our Pennsylvania German illustrators, Augustus Kollner (1812–1906), has been chosen to represent accomplishment in the distinctively German art of lithography.

The art of lithography was originated by Alois Senefelder, a young German artist, in Munich in the 1790s. "In 1800 he sought a patent in London, where the process was introduced through an album of lithographs by prominent artists. The Philadelphian president of the Royal Academy, Benjamin West, started the series in 1801 with the earliest dated lithograph by any artist who is still remembered."[34] The first American lithograph, most appropriately, was done in Philadelphia by Bass Otis in 1818 or 1819. Equally appropriately, Kollner spent most of his life as a lithographer in the same city.

Kollner was born in Württemberg, Germany, in 1812. By 1828 he was an accomplished engraver and etcher working in Stuttgart. He then moved to Paris where he worked as a lithographer. From Paris in 1839 he moved to Washington, D.C. In 1840 he moved to Philadelphia, where he remained until his death in 1906.[35]

In spite of an extremely long life Kollner's major work as a lithographer was done in the 1840s and 1850s. His first important American illustrations were the hand-colored prints he made for William M. Huddy's U.S. *Military Magazine,* one of the handsomest American color-plate books.

Although Kollner continued the rest of his life as an etcher and painter, it was as a commercial artist and illustrator that he achieved his greatest success. Probably in the late 1840s Kollner produced one of his most splendid commercial works in the form of a large trade card for John Krider, a Pennsylvania German gunsmith of Philadelphia. But some of Kollner's most delightful works were books he illustrated for the American Sunday-School Union. In 1850 he drew the plates for *Common Sights in Town & Country.* In 1852 this was followed by *Common Sights on Land and Water,* in 1856

Fig. 269. Augustus Kollner, *A Ride to the City.* From *Common Sights in Town & Country Delineated & Described for Young Children.* (Philadelphia: American Sunday-School Union, [1850]), unpaged. (Collection of Printed Books and Periodicals, Winterthur Museum Library.)

by *City Sights for Country Eyes,* and in 1858 by *Country Sights for City Eyes.* Kollner's ambition was to work as a horse and landscape painter. Although he never achieved popular success as a painter, he had great success as an illustrator.

[Augustus Kollner, lithographer]. *Common Sights in Town & Country Delineated & Described for Young Children.* Philadelphia: American Sunday-School Union, [1850].

The Winterthur copy of *Common Sights* is in its original pictorial wrappers. The pictures on both covers are the same. The front cover gives the title of the book. The back wrapper gives addresses for American Sunday-School Union quarters in Philadelphia, Boston, St. Louis, New York, Louisville, and Rochester. Although the book's illustrations are genre scenes in country and town, its real subject is the horse. At least one occurs in each plate. A mare and colt and two plow horses decorate the covers. The illustration reproduced as figure 269 shows a prototype of the present-day Amish buggy passing a farm with a typical Pennsylvania German barn.

Major illustrated book types. Religious books. German interest in Bible illustration continued well into the eighteenth century, and illustrated New Testaments are by no means rare in early nineteenth-century Pennsylvania German printing. Some seventeenth-century German illustrators were inspired by the philosophical-theological writings of Robert Fludd and Jacob Boehme. Among the latter's visual interpreters were Dionysius Andreas Freher and Johann Georg Gichtel. Gichtel's illustrations of Boehme

[34] A. Hyatt Mayor, *Prints and People,* p. 612.
[35] Nicholas B. Wainwright, "Augustus Kollner, Artist," *Pennsylvania Magazine of History and Biography* 84, no. 3 (July 1960): 325–51.

were reprinted at Ephrata at least as late as 1822.

One of the most popular forms of German religious illustration in the seventeenth and eighteenth centuries was the emblem book. In several cases emblem books that had been written by Catholic authors and illustrated by Catholic artists were translated from Latin or French into German by German Protestants. Like Gichtel's work, these were reprinted in Pennsylvania. But the most popular of all Pennsylvania German emblem books was written by a Lutheran pastor of the early seventeenth century named Johann Arndt.

Johann Arndt. *Des Hocherleuchteten Theologi . . . Sechs . . . Bücher Vom Wahren Christenthum.* Philadelphia: Benjamin Franklin and Johann Boehm, 1751.

More than eighty editions of Arndt's *Wahren Christenthum* are recorded from 1606 to 1835. Many were imported to the United States. Several were printed in this country. Of these, the first was the edition published by Benjamin Franklin in 1751. Franklin and Johann Boehm, one of Franklin's German printing partners, "worked from the text of the 1727 reprint of the Leipzig edition of 1696 where the editor had added new symbols and 'supplemented the accompanying religious explanations . . . adding appropriate Bible verses.' "[36]

Advertisement for the Philadelphia edition began May 16, 1749. It was aimed at the German Reformed and Lutheran congregations of the middle colonies. An American pastor wrote a new preface. Comparison of it with an edition of 1706 printed in Stade, a city near Hamburg, Germany, shows that the original *Vier Bücher* [Four books] was expanded by the addition of two more "books" and some illustrations.

The illustrations consist of engravings "evidently imported from Germany."[37] Comparison with the Stade edition shows that the engraved portrait frontispiece of the author (and the accompanying scene of David and Goliath) have been reengraved. The same is true of the emblematic plates. Each of the original four books and the two additional ones of the Franklin printing seem to have been given new frontispieces in 1751. These consist of female figures holding attributes (fig. 270). The accompanying text explains the various spiritual states symbolized by those complex allegorical images. It should be pointed out that the new material of the Philadelphia edition in the case of both text and illustrations may be reprints of the 1727 Continental edition.

Scientific publications. Among the Pennsylvania Germans there were many learned scientific men. The story of erudition among them begins with the arrival of Francis

36 Miller, *Franklin's Printing*, p. 280.
37 Miller, *Franklin's Printing*, p. 280.

Fig. 270. Allegorical frontispiece. From Johann Arndt, *Wahren Christenthum* (Philadelphia: B. Franklin and J. Boehm, 1751). (Collection of Printed Books and Periodicals, Winterthur Museum Library.)

Daniel Pastorius in 1683. It was continued and developed by a long line of scholars. But, unlike the English-speaking Pennsylvanians such as John and William Bartram and, above all, Benjamin Franklin, most were concerned with scholarship in libraries rather than close examination of tangible nature as found around them in the New World. The major aspect of nature that greatly concerned Pennsylvania German-American scholars in the years before the

P.I.

Psalm XIX.1

The heavens declare the glory of God; and the firmament sheweth his handy work.

Egelman sculpt

Fig. 271. Carl Friederich Egelmann, Psalm XIX.1. From E. L. Walz, Vollständige Erklärung des Calenders (Reading: Johann Ritter and Co., 1830), frontispiece. (Collection of Printed Books and Periodicals, Winterthur Museum Library.)

sophisticated horology. Emperor Rudolf II had been interested in astronomy—he was patron of Tycho Brahe and Johann Kepler—and the occult. These interests the emperor combined with a passion for clockwork, including automata. Whether he set or followed style, his court in Prague at the turn of the sixteenth century was a center for the study of astronomy, astrology, and clockwork. This combination of interests recurred in Pennsylvania.

Perhaps the most remarkable mind of the native-born Pennsylvania Germans of the eighteenth century belonged to David Rittenhouse. He was a clockmaker who became a preeminent astronomer. He brought the two fields together in the manufacture of orreries for Princeton and the University of Pennsylvania. Those mechanisms, as well as his astronomical clock (now at Drexel University), are probably the most sophisticated pieces of machinery produced by any eighteenth-century American. Rittenhouse also made extensive contributions to Pennsylvania German almanacs, the most common and popular works of science read by his fellow countrymen in the eighteenth century.[38] He was in no way interested in the occult, so his astronomical calculations completely avoided any kind of astrological material.

Pennsylvania German engraver Egelmann was, like Rittenhouse, a professional calculator for almanacs who also eschewed astrology. He was a thoroughgoing theist. Although, like Rittenhouse, the majority of his published writings consisted of astronomical calculations published in almanacs, he collaborated with E. L. Walz, Lutheran minister from Berks County, to produce the most striking illustrated scientific book published by Pennsylvania Germans, a history of the calendars and their relationship to the solar system.

E. L. Walz. *Vollständige Erklärung des Calenders, mit einem fasslichen Unterricht über die Himmelskörper, insbesondere über die Sonne und der sich um sie bewegenden Planeten.* Reading: Johann Ritter and Co., 1830.

The book is purely historical and scientific in its principles and practical in its application. Walz, as was appropriate for a minister of a denomination whose founder vehemently denounced astrology, confined his attention largely to astronomical matters. He explained the origin and development of the Julian, the Gregorian, and the liturgical calendars. The only departure from history and astronomy was an invitation to meditate on the wonders of the universe as a foundation for the love and praise of its Divine Maker.

Egelmann's large engraving of the solar system is a pictorial

nineteenth century was the observable movements of the solar system. It is a moot point as to whether their interests in the planets and their cycles were primarily astronomical or astrological.

There is another related field in which Germans in both Europe and Pennsylvania were preeminent. They combined an interest in astronomy and astrology with a fascination with time which led to the development of a

[38] Louis Winkler, "Pennsylvania German Astronomy and Astrology VIII: David Rittenhouse," *Pennsylvania Folklife* 23, no. 3 (Spring 1974): 11–14.

summary of his and the author's knowledge of current astronomy in 1830. The frontispiece, inscribed in English, like all the plates in this otherwise German book, shows that both artist and author shared the religious interests that characterize so many aspects of German life in America (fig. 271).

Almanacs. Pennsylvania German almanacs were characterized by three common illustrative features: a cover picture, a series of twelve woodcuts known as Labors of the Month, and Vein Man. Printers sometimes used the same cover illustration over a period of many years on a given almanac. Especially among early almanacs the cover thus functioned as a kind of trademark for the publication. In the nineteenth century the cover was sometimes varied to catch the jaded reader. But in no case was the early almanac cover changed yearly as a matter of policy.

Vein Man and Labors of the Month also changed little, if at all, once the basic design had been settled. They were meant to function with the heart of the almanac. That heart consisted of a variety of calendars. The first of these was natural. It consisted of the tables which identified for a given year the regular and extraordinary operations of the solar system, the events of the seasons (such as the proper time to perform agricultural operations), the correlation of the movements of the moon and stars with the four elements and the four humors, and the consequent optimal times for bloodletting and cupping. Nature, for the early Pennsylvania German almanac, consisted of the macrocosm of the visible universe and man the microcosm. To understand man from this point of view one has to understand his relation to the macrocosm. The natural calendar was the basis of both astronomical and astrological interpretations. The almanac became, therefore, a necessary handbook for understanding and manipulating nature. But time for the Pennsylvania German consisted of more than the operations of the solar system and the seasonal cycle of nature. There also was a civil calendar. It was particularly important for the German immigrant to have a court calendar since the Pennsylvania legal system was English in derivation and completely foreign to the justice and law courts the immigrant had known on the Continent. Finally, of vital importance for the pious Pennsylvanian was the liturgical calendar for, of course, his year was marked also by the annual development of the church's year. For the Lutheran this aspect of the almanac was not quite as important as it was for the Catholic. But, in point of fact, all the calendrical systems of the Pennsylvania German, his entire life structure, depended on the solution to a quarrel between the Catholic and the Protestant churches over the liturgical calendar. We first must examine this liturgical question if

we are to understand fully time and the organization of life among the Pennsylvania Germans.

The Lutherans of the Continent had modified Catholic culture as well as doctrine, but less so than had the English. The difficulties of constructing a calendar were due to the need to combine units based on physical phenomena—the day, the month, and the year—with the week, a unit incommensurable with the operation of the natural world, and to combine a seasonal natural cycle with a cycle peculiar to the Christian liturgical year.

The week, a unit of calendrical time introduced about the time of Christ, is a fundamental unit of the liturgical calendar. According to the laws of the Roman Church, "Easter was to be celebrated on the first Sunday after the full moon following the equinox. Paschal dates were reckoned as if the equinox occurred on March 21, although in the sixteenth century the actual date was March 11. Hence Easter might arrive as much as a month late, in May."[39]

The need for reform of the Julian calendar had been felt and attempted at least as early as the eighth century. The reform was finally accomplished and sanctioned by Pope Gregory XIII in 1582. The reform had only papal authority. All Christian countries who had rejected that authority also rejected the papal reform. The Reformation was a major block to calendrical reform—for reasons of religion, not science. In Catholic Germany the reform was accepted in 1583. The Protestant states of Germany refused to consider it for more than a century; it was finally accepted at the Imperial Diet of Regensburg in 1700. England (and, therefore, its colonies) refused to accept the Gregorian calendar until 1752. As a result, until the mid eighteenth century, German immigrants who were used to Catholic calendrical innovations needed almanacs to guide them in a land that clung to the Julian system.

In addition to the calendars, the Pennsylvania German almanac presented educational and entertaining material. In common with English-speaking early America, first place was given to education. This was particularly useful among the German "foreigners." They had to learn from scratch all sorts of things their English neighbors took for granted. One such subject during the colonial period was an introduction to British history for the German immigrants to whom Magna Charta, habeas corpus, the Civil War, Cromwell, and the kings of England were all new. To help German readers, portraits of the monarchs were provided. During the Revolution, Pennsylvania German almanacs encouraged patriotism and used visual allegory to do so. After the Revolution a considerable amount of space was

[39] George Sarton, *Six Wings: Men of Science in the Renaissance* (Bloomington: Indiana University Press, 1957), pp. 69–72.

272 273 274

Fig. 272. Justus Fox, almanac cover. From *Der Hoch-Deutsche America-nische Calender* (Germantown: C. Sower II, [1765]). (Collection of Printed Books and Periodicals, Winterthur Museum Library.)
Fig. 273. [Samuel?] Leech, almanac cover. From John Tobler, *The Pennsylvania Town and Country-Man's Almanack* (Germantown: C. Sower II,

[1756]). (Collection of Printed Books and Periodicals, Winterthur Museum Library.)
Fig. 274. Almanac cover. From *Der Gantz Neue Verbesserte Nord-Americanische Calender* (Lancaster: Francis Bailey, [1778]). (Collection of Printed Books and Periodicals, Winterthur Museum Library.)

given to both texts and pictures designed to acquaint the German-speaking inhabitants of Pennsylvania with the new American concepts of life, liberty, the pursuit of happiness, and democratic (or at least republican) government—none of which were a familiar part of daily life in the Holy Roman Empire. Nineteenth-century almanacs tried to entertain as well as educate and inform. They used pictures for this purpose as well as words. They also tried to acquaint readers with popular movements such as temperance reform and reactions against the Masons.

Pennsylvania German almanacs and illustrations yield evidence of the death of old ways and the growth of new ones. Most conspicuous of these are the slow death of the idea of the relationship of macrocosm and microcosm, the final acceptance of the Gregorian calendar, and, finally, the elimination of the German-language almanac in Pennsylvania.

*Der Hoch-Deutsche Americanische Calender, Auf das Jahr . . .
1766. Germantown: Christoph Sower II, [1765].*

The earliest of the German-language Sower almanacs in the Winterthur collection was published by Christoph II. The first edition of this almanac was published in 1738 for the year 1739 by Christoph Sower I.

The original version of the cover print was cut for and used in the fifth issue of the almanac, that for 1743.[40] Possibly the elder Sower was responsible for its design. In 1759 Justus Fox recut the woodblock for the 1760 issue. The cover of the 1765 almanac is from that recut design (fig. 272). The precise significance of the design is unknown. The winged figure above the rainbow frequently has been identified as an angel. In point of fact, the figure represents Mercury, who among other functions was the classical god of communication. The inscription in the banner he carries was frequently changed from issue to issue of the almanac. In this case his news is *Kümmerliche Zeiten* ("troublesome times"). The messenger from the British ship hands news, possibly of the wars in Europe, to the gowned figure (the staff the latter carries may be intended to symbolize a pilgrim).

The contents of the issue consist of both verse and prose. In addition to essays on health and history, it contains conversion tables for currency and an advertisement for books available from the publisher. There is a court calendar and one of fixed and movable feasts of the Church. The detail given in the astronomical tables consists of both scientific and astrological data. The almanac contains a picture of Vein Man and a full-scale chart "vom Schröpffen und Aderlassen."

[40] Hamilton, *Illustrators*, p. 13.

John Tobler. *The Pennsylvania Town and Country-Man's Almanack, For the Year of our Lord 1757.* Germantown: Christoph Sower II, [1756].

Winterthur owns several issues of John Tobler's almanacs. Tobler, a native of Switzerland who first immigrated to South Carolina, claimed in the text of his almanacs to have kept up relations with the fatherland. The example is the earliest in Winterthur's collection (fig. 273). The impression of the woodcut selected for reproduction shows the signature "Leech S[culpsit]" at the lower left more clearly than the others. This woodcut was first used in 1754 and probably was used continuously until 1765.[41]

In the text of the catalogue of his collection Sinclair Hamilton asked if Leech was "the Samuel Leach who . . . advertised in the *Pennsylvania Gazette* of Dec. 10, 1741." The Alfred C. Prime cards at Winterthur quote that advertisement: "Performs all sorts of Engraving, such as Coats of Arms, Crests, Cyphers, Letters &c. on Gold Silver or copper: Also Engravings of all kinds for Silversmiths. N.B. The said Leach may be heard of at Mr. Samuel Hazzards, Merchant, opposite the Baptist Meeting House, in Second Street, or at Andrew Farrel's, in Chestnut Street, Philadelphia."[42] Although we have discovered no examples of documented engraving on silver by Leech there is at least some American silver with the mark *SL* which has been attributed to him. Leech presumably was of British origin, but his almanac cover probably was done at the direction of a Pennsylvania German. A similar motif, a landscape with a sky dominated by winged figures and the zodiac, was used by Anton Armbrüster as early as 1753 and again in 1763. Henrich Miller in 1765 published a cover decorated with a view of Philadelphia, and in the sky above the city the zodiac appears between the sun and the moon.[43]

Der Gantz Neue Verbesserte Nord-Americanische Calender Auf das 1770ste Jahr Christi. . . . Lancaster: Francis Bailey, [1778].

Of all the printers on whom William McCulloch attempted to write a report for Isaiah Thomas, the most elusive was Francis Bailey. Time after time McCulloch attempted to interview the old printer. He seems never to have been able to get an interview, in spite of (or because of) their previous acquaintance. Many corners

of Bailey's life are unexplored. One of them is his connection with the graphic arts; another is his connection with the Pennsylvania Germans. Both came together in the 1778 almanac in which Bailey attempted to act as a propagandist for George Washington and to stir up nationalism among the Pennsylvania Germans.

In 1891 Samuel W. Pennypacker, governor of Pennsylvania, spoke on the state's German almanacs. "I brought with me a specimen of these almanacs, printed at Lancaster in 1779 [1778]. Its special interest consists in the fact that in it for the first time General Washington was called 'The Father of his Country.' . . . You will see upon the page of this German almanac, a representation of Fame [fig. 274]. She is holding in one hand a rude portrait, under which is inserted the name of Washington; with the other hand she is holding to her mouth a trumpet, from which she blows with a loud blast 'Des Landes Vater.' "[44]

In his original letter of September 1, 1812, McCulloch wrote: "With Mr. Bailey I am well acquainted. . . . He is a very aged man, has often the vertigo, and is not always to be seen. He was bred a carpenter, in Lancaster county. He obtained some knowledge of printing in a country town. . . . He is a very ingenious mechanist, and was a successful caster of types. All the Bourgeois letter in the standing edition of his Testament were cast by himself. He cut and engraved many ornaments, and the cuts for a great variety of children's books." On December 9, two years later, McCulloch added that "Bailey . . . [had] obtained some smattering of instruction in the art of printing at Ephrata, in Lancaster County."[45] Since Bailey was born about 1735, he may have begun his training at the Ephrata press under Peter Miller's supervision in the late 1740s. It probably was there that Bailey was introduced to the cutting and engraving of ornaments and illustrations as well as printing with German type.

Bailey began to publish an almanac in English in 1771 and in 1775 printed his first German almanac under the name Frantz Bailey. Both continued until 1781. Meantime Bailey had become an active patriot. In 1777/78 he served as brigade major of state troops at Valley Forge. In 1778 he was one of the officers charged with conducting prisoners of war from Winchester, Virginia, to Lancaster, Pennsylvania. In the same year he combined his roles as publisher of a German almanac, printer, and patriot to produce the cover picture described by Governor Pennypacker. Bailey may have made the cut himself. What is certain is that, like the unknown craftsman at Ephrata who recut the emblem for the title page of *Martyrs' Mirror*, the man who cut the block for this cover reworked a design first used by Anton Armbrüster in 1753. The difference lies in the fact that in 1753 the portrait was labeled "Georgius II." Bailey had the original legends removed and sub-

[41] Reilly, *Dictionary*, p. 292. The Hamilton issue of 1755 and Winterthur issue of 1756 are not recorded by Reilly.

[42] Hamilton, *Illustrators*, p. 12. The A. C. Prime cards consist of the original research notes compiled by Phoebe and Alfred Coxe Prime on which he based *The Arts and Crafts in Philadelphia, Maryland, and South Carolina, 1721–1785: Gleanings from Newspapers* (Topsfield, Mass.: Walpole Society, 1929) and *The Arts and Crafts in Philadelphia, Maryland, and South Carolina, 1786–1800, 2d ser. Gleanings from Newspapers* (Topsfield, Mass.: Walpole Society, 1932). Only a selection from these notes was published by Prime in his two volumes. The complete file is available for use by researchers in the Decorative Arts Photographic Collection, Winterthur.

[43] Reilly, *Dictionary*, pp. 296–98.

[44] Samuel W. Pennypacker, "The Early Literature of the Pennsylvania-Germans," *Proceedings and Addresses of the Pennsylvania-German Society*, vol. 2 (Lancaster, 1892), p. 40.

[45] Brigham, "McCulloch's Additions," pp. 98, 103.

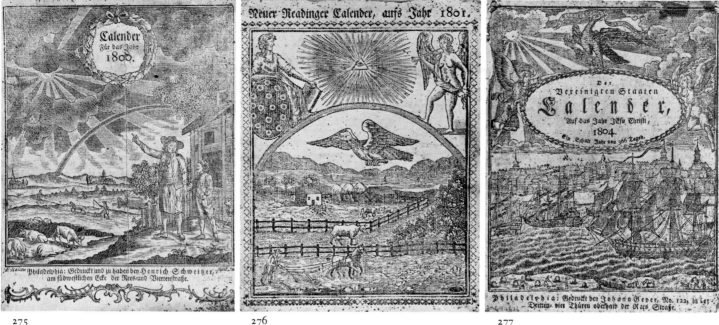

275 276 277

Fig. 275. Frederick Reiche, almanac cover. From *Neuer Hauswirthschafts Calender* (Philadelphia: Henry Schweitzer, [1799]). (Collection of Printed Books and Periodicals, Winterthur Museum Library.)

Fig. 276. Almanac cover. From *Der gemeinüzige Americanische Calender* (Reading: [Jacob Schneider and Co., 1800]). (Collection of Printed Books

and Periodicals, Winterthur Museum Library.)

Fig. 277. Frederick Reiche, almanac cover. From *Der Vereinigten Staaten Calender* (Philadelphia: John Geyer, [1803]). (Collection of Printed Books and Periodicals, Winterthur Museum Library.)

stituted new ones reading "Waschington" and "Des Landes Vater." Like so much else in Pennsylvania German culture this striking piece of patriotic propaganda was a union of German and English elements fused in the fires of the new nationalism. So far as we have been able to discover, Pennypacker was correct when he said that this picture marks the first time that Washington was given the title "Father of his Country."

Neuer Hauswirthschafts Calender, Auf das Jahr, nach der heilbringenden Geburt unsers Herrn und Heylandes Jesu Christi, 1800. Philadelphia: Henry Schweitzer, [1799].

Seldom are prints by or after Pennsylvania German artists signed. The signature "F. Reiche" (fig. 275) is an exception. Reiche did copperplate engraving; however, most of his signed work consists of woodcuts. He worked in Philadelphia between 1794 and 1804, and Philadelphia directories list him as Frederick Richie (1794), Frederick Reiche or Reicke (1795–96), and Francis Reiche (1798).[46] He signed woodcuts "J. F. Reiche" and "F. Reiche."

The cover of the calendar for 1800, when compared with one he did for *Der Vereinigten Staaten Calender, Auf . . . 1804* (fig. 277), looks as though it is a copy of a European prototype. The

[46] George C. Groce and David H. Wallace, *The New-York Historical Society's Dictionary of Artists in America, 1564–1860* (New Haven: Yale University Press, 1957), p. 529.

perspective of the 1800 landscape is comparatively sophisticated, while that of the 1804 example is extremely naive. The aproned dress of the main figure in the 1800 scene looks more European than American.

There are several examples of the use of the Reiche design on almanac covers in Winterthur's collection. The example reproduced is not the earliest; it is the best impression. The earliest example in our collection was published by Schweitzer in 1798 for the year 1799 and has its original blue paper wrapper and an early cord for suspension.

The latest example we own was published for the year 1813 by Jacob Schnee in "Libanon," Pennsylvania. The title is the same as that Schweitzer used. The rural, small-town restrike of Reiche's original print is identical, even to the asymmetrical rococo ornament under the publisher's legend.

Der gemeinüzige Americanische Calender Auf das Jahr Christi 1801. Reading: Jacob Schneider and Co., [1800].

The new century in Reading was greeted with an almanac whose cover title proclaimed it a *Neuer Readinger Calender* (fig. 276). The title page proclaimed the freshness of the almanac ("Zum Erstenmal herausgegeben"). Patriotism was stressed both on the cover and in the lead story, "Der deutsche Patriot."

The cover is decorated with a peaceful rural scene above which

are three allegorical figures. The eagle symbolizes the emphasis on the nationalism of Pennsylvania Germans. Above a rainbow, to either side of the *Oculus Dei* (the terminus of the unfinished pyramidal symbol on the reverse of the Great Seal of the United States), are two female personifications. As is very common in the art of the early republic at all levels and in all media, these allegorical figures are based on *Iconologia*, an encyclopedia of allegorical figures. The first edition, published in Italian by the original author, Cesare Ripa, in Rome in 1593, was unillustrated. The first illustrated edition, also published in Rome, was issued in 1603. It was translated into many languages and went through many editions. It is not certain whether the source used by the anonymous artist of our cover design was or was not a German edition of *Iconologia*.

In the upper left of the almanac cover an allegorical figure holds an oval shield decorated with sixteen stars. In the first English edition of Ripa (1709) the major attribute given to Astronomy is a tablet on which is displayed a star chart. According to the text of that edition, this attribute distinguished her from Astrology. The same distinction is made in the edition published by George Richardson in 1778. Presumably the designer of the Reading cover of 1801 was also making that distinction, perhaps combining the personification of Astronomy with an image of America's shield decorated with the symbols of the sixteen states of the union in 1800. But the text of the main body of the almanac tells a different story. Both it and its full-scale unmodified use of the Aderlassen und Schröpfen chart with Vein Man proclaim inner belief in the astrological value of the stars. On the upper right the allegorical figure of Fame blows her trumpet to spread the news of the birth of the new century—and perhaps the new almanac. Mannerist symbolism, English astronomy, German astrology, and the new nationalism met the German rural scene in Berks County in 1800 to produce the *Neuer Readinger Calender* for the new century.

Both copies of this almanac in the Winterthur library are signed with a monogram in a small cartouche on the lower right. In neither case is the monogram legible.

Der Vereinigten Staaten Calender, Auf das Jahr Jesu Christi, 1804. Philadelphia: John Geyer, [1803].

The earliest identifiable Philadelphia view on a Pennsylvania German almanac in the Winterthur collection is the cover of *Der Vereinigten Staaten Calender, Auf . . . 1804* (fig. 277). It is a signed woodcut by Reiche.

Reiche's woodcut is based on Nicholas Scull and George Heap's *East Prospect* of the city (probably the contracted revision of 1756 with human figures in the foreground). The shipping in the middle ground has become much more important in Reiche's view than in its predecessors. The largest ship, to the right, has been carefully identified as American by its flag. The title is in a cartouche surrounded by a husk garland in the neoclassical style. It

is supported by two winged creatures. The place of the banner-carrying Mercury of the Sower almanac covers has been usurped by the banner-carrying national bird whose beak grips a streamer inscribed *E Pluribus Unum*, the motto on the obverse of the Great Seal of the United States. Reiche combined a somewhat free and easy naturalism, the Adamesque style, and full-fledged patriotism (with what may be a religious reference in the form of angels).

Der neue Nord-Americanische Stadt und Land Calender, Auf das Jahr unsers Heilandes Jesu Christi, 1807. Hagerstown, Md.: Johann Gruber, [1806].

The Hagerstown almanac is one of the oldest still being published in the United States. The original publisher was Johann Gruber (1768–1857). Born to a physician of Strasburg, Lancaster County, he was apprenticed to Charles Cist of Philadelphia, worked as a printer in Santo Domingo, and, on his return, worked in Philadelphia. In 1793 he was coeditor with Gottlob Jungmann, publisher of the Reading newspaper, *Neue Unpartheyische Readinger Zeitung und Anzeigs-Nachrichten*. About 1794 Gen. Daniel Hiester of Berks County, then a member of the House of Representatives, proposed that Gruber establish a German newspaper in Hagerstown. Gruber started publication of *Westliche Correspondenz* on June 10, 1795. The first issue of Gruber's German-language almanac, *Der neue Nord-Americanische Stadt und Land Calender*, was published in 1796 for the following year. Under various titles the almanac was published in German until 1918. An English-lanaguage edition for 1822 was published under the title *The Hagerstown Town and Country Almanack*. Gruber's English-language almanac has continued publication up to the present.[47]

The design is signed J. F. Reiche (fig. 278). In this cut, Reiche represented a landscape even more free in its perspective than that in his signed woodcut view of Philadelphia (fig. 277). Reiche may have used a European print as a prototype. One of the buildings on the right has stepped gables of Lowlands type. As so often in Pennsylvania almanac covers, the water-drawing sun is coupled with a moon and stars. But the most intriguing part of this cover consists of a seminude figure who stands on top of a globe inscribed with the words *America, Europa, Africa,* and *Asia*. The figure carries a staff over her left shoulder. In all seven impressions in the Winterthur collection the top of the staff appears to penetrate a cloud on the right. With her right hand the figure points up to a half-moon in the sky above. The identification of this figure is uncertain. A somewhat similar allegory containing a standing figure on a globe inscribed with the single word *America* occurs in a famous emblem book first published in Antwerp in 1627 called (in short title) *Typus Mundi* [Type, or symbol, of the world]. In

[47] Louis Winkler, "Pennsylvania German Astronomy and Astrology, XV: The Gruber-Baer Era," *Pennsylvania Folklife* 27, no. 3 (Spring 1978): 33–39; Arndt and Olson, *German Language Press*, vol. 1, *History and Bibliography*, pp. 200–201.

Fig. 278. Frederick Reiche, almanac cover. From *Der neue Nord-Americanische Stadt und Land Calender* (Hagerstown, Md.: Johann Gruber, [1806]). (Collection of Printed Books and Periodicals, Winterthur Museum Library.)

the older example, the figure is Saint Ignatius Loyola. There is undoubtedly no direct connection between the seventeenth-century Flemish copperplate and the Hagerstown wood engraving, but an unknown link between the two allegories must exist.

Der Pennsylvanische Anti-Freimaurer Calender, Für das Jahr unseres Herrn und Heilandes Jesu Christi 1833. Lancaster: Samuel Wagner, [1832].

The wood engravings in Samuel Wagner's almanac for 1833 illustrate two major themes of concern to provincial Pennsylvania Germans in the 1830s. The first is a growing interest in astronomy—as opposed to astrology; the second is anti-Masonry. Together, they point up the fact that by 1833 the content of the Pennsylvania German almanac outside Philadelphia still focused on matters of particular concern to the German community in Pennsylvania and that it had opened its pages to out-of-state issues of a more than political nature.

The astronomical calculations of the *Anti-Freimaurer Calender* for 1833 are by polymath Carl Friederich Egelmann. The Aderlassen und Schröpfen chart was included, but, except for the identification of humoral qualities assigned to planets, astrology had vanished from the calendar. In keeping with this modified anti-astrological policy, the lead article, possibly by Egelmann, deals exclusively with comets as astronomical phenomena. Both text and illustrations eschew any of the occult implications of the comet.

The Wagner almanac also was a vehicle for attack on secret

societies. As might be expected in a German publication, the Rosicrucians (the name originated in early seventeenth-century Germany) are given special attention, but the major target is the Masons. In this respect, both text and at least one illustration share the current interests of New Englanders.

The mysterious disappearance of anti-Masonic author William Morgan at Canandaigua, New York, in 1826 had been accompanied by rumors of murder. Although never heard from after his arrest in September of that year, his exposé of the Masons was published in the autumn. The events surrounding the disappearance of Morgan served as a focus for various movements attacking secret societies, gave rise to an anti-Masonic political party, and produced a minor flood of literature. The first of the American anti-Masonic almanacs was printed in Rochester in 1828.[48] *The New England Anti-Masonic Almanac* soon followed, and a series of seven were published by John Marsh in Boston between 1829 and 1835. The issues for 1829 and 1830 had covers decorated with a cut entitled *A "Poor Blind Candidate" Receiving His Obligation; Or, The True Form of Initiating a Member to the Secret Arts and Mysteries of Free-masonry.* The original design has been attributed to David Claypoole Johnston (1798–1865). This Philadelphia-born artist (unfortunately dubbed the American Cruikshank) worked in Boston most of his life. He produced a large body of brilliant work. If the original wood engraving was his, the Lancaster reengraving of 1832 (fig. 279) is an incidental tribute to the humorous art of a native Pennsylvanian. The Pennsylvania almanac is full of other Masonic illustrations whose relation to the New England prototype is unexplored.

Deutscher Mässigkeits-Calender auf das Jahr unsers Herrn 1837. Philadelphia: Georg W. Mentz and Son, [1836].

German American almanacs in Pennsylvania are sensitive indicators of what editors believed were current issues that would interest their audience. Georg W. Mentz published a Philadelphia almanac for 1837, and it is no surprise that it is much less conservative than those published in Lancaster and Reading. The church calendar of fixed and movable feasts is like that published in Lancaster and Reading, but the astrological data is minimal. Although bloodletting and cupping data are given in monthly calendars, the traditional Aderlassen und Schröpfen chart has been replaced by Man of Signs.

The principal innovations in illustrations are the substitution of distinctly American scenes for traditional German Labors of the Month and the thorough assimilation to the temperance movement. For example, in the cover illustration a poor man sits on a fancy Windsor in his neglected kitchen and signs the pledge of total abstinence, which is printed in English (fig. 280). The major internal illustration shows a rakish, cigar-smoking dandy, Major

[48] David L. O'Neal, *Early American Almanacs: The Phelps Collection, 1679–1900* (Peterborough, N.H.: David L. O'Neal, [1978?]), p. 100.

279 280 281

Fig. 279. Almanac cover. From *Der Pennsylvanische Anti-Freimaurer Calender* (Lancaster: Samuel Wagner, [1832]). (Collection of Printed Books and Periodicals, Winterthur Museum Library.)

Fig. 280. Almanac cover. From *Deutscher Mässigkeits-Calender* (Philadelphia: Georg W. Mentz and Son, [1836]). (Collection of Printed Books

and Periodicals, Winterthur Museum Library.)

Fig. 281. Almanac cover. From *Neuer Calender für Nord-America* (Philadelphia: Mentz and Rovoudt, [1848]). (Collection of Printed Books and Periodicals, Winterthur Museum Library.)

Tipple, leaning casually in the doorway of a bar, talking in English to a farmer. "Good morning Farmer Temperance[,] won't you take a horn [cup of liquor] with us this morning." Farmer Temperance replies: "No thank you Major Tipple[,] the Horn that suits me best is that which calls me to Breakfast in the morning." This temperance theme is shared with many almanacs on the same subject published from Philadelphia to Boston in the 1830s and 1840s.

Like Lancaster's *Anti-Freimaurer* almanac of 1833, the calculations of the Philadelphia publication were done by Carl Friederich Egelmann. The text contains no astronomical essays.

Neuer Calender für Nord-America auf das Jahr unsers Herrn 1849, . . . Philadelphia: Mentz and Rovoudt, [1848].

The content of the Mentz and Rovoudt almanac for 1849 is evidence of the breakdown of conservatism in urban Pennsylvania German culture. In spite of the broad geographical name, the court calendar is exclusively Pennsylvanian. The astronomical calculations were specifically made by Egelmann for Pennsylvania and bordering states. Although the tables of abbreviations and symbols give the usual signs for bloodletting and cupping, they are not inserted in the actual calendar. Vein Man has been replaced by Man of Signs. Man of Signs is labeled in German, but that is the only characteristic he does not share with his English-speaking

contemporaries outside Pennsylvania.

The cover was chosen for reproduction because of its historical reference to Christoph Sower I's design for his first almanac cover cut of 1743 (a design the Sowers used many times [see fig. 272]). Comparison of the two shows that Mercury still flies overhead with his German-inscribed banner (fig. 281). But this time it reads, in translation: "Hope for better times." The ship is in the harbor of what is presumably an American city. But on this cover the oarsman pulls away from the dock, and the two figures on it are engaged not in the delivery of news as on the Sower-Fox cover, but in the unpacking of cargo bearing merchants' marks. The buildings in the foreground and far to the rear are warehouses. In 105 years the Pennsylvania almanac has turned from a statement of colonial dependence on Britain for news to the celebration of American commerce. There is nothing new about Mercury's location in the picture, but he has changed roles. In Sower's woodcut he played his part as the god of communication. For the ancient world he had also been the god of commerce, and in 1849 the United States, still classically oriented, connected him with the business interests of the young nation. The symbolism of the 1849 cover is just as decorous and congruous from the viewpoint of the classical tradition as that of 1743, but it belongs to the world of Greek revival and Thomas U. Walter's Greek temple at Girard College, Philadelphia.

BOOKBINDING

In 1810, Isaiah Thomas noted: "1773. *George Reinhold,*— 'in Market-Street,' traded in Dutch books." Thomas may have understood Dutch to mean Netherlandish, or he may have been using it in the sense of Pennsylvania German. McCulloch's comment, in contrast, was unambiguous: "P. 449, vol. 2. George Reinhold lived in Market Street, the first house west of Fifth Street. He was also a bookbinder. Reinhold was from Germany, and there served an apprenticeship to bookbinding." This is only one of several possible examples that could have been chosen to show how important it is for the student of the history of Pennsylvania German binding, as well as the other graphic arts, to turn to McCulloch's notes. For instance, after a long discussion of Christoph Sower II's career and the misfortunes he encountered in revolutionary America because of his pacifism, McCulloch wrote: "Saur 2nd removed, from the house of his brother in law, to Methatchen settlement, April 7, 1780. This was his last voluntary movement. He kept house, at this place, by the assistance of his female children, and employed his working hours at binding books. At this business he obtained his death. Beating some copies of the same quarto Bible that he had lately published, he worked very diligently, and went through a day's work in half the day."[49] McCulloch then went on to give a detailed account of the death of that good man in 1784.

[Tieleman Janszoon van Bracht]. *Der Blutige Schau-Platz oder Martyrer Spiegel.* Ephrata: Brüderschafft, 1748 / 49.

Among the early American bookbindings at Winterthur there is a considerable number collected by du Pont which are of interest as works of early American art. The most impressive in size and wealth of ornament is the one that covers our copy of *Martyrer Spiegel* (fig. 282). It was produced at the Cloisters of Ephrata in Lancaster County.

Although usually bound as one, *Martyrer Spiegel* was published with two printed title pages, one dated 1748 and the other 1749. The binding probably is as elaborate as any produced in eighteenth-century America, not because of the tooling of the leather, but rather as a result of its brass ornaments. The two hooks, the catches in which they snap, and the four brass outer corners of the two boards were elaborately chased. Other matching mounts (purely decorative) were nailed to the top and bottom of each board next to the spine. All these mounts were elaborately decorated with ornament, partly floral and partly geometric. The binding is highly Germanic in style. Although mounts of this type were used on medieval illuminated bindings, there is nothing about the deco-

[49] Thomas, *History of Printing*, 2:449; Brigham, "McCulloch's Additions," pp. 107, 156.

Fig. 282. Binding and hooks on Tieleman Janszoon van Bracht's *Martyrer Spiegel.* Ephrata, ca. 1749. H. 38.1 cm., W. 25.4 cm. (Collection of Printed Books and Periodicals, Winterthur Museum Library.)

ration of the mounts that does not appear to be seventeenth or eighteenth century in style. The bindings at Ephrata, like its illuminations and music, represent sixteenth- and seventeenth-century reworking of Gothic forms. The custom of binding books with straps and clasps was used as early as 1743 in Pennsylvania and occurred as late as the second quarter of the nineteenth century. It has been found so far in American bindings only on Pennsylvania books printed in the German language.

As for the ethnic origin of the Ephrata binders, one must not assume that the craftsmen were all Germans. A simple calf binding in a private collection is inscribed: "This Book is A Gift made by Samuel John Senior 1755 to James Speary and New Bound by the said JS at Ephrata y. 3rd mo. y. 16th 1756 Price 2 / 6." The book is a copy of an English translation of one of the works of Jacob Boehme, the early seventeenth-century German theologian whose thought was influential among the members of the Cloister. The names inscribed in the volume indicate the binder's British origin. One author has suggested that the brass mounts on Ephrata bindings were American made, but it seems more probable that they, like the engraved, pictorial title page, were imported from Europe.

BOOK DEALERS

AND IMPORTED BOOKS

One of the major desiderata of Pennsylvania German studies is an investigation of the books available in the eighteenth century. Phoebe and Alfred Coxe Prime performed a pioneer work in their study of the eighteenth- and early

Fig. 283. Weaving pattern. From Johann Michael Frickinger, *Weber-Bild-Buch* (Neustadt and Leipzig: Jacob S. F. Riedel, 1783), p. 67. (Collection of Printed Books and Periodicals, Winterthur Museum Library.)

nineteenth-century advertisements in newspapers and periodicals in Philadelphia and the South. They published only a part of the material they uncovered; even so their research notes at Winterthur show that they excluded German-language publications. A cursory examination of a few Pennsylvania German almanacs and newspapers shows that they contain a wealth of information that the social and cultural historians have hardly tapped. They contain much evidence for the importation of German books as well as American publications. These imported books served as stimuli to Pennsylvania German arts, crafts, and religious life.

Johann Michael Frickinger. *Nützliches in lauter auserlesenen, wohl-approbirt- und meistentheils Neu-inventirten Mustern bestehendes Weber-Bild-Buch.* Neustadt and Leipzig: Jacob S. F. Riedel, 1783.

The German-language population was not isolated from its homeland. The advertisements in German-language newspapers and almanacs show that throughout the eighteenth and early nineteenth centuries there was a constant stream of publications from Europe which freshened and gave direction to German culture in the New World. Among the books that were imported were technological works as well as the literature of music, art, philosophy, and belles lettres.

Weaving was one of the crafts in which the Germans of early Pennsylvania expressed their ideas of pattern and developed their technology. In some cases the European prototype was copied lit-

erally. In others it was adapted. Among the books collected by du Pont was a well-known book of weaving patterns by Johann Michael Kirschbaum called *Neues Bild- und Muster-Buch.* It was published in at least two editions, 1771 and 1793. A copy is known that is inscribed "Henry Clairs Book Bought in August in the Sitty of Lancaster in the year of Our Lord Ano 1825 prise $5." In 1980 we added a book to our collection that is referred to in Kirschbaum's text. There is evidence of its wide use in Pennsylvania. It is *Weber-Bild-Buch* by Johann Michael Frickinger.[50]

Frickinger was court weaver to the Margravine Friedrich Caroline of Onolzbach (now Ansbach) in Bavaria. Although not born there, in 1723 Frickinger became a citizen of Ansbach and by 1740 had been appointed court weaver. Produced in the era of the best high-style German rococo, surprisingly Frickinger's designs are rectilinear patterns of the type common in nineteenth-century Pennsylvania coverlets. An anonymous portrait of Frickinger's patron shows the Margravine seated in an elaborately carved rococo, thronelike chair in what appears to be the fashionable wrapper of the period. But the skirt of the dress worn under the wrapper is white, woven in damask with the same sort of rectilinear, block patterns shown in Frickinger's book (fig. 283).

German Language Manuscripts
and Their Decorations

MANUSCRIPTS AND
THEIR HANDS

GERMAN CALLIGRAPHY

Pennsylvania Germans in the eighteenth and early nineteenth centuries used the current English hands, but they also used other, German types of script. One was a style of lettering rather than handwriting as we understand the term today. It was closely based on the German traditions of printed letters. Among these printed prototypes was the Fraktur face, first used in the publication in 1513 of Emperor Maximilian's prayer book. The calligraphic parallel to this printed type was also called Fraktur in Pennsylvania (fig. 284). By generalization the popular name for all decorated manuscripts of the Pennsylvania Germans has become

[50] Patricia Hilts, "Eighteenth Century German Court Weaver: Johann Michael Frickinger," *Shuttle, Spindle, and Dyepot* 11, no. 4 (Fall 1980): 16–19, 58–59.

"fraktur." But by no means is all Pennsylvania German handwriting of that lettered type. Most of it is in a cursive, gothic running hand which is very different (fig. 285).

The student in German-speaking Europe had a variety of copybooks from which he could learn various hands. No such publications seem to have been printed in Pennsylvania until Christoph Sower I began to publish single examples in the *Hoch-Deutsche Americanische Calender* in 1754. In the issue of 1756 Sower printed an example designed for those who could read printed German but who had no writing master and wished to learn to read and write German script. His aim was modest. The accompanying text states that Sower's models were intended "for children or persons who wish to learn to write just a little."[51] In it the letters of the woodcut translated a printed Fraktur text into cursive gothic script for the beginner's study. Christoph II continued his father's policy in the almanac until it closed publication in 1778.

A complete copybook for Pennsylvania German students of Fraktur lettering and of gothic script was not produced until 1821 when Carl Friederich Egelmann is thought to have engraved the first edition of his *Deutsche & Englische Vorschriften für die Jugend* in Reading. The paucity of writing books among the Germans of Pennsylvania presumably is accounted for by their many schools and schoolteachers. But the large quantity of handwritten examples of Fraktur extant today is to be accounted for by the existence among the German-speaking population of the professional writing master. As so often in Europe itself, the writing master was also a professional scribe. He taught children, wrote out letters and other documents for the poorly educated and the illiterate, and even engrossed and decorated them for literate clients (see fig. 268).

DOCUMENTS OF DAILY LIFE, BUSINESS, AND CRAFTS

The best-known collections assembled by du Pont consist of objects of decorative art. Of these an important ensemble is made up of furniture, ceramics, metalwork, glass, and textiles made by the German-speaking inhabitants of Pennsylvania. These are displayed in rooms taken from buildings created by the same people. The museum's extensive collection of manuscripts provides documentation of the daily life of the inhabitants of the rooms and of the work of the men and women who made the rooms' contents and woodwork. Among the documents of daily life are not only land

[51] Ray Nash, *American Writing Masters and Copybooks: History and Bibliography through Colonial Times*, (Boston: Colonial Society of Massachusetts, 1959), pp. 25, 47–49.

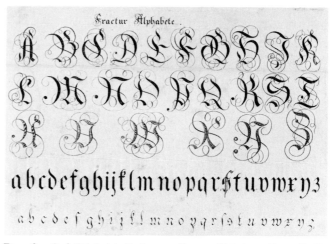

Fig. 284. Carl Friederich Egelmann. *Fractur Alphabete*. From C. F. Egelmann, *Deutsche & Englische Vorschriften für die Jugend* (Reading, [1821?]), unpaged. (Collection of Printed Books and Periodicals, Winterthur Museum Library.)

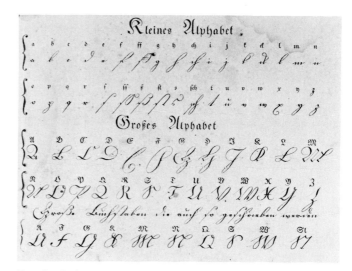

Fig. 285. Carl Friederich Egelmann. *Kleines Alphabet* and *Grosses Alphabet*. From C. F. Egelmann, *Deutsche & Englische Vorschriften für die Jugend* (Reading, [1821?]), unpaged. (Collection of Printed Books and Periodicals, Winterthur Museum Library.)

surveys and deeds but also bills of the householders, account books of taverns, and ledgers of the many general stores of country towns which were so important in the life of the Pennsylvania German community. The ledgers cover the second half of the eighteenth and the first of the nineteenth centuries. Most of the general-store ledgers deal with the lives of communities dominated by Lutheran and Reformed congregations, but we do have the records of a Moravian general store of the late eighteenth century. The largest single group of these account books purchased by du Pont were

records of country merchants Abraham and Samuel Rex from 1791 to 1818.

Records that documented the craft activities of the Pennsylvania Germans also were eagerly sought by du Pont. The largest group of these consisted of the ledgers of the iron furnaces for which the state in the eighteenth century was so well known. These books include those of Berkshire Furnace for 1765–67, 1770–72, 1789–90, and 1791–94 and of Reading Furnace, also in Berks County, for 1765–67.

In addition, the collection contains the papers of individual craftsmen. Among them are the ledgers for 1850–53 of Josiah Swank, potter in Lancaster County, and for Jacob Bucher, hatmaker in Lebanon County, 1795–1824. Among the later additions to this part of the collection are papers of cabinetmakers. The records of Jacob Bachman of Lancaster County for the years 1816–61 are particularly valuable because of the large number of pieces of existing furniture attributed to that family. Another cabinetmaker whose record we own is Jacob Landes of Bedminster Township. His books cover the years 1819–59. We also have the records of carpenters. For example, the accounts of David Zeller, of Easton, Pennsylvania, run from 1823 to 1857. Other craftsmen represented include shoemakers, blacksmiths, wainwrights, saddle and harness makers, millers, and weavers. Some of these records are particularly interesting because they contain drawings and patterns.[52]

DECORATION OF

PENNSYLVANIA GERMAN

MANUSCRIPTS

In 1897 Henry C. Mercer delivered a lecture in which he first called scholarly attention to the decorated calligraphy of Pennsylvania. In its published form he titled it "The Survival of the Medieval Art of Illuminative Writing among Pennsylvania Germans." Mercer, an anthropologist strongly influenced by contemporary interest in survivals of ancient customs in the industrial environment of the nineteenth century, drew a parallel between the miniatures used to decorate medieval illuminated books and the decorations of Pennsylvania German calligraphic manuscripts.[53] Research

in art history and anthropology since 1897 makes it advisable to qualify Mercer's thesis carefully.

Our first qualification involves the handwriting used in Pennsylvania's "illuminative writing." Speaking of the schoolmasters who produced so many examples of the art, Mercer wrote that "they had instructed scholars in the art of Fraktur or illuminative handwriting until about the year 1840."

In our discussion of German typography we saw that Fraktur is the proper name for a type face first used in the prayer book printed by Johann Schoensperger for Emperor Maximilian in 1513. In our survey of calligraphy we saw that the earliest models printed for the guidance of the Pennsylvania student of German handwriting were the Sowers' woodcuts in which a printed Fraktur text was transliterated into cursive gothic script. We also saw in figure 284 an example of an engraved plate in which Fraktur models were provided for imitation by penmen. From this evidence it should be clear that while Fraktur was imitated in Pennsylvania German calligraphy, it was by no means the only form of handwriting used. For this reason the identification of all Pennsylvania "illuminative writing" as Fraktur is misleading. But, on the other hand, the fact that some examples of that art contain handwritten imitations of Fraktur is itself proof that the style is, at least in part, postmedieval in origin.

There are several other major differences between medieval illuminated manuscripts and the calligraphic exercises of the Pennsylvania Germans. These are readily seen if we turn from the subject of handwriting to that of its decoration. The most basic difference is one of technique. The decorations of the medieval manuscript most characterisic of illumination were painted in miniature technique. Those used in Pennsylvania German illuminations consist of drawings or calligraphic exercises in pen and ink, frequently washed with watercolor and sometimes heightened with various vegetable gums. Other differences between Pennsylvania manuscripts and medieval illuminations are found in their calligraphic decoration and representational subject matter, that is, in iconography and symbolism.

CALLIGRAPHIC DECORATION

In 1514 Dürer had accepted a commission from Maximilian I to decorate the Schoensperger-printed prayer book. He did so not with the techniques of the medieval miniaturist, but with line drawings in red, green, and violet inks (fig. 262).[54] Dürer's drawn decorations of the book's Fraktur

[52] A full account of the Pennsylvania German documents at Winterthur will be found in a handbook to the Joseph Downs Manuscript and Microfilm Collection being prepared by librarian Beatrice K. Taylor.

[53] Mercer's lecture was read September 17, 1897. It was first published in the *Proceedings of the American Philosphical Society* 36, no. 156 (December 1897): 423–32, and then reprinted as Bucks County Historical Society's Contributions to American History, no. 2 (n.p., n.d.).

[54] Wolfgang Hütt, *Albrecht Dürer, 1471 bis 1528: Das gesamte graphische Werk; Handzeichnungen* (Munich: Rogner & Bernhard, 1971), 1:746–47.

text are of two types: the first consists of abstract, nonrepresentational calligraphic ornaments or flourishes; the second are representational drawings. Both were repeated on Pennsylvania German manuscripts. Some of these American works of art, like Maximilian's prayer book, have a text printed with Fraktur type (pls. 43, 44). Others have a manuscript-text lettered, at least in part, in the style of Schoensperger's alphabet (pl. 46).

One group of Dürer's calligraphic flourishes was drawn as patterns of conventionalized tendrils growing out of grapevines. Another consists of purely abstract, symmetrical, geometrical interlaces. Dürer's grapevine flourishes and calligraphic abstractions entered the vocabulary of the writing master later in the sixteenth century. Figure 286 shows brilliant examples of their use as published by Fra Augustino da Siena in 1568. It also illustrates the introduction into the tradition of Fraktur of the technique of breaking the structure of the letters. An example of this in American printing can be seen in the *Martyrs' Mirror* (fig. 263).

If Augustino's plates are compared with a third from Egelmann's book (fig. 287), we can see clearly illustrated the relationship between the nineteenth-century handwriting model (*Vorschrift*) and the sixteenth-century, postmedieval innovations made by Schoensperger, Dürer, and Augustino. Dürer's grapevines are no longer used, but the symmetrical, geometic flourishes drawn by Dürer and Augustino are clearly present, as is the breaking of the letters used by the latter. In technique, in the use of the Fraktur alphabet, and in the form of drawn ornament, Pennsylvania German manuscripts depended on innovations in the Gothic, medieval tradition that were made in the sixteenth century, the period of the German Renaissance and of Mannerism.

ICONOGRAPHY

My own investigation over a period of more than thirty years has shown that a similar dependence on sixteenth-century and later innovations is characteristic of the subject matter of Pennsylvania illuminations. The majority of cases investigated shows either that the images originated after the Middle Ages or that they were the product of postmedieval transformations of icons or symbols. Two examples will illustrate my conclusions.

The postmedieval origin of a fairly common Pennsylvania image illustrates the first point (fig. 288). Anglicisms in the text of the manuscript demonstrate that it is American, not Continental, in origin. It is dated 1806. At the bottom of the sheet is a geometric, symmetrical interlace which, together with its Fraktur alphabet, demonstrates its relation to the drawings of Dürer (fig. 262) and the later sixteenth-

Fig. 286. Augustino da Siena, *Lettera Todescha* (German alphabet). From Alfred Fairbank, *Augustino da Siena: The 1568 Edition of His Writing Book in Facsimile* (Boston: David R. Godine, The Merrion Press, 1975), unpaged.

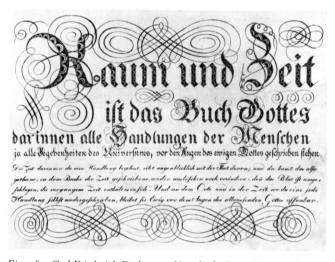

Fig. 287. Carl Friederich Egelmann, Vorschrift. From C. F. Egelmann, *Deutsche & Englische Vorschriften für die Jugend* (Reading, [1821?]), unpaged. (Collection of Printed Books and Periodicals, Winterthur Museum Library.)

century designs used in Augustino's book. It is transitional to the slightly later work of Egelmann. But the image itself is clearly postmedieval in origin. According to the text, it represents a monstrous fish caught at Geneva in 1740. Surviving evidence shows that the monster was not the invention of an American imagination. It had its source in a

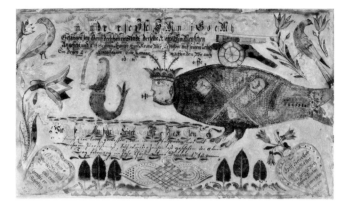

Fig. 288. Ein Wunder Grosse Fisch. Southern Pennsylvania, 1806. Ink and watercolor on paper; H. 19.5 cm., W. 32.9 cm. (Winterthur 61.1120.) Translation: "A wonderfully big fish which was caught with effort near Geneva, the beautiful city. The same had a man's face and on his head a crown with crosses, on his body a dagger, 2 war flags, a cannon and 3 guns as well as three skulls. As this drawing shows in detail the same was 3 yards[?] tall and also five yards[?] long as is obvious in following song with more. Such a miraculous sign happened the 11th day of February in the year of Christ, Anno Domini 1740. [Left Heart:] O Lord, thy mighty deeds are ——— and thy judgments are horrifying. March 18. [Right heart:] Help, Lord, God. Do not enter into judgment with us according to our works. Give us obedient hearts. 1806."

Fraktur broadside printed in Prague in 1624 (fig. 289).[55] The 1624 text states that the monster was caught in the Vistula River near Warsaw in 1623. Thus, the American image ultimately is the invention of a Bohemian imagination of 1624—again a product of the age of German Mannerism.

A second example illustrates the second point: even when Pennsylvania images were of ultimately medieval origin, their specific form was due to postmedieval reworking of the original. Our example consists of the history of a medieval heraldic symbol which was given a new form by a sixteenth-century Holy Roman Emperor, a sixteenth-century German scholar, and an eighteenth-century Secretary of Congress before it was adapted further as part of the vocabulary of Pennsylvania German folk art.

In 1515 Dürer decorated the foot of a page in Emperor Maximilian's Fraktur prayer book with the image of a spread eagle (fig. 262). It is a medieval, heraldic symbol of Maximilian's role as King of the Romans, a title to which he was elected by the Electors of the Holy Roman Empire in 1483. His grandson, Emperor Charles V, received the same title on October 23, 1520. As one of Charles's devices in 1551 he used the image of an eagle with the motto *Cuique Suum.*

[55] Dorothy Alexander and Walter L. Strauss, *The German Single-Leaf Woodcut, 1600–1700: A Pictorial Catalogue,* vol. 2 (New York: Abaris Books, 1977), pp. 467–68, 766.

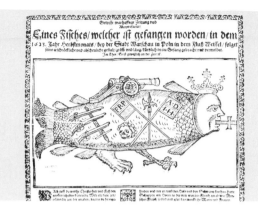

Fig. 289. Jacob Schmaritz, broadside. Prague, 1624. From Dorothy Alexander and Walter L. Strauss, *The German Single-Leaf Woodcut, 1600–1700: A Pictorial Catalogue,* vol. 2 (New York: Abaris Books, 1977), p. 468.

The device symbolized his role as source of justice as defined by Emperor Justinian. The spread eagle and Charles V's motto were combined and published in 1597 in a German anthology of emblems and devices by Joachim Camerarius, Jr., a German scholar who was the son of one of the editors of Dürer's writings.[56]

The first edition of the Camerarius anthology with its eagle device was reprinted many times (fig. 290). A copy of an edition of 1702 was obtained by Benjamin Franklin. Several of its other images were used on the paper money first issued by the Continental Congress in 1775. In 1786 Charles V's eagle of justice was reworked by Charles Thomson, Secretary of Congress, given the new motto *E pluribus unum,* and approved as the basis of the obverse of the Great Seal of the United States.[57]

The twice-adapted spread eagle of the seal became popular as a symbol of patriotism of the new nation. It was

[56] Edward Francis Twining, *European Regalia* (London: B. T. Batsford, 1967), p. 89; Fritz Saxl, *Lectures,* vol. 2 (London: Warburg Institute, University of London, 1957), pl. 177; Karl Brandi, *The Emperor Charles V: The Growth and Destiny of a Man and of a World Empire,* trans. C. V. Wedgwood (New York: Alfred A. Knopf, 1939), pp. 123–24; Richard S. Patterson and Richardson Dougall, *The Eagle and the Shield: A History of the Great Seal of the United States* (Washington: Department of State, 1976 [1978]), p. 95. In 1981 I identified the source of the motto *Cuique Suum* above the head of the eagle for the first time. It is a tag from the definition of justice used both in Justinian's *Pandects* and *Institutiones:* "Justitia est constans et perpetua / voluntas jus suum cuique tribuendi."

[57] Eric P. Newman, "Continental Currency and the Fugio Cent: Sources of Emblems and Mottoes," *Numismatist* 79, no. 12 (December 1966): 1587–98; Frank H. Sommer ("Emblem and Device: The Origin of the Great Seal of the United States," *Art Quarterly* 24, no. 1 [Spring 1961]: 56–76) established that the Camerarius, Jr., version of the eagle-*Cuique Suum* device of Charles V was the source used by William Barton and Charles Thomson for their design of the obverse of the Great Seal.

Fig. 290. Device of Emperor Charles V. From Joachim Camerarius, Jr., *Symbolorum et Emblematum centuriae quatuor* (Frankfort: Johann Ammon, 1654), unpaged. (University of Delaware Library.)

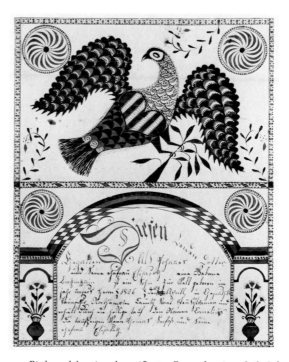

Fig. 291. Birth and baptismal certificate, Pennsylvania, 1826. Ink and watercolor on paper with the watermark LEVAN; H. 39.8 cm., W. 31.45 cm. (Winterthur 61.1105.) Translation: "To these two married persons, namely Johannes Dotter and his wife, Elisabeth, née Brotzmen, a son was born into this world in the year of our Lord 1826, the 23d of April in Chestnut Hill Township, Northampton County, state of Pennsylvania, and received through holy baptism the name Cornelius. The sponsors were Thomas Serfuss and his wife, Elisabeth."

accepted and again transformed by the Pennsylvania Germans. In the example reproduced as figure 291 the bird of the Great Seal was combined with the symbol of the heart, long accepted by the Pennsylvania Germans as a symbol of spiritual regeneration. It was appropriately applied to Cornelius Dotter's 1826 certificate of baptism, both as a symbol of his Christian rebirth and as a proclamation of German American patriotism.

One may say of Luther's theology, as Henry Mercer did of Pennsylvania illumination, that it was a survival of the medieval. But it was Luther's distinctive adaptation and transformation of medieval thought that created his Protestant theology. On a more modest level in the same way, the scholar who designed the Fraktur alphabet for Schoensperger executed it out of gothic ones, Dürer supplied it with its characteristic decorations, and Charles V, Camerarius, Jr., and Charles Thomson created a Mannerist adaptation of a medieval image which became a part of the vocabulary of Pennsylvania German folk art. There may be examples of Pennsylvania manuscripts that are direct survivals of the medieval art of illuminative writing. But, even so, it seems probable that in technique, decoration, and iconography, they were largely a product of the postmedieval German mind. This conclusion is given strong support by the manuscript illuminations produced by the sisters of Ephrata, the mother house of a Protestant religious order established by German mystic Johann Conrad Beissel.

MUSIC OF EPHRATA

The collection of Ephrata illuminated material at Winterthur consists of eight bound volumes of music. Of these, three are completely in manuscript and three are manuscripts with a printed "register" of the contents in which the titles are arranged alphabetically. Two of the volumes have a printed text, but music ruled by hand. In both, the notes of the music are also handwritten. The printed books have illuminations drawn in ink and tinted with light washes of watercolor. These volumes show considerable variation. They have never been studied with care. Since the purpose of this book is to introduce the reader to the collections at Winterthur, only three items in the group will be discussed here.

"Paradisisches Wunder Spiel Welches sich In diesen letzten Zeiten und Tagen In denen Abend ländischen Welt Theilen als ein Vorspiel der neuen Welt hervor gethan. Bestehende in einer gantz neuen und ungemeinen Sing-Art auf Weise der Englischen und Himmlischen Chöre eingerichtet, . . . 1754." Joseph Downs Manuscript and Microfilm Collection 65 x 560.

Of the Ephrata illuminated material, the finest of the Winterthur manuscripts are copies of "Wunder-Spiel," dated 1754 (pl. 46). The complete translated title is as follows:

Miracle-play of Paradise which has come to the fore in these latter times and days in this Western World as a prevision of the New Earth, consisting of an entirely new and uncommon art of singing according to the manner of the angelic and heavenly hosts in which the Song of Moses and the Lamb and also the Song of Solomon, together with choice witnesses from the Bible and other saints are set forth in lovely melodies, whereby nothing less than the call of the Bride of the Lamb together with preparations for the joyous wedding-day is admirably symbolized. All embellished in the mode of singing by the angelic choirs by a Peaceful One who seeks no other name nor title in the world. 1754.[58]

The manuscript version consists of 161 illuminated sheets of music and a single sheet, both sides of which are covered with text, of a register of hymn titles that parallels the register in our printed copies of "Wunder-Spiel." The content of the register in our manuscript differs considerably from that in our printed copies.

Music of the "Wunder-Spiel." Mercer's belief that the decoration of Pennsylvania German manuscripts is a survival of medieval illumination must be examined with particular care in the case of those produced in the Ephrata community during the eighteenth century. The way of life of that community (and its sister community in Snowhill, Franklin County), the music, and the use of beautifully decorated music books by the community's members while singing together at night have many apparent similarities to what we know of the life of the monks and nuns of the Middle Ages.

The community at Ephrata and the decoration of its musical manuscripts caught attention even during the lifetime of its founder, Johann Conrad Beissel. In 1752, Boston physician William Douglass wrote: "We mentioned a Branch of the German Anabaptists called Dumplers; they are generally ignorant People, but some of their Heads are not so; for Instance, Peter Miller a German, writes elegantly in Latin upon Religion and Mortification: They have a Printing Press, and are continually Printing; they are very curious in writing fine, and delight much in scrouls of Writing on Religious Subjects, stuck up in their Halls and Cells, the initial Letters are beautifully illuminated with Blue, Red, and Gold, such as may be seen in old Monkish Manuscripts."[59]

When Mercer looked at manuscripts in 1897 and saw "medieval survival," his interpretation of the evidence was phrased anthropologically. There was nothing new about the parallel he drew with medieval illuminations.

An early visitor whose learning equaled that of Peter Miller was Swedish visitor Israel Acrelius, who wrote in 1753: "The sisters also live by themselves in their convent, engaged in spinning, sewing, writing, drawing, singing, and other things. The younger sisters are mostly employed in drawing. A part of them are just now constantly engaged in copying musical note-books for themselves and the brethren. I saw some of these upon which a wonderful amount of labor had been expended."[60]

To understand the relation between the Ephrata way of life and its music we can turn to a commentary on them published just after World War II. In 1947 German novelist Thomas Mann published *Doctor Faustus*, one of the fruits of his wartime exile in the United States. It is a fictional account of a German musician named Adrian Leverkühn who, as a boy, had as a music teacher in Germany a native of Pennsylvania named Wendell Kretschmar. The teacher told his young student about Ephrata and its music. The subject fascinated Mann. He made it the basis of his novel; the tale of a man who sold his soul to the Evil One to be able to develop in his own work the musical theory and practice of Beissel.

The spirit commanded him to take to himself in addition to the role of poet and prophet that of composer.

. . . Most of the chorals, which had come over from Europe, seemed to him much too forced, complicated, and artificial to serve for his flock. He wanted to do something new and better and to inaugurate a music better answering to the simplicity of their souls and enabling them by practice to bring it to their own simple perfection. . . .

[He] set to music all the hymns he had himself ever written, as well as a great many by his pupils. Not satisfied with that, he wrote a number of more extended chorals, with texts taken direct from the Bible. It seemed as though he was about to set to music according to his own receipt the whole of the Scriptures; certainly he was the man to conceive such a plan. If it did not come to that, it was only because he had to devote a large part of his time to the performance of what he had done, the training in execution and instruction in singing—and in this field he now achieved the simply extraordinary.[61]

Mann was so moved by his American encounter with the music of Ephrata that he built the whole structure of *Doctor Faustus* on a foundation laid by Beissel's musical theories. But, in the entire novel, Mann said not a word about the

[58] John Joseph Stoudt, *Pennsylvania German Folk Art: An Interpretation*, Pennsylvania German Folklore Society, vol. 28 (Allentown, Pa., 1966), p. 159.

[59] William Douglass as quoted in Felix Reichmann and Eugene E. Doll, *Ephrata: As Seen by Contemporaries*, Pennsylvania German Folklore Society, vol. 17 (Allentown, Pa., 1952), p. 49.

[60] Israel Acrelius, *A History of New Sweden; or, The Settlements on the River Delaware*, trans. and ed. William M. Reynolds (Philadelphia: Historical Society of Pennsylvania, 1876), pp. 375–76.

[61] Thomas Mann, *Doctor Faustus: The Life of the German Composer Adrian Leverkühn as Told by a Friend*, trans. H. T. Lowe-Porter (1948; reprint ed., New York: Vintage Books, 1971), pp. 65–66.

manuscript notebooks in which the music was recorded.

Examination of Ephrata music shows that its manuscripts and decoration, like the compositions they recorded, were new and different. That the newness was self-conscious is indicated by the official history of Ephrata, *Chronicon Ephratense*. After discussing Beissel's music, the *Chronicon* turned to the writing school,

where the writing in ornamental Gothic text was done, and which was chiefly instituted for the benefit of those who had no musical talents. The outlines of the letters [Beissel] himself designed, but the shading of them was left to the scholar, in order to exercise himself in it. But none was permitted to borrow a design anywhere, for he said: "We dare not borrow from each other, because the power to produce rests within everybody." Many Solitary spent days and years in these schools, which also served them as a means of sanctification to crucify their flesh. The writings were hung up in the chapels as ornaments, or distributed to admirers.[62]

On the evidence of the *Chronicon* it seems safe to conclude that the decorations of the manuscripts were inspired by the belief that their designs were the fruit of the spiritual battle for sanctification. Comparison of the same page of "Wunder-Spiel" from two different copies of the book shows that there was a major difference in the work of the writing school between music and text and the method of its decoration (pls. 43, 44). The printed text is identical in both cases. The score was ruled and written by hand, but it, too, is identical in both cases. In contrast, the decorations were drawn almost completely ad libitum. This condition holds throughout both copies of the book. On this evidence it seems fair to suggest that at Ephrata decoration of text and music was conceived as the fruit of divine inspiration blowing where it willed.

The heights of the performance of Beissel's music were reached—according to all accounts—in his own lifetime. The illuminations of the Cloister are a permanent record of their makers' spiritual aspirations, inspirations, and experience of creative, holy joy.

The intent of Beissel and his artists was to produce something new. But, of course, nothing is produced out of nothing. The manuscript illuminations at Ephrata had prototypes, but they were not those of medieval illuminations. Although red, blue, and gold may have been used, as Douglass claimed in 1752, the surviving manuscripts of the 1750s show a very different pattern of facts. In Winterthur's two copies of *Wunder-Spiel*, presumably illuminated at about 1754, we find that the unfaded colors of the decorations are in a variety of earth tones and greens more like the colors of Pennsylvania German textiles than of medieval illuminations. Much of their ornament, too, reminds one of the checks and squares of simple coverlet patterns rather than painted medieval illumination. The representational images, when they occur, are comparable to those of contemporary heraldry and folk art.

Resurrection diptych of the "Wunder-Spiel" manuscript. Postmedieval innovation occurred in Ephrata iconography and symbolism as well as in its music and manuscript decoration. The symbolism of at least one major Ephrata picture was based on Beissel's interpretation of the philosophy and theology of Jacob Boehme.

The essence of Beissel's interpretation of Boehme's Christian anthropology was published in *A Dissertation on Man's Fall* in 1765.[63] According to Boehme, the first man was androgynous and created in union with the Virgin Sophia, the Wisdom of God. Adam's fall was a process that began when he aspired to knowledge of the merely temporal. In a deep sleep the female was separated from him as Eve. The culmination of the fall was the seduction of both the female and the male by Satan and their expulsion from paradise. Since the expulsion, the sexes have been separated both from each other and from the Virgin Sophia.

Beissel believed that the spiritual life should be based on Boehme's anthropology. The highest form of life in this world, Beissel taught, was celibacy for both sexes, a monastic life in which one rejected the desire for sexual union and aspired to reunion with Divine Wisdom, the Virgin Sophia, guided by the new and perfect Adam, Jesus Christ.

Boehme held that spiritual perfection could be achieved only through the resurrection and Last Judgment. This was the "Marriage of the Lamb." It began with the raising of the dead and their judgment. The damned, according to Boehme, received a spiritual body and, after judgment, departed into eternal hell. The saved, in their new bodies, like Christ were united with Holy Wisdom in the new paradise of eternal heaven.

The Winterthur manuscript's principal decoration is a diptych of the Resurrection (pl. 47). The left-hand leaf bears a German translation of the description of the Last Judgment as found in 1 Corinthians 15. The Holy Ghost in the form of a dove hovers at the top of the leaf. Above a grove of trees looms the angel of the last trump.

The right-hand leaf is divided into two major zones. In the lower stands Christ as the Heavenly Lamb, surrounded by the saved. In the upper is Virgin Sophia carrying the cross, symbol of Christian victory over death.

[62] Lamech and Agrippa, *Chronicon Ephratense*, pp. 168–69.

[63] [Johann Conrad Beissel], *A Dissertation on Man's Fall, Translated from the High-German Original* (Ephrata, 1765).

Fig. 292. Title page. From John Dotterer, [Song] Noten Buchlein, Upper Saucon Township, Lehigh County, 1800. (Joseph Downs Manuscript and Microfilm Collection 65 x 549, Winterthur Museum Library.)

Beissel presented his vision of the Last Judgment:

The new Jerusalem shall descend from God out of heaven, as a bride adorn'd for her husband. *Rejoice O heaven! rejoice, O earth! Let the thrones, authorities and dominions rejoice! Let all pure ministerial spirits rejoice over the bridgegroom and bride! Let all the companions of the bridegroom and bride rejoice, for the marriage of the Lamb is come.*

Now the sorrowful have ended their days of mourning, and the afflicted and miserable are lifted up out of the dust: the marriage feast will continue for many days; but the last day will be the most glorious, then shall they drink of the richest wine of the best vineyard, and the maidens will go forth, to conduct and attend the bride into the king's bed-chamber. O peace! O rest! O safety for ever and ever! Now the king awaketh from his last sleep, and immediately giveth orders for the last trumpet to be blown, to proclaim the everlasting day, for night shall be no more, HALLELUIA.[64]

Both text and picture are closely related. The figure of the Lamb recalls the Ghent altarpiece (1425–32) of the Van Eyck brothers, but the meaning of the picture is eighteenth century. Beissel's anonymous artist followed Boehme on the whole, but departed from his theology in one major feature. Boehme had maintained orthodox Lutheran belief in the eternity of the pains of hell. Living in eighteenth-century frontier Pennsylvania, this artist portrayed only the eternal joys of heaven.

To those familiar with the history of the early Christian church and Western monasticism there is much that is familiar in the theories of Boehme and Beissel and in the religious life of Ephrata. The celibacy of monks and nuns, the use of choir books to sing a choral office, and the illumination of books as part of the spiritual life are all survivals

of the medieval. And yet these remnants of a Catholic past were given a new Protestant form and life by Beissel and the Ephrata community. Beissel's artist went further than Boehme in an emphasis on Christian love and gave the Last Judgment a less traditional interpretation.

In music, calligraphy, and iconography the *Wunder-Spiel* represents a facet of the New American unaccounted for in Frederick Jackson Turner's concept of the frontier. The book is much more than a mere "survival of the medieval art of illuminative writing." It is the product of a Protestant metamorphosis of the medieval, evidence of an opening phase of what was to become the American Protestant communal society. This and the other Ephrata illuminations are closer to the so-called spirit drawings of the Shakers than to anything medieval.

OTHER GERMAN MUSIC IN PENNSYLVANIA

A long line of émigrés both sophisticated and unsophisticated began in the eighteenth century to bring to this country one of the greatest glories of German culture—its music. German music in that century, with little doubt, was the most sophisticated in North America. The major focuses of that art were the Moravian settlements of Pennsylvania and North Carolina.

E. Power Biggs, through his recordings, brought to attention the organs made by the Pennsylvania German Tannenberg family. He believed that some of their instruments "still rank among the finest in the United States, and are inferior to none in Europe save in size."[65]

The musical manuscript collection formed by Moravian musician Johannes Herbst (1735–1812) demonstrates that the European compositions available to eighteenth-century American Moravian performers ranged from the work of Handel, the Bach family, and Haydn to a broad spectrum of lesser-known German names. The collection also contains the work of American composers—including Herbst. The music performed and written by Moravians was by no means completely religious. When the Marquis de Chastellux traveled through Pennsylvania in the 1780s, he encountered musical programs. On December 11, 1782, he visited in Bethlehem the single sisters' house. In the chapel he saw an organ and "several musical instruments hanging from hooks." In the brothers' house he "entered the intendant's apartment, and found him busy copying music." An organ performance followed in the chapel at the request of the marquis.[66]

[64] Beissel, *Dissertation*, p. 37.

[65] E. Power Biggs, *The Organ and Music of Early America: An Exploration* ([New York]: Columbia Records, n.d.), n.p.

[66] Marquis de Chastellux, *Travels in North America in the Years 1780,*

The eighteenth-century translator of the marquis's *Voyages*, George Grieve, added: "At one of their cleared-out settlements, in the midst of a forest, between Bethlehem and Nazareth, . . . I was astonished with the delicious sounds of an Italian concerto, but my surprise was still greater on entering a room where the performers turned out to be common workmen of different trades, playing for their amusement. At each of these places, the brethren have a common room, where violins and other instruments are suspended, and always at the service of such as choose to relax themselves, by playing singly, or taking a part in a concert."[67] Moravians provided instruction in music for the students in their schools as early as 1748. Some Moravians also composed music.

The most distinguished German composer working in eighteenth-century Pennsylvania probably was John Frederick Peter (1746–1813). He was born in Holland of German parents. After a musical education in Europe he came to this country in 1769. He worked in Nazareth and Bethlehem as teacher and organist. Between 1780 and 1793 Peter worked as musician and teacher in Hope, New Jersey, Lititz, Pennsylvania, Graceham, Maryland, Salem, North Carolina, and then returned to Pennsylvania. The greater part of his life, after his return, was spent in Bethlehem. More than thirty of his compositions were for voice and orchestra, but he also wrote sophisticated chamber music, including quintets for two violins, two violas, and cello.[68]

The concern for music as a necessary part of one's education and life extended through the Lutheran and Reformed congregations as well, as David Tannenberg's splendid organ case of 1774 in Trinity Lutheran Church, Lancaster, and the 1804 organ made for Christ Lutheran Church, York, testify. This interest in music was also found, if in a much more simple form, among sects such as the Schwenkfelders and the Mennonites.

Winterthur has no important German-American instruments, and the library contains no manuscripts by Peter or any of the other early, sophisticated German-American composers. But, thanks to du Pont's interests in the visual dimensions of American culture, we do own a splendid collection of decorated religious notebooks that record simple Pennsylvania music, tunes rather than compositions. In some cases the artist-decorator is unknown, but the name of the pupil for whom the book was prepared, his school

and the date are given. One book was made for John Dotterer (fig. 292) when he was a pupil in the school in Upper Saucon Township, Lehigh County, in 1800. Today, we are learning more about the artists. As the result of such studies as Frederick S. Weiser's recently published work on artist Johann Adam Eyer, we have entered a new and more sophisticated phase of scholarship. Weiser has shown that music and words from the Marburg hymnal were not used exclusively by Lutherans and that Eyer, a Lutheran, taught in Mennonite and Schwenkfelder schools.[69]

COPY AND EXERCISE BOOKS

The initial wave of German immigration to Pennsylvania was headed by what were then called "separatists," people whose religious orientation was Protestant, but who were not members of official, or state, churches. Francis Daniel Pastorius, leader in the settlement of Germantown, and his followers had rejected membership in both Lutheran and Reformed churches. In this rejection of the affiliation of church and state, Pastorius was wholly at one with William Penn and other strict Quakers and their rejection of the established Church of England. Although many people who had been members of Lutheran and Reformed churches in Europe fast followed on the first separatists in Pennsylvania, they were without an organized ministry to supervise and direct their lives. Leaders developed, but most came from the ranks of the separatists.

Various efforts were made by members of the state churches to bring order into Pennsylvania's German life. Lutheran-ordained Count Nikolaus Ludwig von Zinzendorf and his followers used the oldest protestant episcopal church, the Unitas Fratrum, or Moravians, to try to develop ecumenism among all Pennsylvanians. The Reverend Henry Melchior Mühlenberg was sent by Lutherans of Germany as a pastor. After his arrival in Pennsylvania, he organized the American members of his church along denominational lines. The Reverend Michael Schlatter worked in Pennsylvania to the same end on behalf of the Reformed Synods of Holland. The Reverend William Smith, an Anglican priest, entered the fray on a line opened by Benjamin Franklin.

A basic issue in all the efforts at organization was education, and among Pennsylvania Germans it remains a basic issue today. The separatists have never been completely

1781 *and* 1782, rev. and trans. Howard C. Rice, Jr., vol. 2 (Chapel Hill: University of North Carolina Press, 1963), p. 523.

[67] Chastellux, *Travels*, p. 644.

[68] Donald M. McCorkle, *Arias, Anthems and Chorals of the American Moravians* (New York: Columbia [Records], n.d.), n.p.; *Dictionary of American Biography*, s.v., "Peter."

[69] Frederick S. Weiser, "IAE SD / The Story of Johann Adam Eyer (1755–1837) Schoolmaster and Fraktur Artist with a Translation of His Roster Book, 1779–1787," *Ebbes fer Alle-Ebber, Ebbes fer Dich: Something for Everyone, Something for You*, Publications of the Pennsylvania German Society, vol. 14 (Breinigsville, Pa., 1980), pp. 435–506.

assimilated, and yet, both then and now, because their Bible-oriented culture demands literacy, they were and are still faced with the problem of education, especially at the grammar school level. A basic issue was German versus English literacy.

We have reviewed Franklin's first efforts at German assimilation through publication. His second thought was to send the Germans to English schools. The end result of his idea was the formation of the German Society in London. Its purpose was to provide free English schools for Pennsylvania German children. The program was initiated to teach English in order to win the Germans completely to the political causes of the British Empire in North America.[70]

German charity schools were vigorously opposed by Christoph Sower I. He used his newspaper to fight the scheme, and in 1754 he began to use his almanac to teach German script. He publicly opposed assimilation and provided ammunition for the fight to stay German—and separatist—by using all the ideological and educational means at his hands. The first phase of the war for separatism, the preservation of German language, German literature, German types, and German script, was won by Sower and his followers. After his death in 1758 his son, Christoph II, continued his father's editorial policies. In 1769 the German Society gave up its efforts and turned over the remainder of its funds—£88.12.4—to the trustees of the College of Philadelphia. But the war against separatist education continued.

After the collapse of the German charity-school plan, various alternative solutions to the problems of education among the Pennsylvania Germans were attempted. The Lutherans established an academy in Philadelphia in 1773. It survived until the British occupation of the city and was revived in 1779 under the German Department of the University of Pennsylvania. Another alternative was the establishment of an interdenominational college for German education, Franklin and Marshall College in Lancaster, in 1787.[71] The Moravians continued to develop their own schools. After the Revolution they opened them to students of other denominations.

The majority of Pennsylvania Germans contented themselves with elementary education either in English-speaking schools or in German-speaking, parochial schools.

[70] Whitfield J. Bell, Jr., "Benjamin Franklin and the German Charity Schools," *Proceedings of the American Philosophical Society* 99, no. 6 (1955): 381–87.

[71] Lyman H. Butterfield, ed., *A Letter by Dr Benjamin Rush Describing the Consecration of the German College at Lancaster in June, 1787* (Lancaster: Franklin and Marshall College, 1945).

Winterthur Museum Library contains educational artifacts that were the products of Moravian schools, of assimilation by English-speaking schools, and of isolationist schools run by sects.

Exercise book, Nazareth Hall School, Fall Examination, 1793. Joseph Downs Manuscript and Microfilm Collection 78 x 266.

A group of school examination papers are bound together in boards covered with a German-style decorated paper. The neatly labeled spine reads, in part, "Autumnal Examination 1793." The book contains exercises by scholars of the "first, second and third class" of that year at Nazareth Hall.

That there is a printed history of the school and that these, like all the other exercises from the school in our collection, are signed and dated, permits us to begin to reconstruct much of the life of the school. The students were boys in early adolescence rather than of college age. But they were being subjected to a uniform education in which they were being taught to write both German and English and to learn both calligraphic systems. They were also being taught to speak both languages. At the time, the school was open to students of denominations other than Moravian.

The exercises also include science, mathematics, both pure and applied, and art. The boys were taught to draw human and animal figures and were instructed in the drawing of architectural plans and architectural rendering. The styles of architecture taught were both Anglo-American and German American.

"John Eckman, in Lampiter Township, Lancaster County, Decemb'r 3d 1804." Joseph Downs Manuscript and Microfilm Collection 78 x 182.

The John Eckman manuscript consists of a bound volume of exercises, all of which deal with one or another form of arithmetic and quantitative measure. The book opens with exercises in the reduction of guineas, crowns, shillings, pence, groats, and farthings. It goes on to deal with pounds and ounces of silk, tons of iron, hogsheads of tobacco, and chests of sugar. Apothecaries' weights, "long measure" (miles, yards, and "barley cornes"), dry measure, time, motion, and wet measure are all presented. These are followed by exercises in which practical problems using the units of measure are solved with particular attention to accounting. After its maker's school days it served as a day-to-day account book. The formal text of the exercises is completely in English, but the pages devoted to the details of "A Memorandum of the Cash paid for My House" also include some notes in German.

The pages of exercises are decorated with illuminated roman capital letters which differ little, if at all, from those in exercise books produced in New England in the early nineteenth century. It is in the endpapers of the book and in various small, closely similar drawings scattered through the text that the decorator was at his best (pl. 45). Whether the artist was Eckman or an uniden-

tified calligrapher who decorated the book for him, these illuminations are among the most vigorous surviving works of Pennsylvania folk artists. Together, text and decorations help to document the thorough interpenetration of Pennsylvania German and English-speaking culture in Lancaster County education as early as 1804.

Drawings

Under the heading of drawings we present three groups that are very different from those usually thought of as Pennsylvania German. All three consist of drawings made by Germans working in Pennsylvania. All three are characterized by an interest in nature as opposed to the decoration of texts.

The three groups are academic drawings, drawings of Pennsylvania scenes and subjects, and working drawings. The first two groups are united by the fact that they are exercises in reproducing nature according to the standard canons of traditional Renaissance and post-Renaissance art. Albertinian perspective, for example, is a fundamental part of academic landscape drawing. It is a method of representing apparent space, very different from that of the folk artist who forgets about natural space and rearranges nature in a manner he finds more satisfactory as pattern. Foreshortening and anatomy are other aspects of traditional art disregarded by the maker of folk art. In contrast, our first two groups of drawings deal first with the representation of the human figure and second with landscape in the widest sense of that term. Our third group of drawings is also closely related to nature in the sense that they are drawings made for the purpose of providing visual instruction for those engaged in the practice of a trade or craft. Their limiting factor is the need to provide exact information for work to be done. They range from architectural plans and elevations to weaving patterns and furniture designs. While our first two groups of drawings belong to the arts considered as fine or intellectual, our last group is made up of utilitarian drawings—drawings meant for use, no matter how beautifully executed.

ACADEMIC DRAWINGS

The earliest surviving physical evidence for academic art instruction in the United States appears to be a large group of exercises in drawing and watercolor done by the boys of the Moravian school at Nazareth Hall. It is not known when the Moravians began teaching drawing as part of a school's

regular curriculum, nor is it known when instruction started at Nazareth Hall. The drawings at Winterthur belong to the period beginning in 1785 when the school was reopened and non-Moravian students were admitted.[72]

It is not surprising that a Moravian school should offer such instruction. The most famous member of the church was the seventeenth-century bishop Amos Comenius, who in his work as an educator placed great stress on the importance of visual images in the teaching of languages. He was certainly one of the major figures in advanced methods of education in his day. Further, the Moravians were a body whose major eighteenth-century patron, Count von Zinzendorf, had been a noble member of the court of the Elector of Saxony. He belonged to the Protestant branch of one of the great families of the Holy Roman Empire. His disciples included both titled people and gentlemen. The literature of the European courtesy book as far back as Castiglione's *Book of the Courtier* of 1528 had recommended a knowledge of drawing as part of the education of gentlemen. The recommendations of the Synod of 1764 did not stress that Moravian education should prepare students for life as gentlemen, but there were many gentlemen among them. Demand may have suggested that drawing be a part of Moravian training at Nazareth Hall.

The students after 1785 were the only early American schoolboys so far identified who received instruction in drawing, painting (at least in watercolor), and architectural drawing as part of their regular academic curriculum. The instruction was specifically modeled on the procedures followed in education in the contemporary European academies of art. The boys began by using textbooks teaching how to draw the various parts of the body—especially head, face, and hands. They continued to develop their skills by copying prints, most of which were European. But they also copied contemporary American prints. Pasted into a nineteenth-century album at Winterthur, which seems to have been compiled from their work by their proud teacher, is a watercolor copy of a contemporary American print mourning the death of George Washington (pl. 49). Although the school was denominational, its instruction by no means avoided the current issues of American nationalism. The copy is signed by Charles F. Kluge and dated May 25, 1816. The original, hand-colored, stipple engraving by Samuel Seymour was first published by J. Savage in Philadelphia in 1804. The drawing may have been made after a later issue, since the print is known to have been reissued in 1814. Of

[72] J. Taylor Hamilton and Kenneth G. Hamilton, *History of the Moravian Church: The Renewed Unitas Fratrum, 1722–1957* (Bethlehem, Pa., and Winston-Salem, N.C.: Interprovincial Board of Christian Education, Moravian Church in America, 1967), p. 221.

the engraving it has been said: "Perhaps more widely copied in needlework than any other Washington Memorial print, this now rare engraving also inspired countless paintings on paper, velvet, and glass."[73]

PENNSYLVANIA GERMAN
SCENES AND SUBJECTS

The countryside in which the Pennsylvania Germans took up residence has drawn the eyes of many artists since the eighteenth century. Painters, printmakers, and photographers have recorded and interpreted the landscape and its people. In spite of the hideous damage inflicted by the automobile and its associated highways and motels, the "Dutch" countryside is still beautiful. It is still studded with memorable and handsome buildings.

Some of the artists who recorded the scenes were German Americans. The earliest distinguished artist to draw and paint the Pennsylvania German country was Benjamin Henry Latrobe (1764–1820). Although born in the Moravian community at Fulneck in Yorkshire, his mother, Anna Margaretta Antes, was a Pennsylvania German whose father, Henry Antes, was an important supporter of the American Moravians in Bethlehem and Nazareth in the 1740s. Latrobe, therefore, was half German American by birth. Latrobe began his education in the Moravian colony at Fulneck. He received further education in Germany itself. Thus, when the future architect of our Capitol came to this country it was new to him, but when he traveled among the Pennsylvania Germans, he was among his own people. Certainly he could speak German. It is probably no coincidence that this first known American student was Pennsylvania German architect and engineer Frederick Graff. During his early travels throughout the South and the Middle Atlantic states Latrobe constantly sketched the scenery, buildings, and people he encountered. Among his drawings some of the most valuable historical documents represent contemporary Pennsylvania German houses, inns, and barns.

The subject of the life and landscape of the Pennsylvania Germans was of equal interest to a German-born emigrant who also took up residence in Pennsylvania. John Lewis Krimmel (1789–1821) was younger than Latrobe, but their periods of residence in this country overlapped. Krimmel was a native of Ebingen in Württemberg. He emigrated to the United States in 1810 and lived first in Philadelphia.

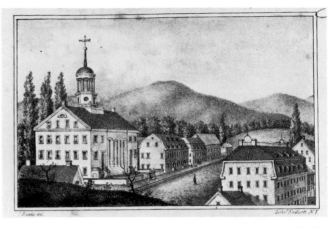

Fig. 293. Samuel Reinke, *Church & Young Ladies Seminary, at Bethlehem, Penna.* From *Twelve Views of Churches, Schools and Other Buildings Erected by the United Brethren in America* (New York: D. Fanshaw, 1836), unpaged. (Collection of Printed Books and Periodicals, Winterthur Museum Library.)

There, although he had received prior training in art in Germany, he became a student in the newly founded Pennsylvania Academy. From 1817 to 1819 he returned to Europe and traveled on the Rhine. He went at least as far as Salzburg and Vienna before returning to this country.

Winterthur has no original Latrobe watercolors but is fortunate enough to own two of Krimmel's oils, including *Election Scene in Front of the State House, Philadelphia,* and a group of sketchbooks. These include drawings of Pennsylvania German subjects and scenes of German peasant life in Europe. They provide an admirable cross-cultural survey of German country life on both sides of the Atlantic in the first quarter of the nineteenth century. Krimmel's drawings of this country portray landscape, people, and animals, interior scenes, and exterior architecture (pl. 48).

Augustus Kollner, like Krimmel, immigrated to this country from Württemberg. His lithographs frequently reproduced his sketches of the Pennsylvania countryside (fig. 270). He made many unpublished drawings and paintings of the same region. Other pictures of the Pennsylvania German scene were painted by Moravians. The Winterthur collection contains several original views of Moravian origin and a volume of lithographs: *Twelve Views of Churches, Schools, and Other Buildings Erected by the United Brethren in America* (1836). Reproduced is a lithograph after Samuel Reinke, portrait painter, schoolteacher, minister, and bishop of the Moravian church (fig. 293).

The Pennsylvania German scene has also been a subject of great interest for visiting artists. In our period the most gifted of foreign visiting painters probably was Swiss-born

[73]Davida Tenenbaum Deutsch and Betty Ring, "Homage to Washington in Needlework and Prints," *Antiques* 119, no. 2 (February 1981): 415.

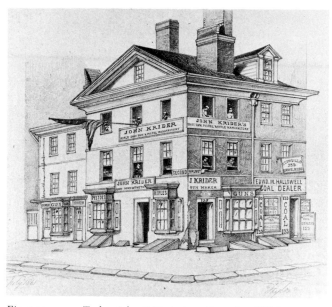

Fig. 294. —— Taylor, John Krider's shop, Second and Walnut streets, Philadelphia. 1861. Pencil and wash drawing; H. 16.99 cm., W. 21.43 cm. (Joseph Downs Manuscript and Microfilm Collection 75 x 47, Winterthur Museum Library.)

Karl Bodmer. He came to the United States in 1832 as the staff artist to Maximilian, prince of Wied-Neuwied, a retired military officer and a passionate naturalist. The prince's major goal was to study the American Indian. But on his way to what is now Nebraska, he had Bodmer paint views of the settled parts of the United States, including several sketches of the Pennsylvania countryside. One was a picture of Bethlehem. Bodmer's views are represented in the Winterthur collection only by prints made after his original paintings.

Winterthur also has drawings of Pennsylvania German subjects, probably intended for publication, made by another nineteenth-century artist who seems to have been an English-speaking visitor. These are drawings of Philadelphia done in 1861 by an artist who only signed his work "Taylor." We have been able to discover virtually nothing about the artist. He is of particular interest in the present context because several of his drawings are views of Pennsylvania German buildings in Philadelphia. Among them is a detailed picture of the shop of well-known gunmaker John Krider (fig. 294), a Pennsylvania German craftsman whose trade card was made by Kollner.

WORKING DRAWINGS

Although drawing was taught at Nazareth Hall as part of the education of a well-rounded man, it was also taught as part

Fig. 295. Ludwig Schweiniz, cupola in the German style. Nazareth Hall School, Nazareth, 1793. Ink and wash drawing; H. 32.84 cm., W. 20.48 cm. (Joseph Downs Manuscript and Microfilm Collection 78 x 266, Winterthur Museum Library.)

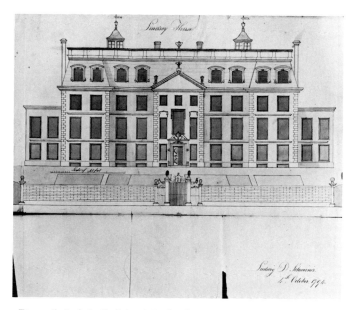

Fig. 296. Ludwig D. Schweiniz, *Lindsey House*, Nazareth Hall School, Nazareth, 1794. Ink and wash drawing; H. 37.78 cm., W. 44.29 cm. (Joseph Downs Manuscript and Microfilm Collection 60 x 10.8, Winterthur Museum Library.)

of the equipment for living. Boys were instructed in the drawing of formal floor plans and elevations as well as architectual rendering. The surviving drawings also demonstrate that, as with English and German script, the boys were taught how to draw in two architectural languages. The pupil who signed himself "Ludwig Schweiniz," a member of an extremely important Moravian family and later one of the most distinguished men of his church in early nineteenth-century America, drew both German and English exercises. While the first color drawing probably is ideal (fig. 295), the second is an elevation of a building that still exists (fig. 296). It is Lindsey House, a building in the Chelsea district of London purchased by Count von Zinzendorf in 1750/51 as his English town house and headquarters for his missionary activities. It was extensively remodeled while owned by the Moravians. After the count's death the building was used as headquarters by his successors, the administrators of the British Moravian church. Schweiniz was not drawing abstractions or purely imaginary, projected buildings; he was learning about the realities of the property held by an international Protestant denomination.

Drawings by Frederick Graff, done before he became Latrobe's pupil, show that the Pennsylvania Germans outside the Moravian church also thought in Anglo-American rather than purely Germanic architectual language. Even before meeting Latrobe, Graff was very interested in studying contemporary handbooks of architecture and learning the fashionable vocabulary of Adamesque neoclassicism (fig. 297). Like young Schweiniz, he was interested in color as well as form.

Manuscript materials in the library also show Pennsylvania Germans at work in the crafts. Weaving patterns frequently were drawn by or for the artisan. Pennsylvania Germans when seated at the loom did not merely reproduce existing patterns; they also produced variations on a received theme or inventions of their own. An example of such German ingenuity is a pattern book of F. Walborn written and drawn in Lehigh County in 1815.

Much rarer in the documents of early American craftsmanship than weaving drawings are working drawings for furniture. The account book of Peter Ranck of Lebanon County covers the years 1794–1817. His drawings were discussed by Benno M. Forman elsewhere in this volume. It is sufficient to say here that they are among the few surviving American furniture drawings of their period. They demonstrate that in the minor arts as well as the major the Pennsylvania German was an active participant in the artistic life of his day. In writing and in drawing, as in language, the Pennsylvania German was a member of the Pennsylvania community—participating, sharing, and contributing to the life of early American culture.

Fig. 297. Frederick Graff, title page with drawing. From F. Graff, "First Book of Architecture," Philadelphia, 1798. Ink and watercolor. (Joseph Downs Manuscript and Microfilm Collection 76 x 138.1, Winterthur Museum Library.)

Index

[Page numbers in **boldface** refer to illustrations.]

Notes on Contributors

SCOTT T. SWANK
is Deputy Director for Interpretation at Winterthur. He has had a long-standing interest in the Pennsylvania Dutch and, since 1974, has had the advantage of working with the world's largest and finest collection of Pennsylvania German artifacts—the Winterthur Museum collection.

BENNO M. FORMAN
was a recognized authority on seventeenth- and eighteenth-century American furniture who taught at Winterthur until his death in 1982 at the age of fifty-one.

FRANK H. SOMMER
is Head of Winterthur Museum Library and has done work in the fields of archaeology and anthropology.

ARLENE PALMER SCHWIND,
formerly associate curator in charge of glass and ceramics at Winterthur, works as a museum and historic house consultant and lives in Yarmouth, Maine. She is a well-known authority on America's eighteenth-century glass industry.

FREDERICK S. WEISER
is a prolific writer, editor of the publications of the Pennsylvania German Society, and pastor of Saint Paul's Lutheran Church, Biglerville, Pennsylvania.

DONALD L. FENNIMORE
is an associate curator at Winterthur who specializes in the study of metals.

SUSAN BURROWS SWAN
is an associate curator at Winterthur and a specialist in Anglo-American needlework.

Arts of the Pennsylvania Germans